Egypt's Golden Age:

The Art of Living
in the New Kingdom
1558 -1085 B.C.

**Egypt's
Golden Age:**

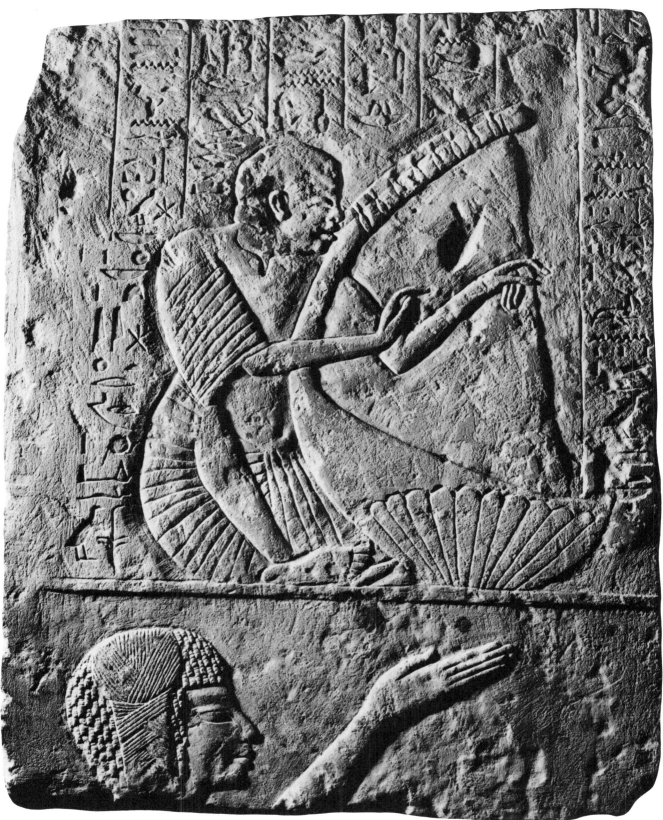

The exhibition at the Walters Art Gallery has been made possible by grants from the Mayor and City Council of Baltimore, Martin Marietta Corporation, and the National Endowment for the Humanities.

Egypt's Golden Age:

The Art of Living in the New Kingdom 1558 -1085 B.C.

Catalogue

of the Exhibition

Museum

of Fine Arts

Boston

Copyright © **1982** by the
Museum of Fine Arts, Boston,
Massachusetts

Library of Congress Catalogue
Card No. 81-84810

ISBN 0-87846-207-4

Typeset by Craftsman Type Inc.,
Dayton, Ohio

Printed by The Meriden Gravure Co.,
Meriden, Connecticut

Designed by Carl Zahn

Dates of the exhibition:

Museum of Fine Arts, Boston,
February 3-May 2, 1982

Houston Museum of Natural Science,
July 14-September 19, 1982

The Walters Art Gallery, Baltimore,
October 27, 1982-January 2, 1983

Contents

Prefaces

The Egyptian collection of the Museum of Fine Arts differs from most other collections in this field in the western world in that it was not acquired in the art market but was excavated by its own staff under an agreement with the government of Egypt. As the publication of the excavation reports by Dows Dunham has gradually made the wealth of our collection accessible to the scholarly world, the Department of Egyptian and Ancient Near Eastern Art has become an important center of Egyptian studies.

The present exhibition is the fruit of years of research by Edward Brovarski and his co-workers Susan K. Doll and Rita E. Freed. It represents an Egyptologist's response to the most recent groundswell of interest in ancient Egypt, generated by the American tour of "The Treasures of King Tutankhamun." Although much of the material in the exhibition owes its survival to Egypt's ancient mortuary traditions, it reflects not life after death but real life along the banks of the Nile as it was lived in the days of the pharaohs. We hope that this focus on the people in their daily activities will offer a human perspective on ancient Egypt, its people and its culture.

Given the scope of the exhibition, there is not room here to properly acknowledge all the members of the Museum staff who worked so diligently on this project. In addition to the curatorial personnel, I would like to make special mention of the Museum's support staff, which guided the exhibition to fruition. They include the Museum's Associate Director Ross W. Farrar, the Registrar and Assistant Registrar Linda Thomas and Lynn Herrmann, the Superintendent and Assistant Superintendent John E. Morrison and J. Clifford Theriault, the Development Office under the management of William B. Bodine, Jr., Manager of Exhibition Projects Katherine B. Duane, and my assistant G. Peabody Gardner, III. Finally, for preliminary work on this project, I wish to express my appreciation to Robert C. Casselman, former Associate Director.

The exhibition would not have been possible without two grants from the National Endowment for the Humanities, a Federal agency. One grant enabled the staff of the Department of Egyptian and Ancient Near Eastern Art to embark on the planning of this complex project, and a second makes possible its implementation and the publication of the important catalogues that accompany it.

JAN FONTEIN
Director

Ancient Egypt is known mainly through its architecture, especially the pyramids at Giza and Saqqara and the great temples at Karnak, Luxor, Edfu, Dendera, and Philae. In more recent years we have come to know Abu Simbel through the successful rescue operation at the time of the building of the High Dam at Aswan, and the treasures of the funerary equipment from the tomb of Tutankhamen through the exhibition that has traveled recently throughout major cities in America, Europe, and the Far East.

These splendid achievements arise from a wider context little known and appreciated by the general public. We think of the extraordinary and exceptional jewelry, costumes, and furnishings of the royal court, but neglect to consider the sober, careful, and imaginative craftsmanship of the property of the officials and lesser folk. In this catalogue conceived and developed by my colleague, Edward Brovarski, we have an unparalleled opportunity to see how the Egyptians of the New Kingdom lived. We see them in their finery but also visit the farm, barnyard, and kitchen. The objects included range from jewelry to humble utensils and tools, such as a plasterer's float and a winnowing fan, and utilitarian pottery and basketry. Throughout, a high standard of excellence and an uncanny and sure sense of design are inherent.

From the very earliest predynastic times the material culture of Egypt exhibits a remarkable standardization. The same superb forms of predynastic slate palettes have been found at sites from the Delta in the north to the Sudan in the south. This uniformity of excellence obtains in the New Kingdom, and, moreover, Egypt is increasingly sophisticated and international at this time. Its design repertory spreads abroad to its neighbors, and the interchange is reciprocal: Aegean and Near Eastern elements influence Egyptian crafts.

The legacy of Egypt was technological as well as artistic. Its contributions extended to agriculture, building techniques, medicine, and social development. Ethical and religious activities, best known from their literature, are also reflected in objects of daily use.

Too often we admire only the gifts for the dead. In this catalogue we hope to show the way the Egyptians lived, played, and worked.

WILLIAM KELLY SIMPSON
Curator of Egyptian and Ancient Near Eastern Art, Museum of Fine Arts, Boston
Professor of Egyptology, Yale University

Foreword

In recent years two outstanding exhibitions have offered to American audiences aspects of the culture of ancient Egypt. The first was "Akhenaten and Nefertiti," organized by the Brooklyn Museum and the Detroit Institute of Arts in tribute to the art and revolutionary ideas of the pharaoh Akhenaten, who, with his wife Nefertiti, sat on the throne of Egypt for seventeen years. The second was, of course, "Treasures of Tutankhamen," a selection of the objects discovered by Howard Carter and Lord Carnarvon in the Valley of the Tombs of the Kings at Thebes in 1922. Offered by the United Arab Republic of Egypt to the United States as a gesture of friendship in our bicentennial year, the exhibition was organized by the Metropolitan Museum of Art in New York.

Both exhibitions aroused among Americans a new interest in ancient Egypt's high culture. "Egypt's Golden Age" differs from them in one important respect: the objects in it derive not from royal tombs or temples but from the homes of average Egyptians. Some belonged to the well-to-do, others to those not so privileged. Certain pieces exhibit the refinement of the nobility, others were designed for everyday use by those of less fastidious tastes. Even the humblest exhibit the excellence of design that was the hallmark of the ancient Egyptian craftsman.

The civilizations of other countries have left behind remains of their material culture, but Egyptian funerary practices coupled with its dry climate have preserved to us a wealth of objects that seems nearly inexhaustible. Sculptures, reliefs, and paintings of all periods are familiar to a wide audience. Yet the decorative or minor arts of ancient Egypt, unlike those of the Far East, are little known. In the New Kingdom, when the country's rapidly growing prosperity was no longer, as in earlier periods, confined to a privileged few, the decorative arts flourished as never before. Consequently, the period is well represented in museums and private collections and was selected as the subject of the present exhibition and catalogue.

Some of the objects included are reproduced over and again in popular books on Egyptian art, but many have never before been illustrated, even in scholarly works. Together they present a reasonably complete picture of life in an affluent age, when Egypt ruled much of the ancient Near East. Through them we hope to introduce the average American of today to his ancient counterpart. In keeping with this theme, an effort has been made to exclude objects known to have belonged to royalty. In one instance, because of its rarity (cat. 400), we have violated our own stricture, and in a few other cases it might be open to question whether the pieces were owned by royalty. In another instance, a lyre with horses' heads (cat. 365), probably later in date than the New Kingdom, is included because it conforms to an earlier type. When all is said and done, we believe that the visitor will come away sharing with us the feeling that the Egyptians were among the most attractive peoples of antiquity.

Many more people were involved in the realization of this exhibition and catalogue than there is room to thank here by name. A grant from the National Endowment for the Humanities permitted us to visit the various European collections, and we would like to express our appreciation to the directors and curators in West Berlin, Brussels, Cambridge, Hannover, Hildesheim, Leiden, Liverpool, London, Manchester, Munich, Oxford, and Paris. Besides providing access to their collections and storerooms, their staff members spent long hours with Edward Brovarski and Wayne Lemmon, the Museum photographer, examining and photographing objects for study and exhibition. Special thanks are extended to the authorities of the Egyptian Antiquities Organization and the Egyptian Museum in Cairo, who provided photographs of several objects illustrated in the catalogue. Gratitude is likewise due the curators on this side of the Atlantic in Baltimore, Berkeley, Brooklyn, Chicago, Cleveland, Corning, Detroit, Grand Rapids, New York, Philadelphia, Princeton, St. Louis, Toledo, and Toronto for their generous expenditure of time and effort. We would like to acknowledge in particular the active interest of Ernst Kofler of Lucerne and Norbert Schimmel and Frederick Stafford of New York.

In addition, we extend our thanks to Bernard V. Bothmer, Chairman of the Department of Egyptian and Classical Art at the Brooklyn Museum and Keeper of the Wilbour Collection, for permitting us access to the considerable resources of his department and the Wilbour Library, as well as to Robert S. Bianchi, Richard M. Fazzini, and Diane Guzman for providing information otherwise inaccessible to us. For information on specific objects, thanks are due others, including Bruce Williams and John Larson of the Oriental Institute, Chicago, and Bettina Schmidt of the Roemer-Pelizaeus Museum, Hildesheim.

The decorative arts of ancient Egypt have been the subject of limited scholarly research. Given the dimensions of the task imposed, we are greatly indebted to the scholars at home and abroad who contributed essays and entries for the catalogue in their particular field of expertise. The task of integrating over twenty individual and diverse styles of writing fell to Judy Spear, Editor in the Department of Publications at the Museum of Fine Arts, who pursued it with diligence and enthusiasm. We benefited much from consultations with Jonathan Fairbanks, Curator, and Robert Trent, Research Associate, in the Department of American Decorative Arts. who generously shared with us their extensive knowledge of furniture making. The line drawings in the text and the hieroglyphic appendix are the work of Lynn Holden, Curatorial Assistant in the Department of Egyptian and Ancient Near Eastern Art. The catalogue was designed by the Director of Publications, Carl Zahn.

The design for the installation was the work of Tom Wong and Judith Downes. Preliminary drawings for the installation were the product of Timothy Kendall, John Halper, and Susan Osgood. The staff of the Research Laboratory under Lambertus van Zelst took great interest in cleaning and restoring objects. Catherine Hunter, Acting Curator of Textiles, and Leslie Smith, Associate Conservator, cleaned and mounted the linen fragments included as cat. 208. Joanna Hill, Conservation Assistant in the Textiles Department, reconstructed the tunic of Nakht (cat. 206) in modern materials for exhibition. Genevieve Good arranged for the trees, shrubs, and flowers in the Egyptian garden, and Mimi Braverman organized the exhibition lecture series.

Special acknowledgement is due the consultants for the exhibition, to Mme. Christiane Desroches-Noblecourt, Inspecteur Général des Musées de France and Chef du Département des Antiquités Egyptiennes, for her interest in the exhibition from its inception and her continued encouragement; to Nora Scott, Curator Emeritus of Egyptian Art at the Metropolitan Museum of Art, and Henry G. Fischer, Wallace Curator of Egyptology at the same institution, for reading preliminary drafts of the catalogue and for their helpful comments and criticisms; and to John D. Cooney, Curator Emeritus of Ancient Art at the Cleveland Museum of Art, and William H. Peck, Curator of Ancient Art at the Detroit Institute of Arts, for their invaluable advice.

In conclusion, we would like to thank William Kelly Simpson, Curator of Egyptian and Ancient Near Eastern Art, for his unflagging interest and support, without which the exhibition would never have become a reality, and the staff of that department—Timothy Kendall, Lynn Holden, Mary Cairns, Suzanne Chapman, Gretchen Spalinger, Sue d'Auria, and Peter Lacovara—who contributed to the exhibition in so many ways.

EDWARD BROVARSKI

SUSAN K. DOLL

RITA E. FREED

Lenders

The Art Museum, Princeton University

Ashmolean Museum, Oxford

Baker Museum for Furniture Research, Grand Rapids

The Bancroft Library, University of California, Berkeley

British Museum, London

The Brooklyn Museum

Cleveland Museum of Art

The Corning Museum of Glass

Detroit Institute of Arts

Field Museum of Natural History, Chicago

Fitzwilliam Museum, Cambridge (England)

Kestner-Museum, Hannover

E. and M. Kofler-Truniger Collection, Lucerne

Lowie Museum of Anthropology, University of California, Berkeley

Manchester Museum, University of Manchester (England)

Merseyside County Museums, Liverpool

The Metropolitan Museum of Art, New York

Musée du Louvre, Paris

Musées Royaux d'Art et d'Histoire, Brussels

Museum of Fine Arts, Boston

The Oriental Institute Museum, The University of Chicago

Pelizaeus-Museum, Hildesheim

Rijksmuseum van Oudheden, Leiden

Royal Ontario Museum, Toronto

The St. Louis Art Museum

Norbert Schimmel Collection, New York

Science Museum, London

Staatliche Museen Preussischer Kulturbesitz, Agyptisches Museum, Berlin

Staatliche Sammlung Agyptischer Kunst, Munich

Frederick Stafford Collection, New York

Toledo Museum of Art

University College, London, Petrie Museum

University Museum, Philadelphia

Victoria and Albert Museum, London

Walters Art Gallery, Baltimore

Chronology

Dynasty 18, ca. 1558-1303 B.C.

Ahmose
Amenhotep I
Thutmose I
Thutmose II
Queen Hatshepsut
Thutmose III
Amenhotep II
Thutmose IV
Amenhotep III
Akhenaten
Smenkhkare
Tutankhamen
Ay
Horemheb

Dynasty 19, ca. 1303-1200 B.C.

Ramesses I
Seti I
Ramesses II
Merneptah
Amenmesses
Seti II
Siptah
Queen Tawosret

Dynasty 20, ca. 1200-1085 B.C.

Sethnakhte
Ramesses III
Ramesses IV to Ramesses XI

Authors

J.D.B. Janine D. Bourriau, Cambridge (England)

E.B. Edward Brovarski, Boston

W.V.D. W. Vivian Davies, London

S.K.D. Susan K. Doll, Boston

M.E.-K. Marianne Eaton-Krauss, Berlin

B.F. Biri Fay, Berlin

R.E.F. Rita E. Freed, Boston

S.M.G. Sidney M. Goldstein, Corning

G.G. Genevieve Good, Boston

A.G. Andrew Gordon, Berkeley

L.H.H. Lynn H. Holden, Boston

C.A.H. Colin A. Hope, London

T.K. Timothy Kendall, Boston

P.L. Peter Lacovara, Chicago

C.L. Christine Lilyquist, New York

P.D.M. Peter Der Manuelian, Boston

J.K.M. John K. McDonald, New York

A.J.M. Angela J. Milward, London

D.N. Del Nord, Boston

D.O'C. David O'Connor, Philadelphia

W.H.P. William H. Peck, Detroit

J.F.R. James F. Romano, Brooklyn

L.S. Larry Salmon, Boston

D.P.S. David P. Silverman, Philadelphia

G.L.S. Gretchen L. Spalinger, Auckland

P.V. Pamela Vandiver, Cambridge (Massachusetts)

E.T.V. Emily Townsend Vermeule, Boston

C.Z. Christine Ziegler, Paris

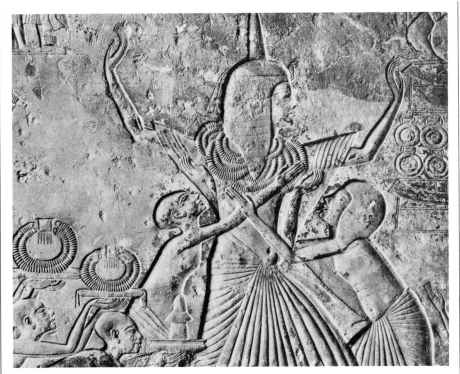

Fig. 1. Horemheb invested with the Gold of Honor
(in a relief from his tomb at Saqqara; Rijksmuseum,
Leiden C. 1-3.)

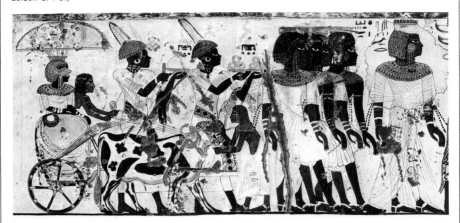

Fig. 2. The linen garments of this Nubian
delegation in the tomb of Huy, Viceroy of Kush in
the reign of Tutankhamen, are distinctly Egyptian,
but the hairstyles, the feathers, and the ivory
necklets and bracelets are southern features.

Introduction

Egypt in an Imperial Age

Within a few generations of the expulsion of the Hyksos — the foreign invaders who occupied Egypt for a hundred years during the Second Intermediate Period — the pharaohs of Egypt conquered a vast territory stretching from the Fourth Cataract of the Nile in the Sudan[1] to the Euphrates in Syria.[2] The wealth of an empire mounted steadily, at first as plunder from Egypt's victorious armies, later as tribute from the vassal states of Asia and Africa. From Asia came silver and lapis lazuli, turquoise and other precious stones, copper and lead, horses and their chariots, slaves, wine, incense, oil, woods and resins, sweet-smelling herbs,[3] elaborate gold and silver cups and vases, and furniture, all wonders of foreign workmanship and ingenuity. From Africa came ebony, ivory, fine woods for furniture, fragrant gum resins for use in incense, ostrich feathers and leopard skins for ceremonial flabella and priestly garb, and monkeys and giraffes destined for the royal zoos, as well as red jasper and green feldspar[4] and gold in bars, rings, and bags of nuggets and dust. The pharaohs of the New Kingdom corresponded and exchanged diplomatic presents with their counterparts in far-off Mitanni, Babylon, Assyria, Hatti (the land of the Hittites), and the Greek isles. Egypt was rich as never before, and Tushratta of Mitanni wrote to Amenhotep III: "So let my brother send me gold in very great quantity without measure. For in my brother's land gold is as plentiful as dust"![5]

To conquer so great an empire, the pharaohs needed soldiers, and the small army of regular troops maintained in earlier periods became a standing national army of considerable size.[6] For the first time, the Egyptians spoke of "our army" with a sense of pride, and country folk from the far south of Egypt hastened north to swell the ranks of recruits. Many saw it as a chance for excitement, advancement, and reward, for deeds of bravery on the battlefield were rewarded with gold ornaments and decorations. All members of the armed forces shared the slaves, weapons, jewelry, clothing, and household effects captured from an often prosperous and luxuriously equipped enemy.[7] As patron of Egypt's far-flung empire, the god Amen-Re of

Thebes received a lion's share of its revenues.[8] His great temple at Karnak (fig. 6) became the richest shrine in the land, its portals and obelisks gleaming with gold. Much of Amen-Re's income reverted to his clergy in recompense for their services.

A civil service was necessary to govern Egypt's newly conquered domains, and membership in the civil service was to a great extent based upon education and natural ability, regardless of birth.[9] Hardworking members of the pharaoh's court and administration were rewarded with strings of disk beads, the "gold of honor" (fig. 1).[10]

By such means the wealth of the empire was widely distributed and there arose a substantial middle class of soldiers, priests, and civil servants who grew rich in the service of the king and state. The country's rapidly growing prosperity was no longer, as in the Old and Middle Kingdoms, confined to a privileged few but was shared by many of Egypt's citizens.

The citizens of Egypt's empire also benefited from the Pax Aegyptiaca that endured for over a century. Syria and Palestine enjoyed a stability of government that had never before been theirs, and commerce thrived.[11] The city-states of Syria and Palestine continued to retain their kings or princes, once they had sworn an oath of allegiance to pharaoh, and loyalty and the flow of tribute were maintained by Egyptian resident commissioners, whose powers extended to quelling disturbances in the cities and settling local disputes between city-states.[12] Africa was subjugated as far as the Fourth Cataract and Egyptianized as far as the Second Cataract, with artistic conventions of Egypt being adapted by Nubian craftsmen. Although the local rulers (see fig. 2) retained their titles and honors and continued to enjoy a share in the government,[13] they also maintained a sense of identity. In 1961, the tomb of the Prince of Miam, Hekanefer, was identified at Toshka East in Nubia.[14] The chapel was of Egyptian type and around the entrance were carved prayers to Egyptian gods and representations of Hekanefer in Egyptian costume.[15] For a long time before 1961 Hekanefer had been known from a wall painting in the Theban tomb of the Nubian viceroy Huy,[16] where he

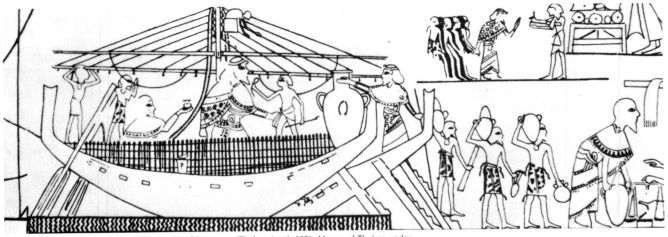

Fig. 3. A Syrian trading scene from the tomb of Kenamen (Theban tomb 162), Mayor of Thebes under Amenhotep III: small-scale private trading between Syrian sailors and Egyptian merchants takes place in the harbor.

appears in a colorful costume.[17]

The long interval of peace after the reign of Thutmose III provided the leisure to enjoy the fruits of conquest. Expanding commerce and foreign trade provided material luxuries unheard of in earlier times. Through trade, a profusion of new materials became available and skilled labor was not lacking to convert them into symbols of wealth. All the world traded in Egypt's markets. Syrian merchants in gaily colored woolen garb disembarked from sailing ships with great jars of oil and Syrian wine for sale[18] (fig. 3). Richly laden galleys of Aegean registry carried the decorated vessels and damascened bronzes from the Mycenaean industrial settlements of the Aegean, and the products of Egyptian industry appeared in the palaces of Knossos and Mycenae.[19] The light-hearted elegance of the Aegean world had a special appeal for the Egyptian artist of the New Kingdom, and Aegean forms were imitated in native Egyptian materials like faience. (Syrian wares were also imitated.) Glass vessels first appear, in great perfection and great beauty, in the Eighteenth Dynasty, perhaps resulting from inspiration from Asia, where the technique of glass-making had previously been perfected. From Asia, too, came new plants and trees and their fruits, like the pomegranate, to grace the tables of the wealthy. The humped bull, an animal related to the *zebu,* or Brahmany bull, of India, was first introduced into Egypt in the Eighteenth Dynasty, as was the barnyard fowl, which laid an egg every day, much to

the surprise and delight of the Egyptian farmer.

The minor arts flourished as never before in the country's history. Taste, fantasy, and skill were admirably combined in a series of exquisitely carved small objects that had no more serious purpose than to delight and amuse their owners.[20] Of course, demand for more and more luxuries produced objects whose design did not unfailingly conform to the highest standards of good taste but, by and large, in all the refined arts, the New Kingdom was an age as elegant as that of Louis XIV and as inventive as the West in the era of Art Nouveau.

Out of this background of wealth and material comfort there emerged a cosmopolitan and urbanized society, transformed by many factors. By the late Eighteenth Dynasty the country swarmed with Asiatic slaves, captives of Egypt's foreign wars. As captives, they might be branded with the name of the pharaoh,[21] but the position of the slave was not one of abject servitude, as in other climes and ages; a slave could marry a free woman and could even be a landholder with a right to dispose of his property.[22] Partly through them, foreign notions permeated Egyptian thought, and Semitic gods like Reshep, Astarte, Qadesh, and Baal found a place in the Egyptian pantheon. Scribes were fond of garnishing their writings with foreign loan words, which passed into the common parlance. The old notion of Egypt as a land apart was dispelled. The Egyptians saw the pharaoh ruling lands far beyond the boundaries of

Egypt, and they grew accustomed to the idea of a larger rule that included a great part of the world they knew. At the end of the dynasty, Akhenaten became convinced that the sun god was the god of the whole world and had created all races of men, Egyptians and foreigners alike.[23]

Akhenaten's heresy was short-lived, but many a foreigner continued to find favor at court. A Syrian sea captain was even able to procure a son of Ramesses II for his daughter in marriage.[24] At the same time, the army came to be controlled by generals of foreign blood who commanded a rank and file composed increasingly of foreign mercenaries. By the end of the New Kingdom the martial age and the creative spirit had passed in Egypt, not to be revived for several centuries. E.B.

1. Säve-Söderbergh 1950, pp. 36-39; Vercoutter 1956b, pp. 67-70.
2. See Kemp 1978, p. 44.
3. Gaballa 1977, pp. 122-123.
4. Ibid.
5. Breasted 1905, p. 334.
6. Hayes 1973, pp. 363-364.
7. Ibid., p. 371.
8. Hayes 1973, pp. 324-326.
9. Ibid., pp. 353ff.
10. Schäfer 1934; Hermann 1963; Feucht 1976.
11. Kenyon 1973, p. 556.
12. Kemp 1978, pp. 45-47.
13. Ibid., pp. 34ff.
14. Simpson 1963, pp. 2ff.
15. Ibid., p. 9, fig. 7.
16. Davies and Gardiner 1926, p. 23, pl. 26.
17. Cf. Kemp 1978, pp. 36-37.
18. Davies and Faulkner 1947; Davies 1963, p. 14, pl. 15.
19. Breasted 1912, p. 337.
20. Hayes 1973, p. 414.
21. Bakir 1952, pp. 98-99; Caminos 1954, pp. 24, 230, 408.
22. Bakir 1952, pp. 97-98.
23. Breasted 1912, pp. 312ff.
24. Spiegelberg 1894, p. 64.

Literature: Hayes 1973, pp. 313ff; Kemp 1978.

Cities and Towns

The cities and towns of the New Kingdom arose out of a long history of urbanism in Egypt, although this fact has often been difficult to recognize, since their mud-brick walls have all but vanished. While many scenes of daily life have survived in the temples and tombs of Egypt, actual depictions of towns are rare and, when attempted, appear in very summary form, partly because the conventions of Egyptian art made it difficult to depict such large and architecturally complex entities. Temples and tombs, which were very important to the Egyptians, are rarely, if ever, depicted before the New Kingdom for the same reason. Likewise, the presence of the town is not felt in the textual record. Texts from temples and tombs were concerned with religious matters, and archival texts with the minutiae of administration and daily life. Both types of text include a number of terms that have long been translated as "town," "city," "village," "fortress," and the like.

The archaeological reality behind these terms, however, was sufficiently unobtrusive to suggest to some that Egypt was a "civilization without cities," but recent research has conclusively demonstrated that towns became recognizable features of the archaeological landscape in the early third millennium B.C., in association with the development of a centralized and literate government. These towns were comparatively large and internally complex entities, and the houses and streets within them probably developed in an irregular and "organic" fashion. The Egyptians were quite capable of laying out a settlement within a rigid, rectilinear framework with houses of uniform type and size, and a number of such sites have been excavated on the desert fringes of the valley. Their functions, however, were unusually specialized ("pyramid" towns, fortresses, workers' villages) and they may not have represented the norm followed in a more diversified town.

The origins of towns in Egypt, and the complex combinations of social and economic conditions that contributed to their history, cannot be understood without much more excavation. One general process, however, is already clear in the textual and pictorial record. In periods of internal disunity and stress, of which there were three major instances in ancient Egyptian history, towns became heavily fortified and perhaps their internal plans were modified in the interests of defense. In peaceful periods of centralized government before the New Kingdom, towns sometimes (and perhaps usually) had a defining wall but not a fortified one. Towns, however, seemed to concentrate on the same site for a very long period, and it is not until the New Kingdom that there is good evidence for a major lateral expansion of individual towns, and even the partial abandonment of the old, inconveniently high city mound.

The general settlement pattern fell into a hierarchical pattern, headed by royal centers, provincial capitals, and some other sites, all three categories consisting of true towns. Urbanism naturally had its effects beyond the confines of the town: there is evidence suggesting that in times of stability there was a comparatively dense zone of agricultural villages surrounding each center, an indication that the town had particular attractions and conveniences, whereas further away from the town settlement thinned. Unfortunately, we know little of the settlement pattern in disturbed periods, but it is reasonable to infer that settlement contracted in toward the now fortified centers and that the population of the towns increased as people sought security within them. In considering the sizes of Egyptian towns (on which we have no exact information) we must remember that we are dealing with an order of magnitude much smaller than that of modern Egypt. Today Egypt's population is over 40 million; in ancient times it probably never exceeded 4 or 5 million.

Urbanized Society in New Kingdom Egypt

Urbanized Egyptians had permanent residences in the cities and towns and their work and lifestyle differed in important ways from those of rural society. However, the interconnections between town and country were very strong in both utilitarian and symbolic terms and this fact strongly affected the physical structure and appearance of Egyptian towns. Some of the interconnections are obvious. The main cult centers were usually located in towns and from these temples emanated the divine power sustaining the cycle of inundation and abundant harvest upon which Egypt's survival depended; government was a town-based phenomenon that intervened obviously into rural society through tax collectors, the recruiters of military and state labor forces, and officials administering justice.

But there were other more complex interrelations, typified in the Wilbour Papyrus, a record of rents and dues owing on temple lands in approximately 1141 B.C.[1] In this ancient accounting document we find high-ranking officials and priests renting large farms that their agents worked for the lessor's profit and, from elsewhere, we know that elite members of urban society owned country estates and appreciated the bucolic pleasures of rural life. We also find that many men from the lower ranks of temple establishments were assigned small, dues-paying farms and worked them directly for their family's subsistence. Some of these men were typically rural, e.g., cultivators and herdsmen, but others were *wab* priests and scribes who must often have had duties and quarters in the provincial towns of the region. Other small holders were military men, mainly chariot masters and soldiers, apparently assigned the land in return for their service to the government but paying dues to the temple owning the land. Although most of them probably lived in the countryside, some presumably served tours of guard duty in the towns, and many would have been periodically drawn into the great armies mustered at the royal cities and launched against the city-states of Palestine and Syria or against the powerful tribes of the Sudan.

Egyptian society was divided vertically into professions and occupations; horizontally it formed a strongly defined socioeconomic hierarchy. The elite was numerically small but wealthy and influential. It was composed almost entirely of individuals in the upper ranks of the various segments of government — the royal domain (palaces and estates throughout Egypt), the civil government, the ecclesiastical establishment, and the armed forces — and was distributed throughout the royal cities and provincial centers of the country. The elite of the royal cities was the wealthier and more influential but was susceptible to purges by newly crowned or dissatisfied kings; that of the provinces was poorer and more countrified but more secure in the hereditary possession of its offices and sinecures. Both were urban in the sense that their duties were a result of the existence of towns and they divided their life between town and countryside.

The middle and lower classes included many who belonged to the lower ranks of government service, a large segment of whom lived and worked in towns, although others were located in the rural villages. Towns also contained large service populations that met the needs of institutions and the elite; these populations included servants, laborers, and specialists of various kinds, particularly important among the latter being artisans (metalworkers, sculptors, woodworkers, painters, and the like). Artisans seem to be chiefly an urban phenomenon, for they rarely appear in lists of landowners or renters; their subsistence was apparently derived from institutional wages and salaries, and from participation in the private market. Both in towns and in villages many artifacts and manufactured items were probably produced directly by households, but the demand for more specialized artifacts and products would certainly be higher in towns than in the countryside. By far the greater part of the national population was rural, made up of the rural representatives of the institutions that owned most of the land (the kingship, temples, and government departments), of the inhabitants of privately owned estates and farms, of many tenants and dues-payers, and of

landless agricultural laborers and herdsmen.

The existence of urbanized society in New Kingdom Egypt provokes some important questions. What did the cities and towns look like and how did they function? In what ways did a city's overall plan, and the specific plans, architectural forms, and decoration of the structures the city contained, reflect its symbolic and utilitarian functions and the lifestyles of the various strata of the community inhabiting it? Only two sites provide some reasonably representative, if still partial, answers to these questions. One is Akhetaten (Amarna), of which large sections of the actual city have been excavated. The other is Thebes, best documented in terms of its monumental skeleton of temples and rock-cut tombs but still yielding some important archaeological, textual, and pictorial information about its appearance and life as a city.

The essential characteristic of an Egyptian royal city was that it combined a major and permanent royal residence with the offices and residences of a substantial part of the national government. Usually there was more than one royal city in a given period, for the requirements of efficient government and communication in the long, ribbon-like country encouraged the sharing of royal government between Memphis and Thebes. Briefly, Akhetaten appeared as a new royal city of superior status to the other two and later Per-Ramesses in the eastern Delta became a permanent third (and higher ranking) royal city.

The functions of the royal cities were both utilitarian and symbolic. New Kingdom government was a comparatively highly centralized one, dominating a national redistributive economy (which still permitted a substantial if subordinate private market to exist). The offices of government were naturally located in the same cities as the chief royal residences, for the king was the effective political leader. He was also society's religious leader, the sole mediator between men and the all-powerful gods upon whom the stability of Egypt and the universe depended. Throughout the country were many temples and chapels in which priests officiated in

the king's name, but the major power of the gods was focused at the royal cities. Here the chief gods had their greatest temples (of Amen-Re at Thebes, and Ptah at Memphis) and the royal city was regarded (as in many other cultures) as an *axis mundi,* a specific intensely sacred area in which the divine creation of the universe was continually reenacted, the forces of supernatural chaos successfully resisted, and the great cycle of the supernatural renewal of nature and of the institutions of Egyptian society maintained in perpetuity. Thus, Thebes was described as the site of the first ground created out of chaos, the place where mankind was created, and the archetype of every city; daily, the gleaming sun-disk rose over Akhetaten, banishing night, the symbol of primeval chaos and darkness, rejuvenating all living creatures and perpetually renewing the creative process. Per-Ramesses was the center of the universe, the sun (god) rose and set within it, and the king's temple there was like the horizon of heaven. For the most part, the phrases are interchangeable from one royal city to another, and the theme is the same; the royal city and its natural setting symbolize the source of creative power, a concept that strongly influenced their design.

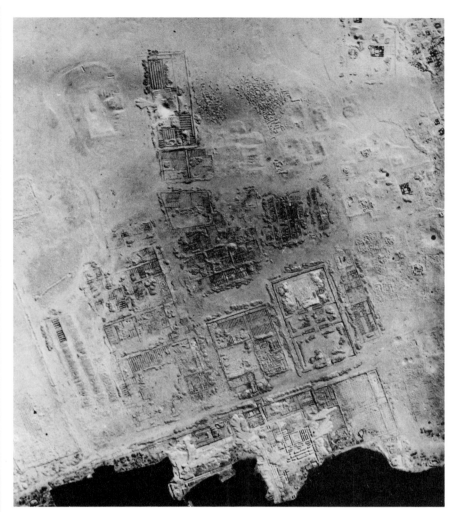

Fig. 4. Aerial view of the central city at Akhetaten (Amarna).

Akhetaten and the Urbanized Elite

Akhetaten has preserved for us a New Kingdom royal city (fig. 4) and a vivid impression of its elite society, both frozen at a particular moment in time, the reign of Akhenaten (ca. 1379-1362 B.C.). The picture is not complete, for large parts of the city have been destroyed or are not yet excavated and the informative decoration in the tomb chapels of the elite was often unfinished. Moreover, some aspects of the city are atypical. Akhenaten imposed upon the traditionally pantheistic Egyptians a monotheistic religion, focused on the Aten or sun-disk, and his temples, in response to novel theological and ritual needs, deviate substantially from the New Kingdom norm. Simultaneously, Akhenaten elevated the divine aspects of the king to an unprecedented height, so the architecture for royal ceremonial is

probably also innovative. However, even in these two areas Akhenaten was basing himself on existing tendencies in religion and royal ideology, while in other areas he remained traditional. The normal administrative structure was maintained and official customs and ideology were skillfully manipulated to reinforce the loyalty of bureaucrats, soldiers, and priests. Closest of all to traditional models were probably the nonroyal residential zones, and perhaps even the royal.

The origins of the city reveal the rich intermixture of the symbolic and utilitarian that pervaded not only Akhetaten but also the other royal cities throughout the New Kingdom. Political reasons may have influenced Akhenaten's move to a virgin site, but in the formal statements about the city's origin the symbolic is dominant.

Seeking a new city site as instructed by the Aten, the king found in Middle Egypt a suitable plain dominated by hills resembling the hieroglyph for horizon, a clear sign that Aten had created this setting for Akhetaten, "the horizon of the Aten." Quite secular and probably typical of other newly founded or rededicated cities are the defining of the city boundaries in Year 4, and of its territorial boundaries in Years 6 and 8, accompanied by an oath that Akhetaten, as a corporate entity, would not absorb territory beyond its boundaries. Yet here, too, symbolism emerges, for the agricultural land of Akhetaten, on the opposite bank of the river, was defined strictly by the imagined projection of the horns of the horizon in which the city was set, a microcosmic version of the Aten's absorption of the entire

world from its "real" horizon. By Year 9 the court and government had moved into the city (fig. 5) to remain there until Akhenaten's death in his seventeenth regnal year; within a generation after that, it was completely abandoned.

From the outset, there was a concept of how, in broad terms, the city should be laid out in order to fulfill symbolic and utilitarian functions. This is evident from a list of projected structures given on some of the boundary stelae and in a deliberate functional patterning in the city architecture, a patterning reflected in the elite cemetery, which was planned at the same time. The city is a ribbon-like feature running along the east bank of the river and divided into (from north to south) a residential palace zone with a ceremonial palace, a private residential zone, the main cult structures, the bureaucratic center, another private residential zone, and finally another cult place called a "Maru-Aten." This pattern influenced the disposition of the elite cemetery in the eastern cliffs, with officials of the king's private quarters (i.e., royal residential zone) buried nearby, the chief ecclesiastics in tombs loosely overlooking the main cult area, and the bulk of the more secular officials of national and city government buried to the south, overlooking their chief area of residence but also more distantly the bureaucratic center where they carried out their duties. The royal family tomb was set deep in desert valley, at the approximate center of the natural "horizon."

The relationship between the elite and the city is—in some aspects—rendered uniquely vividly in the decorated tombs; nowhere else in Egyptian tomb decoration are parts of the cityscape so frequently and carefully (albeit impressionistically) rendered. The official hierarchy revealed in the tombs and elsewhere on the site is, with some changes in detail, the traditional one of the New Kingdom; apart from the residential palace officials and the ecclesiastics mentioned above, there was the vizier (roughly, prime minister), two important chancellors with responsibility for economic and related matters, and several high-ranking military officers, as well as such purely city officials as the mayor

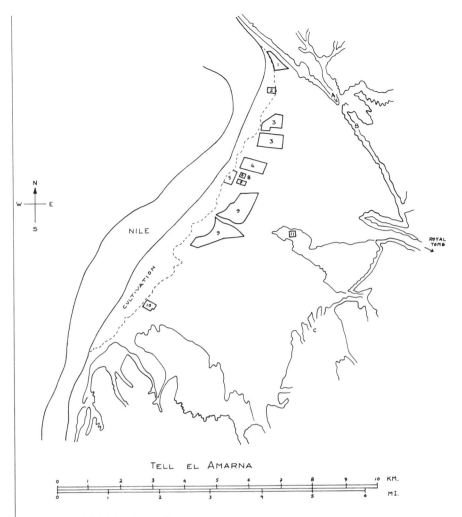

Fig. 5. Map of Akhetaten (Amarna).

1. Northern royal residential palace
2. "North Palace"
3. North residential zone
4. Great Temple="House of the Aten"
5. Great Palace="House of Rejoicing of the Aten"
6. King's House=the palace of the "Mansion of the Aten"
7. The Temple of "the Mansion of the Alten"
8. Offices of the bureaucracy
9. Southern residential zone
10. Maru Aten
11. Workers' village

A. Tombs of the residential palace administrators
B. Tombs of the ecclesiastics
C. Tombs of the officials of national and city government

and the chief of police. The decoration in their tombs follows a consistent pattern, reflecting principally their varied duties (and the architectural settings in which they occurred) in the ceremonial or symbolic life of the city, with the utilitarian being present chiefly by implication, although occasionally it becomes overt.

A reasonable, if to some degree hypothetical, functional interpretation of Akhetaten can be derived from the evidence of tomb decoration and texts combined with the archaeological remains of the city and associated inscriptions. The symbolic importance of the site was asserted by the visual dominance of its chief cult centers. These were two structures at right angles to each other, covering in all (including open spaces defined by enclosure walls) over thirty hectares. Built mainly of stone and once richly decorated with scenes in relief, the structures consisted of a roofless "House of the Aten" and a "House of Rejoicing for the Aten," partially roofed and intended probably for the celebration of the royal cult. Both occupied an area described as the "Island of Aten distinguished in jubilees," a term reminiscent of the primeval island on which creation began, and were probably for the celebration of the perpetual renewal of Aten and the king, so closely identified at Akhetaten as to be virtually two aspects of the same divine being.

South and east of the principal cult centers was a complex of buildings identified collectively as the "Mansion of the Aten," a term combining the concepts of a symbolically fortified temple and of an administrative district or center. This complex was the focus of the ceremonial and official life of the government, and symbolically (as well as, in topographical terms, literally) it marked the transition from the sacred "island" of the festivals of Aten and the king to the impure and mundane world, where there was potential harm from the omnipresent forces of supernatural chaos. The chief features of the "Mansion" were a small palace, which played a major role (described below) in official life and which was linked by a bridge to the "House of Rejoicing," the palace-like temple of the royal cult; adjacent to this was an Aten

temple surrounded by a pseudo-fortified supernaturally protective wall traditionally erected around Egyptian temples. This temple was, in all probability, the "city temple," the focus of the general population's ritual activity, while the greater Aten temple was more specifically linked to the king's ceremonial life. Extensive magazines were attached to both Aten temples and the small palace, a dramatic expression of the inflow of goods and items required for the cults and the support of the royal and temple establishments.

The small palace presented its blank eastern wall to an extensive complex of buildings running off to the east. These consisted of many offices, known to have been occupied by the staffs and archives of various government departments, and they culminated in a regularly laid out series of four large, impressive complexes of gardens, halls, and magazines, perhaps the administrative centers of the four highest government officials. On their east was an extensive building, archaeologically shown to have housed many horses; it was perhaps literally the "parking lot" at which the horses and chariots of officials arriving from the residential zones were kept.

Extensive residential zones were situated north and south of the central quarter. For the most part, they lay east of a wide north-south avenue, which was the structural backbone of the western part of the city. To the south it led to a "Maru-Aten," a formally laid out, garden-like cult place intended for the recreation of the Aten; to the north to a ceremonial "North Palace," roofed at the rear and intended for the king. Different in plan from the "Maru-Aten," this palace, by combining pools, gardens, an aviary, and animal stalls, conveyed also the impression of a temple-like recreation area, perhaps a rough royal equivalent to the Aten's "Maru." Finally, in the extreme north a monumental ramp over the road marked the entry to the residential palace complex of the royal family, the principal structures being enclosed by a massive towered wall.

The ceremonial life of Akhetaten revolved around the king as much as the Aten; and the king's frequent processions through the city enhanced his

divine status by recalling the frequent public processions of the traditional gods, now abolished. The regular routine seems to have been for the king and his retinue to ride down the avenue to the small palace of the "Mansion," and to eat there before proceeding to a ceremony elsewhere in the central zone. These ceremonies included cult activities in the "House of the Aten" and probably in the king's "House of Rejoicing;" the periodic reception of tribute from the empire, depicted with great vividness in two of the elite tombs; and the carefully and impressively stage-managed ceremonies of appointing and rewarding officials. These usually took place in the small "Mansion" palace itself, with the king seated in a lofty, richly decorated "Window of Appearances," while in the courtyard below the lucky official was seen by his attendants and foreign ambassadors to be the recipient of a virtual shower of golden objects, supplemented later by a variety of other gifts. This shrewd amalgam of the symbolic and the practical demonstrated the boundless generosity of the Aten and the king, emphasized the king's extraordinary status (as did, incidentally, the remoteness of his residential palace from the city proper), and reinforced the loyalty of the bureaucracy.

In their tombs officials are often shown participating in the city's ceremonial life, the scenes varying according to specific function. Royal stewards were prominent at the reception of tribute, much of which went directly to the king's domain; ecclesiastics attended the king at the performance of ritual; the police chief supervised the security of the great avenue along which the king and his military guard passed. The high points of a career were of course the appointment and reward ceremonies, frequently depicted; the official then left the small palace, to be welcomed by a jubilant crowd including his family and staff, probably stopped outside the "Mansion of the Aten" to give thanks, and then proceeded to a celebration in his house.

So important was the symbolic life of the city that the performance of mundane duties is rarely depicted and the details of an official's domestic life never. Nevertheless, Akhenaten's

government was an efficient one, as the prosperity and internal stability of his momentous reign attests, and the material reality of the bureaucratic buildings east of the "Mansion" reflects the continuous performance of administrative tasks. Occasionally we get direct glimpses of city government, as when the police chief presents some suspicious characters captured in the desert to the vizier, the "great nobles" of pharaoh, and the king's "commanders of soldiers," standing probably before the gate of the small palace. The latter was probably the location of the frequent business meetings between king and officials necessary for effective government, a type of gathering documented in some detail during other reigns at the other royal city of Thebes. It is also clear that much of the ceremonial life of the bureaucracy at Akhetaten was derived from preceding customs, and continued to be maintained in the royal cities of the post-Akhenaten period.

Textual and pictorial information on the domestic life of the elite and the city population as a whole is non-existent, but the unique archaeological remains of the residential zones (outside the central zone) richly compensate for this. These zones were not rigidly planned; access roads were roughly sketched out and land apportioned to various groups of the future inhabitants of the city, who probably then had their house-building organized by private contractors, while simultaneously the houses of the "service population" began to grow up around the larger and more formally organized elite residences. The result is a chiefly "organic city," where clusters of dwellings continuously exhibit an internal grading from elite houses down through "middle-class" to "lower-class" ones. The overall impression is of a series of autonomous neighborhoods, reflecting a complex social and economic life.

Thebes and the Middle and Lower Classes of a Royal City

Thebes is a richer source of information than Akhetaten on at least some elements of the middle and lower classes of urbanized society. As a royal city Thebes had a political and building history very different from Akhetaten's. Thebes was a royal center from the end of the third millennium B.C., but its monumental history and the implicit urban elements are best documented in the New Kingdom (fig. 6). Two developments are visible. The temple of Amen-Re (the "national" god) on the east bank was continually enlarged, as were peripheral cult centers on the same bank. Simultaneously, along the low desert of the western side of the valley, a string of royal funerary temples gradually stretched along the foot of the towering natural peak in which the royal tombs were cut. As well as being very different in history from Akhetaten, Thebes as a whole presents the picture of a much more diffuse layout and a less explicit urban character; and its religious rituals and architecture were always traditional except during the reign of Akhenaten.

However, both in general and in specific ways, there are important parallels between Thebes and Akhetaten, indicating that in some important aspects the latter was part of the mainstream of New Kingdom urban developments. Symbolism was as overt at Thebes as at Akhetaten. The great natural peak of the west bank clearly resembled a gigantic hieroglyph for "pyramid" and was therefore associated with ideas of the primeval mound of creation, the interconnections between the natural and the supernatural, and the downpouring of the sun (god's) rays, continually renewing the universe. Opposite it was the formal cult center of the chief New Kingdom manifestation of the creator sun god Amen-Re; like all traditional Egyptian temples, it was simultaneously the palace and fortress of the god and a formalized microcosmic version of the primeval landscape of creation. And finally the royal funerary temples were the most unequivocal statement existing about the divine aspects of the kingship.

Around this monumental skeleton urban developments certainly clustered. The main city of Thebes lay east of the Amen-Re temple (modern Karnak) and its two subsidiary temples to Montu and Mut. Another Amen cult center in the south, "southern Opet" (modern Luxor), must have had an associated town, and so to some degree did the ever-growing string of funerary temples on the west. In a sense, what one had was a major urban center and some far-flung, physically quite separate suburbs, but it is important to remember that the ceremonial and official life of Thebes tied all these together. Great processional rituals linked Karnak, Luxor, and the royal funerary temples, and the administration of the entire area was centralized under the vizier.

Thebes anticipated certain aspects of Akhetaten even more closely during the rein of Amenhotep III (ca. 1417-1379 B.C.), Akhenaten's father. Amenhotep appears to have broken the formerly close topographical relationship between main cult center and royal residential palace. Until his reign there had been a royal palace adjacent to the forecourt of the Amen-Re temple, a palace that (like the palace in the "Mansion of the Aten" at Akhetaten) seems to have served as the ceremonial contact point between king and government, for formal royal audiences are several times referred to as being in the "audience hall on the west" (of Karnak). It is not clear if this was also the royal residence, or whether this was closer to the city on the east of Karnak, but there are no indications that the residence palace was away from the city area. However, Amenhotep not only built the then southernmost and largest of the royal funerary temples on the west bank (itself an indication of the growing emphasis on royal divinity that was to be so explicit under Akhenaten); he also laid out south of this at Malkata an extensive palace complex on the shores of a vast (well over a square kilometer) artificial harbor. At this palace—"the House of Rejoicing"—he celebrated unusually frequent festivals of royal renewal and apparently lived there permanently in his later years.

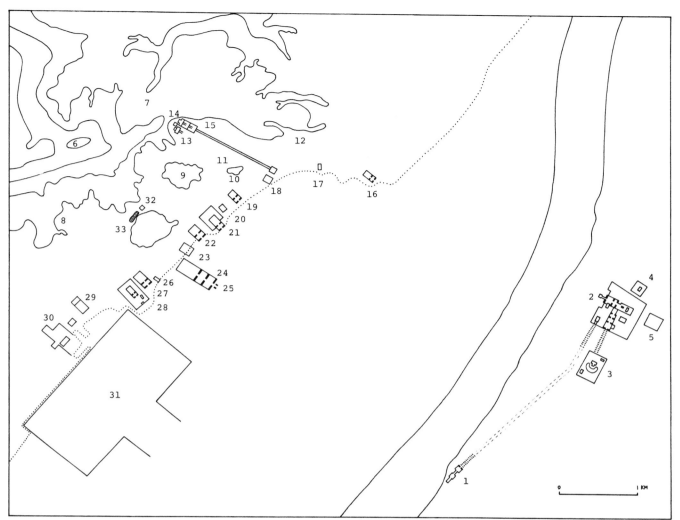

Fig. 6. Map of Thebes.

 1. Luxor Temple
 2. Temple of Amen, Karnak
 3. Temple of Mut, Karnak
 4. Temple of Montu, Karnak
 5. Temple of Aten, Karnak East
 6. El Gurn, Sacred Peak of Western Thebes
 7. Valley of the Kings
 8. Valley of the Queens
 9. Gurna
10. Khokha
11. Asasif
12. Dra Abu el Naga
13. Deir el Bahri, mortuary temple of Mentuhotep II
14. Deir el Bahri, temple of Thutmose III
15. Deir el Bahri, mortuary temple of Hatshepsut
16. Mortuary temple of Seti I
17. Mortuary temple of Amenhotep I
18. Mortuary temple of Ramesses IV
19. Mortuary temple of Thutmose III
20. Mortuary temple of Amenhotep II
21. Mortuary temple of Ramesses II
22. Mortuary temple of Thutmose IV
23. Mortuary temple of Merneptah
24. Mortuary temple of Amenhotep III
25. Mortuary temple of Amenhotep III, Colossi of
 Memnon
26. Mortuary temple of Thutmose II
27. Mortuary temple of Ay and Horemheb
28. Mortuary temple of Ramesses III
29. Temple of Amen, Malkata
30. Palace of Amenhotep III
31. Harbor of Amenhotep III
32. Deir el Medineh temple
33. Deir el Medineh, workmen's village

Amenhotep presumably still visited Karnak (by canal and river) for cult purposes and perhaps governmental reasons, for the bureaucratic center may have stayed near Karnak; his movements, celebrated with considerable pomp, recall the ritualized movements of Akhenaten around Akhetaten. There may have been built in front of Karnak a palace-cum-temple of royal divinity called ''Amenhotep III is the shining Aten,'' in the area where Akhenaten later had an apparently similar temple-palace called ''[Akhenaten] rejoices in the horizon of the Aten,'' while the former ''official palace'' may have retained an identity of its own. At least in Akhenaten's early years at Thebes the palace in which officials ceremonially dined, and which contained a ''window of appearances,'' does not seem identical with the palace ''[Akhenaten] rejoices in the horizon.''

All this material conveys the strong impression that Akhenaten adapted in a concentrated form aspects of the royal city developed by his father and himself at Thebes in order to form an ideal city at Akhetaten. This ideal was dominated by temples celebrating the identity between and continual renewal of creator-god and king. The king's exalted status required the royal residence to be remote from the city, but in the central zone, at Thebes and Akhetaten, an effective architectural setting was created for the ceremonial and utilitarian interrelations between the king and his bureaucracy.

As an urban phenomenon Thebes appears as much more diffuse and loosely integrated than Akhetaten, but within its major urban sub-units it is quite probable that we should find the same types and variable sizes of houses as at Akhetaten, and the same arrangement of them into irregularly laid out neighborhoods roughly defined by streets. The idea that New Kingdom cities consisted of multi-storied houses tightly jammed together may have been true of the oldest parts of such cities, but expansion was typical and in these new areas the pattern of Akhetaten is the one indicated by the admittedly very slight pictorial and archaeological evidence. Although few of the residential areas of Thebes have been excavated, the one major exception (apart from the palace complex of Amenhotep III at Malkata) fortunately provides some important insights into the lifestyle and houses of the middle and lower classes of a royal city.

The village of Deir el Medineh, at the southwestern corner of Thebes, is by no means fully representative of these strata of urban society. The community that occupied it had a highly specialized function, the cutting and decorating of the royal tombs, established in the early Eighteenth Dynasty, it continued to carry out this function, generation after generation, for over 400 years. The village was outside of any urban matrix, in a desert valley at the foot of the western cliffs and, as a state-founded establishment, was more rigidly planned than would be normal in most residential parts of a city. Economically, it was dependent upon wages and supplies paid by the state and it had very little agricultural land.

However, the community's skilled craftsmen were well represented in cities and towns and their general socioeconomic status was shared by a large proportion of town dwellers. Many of the houses in Akhetaten, for example, are similar in their size and living arrangements to those of Deir el Medineh, although they tend toward a square rather than rectangular plan and make considerable use of communal courtyards. At Deir el Medineh, the planned nature of the town created rectangular structures with party walls and no court-yards. Given, however, the important parallels with people of the same socioeconomic status in the cities, and the rich textual documentation at Deir el Medineh, it provides the best impression available of the life of the non-elite levels of urbanized society throughout the New Kingdom.

Despite its early foundation, Deir el Medineh is best known to us in the Nineteenth and Twentieth Dynasties, during which time the village expanded to a total of about seventy houses (plus a few outside its defining wall), representing a population of about 300. The work routine, which kept about sixty of the men away in the Valley of the Kings for twenty-seven days of every month, was unusual, but domestic life and its setting would have been replicated in the city. Despite the small size and specialized function of the community, it was nevertheless stratified socially and economically. The village elite consisted of the two foremen of the work gang, who received the highest wages, and the two scribes who administered the gang's operations and maintained much of its contact with the government (see pp. 51-52). The workers as a whole were paid varying amounts, depending on their familial status and other factors, while the lowest ranks of village society were represented by the slavewomen and serfs assigned to it by the government. The serfs would have lived in a small village (not yet discovered, but paralleled by the similar royal artisans' village at Akhetaten) outside the village wall. Internal socioeconomic differences, clear in the textual record, are visible archaeologically in the larger houses of the village elite and in the considerable variety in the size and ostentation of the family tombs in the village cemetery, immediately on its west. While to the administration as a whole the villagers were merely the ''gang'' and the ''workers,'' they had a definite image of themselves, and in nonadministrative contexts proudly called themselves ''the servants in the Place of Truth,'' i.e., the royal tomb. The character of their houses, tombs, and lifestyle shows that they were fairly affluent, and are middle class rather than lower; the latter was represented by the serfs.

North of the village were a number of chapels, some of which were rather elaborate, dedicated to the deities venerated by the villagers, who themselves functioned as the priests serving the cults, as always in the king's name. Particularly popular was the deified king Amenhotep I (ca. 1546-1526 B.C.), the first to have a tomb cut in the Valley of the Kings. When, like the gods of Thebes itself, his image was carried through the village street at the time of festival he was often asked to deliver an oracular decision. Sometimes he was asked to indicate (by forcing his bearers to move to one side or another) what was the

right personal decision for an individual; often he was asked to identify the guilty party in a crime. In the regulation of its internal affairs the village had a remarkable degree of autonomy, the local *kenbet* council (made up of the leading members of the community) resolving all disputes that did not involve capital punishment. When insufficient evidence or potential conflict among the villagers made a decision difficult, however, the *kenbet* appealed to an impeccably neutral arbitrator, their local god. Other cities and towns also had their *kenbet* councils, made up of local people who were in touch with the feelings and characters of the inhabitants and hence best able to maintain order and settle disputes. Here, too, there was involvement with the supernatural; a city had its popular local shrines, and one of the gateways of its major temple or temples was identified as a "place of hearing," where petitions could be made to the god, where the *kenbet* assembled because oaths taken before it in such a setting were particularly sacred and binding, and whence came the image in procession, no doubt to deliver oracles.

The last centuries of the New Kingdom were marked by the gradual disintegration of centralized royal government, a marked drop in the general level of prosperity and increasing disorder, as unruly mercenary troops of the Egyptian army began to harass unprotected communities. The last years of Deir el Medineh typify a process occurring all over Egypt; with government collapsing, supplies became irregular (provoking several strikes by the artisans) and, as insecurity mounted, the villagers moved into a fortified town that had developed around the nearby funerary temple of Ramesses III. As a golden age ended, strongly walled towns began to appear throughout the country and marked changes in urban life must have developed. These have yet to be documented by excavation.

D.O'C.

Bibliography: Davies 1903; Davies 1905a; Davies 1905b; Davies 1906; Davies 1908a; Davies 1908b; Fairman 1951, pp. 189-212; Nims 1965; Kemp 1972, pp. 657-680; O'Connor 1972; Smith 1972, pp. 705-720; Černý 1973a; Černý 1975; Aldred 1976, p. 184; Kemp 1976, pp. 81-99; Kemp 1977a, pp. 185-200; Kemp 1977b, pp. 123-139; Bietak 1979.

The House

Unlike the great stone monuments that gave Egyptian towns of the New Kingdom their respective "skylines," the private architecture of the period did not survive in any immediately recognizable or intact form. Rich and poor alike seem to have built their houses almost exclusively of sun-dried mud brick. Palm logs served for the columns, the staircase supports, and the ceiling beams, and upper floors and roofs were merely deep layers of puddled mud or mud bricks spread over mats that were stretched across the palm rafters. Without constant maintenance, such fragile structures fell quickly into ruin. On the flood plain, the ruins rapidly disappeared beneath the alluvium, only to be further destroyed by centuries of plowing. On the desert's edge, they were quickly eroded by wind-blown sand and buried. Nevertheless, rather crisp images of the exteriors and interiors of different types of houses of the New Kingdom can be reconstructed in our imaginations with comparatively little effort due to the variety of evidence that, remarkably, has survived.

Apart from the very substantial archaeological data, particularly that recovered from Amarna, that enable us to restore the ground plans and to some extent the interior decoration of late Eighteenth-Dynasty houses, there exist many drawings and paintings on ostraca, in papyri, and on tomb walls, providing vivid views of house exteriors and interiors. Several models of houses that may be contemporary afford three-dimensional impressions of modest homes (cats. 1 and 2), while a number of texts furnish literary descriptions of ideal country estates that seem to codify the characteristics most desired by an Egyptian in the house of his dreams.

Although at Thebes proper (see pp. 22) there are no excavated remains of houses datable to the New Kingdom, illustrations of houses belonging to members of the Theban aristocracy appear occasionally on the walls of their tombs. These fall essentially into two categories: the townhouse — which was built "downtown," possessed little or no yard, and often shared walls with neighboring houses — and the suburban villa — which was

built on the outskirts of the settled area or in the country amid substantial surrounding fields and had its own walled enclosure for a yard and garden.

The classic illustration of the first type, the ancient Egyptian "brownstone," is that found in Theban tomb 104, belonging to the royal scribe and superintendent of the treasury Djehuty-nefer (fig. 7).[1] Doubtless erected in a "posh" quarter of Thebes, this splendid, airy establishment appears to have had four stories in front and three in back with a rooftop terrace as well. The main entrance to the house, which would have appeared on the right in the now obliterated portion of the illustration, probably opened directly onto the street, via a short flight of steps from the main or second floor. Above the front door and foyer there were apparently two floors of apartments, either bedrooms or workrooms, in which partially preserved figures of servants may be seen scurrying about their chores. Three more servants, carrying various comestibles, are shown ascending a central staircase to the roof, where a scullion sets meat out to dry. The roof also provided ample space for food storage, and a row of grain bins appears along the parapet. The basement or ground floor seems to have served as the domestics' quarters and workrooms, where individuals may be seen performing such tasks as grinding corn, sifting grain, and, on the left, carding, twining, spinning, and weaving.

Beyond the stairwell on the main floor of the house lay the reception hall, an elegant room with high ceilings supported by papyriform columns and rafters decorated in colorful block patterns. Through an elegant portal, adorned with a decorative latticework lintel (cf. cat. 3), this hall led to the central room of the house, the master's living room, which had the highest ceiling of all, supported by a single palmiform column. Windows were mounted high in the wall, not so much to ensure privacy as to permit more easily the escape of heat. Furniture was set above floor level on a dais to protect it from dampness. It was in this room that the owner of the house relaxed, ate his dinner, and entertained his guests. In the evenings he and his family probably withdrew

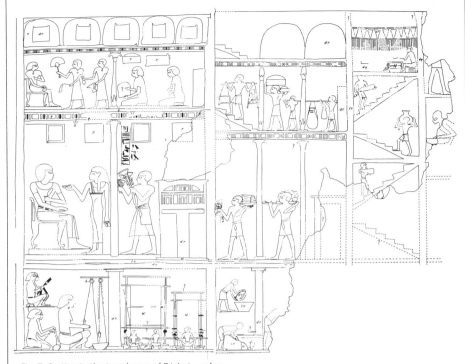

Fig. 7. Section in the townhouse of Djehuty-nefer, who takes a meal in the reception hall and conducts business in the room above.

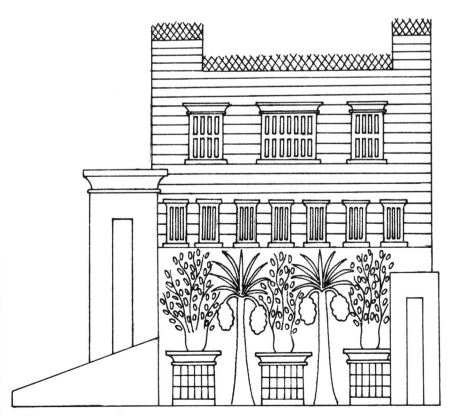

Fig. 8. Exterior view of the townhouse of Mose; similar houses were to be seen in Khargeh oasis 50 years ago.

to more intimate quarters upstairs. The artist depicted the structure of the house with considerable veracity, for it will be noted that all the columns of the different floors are shown resting one on top of the other so that each floor is correctly supported.

An exterior view of such a house may be seen in Theban tomb 254, the tomb of Mesi (fig. 8).[2] This two- or possibly three-storied building has a large, elevated front door, approached by a flight of steps, and an ordinary door at ground level in the rear. Potted shrubs in raised brick planters[3] alternating with date palms adorn the side or front of the house, and crisscrossed reeds serve as a fence around the roof terrace.

Some townhouses were doubtless more spacious than these, both inside and out, and even within the city, although land was at a premium, some rich families would probably have been able to maintain small yards and gardens. Humbler folk naturally had less well-appointed homes, a great many of which probably consisted of no more than one or two internal floors with a roof pavilion and terrace.

In the suburbs and out in the country, where space was less restricted, the prosperous could plan especially comfortable residences with freestanding single or multistoried dwellings surrounded by gardens and shade trees.[4] The view of the domicile of the gentleman farmer, architect, and overseer of the granaries of Amen, Ineni, in Theban tomb 81 depicts just such an estate (fig. 9). Here house and grounds are entirely surrounded by a serpentine enclosure wall with front and rear gates. That the wall was indeed sinuous and not straight with scalloped top is proved by the discovery of similar walls surrounding private houses at both Amarna and Medinet Habu, where they were so constructed apparently to give added strength.[5] Such walls may have had the added advantages of reducing street noise and serving as a better windbreak.[6] The house, whose windows on two upper floors are visible above the wall, probably had a ground floor with rear porch opening on a spacious back yard. Here, beneath the shade of a tall tree, rise two large silos and a magazine or barn. Behind these structures (i.e., drawn immediately above) lay a

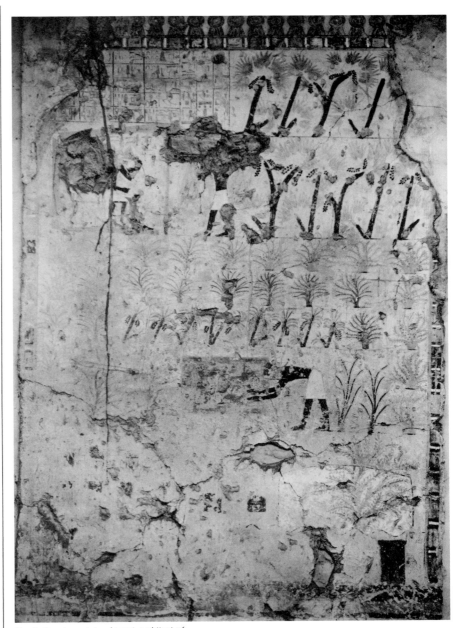

Fig. 9. Country estate of Ineni, architect of Thutmose I (from Theban tomb 81).

large pleasure garden with shrubs and trees, whose names are enumerated in an accompanying text, and an artificial rectangular pond.[7]

In Theban tomb 90, that of the chief of police Nebamen, a quite different type of country house appears (fig. 10). Here we see what might be described as an Egyptian cottage; its unusually small appearance has even led to the supposition that it was not Nebamen's main residence at all but simply a "rest house"— or what we might call a "summer house" — built on his lands in the country.[8] The front door, displaying a painted wood grain, is framed by red jambs and a red lintel. Over it is a high window or balcony, grated in its lower half, partitioned vertically by a papyriform column and set within a yellow frame, which is similar to but smaller than that of the doorway. At the side of the house, there are two more grated windows, each gaudily painted in patterns of blue and red, while on the rooftop two ventilators appear, set so as to catch the wind and hence "air-condition" the interior. *Dom* palms shade the far side.

In this particular scene, Nebamen sits on a stool gazing out upon his garden, in which may be seen two grape arbors supported by rows of papyriform columns, a T-shaped pond or reflecting pool, and a small shrine beyond, dedicated to Amenhotep III. His vintners are harvesting the grapes and transporting them to an ornately painted wine press, where more men, holding ropes to maintain their balance, tread the grapes into wine.

Among the many standard compositions that Egyptian schoolboys of the New Kingdom were made to copy in order to perfect their handwriting and improve their vocabulary, two texts have survived in multiple copies that describe ideal country estates.[9] The more picturesque of the two, and one worth quoting at length, is an account of the mansion of a man named Ra'ia, a chief overseer of the cattle of Amen, whose great domicile is presented as a kind of ancient Egyptian Camelot.

Ra'ia has built a goodly villa which is opposite Edjo. He built it on the verge [of the river] . . . as a work of eternity and planted with trees on every side of it. A channel is dug in front of it, and sleep is broken

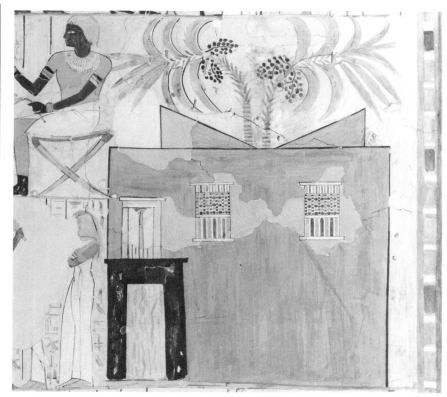

Fig. 10. The country house of the police captain Nebamen (from Theban tomb 90).

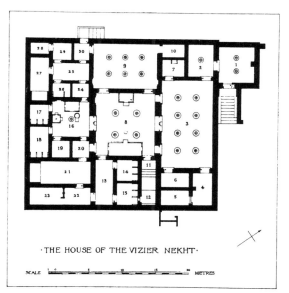

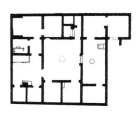

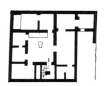

·THE HOUSE OF THE VIZIER NEKHT·

SCALE

METRES

Fig. 11. Plan of the house of the vizier Nakht at Amarna (K.50.1), compared with a smaller mansion (P.47.30) and a humbler dwelling (U.36.32), all with the square plan typical of Akhenaten's capital city.

[only] by the lapping of the wave. One does not become tired at the sight of it: one is gay at its portal and drunk in its halls. Fine door-posts of limestone, inscribed and carved with chisel, fine portals hewn anew, and walls inlaid with lapis lazuli. Its granaries are supplied with plenty and packed [?] with abundance. A fowl-yard and an aviary with *ro-geese*; byres full of oxen; a breeding bird-pool with geese; horses in the stable; [boats] moored at its quay. The poor, old and young alike, have come to live in its neighborhood Joy dwells within it, and no one says 'would that I had!' unto it. Fishes [in the irrigation basins] are more plentiful than the sands of the river banks You sit in the shade [of the trees] and eat their fruit. Wreaths are made for you of their twigs, and you are drunk with their wines[10]

The remains of houses coming very close to fulfilling this ideal, as well as a great many less pretentious examples, are fortunately known from the excavations at Amarna, ancient Akhetaten. Three hundred miles north of Thebes, this was the site of the capital of the pharaoh Akhenaten, a city built and occupied only during this king's reign late in the Eighteenth Dynasty. Here on a broad plain on the east bank of the Nile, hundreds of modest homes, as well as many large estates, were laid out, inhabited briefly, and abandoned. Their ruins were unearthed by successive British and German expeditions between 1891 and 1932.

Two very distinctive types of private houses are in evidence here. One was a freestanding house type of square (or nearly square) plan, in which all domestic quarters and subsidiary rooms were arranged around a perfectly square living room or "central hall." But for minor differences in detail, virtually all the houses of this type, whether mansions or cottages, are identical to one another in the arrangement of their important rooms. Those of the rich, it seems, differed from those of the poor and middle classes only in their relative scale, in the size of the major rooms, in the number of columns required to support their ceilings, in the numbers of nonessential rooms, in the relative expense of the materials used in their

architectural trim (for example, stone doorways as opposed to wooden or painted plaster imitations), and ultimately in the richness of their furnishings. Even the traces of colorful painted plaster found in the ruins of these houses suggest a certain uniformity of interior decoration and a common standard of taste among rich and poor.

The "square" house was the standard at Amarna, and versions of it were built all over the city by persons of independent means. Quite another type of housing, however, existed for the lower-ranking employees of the government, or, in other words, all those who were dependent for their daily sustenance on state rations rather than their own produce or barter. These workers, providing some daily service to the court, lived, of necessity, in government "housing projects" near their place of service. Their quarters were not independent dwellings but rather apartments built in long blocks, where each unit was of identical size and plan and shared its side walls with its neighbors. Whereas the remains of the largest villas at Amarna are evidence of the comforts of the privileged, these small "condominiums" of the state laborer and palace servant attest as eloquently to the wretched conditions under which the lowest classes lived. Here a brief discussion of each type of dwelling should provide at least an impression of the domestic environment at the opposite poles of society in the late Eighteenth Dynasty.

One of the grandest houses at Amarna, that of the vizier Nakht, was situated at the southern end of the "main city" (see fig. 5). The internal dimensions of this great house were an ample thirty-five by twenty-six meters; its preserved ground plan reveals that the main floor consisted of some twenty-eight rooms (fig. 11).[11] As in all of the larger houses at Amarna, and presumably in those all over Egypt, the ground floor of Nakht's house was elevated slightly from the level of the plain, and its front door was reached by a shallow, ramp-like staircase (cf. p. 27 and fig. 8).[12] The door opened from a cubical lobby that projected from one corner of the otherwise perfect block form of the house. This door was framed in heavy limestone jambs,

painted yellow, which bore the lord's names and titles in incised, blue-filled hieroglyphs. Judging by the evidence from other houses, these jambs were capped by a heavy stone lintel, carved and incised with further inscriptions and surmounted by a torus and cavetto cornice, painted with vertical bands of alternating colors.[13] For the nobility, stone doorways were clearly a "status symbol," and were used to frame as many of the important doorways in a house as its master could afford.[14] Where these and other doorways in the Amarna houses remain standing entire, the total height of the opening can be shown to be only slightly above one and a half meters, which would be very low by modern standards and would have required most of us, in moving about these buildings, to duck our heads frequently.[15]

Once inside the lobby of Nakht's house, the visitor was probably received by a doorkeeper.[16] The room possessed two wooden columns, both carved and doubtless brightly painted, set on limestone bases. These, it may be supposed, supported square wooden beams, plastered and painted with the "block pattern," a design that may be seen in the picture of Djehuty-nefer's house (fig. 7).[17] Although no trace of the actual plaster from the ceiling was found here, at least one large Amarna house[18] preserved in its lobby a fragment suggesting that its ceiling had been painted with a very ornate pattern of colored bars and rows of rosettes.[19] The walls in the vizier's lobby seem to have been entirely whitewashed, as were those of the inner lobby or anteroom, which possessed a single column. Whether there were windows in either of these rooms, one cannot say, but contemporary illustrations of Egyptian houses, such as that of Nebamen (fig. 10), sometimes depict very fancy window frames immediately over the front door, and in the lobby of one Amarna house[20] fragments of a very ornamental window jamb and cornice were actually recovered.[21]

After passing through the third door, the visitor emerged into a grand reception hall, a room traditionally called the "north loggia," which, because of its very public nature as

the place where all guests were received, seems to have been the most lavishly decorated room in the house. This was true not only of Nakht's residence but of a great many others as well.[22] The room was a grand gallery supported by eight wooden columns set upon massive stone bases. Windows in the outer walls admitted light that reflected upon the predominantly white walls and brought to their full brilliance the colors of the painted elements within.

The ceiling was painted bright blue, perhaps imitating the sky, while the rafters were doubtless painted in block patterns (cf. fig. 7). The columns, with their exquisitely carved, presumably floral capitals, would likewise have been splendidly tinctured.[23] Even the floor, paved with unbaked tiles, bore traces of red and yellow paint. Furthermore, on the whitewashed walls, at or near the juncture of the ceiling, a narrow painted frieze of blue lotus petals beneath a solid red band seems to have extended about the perimeter of the room. And if the evidence from similar rooms in other Amarna houses may be considered relevant to Nakht's loggia, one would certainly have expected to find here, at the approximate center of each wall and painted as if hanging from the lotus frieze, a large floral garland or swag composed of several concentric bands of flowers or fruits and perhaps also displaying lateral ribbon streamers, bejeweled pendants, or clusters of ducks hanging upside-down.[24]

At either end of this hall, doorways led to small "service chambers." The one next to the anteroom, bearing brick supports for a shelf, was perhaps used as a closet, while the three at the opposite side may have been a butler's apartment. Access to the interior of the house and the great square central hall was afforded either by a large ornamental double door in the center of the inner wall of the loggia or by one of the single doors on either side of it (cf. fig. 11; cat. 3).[25] The purpose of such extra doorways, with their tall, multicolored cornices and inscribed jambs, was probably decorative,

although it may be argued that such apertures improved ventilation and permitted the light from the loggia windows, doubtless directly opposite them, to penetrate the grand salon within.

The elegant central hall served as both living room and dining room of the house and, as can be seen in Djehuty-nefer's residence (fig. 7), it also bore the highest ceiling. In Amarna houses in general, the ceiling of this room must have risen well above the domestic quarters adjoining it, so that clerestory windows could be set near the top of its walls at or near the level of the surrounding roof terrace to permit light and fresh air to penetrate the room.[26]

While the interior decoration of this room was of much the same sort as that in the reception hall, the ceilings were probably twice the height of the latter, and, as the visitor entered, the soaring verticals of the columns within would have presented a dramatic visual and spatial transition.

The four wooden columns were probably palmiform, carved and plastered, the shafts presumably painted red and the capitals green.[27] As before, the main rafters were very likely painted in multicolored block patterns, and the ceiling either blue or white with the secondary cross rafters, if showing, painted red.[28] A frieze of lotus petals or blossoms served as a colored band near the top of the walls, and, again, painted floral festoons may have hung from it, centered between the clerestory windows. Although in the vizier's house the walls of the central hall seem to have been entirely whitewashed, those of the central halls of several other elegant houses at Amarna seem to have been whitewashed only to the height of about one and a half meters, while the upper walls, apart from the friezes and garland patterns, were left the dull brown color of the mud plaster.[29] To modern tastes, the presence of this rather predominant dreary tone amid such otherwise brightly colored elements seems odd, and, at first thought, even repellent; yet to the Egyptians this dark hue probably provided a welcome relief from the brilliant sunshine of the outside and afforded a cooling artificial shade.

The principal decoration of the walls of the central hall would have been the painted and inscribed doorways, which, as elsewhere in the more public parts of the house, were usually surmounted by high multicolored cavetto cornices. Several actual examples of these ornamental lintels have survived from Amarna, though not from Nakht's house.[30] Typically, beneath the torus and cavetto, symmetrically opposed figures of the owner of the house, kneeling in praise before the cartouches of the Aten, were carved in relief and painted. A more traditional type of formal doorway, however, bore a carved lattice-work lintel, such as that appearing in the entry to the central hall of Djehuty-nefer's house (fig. 7) or that sketched on an ostracon in the Fitzwilliam Museum (cat. 3).

A unique feature of Egyptian houses is their frequent use, particularly in the central halls and loggias, of one or more false doors. Since the symmetry of a room was as important as its functional components, the Egyptians placed all doorways in a wall so that they confronted precisely those in the opposite wall. Where a real entry was unessential or undesirable, however, the same carved and painted jambs and lintel of a proper door were set into the wall anyway, and the niche within became a miniature household shrine. Just such a false door was found in the west corner of the south wall of the central hall in Nakht's house, where red painted jambs inscribed with yellow hieroglyphs framed a yellow panel bearing a painted scene of Akhenaten worshiping the cartouches of the Aten.[31]

In this room, as in those of so many other houses excavated at Amarna, a wide brick dais and stone lustration slab were set on the floor against opposite walls. The one was a low platform on which the vizier's furniture was set (cf. fig. 7), and the other was a raised basin-like stone slab with a step and a rim about its perimeter, on which he and his guests might stand and wash their hands and arms prior to or after eating.[32] A depression in the pavement beside it indicated the spot where the water jar was kept. Furthermore, on cool evenings those sitting in this room could have warmed themselves before a brazier,

which was usually placed immediately in front of the dais.[33]

To complete our image of this elegant salon, we need only imagine it furnished with the types of things so frequently seen in tomb paintings, many of which are actually represented in this catalogue: on the dais, finely carved and inlaid wooden armchairs with stuffed cushions, and folding stools, rush or wooden tables bearing basket platters of fruit or bread, jugs of wine beside blue faience goblets, and painted pottery or precious metal vessels; on the brick tiles of the floor, colorful woven mats; and against the walls, at least on festival days, tall bouquets of flowers. Indeed, not the least of the room's ornamental details would have been the garlanded, bejeweled, and bewigged residents of the house.

In most of the smaller homes at Amarna, the central hall connected on three sides directly with the living quarters. In the vizier's residence, as in all the more grandiose houses, however, much more space was available for nonessential uses, so that the central hall opened on the west to a second broad hall known as the "west loggia," to our eyes looking for all the world like a ballroom. In Nakht's house this room, with its blue ceiling, tall yellow doorframes, double opposing painted niche-shrines, and its six brightly painted columns, must have been fully as magnificent as the central hall. If we recall the fact that in representations of Egyptian parties the men and women are frequently shown congregated in separate groups, it may be that the west loggia, being directly accessible to the apartments of the vizier's wife and what might be termed the "powder room" and "ladies' lavatory," may well have been a lounge where the mistress of the house entertained the wives of visiting guests. If this theory is correct, one might further assume that the central hall was primarily the sitting room of the men, for on its east wall it connected, via a corridor, to the vizier's quarters and the "men's room."

On the south, the central hall opened through a double door to a much smaller, more private version of itself, furnished again with a dais, a lustration slab, and a brazier, but bearing only one column. This was obviously an informal living room, where the residents normally sat and took their meals, which would have been brought to them by servants via the small rear door on the east side of the house from the kitchen outside.

At the rear of this "family room," as on the east side of the central hall, lay two storerooms or closets, identifiable by the brick supports on which their wooden shelves rested, and on either side of it lay the separate apartments of the vizier and his wife. The bedrooms were rectangular with niches at one end, bearing low brick platforms that served as the placements for the beds. The vizier's bedroom connected to a shower room and latrine, while his wife's opened onto a "robing room," from which a closet, shower room, and lavatory were easily reached. While none of these small private rooms seems to have been more than whitewashed, their appearance would surely have been much enhanced by the splendid beds, chairs, stools, tables, chests, jewelry stands, musical instruments, toilet articles, pottery and metal vessels, linens, and mats stored within them.

Not without particular interest are the sanitary facilities of the Amarna houses, which were always immediately adjacent to the bedrooms. The shower room normally possessed, behind a low screen wall, a rimmed limestone slab set into the floor. Around it, the mud-brick walls were also sheathed in limestone to prevent damage from splashing water. The bather apparently stood on the slab on the floor and either poured water over himself from a jar or had a servant do it from behind the screen wall. The water ran off through an outlet to a removable receptacle that could be emptied outside.[34]

Located beside this was the lavatory, which had a toilet seat set over a large bowl of sand. In the absence of standardized plumbing fixtures, these seats were either of a portable type made of wood or terracotta, or else they were of stone and bricked in place (fig. 12).[35] In one house, the bathroom contained a terracotta vessel set into the wall, which the excavators interpreted as a urinal.[36]

Fig. 12. Latrine seat from an Amarna house (T.35.22); most of the surface of the square slab of limestone is hollowed out to contour and the central cavity is cut in a keyhole outline.

The presence of a second story in Amarna houses is indicated not only by the staircase that always appears at one side of the central hall but also by fragments of the rooms on the second floor that are often found mixed in with the ruins of the first.[37] Allowing for the fact that the "family room" in Nakht's house must also have had clerestory windows at least in its outer wall, the rooms on its second floor would presumably have been arranged around the walls of the central hall in much the same configuration as those below them, since walls would have to be built upon walls and columns set upon columns (cf. fig. 7). Upstairs there may have been children's rooms or nurseries, maid's quarters, offices, and/or workrooms, and, over the west and north loggias, two more broad halls or lounges. Over the lower staircase, a second would perhaps have led to the roof parapets and a terrace from which the gardens, and indeed the entire city, could be viewed. Altogether, Nakht's house may have contained as many as forty rooms.

At Amarna, all but the meanest homes were enclosed by mud-brick perimeter walls, which secluded each and its entire property from the busy street on which it lay, as well as from the neighboring houses. It was suggested in the above-quoted description of Ra'ia's estate that the poor often settled in the vicinity of the finest homes; this fact was certainly borne out by the Amarna excavations, which revealed numerous small houses, closely packed, lying immediately outside the walls of many of the great estates.[38] Most often the enclosure walls were rectilinear, but occasionally, as noted above, they were

sinuous. And judging from excavated fallen sections of the walls surrounding the better houses, they seem, on average, to have been slightly more than three meters in height, affording each house and yard absolute privacy.[39] One or two narrow gateways in the walls gave access to the street.

Within the smallest of these walled yards, besides the house, there was normally at least an outdoor cooking area or a well and several grain bins. The larger enclosures, however, were also likely to contain a number of outbuildings: servants' quarters, cattle byres, stables, kennels, etc., all of which were built apart from the main house, concentrated on one side of the property and further isolated from the manor and each other by secondary walls.[40]

Like Ra'ia's property, as well as Ineni's (fig. 9) and Nebamen's (fig. 10), a substantial portion of each of the larger estates was devoted to its master's pleasure garden, and this was, of course, completely walled off from the work areas. The excavators at Amarna frequently discovered beside the remains of the houses neat rows of pits and rectangular beds, dug from the sand and filled with rich Nile mud, all indicating perfectly the original positions of trees, bushes, and flower beds. Depressions in the soil also suggested where artificial ponds had been placed. One particularly large estate bore what can only be described as a private park, the area of planted trees being no less than 1,700 square meters (see pp. 37 ff.).[41]

Within the gardens of the finest residences, approached by tree-flanked walkways, single outdoor chapels or shrines honoring the royal family and the Aten were frequently built. Aesthetically, these pleasant structures, shrouded in foliage, must have appealed to the Egyptian of the Eighteenth Dynasty in much the same way that a gazebo appealed to the Victorian. Entered by means of low ramps or ascending short flights of steps, these highly ornamental buildings typically were small elevated kiosks with columnar fronts surmounted by brightly painted cavetto cornices. Within, they were probably furnished with single altars for offerings and as likely contained a statue group, a stela, or a wall painting rep-

resenting the royal family beneath the Sun Disk.[42] The remains of one such chapel were substantial enough to indicate that its ceiling had been stunningly painted in imitation of a grape arbor, in which, against a yellow background, blue clusters of grapes amid green leaves were entwined about a red lattice. To enhance the illusion, bunches of grapes modeled plastically in deep blue faience had been affixed to the rafters of the ceiling.[43]

In marked contrast to these luxurious manors were the humble quarters of the state-employed laborers, which were not independent dwellings but individual units in long, single-level apartment complexes. The most perfectly preserved examples of these New Kingdom "housing projects" are the walled village at Deir el Medineh, near Thebes (see pp. 24 ff.), and its more impoverished counterpart at Amarna, the similarities of which are striking and whose remains convey very vivid impressions of the living standards and changeable fortunes of the ancient Egyptian artisan class.

In each case these small settlements were built to accommodate draftsmen, sculptors, and masons. At Deir el Medineh the residents were employed specifically in the preparation of the royal tomb, while at Amarna, they were engaged in the preparation of private tombs as well. Each village was built in a rather remote, inhospitable area near the tombs, and each was guarded by police outposts, perhaps to prevent the interchange of secret information. Neither had its own water supply, which of course necessitated a crew of workmen employed in the transport of water and probably also of food. The colonies were entirely surrounded by stone walls, within which rows of contiguous houses were built between narrow streets.

Of the two towns, the short-lived workmen's village at Amarna was a much more unpleasant place, the houses poorer and distinctly cramped, showing a steady degeneration.[44] Yet this village is of particular interest for the very fact that it was planned and built as a single entity. Contained within a wall just over sixty-nine meters square with a height just over two meters, the settlement con-

sisted of six rows of conjoined houses separated by five streets about two meters wide (fig. 13). The total number of housing units seems to have been seventy-two, with an additional larger house for an overseer at one corner. With the exception of the latter, all of the houses were of uniform size and plan, and all were twice as long as they were wide, measuring approximately five by ten meters. Each was, in fact, half a perfect square of twenty cubits. In the perimeter wall, there was only one gate, which connected with the roads leading to the north and south tombs or to the city of Amarna due east. Immediately inside the wall was a courtyard where the villagers could corral some of their animals and against it, just to one side of the gate, was a public wall shrine to the royal family and the Aten. With the exception of the fifth and sixth blocks of houses, which were forced to share a street, each block opened onto its own street; on its other side was the stark rear wall of the next block. The excavators noted that these streets were often cluttered with mangers and tethering posts for animals, or with water jars; sometimes even evidence for awnings and looms was discovered, further suggesting the impediments clogging these narrow access ways. Like many narrow alleyways in Cairo today, the streets must have been filled at all hours of the day with people, dogs, goats, and donkeys.

Each house was divided into three equal sections by cross walls, with the third subdivided, making a total of four tiny rooms (fig. 14). The entrance room, opening directly on the street, often, like the street itself, contained mangers and tethering posts and probably served as a shelter for animals, while the central room served as the living room and dining room. As in other houses at Amarna, the central room probably possessed one or more clerestory windows; its roof was supported by a wooden pole and a low brick dais was built along one or two walls. Here the residents sat, either on mats or simple stone or wooden stools, ate their meals from low tables, and even slept. A small brazier provided heat, and a water jug took the place of the lustration

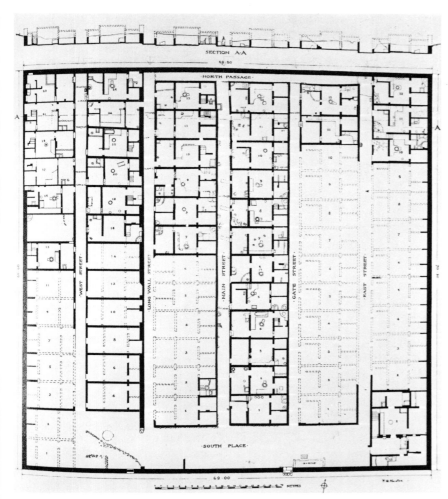

Fig. 13. Plan of the workmen's settlement at Amarna.

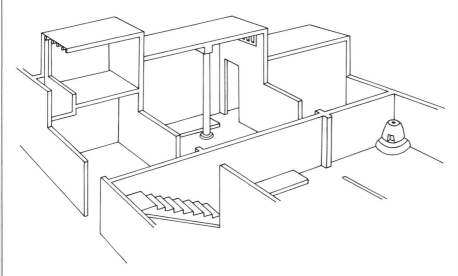

Fig. 14. Section of a workman's house at Amarna.

slab in the larger homes. Sockets in the walls indicated places where the beams of looms were set (cf. fig. 7).

The rear of each house was divided into two tiny sections, one a bedroom or storeroom, and the other a very cramped kitchen area in which were often found stone mortars for grinding grain, shallow bins for grain storage, small ovens, and stores of fuel: straw and sheep dung. Since there was no trace of a latrine in any house, it is most likely that "chamber pots" were used and then emptied outside the settlement. The confined, airless nature of the apartments would have made them most uncomfortable in this desert location, particularly during the summer months, and it may be imagined that the residents spent most of their time, when at home, on the roof, where there would have been small brick or matwork pavilions. A staircase leading to the roof was normally built on one side of the kitchen area, severely hampering movement within that space.

Even such rude dwellings as these were cheerily decorated with paint. When newly built, they must have sparkled with bright frescoes of dancing Bes figures, floral designs, and other purely decorative patterns. In the later phases of the settlement, however, the frescoes seem to have been plastered over and were never replaced. Ultimately, with the removal of the capital to Thebes, the already poor village was abandoned to a few miserable squatters.[45]

The similar village at Deir el Medineh, on the other hand, was the very image of prosperity and had a lifespan of over 400 years. Founded by Thutmose I and originally consisting of a mere twenty homes built within an irregularly shaped perimeter wall, it flourished throughout the New Kingdom and over time greatly expanded so that, ultimately, by Dynasty 20, it had grown by accretion to include about seventy house units contained within a nearly rectangular enclosure of about 50 by 130 meters. The houses, though small, were larger than those at Amarna, were well constructed, and were beautifully painted and adorned as one would expect of the homes of artists and sculptors.

They also bore features, such as carved and painted stone doorways and household shrines, that were commonly found only in the houses of the rich. All evidence attests to the material well-being of this artisan class, many members of which are known to have grown to achieve considerable substance, being able to produce and outfit for themselves tombs rivaling in magnificence those of the nobility.

T.K.

1. Davies 1929, pp. 233ff.
2. Ibid., p. 242, fig. 8.
3. Černý 1970.
4. Kemp 1977b.
5. Frankfort and Pendlebury 1933, pp. 5, 56; pls. 2, 3; Oriental Institute 1939, pp. 70ff.
6. Berman 1947, pp. 70-72.
7. Wreszinski 1923, pl. 60a.
8. Badawy 1968, p. 22.
9. Caminos 1954, pp. 164ff., 410ff.; cf. Badawy 1968, pp. 13ff.
10. Caminos 1954, pp. 412ff.
11. Woolley 1922, pp. 61ff.; Peet and Woolley 1923, pp. 5ff. .
12. Woolley 1922, pl. 10.
13. Frankfort 1929, p. 51; Frankfort and Pendlebury 1933, p. 64.
14. Frankfort and Pendlebury 1933, p. 64.
15. Ibid., p. 65; Woolley 1922, p. 64, pl. 11.
16. Cf. Davies 1905a, p. 38, pl. 36.
17. Frankfort 1929b, pp. 40ff.
18. V.36.6.
19. Frankfort and Pendlebury 1933, p. 29.
20. L.15.1.
21. Peet and Woolley 1923, p. 18.
22. Frankfort 1929a, pp. 52ff.
23. Cf. Woolley 1922, pp. 64ff.
24. Frankfort 1929a, pp. 43ff.; Frankfort and Pendlebury 1933, pp. 12, 29.
25. Borchardt 1916, p. 546, fig. 53; Peet and Woolley 1923, pl. 4; Winlock 1955, pl. 57.
26. Cf. Lloyd 1933, p. 4, fig. 3.
27. Peet and Woolley 1923, pl. 4.
28. Frankfort and Pendlebury 1933, pp. 28, 34, 42, 44, et passim.
29. Ibid., p. 12; Borchardt 1916, pp. 553ff., fig. 61; Frankfort 1929a, pp. 39, 53.
30. Cf. Borchardt 1916, color pl. 1.
31. Cf. Woolley 1922, p. 65; Peet and Woolley 1923, pp. 24, 28, 29, et passim; Frankfort 1929a, pp. 54ff.; Ricke 1932, pp. 29ff.
32. Ricke 1932, p. 30; Peet and Woolley 1923, pl. 5:4; Honigsberg 1940, pp. 216ff.
33. Ricke 1932, pp. 31ff.; Peet and Woolley 1923, pls. 4-6.
34. Honigsberg 1940, pp. 220ff.
35. Ibid., pp. 213ff.
36. Frankfort and Pendlebury 1933, p. 69.
37. Peet and Woolley 1923, pp. 8ff.
38. Cf. Frankfort and Pendlebury 1933, pls. 2-7, 9.
39. Peet and Woolley 1923, pp. 15, 20; Frankfort and Pendlebury 1933, p. 63.
40. Ricke 1932, pp. 44ff.; Lloyd 1933, p. 1ff.
41. Peet and Woolley 1923, pp. 47ff.; Frankfort and Pendlebury 1933, pp. 9, 13, 39.
42. Peet and Woolley 1923, p. 48.
43. Frankfort and Pendlebury 1933, p. 24.
44. Woolley 1922, pp. 48ff.; Peet and Woolley 1923, pp. 51ff.
45. Kemp 1979b, pp. 47ff.

Literature: Petrie 1894; Borchardt 1907, pp. 14-31; Borchardt 1911, pp. 1-32; Borchardt 1912, pp. 1-40; Borchardt 1913, pp. 1-55; Borchardt 1914, pp. 3-39; Borchardt 1916, pp. 509-558; Peet 1921, pp. 169-188; Woolley 1922, pp. 48-82; Peet and Woolley 1923; Newton 1924, pp. 289-298; Davies 1929, pp. 233-255; Frankfort 1929a; Frankfort 1929b, pp. 143-149; Pendlebury 1931, pp. 233-244; Ricke 1932; Frankfort and Pendlebury 1933; Lloyd 1933, pp. 1-7; Pendlebury 1933, pp. 117-118; Porter and Moss 1934, pp. 199-207; Koenigsberger 1936; Smith 1938, pp. 201-210; Oriental Institute 1939; Honigsberg 1940, pp. 199-246; Badawy 1948, pp. 75-97; Pendlebury 1951; Caminos 1954, pp. 164-168, 410-412; Vandier 1955, pp. 984-996; Winlock 1955; Smith 1958, pp. 189, 192-193, 199-204; Porter and Moss 1964, pp. 702-706; Badawy 1966, pp. 25-28, figs. 2-4; Badawy 1968, pp. 11-29, 55-70, 73-74, 80-81, 92-117, 126, and color pls. 4, 6; Kemp 1972, pp. 657-680; Scott 1973, pp. 128-131; Brinks 1977, cols. 1055-1061; Helck 1977, cols. 1061-1062; Arnold 1977, cols. 1062-1064; Martin 1977, cols. 1064-1065; Kemp 1977b, pp. 123-139; Bietak 1979; Borchardt and Ricke 1980.

1

House model
Provenance not known
New Kingdom or later
Height 17 cm.; length 7.1 cm.; width 10 cm.
Musée du Louvre, Paris (E 5357).
Formerly in the Rousset Bey Collection

This carved model of a townhouse in limestone shows three separate levels. The top story has a large loggia, supported by a single column, occupying the rear half of the model and opening onto a terrace surrounded by a short parapet. The loggia is pierced by three windows and a horizontal vent with a crossbar. The middle story exhibits eight windows of various heights and sizes; below is a low entrance and seven air vents. It has been suggested that this lowest story was in reality a basement (technically a half-basement) used by servants for such activities as spinning, brewing, and baking (see fig. 7), and that it was partially below ground with horizontal vents at ground level to let in light and air.[1] The large windows contain crossed mullions that divide the windows into four sections, the lower two of which are slatted. Unlike other models, this one shows the vertical mullion extending the full height of the window.

A New Kingdom date has been suggested for this model, based on representations of houses painted in New Kingdom tombs at Thebes.[2] According to this theory it is only in the New Kingdom that windows have slats on the lower half and a mullion on the upper half. However, Greco-Roman models with a vertical mullion on the upper half and slats on the lower half have been found.[3] After examination of a house model in Hannover (cat. 2) and the Greco-Roman town of Karanis, it has also been proposed that both that model and this are Greco-Roman.[4] Basement vents similar to those of the Louvre model have been found not only at Karanis but also at Dimeh, another Greco-Roman town.[5] While the house model might be Greco-Roman, the conservative nature of Egyptian house building led to the preservation of traditional forms down to Roman times and beyond.

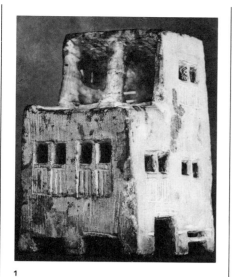

1

Fifty years ago, in a village in the Kharga oasis, houses very much like this were seen.[6]

A.G.

1. Desroches-Noblecourt 1938, p. 19.
2. Ibid., pp. 19-25.
3. Engelbach 1931, p. 130, fig. 5; Wreszinski 1923, p. 48b, no. 4; Petrie 1886, pl. 18:3; Ricke 1966, pl. 7.
4. Ricke 1966, pp. 122-123.
5. Ibid., p. 122.
6. Cf. Davies 1929, p. 241, fig. 5.

Bibliography: Perrot and Chipiez 1882, p. 475, fig. 273; Desroches-Noblecourt 1938, pp. 17-25, pls. 1-2; Badawy 1948, pp. 82-83, fig. 85; Badawy 1966, pp. 27-28; Ricke 1966, pp. 121, 122-123; Erman 1971, p. 168; Kemp 1977b, p. 125.

2

House model
Provenance not known
New Kingdom or later
Height 7.5 cm.; width 7.1 cm.; length 4.4 cm.
Kestner-Museum, Hannover (1935.200. 168.) Formerly in the von Bissing Collection

This limestone model of a freestanding town house appears to have four levels. The small loggia set against one corner has a window opening on two sides, and opens onto a roof terrace surrounded by a parapet with crenellations. Below the loggia is a level represented by a small window, somewhat similar to those found in an actual house[1] at Karanis, and an air vent. Beneath is the main level, lit by five windows, the upper half of which have a vertical mullion, and the lower half of which are slatted, presumably to preserve privacy and to let in breezes. Two horizontal incisions on this level may represent wooden beams placed above and below a

series of small windows, such as are found at Karanis. The height of the entrance at the side of the house may indicate that a sizable portion of the bottom of the model has been broken away,[2] or the model may be an inaccurate portrayal by the model builder. On the other hand, Egyptian doorways usually were quite low.[3] The other house model in the catalogue (cat. 1) also has a doorway of less than expected height. The four air vents arranged diagonally around the corner of the house at which the loggia is located suggest a stairway leading up to the roof.

A New Kingdom date for the model has been advanced[4] but, based on a comparison with the houses at Karanis, a date in the third or second century B.C. has also been proposed.[5] Among other factors, the ground plan,

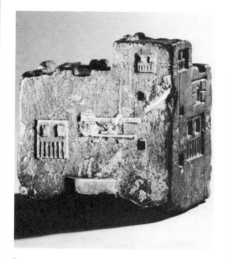

2

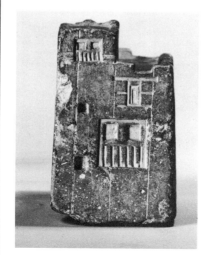

2

the model's freestanding nature, the presence of windows on all sides, and wooden beams delineating small windows resemble the house remains from Greco-Roman towns. The windows with the vertical mullion and the slats on the lower half are also found on Greco-Roman house models, such as two from Naucratis.[6]

A.G.

1. C42.
2. Ricke 1966, pl. 7.
3. E.g., Woolley 1922, pl. 11; Desroches-Noblecourt 1938, p. 18 n. 2.
4. Kestner Museum 1958, p. 73, fig. 46.
5. Ricke 1966, pp. 119-123.
6. Petrie 1886, pl. 18:3; Engelbach 1931, pp. 131-132, fig. 5.

Bibliography: Kestner Museum 1958, p. 73, fig. 46; Ricke 1966, pp. 119-123, pl. 7; El-Nadoury and Vercoutter 1979, p. 51, fig. 3.

3

Ostracon with a representation of a doorway
Probably from Thebes
Late Dynasty 18-19
Height 28.7 cm.; width 42.5 cm.
Fitzwilliam Museum, Cambridge (EGA.4298.1943)

An unusual architectural study of a doorway is the main focus of this limestone ostracon, inscribed on both sides with black ink. A New Kingdom nobleman is portrayed to the left of the door as well as on the reverse, where a short funerary text accompanies the drawing. On the obverse, in addition, is a small sketch of the head of the god Ptah and a short text, both probably unrelated to the architectural study.

The doorway is composed of a cavetto cornice with torus molding and an elaborately decorated architrave or lintel. Between the jambs is a two-leaved wooden door painted with a bead pattern. The rectangles in the upper half of the doors would have been either windows or panels inscribed with the name and titles or figure of the owner.[1]

The lunette or entablature is portrayed as a painted or sculpted window, whose design is divided into two parts by a papyrus column. Such windows, positioned over doors, are found as early as Dynasty 3.[2] Within the lunette the owner presents himself before Horus on the left, and before either Isis or Hathor on the

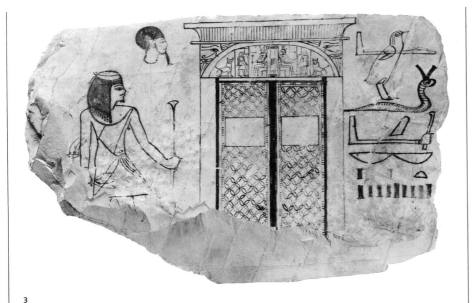

3

right. At each end sits a cat whose body is in profile but whose head faces the viewer. Between the lunette and the cavetto cornice are stylized motifs including the *uadjet* eye of Horus.

The cat-in-the-window motif is found in tombs of the Theban necropolis, such as those of Kenamen and Amenemhat-Surer,[3] on two fragments of stelae from Deir el Medineh,[4] and on a faience tile in Berlin;[5] a reclining jackal takes the cat's place on a fragment of lintel from Thebes.[6] Kneeling figures of the owner may replace cats or jackals, as in the Theban tomb of Hori[7] and above a false door in the house of General Ramose at Amarna.[8] On royal monuments, sphinxes, winged uraei, and kneeling kings[9] replace the non-royal representations.

Judging by the presence of the cat-in-the-window motif, the painted bead pattern, and the fact that a noble rather than a king presents himself before the gods on the lunette, the architectural study would be likely to represent a doorway in a noble's house or tomb chapel[10] rather than a royal shrine. As tomb architecture was derived from domestic architecture, the representation would not have been dissimilar to an actual door to a noble's house. Cats were kept to get rid of vermin, and can still be seen today on the lintels of doors in the Middle East. Since the cat is connected with the sun-god Re (see

cat. 411), its appearance in these lunettes may have religious connotations.

All the known portrayals of the cat-in-the-window motif date from the second half of the Eighteenth Dynasty through the Ramesside Period. In addition, the shape of the nose and skull and the presence of neck wrinkles on the head of Ptah, the size and position of the eyes as well as the neck wrinkle of the noble, and the cluttered treatment of the details on the architrave of the door indicate a probable Nineteenth-Dynasty date. As to provenance, the mention of Thebes *(niut)* and Amen-Re on the reverse indicate the probable origin of the ostracon.[11]

A.G.

1. Cf. Hayes 1959, fig. 44; Desroches-Noblecourt 1976, pp. 189ff.
2. Lauer and Altenmüller 1975, p. 137 and pl. 20.
3. Davies 1930, pls. 6b, 25a; Säve-Söderbergh 1957, pl. 56.
4. Bruyère 1933, pl. 25:3.
5. Hermann 1937, pl. 9c.
6. Mond and Emery 1927, pl. 37b.
7. Ibid., pl. 9b.
8. Badawy 1968, color pl. 6.
9. Gardiner et al. 1933, pls. 1b, 21, 29; Gardiner et al. 1935, pls. 9, 17, 35; Oriental Institute 1941, pls. 36a, 36b, 37.
10. Brunner-Traut 1979, p. 23.
11. For a Ramesside ostracon of a false doorway from a royal monument, see Vandier d'Abbadie 1937, p. 145, pl. 91:2702.

Bibliography: Murray 1963, p. 208, pl. 80; Peck 1978a, pp. 52, 198-199, 206; Brunner-Traut 1979, pp. 22-25, pl. 1.

The Garden

Nowhere did the Egyptian's love of nature show itself more than in his attitude to trees, flowers, and decorative plants. At festivals, floral collars hung around the necks of guests, and garlands of flowers decorated wine jars at dinner parties. Egyptian ornamentation was, to a great extent, based on floral motifs, and one of the most original creations of Egyptian art was plant columns based on the papyrus, lotus, and palm.[1]

Despite its pleasures, gardening required constant effort and attention. Rainfall averaged about two inches per year, and Egypt was totally dependent on the Nile. Planting began in October when the river was receding, leaving a vital covering of fertile soil. The prime land in the flood plain was given over to agriculture, while orchards were situated on the levees[2] and small garden plots seem generally to have been restricted to peripheral areas, within house or temple compounds, often on made ground. The restriction of gardens to areas at a higher elevation than the river, flood basins, and irrigation canals may have prompted the development of the *shaduf,* a device consisting of a long pole on a pivot with a bucket tied to one end and a weight at the other (fig. 15), to assist in obtaining water from pools and wells for the gardens. The *shaduf* does not appear before the New Kingdom and is first represented in a tomb at Amarna.[3] It is more common thereafter,[4] but its use in the New Kingdom appears limited to gardening alone.[5]

Most of the gardens of which actual traces remain were originally appendages of temples. The gardens associated with the mortuary temple of Ramesses III at Medinet Habu, for example, were watered from a pool[6] and also a well.[7] The pool was bordered on the west by a row of trees planted in pits that were dug into a prepared bed of gravel and soil, coated with a layer of clay to help retain water, and filled with humus.[8]

Similar pits were found in front of the Eleventh-Dynasty temple of King Mentuhotep at Deir el Bahri. The Metropolitan Museum's excavations uncovered a geometrically ordered grove consisting of three rows of seven plots of tamarisk and sycamores, some of which still contained the original sprouted cuttings.[9] Moreover, an ostracon was discovered bearing a plan of this arrangement, which had been worked out and corrected by some ancient groundskeeper.[10]

At the Deir el Bahri temple of Queen Hatshepsut the grove of trees was replaced by a single pair of trees flanking the entrance ramp and before them T-shaped pools that still contained the remains of papyrus stalks.[11] Hatshepsut also created a botanical garden for the god Amen stocked with exotic species from the land of Punt,[12] and Thutmose III carefully recorded the natural history of the lands he conquered, both their flora and fauna, in reliefs on the walls of the temple of Karnak.[13]

The typical private garden of the New Kingdom was symmetrical in design with a rectangular or T-shaped pond or pool at the front or side of the house surrounded by trees and decorative plants and flowers (fig. 16), but at least one house at Amarna, with naturalistic landscaping appears to have departed from the formal garden layout.[14]

In a painting in the tomb of Kenamen,[15] grapes form a pergola or arbor of vines supported by gaily painted wooden papyrus columns ranged around the central pool. Located in such a prominent place, it is indicative of the appeal of the fresh fruit and its by-products, raisins, wine, and vinegar, to the ancient Egyptians, and of its central role in the economy. The cultivation of the grape goes back to a time well before the Pharaonic Period,[16] and the ancient Egyptians well understood its requirements. Indifferent to the soil, the grape required hot sun and considerable moisture.

The pool in fig. 16, crowded with fish and waterfowl, includes blossoms of the blue water lily or lotus. Although the blue and the white lotus are equally common in the Delta today,[17] the blue lotus was more popular in the gardens of ancient Egypt. Both species[18] flower from December to March, the white lotus through the night until 11 a.m. and the blue lotus from about sunrise to midday. The blue lotus rises slightly above the water and opens and closes daily without submerging; its sepals, or

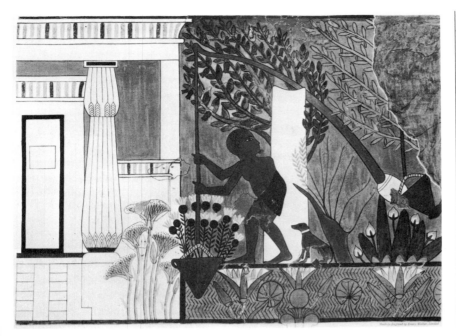

Fig. 15. Water for irrigating the garden of Ipuy is lifted from the Nile by a *shaduf* (from Theban tomb 217).

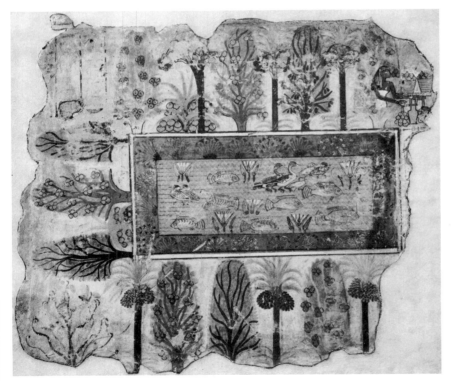

Fig. 16. A pool in the garden from an unlocated tomb at Thebes; in the upper corner the goddess of the sycamore proffers dates and figs.

leaves, and petals are narrow and pointed. Both have a large leaf, cleft nearly to the center, which floats flat on the water's surface, but the leaf of the white is denticulate. Each white lotus has four green sepals, which are ovoid with rounded tips. While the blooms are usually pure white, there is a variety with rose-tipped or colored petals;[19] the blue sometimes shades off into pink. The ovary of both types has a rayed stigma of bright yellow color, from the base of which numerous flattened yellow stamens emerge. The scent of the blue lotus is extremely sweet and it is often represented held or sniffed by Egyptian men and women. The white blossoms are not as fragrant, possessing a pleasant, piquant aroma.

Trees, alternating in species and symmetrically positioned, are commonly shown bordering a pool in Egyptian gardening.[20] The sycamore fig, the date palm, and the *dom* palm are represented again and again in Theban tombs (see fig. 16), and the garden of Ineni, architect of Thutmose I, contained nineteen species or varieties of trees.[21] A strong tree growing to thirty or forty feet, the sycamore fig *(Ficus sycamorus)* was appreciated more for its shade than for its fruit. The common fig *(Ficus carica)* produced a better fruit, but its form lacked the nobility of the sycamore fig, sometimes becoming a straggling shrub. The fig depends upon one specific insect, the blastophaga wasp, to ensure fertilization. She enters the fig through the petiole and, in the process of laying her eggs, brushes the pollen off the male flower and onto the female flower. It is necessary for cultivators to scrape or puncture the fruit a few days before picking. Unless this operation is performed the syconium produces a quantity of liquid and does not ripen. Once notched, the drying process prevents the insect eggs from hatching and the fig darkens and sweetens.[22] Both carica and sycamore figs are frequently seen together on offering tables, the latter represented with an incision.[23]

The skill of Egyptian gardeners is attested by their cultivation of the date palm *(Phoenix dactylifera)*, which requires a sophisticated knowledge of artificial propagation.[24] This skill

probably reached Egypt from Babylonia, where it was a well-known process, covered by at least two paragraphs of the Hammurabi code at a time contemporaneous with the Middle Kingdom in Egypt.[25]

From the Old Kingdom only finds of leaves and fibers of the date palm are known, but the fruit is frequently found in tombs from the Middle Kingdom onward. Dates were an important part of the ancient Egyptian diet, providing important nutrients, and the fronds and trunk of the tree were made into roofing, cages, crates, brooms, and many other items. The Egyptian found that, after they sliced off the main bud of the palm, a liquid flowed from the wound, and left in jars for a brief period, the liquid would ferment.[26] However, the operation sealed the fate of the tree, and the liquor was probably not drunk extensively.[27]

The *dom* palm (*Hyphanae thebaica*) also grew in the Egyptian garden. One of the few palms with a forked trunk, it is easily identifiable by its fan-shaped foliage. Like the date, it produced an edible fruit (see cat. 98); its strong fibers were used in mats[28] and its wood was sometimes employed by the carpenter and joiner.[29]

Other popular trees were the tamarisk, always green and bright in the spring with its spikes of pink flowers; the willow, whose leaves were used for making funerary garlands and whose wood made excellent tent poles;[30] and the acacia, whose blossoms have been identified in garlands and floral collars and whose pods were a tanning agent.[31]

Other indigenous trees such as the persea (*Mimusops schimperi*), the jujubee (*Zizyphus spina christi*), the carob (*Ceratonia siliqua*), and the Egyptian plum (*Cordia myxa*) were grown for their fruits. The persea, a native of tropical Africa and Arabia, produced a fruit with a sweet apple-like taste. Twigs and leaves of this tree have been discovered in funerary bouquets and garlands,[32] and legend foretold that the sun god, or Thoth, or the goddess of writing on his behalf, inscribed the oval cartouche of the king on the countless leaves of the persea.[33] It is extinct in Egypt today except for a few specimens

outside the Egyptian Museum in Cairo grown from seeds brought from Arabia.[34] The fruit of the zizyphus (Arabic *Nabq*), about the size of a cherry, is a well-flavored yellow or reddish berry that frequently appears in divided dishes (see cat. 101) with figs and persea fruit. The carob was grown for its edible pod,[35] the seeds of which were used as a sweetener.[36]

The *Balanites aegyptiaca* produced a fruit that yielded the important balanos oil after pounding and boiling,[37] and the sweet ben oil was extracted from the horse-radish tree (*Moringa aptera*).[38] The olive tree (*Olea europa*) was probably introduced into Egypt in the New Kingdom.[39] Its fruit and oil were never an important crop, but its leaves are commonly found in floral garlands, including several in the tomb of Tutankhamen.[40]

At the margin of the pool in fig. 16 are clumps of papyrus, poppies, and other small bushes and plants. A striking plant rising ten to fifteen feet, the papyrus head (or umbel) and stalk (or culm) lent its form to a number of decorative motifs in architecture, and was also incorporated into floral collars and other decorations. Today papyrus occurs in Egypt only in isolated pools and gardens; in ancient times it was so dominant a feature in the northern marshes that it became the symbol of Lower Egypt. The stalk of the papyrus was used in making light boats or skiffs and numerous objects were made from the outer plinth, including baskets, boxes, cordage, matting, ring stands, sandals, sieves, and stools.[41] In addition to its use as a fuel, the rhizome was a nutritious source of food and might be eaten raw, boiled, or roasted.[42] Its principal value was, however, for making sheets of material for writing purposes, the forerunner of modern paper, to which it gave its name (see p. 282).

The mandrake (*Mandragora officinalis Mill.*), a native of Palestine, was popular in flower borders;[43] its yellowish fruit was a common decorative motif (see, e.g., cats. 6, 83, and 308). In fig. 16 the mandrake appears among the trees; in the tomb of Sennedjem[44] it alternates with blue cornflowers and red poppies. It is a perennial producing a rosette of large flat leaves

from the center of which the flowers develop. The fruits that follow are about the size of plums, and possess a rather desirable odor and a sweetish taste. In medieval Europe the fruit was credited with having narcotic and aphrodisiac qualities. In ancient Egypt it was something to be enjoyed at festivals or on gala occasions by way of a taste or sniff.[45]

The pomegranate (*Punica granatum*) was also popular as a decorative shrub. This small tree or bush with its bell-like rosy flowers added a dash of color in the garden. Its tasty fruit was much prized and its form copied in silver, glass, and other materials (see cat. 99). Although several immature fruits were found at a Middle Kingdom site,[46] the cultivation of the tree probably began during the New Kingdom; it was introduced from Asia about this time and adapted well to the climate because its fruit needed the long, hot summer to ripen. Jasmine (see cat. 13) and oleander were known in ancient Egypt[47] but were rarely depicted.

Tomb paintings show red poppy or anemone, white marguerites or daisies (*Chrysanthemum coronarium L.*), and the blue cornflower (*Centaurea depressa*), which was introduced in the Eighteenth Dynasty possibly from Greece or Syria.[48] The larkspur (*Delphinium orientale*) and ivy (*Hedera helix L.*) were also cultivated.[49]

G.G./P.L.

1. Kees 1961, p. 84.
2. Butzer 1976, pp. 22ff.
3. Davies 1903, pl. 32.
4. Davies 1933, pp. 70-73; Klebs 1934, pp. 34-35.
5. Butzer 1976, pp. 43-47.
6. Hölscher 1951, pp. 18-21.
7. Oriental Institute 1941, p. 66.
8. Oriental Institute 1951, pp. 20-21.
9. Winlock 1942, pp. 48-51, pl. 5.
10. Winlock 1942, p. 50.
11. Ibid., p. 90.
12. Badawy 1968, pp. 488-489.
13. Wreszinski 1935, pls. 26-33; Täckholm 1952, pp. 186-193.
14. Pendlebury 1935, p. 120.
15. Scott 1973, pl. 10.
16. Darby et al. 1977, p. 316.
17. Ibid., p. 634.
18. Spanton 1917, pp. 1ff.; Tait 1963, pp. 95-96.
19. Spanton 1917, p. 2.
20. See Pendlebury 1935, p. 117.
21. Sethe 1906, p. 73; Wreszinski 1923, pl. 602.
22. Täckholm 1952, pp. 45-51; Keimer 1957.
23. Täckholm 1961, p. 11.
24. Rzoska 1976, pp. 51-52.
25. Täckholm 1961, p. 8.
26. Lucas 1962, p. 23.
27. Darby et al. 1977, pp. 614-615.

28. Greiss 1957, p. 41.
29. Lucas 1962, p. 444.
30. Ibid., p. 448.
31. Ibid., pp. 34, 442.
32. Ibid., p. 445.
33. Gardiner 1946, p. 50.
34. Täckholm 1961, p. 27.
35. Täckholm 1961, pp. 21-22.
36. Gardiner 1957, p. 82; Montet 1962, p. 82.
37. Lucas 1962, p. 331; Täckholm 1961, p. 23.
38. Darby et al. 1977, p. 784.
39. Lucas 1962, pp. 333-335.
40. Carter 1927, pp. 189ff.
41. Lucas 1962, p. 137.
42. Darby et al. 1977, p. 645.
43. Keimer 1924, pp. 172-173, 176-177; Moldenke
 and Moldenke, pp. 13-15.
44. Scott 1973, fig. 2.
45. Davies 1916, pl. 17.
46. Täckholm 1952, p. 220.
47. Keimer 1924, pp. 28-31.
48. Ibid., pp. 8-10.
49. Vandier 1964a, figs. 238, 248, 249.

Literature: Loret and Poisson 1895; Piovano 1952.

4

Lotus flower inlays for game box
From Abydos tomb D4
Dynasty 18
Height of sepal 6.4 cm.; height of petals
5.2 and 5.3 cm.
Museum of Fine Arts. Gift of Egypt
Exploration Fund (00.711a-c)

Three of seven pieces of ivory of grad-
uated sizes, delicately carved and
stained in pink and green in the form
of the open flower of the white lotus,
these were found along with scraps of
ivory and ebony inlay, ivory rosettes,
and a large number of agate marbles.
Small gold nails had held the ivory
rosettes found with them in place, and
it is clear that the ivory flowers fitted
into one scheme of decoration and
had perhaps been set in order into a
wooden box. Considering the accom-
panying marbles, they might have
adorned the box of a game, but the
inscriptions scratched on their backs
provide no clue to their actual
arrangement.

4

The delicate rounded sepals or leaves
and the petals of the white lotus are
accurately observed, the petals being
tinged with pink and the green leaf
modeled with a pronounced veining.
Four other inlays, forming parts of
two identical flowers, are in the
Ashmolean Museum, Oxford.

E.B.

Bibliography: MacIver and Mace 1902, p. 90, pls.
40:14 and 49.

5

Tile with *dom* palm
From Hermopolis Magna
Dynasty 18, reign of Akhenaten
Height 10.8 cm.; width 9.2 cm.
The Brooklyn Museum, Brooklyn, New
York. Charles Edwin Wilbour Fund
(52.148.1)

The lush *dom* palms are preserved in
this fragment of a white glazed faience

5

tile. Between the palms is an uniden-
tified plant that appears in at least
one other tile from Amarna.[1] The
colors of the vegetation are naturalis-
tic, with green palm foliage, brown
trunks, and magenta red details. The
plant leaves are yellow with red
veins. Some of the leaves of the plant
and many of the tips of the palm
branches failed to retain color during
firing.[2]

Fragments of tiles similar to this and
to cat. 6 were found in the official
residence of the high priest Panehsi at
Amarna.[3] Many buildings at Amarna
were demolished under Ramesses II
to serve as rubble for his construction
at Hermopolis and the two tiles are
said to have come from Hermopolis
Magna, across the river from Amarna.

1. Brooklyn 1956, p. 35.
2. Ibid.
3. Pendlebury 1951, pp. 26-27, pl. 62:2 and 3.

Bibliography: Brooklyn 1956, pp. 34-35, no. 38a,
pl. 62; Brunner-Traut 1956, p. 114, no. 6; Smith
1958, p. 200, pl. 154a; Brooklyn 1968, p. 98, no.
27; Aldred 1973, p. 216, no. 159.

Literature: Wallert 1962; Samson 1972, pp. 86-92.

6

Tile with mandrake
From Hermopolis Magna
Dynasty 18, reign of Akhenaten
Height 7.5 cm.; width 13.5 cm.
The Brooklyn Museum, Brooklyn, New
York. Charles Edwin Wilbour Fund
(52.148.2)

This fragment of tile shows a boldly
drawn clump of mandrake in full
blossom against a white background.
The great lancet-shaped leaves are
light green outlined in red-brown with
their veining carefully indicated. The
fruits, in clear orange-yellow, are in
very low relief. This tile, like cat. 5, is
an example of the command New
Kingdom craftsmen exercised over
the ceramic art.[1]

E.B.

1. Aldred 1973, p. 216.

Bibliography: Brooklyn 1956, pp. 34-35, no. 38b,
pl. 62; Brooklyn 1968, p. 98, no. 28; Caubet and
Lagarce 1972, p. 117, no. 6; Aldred 1973, p. 216,
no. 160.

Literature: Keimer 1924, pp. 20-23, 172-173.

6

7

Lotus flower inlay
Said to be from Amarna
Dynasty 18, reign of Akhenaten
Height 6.3 cm.; width 5 cm.
The Brooklyn Museum, Brooklyn, New
York. Charles Edwin Wilbour Fund (49.8)

The faience inlay may represent a
part of a formal bouquet used as an
architectural element.[1] The yellow ob-
ject inserted in the bluish-white lotus
blossom with green leaves and buds is
probably a mandrake fruit. This union
of lotus and mandrake is common in
the formal bouquets presented to the
king on state occasions by eminent
courtiers,[2] or given by a god as a sign
of divine favor to a worshiper on holy
days,[3] and in the great standing bou-
quets set upright in the ground before
the tomb on the day of burial.[4] It

7

occurs in painted model bouquets[5]
and in cosmetic spoons like cat. 247
or the famous ivory specimen in the
Wilbour collection.[6]

Similar floral tiles from columns and
door frames were found at Amarna.[7]

E.B.

1. Brooklyn 1968, p. 98.
2. Davies 1932, pls. 35 and 41.
3. Davies 1925b, pl. 17; idem, 1933, pl. 41.
4. Davies 1925b, pl. 19.
5. Cooney 1948, p. 9, fig. 7.
6. Ibid., pp. 7ff.
7. Pendlebury 1951, p. 228, pls. 78:4 and 107:6;
 Samson 1972, pp. 86, 93ff.

Bibliography: Brooklyn 1968, pp. 29, 98, no. 29, pl.
6; Caubet and Lagarce 1972.

Literature: Frankfort and Pendlebury 1933, p. 21,
pl. 30:3; Keimer 1925, pp. 145-161.

8

8

Lotus flower inlay
From Semna Fort
Dynasty 18
Height 4.8 cm., width 4.6 cm.
Museum of Fine Arts, Boston, Harvard
University-Museum of Fine Arts
Expedition (27.1438)

This faience inlay tile in the form of a
blue lotus has a deep blue glaze. The
leaves and petals are in raised relief
with some modeling. The rectangular
mortises found on the back of other
lotus inlay pieces are absent from this
specimen, whose back is perfectly
smooth. In addition to floral inlays,
the Egyptians also used the inlay tech-
nique for human figures during the
New Kingdom.[1] The right edge of the
Boston inlay is a modern restoration.

S.K.D.

1. Samson 1972, pp. 66ff.; Hayes 1959, p. 318.

Bibliography: Dunham and Janssen 1960, p. 19, pl.
119c.

9

9

Lotiform necklace terminal
Provenance not known
Dynasty 18
Height 4.1 cm.; width 5.6 cm.
Musées Royaux d'Art et d'Histoire,
Brussels (E. 7308)

Such faience necklace terminals are
very common during the Eighteenth
Dynasty.[1] Along the flat top at the
back are several holes through which
the various threads of the necklace
elements were passed. They emerged
from one hole at the base of the
flower, where they were tied together
or knotted.[2] The white portion of the
flower was cast in a mold and the
material composing the blue and
yellow leaves was then added before
firing. Greek jewelers later borrowed
this motif for their collar terminals.[3]

S.K.D.

1. Hayes 1959, p. 321.
2. Samson 1972, p. 69, pl. 8; p. 94.
3. Segall 1943, pl. 1, pp. 44, 46.

appear in actual bouquets and is probably a decorative afterthought.[1] On various items of cosmetic nature, the formal bouquet assumes an important decorative function, often appearing as the handle of ointment spoons[2] (see cat. 247).

S.K.D.

1. Keimer 1925.
2. Wallert 1967, pls. 22, 23, 26, 27, 30.
Bibliography: Sotheby 1930, lot 183.

11
Seed pod
Provenance not known
Probably New Kingdom
Height 3.8 cm.; diameter 7.2 cm.
Walters Art Gallery, Baltimore (48.459).
Formerly in the MacGregor collection

The faience seed pod has about forty-five cells inset with small reddish-brown pellets representing individual seeds. It is possible that the seed pod imitated here belongs to the *Nelumbo nucifera,* although its seeds are spherical rather than columnar and they usually number about thirty per pod and not forty-five. In dating this piece, however, one has to account for the impression left by Egyptian texts and representations that the *Nelumbo nucifera* does not occur in Egypt prior to Dynasty 27, when it is generally thought that it was imported from India via Persia. The fact that elaborate faience forms of this sort were produced in great numbers during the New Kingdom is the strongest argument for the early dating.

J.K.M.

Bibliography: Sotheby 1922, p. 34, no. 246.

11

12

10

10
Mirror handle in the form of a bouquet of lotus
Provenance not known
New Kingdom or later
Height 18.3 cm.; width 4.6 cm.
Fitzwilliam Museum, Cambridge. Bequest of E. Towry Whyte (E. 423.1932)

This wooden handle takes the form of a formal bouquet of lotus flowers and closed buds. The base of actual bouquets was a cylinder of stalks bound together into which the flower stems were inserted. Additional flowers were then impaled on split palm leaves, which were also inserted into the cylinder. Sometimes a fruit was so pierced, the opposite end of the palm leaf strip being pushed through the center of a flower, to create the impression that the fruit actually rested there (cf. cat. 7). The cushion-like element at the top does not

12
Grape cluster
Provenance not known
New Kingdom
Height 9.5 cm.
Museum of Fine Arts. Gift of the Estate of Robert N. Gardner (39.733)

Objects of this kind seem to have been used in varying architectural contexts. The ceiling of a garden chapel in the finest house in the south-central quarter at Amarna was painted with a vine and grape pattern and its rafters bore bunches of faience grapes.[1] Such grapes also hung suspended from the ornate baldachins erected over the royal throne in the New Kingdom.[2] Fifteen to twenty grape clusters were found at Medinet Habu in the palace and among foundation deposits of Ramesses III.[3] Like the present example they were molded in two parts and joined with a thick faience slurry; half of the top part of the cluster was cut away and two holes made in the remaining front part to receive a peg for attachment. Smaller grape clusters were made into pendants for use in jewelry.[4]

A section is now missing from the top part of this cluster.

E.B.

1. Frankfort and Pendlebury 1933, pp. 24-25, no. 239.
2. E.g., Davies and Davies 1933, p. 38, pl. 51; Säve-Söderbergh 1957, pl. 1.
3. Oriental Institute 1951, p. 46m, fig. 58.
4. Frankfort and Pendlebury 1933, pl. 36.

Literature: Petrie 1894, p. 30, pl. 19.

13

13

Jasmine blossom necklace
Said to be from Melawi
New Kingdom
Length 92.3 cm.
The Oriental Institute, The University of Chicago (532)

The tubular shape of the nine large and thirty-six small blue faience beads that compose this necklace identifies them as jasmine.

Although not native to Egypt, by the New Kingdom jasmine had come to be appreciated there. The pungent scent of jasmine accounts for the blossoms being strung together and worn as an aromatic necklace in Egypt today, and it is likely that the same was done in ancient times. Jasmine blossoms were found among plant remains dating to Roman times in Hawara[1] and can be recognized among other blossoms in a Twentieth-Dynasty tomb painting.[2] During the New Kingdom, jasmine blossoms were imitated in various materials, and strung as beads on necklaces. One such piece, dated to the end of the New Kingdom, is in Berlin.[3] Like the necklace presented here, it is composed of two sizes of beads.

G.L.S.

1. Keimer 1924, p. 28.
2. Schäfer 1905, p. 28, fig. 57.
3. Keimer 1924, pp. 28, 92, n. 3, 175, fig. 2.

The Farm and Barnyard

". . . that Egypt to which the Greeks sail is land acquired by the Egyptians and given them by the river . . . it is a land of black and crumbling earth, as if it were alluvial deposit carried down the river from Aethiopia."[1] Herodotus' assessment of the importance of the Nile to Egypt is correct: the Nile both waters and fertilizes the very flood plains it created. Inundation begins at Aswan in June and is at its height in northern Egypt by the end of September or the beginning of October. Great anxiety attends the season of flooding. There is little or no rain in many areas of Egypt; if the waters are insufficient the result may be famine and death, but if the Nile rises too much its flood will cause great damage.

The retreat of the waters begins about two weeks after the flood has reached its crest. This pattern has been permanently altered by the erection of the Aswan dam, but in ancient times, work in the fields began as soon as the land emerged. Artificial fertilization was not usually necessary because of the regular deposits of fresh silt left by the Nile waters as they receded. On fields not reached by the flood and watered artificially, marl clay was probably distributed as fertilizer; the passage in the *ushebti* spell[2] that mentions carrying sand may well be a reference to this practice.[3]

Most of the agricultural process can be seen in the tomb of Paheri[4] (see fig. 17). In the lower register, fields are plowed and planted. In some cases, the seed may have been sown first and the ground then plowed up to cover it.[5] Herodotus[6] says that in his time the Egyptians didn't plow but merely sprinkled the seed about and drove swine through the fields to tread it in. There is little to suggest, however, that this was usually the case (cf. fig. 32), and in Paheri's tomb several cow-drawn plows are seen, in addition to one drawn by men. Some men are hoeing, others sowing seed. In other tomb scenes, men with wooden hammer-shaped mallets (see cat. 25) accompany the plows to further break up clods of earth.[7] In Paheri's tomb three kinds of crop are harvested, probably barley, emmer, and flax. The heads of the grain crops are cut off near the top of the stalk with a lunate sickle (cat. 15), and gleaning women follow the reapers. Scenes of the flax harvest show the entire plant being pulled from the soil so as to avoid breaking the precious fibers. Dirt is then cleaned from the roots and the seed heads are combed off for planting the following year.[8] In the third register, ears of grain are packed into large baskets[9] and carried to a threshing floor. In the tomb of Menna[10] the actual preparation of a circular threshing floor can be seen, accomplished by men using pitchforks that look remarkably like those used today. Cattle are then driven around the floor in order to tread the grain. Winnowing follows (cat. 16) and, finally, the ears are heaped up, measured, recorded, and carried off to Paheri's storehouse, from which a shipment will be sent to the royal granaries as a tax payment. The proportion of tax to be paid by an individual was calculated just before harvest by measuring the size of each individual field with ropes, and scenes of field measurement show a swarm of scribes and officials of the civil authority involved in the process, while the estate owner watches in the shade of a booth.[11] (Egyptians of the Late Period apparently attributed to King Sesostris of the Middle Kingdom the practice of reducing a man's taxes if he had lost arable land during the inundation.[12])

Among the officials are the field measurers themselves, who carry on their shoulders heavy bound coils of rope from which may protrude a head of Amen-Re in the form of a ram, their patron god.[13] Also included in the troop is an elder member of the surveying team, who carries a special staff and whose function is to pronounce an oath over the field boundary stone, swearing that it is standing in its proper place[14] (fig. 18). Disputes over boundary and water rights were probably common and the "Negative Confession" of the Book of the Dead[15] includes assertions by the deceased that he has not appropriated another's fields or illegally diverted or blocked the flow of irrigation water.

Above the winnowing scene in several Theban tombs is a strange object to which offerings are made. Crescent-shaped, or in the very rough form of a human or bird, it is apparently an aru-seh or "corn maiden" sacred to Rennu-

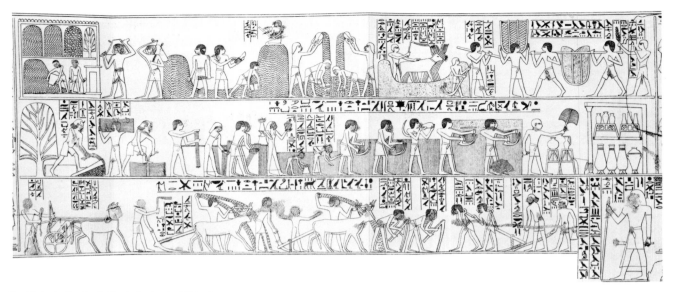

Fig. 17. Agricultural activities in the tomb of Paheri at El Kab.

Fig. 18. Old man swearing an oath over a boundary stone.

tet, goddess of the harvest (fig. 19). Made just before the harvest from the best ears of grain in the fields, it was woven into this shape, and similar examples can even now be found in Europe and in modern Egypt, where it may be hung in the storeroom or in the door of a shop, or placed with the rest of the harvest in order to ensure continuing agricultural bounty and general prosperity.[16]

The scene from Paheri's tomb records the agricultural practices on a large estate. Papyri containing the litigation proceedings between herdsmen over the services of their slaves provide evidence of small independent farmers who were able to support their own laborers.[17] A hint of the routine of the life of a small farmer is given in the introduction to a New Kingdom story entitled "The Tale of Two Brothers."[18] Bata did the plowing, sowing, and reaping for his older brother, a farmer and householder. Every day, when he returned from the fields, he brought back produce, wood, and milk. In addition to these duties, he also cared for the cattle, spending the night with them in the stable and taking them out to pasture in the morning. There is one aspect of Bata's story that was not part of the everyday routine of a herdsman. Bata's cows talked! They told him where they found the tastiest bits of herbage, and he took them to the locales they preferred. This episode in the story, along with a frag-

mentary veterinary papyrus from the Middle Kingdom (offering two treatments for eye diseases in cattle),[19] confirms the importance with which cows were regarded.

There is considerable disagreement over the varieties of cattle kept in the New Kingdom. Some authors state that only the long-horned variety remained, and that short-horned and hornless types, known in the Old and Middle Kingdoms, had vanished;[20] others have stated exactly the opposite.[21] One text mentions not only oxen but also short-horned *wenedju* cattle.[22] Long-horned *negau* cattle[23] are often represented in scenes and mentioned in texts. Hornless, short-horned, and long-horned cattle are grouped together in the tomb of Puyemre,[24] although it is possible that the hornless animals had been mutilated, perhaps to provide the bovine horn from which horn vessels were made (cat. 403).

It is probable that the humped *zebu* or Brahmany bull, which first appears in the New Kingdom, was imported from Syria. Pied humped bulls are shown as part of a Syrian shipment in the tomb of Kenamen (fig. 3),[25] a humped bull appears in a Syrian setting in the tomb of Amenmose, [26] and a black humped bull is led in procession in the tomb of Benya.[27] Most indicative of their wide acceptance is a scene of activities on a Theban farm, where two humped bulls are shoulder-yoked to a plow. An

interesting sidelight to this relief is the apparent rare use in the upper register of a wheeled farm cart, drawn by oxen and used to haul grain to the threshing floor.[28]

Cattle were often heavily taxed, and branding irons were used to mark them with their destination (see cat. 19). They apparently grazed under supervision on the borders of the desert, since valuable arable land would not have been wasted as pasture[29] and after the threshing process was finished, cows ate the remaining straw.[30] Sometimes they were fattened in enclosures with semiwild animals (see cat. 17), or stalled and fed by hand.[31]

Other animals kept by the Egyptians include donkeys, sheep, goats, and pigs.[32] It appears that geese and ducks were regularly found in the barnyards; other birds were usually snared and penned during migration season.[33] Domestic chickens may have been known too, even if they were not commonly kept by farmers (see cat. 18).

S.K.D.

1. Herodotus II, 5 and 12: Godley 1921, pp. 279-280, 289.
2. Book of the Dead 6: Allen 1974, p. 8.
3. Keimer 1926, pp. 287-288.
4. Tylor and Griffith 1894, pt. 2, pl. 3, pp. 12-15.
5. Montet 1962, p. 109.
6. Book II, 14: Godley 1921, p. 291.
7. Davies 1917, pls. 18ff.
8. Lucas 1962, pp. 142-144.
9. See also Davies 1917, pls. 18ff.
10. Mekhitarian 1954, p. 77.
11. Wreszinski 1923, pl. 11; Klebs 1934, pp. 6-8.
12. Herodotus II, 109: Godley 1921, p. 397.
13. Or Khnum. Graefe 1973; Borchardt 1905b; Säve-Söderbergh 1957, p. 42 and pl. 42.
14. Farina 1929, pls. 107, 127; Berger 1934; Wilson 1948, pp. 130, 133ff.
15. Allen 1974, ch. 125, pp. 97ff.
16. Blackman 1922.
17. Gardiner 1906, pp. 27-47.
18. Simpson et al. 1973, pp. 92ff.; Gardiner 1932b, pp. 9ff.
19. Griffith 1898, pp. 12-14.
20. Kees 1961, p. 86.
21. Darby et al. 1977, p. 98.
22. Caminos 1954, p. 210.
23. Ibid., p. 439.
24. Davies 1922, pl. 13.
25. Davies and Faulkner 1947, p. 45 n. 3 and pl. 8.
26. Davies and Davies 1933, pl. 36.
27. Guksch 1978, color pl. 1, pl. 11, p. 19, scene 7.
28. Hayes 1959, fig. 90, p. 165; Säve-Söderbergh 1957, pl. 23.
29. Kees 1961, p. 90.
30. Tylor and Griffith 1894, pt. 2, p. 15 and pl. 3.
31. Davies 1903, pl. 25.
32. Kees 1961, p. 90; Tylor and Griffith 1894, pt. 2, pl. 3; Davies 1927, pl. 30.
33. Kees 1961, pp. 93-94; Davies 1927, pl. 30.

Literature: Rushdy 1911; Paton 1925; Darby et al. 1977; Hartmann 1923.

14

14
Hoe

From Deir el Bahri
Dynasty 18-20
Length of handle 45.7 cm.; length of blade 33.6 cm.
Royal Ontario Museum, Toronto. Gift of Egypt Exploration Fund (907.18.31)

The wooden hoe with original binding has a broad blunt blade with two rectangular holes and a curved handle. The upper part of the handle is round; the lower part is wider and flatter with a rectangular perforation for the insertion of the blade tenon. A three-ply rope, tied around the handle and passed through the holes in the blade, could be loosened or tightened to change the angle between the blade and handle.

Hoes were used for breaking up the soil after plowing, or for cultivating already planted crops;[1] they were also employed for mixing mud for bricks.[2] Since this hoe was found with other tools, including a mallet (cat. 25), a chisel (cat. 26), and boning rods (cat. 27), it may have been used for brickmaking.

Originally hoes were probably simply forked tree branches.[3] Blades were variously shaped to suit the intended use. Examples have been found with broad, flat, and blunt blades, such as that of the present hoe.[4] Other blades have flat triangular shapes below the binding.[5] Hoes are commonly seen in the hands of ushebtis, small figurines placed in tombs, who, with the recitation of the proper magical spell, supposedly came to life and performed field work for the deceased in the afterlife. The hoe figured prominently in the ritual life of the Egyptians, too, especially in the rite of "hacking up the earth," a part of the foundation ceremonies performed at the construction of each temple.[6]

S.K.D.

1. Davies 1917, pl. 18.
2. Davies 1943, pl. 58.
3. Petrie 1891, p. 12 and pl. 7:28.
4. Letellier 1978, p. 63, no. 80.
5. Agyptisches Museum 1967, nos. 287-289, p. 31; Petrie 1917b, pl. 68.
6. David 1973, pp. 71 and 73.

Bibliography: Naville 1907, p. 16; Naville 1913, pp. 18, 26, pls. 29, 33.

Literature: Petrie 1917b, pp. 18-19 and 54; Schäfer 1971, pp. 140-142; Eggebrecht 1977, col. 924-925; Agyptisches Museum 1967, pp. 49-50, nos. 541-542.

15

Ritual sickle of the fieldworker
Amenemhat
Possibly from Theban tomb 82
Dynasty 18
Length 38.8 cm.; width 22.5 cm.
The Brooklyn Museum, Brooklyn, New
York. Charles Edwin Wilbour Fund (48.27)

The handle, body, and tip of the wooden sickle were made in separate pieces and pegged together. An inscription usually translated as "the fieldworker of Amen, Amenemhat, repeating life" is inlaid in blue paste on the yellow body. The handle and tip segments were stained to imitate ebony, but the body was left its natural yellow color. On a sickle for actual use, slightly curved, rectangular serrated flint blades would have been inserted and glued into slots on the inner curve of the body.

An excavated sickle of the New Kingdom, probably also of tripartite construction, with peg holes and some flint teeth remaining, and showing the same graceful curve and handle type as Amenemhat's sickle, was found at Kahun.[1] Still another type is suggested by a reconstructed sickle with ancient blades in place.[2]

The title "fieldworker of Amen," inscribed on the body, does not

necessarily mean that the owner of the sickle was actually a fieldworker during his lifetime. Rather, it may only remind us that a deceased individual had ritual agricultural duties to perform in the afterlife, and that this sickle was provided for his use in performing those duties.[3]

Whether or not this is the same Amenemhat who was the owner of Theban tomb 82[4] is somewhat difficult to ascertain, since he did not include "fieldworker of Amen" among the titles listed in his tomb. Several Amenemhats lived during the required time period and may have owned the sickle.[5] Amenemhat of tomb 82 was, however, an official in the granaries of Amen[6] and, as such, seems a likely candidate for the sickle's owner.

S.K.D.

1. Petrie 1891, p. 12, pl. 7:27.
2. Hayes 1959, fig. 259, p. 409; for the changing angles of sickle grips from the Neolithic Period to the Middle Kingdom, see Drower 1954, p. 542, fig. 356.
3. Cooney 1951, p. 8.
4. Ibid., p. 4.
5. James 1974, cat. 190, p. 82; Cooney 1951, p. 7.
6. Davies and Gardiner 1915, pp. 7-8.

Bibliography: Cooney 1951, pp. 6-8, figs. 4-5; James 1974, no. 190, p. 82.

16

16

Winnowing fan
From the Valley of the Kings
Probably Dynasty 18
Length 31.7 cm.
Royal Ontario Museum, Toronto. Gift of
Theodore M. Davis (906.6.9)

The right-hand winnowing scoop or fan, carved from a single piece of wood, has a rectangular handle with a cylindrical grip. The other end is roughly spoon-shaped, thin, and slightly hollowed. It appears that the fan was used heavily, for the left edge, originally straight, is quite worn and the tip of the spoon is gone.

Winnowing scoops were used in pairs — the left-hand mate for this scoop would have been identical but reversed in shape. The straight edges served to scoop grain up from the threshing floor; it was then tossed into the air, where the wind blew away the chaff and dust. In most depictions of this process in Theban tombs the winnowers wear white scarves to keep the chaff and dust from their hair, and assistants keep the floor swept.[1]

15

Winnowing fans changed little in form during the pharaonic period. An almost identical example from the Twelfth Dynasty, but with incised lines on the grip, was found at Kahun[2] and Eighteenth-Dynasty fans have been found at neighboring Gurob.[3]

S.K.D.

1. Wreszinski 1923, pl. 83; Davies and Gardiner 1936, pl. 51.
2. Petrie 1890, pl. 9:11.
3. Ibid., p. 35.

Literature: Petrie 1917b, p. 54, pl. 68; Schäfer 1971, pp. 142-143.

Fig. 19. Aruseh or "corn maiden" (in the winnowing scene from the chapel of Djeserkareseneb, Theban tomb 38).

17

Manger

From the Northern Palace, Amarna
Dynasty 18
Height 29.5 cm.; width 52.1 cm.
Toledo Museum of Art. Gift of Egypt Exploration Society (25.744)

Two ibexes approaching a well-stocked manger decorate this actual limestone example. Traces of black on the bodies and horns of the animals and traces of green on the bundles of fodder indicate that this manger, like the others found with it, was originally painted. An additional bundle of fodder appears in the upper right corner of the scene.

Thirteen other mangers, also decorated with feeding animals and troughs, were found around the walls of an enclosure at the Northern Palace. (There were originally more, some apparently having been removed in antiquity.) The nature of the enclosure and the decoration on the mangers suggests that the area was a pen for animals, some of which were probably wild or semidomesticated varieties. Between the mangers were placed stone tethering rings, to which the animals were tied while they ate. In a depiction of another such enclosure from a much earlier period, dating from the Old Kingdom tomb of Mereruka at Saqqara,[1] similar kinds of tethered animals eat from individual mangers. It may be that animals were kept at Amarna as a sort of zoological exhibit,[2] but it is also possible that, as in the tomb of Rekhmire,[3] they were kept to be hunted for sport and for food by kings or nobles. In addition, it may be that such pens provided a ready source for sacrificial animals.

S.K.D.

1. Oriental Institute 1938, pl. 153.
2. Aldred 1973, p. 212.
3. Davies 1943, pl. 43.

Bibliography: Newton 1924, pp. 295-296, pl. 30; Luckner 1971, p. 65, fig. 6; Aldred 1973, no. 151, p. 212; Toledo 1976, p. 6.

Literature: Paton 1925; Darby et al. 1977; Hartmann 1923.

18

18

Ostracon with drawing of a red jungle fowl

From Thebes
Dynasty 18-20
Height 15.5 cm.; width 19 cm.
British Museum, London (68539)

The strutting cock drawn in black ink displays a well-developed erect comb with four points. The beak is slightly exaggerated in length and curves upward. Below and to the left of the eye is an indication of the ear and lobe. Wattles are shown at the neck, and saddle feathers appear at the end of the wing. A spur projects from each leg, but no talons are represented. The tail appears in two parts; the upper portion, drawn with heavy lines, represents the sickle feathers, and the lower portion indicates the lesser sickle feathers and tail coverts.

This limestone ostracon was found in the Valley of the Kings in undisturbed strata between the tomb of Ramesses IX and tomb 55.[1] Whether the drawing actually represents a domestic bird is a matter of some debate, since chickens were not well known in Egypt until about 50 B.C.[2] It seems possible, however, that the sketch shows a domestic fowl of the type mentioned in the Annals of King Thutmose III, a bird of a foreign land that "gives birth every day."[3] The Egyptians left a tremendous amount of documentation regarding the animals and birds they knew and used, and it is likely that, since it is hardly represented, the domestic chicken may have been known only rarely during the New Kingdom and perhaps even died out soon after its introduction. The domestic fowl originated in southeast Asia and by 2500 B.C. was known in Babylon.[4] Other representations of domestic

17

fowl in Egypt include a chased and *repoussé* bird on a Ramesside silver bowl[5] and a graffito of a cock from Medamoud dated by its excavator to the Middle Kingdom,[6] but possibly of New Kingdom date. A now destroyed painting of a rhyton in the shape of a bird's head, among Cretan tribute in the tomb of Rekhmire,[7] is usually described as the head of a griffin, but it has been argued[8] that it represents a cock, partly because the bird has wattles.[9]

The skeleton of a chicken and associated eggs dated to the New Kingdom[10] may be merely the remains of some later tourist's lunch.

S.K.D.

1. Carter 1923, pp. 1-4.
2. Carter 1971, p. 187.
3. Sethe 1907b, p. 700, ll. 13-14.
4. Cottevieille-Giraudet 1931, p. 42.
5. Simpson 1959, pl. 13a; Smith 1965, p. 29.
6. Cottevieille-Giraudet 1931, pp. 41-43, 74, pl. 8.
7. Drawn before its destruction by Prisse d'Avennes; 1878, pl. [75].
8. See Montet 1937, pp. 124-125.
9. Cocks are also represented in four ivory plaques from the Nuri pyramid of Queen Yeturow, daughter of Taharqa and sister-wife of Atlanersa (ca. 653-643 B.C.). (Dunham 1955, p. 37a, e, fig. 22b, e.)
10. Darby et al. 1977, p. 301, figs. 6.32, 6.33.

Bibliography: Carter 1923, pp. 1-4, pl. 20; Smith 1965, p. 29, fig. 39; Darby et al. 1977, pp. 297ff.; Peck 1978a, p. 118.

Literature: Sethe 1916, pp. 110-116; Petrie 1927, p. 37:18, pl. 34:18; Keimer 1956, pp. 6-11; Coltherd 1966, pp. 217-223; Volker-Carpin 1970, pp. 276-287; Carter 1971, pp. 182ff.; Brunner-Traut 1980b.

19

Branding iron

Said to be from Amarna
Dynasty 18
Length of handle 11 cm.; width 9 cm.
Staatliche Sammlung Ägyptischer Kunst, Munich (5520)

Each circlet on the stamp of this copper branding iron contains a hieroglyphic sign. The handle consists of two forks, each supporting both the top and bottom of a circlet. The forks join and are twisted together to form a single grip. Part of one fork has been broken off.

The hieroglyphic signs, after branding, would have read *ankh nefer,* probably "living and perfect," or possibly "perfect small cattle."[1] Cattle-branding scenes and irons appear in the tombs of Kenamen[2] (fig. 20), Neferhotep,[3] Huy,[4] Nebamen,[5] and Userhat.[6] Twisted handles such as that on the Munich brand are seen most clearly in the representations of the tombs of Huy and Kenamen.

Irons were kept in caskets until needed and then heated in a fire before application. Branding usually designated the cattle for specific purposes, although this example merely names their qualifications. Cattle might have been marked with the name of the festival during which they were to be sacrificed[7] or with the name of the

Fig. 20. Branding irons of Kenamen (from Theban tomb 93). The one on the left marked cattle as property of the king, that in the center was used for a cattle tax, and the brand on the right marked animals as property of a specific institution.

king or institution by which they were owned or to which they might be paid as tax.[8] Others were marked with a hieroglyphic sign indicating that the animal was part of a special cattle-tax payment.[9] Much smaller brands were sometimes used for marking prisoners of war and slaves.[10]

S.K.D.

1. Janssen 1975, pp. 164-165.
2. Davies 1930, pls. 27-28.
3. Davies 1933, pl. 43.
4. Davies and Gardiner 1926, pl. 40.
5. Davies and Davies 1923, pl. 32.
6. Wreszinski 1923, pl. 187.
7. Leclant 1956, p. 133.
8. Davies and Gardiner 1926, pl. 40; Davies 1930, pl. 27.
9. Davies 1930, p. 33 n. 4.
10. Caminos 1954, p. 320 n. 7.6; Oriental Institute 1930, pl. 42.

Bibliography: Ägyptische Sammlung 1966, no. 63; Müller 1970, p. 186.

Literature: Petrie 1917b, pp. 56ff., pl. 71; Petrie 1932, p. 9, pl. 19:272; Eggebrecht 1975b, cols. 850-852.

19

20

Decorative butcher knife

From Kerma tumulus 20
Late Second Intermediate Period
Length 34.4 cm.; width 4.5 cm.
Museum of Fine Arts. Harvard University-Museum of Fine Arts Expedition (20.1799)

The large bronze straight-backed knife has an angled handle in the form of the hoof of an herbivore. The elongated tip, which is curved around and bent back, is worked into the form of a goose or duck head (cf. cat. 394). The handle is riveted to the blade in three places and the blade edge shows signs of use.

There are several New Kingdom knives with handles in the form of the leg of a cow or bull.[1] Most like the Kerma knife in shape and handle decoration is an excavated example from the early Eighteenth-Dynasty tomb of Nefer-khaut.[2] It too has a straight back; the tip of the blade, although curved upward, is plain. A similar knife from Dynasty 25 in the Athens Museum is inscribed with the name of Amenirdas, sister of Piye (Piankhi) and Shabaka.[3] The foreleg and bird's head in hieroglyphic writing are connected with the symbolism of sacrifice.[4] The knives shown in most New Kingdom butchering scenes are double-sided, with a straight handle on the same axis as the central rib.[5] Those in the tomb of Rekhmire, however, are of this type, with a straight back and angled plain handle.[6] In the tomb of Puyemre, a knife of this shape is seen being used for cleaning fish.[7] The present example, however, seems most suitable for butchering large animals, especially if it was necessary to preserve the hide for tanning. A rounded, decorative tip would have made it much easier to skin an animal without accidentally piercing the valuable hide.

S.K.D.

1. Petrie 1917b, p. 25, pls. 26:145, 29:231 and 232; Petrie 1890, p. 34, pl. 17:32.
2. Hayes 1935, pp. 28-29, fig. 10.
3. Boufides 1970, p. 283, figs. 9-10.
4. Fischer 1977b, pp. 121ff.
5. Davies 1948, pl. 2.
6. Davies 1943, pls. 82, 83, 92.
7. Davies 1922, pl. 17.

Bibliography: Reisner 1915, p. 79, fig. 13; Reisner 1923b, pp. 198:6, 199, fig. 189:6, pl. 50:2, 1.

Literature: Petrie 1928, p. 13, pl. 23:9; Dothan 1979, pp. 18-19, figs. 32-33.

20

21

21

Serrated knife

Provenance not known
Dynasty 18; probably reign of Akhenaten
Length 31.5 cm.; width of blade 4.2 cm.
The Brooklyn Museum, Brooklyn, New
York. Charles Edwin Wilbour Fund (65.133)

The serrated blade of this bronze
butcher knife enabled it to cut easily
through tendon and gristle. The shape
resembles that of the feather of truth,
emblem of the goddess Maat. Essen-
tially, however, the form is the same
as that of cat. 20, with a straight back
and angled handle, which on this ex-
ample is ribbed and terminates in a
papyrus flower or umbel. At the center
of the umbel is a suspension ring. The
rounded, turned-up blade tip would
have served the same purpose as the
duck's-head tip on cat. 20.

The only other example of a knife like
this was found at Amarna.[1] In the
same house[2] were found several
other butchers' implements and an
ostracon that mentions several dif-
ferent cuts of meat.[3]

<div align="right">S.K.D.</div>

1. Aldred 1973, p. 214; Frankfort and Pendlebury
 1933, p. 68.
2. S.33.1.
3. Frankfurt and Pendlebury 1933, pl. 57:4.

Bibliography: Brooklyn Museum 1966, p. 119;
Aldred 1973, p. 214, no. 156.

Literature: Frankfort and Pendlebury 1933, p. 68,
pl. 47:1.

Crafts and Tools

Credit for the outstanding perform-
ance of the Egyptians in the manufac-
ture of arts and crafts is due not to
advanced techniques and equipment
but to organizational talent and un-
ending patience. Time was not neces-
sarily money, as it is now, and, while
the efficient completion of a task was
something to strive for,[1] many jobs,
especially those involving work in
stone, simply took weeks or months to
complete. No quick alternatives were
available. The extraction of one obelisk
from living rock during the time of
Queen Hatshepsut, for example, may
have taken hundreds of men as long as
seven months,[2] and additional time
would have been required for removal
from the quarry, shipping, and
installation.

Most New Kingdom artisans were not
self-employed but worked in state,
royal, or temple workshops.[3] The ac-
tivities in a Theban workshop attached
to a temple of Amen, as shown in the
tomb reliefs of the vizier Rekhmire
(fig. 21), give us a good idea of such a
place. Many of the items being made
there are intended not only for presen-
tation to the temple but also for in-
clusion in the royal tomb or for the
use of the army.[4] Craftsmen pictured
include leather-workers, smiths, car-
penters, stone-workers, and jewelers,
and assembly-line methods are clearly
in evidence. Among the leather-
workers, for example, the divisions of
labor are clear. One man is responsible
for softening hides, another for soak-
ing, others for cleaning and scraping,
and another for cutting. Different
groups of men are separately engaged
in sandal-making, the preparation of
shields, and leather rope-making.[5]
Carpenters, too, show the same degree
of labor specialization.[6]

A different view of the life of an artisan
can be gained from a perusal of the
records left by the Ramesside work-
men's village of Deir el Medineh. Here
the focus of attention was the prepa-
ration of tombs for the reigning
pharaohs. Workmen were divided into
two gangs[7] and at one point as many
as 129 men were employed in them.[8]
Promotions were usually made from
within and may have been influenced
by the age of the applicant, or, in the
case of a young man, by his father's
ability to bribe the proper official.[9]
Each gang usually had one foreman,
whose duties were much the same as

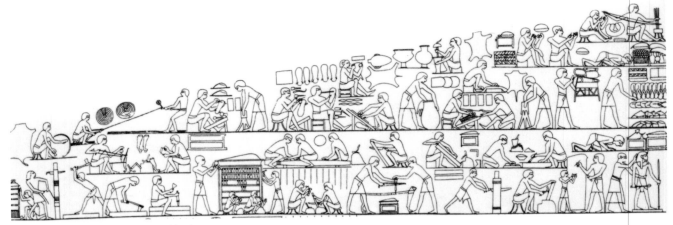

Fig. 21. Carpenters (bottom register) and leather workers (top register) (in the tomb of the vizier Rekhmire, Theban tomb 100).

they might be today. Foremen had high rank and were better paid than other workers;[10] they assigned tasks, supervised the ongoing work, settled disputes, made inspections, and had some responsibility for tools and materials.[11] They were assisted in their duties by deputies, guards and door-keepers, and captains.[12] Definitely "management," during a strike that took place in the twenty-ninth year of Ramesses III,[13] they tried to coerce the men back to work. An example of a foreman siding with the workmen was rare.[14] Slaves of the king, both male and female, were kept to assist the workmen in household duties and acted for the community as fishermen, water-carriers, woodcutters, garden-ers, potters, and confectioners.[15] Such household work performed by slaves was part of a workman's wages.[16] Since wages were paid in kind, fami-lies also received vegetables, fish, beer, grain, oil, clothing, sandals, pottery, etc.[17] Bonuses of meat, fruit, and other delicacies were given on holidays.[18] Although it is not possible to compare such wages to a modern salary, workers at Deir el Medineh seem to have been quite comfortable, that is, when wages were paid on time. The text of the Strike Papyrus (see p. 25) suggests that such was not always the case, but many ordinary workmen were apparently able to provide very well for their families and had enough left over to equip elaborate tombs for themselves.[19]

Although most New Kingdom crafts-men are known to us only as nameless figures in a larger scene, a few indi-viduals do stand out, mostly from Deir el Medineh.[20] Rarely did they rise to a

position high enough to gain fame, as did Akhenaten's sculptor Bak,[21] but their excellent work must often have earned them the gratitude of their employers. One satisfied customer, Amenemhat, owner of Theban tomb 82 (cat. 15), is shown hosting a ban-quet for the artisans who worked on his tomb.[22]

The tools available to the Egyptian artisan of the New Kingdom were limited in number and quite simple. Many hardly differ from those used in the Old Kingdom, and when some evolution of types is noticeable it is often difficult to see what advantage has been gained by such changes in form. Exceptions to this are most often found among the tools with metal parts — axes, adzes, chisels, etc. — where improved casting techniques, coinciding with the spread of the use of bronze and the resulting better methods of hafting, made metal and compound tools more effective.

S.K.D.

1. Habachi 1977, p. 78.
2. Ibid., pp. 20, 66.
3. Harris 1971b, p. 85; Drenkhahn 1976, pp. 134ff.
4. Davies 1935, pl. 23; Davies 1943, p. 36.
5. Davies 1943, pls. 52-55.
6. Ibid., pl. 55.
7. Černý 1973a, pp. 99-100.
8. Ibid., p. 108.
9. Ibid., pp. 115-116, 127.
10. Ibid., p. 128.
11. Ibid., pp. 129-131.
12. Ibid., pp. 133ff., 149ff., 161ff., 237ff.
13. Gardiner 1948a, pp. xiv-xvii, 45-58a.
14. Černý 1973a, pp. 131-132.
15. Ibid., pp. 177-179, 189.
16. Ibid., p. 186.
17. Janssen 1975, pp. 455-493.
18. Ibid., p. 489.
19. Bruyère 1926; Bruyère 1929.
20. Cerný 1973a, passim.

21. Habachi 1965, pp. 70-92.
22. Wilson 1947, pp. 243-344 and n. 56; see also Davies and Gardiner 1915, pp. 36-37.

Literature: Clarke and Engelbach 1930; Černý 1954 pp. 903-921; Erman 1971, pp. 446-478; Aldred 1975, cols. 800-805; Helck 1975b, cols. 371-374; Monica 1975; Śliwa 1975; Drenkhahn 1976; Bogoslovsky 1980.

an ax intended for use, a leather lashing would have been wound and woven around the handle and lugs when still fresh or wet so that it would shrink and tighten after drying. Additional tightening of this binding would have been achieved by forcing a wedge between the back of the handle and the lashing.

Similar axes were carried by Egyptian troops under Ramesses II at the Battle of Kadesh[2] and an actual battle ax was found at the same site as the present example.[3] Visually, however, this type of ax is not distinguishable from those shown in many tomb paintings, where they are employed to split planks[4] or to chop down trees.[5]

S.K.D.

1. Hayes 1959, p. 68, fig. 36.
2. Wreszinski 1935, pl. 17.
3. Hayes 1959, p. 68, fig. 36.
4. Davies 1943, pl. 52.
5. Davies 1917, pl. 21.

Bibliography: Metropolitan Museum 1944, fig. 30; Hayes 1959, p. 68, fig. 36.
Literature: Petrie 1917b, pl. 7; 151-152; Kühnert-Eggebrecht 1969, pp. 38-42, pl. 4:8; Davies 1974, pp. 114-118; Eggebrecht 1975a.

23
Adze
From Thebes
New Kingdom
Length of blade 59 cm.; length of handle 29.5 cm.
British Museum, London (22834)

23

This heavy wooden adze with a bronze blade and leather lashing was found in a basket of carpenter's tools that also contained chisels, a saw, and an oil horn[1] (see cat. 402). The blade is splayed a bit at the bottom and has a slightly curved cutting edge. Its sides taper inward near the top, where they again splay out into a flattened knob.

The blade was lashed to the handle while the leather strapping was wet and elastic, so that when it dried the blade would fit tightly against the haft (cf. cat. 22). Since the blade tapers gradually outward at the bottom, however, repeated blows pushing the blade upward would have had the effect of first tightening the lashing somewhat, then eventually stretching and loosening it, so that occasional replacement was probably necessary.

Adzes and hoes (see cat. 14) are structurally much the same, with the blade at a right angle to the handle. Since the action involved with both is one of striking out and pulling back, it is possible that the form and employment of a primitive forked-branch hoe[2] suggested the specialization of the form (with the addition of a blade) for woodworking purposes.[3]

Adzes were used by woodworkers for cutting and trimming rough wooden planks and shaping and smoothing wooden surfaces. They thus acted both as carving knives and as planes, neither of which was known to the

22

22
Model ax with restored lashing
From the Asasif
Early Dynasty 18
Length of handle 35 cm.; length of blade 7.4 cm.
The Metropolitan Museum of Art, New York. Gift of Edward S. Harkness (26.7.839)

This ax has a bronze blade with two laterally projecting lugs that fit into a grooved handle. Found in a child's coffin,[1] it is a model or toy weapon, and the lashing is not as substantial as that found on a working example. On

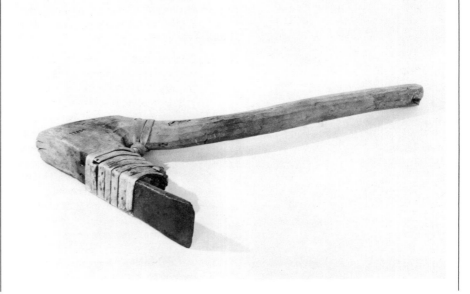

Egyptians. In the tomb of Rekhmire[4] carpenters can be seen using adzes for smoothing planks, shaping furniture legs, and carving the elements of an openwork shrine. After the initial carving of an object, a fine finish would be given to the wood with some sort of abrasive stone rubber or scraper (see p. 64).

S.K.D.

1. British Museum 1964, fig. 79, p. 213; Wilkinson 1883a, p. 401.
2. Cf. Petrie 1917b, pl. 68:57.
3. Ibid., pp. 16-18; pls. 55:130 and 68:57.
4. Davies 1943, pls. 52 and 55.

Bibliography: Aldred 1954, fig. 487g, p. 688; British Museum 1964, p. 213, fig. 79; Baker 1966, p. 296, fig. 458.

Literature: Clarke and Engelbach 1930, pp. 17, 194; Hayes 1959, p. 217, fig. 129, p. 226; Otto 1960, pp. 17ff.; Śliwa 1975, pp. 24-26.

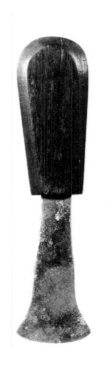

24

24
Leather-cutting knife with handle
From Medinet Habu, Foundation Deposit of Ay Temple
Dynasty 18
Height 10.87 cm.; width of blade 2.66 cm.
The Oriental Institute, The University of Chicago (16528)

This implement has a wide, splayed, convex edge for cutting leather. The bronze blade is tanged and is inserted into a rounded, cone-shaped wooden handle.

Leather provided any much-needed items for the ancient Egyptians. Sandals were often made from it (cf. cat. 201); rope, writing materials,[1] shields, water bottles (cf. cat. 85), quivers, parts for chariots (including harnesses and floors),[2] seats for stools,[3] binding thongs for hafting (cf. cat. 22), and even kilts (cat. 199) were made of leather. Workshop scenes from the tombs of Rekhmire[4] and Menkheper-re-seneb[5] show such products being made and, in both scenes, the leather-cutters used are similar to this one, though less elongated. Another type of knife, T-shaped and larger, with a broader blade, was also used on leather in the New Kingdom.[6]

S.K.D.

1. Hooke 1954, p. 757.
2. Childe 1954, p. 728.
3. Killen 1980, p. 2.
4. Davies 1943, pls. 52-54.
5. Davies and Davies 1933, pp. 11-12, pl. 21.
6. Hayes 1959, p. 218, fig. 129.

Bibliography: Oriental Institute 1939, p. 88, pl. 54, B1.

Literature: Petrie 1917b, p. 50, pl. 62:1 and 2; Oriental Institute 1939, p. 88, pl. 53, Bb-c.

25
Mallet
Deir el Bahri
Dynasty 18-20
Length 25.4 cm.
Royal Ontario Museum, Toronto. Gift of Egypt Exploration Fund (907.18.54)

Found in the same location as cats. 14, 26, and 27, this acacia-wood mallet made in one piece has a conical head and cylindrical handle. Pounding has worn a depression around the head of the mallet and the handle is smooth and shiny from use.

Mallets were apparently first made from heavy tree branches[1] and the distinctive large heads developed later. Baton-shaped examples are known from all periods.[2] True hammer-shaped mallets, though less common, are also known;[3] they were often used for agricultural purposes (see p. 44). A scene from the tomb of Ipy shows workmen using mallets with chisels or engravers and also directly on wooden beams.[4] Sometimes two mallets were used together, one to strike and one to absorb the blow; this method was most in use where workmen assembled furniture.[5]

25

The form of the large-headed mallet changed little throughout the Pharaonic Period. Excavated examples from the Old Kingdom[6] and the Middle Kingdom,[7] although sometimes with a narrower head, differ very little from the Toronto mallet. A Twelfth-Dynasty mallet from Kahun[8] is quite rare, being made of limestone.

S.K.D.

1. Petrie 1917b, p. 40, pl. 45.
2. Davies 1943, pl. 52; Petrie 1917b, pl. 46:60; Newberry 1893a, pl. 29.
3. Petrie 1917b, pls. 46, 71-75; Davies 1917, pl. 21; Peet and Woolley 1923, pl. 19; Ägyptisches Museum 1967, pp. 49-50, no. 540.
4. Davies 1927, pl. 37.
5. Davies 1922, pl. 23.
6. Petrie and Brunton 1924, pl. 22:6.
7. Petrie 1890, pl. 9:4.
8. Petrie 1917b, pl. 46:62 and p. 40.

Bibliography: Naville 1907, p. 16; Naville 1913, pp. 18, 26, 30.

Literature: Letellier 1978, no. 80, p. 66.

26

26

Stonemason's chisel
From Deir el Bahri
Dynasty 19-20
Height 16.2 cm.; thickness 0.9 cm.
Royal Ontario Museum, Toronto.
Gift of Egypt Exploration Fund (907.18.26)

A splayed and slightly convex cutting edge and clearly defined butt distinguish this sturdy bronze chisel. The shank is rectangular in section and somewhat thicker near the butt, which has a bevel-like piece cut out of it. In profile, it appears thinner, with a pointed tip. The shape of the chisel is not unlike that of its modern counterpart, although, being bronze rather than steel, it had to be a bit more sturdy to perform the same task without snapping.

This example is apparently one of those found in the debris above the Eleventh-Dynasty temple of Deir el Bahri and dated to a period during or after the reign of Ramesses II[1] (see also cats. 14, 25, and 27). Chisels appear in various materials in the New Kingdom, including wood, stone, copper, and

bronze. Metal examples were cast in rough pottery molds.[2] The shank might have been hammered round while the metal was still hot, or left roughly rectangular, as in this case. A chisel of this type, used with a wooden mallet (cat. 25), would have been most effective on a soft material such as limestone, or for very rough work on wood or copper.[3]

Chisels were issued to workmen at Deir el Medineh by their supervisors. They were weighed before issue and again when returned, to ensure that the workmen did not remove any of the valuable metal for their own use.[4]

S.K.D.

1. Naville 1913, pp. 18, 30.
2. Petrie 1915b, p. 15.
3. Clarke and Engelbach 1930, p. 194.
4. Simpson 1965, p. 24; Janssen 1975, p. 314.

Bibliography: Naville 1913, pp. 18, 30.

Literature: Petrie 1890, pl. 17:24; Petrie 1909a, pl. 28:30, p. 12; Petrie 1917b, pls. 21-22, p. 20; Clarke and Engelbach 1930, p. 224 and fig. 263.

27

Set of "boning rods"
From Deir el Bahri
Dynasty 18-20
Length of each 10.8 cm.; average diameter of rods 1.6 cm.
Royal Ontario Museum, Toronto. Gift of Egypt Exploration Fund (907.18.280)

An L-shaped perforation is drilled in two rods, beginning at the top end and emerging on the side. A two-ply string, now broken and knotted together, is fed through the holes in the

27

Fig. 22.

sides and tied, so that on each rod it emerges at the hole in the end. A third rod, of the same height but unperforated, accompanies the set. These so-called boning rods were excavated from the same area at Deir el Bahri as cats. 14, 25, and 26, and several other excavated sets of New Kingdom date are known.[1] Examples from other periods are also available for comparison,[2] some Middle Kingdom sets are being square rather than cylindrical.

A scene from the tomb of Rekhmire showing workmen preparing the face of a stone block explains how boning rods were used (fig. 22),[3] a procedure still followed in the Middle East today. One man holds each perforated rod at a right angle to the face of the stone. (Two flat vertical facing surfaces, at both points of contact with the rods, must already have been established, perhaps by means of a plumb line.) The string is held taut and the third, unperforated rod is passed under it. Points at which the surface is uneven then become obvious because of varying tension exerted on the cord by the third rod. These areas are dressed level by a third man wielding a mallet and chisel.

A test of the surface obtained is made by stretching a cord dipped in red ochre over the surface of the stone. Raised areas pick up color from the string and can then be dressed again, until the desired accuracy is obtained.

S.K.D.

1. Letellier 1978, no. 84, p. 65; Hayes 1959, fig. 129, pp. 217, 409; Clarke and Engelbach 1930, fig. 265.
2. Petrie 1917b, pl. 44:44-50.
3. Davies 1943, pl. 62.

Bibliography: Naville 1913, pp. 26, 30.

Literature: Petrie 1883, p. 99; Garstang 1907, p. 130, fig. 128b; Petrie 1917b, p. 42; Clarke and Engelbach 1930, pp. 105-106; Lloyd 1954, pp. 456-490; Hayes 1959, pp. 217, 409.

28

28
Plasterer's float
Probably from Gurna
New Kingdom
Length 28 cm.; width 9.2 cm.
The Metropolitan Museum of Art, New
York. Rogers Fund (11.150.34)

Carved from one piece of wood and then painted white, this rectangular plasterer's float has a grip at one end.

Most Egyptian painting, especially that in Theban tombs, was done on plaster. In many cases, the underground chambers were left in a very rough condition by the stonecutters and had to be covered with several layers of thick mud plaster mixed with straw. Smoothing of these layers was accomplished with a float. When a fairly smooth surface had been obtained, a thin mixture of plaster and powdered stone was applied and smoothed again in order to obtain a good surface for painting.[1] Two plasterer's floats from the Middle Kingdom excavations at Kahun illustrate the types of implements necessary in this process. One, similar to the Metropolitan Museum example and to a piece from one of Hatshepsut's foundation deposits,[2] consists of a thick rectangular slab of wood with a cylindrical grip at one end. A portion of the slab extends beyond the grip. Such a float would have been most useful in the first part of the process, for building up the wall and covering imperfections and irregularities. The extension permitted a plasterer to work conveniently in corners and near the ceiling and floor without spoiling other plastered surfaces or scraping his knuckles. The second type of float found at Kahun[3] consists of a thin, flat, rectangular piece of wood with a cylindrical handle extending the entire length of the float. An example of this type in the Cleveland Museum,[4] assigned a New Kingdom date, is virtually identical to the float from Kahun, except that it is made in alabaster and has been considerably worn from use. This is the type probably used in the finishing process to smooth the last fine coat of plaster.

A float almost identical to the present example comes from Thebes.[5] In a relief from Karnak from the time of Thutmose III[6] a small vignette pictures model tools apparently intended for a foundation deposit. Beside a brick

29

mold is a long, flat object with a rounded handle at one end that, in profile, looks very much like this float. It has been suggested that this object represents a brick stamp, used to mark bricks with a king's name (cf. cat. 388). Examples of such stamps in bronze have come from several foundation deposits,[7] and a limestone stamp from Amarna[8] is of a shape exactly similar to the float in Cleveland and the second type of Middle Kingdom float from Kahun. It is questionable, however, whether the Egyptians would have chosen a profile view as the most characteristic for brick stamps, when it was possible to show the stamp *en face,* with the cartouche of the king clearly visible to the viewer, and thus the Karnak relief probably shows a plasterer's float. Speculation aside, for the most part, floats and stamps are distinguishable only by the presence or absence of texts engraved on the working surface.

<div style="text-align: right">S.K.D.</div>

1. Mekhitarian 1954, p. 28.
2. Weinstein 1973, pp. 96:2, 98; see also Petrie 1890, p. 26, pl. 9:10.
3. Petrie 1890, p. 26, pl. 9:9.
4. 14.825.
5. Wilkinson 1883b, p. 175.
6. Wreszinski 1935, pl. 33a.
7. Leclant 1953, pp. 48-52.
8. Frankfort and Pendlebury 1933, pl. 32.

Bibliography: Hayes 1959, pp. 216-217, fig. 129.

Literature: Anthes 1943, p. 66.

29

Fire drill and board
From the Valley of the Kings
Probably New Kingdom
Length of stick 23.5 cm.; length of board 23 cm.
Royal Ontario Museum, Toronto. Gift of Theodore Davis (906.6.10-11)

A rough charred stick and broken bitumen-coated board are all that remain of this fire-making kit.

The form of the hieroglyphic sign for the fire drill,[1] which was established at an early period, consists of only these two pieces, the stick and the board. It is probable that originally the stick was held at a right angle to the board and rolled rapidly between the hands until friction caused sparks to form at the point of contact between the two. By the time of the Middle Kingdom, however, and probably even earlier, the drill kit had become more complicated. A cap of stone, or perhaps half of a *dom*-palm nut, was fitted onto the top of the stick and held by the left hand to provide a socket in which the stick might be supported. The stick was turned by means of a bow, with its string or thong looped about it. When the bow was held at a right angle to the stick and drawn back and forth rapidly across it, the stick turned and created the heat necessary to ignite straw or dry tinder.

Middle Kingdom bow drills, sticks, and boards were found at Kahun.[2] A complete assembled example, including board, stick, cap, and a strung bow, is on view at the Manchester Museum.[3] Some New Kingdom kits were even more sophisticated. An example from Gurob has a wooden cap and separate sleeve fitting around the top of the stick, which is knobbed. A separate wooden bit fitted into the bottom of the stick came into contact with the board and produced sparks. When charred beyond further use, the bit could be removed and replaced.[4] Tutankhamen's fire-making kit was of this type. The board had twelve drilled holes at the edges, each slotted through the thickness of the board, in order to give the sparks more access to the tinder upon which the board would have rested. In addition, the holes were treated with resin to increase friction and speed the creation of sparks.[5] Perhaps the same purpose was achieved by the bitumen coating on the Toronto board. No representations of a fire drill in use have been preserved, but the similar principle of the bow drill was well known (see fig. 26).

<div style="text-align: right">S.K.D.</div>

1. Gardiner 1957, p. 519, U28.
2. Petrie 1891, p. 11, pl. 7:24-26.
3. 63 A.
4. Brunton and Engelbach 1927, pl. 46:19, p. 18.
5. Carter 1933, pl. 38, pp. 121-122.

Literature: Petrie 1890, pl. 9:6; Hayes 1959, p. 210.

Weights and Measures

The relative weights of two objects were probably first calculated by the ancient Egyptians by simply holding one in each hand and "feeling" which was heavier. Standing straight with arms outstretched and parallel to the ground, the human form is not unlike the shape of a balance beam on a stand, and we still preserve today this ancient association in anthropomorphic terminology for the parts of a scale. The ends of the balance beam on either side of the stand are called the "arms," and the base of the stand is called the "foot." Such a derivation of the equal-arm balance on a stand is confirmed by the design of an example pictured in the Old Kingdom mastaba of Ka-irer. Its vertical post is in the form of a woman standing on a pillar. Her outstretched arms act as the beam, and in each hand she holds the strings to which scale pans are attached.[1] The head of Maat, goddess of truth, was a popular and appropriate capping piece for the later balance stands of the New Kingdom (fig. 23).

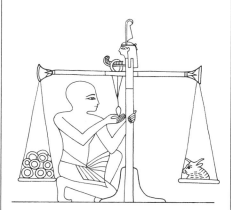

Fig. 23. The head of Truth crowns the post of the balance in this weighing scene from Theban tomb 181. The operator is checking the precision of his results with a plumb line.

Practically, the mechanics of design were probably suggested by the common practice of carrying things suspended from the ends of a long pole resting on the shoulders of the bearer.[2] By Amratian times (before 3600 B.C.), balances must have existed, for *beqa,* or gold standard, weights have been found in graves of that period.[3] The earliest balance beam preserved is a limestone one, perhaps as early as the Gerzean Period (3600-3100 B.C.):[4] the cord for pans or hooks was passed through holes drilled vertically near the ends of the beam, and this appears to have been the usual design through-

out the Old and Middle Kingdoms.[5] Sometimes the pan cords were simply hung over the ends of the beams.[6]

Much improved scales appear in the Eighteenth Dynasty. The balance rods are drilled through horizontally (cf. cat. 31), bringing the strings for the pans in direct contact with the ends of the beams, thus considerably increasing the sensitivity of the scale. A vertical tongue driven through the arm at right angles was often matched up to a plumb line, so that the operator could be more certain when the scale was in balance.[7] Mixtures of these types of balance arms are also seen.[8] Although hand-held scales were probably always in use, they are represented less frequently (see fig. 24) because the contexts in which they were employed were somewhat less likely to be the subjects of monumental representation[9] (cf. cat. 32). Scales were undoubtedly first used for weighing gold as part of a tribute or payment received, and before and after issue to a jeweler or artisan (cf. cat. 26). Scenes of weighing are quite common in religious contexts, such as the afterworld judgment scene, where the heart of the deceased is weighed against the feather of truth.[10]

Builders in early times probably measured materials according to their own body proportions, which would have remained relatively standard throughout the course of one's adult life. This is confirmed by the markings on cubit sticks, the standard length measurement for the ancient Egyptians. The hieroglyphic word for the cubit was a picture of a forearm and extended hand. Subdivisions of the cubit were indicated by the length or width of the hand in various positions, appropriately called palms and spans, and the width of the fingers, called digits (cf. cat. 30). Standards must, of course, have existed and were perhaps kept in temples but, as with weights, copies were not always made from a standard, so there is almost always some slight deviation in the lengths or weights of different examples. Cubit sticks are found in both wood and stone, and have two lengths, the short cubit (six palms) and the royal cubit (seven palms).[11]

Capacity measures, too, probably originated in a simple natural gesture.

The amount of grain that an individual could contain in cupped hands was undoubtedly the first standard. This quantity, of course, varied from person to person, and pots or gourds were probably substituted.[12] Some were intended in a general way to contain approximately a certain amount, and others were intentionally made as gauges, marked to show some desired level of contents[13] (see cat. 68). As with weights, several standards of capacity measures were in existence simultaneously during the New Kingdom (see cat. 36).

S.K.D.

1. Lauer 1976, p. 77, pl. 68.
2. Kisch 1966, p. 26; Skinner 1967, p. 4.
3. Petrie 1926, p. 4.
4. Skinner 1967, p. 3.
5. Ducros 1908, pp. 49:1, 50:16; Skinner 1967, p. 6.
6. Ducros 1908, p. 51:24.
7. Ibid., p. 52:40-43; Skinner 1967, p. 33.
8. Ducros 1908, p. 50:16.
9. Ibid., p. 50:17-18.
10. British Museum 1894, pl. 3.
11. Skinner 1967, pp. 4, 35; Scott 1942, pp. 70-75.
12. Skinner 1967, p. 5.
13. Petrie 1926, pp. 33ff.

Literature: Chabas 1869; Brugsch 1889; Griffith 1892; Griffith 1893; Weigall 1901; Weigall 1908; Ducros 1910; Ducros 1911; Cortland 1917; Daressy 1918; Sobhy 1924; Klebs 1934, pp. 107-108; Petrie 1934; Glanville 1936; Sarton 1936; Hemmy 1937; Petrie 1938; Berriman 1955.

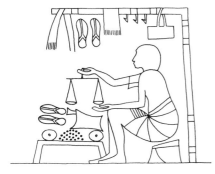

Fig. 24. Hand-held scales used by merchants are visible in this market scene (from Theban tomb 162).

30

30

Cubit rod of the chief of the treasury, Maya

Provenance not known
Dynasty 18
Length 52.3 cm.; width 3.2 cm.
Musée du Louvre, Paris (N. 1538)

The wooden rod measuring the length of the royal Egyptian cubit is painted black and has white markings. The rod is rectangular in section, with a beveled edge between the top surface and the marked side.

The royal Egyptian cubit was seven palms long, each palm being divided into four digits, or fingers, and each digit further subdivided. These subdivisions, up to a sixteenth of a digit, are marked by strokes on one of the vertical sides. On the beveled edge are two registers, one showing the subdivision of the digit written out as fractions, and the second containing markings for other kinds of internal cubit divisions, such as that for the short cubit (six palms), the great and little *shat,* and various other measurements based on the hand. Along the flat top surface are the names of the gods who preside over each digit. On the bottom of the rod and on its back are three columns of dedicatory inscriptions.

The royal cubit was most commonly used for land measurement and architecture. A unit of measure called the *remen* was also employed and area measurements were based on the belief that a square one cubit long on each side had a diagonal equal in length to a double *remen,* or ten palms. Conversely, a square area with each side having the length of one *remen* had a diagonal the length of one royal cubit.[1] Although not the most precise formulation, this is, in fact, an early statement of the Pythagorean theorem.[2] Some Egyptian cubit rods also show indications of a foot measure at the eighteenth digit. Its length is thus about thirteen and one quarter inches; this measure is the origin of the twelve-inch foot used today in England and North America.[3] Another cubit rod belonging to Maya is now in Turin.[4]

S.K.D.

1. Leach 1954, p. 111.
2. Skinner 1954, p. 777.
3. Skinner 1967, pp. 40-41.
4. Lepsius 1865, pl. 2:2.

Bibliography: Legrain 1903, p. 213 n. 3; Skinner 1954, p. 776, fig. 566b; Helck 1958, p. 513:14b.

Literature: Leemans 1842, pl. 248; Lepsius 1865; Griffith 1892, pp. 403-420; Griffith 1893, pp. 301-306; Borchardt 1920, p. 33; Petrie 1926, pp. 38ff.; Schiaparelli 1927, p. 80; Bruyère 1929, p. 18:5; Frankfort and Pendlebury 1933, p. 70, pl. 46:4; Scott 1942; Hayes 1959, pp. 412-413; Skinner 1967, p. 35, fig. 8; Gabra 1969; Schlott 1969; Schlott 1972; Zivie 1977; Zivie 1979.

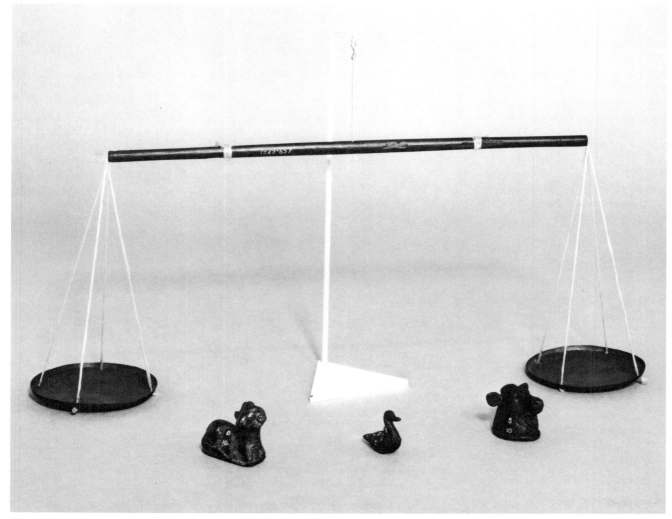

31

31

Scales

From Amarna house U.36.41
Dynasty 18, reign of Akhenaten
Length of balance arm 30 cm.; diameter
of pans 7.4 cm.
Science Museum, London. Gift of the
Egypt Exploration Society (1929-657)

The tapering balance arm of this set is
of wood, with a drilled central vertical
hole. A string was passed through the
hole and tied to create a fulcrum. Each
end of the beam is drilled through
horizontally to intersect two other
vertically drilled holes about seven
and a half centimeters from each end
of the arm. The scale pans were at-
tached by string first fed through the
vertical holes and longitudinal bores
and then knotted. Each of the copper
balance pans is pierced with four holes
for the suspension threads. The strings
are modern.

This scale is slightly larger than one
excavated at Deir el Medineh (see cat.
32) but is essentially of the same de-
sign and may originally have been
hand held. It has a sensitivity of plus
or minus two grains per hundred in
each pan.[1]

1. Skinner 1967, p. 33.

Bibliography: Frankfort and Pendelbury 1933, p.
19, pl. 33:3; Glanville 1936, pp. 23ff.; Skinner 1954,
p. 783, fig. 569; Skinner 1967, pl. 5.

Literature: Weigall 1908, p. 62, no. 31489, pl. 9;
Ducros 1910; Dunham and Janssen 1960, pl. 130c.

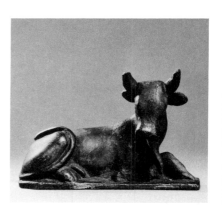

33

32

32

Case for balance arm and pans
From Abydos tomb D77
Dynasty 18
Length 33.5 cm.; width 2.6 cm.
Museum of Fine Arts. Gift of Egypt
Exploration Fund (01.7426)

Described by its excavators as "a hollow wooden sheath for some kind of instrument,"[1] this object and others of its type have long been a puzzle. It consists of a long narrow hollow case with a semicircular compartment in the center. The rounded compartment is decorated with an incised rosette originally filled with white pigment. One arm has been restored and the lid is missing. Both the arms and the lid were probably pierced at each end, one hole being pegged, nailed, or tied permanently and serving as a pivot, the other enabling the lid to be tied closed with a piece of leather.

An identical, intact piece with lid and leather closures excavated from the tomb of Kha has been identified as a level.[2] Still other cases are documented,[3] one of which is inscribed around the central rosette with the prenomen of Amenhotep III and several unidentifiable signs. The lid of one probably originally pivoted on a nail, and its case was pierced through at the center of the semicircular compartment.[4]

Two similar examples (found with arm and pans inside) from Deir el Bahri[5] and Deir el Medineh[6] prove that these are carrying cases for handheld scales. The pans were stored in the rounded compartments, the balance arm in the long transverse sections.

Hand-held scales like those contained in these cases were used by tradesmen[7] (see fig. 24) and probably also by private persons for weighing oils, powders, metals, or any small items offered in private exchange. Since the Egyptian economy operated without currency, bartering situations would have been a regular means of obtaining necessities, and by the New Kingdom scales were probably often used for such purposes[8] (cf. cat. 31).

The number of cases found for handheld scales indicates that their use was more common than one might suppose from the reliefs, which show mainly large scales with stands.

S.K.D.

1. MacIver and Mace 1902, p. 91, pl. 51.
2. Schiaparelli 1927, p. 83, fig. 51.
3. Brunton and Engelbach 1927, p. 18, pl. 13:7; Petrie 1927, pl. 40:73-74.
4. Petrie 1927, p. 47.
5. Cairo, JE 63716.
6. Bruyère 1937b, pp. 119ff, fig. 68.
7. Davies and Faulkner 1947, pl. 8.
8. Glanville 1936, pp. 25ff.

Bibliography: MacIver and Mace 1902, p. 91, pl. 51.

33

Animal weights
a. Weight in the form of a ram
Dynasty 18
Height 3.2 cm.; length 4.2 cm.
Present weight 1289 gr.; original weight 1268 gr.
Science Museum, London. Petrie Collection. Lent by University College, London (Sc. M. 1935-421)

Bibliography: Petrie 1926, pl. 9 (frontispiece), no. 4801, pl. 43; Skinner 1954, p. 783, fig. 569; Skinner 1967, pl. 5.

b. Weight in the form of a bull's head
Dynasty 18
Height 3 cm.; width 2.8 cm.
Present weight 1354.1 gr.; original weight 1348 gr.
Science Museum, London. Petrie Collection. Lent by University College, London (Sc. M. 1935-427)

Bibliography: Petrie 1926, pl. 9 (frontispiece), no. 4939, pl. 44; Skinner 1954, p. 783, fig. 569; Skinner 1967, pl. 5.

Literature: Weigall 1901, p. 382, pl. 2: 7018, p. 383, pl. 2: 7025; Cortland 1917, p. 89, fig. 4; Frankfort 1929b, pl. 28:2; Roeder 1956, pl. 49d.

c. Weight in the form of a reclining cow
Said to be from Abydos
Probably Dynasty 18
Height 3.5 cm.; length 5.4 cm.
Present weight 1395.8 gr.
Royal Ontario Museum, Toronto (910.139.1).

Bibliography: Roeder 1937, pp. 43-44, 47, no. 183; Needler 1967, p. 97, fig. 4.

Literature: Cortland 1917, p. 90, fig. 7; Petrie 1926, pl. 9 (frontispiece): 5253, 4749; Glanville 1936, p. 24; Roeder 1937, pp. 43-44, no. 183; Pendlebury 1951, pl. 77, pp. 109, 125; Roeder 1956, pp. 334-336, pl. 49c,g,h.

d. Weight in the form of a duck
Probably Dynasty 18
Height 2.4 cm.; length 3 cm.
Present weight 260.2 gr.; original weight 256 gr.
Science Museum, London. Petrie Collection. Lent by University College, London (Sc. M. 1935-421)

Bibliography: Weigall 1901, p. 386, no. 7056, pl. 5; Petrie 1926, pl. 9 (frontispiece): no. 4815; Skinner 1954, p. 783, fig. 569; Skinner 1967, pl. 5.

Literature: Petrie 1926, pl. 9 (frontispiece): 5120, 5050, 5233.

Domestic and semidomestic animals were very important to Egyptian agriculture and the economy. Since they were a symbol of prosperity, it is not surprising that weights measuring value should have been cast in the forms of cattle, sheep, rams, antelopes, and goats.[1] Most bronze animal weights date from the New Kingdom; they were hollow-cast and then filled with an amount of lead sufficient to bring the piece to the necessary weight.[2] Weights in the form of cattle or shaped like the head of a bull are most common in New Kingdom weighing scenes;[3] a glass weight in the form of a bull's head was found at Thebes.[4] Duck-shaped weights were most often made to the *beqa* or gold

standard.[5] The ram was perhaps once a standard in a temple to Amen, who sometimes took the form of that animal (cf. cat. 34).

The use of bronze figures was restricted mainly to the Eighteenth and early Nineteenth Dynasty; because it was realized soon after their introduction that corrosion altered the weights, they were made subsequently in stone and glass, like the simpler weights of earlier times.

S.K.D.

1. Skinner 1954, p. 783, fig. 569; Needler 1967, p. 97, fig. 4.
2. Roeder 1956, pp. 334-336, pl. 49c,g,h.
3. Wreszinski 1923, pls. 41, 50, 74, 78, 82, 149, 162, and 164.
4. Cortland 1917, p. 90.
5. Petrie 1926, p. 2; Weigall 1901, p. 386, no. 7056, pl. 5.

Literature: Birch 1868, p. 38; Roeder 1937, pl. 29a,b,c; Fischer 1969, p. 70.

3 4

3 4
Weight in the form of a hippopotamus head
From the Set temple at Ombos
Dynasty 18
Height 3.2 cm.; length 4.3 cm.
University College, London. Petrie Collection (29019)

A high polish and good craftsmanship distinguish this black haematite weight. On the upper lip of the animal is marked its weight, ten *qedet,* in two numbering systems.[1] The weight was found in a temple to Set, who sometimes takes the form of a hippopotamus; probably it is a temple standard.

Representations of hippopotamus weights are known from the Eighteenth Dynasty; in the tomb of Baka at Gurna a weighing scene shows a hippopotamus weight resting in one of the scale pans.[2] Another can be seen

in a weighing scene from the tomb of Rekhmire.[3]

S.K.D.

1. Petrie 1926, p. 15.
2. Petrie 1909b, p. 11, pl. 35.
3. Davies 1943, pl. 55.

Bibliography: Petrie 1896b, p. 67; Weigall 1901, p. 381, no. 7007; Petrie 1926, p. 15, pl. 9 (frontispiece): 3218.

3 5
Inscribed weight
Probably from Deir el Medineh
Dynasty 19-20
Height 10 cm.; diameter at base 12 cm.
Musées Royaux d'Art et d'Histoire, Brussels (E. 7041). Formerly in the Scheurleer collection

An inscription reading "weight for fresh, cleaned fish" marks this dome-shaped limestone weight as one of those used at Deir el Medineh to weigh out portions of fish issued to the workers in partial payment of their wages (see p. 52). Similar weights inscribed for this purpose have been discovered at Deir el Medineh;[1] one specifies that the fish issued are destined for the western or "right" gang. While rations of fish were part of the workmen's wages, it is thought that they were sometimes sold in the village, where they must have been,

3 5

with bread and beer, among the cheapest foods available.[2]

The species of fish depicted here appears to be the *Synodontis Schall,* known to the Deir el Medineh villagers as the *sal* fish, the same fish is called *shal*[3] by modern Egyptians.

S.K.D.

1. Bruyère 1934, p. 90; Bruyère 1939, pp. 219ff.
2. Janssen 1975, pp. 348-350.
3. Černý 1937-1938, pp. 36-37.

Literature: Gaillard 1923, pp. 67-70; Gamer-Wallert 1970, pp. 32ff.

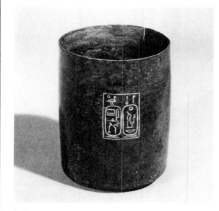

3 6

3 6
Capacity measure inscribed with the names of Amenhotep III
Provenance not known
Dynasty 18
Height 10.3 cm.; diameter 8.1 cm.
Science Museum, London. Petrie Collection. Lent by University College, London (Sc. M. 1935-468)

A simple cylindrical copper cup is inscribed "The Good God, Neb-maat-re, Son of Re, Amenhotep, Ruler of Thebes." Its capacity is 33.26 cubic inches, or a bit more than a U.S. liquid pint (28.875 cubic inches) and almost exactly a U.S. dry pint (33.6 cubic inches). This capacity is clearly based on the Syro-Babylonian *log* standard, and its use in Egypt is an eloquent testimony to the lively trade carried on between the Near East and Egypt at this period. The chief native Egyptian measure was the hin (29.1 cubic inches) but the Syro-Phoenician *kotyle* (21.4 cubic inches) was also very popular.

S.K.D.

Bibliography: Griffith 1892, pp. 421-435; Griffith 1893, p. 306; Petrie 1926, p. 35, pl. 22:70A; Skinner 1954, pp. 782-784, fig. 570; Skinner 1967, p. 46, pl. 6.

Literature: Davies and Faulkner 1947.

Furniture

The extremely dry climate of Egypt has preserved numerous beds and headrests, chairs, stools, tables, chests, and boxes, examples of which have, for the most part, disappeared from the legacies of other ancient cultures. These pieces, together with accurately detailed representations of furniture in painting, relief, and sculpture in the round, constitute a corpus that is invaluable to our understanding of daily life in ancient Egypt.

Although painting and relief sculpture provide a continuous chronological picture of the evolution of furniture, most of the actual surviving examples date to the New Kingdom. An important exception is the tomb at Giza of Queen Hetepheres, mother of King Cheops, or Khufu, which contained pieces of Fourth-Dynasty royal furniture reconstructed after many months of labor by Reisner and Haji Ahmed Yousef.[1] The furniture interred with the queen included a bed, a canopy, a curtain box, two chairs, and a litter. This find and fragments of furniture of the Archaic Period indicate that all of the basic woodworking techniques were practiced from the start of Egyptian dynastic civilization.[2]

Reflecting the spirit of the Old Kingdom, the furniture of that era has bold, almost massive forms.[3] Very little furniture from the Middle Kingdom has been preserved, but evidence suggests that the Old Kingdom emphasis on weighty forms seems to have diminished.[4] The New Kingdom displays a more refined, elegant style, no doubt influenced by the cosmopolitan tastes of the time. The stools, chairs, and beds of the period exhibit an abundance of detail and a delicate balance of curves and supports (cats. 40 and 42). One illustration is provided by the nearly universal replacement in the New Kingdom of bull legs with more elaborate feline legs on theriomorphic furniture, although this substitution occurs sporadically as early as the Fourth Dynasty.[5]

Among the archaeological discoveries that yielded furniture of the New Kingdom are the tomb of Yuya and Thuya, parents of the wife of Amenhotep III,[6] the tomb of the architect Kha,[7] the well-known tomb of Tutankhamen,[8] and the excavations at the workmen's village of Deir el Medineh.[9] Yuya and Thuya were buried like royalty in the Valley of the Kings. Their tomb contained three carved and gilded chairs, two decorated cabinets for jewelry, three beds, and a number of storage chests.[10] Found in the tomb of the architect Kha were thirty-two pieces of furniture, with a preponderance of stools and chests; there were also two beds, chairs, tables, and a lamp on a stand (see fig. 28).[11] It was not until the discovery of the tomb of Tutankhamen in 1922 that the full range of royal furnishings became apparent. In his three-volume work on the tomb, Carter included about twenty pieces of this fabulous collection of furniture; although individual pieces have been illustrated and described in numerous publications, there has been no comprehensive account of the furniture. Altogether, about fifty pieces, ranging from elaborately decorated beds and throne chairs to more ordinary stools and chests, were found jumbled together in the tomb.[12] The chairs, stools, footrests, and beds from the workmen's village are much simpler in design and construction than any of the above.

It is remarkable that the Egyptians achieved such a high level of competence in working wood, a material especially rare in their own country. What few trees do grow in the two narrow strips of land on either side of the Nile are often unsuitable for cabinetwork. Among those native woods positively identified by laboratory analysis are acacia, almond, fig, date palm, *dom*-palm, persea, sidder, sycamore fig, tamarisk,[13] willow, and poplar.

Imported woods, in use from the earliest times onward, included ash, beech, box, carob, cedar, cypress, ebony, elm,[14] fir, juniper, lime, maple, oak,[15] pine, plum, and yew.[16] Most of these were imported from Syria and surrounding regions; cedar from Lebanon was especially popular. The Egyptians visited Lebanon as early as the reign of Khasekhemui in the Second Dynasty.[17] Furthermore, the "Report of Wenamen" describes the voyage of an Egyptian to Byblos in 1075 B.C. to obtain cedar.[18] Ebony, however, was the prized material of master craftsmen, and was imported from the Sudan to the south of Egypt (cat. 40). The enormous value placed on inlaid ebony furniture is no better

illustrated than by the cuneiform letter of Amenhotep III to the king of Babylon, Kadashman-Enlil I, in which beds, stools, chairs, and headrests, all of ebony, were listed, having been sent as gifts.[19]

The tools used by Egyptian artisans differ only slightly from those of today. Saws were pulled instead of being worked in two directions; wood was often lashed to a vertical post that served as a kind of vise for sawing[20] (fig. 25). Adzes with copper or bronze blades (cat. 23) formed the ancient version of the plane used today, and bow drills[21] (fig. 26) cut holes such as were needed to fasten woven rush seats and mattresses to chairs and beds (cats. 38 and 39).

Fig. 25. A knife-shaped bronze saw set in a wooden handle rips logs into planks (from Theban tomb 181).

Fig. 26. Carpenter using a bow drill (from Theban tomb 100).

Hammers, chisels, knives, awls, rasps, and levels were all part of the carpenter's equipment (cats. 25 and 26).[22]

The wood-turning lathe was unknown in Egypt until after the New Kingdom.[23] Its earliest known representa-

tion comes from the tomb of Petosiris, which dates to the fourth century B.C.[24] New Kingdom Egyptians did possess the technology required for a lathe; for centuries their bow drill had operated on the same principle of turning (see cat. 29), and wooden legs were apparently held at each end in a vice, thus freeing both hands for carving. But the actual extension of the principle of turning from the drill to the wood occurred only in the Greco-Roman age under foreign influence. It is a tribute to the Egyptian craftsman that his work appears so mechanically perfect as to generate a controversy today over the possible use of the lathe.[25]

Joinery was often very elaborate. In addition to simple mortise and tenon, butt joints, and half joints, the Egyptians used complex shoulder miters, dovetail housing miters, scarf joints, and a variety of other joints.[26] Pegs and pins, commonly of bronze or wood, reinforced all types of joints and were often capped with precious materials where they appeared on the surface of the wood. Curving pieces were either steamed and bent or adapted from natural forks of trees. Angle pieces, braces, brackets, and stretchers supported seats, frames, and legs. In the Old Kingdom, wood was reinforced with thongs and lashings, but by the Eighteenth Dynasty, this method seems to have been discarded. The New Kingdom saw an increase in the use of glues, whose adhesive elements were manufactured from animal parts[27] in a process similar to that used today.

The ancient craftsmen often painted their furniture. Elaborate examples are polychromed, while modest ones show a single color, usually white, red, or brownish yellow.[28] Other pieces were left with their natural tones or finished with varnish; gilding is known primarily from royal examples.[29] Veneer of high quality covered inferior wood to improve its appearance and marquetry was quite common, with precious stones, ivory, glass, and faience among the materials used for inlay. The finest pieces of Egyptian furniture were of ebony inlaid with ivory (cats. 40 and 41), and sometimes inferior woods were even "grained" to resemble ebony. Plans for the construction of a particular piece were first drawn on papyrus, but much re-

adjustment occurred during the actual building process.[30] The artisan would compensate for inaccurate work on one side by readjusting the other.

Of the types of seating constructed by the Egyptians, the stool was by far the most common. Ranging anywhere from rough, three-legged work stools to finely inlaid pieces with attractive bracing, the stool supplied the basic seating that the conventional chair does today. Representations show Egyptians from all walks of life seated on stools: workmen,[31] nobles at a gathering,[32] and even pharaoh.[33] The ancient Egyptians, like their present-day counterparts, often sat with knees drawn up almost under the chin, a position that was quite comfortable on a floor mat, low stool, or chair, hence the short height of much Egyptian furniture.

Among the numerous types of New Kingdom stools[34] are the low stool, with woven rush seat only a few centimeters off the ground (cat. 44); the animal-leg stool, with legs that have carved lion's feet (cat. 39); the three-legged stool of rough, undecorated wood, used primarily for work purposes (cat. 43); the stool with flared legs, usually provided with a leather seat in addition to elegantly carved and ringed legs (cat. 40); the folding stool, often with legs ending in duck's heads (cat. 41); and the latticework stool, with slatted wood or woven rush seat and diagonal bracing (cat. 42). Footstools were popular with the well-to-do[35] and wickerwork pieces, as well as small slab seats of stone or wood, were common in poorer houses.[36]

Less common than stools, chairs indicated a person's higher status, although a few exceptions, crudely made specimens owned by workmen, are known (cat. 38).[37] Among the most frequently found New Kingdom chair types[38] are the classic chair, the equivalent of the animal-leg stool with the addition of a slanted "triangular" back (cat. 37); the low chair, close to the ground, with a very wide seat, which, in some cases, is capable of supporting a man seated in cross-legged position;[39] and the "posture" chair, so named after chairs with similar seat-to-back angles designed in the modern era at the Bauhaus.[40] Stools, chairs, beds, and perhaps

other furniture as well sometimes rested on truncated limestone cone-shaped supports, which perhaps served the dual purpose of protecting the packed mud floors and keeping the furniture clean and away from crawling insects. Such supports are still used on occasion in modern Nubia.[41]

Tables were probably the most common piece of furniture after the stools and chairs. Among their many household uses was dining; each individual had his own small table, for the large communal dining table was unknown in Egypt.[42] (Less important people kept their plates beside them on the floor.) Many different types were popular, among them the table with splayed legs, often surmounted by a cavetto cornice (cat. 45), the straight-legged rectangular table,[43] and the latticework table.[44]

The Egyptians took pride in their beds as a mark of refinement and civility. The Twelfth-Dynasty hero Sinuhe rejoiced at spending the night on a bed again in Egypt after long years of travel.[45] The earliest beds slanted downward from head to foot, had side rails of round poles often terminating in papyrus flowers, and rested on bull legs.[46] By the New Kingdom, lion legs become standard, the slope is eliminated, and the side rails are shortened to form a rectangular frame. A few surviving beds have straight, undecorated legs; two examples from Deir el Medineh are the beds of Sennefer[47] and of the occupant of tomb 1377m.[48] A representation in the tomb of Ipuy (Theban tomb 217) shows a bed with flared legs.[49] Attendants string a mattress in a scene from the tomb of Men-kheper-re-seneb.[50] Five beds were found in the tomb of Tutankhamen[51] and three in that of Yuya and Thuya;[52] the tomb of the architect Kha produced another two.[53]

In place of pillows, the Egyptians slept on wooden or stone headrests. The standard shape consisted of a curved neckpiece supported by a pillar with an oblong base. Occasionally human or divine figures were incorporated into the design.[54] Headrests possessed a magical and amuletic significance for the dead because the head nestled in the curving neckpiece resembles the hieroglyph ⌒ for the horizon, i.e.,

the sun rising between two cliffs. The identification of the deceased with the morning sun — and all its implications of resurrection — is thus quite vivid, and the pillars were sometimes inscribed with such funerary epithets as "justified," or "repeating life."[55] Included in this catalogue are two headrests, (cat. 46), one of standard shape. Occasionally headrests imitate the form of a folding stool (see cat. 47).

Chests and boxes came in all shapes and sizes and served countless purposes. Plain rectangular boxes with flat lids and with battens underneath (see cat. 200)[56] or with four short legs and a double-pitched gable lid,[57] were used for the storage of linen and household effects; scribes stored their writing materials in shrine-shaped boxes with vaulted lids and cavetto cornices (cat. 384), but the same type of box might serve for the storage of jewelry and other valuables. Small wooden chests of sturdy design on legs[58] or boxes of reed and rush with elaborate lattice bracing often contained personal toilette articles.[59]

In general the Egyptians rose with the sun and went to bed early; however, it is known that work continued at night by the light of oil lamps.[60] Most Egyptian lamps consisted simply of a bowl with a wick; such lamps are often unidentifiable because floating wicks were used, leaving no marks of burning or blackening. However, a wheel-thrown lamp in Cairo (fig. 27)[61] has a central cup in which there still remain fat, a two-ply linen wick, and encrusted salt crystals, probably added to keep the lamp from smoking.[62] A similar lamp with flaring bowl

Fig. 27. Wheel-turned lamp with central cup of Middle Kingdom date (from Meir; Cairo JE 42838).

excavated from a New Kingdom tomb at Deir el Ballas and now in the Lowie Museum[63] suggests that this is a type that did not undergo much change between the Middle and New Kingdoms.

Variants from Deir el Medineh include a simple tripartite pottery bowl with central cup and an elaborate example in the form of a duck.[64]

Fig. 28. Floor lamp (from the Deir el Medineh tomb of Kha, architect of Amenhotep III; Cairo JE 38642).

The tomb of the architect Kha at the workmen's village of Deir el Medineh yielded an elaborate lamp more like a modern floor lamp (fig. 28). A semicircular limestone slab serves as a base for the tall column carved in the shape of the papyrus plant. The column has a peg at the bottom, which fits into a hole in the center of the base. Although the sculptor carefully reproduced the ridged stem characteristic of the papyrus stalk, the umbel at the top has an unusually wide brim that dips downward. Five incised rings ornament the stalk just beneath the umbel.

The bowl at the top of the column rests on three wooden pegs, and forms the lamp proper. Oblong in shape with a rounded bottom, the bowl has a

trapezoidal handle at one end and a spout or beak at the other. The wick, long since lost, was probably of twisted linen coated with oil or animal fat, which also provided the fuel for the lamp. Still remaining inside the bowl are a whitish material (most likely fat), charred fragments, a small twig, and an unidentified substance, possibly used for aromatic purposes.[65] A lamp similar to Kha's, and dating to the reign of Amenhotep III, was unearthed at Abusir; its faience base forms an X.[66] In the Theban tomb of Ken[67] were found fragments of another lamp also with an X-shaped base in wood.

Although common household furniture accompanied the deceased to the tomb and frequently exhibits signs of wear from once-constant use[68] there existed, in addition, funerary furniture constructed specifically for burial and intended for use in the next world. Model and miniature furniture often served in this context as well.[69] Funerary furniture tended to be of poorer quality, since it would be called upon to serve only a spiritual, and not a physical function. Such pieces were often brightly colored, perhaps to compensate for inferior materials (for example, those in the tomb of Sennedjem at Deir el Medineh, most of which are now in the Cairo Museum[70]). Three thousand years after their construction it is still possible to identify with human needs that were as basic to the Egyptians as they are to us; then as now, "Human beings must group, sit or recline, confound them."[71]

P.D.M.

1. Reisner and Smith 1955, pp. 23-40.
2. Baker 1966, pp. 19ff.
3. See Museum of Fine Arts 1960, fig. 40, and Baker 1966, fig. 1.
4. Reisner 1923b, pp. 207-241, pl. 51.
5. Baker 1966, p. 41.
6. Davis et al. 1907; Quibell 1908b.
7. Schiaparelli 1927; Baker 1966, pp. 114-124.
8. Carter and Mace 1923; Carter 1927 and 1933; Baker 1966, pp. 75-109.
9. Bruyère 1929 and 1937b.
10. Baker 1966, p. 63.
11. Ibid., pp. 114-124.
12. Baker 1966, pp. 75-76.
13. Western 1973, pp. 91-94.
14. Ibid.
15. Carter 1927, p. 39.
16. See Aldred 1954, pp. 684-685; Baker 1966, pp. 293-295; Lucas 1962, pp. 429-456; Killen 1980, pp. 1-7.
17. Edwards 1971, p. 45.
18. Simpson et al. 1973, pp. 142-155.
19. Mercer 1939, p. 17, letter 5, ll. 18-24, 30.
20. Davies 1943, pl. 52.
21. The Egyptian drill has been simulated by Hartenburg and Schmidt (1969).
22. Aldred 1954, pp. 687-690; Killen 1980, pp. 12-22.
23. Wainwright 1925b, pp. 112-119; Baker 1966, p. 303.
24. Lefebvre 1924, pl. 10.
25. Manuelian 1981, pp. 125-128.
26. Baker 1966, figs. 457, 465-466; Aldred 1954, figs. 491-496; Killen 1980, pp. 8-11.
27. Lucas 1962, pp. 3-5.
28. Ibid., pp. 338-361.
29. Edwards 1976a, no. 12.
30. Clarke and Engelbach 1930, p. 146.
31. Davies 1943, pl. 53.
32. Davies 1917, pl. 15.
33. Wolf 1957, pl. 591.
34. Killen 1980, pp. 37-50.
35. Baker 1966, p. 83, fig. 93; Scott 1973, fig. 35.
36. Wreszinski 1923, p. 17b n. 5 and p. 16 n. 3.
37. See also Baker 1966, p. 132, fig, 185.
38. Killen 1980, pp. 51-63.
39. Baker 1966, figs. 182-184.
40. Ibid., figs. 186-187.
41. Pendlebury 1931, p. 239; Fernea 1973, illustration opposite p. 58.
42. Davies 1905b, pl. 4.
43. Baker 1966, p. 152, fig. 233.
44. See Wreszinski 1923, p. 48b:10; Killen 1980, pp. 64-68.
45. Simpson et al. 1973, p. 73.
46. Emery 1961, fig. 130; Baker 1966, figs. 8-10.
47. Bruyère 1929, fig. 31.
48. Bruyère 1937b. fig. 92.
49. Davies 1927, pl. 38.
50. Davies and Davies 1933, pl. 30.
51. Carter and Mace 1923, p. 193; Baker 1966, pp. 102-106.
52. See also Davis et al. 1907, pl. 37; Quibell 1908b, pp. 50-51, pls. 28-31; Baker 1966, pp. 71-74, figs. 82-85.
53. Schiaparelli 1927, pp. 120-122, figs. 104-105; Baker 1966, p. 119, figs. 170-171; for other examples, see Killen 1980, pp. 23-26.
54. Edwards 1976a, no. 48.
55. Fischer 1980b, col. 688 nn. 17-18.
56. See also Baker 1966, fig. 224.
57. Ibid., fig. 222.
58. Ibid., fig. 223.
59. Ibid., fig. 231.
60. Montet 1962, pp. 90-91.
61. Kamal, 1911, p. 14.
62. Černy 1973b, p. 54.
63. 6-8041.
64. Bruyère 1939, p. 271, fig. 143, p. 331.
65. Bruyère 1926, fig. 9; Schiaparelli 1927, pp. 144-145, figs. 15, 127-128; Desroches-Noblecourt 1976, no. 43.
66. Borchardt 1910, pl. 184.
67. Bruyère 1928, fig. 2; Bruyère 1926, fig. 9.
68. Petrie 1909a, p. 7.
69. Hayes 1959, p. 203, figs. 117-118.
70. Porter and Moss 1960, pp. 1-5.
71. Frank Lloyd Wright, An Autobiography (New York: 1977), p. 169.

Literature: Fischer 1980d.

37

Classic chair

Provenance not known
Dynasty 18, reign of Amenhotep III
Height 90 cm.; width 45.6 cm. (max.)
The Brooklyn Museum, Brooklyn, New York. New-York Historical Society, Charles Edwin Wilbour Fund (37.40E)

Of all Egyptian chairs, the classic type represented here was far and away the most popular. Its characteristic features are legs in the form of lion feet and a slanted back reinforced from behind by a vertical framework that resembles an acute triangle when observed in profile.

This hardwood chair, although sparingly ornamented, is one of the finest surviving examples of its type. A complex series of mortise-and-tenon joints, each carefully spaced in order to avoid weakening the frame, helps to account for its fine state of preservation. The square frame of the seat forms the central element to which the carved legs are joined from below and the slanted, contoured back from above. The woven seat, originally of palm fibers, has recently been restored with jute.

The back consists of seven slats forming a pieced-out panel that is fitted into rails at the top and bottom. Four angular braces resembling ship's knees help secure it to the seat frame because the mortise-and-tenon joints alone are too shallow. The crest rail, which accepts both back and supporting frame, has a rounded lip extending over its rear edge and a large circular bone inlay. Eight small bone pegs, four to a side, are the only other decoration on the chair.

The lion legs are particularly well carved. The heavier and somewhat bulkier hind legs compensate both literally and aesthetically for the visually complex structure of the back. Toes, nails, and even protruding bones are all finished in minute detail, and the four legs rest on typical Egyptian cone-shaped supports. The outstanding feature of the chair is its cohesive and harmonious proportions. Elegant but restrained in decoration, solid but not squat or weighty, the piece achieves a dignified balance typical of only the finest furniture.

Although the discovery of the Fourth-Dynasty tomb of Queen Hetepheres

yielded important royal chairs,[1] no such early examples of the classic household chair have come down to us. One of the earliest three dimensional representations of a chair with a back is in a Sixth-Dynasty statue from Dendera, although it is questionable whether such a chair was actually in daily use.[2]

In the New Kingdom, the classic chair is the type most frequently represented, both in painting and in sculpture. The increasingly sophisticated tastes of the Eighteenth Dynasty helped account for the addition of the comfortable cant with concave back panel contoured to the body. A chair virtually identical to the present example in Leiden[3] has also been attributed to the reign of Amenhotep III, and both chairs may be products of the same workshop. In the collection of the Cairo Museum is a classic chair of ebony inlaid with ivory[4]; there is another in the Metropolitan Museum with an incised representation of the deceased sitting at an offering table.[5] Two elaborately painted classic chairs are known, both intended for funerary purposes. The first was found in the tomb of Kha (ca. 1400 B.C.)[6] and the second in that of Sennedjem at Deir el Medineh.[7]

Two inlaid papyrus flowers adorn the back of a fine chair in the Louvre dated to Amenhotep III;[8] the legs of this piece were painted blue. Chair legs were occasionally painted with spots to represent the skin of a lion[9] and a banquet scene from the tomb of Nebamen depicts classic chairs with legs painted yellow.[10] In a painting from the tomb of Anen, Queen Tiye sits on a royal variation of the classic chair with legs striped black and white.[11] Four royal chairs from Tutankhamen's tomb represent the opulent extreme of the classic form,[12] and tomb paintings often show classic chairs equipped with plush, decorated cushions.[13]

A representation of the classic chair in the round is provided by an Amarna statuette of a seated man.[14] This piece has back rails in the form of a T and simple stretchers reinforcing the legs.[15] Lattice bracings, indeed stretchers of any kind, do not appear on classic chairs until at least the reign of Amenhotep III, and probably later.[16] Thereafter, such bracing is common in

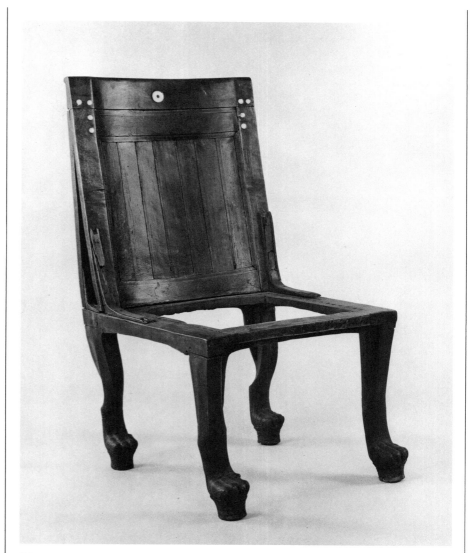

37

representations; the child's chair from the tomb of Tutankhamen provides an actual instance.[17] The bracing becomes more complex during the Ramesside Period.[18] Another Ramesside feature is a rectangular design at the four corners of the chair near the tops of the legs, sometimes plain, often decorated with basketwork or inlaid patterns.[19]

P.D.M.

1. Smith 1958, p. 50, figs. 18-19, pl. 30a.
2. Fischer 1968, p. 102 n. 469, pl. 7.
3. Baker 1966, p. 129, fig. 175; Erman 1971, p. 183; Williams 1913, fig. 6.
4. Wreszinski 1923, p. 7c n. 12.
5. Scott 1973, fig. 15.
6. Baker 1966, p. 117, fig. 160.
7. Desroches-Noblecourt 1976, no. 42.
8. Baker 1966, p. 129, fig. 176.
9. Davies 1917, pl. 13.
10. Woldering 1967, pl. 17.
11. Smith 1958, pl. 107b; Wilkinson 1979, fig. 31.
12. Baker 1966, figs. 89-90, 95-99.
13. Davies et al. 1927, pl. 25.
14. Frankfort and Pendlebury 1933, p. 43, pl. 37.
15. Davies 1943, pl. 52.
16. Fischer 1976, p. 103; Fischer 1977a, p. 17, n. 155.
17. Baker 1966, pp. 84, 86, fig. 99.
18. Davies 1948, pls. 3, 11.
19. Scott 1973, fig. 35; Davies 1948, pl. 2.

Bibliography: New York Historical Society 1915, p. 73, l. 5; Williams 1920, pp. 67-70; Baker 1966, pp. 128-129, figs. 173-174, plan on p. 314; Wanscher 1966, p. 27; Killen 1980, p. 54, no. 3.

38

38

Simple chair

From Deir el Medineh east cemetery
tomb 1389
Dynasty 18, reign of Thutmose III
Height 74.5 cm.; width at top 40 cm.
Musée du Louvre, Paris (E 14437)

This household chair, found in the
tomb of a workman at Deir el Medi-
neh, consists of rough, undecorated
boards fastened together with
mortise-and-tenon joints. The front
legs are rounded at the top and rein-
forced at the bottom by stretchers
shaped with draw knives or scrapers.
The rear legs, which also serve as the
back posts of the chair, are topped by
a crest rail. The rest of the back is
composed of a vertical slat inserted
into a stay rail below and the crest
rail above.

Of particular note is the intact rush
seat. The weave forms an attractive
chevron pattern, which may be con-
sidered the chair's only decorative
element. Signs of wear on the wood
indicate that the chair was actually
used on a day-to-day basis, and not
made solely for funerary purposes.
Very few examples of the simple chair
have been preserved. Two other chairs
were found in tomb 1389[1] and another
similar example is in Berlin.[2] The Berlin
chair was painted white, and contains
a square back frame with a vertical
bisecting rail.

P.D.M.

1. Bruyère 1937b, p. 48.
2. Baker 1966, fig. 185.

Bibliography: Bruyère 1937b, figs. 21, 114, 115;
Baker 1966, fig. 214; Letellier 1978, no. 4; Ecole du
Caire 1981, p. 202.

39

Stool with animal legs

Provenance not known
Dynasty 19
Height 24.13 cm.; width 37.73 cm.
Baker Museum for Furniture Research,
Grand Rapids, Michigan

Forerunners of this sort of stool
usually had rounded papyrusflower
terminals serving as side rails;[1] by the
Nineteenth Dynasty, the frame of the
animal-leg stool was reduced to a
simple square form, as is illustrated by
this well-made example. Mortise-and-
tenon joints connect the longer side
rails with the shorter front and rear

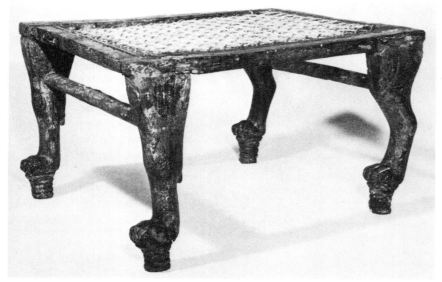

39

rails. Fore and hind legs are well differentiated, and clearly mark the direction the occupant faced. Particularly well carved are the claws and the cone-shaped supports on which they stand. Additional support is provided by two cylindrical stretchers, one for each pair of legs. The restored seat is woven in a pattern similar to those found on ancient stools. Although the deceased is frequently shown in funerary stelae of the Old Kingdom perched upon a stool, the New Kingdom saw it replaced by the classic chair (cat. 37), a more popular seat in representations.[2]

Several New Kingdom parallels to the Michigan stool do exist, however. One with finely carved legs in the Oriental Institute at the University of Chicago dates to the same period as the Michigan piece.[3] Another stool in the Oriental Institute shows bull legs, four connecting stretchers, and decorated panels near the tops of the legs. Despite the absence of feline legs, this stool is thought to belong to the New Kingdom.

On animal-leg stools without stretchers, reinforcing angular braces underneath the frame support the joint of legs and rails. One example with bull legs, now in Edinburgh,[4] dates to Dynasty 17. The most opulent animal-leg stool derives from the tomb of Tutankhamen.[5] With a double-cove seat and bracework in the form of the hieroglyph for the unification of Upper and Lower Egypt, the piece is more

elaborate than any of the private examples mentioned above.

<div align="right">P.D.M.</div>

1. Smith 1963, fig. 1 and cover.
2. Hayes 1959, fig. 93.
3. Baker 1966, fig. 202.
4. Petrie 1909a, pl. 26.
5. Carter and Mace 1923, pl. 74a.

Bibliography: Baker 1966, p. 137, fig. 201.

40
Stool with flared legs
Provenance not known
Dynasty 18, probably reign of
Amenhotep III
Height 38.10 cm.; width 43.81 cm.
British Museum, London (2472)

The finest surviving example of its type, this stool combines precious materials and successful design with superlative craftsmanship. The leather seat dips in a double cove to give contoured support to the body from any of its four sides. Ivory inlay imitating garlands of lotus petals adorns the upper portions of the legs, contrasting brightly with the rich, dark tone of the ebony. Below the lotus garlands are miniature squares of ivory imitating through joints. Inferior examples of this type of stool display squares simply carved in the wood, without the use of inlay.

The supporting lattice bracing, composed of two inner vertical struts on each side, flanked by two angled struts, is also of ivory. The lattice pattern appears first in the Eighteenth

Dynasty and can be found on countless chairs, tables, and other types of stools (cat. 42). Stretchers of ebony terminating in ivory ferrules, which fan out in imitation of a papyrus umbel, hold the legs firmly in place.

The legs taper toward the bottom and then flare out again to form a delicate, aesthetically balanced support. Incised rings ornament the tapered half. This type of leg is often considered, incorrectly, to have been turned on a lathe. Although small holes at the two ends of the leg are visible on some examples, indicating that the piece was indeed held in a sort of vise, the incised rings do not display the regularity normally resulting from lathe work. Imported into Egypt only in the Graeco-Roman Period, the lathe appears to have been a classical invention. One might then wonder why the cylidrical shape of the leg was chosen. The answer lies, aesthetically, in the nature of the form that was popular with the Egyptians and, practically, in the use of naturally cylindrical tree branches for stool legs. The center of the branch is often the center of the leg; thus the need for lathe work was almost eliminated, except for the incised rings. Knives and files were used to shape the wood and cut the rings; diagonal rasping marks resulting from hand-filing are known on at least one example in Boston.[1]

The flared-leg stool was employed at all levels of the social scale, from pharaoh to peasant. Plush embroidered cushions once accompanied the stools of the upper classes, while inferior examples were often without lattice bracing.[2] The symmetry of the design and subtle balance between lightness and solidity account for the popularity of this type of stool throughout the New Kingdom. The earliest examples of flared-leg stools contain stretchers only, without lattice bracing. Four legs of the Hyksos Period in the Metropolitan Museum have their lower parts "waisted and decorated with bands of incised rings";[3] an example of an intact stool of this sort without bracing is known from Dynasty 17.[4] During the reign of Amenhotep III, lattice bracing appears, and subsequently becomes increasingly elaborate on the finer examples, particularly in Dynasty 19. In the Ramesside period, two stretchers

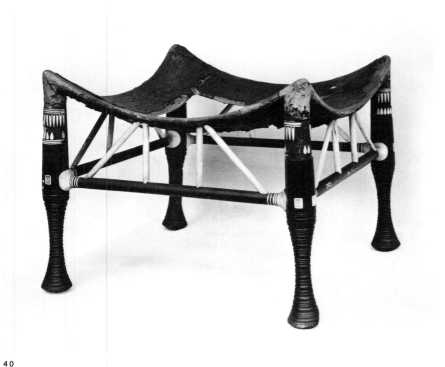

40

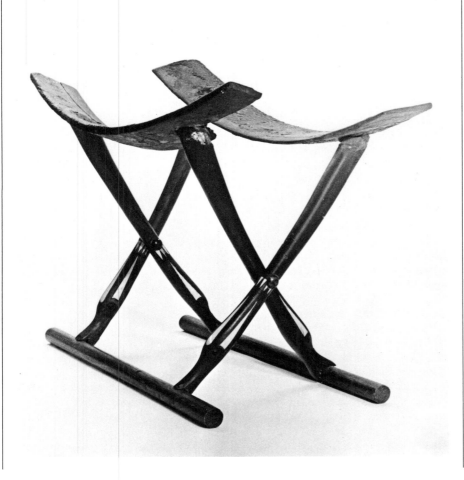

41

appear on each of the four sides[5] and three or even four vertical struts are sometimes represented.[6] The simpler versions, however, both with and without bracing, continue throughout Dynasties 18 and 19. Examples at Amarna show flared stools with bracing in the form of the hieroglyphic sign for unification with papyrus and lotus stems bound together elaborately.[7]

Two intact stools similar to the one under discussion are in the Cairo Museum[8] and the British Museum.[9] The latter has papyriform ferrules, as does a fragment from Sedment dated to Amenhotep III[10] and the so-called child's chair from the tomb of Tutankhamen.[11] One flared-leg fragment from Amarna, of ivory inlaid with green pigment, is in Cairo,[12] and an elaborately detailed wooden leg in Boston also retains traces of green.[13] With the exception of a Ramesside stool found by Bruyère, however, all the flared-leg stools known have double-cove seats.[14]

P.D.M.

1. Manuelian 1981, p. 128, fig. 5.
2. Baker 1966, figs. 207-208.
3. Hayes 1959, p. 27.
4. Baker 1966, p. 138, fig. 207.
5. Foucart 1932, fig. 16.
6. Davies 1948, pl. 29.
7. Davies 1908b, pl. 17.
8. Wreszinski 1923, p. 49b n. 11.
9. Wilkinson 1883a, p. 414; Maspero 1887, p. 280, fig. 260.
10. Petrie and Brunton 1924, pl. 61 n. 68.
11. Edwards 1976a, no. 8.
12. Pendlebury 1951, p. 125, pl. 78:5.
13. Manuelian 1981, p. 126, fig. 2.
14. Bruyère 1926, pl. 5:2.

Bibliography: Wilkinson 1883a, p. 413 n. 164; Breasted 1905, fig. 134; Hayward 1965, fig. 10; Baker 1966, pp. 133-134, fig. 193; Wanscher 1966, p. 51; Erman 1971, p. 184; Killen 1980, p. 49, no. 28.

Literature: Manuelian 1981.

41

Folding stool
From Thebes
Dynasty 18
Length 53.5 cm.; width 37.2 cm.
Ägyptisches Museum, Berlin (12552)

The folding stool, or faldstool, is one of the most graceful designs in all of Egyptian furniture. After simple beginnings as a portable camp stool during the Middle Kingdom,[1] it was refined during the New Kingdom with smoothly finished, often inlaid materials and legs terminating in duck heads. By the latter half of the

41

Eighteenth Dynasty, the duck-head folding stool was a common piece of upper-class furniture; it was a status symbol throughout much of the ancient world and may even have served as a gift of royal favor in Egypt.[2]

The stool is composed of three basic elements: seat, legs, and floor runners. Two concave pieces form the frame of the seat, which was originally of leather. Representations of the faldstool occasionally portray an actual leopard-skin seat, complete with spots and tail,[3] but the Egyptians were also capable of imitating the leopard skin in wood or other media.

Attached to the seat bars are two pairs of rounded legs that taper slightly downward as they cross one another. Each pair is fastened together by a metal pin; the resulting swivel effect allows the stool to fold shut, while the once intact leather seat would have prevented it from falling completely open.

The bottom of each leg is carved in the form of a duck's head and bill. Inlaid

triangles of ivory decorate the heads and form a ring around the "necks"; the eyes are inlaid as well. The mouths are open and hold — by means of shouldered tenons — two parallel runners that anchor the entire stool. Rescuing the duck heads from an awkward right angle with the floor, the elegant arc of the legs produces a successful motif out of a conceptually difficult design.

A painting from the tomb of Nebamen and Ipuki (Theban tomb 181) depicts a group of men seated on latticework stools (see cat. 42), while their superior, seated on a faldstool, enjoys the attention of a servant.[4] Further, Hekanefer, prince of Miam under Tutankhamen, held the title "Bearer of the folding stool of the lord of the two lands."[5] Even the so-called ecclesiastical throne of Tutankhamen displays legs of duck heads; originally a stool, the throne received its back piece as a later addition.[6] The Egyptian term for this type of stool is preserved on an ostracon in Vienna, where it is

called "a folding stool with duck's-head legs."[7]

Among the numerous surviving examples of the folding stool are those from the tombs of Kha[8] and Tutankhamen.[9] Another of Tutankhamen's folding stools has elaborately inlaid duck heads and an ebony seat imitating a leopard skin.[10]

A few inscribed legs are known; one belonged to the "child of the royal nursery, Mahu," who served under Thutmose III and Amenhotep II.[11] A second leg names the "royal scribe and chief steward, Amenhotep," brother of the vizier Ramose under Amenhotep III.[12] Several legs contain the delicate touch of four additional duck heads, one at each end of the two floor runners.[13]

A variation on the duck-head folding stool, which has survived only in paintings, displays legs of carved lion claws. Examples are to be found in the tombs of Khaemhat and Menna.[14] A similar representation has the triangular back characteristic of the Egyptian classic chair (cat. 37).[15]

P.D.M.

1. E.g., Hayes 1953, p. 258, fig. 166.
2. Dittmann 1955, pp. 45-56; Harris 1976, pp. 21-25.
3. Davies 1925b, pl. 7.
4. Ibid.
5. Simpson 1963, pp. 25-26.
6. Baker 1966, fig. 91.
7. Janssen 1975, p. 192; Zonhoven 1979, p. 91, fig. 1.
8. Schiaparelli 1927, fig. 94.
9. Baker 1966, fig. 103.
10. Edwards 1976a, no. 11.
11. Harris 1976, pp. 21-25; Wanscher 1966, p. 43.
12. Leemans 1842, p. 74; Harris 1976, p. 23.
13. Hayes 1959, fig. 116; Hermann 1932, p. 102 n. 8, pl. 11c; Toronto 914.2.1.
14. Baker 1966, figs. 217 and 218.
15. See also Wreszinski 1923, p. 424.

Bibliography: Staatliche Museen 1899, no. 196; Schäfer 1919, p. 158, fig. 81; Hermann 1932, p. 102 n. 7, pl. 11d; Dittmann 1955, p. 46; Agyptisches Museum 1967, no. 643.

42
Stool with lattice bracing
From Thebes
Dynasty 18, reign of Thutmose III
Height 37.46 cm.; width 32.38 cm.
British Museum, London (2476)

A popular household item, the lattice-work stool was often used at social gatherings and banquets. In tomb paintings, the deceased noble is frequently represented perched upon such a stool, benignly surveying his

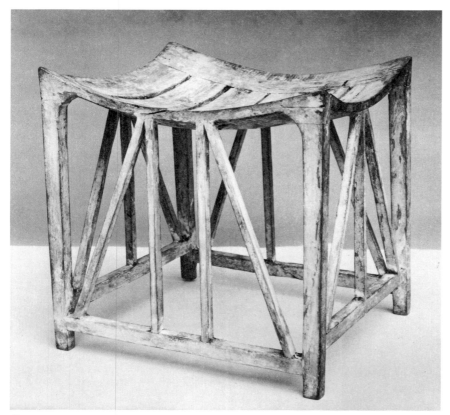

42

estate in the shade of a protective canopy; artisans often labored in their workshops seated on virtually identical, though simpler, pieces. The inviting contour of the seat and refined lattice design make for a comfortable, yet solid and portable piece of furniture.

Lattice bracing gracefully fills the voids between the four legs of the stool. The sides alternate in the use of one and two vertical struts, one for the shorter sides and two for the longer. A feature common in latticework stools is the slightly higher stretchers on the shorter sides, which not only preserve the strength of the wood by separating pairs of mortise-and-tenon joints but also gently offset any monotony in the design. Apart from its use on this type of stool, latticework was applied to many other objects, among them tables, chairs, chests, and stands.

The double-cove seat is formed of curved strips of wood with four slats in the center. The wood was either steamed and bent or cut to shape. Other such stools are known with seats of woven rush. Filler pieces underneath the four corners of the seat

ease the transition to the legs with a gentle curve. The entire stool was originally gessoed and painted white.

Many parallels to this stool have survived, in addition to countless two-dimensional representations in tomb paintings. Perhaps the best-known examples are two royal stools from the tomb of Tutankhamen. One is a virtual duplicate of the British Museum stool,[1] the other a dark red wood piece with a seat veneered with ebony and ivory.[2]

The tomb of the architect Kha yielded four stools with lattice work design.[3] One contains two vertical struts, along with its double-cove, woven rush seat,[4] while two have concave seats of woven rush[5] and the last a double-cove seat with wooden slats.[6] The British Museum possesses other examples,[7] as does the Cairo Museum.[8]

Although latticework bracing does not appear in Egyptian cabinetry until Dynasty 18, earlier forms of bracing are found as early as the Third Dynasty (2686-2613 B.C.). The tomb paintings of Hesyre depict stools in profile with arch-shaped supporting pieces stretching from one leg to the center of the seat, then down again to the other

leg.[9] After the New Kingdom, bracing becomes more complex, with an increasing number of struts, or with curving pieces arching in several directions.[10]

Some variations on the type are known. One, from the tomb of Kha, is a rough work stool with angled struts and a hole in the center of the seat, presumably for portability, although this stool has also been identified as a commode.[11] Another is an inscribed stool from the tomb of Huy, with a double-cove seat of woven rush. This stool contains no lattice bracing whatsoever, although the stretchers are at different heights.[12]

P.D.M.

1. Baker 1966, fig. 100.
2. Ibid., fig. 101.
3. Schiaparelli 1927, fig. 97.
4. Baker 1966, fig. 154d.
5. Ibid., fig. 154a-b.
6. Ibid., fig. 154c.
7. Wreszinski 1923, p. 49(b), no. 8; Wilkinson 1883a, p. 413, no. 185, fig. 3.
8. Mariette 1872, pl. 23.
9. Baker 1966, fig. 27b; Killen 1980, p. 38, fig. 20.
10. Curtius 1913, pl. 141.
11. Ricke 1932, p. 35, fig. 34.
12. Bruyère 1926, pl. 5:1.

Bibliography: Baker 1966, p. 134, fig. 192.

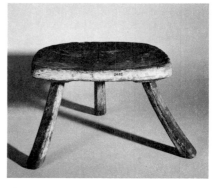

43

43

Three-legged stool
Provenance not known
Dynasty 18
Height 26.5 cm.; seat width 38.8 cm.
British Museum, London (2482)

Of the various types of Egyptian stools, this white-painted piece exemplifies the most utilitarian. Numerous tomb paintings depict workmen seated upon such stools, engaged in all manner of tasks, from carpentry to jewelry making.[1] The semicircular dished seat resembles a wide saddle, which allowed the relatively unrestricted movement necessary for

work purposes. Formed from a solid block of wood, it shows a distinct front edge, to which three legs are oriented, two in the front, one at the rear. Shouldered socket joints connect the legs to the underside of the seat. The splayed curve of the legs, which firmly anchors the stool, was achieved naturally with the use of forked branches. These were rounded with draw knives, rasps, and scrapers.

Many examples of this type of stool are scattered in museums throughout the world. Two were found in the tomb of the architect Kha, one of which displays three additional blocks supporting the socket joints of the legs, and an unusually thick seat.[2] An unpainted, well-worn work stool was discovered in the tomb of Setau at Deir el Medineh,[3] along with a second containing a square block seat.[4] Another three-legged stool, from the late Eighteenth Dynasty, is now in East Berlin.[5] Traces of white paint remain on a similar stool in Edinburgh with three support blocks similar to the Kha example. By far the most elaborately decorated three-legged stool derives from the tomb of Tutankhamen.[6] The seat represents two lions bound "head to tail." The legs are carved with lion feet, and the "unification" hieroglyph forms the bracing underneath.

In later periods, Egyptian furniture fell under foreign influences, many of which were classical. One example of a three-legged stool from Kom Washim, which dates to the third century B.C., shows the profound break with previous styles.[7]

P.D.M.

1. Davies 1905b, pl. 18; Davies and Davies 1923, pl. 10; Davies 1943, pls. 54-55.
2. Schiaparelli 1927, p. 117, figs. 97-98; Baker 1966, p. 117, fig. 159.
3. Bruyère 1937a, figs. 43-44.
4. Bruyère 1937b, fig. 21.
5. Staatliche Museen 1899, fig. 40; Baker 1966, p. 139, fig. 212.
6. Carter 1933, pl. 68a; Baker 1966, fig. 105a.
7. Wainwright 1925a, pl. 1.

Bibliography: Wilkinson 1883a, p. 414 n. 187, fig. 3.

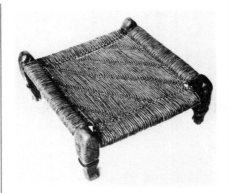

44

44
Low stool
Probably from Deir el Medineh east cemetery
Dynasty 18, reign of Hatshepsut or Thutmose III
Height 15.4 cm.; width 33.5 cm.
Musée du Louvre, Paris (E14654-E20506)

The stool, which might seem uncomfortably low to us, was made for a popular sitting position in the Near East, both ancient and modern: a crouch with the knees drawn up near the chin. The stubby legs, rounded at the top and modeled with knives, chisels, and abrasives, contain sockets into which the four lists of the frame are inserted. The lists are placed at slightly different heights in order to stagger the joints and thus ensure their strength. Inside the legs the list tenons may barely overlap for additional reinforcement.

The outstanding feature of the stool is the rush seat. The pattern in the center gives the illusion of diagonal lines, offsetting the rectilinearity of the frame. This design is created by turning the ends of the rushes over and carrying them to a side list ninety degrees from their original direction. Thus, no one rush strand runs straight across the seat. Single reinforcing strands at the edges of the four lists complete the pattern. The lowest type of Deir el Medineh stool, typified by the present example, ranges from fifteen to twenty centimeters in height.

The excavations at Deir el Medineh produced numerous examples of the low stool in varying heights, rush patterns, and leg designs. The rush seats seem to be a sign of domestic use; seats of hard wood, and occasionally leather, were probably the types used in workshops. It has been suggested that the height of the stool is related to the status of the man of the house; his wife may have sat lower than he, possibly on a floor mat.[1]

Other designs of rush seats, always based on right angles or diagonals, are checks and chevrons; an example of the latter may be found on a Louvre simple chair (cat. 38).[2] Taller stools often have four stretchers near the base of the legs for support.[3] What appears to be an example of the latter is shown in a workshop scene from the tomb of Rekhmire.[4]
A low stool from Thebes which dates to the early New Kingdom displays legs carved with stylized animal feet.[5]

P.D.M.

1. Bruyère 1937b, p. 49.
2. See Wilkinson 1883a, p. 45, no. 188, for a detail of this pattern on a stool.
3. Bruyère 1937b, fig. 24.
4. Davies 1943, pl. 53.
5. Carnarvon and Carter 1912, pl. 71.

Bibliography: Bruyère 1937b, figs. 21-22; Letellier 1978, no. 6; Ecole du Caire 1981, p. 201.

Literature: Staatliche Museen 1899, pl. 40; Williams 1913, fig. 2; Bruyère 1937b, pp. 45-52, figs. 84-85, 90, 92, 97; Hayes 1959, fig. 12; Baker 1966, fig. 194, with plan on p. 316, fig. 215.

45
Table with splayed legs
Provenance not known
Dynasty 18, probably reign of Thutmose III
Height 29.85 cm.; width 26.03 cm.; length 52 cm.
The Brooklyn Museum, Brooklyn, New York. New-York Historical Society, Charles Edwin Wilbour Fund (37.41E)

The low height of this table is characteristic of Egyptian and, indeed, much ancient Near Eastern furniture (see cat. 44); its form imitating the entrance pylons of an Egyptian temple. The legs provide a sense of firm support by gently splaying outward. Four stretchers, attached with mortise-and-tenon joints, fill the spaces between the legs with clean, straight lines. Counterbalancing the splayed legs is the cavetto and torus cornice at the top. An applied astragal or torus molding separates the base of the cornice from the top rails.

Splayed-leg tables were known as early as the Old Kingdom.[1] The scarcity of surviving examples may be due to their use as funerary offerings; placed in the chapel so as to be accessible to the servitors of the deceased,

45

46

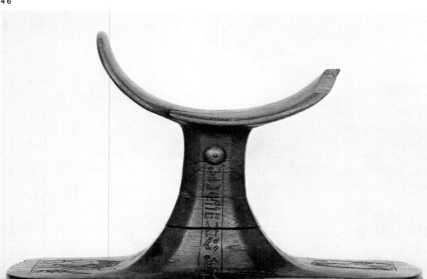

such a table would be much more vulnerable than furniture in the burial chamber.[2]

A virtually identical table from Thebes, now in the Metropolitan Museum, dates to the beginning of the Eighteenth Dynasty.[3] Pegged tenons reinforce the joinery on this piece, and strips of veneer fastened to the rails and legs imitate bead molding. Curved brackets, absent in the Brooklyn table, soften the angularity of the leg joints with the top rails.

A second popular type of Egyptian table has straight legs and an unornamented, flat top. Several examples of this type were found in the tomb of Kha at Deir el Medineh (ca. 1400 B.C.).[4] Kha's tomb also yielded a "garden table" with a slatted top, splayed legs, and simple lattice bracing.[5]

P.D.M.

1. Junker 1947, fig. 92.
2. Baker 1966, p. 150.
3. Hayes 1959, p. 27, fig, 12; Baker 1966, p. 152, fig, 235.
4. Schiaparelli 1927, fig. 100; Baker 1966, figs. 161, 233.
5. Schiaparelli 1927, fig. 103; Baker 1966, fig. 165.

Bibliography: New-York Historical Society 1915, p. 73, l. 6; Baker 1966, p. 152, fig. 236; Killen 1980, p. 66, no. 5.

46

Headrest

Said to be from Saqqara
Dynasty 18, reign of Hatshepsut to Amenhotep II
Height 18 cm.
The Brooklyn Museum, Brooklyn, New York. New-York Historical Society, Charles Edwin Wilbour Fund (37.440E)

This wooden headrest with fluted vertical support is inscribed for the "doorkeeper and child of the *harim*,

74

Yyuy, repeating life." The inscription appears on one side of the vertical support and a frontal Bes-image* stands on the other. There is another Bes-image at one end of the upper surface of the base and what may be a representation of the hippopotamus goddess Taweret at the other end.

Like many people, the ancient Egyptians saw the hours between sunset and dawn as the time when they were most susceptible to malevolent forces that would pose little threat to their safety during daytime. To protect themselves from these injurious powers—either imagined or real, such as snakes or scorpions—the Egyptians called upon a suite of protective deities. The two most common took the form of a hippopotamus goddess, with lion's claws and a crocodile tail down its back, and the Bes-image, seen either full-face or in profile. Representations of these gods had appeared in apotropaic contexts since the Middle Kingdom, when they formed part of the decorative scheme on curved ivory amulets called "magic knives," used to delineate in the ground a sleeping place, a safe area into which no malicious force could enter.[1] By Dynasty 18, these protective deities had become part of the standard decoration on numerous bedroom articles, including headrests and the footboards and legs of beds (see cat. 48). On the present headrest, the hippopotamus and one of the Bes images hold a sa sign, the hieroglyph for "protection," while clutching a long pointed knife. Each also has a great undulating serpent in its mouth, perhaps indicating the fate of any serpent caught violating the area near the sleeper.

The absence of ribs and veins on the torso and limbs and the extremely lion-like aspect of the Bes-image (e.g., the feline forepaws) suggest a date in the first half of Dynasty 18, certainly not later than the reign of Amenhotep II.[2]

J.F.R.

1. Steindorff 1946, pp. 41ff.
2. Romano 1980, p. 44.

Bibliography: New-York Historical Society 1915, p. 31, no. 486; James 1974, p. 90, no. 207.

Literature: Reisner 1923b, pp. 229ff; Fischer 1980b, cols. 686-693.

*In the context of this catalogue, the term "Bes-image" denotes a visual form common to a number of gods, the most familiar of which is Bes.

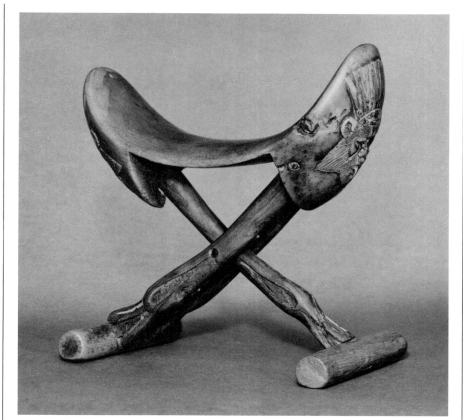

47

47

Headrest in the form of a folding stool
From Akhmim
Late Dynasty 18
Height 19 cm.
British Museum, London (18156)

Complete with a duck-head motif on the legs, this wooden headrest imitates the folding stool that was so popular among the upper classes (see cat. 41). A rivet through the center of the legs actually allows it to fold shut, while the comfortable neckpiece holds it secure when open. In the duck bills at the base are tenons to grip the cylindrical floor runners that anchor the headrest. Two carved heads of the Bes-image, one on each side, adorn the outer portions of the neckpiece.

Although several examples of the folding headrest are known, only one, from the tomb of Tutankhamen, provides an exact parallel, including Bes-images and duck heads.[1] This royal headrest is constructed entirely of ivory, which has been stained in various colors.

Another headrest with heads of the Bes-image on the sides of the neckpiece is in Cairo,[2] and there are two undecorated headrests in the form of folding stools from the New Kingdom sites of Gurob and Kahun.[3]

P.D.M.

Egyptian artisans of the New Kingdom frequently used the apotropaic Bes-image as a decorative device on headrests. The form of this image's headdress, the thick brows running obliquely over his furrowed forehead, and the folds of flesh extending from his nose down across the cheeks all suggest a date in the second half of the Eighteenth Dynasty (cf. cats. 48 and 420).[4]

J.F.R.

1. Carter 1933, pl. 36a; Baker 1966, p. 106, fig. 141.
2. Reisner 1923b, p. 236, fig. 223 n. 38. For examples with similar, though undecorated, neckpieces see Wilkinson 1883a, p. 416, no. 191, fig. 2; Saad 1943, p. 450, pl. 34a; and Garstang 1907, pp. 119-120, fig. 113; see also Reisner 1923b, p. 235, fig. 223 n. 35.
3. Petrie 1890, p. 35, pl. 18:17; Petrie 1891, p. 22, pl. 27:46.
4. Romano 1980, p. 45.

Bibliography: Ruffle 1977, p. 141, fig. 108.

Literature: Reisner 1923b, pp. 229ff.; Hermann 1932; Fischer 1980b, cols. 686-693.

48

Stile

Provenance not known
Dynasty 18, reign of Amenhotep III to
Tutankhamen
Height 11 cm.
Fitzwilliam Museum, Cambridge. Bequest
of C. S. Ricketts and C. H. Shannon
(E.68.1937)

This ivory piece and an ebony example
also in Cambridge (cat. 49) once
served as stiles in openwork panels
adorning a valuable piece of furniture
such as a chair or bed.

The Bes-image that makes up the stile
stands bent-kneed, facing front with
hands on hips, wearing a round-
topped plumed headdress with four
disks at the base. He has large feline
ears, oblique eyebrows running over a
deeply-furrowed forehead, small hori-
zontal eyes, a broad flat nose with
thick folds of flesh extending from the
nasal alae down the cheeks, and an
open mouth with projecting tongue.
A curved beard covers his cheeks only.
The mane, consisting of thick tufts of
hair rendered in a stylized rhomboid
pattern, falls over his shoulders onto
his chest, and continues across the
chest in a broken line. The arms and
legs are muscular, and ribcage, spine,
genitals, and turned-out feet are all
carefully indicated. A tail, mostly gone,
falls between the legs and ends in a
tuft.

The distinctive headdress has par-
allels in several Bes-images dated to
the reigns of Amenhotep III[1] and
Tutankhamen.[2] The existence of
Ramesside examples[3] indicates that
this feature was not unique to Dynasty
18. However, this date is suggested by
the careful articulation of the ribcage,
which occurs only in the second half
of Dynasty 18.[4] Likewise, the juxtapo-
sition of thick plastic eyebrows
running obliquely over a furrowed
forehead, itself divided by a thin
channel, can be noted on several
firmly dated pieces of late Dynasty 18
but not on later examples.[5]

The thick folds of flesh on the face
may provide a clue to the origin of
the Bes-image. Egyptian artisans often
used these thick creases on faces of
foreigners to distinguish them from
the indigenous population. In the
Memphite tomb of Horemheb, for
example, these folds appear on the
faces of both Asiatic and Nubian

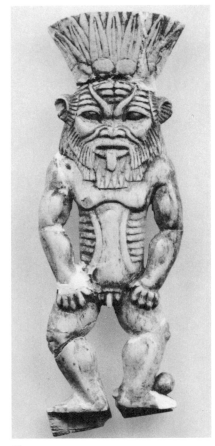

48

49

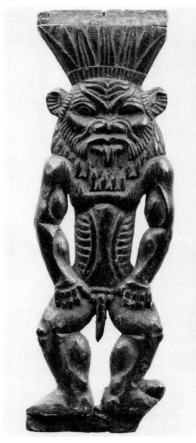

prisoners. Thus the folds could be
seen as a reflection of the Egyptians'
belief, in Dynasty 18, that the Bes-
image originated beyond the borders
of Egypt. They may also refer to the
leonine nature of Bes, since snarling
lions pull back their facial muscles,
producing rolls of flesh identical to
those on the Sedment vase (fig. 31).
Whatever the inspiration for these
folds, they appear on representations
of the Bes-image from the reign of
Amenhotep II to the end of Dynasty
18.[6]

This piece may have been part of the
MacGregor collection.[7]

J.F.R.

1. Quibell 1908b, p. 51, pl. 28:31.
2. Cairo JE59872 (mold), JE61989A (chariot
 ornament), and JE62016 (bed).
3. Prisse d'Avennes 1878, pls. 85, 86, 96; Hayes
 1937, pp. 40-41, fig. 11, pl. 13.
4. Amenhotep III: Quibell 1908b, p. 50, pls. 28-30;
 p. 52, pls. 32-34; Säve-Söderbergh 1957, p. 40,
 pls. 35, 37; Akhenaten: Cairo JE53250 (cosmetic
 container), JE57674 and JE58989 (faience
 amulets); and Tutankhamen: Cairo JE62015 and
 JE62016 (beds) and Desroches-Noblecourt 1963,
 p. 303, pl. 341b.
5. Amenhotep III: Quibell 1908b, p. 50, pls. 28-29;
 p. 52, pls. 32, 34; pp. 52-53, pls. 35, 37; pp.
 53-54, pls. 38-42; Akhenaten: painted pottery
 vase (Peet and Woolley 1923, pl. 45:4).
6. Quibell 1908, pl. 32; Davis et al. 1910, pl. 1;
 Carter 1933, pl. 36; Aldred 1961, pl. 58.
7. See Sotheby 1922, lot 686, pl. 1.

Bibliography: Fitzwilliam Museum 1979, no. 6b.

Literature: Aldred 1954, pl. 26a.

49

Stile

Provenance not known
Dynasty 18, reign of Amenhotep III to
Tutankhamen
Height 11.3 cm.
Fitzwilliam Museum, Cambridge. Bequest
of C. S. Ricketts and C. H. Shannon
(E.67c.1937)

This ebony example differs from cat.
48 only in material, details of head-
dress, the indication of ribs on the
back, and the somewhat more slender
torso.

A second ebony stile of precisely the
same dimensions and displaying iden-
tical details of style and craftsmanship
is in Brussels.[1] No doubt the two
pieces came from the same workshop,
if not from the same piece of furniture.

Like cat. 48, this piece may originally
have been part of the MacGregor
collection.[2]

J.F.R.

1. See Werbrouck 1939, p. 80, fig. 8.
2. Sotheby 1922, lot 569.

Bibliography: Fitzwilliam Museum 1979, no. 6a.

Literature: Aldred 1954, pl. 26a.

Pottery

Ceramics are the most ubiquitous remains of ancient Egyptian civilization and are therefore of great archaeological importance not only in dating but also in what they can tell us about Egyptian society. In the New Kingdom a wide variety of vessel types were used for multitudinous functions, ranging from coarse bread molds to finely crafted and decorated tableware and cosmetic containers.

Painted decoration on pottery is not common during the Dynastic Period, where the aesthetic impact of the potter's craft was concentrated in the form and line of the vessel. Often the surface was a monochrome wash (a solution of water and pigment) or slip (fine clay in solution with pigment), which was occasionally burnished to a high luster (cat. 63). There is no glazed pottery from Egypt until the Roman Period.[1]

Handles that break the symmetry of the profile are more often than not indications of foreign influence (cats. 61, 65, 66). The presence of handles and their placement and position are also indicators of function, suggesting the need to lift, lug, hang, or pour from a vessel. Functions of some of the smaller vessels include holding cosmetics or scented oil (see cats. 57 and 58), the temporary storage of dry foodstuffs such as *dom*-palm nuts or honeycombs (see cat. 56),[2] temporary storage and pouring of wine, beer, and other liquids (see cats. 55, 62), and drinking (cat. 52). Large jars such as cat. 61 may have been used for the longer-term storage of wine or beer. The small hole in the lid of some of these large vessels was probably made to allow gas to escape during fermentation.[3] Large amphorae such as cat. 68, on the other hand, were probably used to keep grain and other foodstuffs in the storerooms of a house.

With the beginning of the Eighteenth Dynasty, painted decoration makes its appearance at first in linear patterns in dark brown or purplish and reddish brown derived from Canaanite styles[4] (cats. 55, 56). These designs degenerate rapidly into sloppy patterns (e.g., cat. 57) and evolve into the simple horizontal bands of color common in the Thutmosid Period.

Another type of decoration with a predominantly blue pigment and imitating the flower garlands placed around large vessels becomes common in the reign of Amenhotep III[5] (cats. 71, 72). The bulk of the ceramics used, however, remained undecorated red or buff wares. The color of the final product was a result of the source material and firing conditions.

Both primary (desert marls) and secondary (Nile alluvium) clays were employed. Firing was done in simple updraft kilns and perhaps in bread ovens as well.[6] Except for the crudest domestic wares, almost all pots were wheel made in the New Kingdom (fig. 29), and pottery production seems to have been conducted principally on a local level.[7] Composed as it was of readily available resources, ceramic had little intrinsic value.[8] The shape of some foreign pottery was admired and imitated by Egyptian potters[9] and by workers in faience, stone, and glass.

P.L.

1. Brooklyn 1968, p. 3.
2. Holthoer 1977, p. 133.
3. Ibid., p. 70.
4. Amiran 1969, pp. 187-190.
5. Hope 1977.
6. Holthoer 1977, p. 347.
7. Butzer 1974; Hope 1978, pp. 72-74.
8. Janssen 1975, p. 408.
9. Merrillees 1974, pp. 33-35; Merrillees 1962, pp. 195-196.

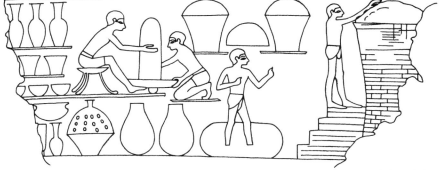

Fig. 29. Fabrication of pottery: the man at the left turns a lump of clay on a pottery wheel with the aid of an assistant, and a standing figure tramples and mixes the clay, while a third individual attends to the mud-brick kiln (from Theban tomb 93).

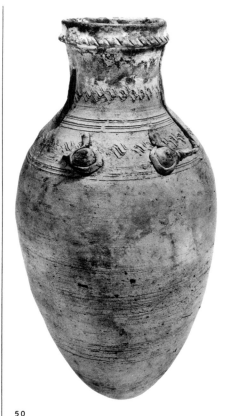

50

50
Milk vase
From Qustul tomb R.29
Early Dynasty 18 to reign of Thutmose III
Height 43.8 cm.; width 20.8 cm.
The Oriental Institute, The University of
Chicago (21044)

The vase is wheel thrown, made of
hard medium-coarse marl clay like
that of cat. 59, and fired to a greenish
white.[1] The decoration was carried out
before firing, and consists of an incised
comb pattern on the shoulder, notches
around the collar neck, and applied
lumps of clay modeled into the shape
of a woman's arms and hands cupping
her breasts. It is hard to escape the
implication of the relief decoration
(of arms and breasts) that this vase
was a container for milk. The idea is
strengthened by the existence of a
Twelfth-Dynasty example with the
breasts pierced to provide two
spouts.[2] From the Second Intermediate
Period to the early Eighteenth Dynasty
similar jars appear sporadically, made
from both Nile silt and marl, with ap-
plied heads, breasts, arms with hands
cupping the breasts, and sometimes
navels. They have medium tall necks,
collar rims, and incised decoration of
horizontal wavy lines.

The crude anthropomorphic vases of
the New Kingdom with pierced
breasts,[3] while related by function, are
different in material and technique.
They fail to achieve the deft com-
promise between sculptured elements
and vase shape evident here.

Qustul tomb R. 29 was a shaft and
chamber tomb containing five intact
burials. The vase belonged to burial
no. 4, that of a mature male. As far
as can be judged from the preliminiary
report,[4] the burials were made early
in Dynasty 18 before the reigns of
Thutmose III and Hatshepsut.

A close parallel from an undisturbed
burial of the same date comes from
Qau grave 3506[5] and is now in the
Manchester Museum. Examples also
occur with a grotesque face applied
to the rim of the vase[6] and these
eventually evolve into the jars with
Hathor heads in relief of the late
Eighteenth and Nineteenth Dynasties.
Cat. 69 represents an intermediate
stage in which the breasts, head, and
pudenda have become vestigial, but
the collar neck, which goes back to
the Second Intermediate Period, is
still retained. A stylized bronze version
of the domestic milk vase (used in
temple rituals)[7] has a dedication to
the goddess Anukis, and probably
dates to the late Eighteenth Dynasty.

J.D.B.

1. Grateful acknowledgment is made to Dr. Bruce
 Williams of the Oriental Institute for additional
 information on this piece.
2. Jacquet-Gordon 1979, pp. 29-30.
3. See Peet 1914, pl. 34; Wainwright 1920, pl. 21.
4. Seele 1974, p. 13.
5. Brunton 1930, pl. 27:100.
6. Downes 1974, pl. 48:169a; Bourriau 1981,
 no. 52.
7. Spiegelberg 1909, p. 23, pl. 13:46.

Bibliography: Seele 1974, p. 13, cf. fig. 7.

51
Bowl
From Zawiyet el Aryan tomb 234
Early Dynasty 18 to reign of Thutmose III
Height 5.2 cm.; diameter 14.1 cm.
Museum of Fine Arts, Harvard University–
Museum of Fine Arts Expedition (11.3003)

Scenes of feasting painted on tomb
walls show similar vessels used as
drinking bowls, but in graves bowls
are often found to have been lids for
wide-mouthed storage jars, or as
containers for grain, nuts, or fruits.

51

A simple shape such as this could
serve a variety of functions.

The bowl was made of a medium-fine,
straw-tempered Nile silt and fired to a
reddish yellow. Although covered on
both surfaces with a red slip, the bowl
was burnished only on the outside,
and a thin black ornamental line was
applied to the rim, as with cat. 52.

Zawiyet el Aryan tomb 234 is an un-
published grave. The tomb card shows
the badly disturbed burial of an adult
containing only one other bowl[1] of the
same ware.

J.D.B.

1. Cf. Brunton 1930, pl. 26:38.
Literature: Holthoer 1977, pl. 24:11R/0/d-e.

52
Drinking cup
From Deir el Ballas
Early Dynasty 18 to reign of Thutmose III
Height 14 cm.; diameter 6 cm.
Lowie Museum of Anthropology, Uni-
versity of California, Berkeley (6-8557).
Hearst Expedition

At an early Eighteenth-Dynasty site in
Egypt cups like this are to be num-
bered in the hundreds.[1] Whether they
were used for beer, wine, or water is
hard to say, although they were in-
variably cheaply made of a porous
fabric, indicating that they were in-
tended for consumption, not storage,
of liquids. The black line painted
around the rim was fashionable during
the late Second Intermediate Period
but died out soon after the reign of
Thutmose III. The cup is of the same
ware and color as cat. 51.

J.D.B.

1. See Holthoer 1977, pp. 171-174, pl. 41.

The form of this basic item of house-hold equipment has scarcely changed since antiquity, although modern scoops are made of plastic rather than fired clay. This example was made by hand, of a marl clay fired to a grayish white.

The scoop may be dated to the period assigned by Reisner to the cemetery as a whole, namely, the reign of Amenhotep I to that of Thutmose III.

J.D.B.

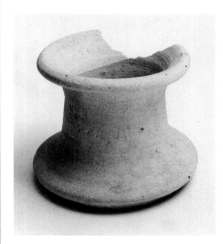

54

54

Pot stand

From Deir el Ballas cemetery 500, mound N
Early Dynasty 18 to reign of Thutmose III
Height 9.6 cm.; diameter 14.2 cm.
Lowie Museum of Anthropology, University of California, Berkeley (6-7916).
Hearst Expedition

Pot stands were used to support round-bottomed jars, not only to make them stable but to raise them up so that their damp, porous surfaces were not contaminated by ground dirt. The shape of the stands hardly changed from the Old Kingdom onward, and so close was the association between the shape of the vase and its support, that the pot stand became an element in the design of stone vases (see cats. 116, 120). Made of a straw-tempered Nile silt fabric, the stand was wheel thrown and then trimmed by hand. The slip is buff on a buff fabric.

J.D.B.

Literature: Brunton 1930, pls. 17, 87T.

52

53

Scoop

From Deir el Ballas cemetery 1, tomb 146
Early Dynasty 18 to reign of Thutmose III
Length 26 cm.
Lowie Museum of Anthropology, University of California, Berkeley (6-6728).
Hearst Expedition

 53

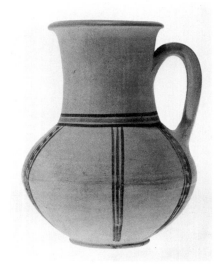

55

55

Pitcher

From Nubia, Firth cemetery 110
Dynasty 18, reign of Thutmose III
Height 18.8 cm.; diameter 14.4 cm.
Museum of Fine Arts (19.1550)

This pitcher is an example of the finest pottery tableware produced during the New Kingdom. On a burnished, pale yellow surface, decoration was applied with a brush in dark reddish brown and reddish-yellow pigment. The design is a stylized rendering of a foliage motif that first appears on broad jars made in the same fabric during the late Second Intermediate Period. The source may be the designs on bichrome ware, which was first imported into Egypt from the Levant at that time,[1] but the fabric and technique are Egyptian. It has been suggested that the shape also derives from Syro-Palestinian pottery.[2]

In addition to skillful manipulation of the surface, obliterating all tool marks so that there is no trace at the base of the neck of the join between the two components, thrown separately on the wheel, the even color shows that the pot was most carefully fired. The fabric is an extremely hard and dense marl clay, the same as that used for cats. 56 and 57. Grave 199 in cemetery 110, from which the pitcher derives, is an intact burial datable to Thutmose III.

J.D.B.

1. Epstein 1966; Wainwright 1920, pp. 37ff.
2. Amiran 1969, p. 187.

Bibliography: Firth 1927, p. 85.

Literature: Holthoer 1977, pl. 21; Bourriau 1981, no. 150.

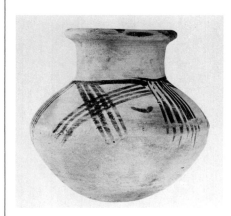

56

56
Carinated jar
From Abydos tomb F15
Early Dynasty 18 to reign of Thutmose III
Height 15 cm.; diameter 16.2 cm.
Museum of Fine Arts. Gift of Egypt
Exploration Fund (09.650)

Jars of this type, used at the table or for storage of dry foods, have been found with the remains of honeycombs, fruits, or grain still inside them. They are of the same ware as cat. 55, although this example is not of the same high quality. The jar is wheel thrown and finished on the wheel after drying; a large particle of limestone protrudes from the vessel surface, and individual burnishing strokes are still visible. The painted decoration is in dark reddish-brown pigment.

F15 is a grave on the eastern ridge of Abydos; it was excavated in 1908 and 1909.[1] A full report of the excavations was never published, but a note de-

scribes the few Eighteenth-Dynasty tombs found as brick-lined shafts with a chamber on each side containing many plundered burials. A close parallel to this jar, also from Abydos[2] has been dated to the Second Intermediate Period.[3] Although it is descended from the carinated jar of that time, the wheel-finished, flattened base, wide lip rim, and long neck of this vessel are characteristic of early Dynasty 18. The date is confirmed by the existence in tomb F15 of two Cypriote base-ring juglets.[4]

Two unusual versions in faience decorated in black paint are in the University Museum, Philadelphia,[5] and in the British Museum.[6] Below the carination in the former there is a design of an open lotus flower like that found on the outside of faience bowls. The vessel comes from Ballas.[7]

J.D.B.

1. Ayrton and Loat 1908-1909, p. 4.
2. Peet 1914, pl. 33.
3. Ibid., p. 69.
4. Type 1, Merrillees 1968a, pp. 113-114.
5. E.1250.
6. BM 24682.
7. See Quibell 1896, p. 6.

Literature: Holthoer 1977, pp. 133-134, pls. 31-32.

57
Double vase
From Deir el Ballas cemetery 1, tomb 119
Early Dynasty 18 to reign of Thutmose III
Height 6.2 cm.; width 12 cm.
Lowie Museum of Anthropology, University of California, Berkeley (6-6562).
Hearst Expedition

This red ware double vase is a rarity, although single jars of the class are common. It belongs in the same group as cats. 55, 56, and 59, and, because of its similar fabric, shape, and decoration, it may have served, like cat. 58, as a container for scented oil or fat. The decoration in purple-brown pigment, though more crudely applied, is similar to that on cat. 56 and may have been inspired by painted pottery imported from Palestine (see cat. 55).

George Reisner's diary shows tomb 119 to have been a robbed shaft and chamber tomb containing at least four burials. The pottery is consistent with a single period of use during early Dynasty 18.

J.D.B.

Literature: Garstang 1901, p. 15, pl. 21, E155; Jéquier 1933, fig. 34g.

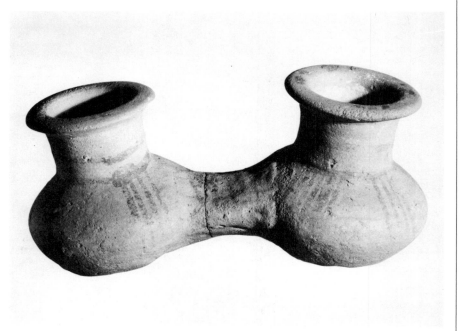

57

58

58
Cosmetic flask

Provenance not known
Dynasty 18, reign of Thutmose III to
Thutmose IV
Height 12.5 cm.; width 11 cm.
Musées Royaux d'Art et d'Histoire,
Brussels (E.5336)

This is a terracotta version of a flask
commonly made in alabaster.[1] How-
ever the painted decoration, horizontal
black and red lines and dots, is char-
acteristic of pottery belonging to this
ware (see also cat. 55).

The fabric is dense and hard, much
less porous than Nile silt, and suitable
for a container for an expensive sub-
stance such as an imported oil or a
cream perfumed with such oil. The
flask is wheel thrown and the surface
carefully smoothed on the wheel
after drying.

Alabaster flasks of this form are found
from the reign of Amenhotep I,
although they are closely related to
a Second Intermediate Period type[2]
and precede the pottery version that
appears from the reign of Hatshepsut.[3]
Examples like this one, with horizontal
bands of decoration only, are slightly
later.[4]

Deir el Medineh tomb 1165[5] provides
a close parallel from an excavated
context.[6] The date range of the tomb
is Dynasty 18 and 19, the earliest
pottery being of the middle of Dynasty
18. Another pottery example from

Deir el Medineh contained a yellow
paste with a base of animal fat.[7]

J.D.B.

1. Engelbach 1915, pl. 11:6.
2. Carter 1916, pl. 22:1-4.
3. Brunton 1930, pl. 28:136; MacIver and Mace
1902, pl. 55:61.
4. Holthoer 1977, pp. 145-146, pl. 33.
5. Bruyère 1929, pp. 77, 110-111, figs. 38, 61, 62.
6. Nagel 1938, fig. 65:24.
7. Letellier 1978, no. 24.

59
Storage jar

From Zawiyet el Aryan tomb 329
Dynasty 18, early reign of Thutmose III
Height 37.4 cm.; diameter 20 cm.
Museum of Fine Arts. Harvard University—
Museum of Fine Arts Expedition. 11.3009

A bold design in red and black con-
trasts with the pale yellow fabric of
this simple storage jar. Rows of simi-
lar jars appear in tomb scenes, and
some still filled with grain have been
found in other graves. Such pots were
turned out in great numbers, pinched
off the wheel and returned later to
be quickly smoothed over, but the
urge to decorate still remained. The
material is a soft, medium-coarse sandy
marl clay, containing some chaff.

Storage jars were often decorated
only on their upper part, because the
rest was hidden by the pot stand or

59

rack in which the jar stood. Many
motifs evoke the wreaths of flowers
customarily placed around the necks
and shoulders of large vessels.

The grave in which the jar was found
contained the apparently intact burial
of a man and a child. Pottery found
with the jar enables it to be dated
precisely, although jars of this shape re-
mained in use throughout Dynasty 18.

J.D.B.

Bibliography: Dunham 1978, p. 62:2, pl. 51.

60

60
Storage jar

Provenance not known
Reign of Thutmose III to late Dynasty 18
Height 30.5 cm.; diameter of body
22.85 cm.
Royal Ontario Museum, Toronto (910.2.62)

This three-handled jar was probably
used for the storage of wine,[1] as a
scene from the tomb of the vizier of
Thutmose III, Rekhmire, suggests.[2] The
jar is made of a marl clay and the han-
dles are applied. As with cat. 59, only
the upper part is decorated, in this
case in light and dark shades of red,
now faded to brown. The pigment was
applied with the fingers as well as a
brush to produce a combination of
abstract and foliage patterns. A simi-
lar jar was found in the Eighteenth-
Dynasty town of Gurob.[3]

61

It has been suggested that the notion of a three-handled vessel was inspired by a foreign prototype.[4] This may be so, but the shape belongs to an Egyptian tradition going back at least as far as the beer jars of the Twelfth Dynasty.

J.D.B.

1. Holthoer 1977, pp. 101-102, pl. 55.
2. Davies 1943, pl. 49.
3. Petrie 1891, pl. 21:5.
4. Holthoer 1977, pp. 101-102.

61
Wine pitcher
Provenance not known
Reign of Amenhotep III to late
Amarna period
Height 51 cm.; diameter 20 cm.
Agyptisches Museum, Berlin. Passalacqua
Collection (1016)

Tutankhamen was equipped for the next world with wine stored in jars like this one.[1] The form has been supposed to derive from a Syrian prototype,[2] but no precise parallels from the region are known. The idea is based on tomb paintings such as one from the tomb of Nebamen,[3] which shows porters carrying vases of this shape along with goods of undoubtedly foreign manufacture. Judging by its material, this pitcher was certainly made in Egypt, as in all probability were the wine jars of Tutankhamen. There are sufficient dated examples to suggest a date range from the middle to the end of Dynasty 18.[4] The ware is the same as cats. 62-64, and is described under cat. 63.

J.D.B.

1. Carter 1933, p. 149, pl. 50.
2. Ibid., p. 149; Desroches-Noblecourt 1963, p. 206, fig. 127.
3. Scott 1973, p. 26.
4. Peet and Woolley 1923, pl. 51:XLI/1056; Steindorff 1937a, pl. 87:47, 3.

Literature: Lesko 1977, pp. 23ff.; Bourriau 1981, p. 244.

62
Pottery jug
Provenance not known
Mid- to late Dynasty 18
Height 14.6 cm.; diameter 6.6 cm.
Museum of Fine Arts. Hay Collection,
Gift of C. Granville Way (72.1427)

A miniature version of cat. 61, this jug is of the sort used to dispense the

spiced liquids that were added to wines at feasts.[1] A little maid in the tomb of the vizier Rekhmire holds two such vessels and pours a liquid from one into the drinking bowl held by a female guest.[2] Two others are seen dangling from the fingers of the obese woman represented in a figure vase from Abydos,[3] now in the Ashmolean Museum.[4]

The elegant shape of the vessel was much admired and was copied in glass (see cat. 178) and alabaster.[5]

<div style="text-align: right">J.D.B.</div>

1. Scott 1973, p. [27].
2. Ibid., fig. 22.
3. Garstang 1901, p. 14, pl. 19.
4. E2427.
5. Hayes 1959, p. 207, fig. 122; Scott 1973, fig. 21.

Bibliography: Hay 1869, no. 795.

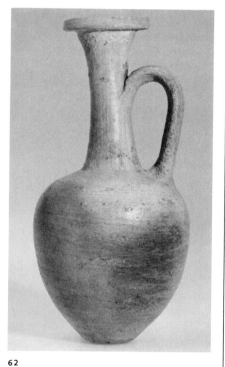

62

63
Pilgrim flask

From Amarna
Dynasty 18, Amarna Period
Height 34 cm.; diameter 25 cm.
Musées Royaux d'Art et d'Histoire, Brussels. Gift of Egypt Exploration Society (E.6852)

The pilgrim flask has a long history in Egypt. Beginning probably in the middle of Dynasty 18,[1] it continued in use sporadically in a variety of materials and styles until the Coptic and medieval periods. It is to these later examples that the name "pilgrim flask"

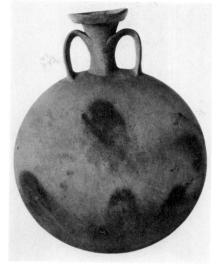

63

was first given because of their manufacture in large numbers for pilgrims to Egypt's famous shrines, but eventually the term was applied to all two-handled flasks, whatever their date or function. The source of the shape is possibly to be found in the pottery repertoire of Mycenae or Syria-Palestine,[2] and the earliest examples from Egypt, in imitation of the foreign prototype, carried a painted design of concentric circles.

Pilgrim flasks were made in faience[3] and glass (cats. 151 and 185), as well as in pottery. (One specimen from Abydos, made of tin, is equipped with a hinged lid.[4]) In instances where they have been found unopened, the mouths are carefully sealed with a strip of linen fastened by string and secured with a blob of clay. The most common fabric, and the one used for this flask, is extremely hard and dense, owing to the presence of large quantities of limestone particles;[5] the surface was covered with a thick slip — a solution of fine body clay and water — and burnished. Both fabric and surface treatment would have reduced loss of contents through evaporation. All the vessels of this ware, which is not known to occur before the reign of Amenhotep II[6] (see cats. 61, 62, and 64), have a distinctive surface color, ranging from greenish white through cream to pink. The variations are due to uneven firing temperatures.

<div style="text-align: right">J.D.B.</div>

1. See also Petrie 1891, pl. 27:32, 41.
2. Holthoer 1977, p. 99; Wainwright 1920, pp. 62-65.
3. Petrie 1891, pls. 17:9 and 18:61.
4. Ayrton et al. 1904, p. 50, pl. 17:20; Lucas 1962, p. 253.
5. Nordström's fabric IV A-B; see Holthoer 1977, p. 61.
6. Brack and Brack 1977, pl. 15.

Literature: Peet and Woolley 1923, p. 138, pl. 51; Frankfort and Pendlebury 1933, p. 42, pl. 53; Bourriau 1981, no. 143.

64
Double vase

Provenance not known
Reign of Amenhotep III to early Dynasty 19
Height 10.5 cm.
Rijksmuseum van Oudheden, Leiden. Anastasi Collection (AT 35/H 463/E.xlii.61)

Double vases made up of two pilgrim flasks,[1] a flask and amphora, or, as in this case, a pilgrim flask and amphora became common from the reign of Amenhotep III. They must have been designed to contain a particular product, since they are storage rather than serving vessels, but the only clue to their nature is an analysis carried out in 1900 on the contents of a similar vase,[2] which identified the presence of gum resin in addition to sand and impurities. The two pots were wheel thrown separately, then joined after drying. The pilgrim flask was thrown in three parts, the neck and two halves. The seam is just visible where the latter were joined together at the sides and the neck inserted; the handles were handmade and applied. The amphora was drawn up on the wheel and provided with a wheel-made ring base. The fabric and ware are the same as cats. 61, 62, 63, and 68. The burnishing was carelessly done, the individual strokes clearly visible on the surface of the pilgrim flask.

Examples of this type of double vase are common in museum collections, perhaps because their intricate design and glossy cream surface were attractive to collectors. The few parallel examples that come from securely datable contexts[3] belong to the period from the reign of Amenhotep III until the beginning of Dynasty 19.[4]

<div style="text-align: right">J.D.B.</div>

1. Petrie 1891, pl. 17:4.
2. Quibell 1901, p. 143.
3. Petrie 1891, pl. 17:4; Brunton and Engelbach 1927, pl. 39:93e; Quibell 1901, pp. 141-143, pl. 1.

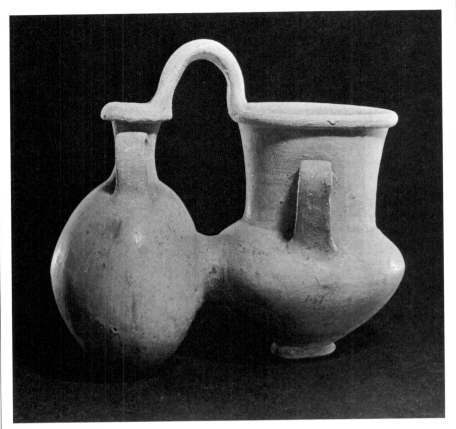

64

4. Grateful acknowledgment is made to Dr. Martin Raaven of the Rijksmuseum for additional information on this piece.

Literature: Hayes 1959, p. 277, fig. 169; Holthoer 1977, pp. 103-104, pl. 56, 1-2; Bourriau 1981, no. 148.

65

Base-ring ware juglet

Provenance not known
Dynasty 18
Height 14.9 cm.; diameter 7 cm.
Museum of Fine Arts. Hay Collection,
Gift of C. Granville Way (72.1500)

Cypriote base-ring ware juglets, or *bilbils,* make their appearance in Egypt from the end of the Second Intermediate Period.[1] This particular example in well-fired, pinkish-buff metallic clay, with a red-brown slip and decoration in white paint, belongs to a type that has a broad, low ring base and a wide mouth.[2] These vases were handmade and are typically asymmetrical. The Boston specimen is decorated with horizontal lines of white paint on the neck and body and two crossing sets of lines on the shoulder. The red-brown slip on the body has been worn and pitted, and both the lip and base are abraded by use.

The advent of the New Kingdom saw a burgeoning of trade with the lands of the Eastern Mediterranean. Base-ring juglets are a common feature of the Bronze Age on the island of Cyprus and are found in great number in Egyptian contexts dating from the first half of the Eighteenth Dynasty. The peculiar shape of these vessels has suggested to one scholar that the juglets originally contained opium,[3] which was marketed by Cypriote merchants to the Egyptians. The shape of the vessel does indeed suggest the unripe pod of the opium poppy; the white line decoration may represent the incisions made on the bud to allow the milky narcotic juice to flow out.[4] Opium was used in ancient Egypt both for medicinal purposes and as a narcotic to induce dreams.[5] A remedy for eczema of the scalp consisted of an opium poppy pod, oil, and the burnt skin of a hippopotamus[6] (see pp. 290-291).

The contents of a few of these juglets have been analyzed and identified as opium, but the tests were not published and thus cannot now be verified.[7] A recent analysis of the contents remaining in base-ring juglets in Boston (including the present example) indicated an organic substance, but the alkaloids that would have been indicative of opium were absent. In other instances, the juglets hold fat, wax, and even grain.[8] Prized for their unusual shape and as foreign oddities,[9] these vessels may have been reused after their original contents were exhausted. Their form was copied by the Egyptians in a variety of different materials, including stone,[10] faience,[11] glass (see cat. 191), and pottery.[12]

The importation of these vessels into Egypt declined in later Dynasty 18 and appears to cease after the reign of Akhenaten, possibly as a result of the stormy political climate in the Near East in the aftermath of the Amarna Period[13] or perhaps as a result of an alteration in the patterns of commerce throughout the Mediterranean world.[14]

P.L.

1. Merrillees 1968a, pp. 147ff.
2. Base Ring II, Type IAa; ibid., pp. 175ff.
3. Merrillees 1962.
4. Merrillees 1968a, p. 289, pl. 43.
5. Gabra 1956; Daumas 1957; Sauneron 1959; Wente 1975/1976, p. 599.
6. Wreszinski 1913a, p. 119.
7. Merrillees 1968a, pp. 157-158.
8. Ibid.
9. Ibid., pp. 36-38.
10. Ibid., p. 148ff.
11. Cairo JE65840.
12. Bourriau 1981, no. 266.
13. Merrillees 1968a, pp. 190-202.
14. Courtois and Lagarce 1969, pp. 153-156.

Bibliography: Hay 1869, p. 93, no. 806.

65

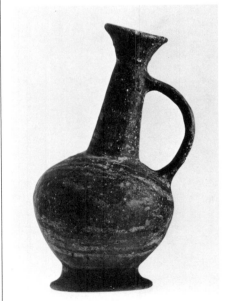

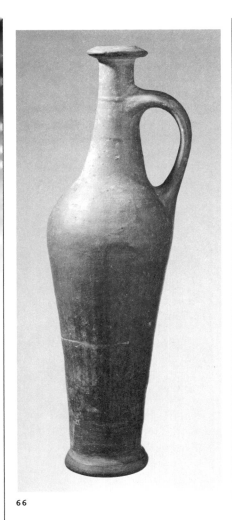

66

66
Red lustrous spindle bottle
Provenance not known
Dynasty 18
Height 28.2 cm.; diameter 7.2 cm.
Museum of Fine Arts. Hay Collection,
Gift of C. Granville Way (72.1370)

Red lustrous spindle bottles appear in Egypt at the end of the Second Intermediate Period and continue until the late fourteenth century.[1] This example[2] is typical of New Kingdom Egypt; it has a tall narrow body tapering to a thick everted ring base, a trumpet-shaped neck, and a circular mouth with a wide angular rim. An applied strap handle descends from the neck to the shoulder. The vessel is wheel made with slight finger impressions on the surface, which is polished with vertical burnish strokes on the body and horizontally on the base, shoulder, and neck.

These flasks are frequently found in Cyprus and Syria-Palestine, as well as in Egypt and Nubia. The style and technique of the spindle bottles have both Canaanite and Hittite affinities[3] and are closely connected with Cypriote base-ring juglets.[4] The Egyptian evidence, however, clearly points to a Syrian origin for this type of container. Tomb paintings of Syrian tribute bearers regularly depict spindle bottles,[5] which are often shown as items of tribute along with horn-shaped ointment bottles.[6] Spindle bottles and the horn- or arm-shaped vessels are frequently found together in archaeological contexts in Syria-Palestine, where they may have served some ritual purpose.[7] They may have held a precious oil, which would be offered in the horn- or arm-shaped vessel (see cats. 402, 403). Analysis of the contents of one of these bottles indicates that it contained oil or resin, while another from Egypt contained fat, and a third probably honey.[8] In all likelihood, spindle bottles were reused in the same way as the base-ring juglets. They were also copied by Egyptian artisans in different media, including glass (cat. 184), pottery (both black and white wares), and polished red-ware examples.[9] Apart from the use of a different fabric, features that distinguish the actual imports, such as this vessel, from Egyptian copies are a modeled band around the neck at the juncture of the handle, and wet-impressed pot marks on the base, which may bear a resemblance to the characters of the Cypro-Minoan script.[10]

P.L.

1. Aström 1969, p. 19.
2. Class RL spindle bottle type I; Merrillees 1968a, pl. 20:4-6.
3. Amiran 1969, pp. 167-172.
4. Merrillees 1968a, pp. 166ff.
5. For example, Davies and Davies 1933, pl. 34, left.
6. Ibid., upper left.
7. Amiran 1962.
8. Aström 1969, pp. 19ff.
9. Merrillees 1968a, p. 174.
10. Merrillees 1962a, p. 194.

Bibliography: Hay 1869, no. 779.

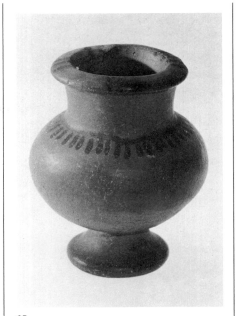

67

67
Footed vase
From Zawiyet el Aryan tomb 312
Late Dynasty 18
Height 8.4 cm.; diameter 6.7 cm.
Museum of Fine Arts. Harvard University--
Museum of Fine Arts Expedition (11.2940)

This vase was found in a grass basket with a few beads and fragments of toilet objects. Circumstances suggest that the burial was a poor one (the body and an unknown number of grave goods having been destroyed by robbers). The vase, a cheaper version of cats. 122 and 170, was carefully made of a fine Nile silt, covered with a thick dark red slip and skillfully burnished to give the surface a uniform luster. On the lip are four groups of strokes and at the base of the neck a row of short strokes, all in black paint. This is perhaps a simplified version of the decoration on cat. 57. The vase was found with a kohl stick, and is small enough to have been used as a container for kohl.

Zawiyet el Aryan tomb 312 also contained an ebony cosmetic container that has been dated to the reign of Akhenaten by analogy with a similar piece in the Brooklyn Museum.[1]

J.D.B.

1. Cooney 1951, pp. 10-12.

Bibliography: New Orleans 1977, no. 59; Dunham 1978, p. 59:2, pl. 46.

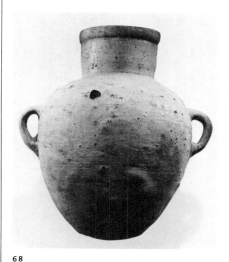

68

68

Amphora
From Nebesheh
Dynasty 18-19
Height 27.4 cm.; diameter 21.6 cm.
Museum of Fine Arts. Gift of Egypt
Exploration Fund (87.548)

This is an example of the most common class of storage amphora in use in the late Eighteenth and Nineteenth Dynasty. Amphorae of this ware (see cats. 61-64) were made in a range of sizes. This is one of the smallest, and its capacity is indicated by a mark cut into the clay near the base before firing. Amphorae were required in great numbers, and the careless manufacture of this one confirms that it was, in the context of ancient technology, an assembly-line product. Overfiring has warped the shape and caused the many limestone inclusions in the clay to expand until they have broken through the covering slip to produce an unpleasant pitted surface. The potter's failure, however, has in no way impaired the usefulness of the amphora, which was probably used to store dry goods such as grain.

It is often the carelessly made pots that tell us most about the potters' technique, and this one confirms that the thick slip so characteristic of the ware is not a colored slip but a solution of the clay from which the body was formed, and that it was applied with a brush. There are several comparable examples from late Eighteenth- and Nineteenth-Dynasty cemeteries, such as Saft el-Hinna and Gurob.[1]

J.D.B.

1. Petrie 1906a, pl. 39c:70; Brunton and Engelbach 1927, pl. 38:46h.

69

Decorated vase
Said to be from Saqqara
Dynasty 18-19
Height 36.2 cm.; diameter 13.3 cm.
The Art Museum, Princeton University
(52.87)

The slender, tall-necked, wheel-made vase has an inverted piriform body, a round base, a concave-sided neck, and a ridged or "collared" rim. In addition to painting in blue, red, and black on a pale background color, the decoration includes modeled and applied forms. The vase represents a female figure with a rather crudely formed face at the rim, flanked by a heavy wig. Two small protuberances below the shoulder were probably intended to represent female breasts. The neck carries painted decoration in the form of three groups of vertical wavy lines and two groups of three horizontal bands. The breasts, converted into lotus leaves on stems by the application of an encircling line, are set amid a frieze of tapering petals and are separated by a lotus bud on a stem, which represents the pudenda.[1] The body of the vase is decorated with two cows wearing the solar disk between horns, and with large lotus flowers hanging from their necks, standing on either side of a papyrus clump. The cows undoubtedly represent the sacred animal of Hathor. In the same panel is a young frolicking bull[2] between two plants that have been identified as a papyrus and a poppy, or "southern lily," with convolvulus vines entwined about their stems.[3]

So-called feminoform vases have a long history in Egypt. The earliest examples would appear to date from the predynastic Naqada I Period; three vessels of this type are known. One preserves a head with flanking horns and arms cupping breasts, while the remaining two lack the head and horns.[4] During the New Kingdom two other versions of this type of vessel existed. The first, which is closely related to the Second Intermediate Period type, has a very tall neck distinctly set off from a slender body (unlike the earlier version) and a collar rim. The face and wig are always applied, as are the breasts, and there are invariably painted wavy lines on the neck. The breasts are never punctured, and the arms are usually lacking; this

is the only example with anything that might be interpreted as the pudenda. Such vessels occur in small and large sizes, are made from both Nile silt and marl, and may incorporate blue in their color scheme. Another example has two painted lines flanking the applied face running down the neck and encircling the applied breasts.[5] They are undoubtedly an echo of the applied arms on the earlier version. A date ranging from mid-Dynasty 18 to Dynasty 19 is suggested by finds from the funerary temple of Thutmose IV at Thebes,[6] from Malkata, and from Deir el Medineh.[7] No examples from Amarna are known, although this is probably a result of the incomplete recording of the pottery from that site. The Ashmolean Museum example referred to was bought at Semaineh. An example without provenance in the Petrie Museum[8] is interesting, as there are two sketchily drawn men on its neck.

The second New Kingdom version normally lacks the modeled breasts and wavy lines representing hair, is usually of large, broad size, and has a large face of the goddess Hathor modeled into its neck.[9] These vessels occurred commonly during Dynasty 18 at Malkata and Amarna, were made predominantly from Nile silt, and usually have blue-painted decoration.

Undecorated vessels of a similar type but with modeled breasts are known,[10] as is one example of the second New Kingdom type with pierced modeled breasts.[11] This vase also has wavy lines like those described above, flanking the large painted wig. It may be that the dependent lotus blossoms painted below the breasts, forming an inverted triangle, were intended to represent the pudenda, as on the present example.

The association of the last version with the goddess Hathor is obvious. A similar association can be suggested for the other New Kingdom version, as represented by the Princeton vase, which incorporates the sacred Hathor cow into its decoration. An elaborate vessel now in the Ashmolean Museum[12] consists of four identical vessels of this type attached to a figure of the Hathor cow wearing the horns and solar disk. This vessel comes from foundation deposit 3 of Thutmose III at Koptos.[13]

Atypically, these vessels have the modeled arms of the Second Intermediate Period version. It does not seem unreasonable to suggest that the applied female heads on some of the feminoform vases of the earlier Second Intermediate Period also represent Hathor. Furthermore, the vessels may actually represent Hathor. If this is so then the function of the early and small feminoform vases as "milk vases" (see cat. 50) is quite appropriate, as is the function of the large New Kingdom versions as wine jars, since Hathor was associated both with maternity and childbirth, and with festivity and drunkenness.

<div align="right">C.A.H.</div>

1. Keimer 1949b, p. 3.
2. Cf. Bourriau 1981, no. 141.
3. Keimer 1949b, p. 5.
4. They are all in the Ashmolean Museum (Baumgartel 1955, p. 31, pl. 3).
5. Ashmolean 1070.1892.
6. University College 15942.
7. Nagel 1938, passim.
8. Wallis 1898, fig. 67; without provenance.
9. See Hayes 1959, fig. 150; Bourriau 1981, no. 52.
10. Guidotti 1978, fig. 6.
11. From Deir el Medineh tomb 359/360 (Nagel 1938, fig. 20).
12. E4291.
13. Petrie 1896a, pl. 14:7.

Bibliography: Keimer 1949b; Jones 1960, p. 10-11.

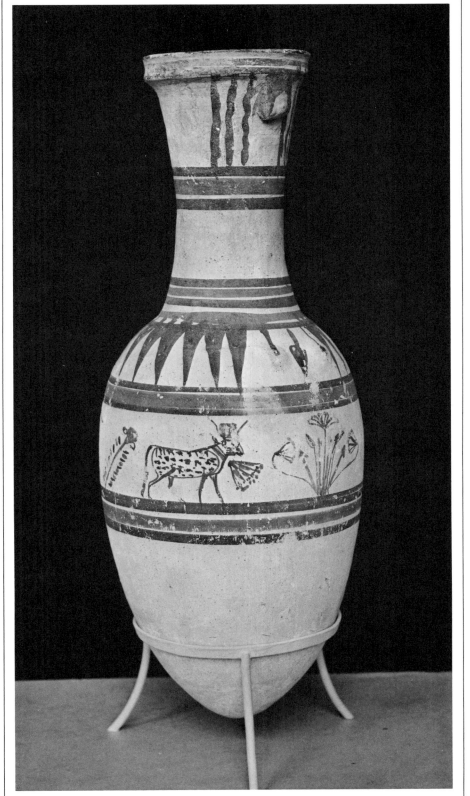

69

Blue-Painted Pottery

Probably the most notable and characteristic feature of the ceramics produced during the Egyptian New Kingdom is blue-painted pottery. This type, so called because of the invariable use of blue in its color scheme, seems to have appeared in the middle of Dynasty 18 and to have been manufactured until Dynasty 20. It was especially common during the late Eighteenth Dynasty, in the reigns of Amenhotep III and his son Akhenaten. The impetus for its manufacture undoubtedly lay in the taste for elaboration during an age of luxury.

The motifs with which it is decorated are primarily floral and linear, the most common of these being derived from the blue lotus. Among the other floral motifs encountered are the white lotus, the cornflower, the poppy, the mandrake, the chrysanthemum, and the papyrus. The vessels are also decorated with representations of pintail ducks, falcons, young or mature bulls (cat. 74), gazelles or ibexes, and horses (cat. 77), which frequently appear in lively riverine scenes or marshscapes. Such scenes may include young girls or men in papyrus skiffs (cat. 74); the Bes-image and hieroglyphs also occur. Apart from painted designs, the pottery often has modeled decoration, usually in the form of faces of the goddess Hathor, and applied decoration in the form of recumbent gazelles or ibexes (or merely their head and neck), occasionally calves (cats. 70, 81), heads of the goddess Hathor (cat. 82), and clusters of flowers or bunches of grapes. Rarely encountered are modeled grooves (cat. 70) and open-work sides of deep bowls.[1] The decorative motifs are all shown around the vessel in panels of varying size, which are delineated by bands of color or black lines. There is little sense of movement in the decoration except in the scenes of marsh activity. The shapes of the blue-painted vessels are those of the standard repertoire of New Kingdom ceramics, although a few shapes are unique to the decorated pottery (e.g., cats. 70, 81, and 83). In some cases, the shape of the vessel is adapted to enhance the effect of the decorative scheme, or is produced with the decoration in mind. The degree of skill or care with which the vessels were painted varies considerably (compare cats. 72 and 74).

The origin of blue-painted pottery lies ultimately in the Egyptian practice of decorating vessels with collars or garlands of flowers on festive occasions. The friezes of petals and flowers painted on the pottery clearly imitate these garlands, even to showing the backing strips to which the petals were attached. The decorative schemes of the pottery are also connected with that of floral elements in wall paintings in the tombs, and the painted frescoes of Egyptian palaces and houses.

Blue-painted pottery seems to have served a myriad of functions, from the ornamental to the domestic, and has been found in religious contexts, in tombs, and in the dwellings of all classes of society. Its use was by no means restricted to the wealthy. However, the manufacture of blue-painted pottery would appear to have been limited to certain major cities that were, perhaps, royal residences as well, such as Memphis, Gurob, Amarna, and Malkata. This is indicated by its distribution pattern and also by the degree of specialization and standardization it shows. It would appear that the decorative schemes of the pottery were laid down and little altered, as though there was a pattern book of designs for particular shapes. This seems to indicate that the pottery was the work of a small number of ceramic artists working in the main centers and not that of just any potter.

The basic colors used were blue, black, and red. The blue was derived from a mixture of cobalt and alum, and is a cobalt aluminate spinel; it may have been obtained from the oases of Dakhla and Kharga, or the Eastern desert. The use of cobalt aluminate spinel was restricted to pottery, though cobalt was also a colorant in faience and glass. The red and black are iron ochers and oxides of iron or manganese. The decoration was applied to the vessels before firing, and was fired on. Occasionally other colors were used, such as yellow, green, and white. The white is a mixture of carbonates and sulphates of calcium, the green is frit, and the yellow either an iron ocher or possibly orpiment. The use of this wider range of colors occurs on a limited number of shapes, mainly two-handled amphorae, and coincides with a different technique

and the use of blue frit instead of cobalt blue. In the case of vessels so decorated only floral and linear elements were used, the motifs are more stylized, the decoration is usually coarse, and the pigments thickly applied (see cats. 81, 83). The decoration would seem to have been applied after the vessel had been fired in the kiln, whereas the more common blue-painted pottery, with only blue, red, and black designs, was probably decorated on the potter's wheel, after the vessel had dried.

When first introduced, the designs were mainly linear and simple. By the heyday of its manufacture during the reigns of Amenhotep III and Akhenaten, the designs included a wide range of motifs and styles, and there was a certain degree of experimentation with the decorative schemes. However, with the advent of the Ramesside Period, the decoration of blue-painted pottery became very conventionalized and, in the case of the painted amphorae, extremely overdone. Eventually the full circle was completed and the simple linear motifs returned before the practice of decorating pottery with blue-painted designs disappeared altogether.

<div align="right">C.A.H.</div>

1. Peet and Woolley 1923, pl. 44.

Literature: Tytus 1903; Cottevieille-Giraudet 1931, pp. 4-9; Nagel 1938; Hayes 1959, passim; Riederer 1974; Hope 1977; Noll 1978, pp. 227-290; Brissaud 1979.

70

Amphora with lid

Provenance not known
Late Dynasty 18
Height of amphora 62 cm.; diameter of rim 21 cm.
Museum of Fine Arts. J. H. and E. A. Payne Fund (64.9)

The wheel-made amphora of Nile silt clay has a tall neck, a square folded rim, an inverted piriform body, and a round base. Two handles are attached to the rim and shoulder of the vase (one of them restored in plaster); the lid is a simple inverted bowl, surmounted by a calf. Decoration is carried out in blue, red, and black over a cream coating. The amphora presents several rather interesting features: the combination of incised, painted, and applied decoration,

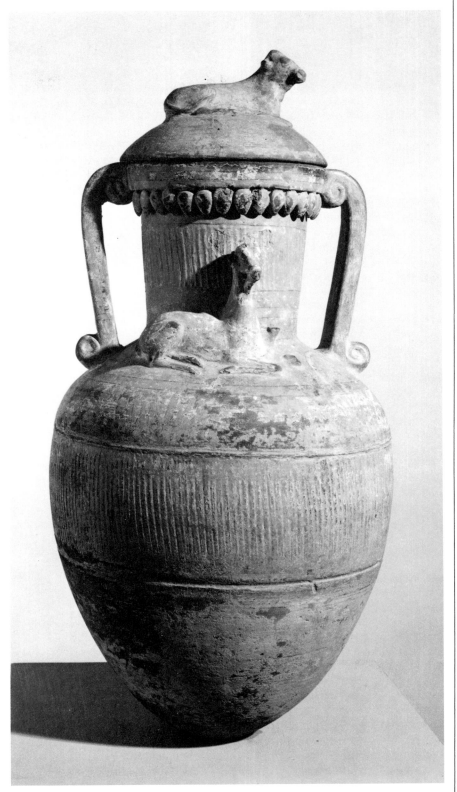

70

which is restricted mainly to the front of the vessel, and the shape of the handles.

With a square section and a pronounced curling at the points of attachment to the vessel, the handles are of a type uncommon in Egypt; they are reminiscent of the handles on archaic Greek vases. The decoration of the amphora, missing in places, is much more elaborate on one half than on the other, so it is undoubtedly correct to speak of a front and a back of the vessel. Black lines on either side divide the front and back, a distinction encountered on very few blue-painted vases, not all of which are as complex or well finished as this one. The applied disks below the rim and the two bands of incised grooves are restricted to the front; there also, at the junction of the neck and the shoulder, is a recumbent ibex and a large papyrus umbel. Above the lower incised band, set off by two horizontal grooves around the entire body, is a band of blue with traces of a floral design outlined in black; this may have been of a papyrus thicket. The recumbent ibex and the calf (now somewhat damaged) were modeled separately and applied to the lid and amphora; it is not certain whether they are solid or hollow. The ornamental use of the gazelle and ibex appears to have become common during the middle of Dynasty 18, from which time they appear on jewelry, pottery, and alabaster vessels.[1] There are a few examples of figure vases in the form of these animals (see cat. 89). In the scenes of tribute being presented to the pharaohs of the mid-Eighteenth Dynasty, Aegean and Syrian envoys are often shown bearing vessels called *iken* or *ikeny,* which are two-handled vessels decorated in some cases with gazelle or ibex heads. Some scholars believe that the use of this element shows Syrian influence;[2] the gazelle is known to be associated with the Canaanite god Reshep.[3]

The vessel undoubtedly had an ornamental value and probably stood in a niche, although it may well have been used to serve wine. It is the only surviving complete example of this type of vessel of this size. In this respect it is exceptional and is of importance to the study of blue-painted pottery. It also confirms the indications of sherd

material that such large vessels were manufactured.

Fragments from similar vessels have been found at Amarna.[4] Of these only one has part of the body of the animal modeled, and that is hollow,[5] while another has the body painted on the shoulder;[6] the others have only the head and neck of the animals, which are modeled. A few fragments of this type of vessel have been found at Malkata. Similar, though much smaller, vessels were found at Malkata and Amarna in greater numbers. Such vessels in pottery would appear to be the product of the Malkata and Amarna potters only.

C.A.H.

1. Aldred 1971, p. 204; Wilkinson 1971, p. 116.
2. Montet 1937; Vercoutter 1956a.
3. Fulco 1976, p. 29.
4. British Museum 59276; Cairo JE66739; Ashmolean 1893 1-41 293-4; University College, London 24631-3.
5. British Museum 59276.
6. University College 24631-3.

Bibliography: Wilson 1964; Terrace 1964, pp. 49-52; Terrace 1968, pp. 49-56; Museum of Fine Arts 1971, p. 183, no. 77; Museum of Fine Arts 1972, p. 19, no. 7; Los Angeles County Museum of Art 1974, no. 50.

71

Jar with lid
Provenance not known
Late Dynasty 18-19
Height of jar 94.5 cm.; diameter of rim 18 cm.
University Museum, Philadelphia. Gift of Sophia Cadwalader (E14369a-b). Formerly MacGregor Collection

The wheel-made jar, shaped like a *hes* vase, has a wide, flat-topped rim, a medium-tall cylindrical neck, and round shoulder; the body tapers to a tall, applied foot. The lid is closed underneath, except for a short central projection that fits into the neck of the jar to keep the lid in position. The jar and lid have been reconstructed partly with plaster at the rim and base, and the decoration has been restored at these points. The body of the jar has patches of pinkish discoloration caused during firing.

The exterior surfaces of the jar and lid are covered with a thick cream coating, which serves as a base for the painted floral and linear motifs in blue, red, and black. Decoration consists of

a series of blue bands, edged with black, and panels of thin tapering petals in blue outlined in black, with additional red lines. On the upper part of the body of the jar and the lid the panels of blue petals imitate floral garlands. The bands above and below these panels, and the underlying red lines, represent the backing of papyrus to which the petals were attached. The lower band of petals on the jar clearly represents an open blue lotus flower, suggesting that the entire vessel is emerging from the lotus flower.

This vessel and its lid are from a set of four that accompanied the burial of a woman, Em-nedjem, and their size and rarity indicate that she was a lady of rank. It is quite possible that the original burial place was on the west bank at Thebes. The vessels are unique in the history of Egyptian ceramics, and it is unfortunate that their exact date is uncertain. They form two pairs, one of which is in the British Museum[1] and the other in University Museum, Philadelphia.[2] The first are the smaller, and are inscribed in black ink hieroglyphs with the docket: "Northern wine for the Osiris Em-nedjem." The larger pair in Philadelphia each carry different dockets, describing a different commodity. One is inscribed: "*Hamu* wine for the Osiris Em-nedjem." The meaning of the word *hamu* is uncertain; such wine is believed to have come from one of the oases. The second of the Philadelphia pair is inscribed: "Sweet *(bener)* wine for the Osiris Em-nedjem." The word *bener* in this context may imply that the wine was sweetened with dates, as *nedjem* is the more common word for sweet. That it was not actually date wine is perhaps indicated by the existence of the word *beniu/beneru,* which means precisely date wine. The name Em-nedjem[3] may be an abbreviated form of the name Mut-nedjem,[4] which occurs from the Amarna Period to Dynasty 21.[5]

Other pottery vessels of similar shape are known from the New Kingdom, from the tomb of Tutankhamen (with spouts), for example, and from Amarna, but they were not common. The shape also appears in faience. Of the other surviving examples of this shape none are of the size of the four Em-nedjem vases, which were un-

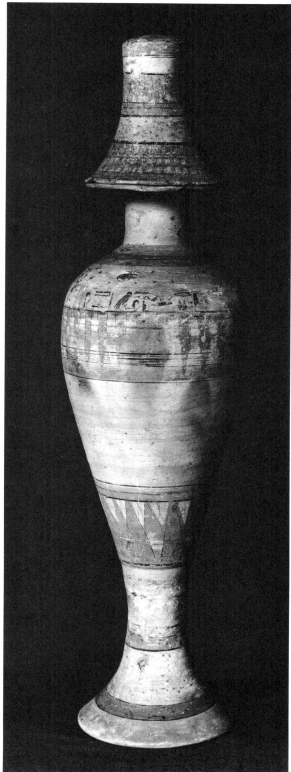

71

doubtedly made especially for the lady's burial to contain the various wines she might require in the afterlife.

C.A.H.

1. BM 59774 and BM 59775; Wallis 1898, pl. 15; Sotheby 1922, p. 225, nos. 1735-1736; Steindorff 1912, p. 183, fig. 149; Burlington Fine Arts Club 1922, p. 64, pl. 35; Schäfer and Andrae 1925, p. 393; Steindorff 1928, p. 266; Hall 1930, p. 50, pl. 22; Posener 1959, fig. 42; Lesko 1977, p. 30.
2. E.14368 and E.14369.
3. Cf. Ranke 1952, p. 288:4.
4. Cf. Ranke 1935, p. 148:8.
5. Hari 1964, pp. 151-156.

Bibliography: Burlington Fine Arts Club 1895, pp. 119-120, nos. 23, 30, 32, 41; Wallis 1898, pl. 15; Sotheby 1922, p. 244, nos. 1733-1734, pl. 51; *Antiquarium Quarterly* 1925-1926, p. 178 and pl. 17; Ranke 1950, pp. 2-3, fig. 41; Cooney 1952, p. 86.

72
Jar

From Amarna house P49
Late Dynasty 18, reign of Akhenaten
Height 36 cm.; diameter of rim 18.5 cm.
Agyptisches Museum, Berlin. Gift of
J. Simon (22597)

The medium-tall necked jar, wheel-made of Nile silt clay, with a wide mouth, flaring neck, and round base, is covered on the outside with a cream coating, and preserves in almost perfect condition a decoration of floral and linear motifs in blue, red, and black. The colors are vivid, and the state of preservation is equaled by very few other blue-painted vessels.

Decoration consists of three sections. The upper section contains the common combination of blue bands with red and black lines and two parallel blue bands, which have been converted into overlapping petals by superimposed outlines in black. The central section is painted with the same linear elements but with tapering petals on a blue background over a series of red lines, separated at their tips by blue buds. There follows a row of inverted blue flowers, probably cornflowers, and then more bands. The lowest section repeats the motif of tapering petals over red lines, and these top a frieze of open blue lotus flowers flanked by buds, all laid on

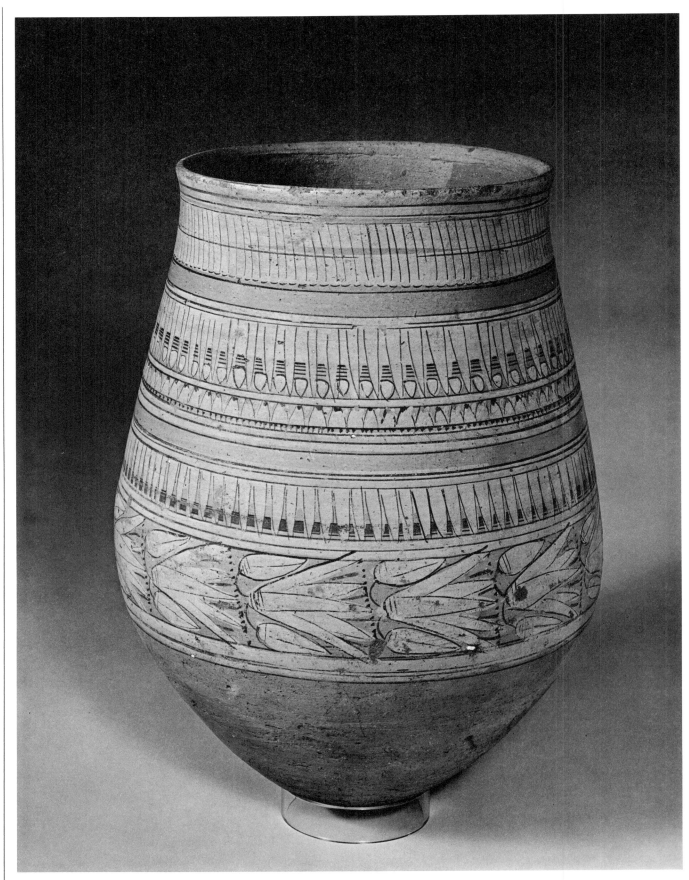

their sides. These are between blue bands with red and black lines. The composition of the upper and central sections clearly shows the origin of the painted motifs in the floral garlands. The blue bands and red lines represent the original backing strips of the garlands to which the petals were attached.

Though all the motifs used here are commonly encountered on blue-painted pottery—indeed, very few vessels so decorated lack the motifs of overlapping or tapering blue petals, bands, and lines—this vessel is undoubtedly one of the most impressive of its type. The decoration was applied with a sureness of hand and care that is infrequently encountered.

C.A.H.

Bibliography: Eggebrecht 1975c, pp. 357-358, pl. 42a; Borchardt and Ricke 1980, pp. 269-270.

73
Piriform jar
From Amarna
Dynasty 18, reign of Akhenaten
Height 31.2 cm.
Museum of Fine Arts. Gift of Egypt Exploration Fund (37.11)

Typical of the blue-painted pottery of the late Eighteenth Dynasty, this small, wheel-made jar of Nile silt clay has an inverted piriform body, a medium-tall neck, a wide mouth, and a round base. The exterior of the vessel is coated with a cream covering over which the painted designs are applied. The decoration in blue, red, and black consists of a frieze of overlapping petals below a composite band of blue, red, and black lines. The frieze was produced by adding the outlines of the petals in black over a solid band of blue paint. The band is cut into sections by a red line. Below this, on the middle of the vessel, is another frieze of tapering blue petals, also produced by adding outlines to a blue band. Between the tips of these petals, which project below the original band and are colored blue also, are a series of irregular thin shapes possibly imitating stamens. Below these is a blue band edged with black. The rim of the jar is chipped and a large section of the decoration is missing. Part of the body is blackened.

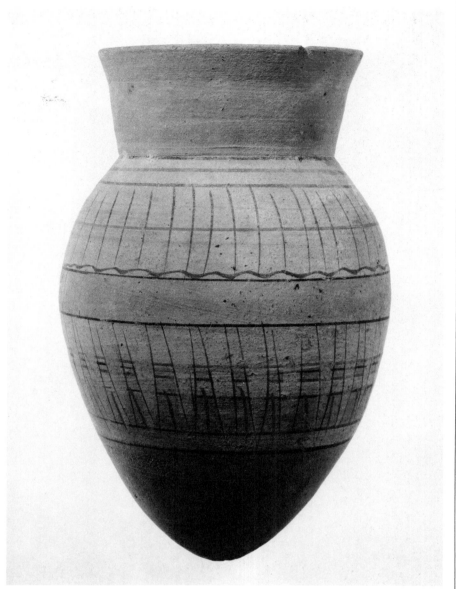

73

Between the two friezes of petals are three hieroglyphic signs, which may represent a potter's mark. This particular mark occurs commonly on painted pottery from Amarna and Malkata during the Eighteenth Dynasty, and is found throughout the New Kingdom at other sites. Such marks were either painted onto the vessel or incised into its surface, in which case they were done either before or after firing. Numerous marks of this kind are known, including lotus flowers, the sedge and reed, mandrake fruits, and the *ankh* sign, as well as groups of vertical lines, crosses, and irregular patterns. The exact function of these marks is uncertain. They may have been the marks of the potters who made them, those of the owners, or in certain cases may have indicated capacity.[1]

C.A.H.

1. Dunham 1965.

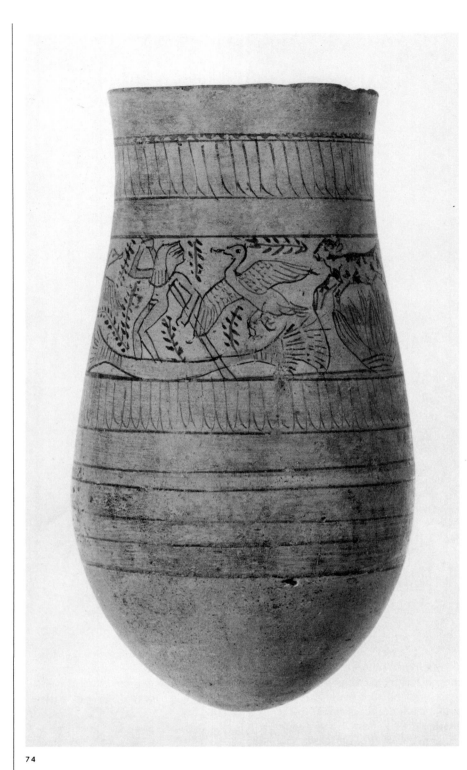

74

74
Piriform jar
Provenance not known
Late Dynasty 18
Height 29.6 cm.; diameter of rim 12.4 cm.
The Brooklyn Museum, New York. Charles
Edwin Wilbour Fund (59.2)

The wheel-made piriform jar, with a
medium-tall neck, a wide mouth, and
a round base, is covered with a cream
coating. Decoration consists of simple
linear bands in blue with red and black
lines and two panels of short tapering
petals in blue. The decoration of the
central panel is of a rather rare type,
depicting a typical Egyptian marsh
scene: two girls in papyrus skiffs, one
punting and the other holding a
bunch of lotus flowers. Two pintail
ducks take flight, disturbed by the
young girls, while two young bulls
gambol among the shrubs on the edge
of the marsh. Intervening spaces are
filled with branches of leaves. Though
the scene is rather clumsily executed
and crowded, it has a feeling of ac-
tivity and a sense of movement that
contrasts sharply with the static
registers of petals and bands. Such
marsh and riverine scenes, typical of
the period, are reminiscent of painted
frescoes from the palaces of Amen-
hotep III at Malkata and Akhenaten at
Amarna, and occur only on painted
pottery from those sites. It is only in
these tableaus that any sense of move-
ment or action is conveyed.
The jar is intact, except for a few chips
out of the rim and abrasion of the
paint in a few places.

C.A.H.

bibliography
Bibliography: Aldred 1968, pl. 10, fig. 35; Fazzini
1975, no. 58.

75
Jar with Bes-image
Provenance not known
Late Dynasty 18 or 19
Height 24.8 cm.; diameter 14.9 cm.
Pelizaeus-Museum,
Hildesheim (4887)

The neck and part of the upper body
from a tall-necked jar has painted dec-
oration in blue, red, and black. The
surviving fragment consists of the
bearded face of the Bes-image sur-
mounted by the neck of the jar, which
was perhaps intended to represent the
feather headdress characteristic of

that god. The upper section, the head-dress, was wheel made separately and then joined to the lower section or face, which was modeled out from the wall of the jar. The juncture of the two sections is clearly visible.

The upper section of the fragment is decorated with tall, tapering forms that resemble the petals of the blue lotus flower in shape, but are colored alternately blue and red. They lack the markings that would definitely identify them as feathers, such as the Bes-image frequently wears as a head-dress. It is possible that there has been some confusion between the lotus petals, so common on blue-painted pottery, and the feathers of the god's crown.

From the New Kingdom such vases are rare. A magnificent, intact example in the Berlin Museum[1] is unfortunately without provenance. Of known provenance are fragments from Amarna in the Petrie Museum[2] and the Ashmolean Museum[3] and fragments from Deir el Medineh. Painted representations of the Bes-image are equally rare on pottery vessels. Fragments of such were found at Amarna,[4] and in the collection of the Fitzwilliam Museum is an impressive piece depicting the Bes-image with feather headdress and possibly playing the double flute,[5] which may also have come from Amarna. All of these pieces are painted with floral designs in blue, red, and black. No examples are known from the site of Malkata

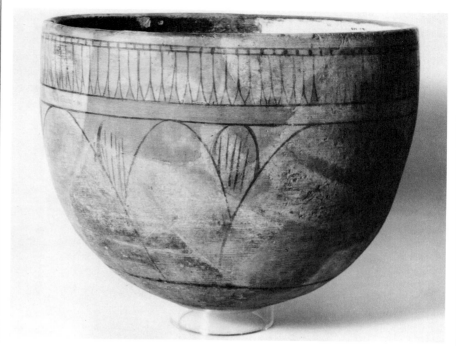

76

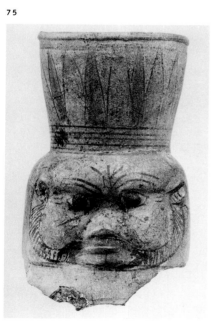

75

(dating to the reign of Amenhotep III) of vessels with either painted or modeled representations of the Bes-image. It would appear, therefore, that such vessels date from the reign of Akhenaten (examples from Amarna) to the Ramesside Period (examples from Deir el Medineh). Following the Ramesside Period, and the disappearance of "blue-painted pottery," "Bes vases" continued to be made; with modeled faces they are fairly common during the Third Intermediate Period.

C.A.H.

Noteworthy on this painted pottery vase are the thin strokes running diagonally from the inner canthus of each eye down across the god's cheek, which may reflect a relationship between the figure and African jungle cats.[6] Indeed, lions, leopards, and other large felines well known to the ancient Egyptians produce a lachrymal excretion reminiscent of the detail on this vase.

J.F.R.

1. No. 22620.
2. University College 24638.
3. 18931-41292.
4. Peet and Woolley 1923, pl. 45:4.
5. EGA 6188.1943.
6. Keimer 1954, p. 141.

Bibliography: Höhr-Grenzhausen, Rastel Haus 1978, pp. 171-172, no. 276.

Literature: Wilson 1975, pp. 77-103; Stern 1976, pp. 183-187; Brissaud 1979, pp. 20, 21, 26.

76
Stemmed bowl
From Amarna
Dynasty 18, reign of Akhenaten
Height 21.5 cm.; diameter 26 cm.
Merseyside County Museums, Liverpool (56.21.603). Formerly in the Norwich Castle Collection

The stem of this deep, round-sided, wheel-made bowl (originally a footed goblet) is missing. The bowl, which is restored from many fragments, imitates the form of the white lotus. It is cream coated on the outside only, and over this are applied floral and linear motifs in blue, red, and black. On the upper part of the vessel these consist of bands and lines of blue, red, and black, a row of red dots,[11] and thin tapering blue petals. These are the petals of the blue lotus; however, the main part of the decoration consists of large, rounded petals that copy the outline of the petals of the white lotus, though the maker painted them blue.

All of the surviving examples of this type and size of goblet or chalice come from Amarna. Smaller and cruder examples in pottery have been found at Deir el Medineh.[1]

A second type of large pottery chalice takes the form of the blue lotus with its flaring profile and is decorated with the tall tapering petals of that

flower. Several blue-painted pottery examples of the type survive, again from Amarna,[2] and one from the palace site of Amenhotep III at Malkata. There are smaller examples from Deir el Medineh in pottery and other materials.[3]

The size of these vessels does not preclude their use as drinking vessels, but the blue lotus chalices in pottery were also used for ritual purposes.[4] At the same time, large brightly decorated blue-lotus goblets, perhaps of pottery, are shown at banquets[5] filled with a comestible or scented fat.

During the Nineteenth Dynasty the potters who supplied the village and tombs of Deir el Medineh seem to have confused the two types of chalice; there again, as at Amarna, are examples of the white lotus chalice decorated with the petals of the blue lotus.

C.A.H.

1. Nagel 1938, pp. 199ff.
2. R.L.H. 1927, p. 63, pl. 39b.
3. Nagel 1938, pp. 199ff.
4. Tait 1963.
5. British Museum 1914, pl. 6; Davies 1963, pl. 6.

Literature: Nagel 1938, pp. 199-206; Tait 1963.

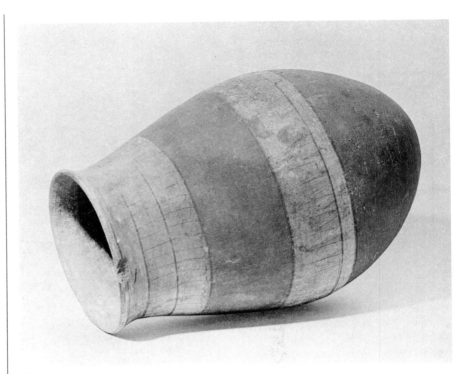

78

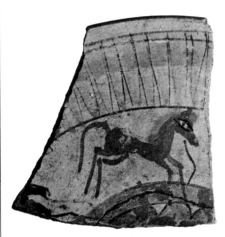

77

77

Bowl fragment

From Amarna
Late Dynasty 18, reign of Akhenaten
Length 6.5 cm.; width 6 cm.
Ashmolean Museum, Oxford. Gift of the Egypt Exploration Society (1924.74)

This fragment from the rim of a shallow wheel-made bowl of Nile silt clay is cream coated on both surfaces, but decorated only on the interior.

Decoration consists of a wide blue band at the rim, with the outlines of thin tapering petals drawn over the band and projecting below it to a black line. The petals are colored blue below the band. The main part of the decoration probably consisted of a series of young horses, only one of which survives intact. Shown with a reddish-brown body, a blue mane, and eyes picked out in black, the horse kicks up its back legs. A loose tethering rope hangs from its neck. Behind this horse is the front part of another, colored black and red with a blue mane. The center of the bowl was decorated with a motif probably imitating the white lotus, for the petals are rounded and not the thin tapering shape of the blue lotus petals; they are, however, shown in blue. The central design is obscured by spots of red paint.

The depiction of horses on pottery is not common, and this is the only one known in the fully developed style of blue-painted pottery. In two studies of pottery decorated with drawings of horses they are dated to Dynasty 19 and believed to be the work of potters of the Theban area.[1] That pottery was decorated with drawings of horses during the second half of Dynasty 18 is evident from a relief in the tomb of Userhat, a contemporary of Amenhotep II.[2] This sherd is the only known

example that can be dated definitely to that period, and so is of great importance for the history of decorated ceramics in Egypt. The style of this drawing is much simpler than that of many of the others, but to judge from the shape of some of the vessels with horse motifs, and from their general decorative schemes, they could also be of the late Eighteenth Dynasty.

C.A.H.

1. Nagel 1931, pp. 185-194; Nagel 1949, pp. 129-131.
2. Nagel 1949, pl. 12.

78

Piriform jar

From Abydos grave D106
Dynasty 18-19
Height 30.3 cm.; diameter of rim 13.4 cm.
University Museum, Philadelphia. Gift of the Egypt Exploration Fund (E.9947)

The small, wheel-made jar has a short flaring neck, a wide mouth, and a round base. There is a partial red coating on those areas not decorated with painted motifs. The latter are in blue, red, and black, and are applied directly to the smooth surface of the vessel. The decoration is in two sections, the upper consisting of overlapping blue petals below a blue band, and the lower of a series of adjacent

blue tapering petals above a blue band outlined in black. The upper section is solidly blue with the outlines of the petals overlaid, while the lower comprises two separate blue bands with the shape of the petals added in blue independently.

The decorative scheme of the blue-painted motifs in conjunction with a red body coating is quite rare; however, vessels of this type are not restricted to any one particular social class. This example, though well finished, was found in a poor grave. Other examples come from the palace site of Amenhotep III at Malkata, from Amarna, and from both the embalmers' cache and the tomb of Tutankhamen.[1] Some of these are extremely elaborate (see cat. 80).

C.A.H.

1. Winlock 1941; Hayes 1959, p. 302, fig. 187, and p. 323, fig. 205; Eggebrecht 1975c, p. 357, no. 349b.

79
Biconical jar
Provenance not known
Probably Dynasty 19-20
Height 38.1 cm.; diameter of rim 11.8 cm.
Field Museum of Natural History, Chicago. Gift of Edward E. Ayer (30912)

Representing the decline of the blue-painted pottery tradition in the New Kingdom, this wheel-made biconical jar of Nile silt clay, with a narrow mouth and round base, is covered with a red coating on its exterior over

79

80

which the motifs are applied in blue, red, and black. It is an example of a rarer decorative scheme (see also cat. 80); most blue-painted pottery has a cream background color. The motifs are restricted to the upper body and are very simple, consisting of a series of blue bands, black lines, and colored dots, and a dependent inverted lotus flower flanked by blue leaves within a semicircular blue band. At the maximum width of the vessel there are a few impressions from the string that supported it during its drying. The surface coating and decoration are missing in places.

The use of simple linear motifs is encountered on examples of blue-painted pottery previous to the reign of Amenhotep III, but is not common during the late Eighteenth Dynasty.

It reemerged during the Ramesside Period, when the manufacture of this type of pottery was in its decline. The use of dependent lotus flowers, rare in Dynasty 18, seems to be more characteristic of Dynasties 19 and 20; it is seen frequently among the painted pottery from Deir el Medineh.[1]

C.A.H.

1. Nagel 1938.

80
Biconical jar
Provenance not known
Late Dynasty 18
Height 69 cm.; diameter 45.6 cm.
The Metropolitan Museum of Art, New York. Dick Fund (55.92.2)

One of the most impressive examples of decorated pottery, this jar has a tall

neck and a biconical body with a round base. It is intact, with the decoration in almost perfect condition, only parts of the red surface coating having flaked away.

The decoration, in blue, red, and black, is painted over a cream background, which may be either a slip or the natural fired color of the clay. Those areas without painted decoration have a deep red burnished slip. The neck carries a band of wavy lines imitating water, while the upper body has four bands of blue lotus petals alternating with other bands of what may be cornflowers, cornflowers alternating with bunches of grapes, and poppy petals. At the transition from the neck to the body there is a series of bands of color, bars of paint and lines, and a checkerboard motif with mandrake fruits. The latter motif is quite rare and more common during the Nineteenth and Twentieth Dynasties. The decorative scheme, with the use of a red, burnished slip, is very similar to that on the unique tall-necked vessel from the embalmers' cache of King Tutankhamen found in the Valley of the Kings, and now also in the Metropolitan Museum of Art[1] (cf. also cats. 79 and 71).

Such jars without painted decoration were used for the temporary storage of water and certain dry foods, while the decorated examples were probably used primarily for the serving of wine and beer at banquets. The wide mouth of these vessels is a necessary feature for this function, and the burnished slip would make the vessel less permeable.

C.A.H.

1. Winlock 1941, p. 15, pl. 10b; Hayes 1959, pp. 302-303, fig. 187.
Bibliography: Scott 1956, p. 83; Hayes 1959, p. 323, fig. 205.

81
Amphora
Said to be from Thebes, probably Malkata
Late Dynasty 18, probably reign of Amenhotep III
Height 32.4 cm.; diameter of rim 11 cm.
Cleveland Museum of Art (20.1977). Gift of the John Huntington Art and Polytechnic Trust

The wheel-made amphora has a tall neck, bulbous body, and a flat ring

82

base. Two handles, originally joined to the neck and shoulder of the vessel, are missing, as is part of the rim and neck. The front and back are painted with two very similar floral collars and the front supports an applied gazelle head attached to the shoulder and neck of the amphora. This was hand-modeled and colored white with black horns and eyes. The two floral collars have a white background, possibly representing the papyrus backing of the actual collars, over which the details were applied in blue, red, and black. The collars are made up of two rows of tapering petals, the upper one white and the lower one blue and white; these are separated by red poppy petals. Below the second row of tapering petals are another row of poppy petals, a row of blue shapes perhaps intended to be petals, and a row of black dots. These dots may represent berries of some type, such as were used in the original floral garlands, possibly those of the woody nightshade *(Solanum dulcamora)*.

This type of amphora with an applied gazelle or ibex head at the neck was particularly common at the sites of Malkata and Amarna of the late Eighteenth Dynasty[1] and seems to have been out of favor during the Ramesside Period.

C.A.H.

1. Hayes 1959, p. 247, fig. 150.
Bibliography: Cooney 1965b, pp. 5-6.

82
Carinated bowl
From Malkata
Dynasty 18, reign of Amenhotep III
Height about 10.2 cm.; diameter of rim about 42 cm.
The Oriental Institute, The University of Chicago (1978.1.8)

Reconstructed from four pieces of a wheel-made carinated bowl of Nile silt clay with slightly concave sides, this piece is covered with a cream coating inside and out but decorated only on the exterior. The main feature of the decoration is two applied heads of the goddess Hathor, with her characteristic bovine ears. These heads have facial features in black, while the wigs are blue with details in red and black. Between the two heads is a band of blue tapering petals separated by red V-shapes. The decoration ends at the carination with a black line.

Bowls of this type have been found at Amarna and Deir el Medineh, as well as at Malkata. The use of applied Hathor heads is restricted to certain bowls and tall-necked jars. The necks of these jars are thin and often preserve a decoration of wavy lines imitating hair, the shoulder may have two applied bosses representing breasts, and in at least one instance the pudenda are shown as a small triangle (see cat. 69). Another similar type of jar has the face and wig of the goddess modeled out from the wall.[1]

All of these vessels would appear to have had some special association with the goddess Hathor though, as is shown by signs of use, they were not cult objects.[2]

C.A.H.

1. Hayes 1959, p. 248, fig. 150.
2. Guidotti 1978, pp. 105-118.

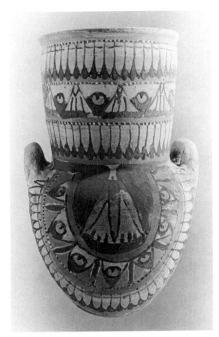

83

83

Piriform amphora
Provenance not known
Dynasty 19-20
Height 26.8 cm.; diameter of rim 13.7 cm.
Musée du Louvre, Paris (N.882)

The small, wheel-made two-handled amphora has a tall, wide neck (repaired on the left side), an inverted piriform body, and a round base. Handles are attached horizontally to the shoulder of the amphora, and it is covered on the exterior with a cream coating over which floral motifs are painted in blue, red, green, yellow, and white. The decoration clearly imitates a series of floral garlands; on the neck are three registers separated by bands of color, the first and third consisting of bands of tapering petals separated at their tips by what may represent red poppy petals. The second register comprises a row of inverted cornflowers and possibly mandrake fruits. The body of the amphora is decorated with a large floral collar, which has as its central element an inverted blue lotus flower. The collar is composed of bands of color, what appear to be mandrake fruits between colored triangles, and tapering petals separated by petals resembling those of the poppy. On either side of the body, beside the handles, are drawn red loops representing the original fastenings of the collar with which it was attached to the vase. The markings at the base of the petals may represent the folded olive leaves that were used to hold the lotus petals in the actual collars.[1]

The shape of this vessel and its decoration are typical of the Ramesside Period (Dynasties 19 and 20); neither is encountered during Dynasty 18. Characteristic of these vessels is a crowded decorative scheme that was carelessly applied after the vessel had been fired in the kiln. Such amphorae, quite common at Deir el Medineh,[2] were probably used for serving wine. Similar shapes were made in faience (cat. 156).

C.A.H.

1. Frankfort 1929a, pp. 45-47.
2. Nagel 1938.

Clay Figure Vases

For about a century between the reigns of Thutmose III and Amenhotep III small clay vases in the form of animal and human figures became popular. Such themes occur frequently in the pottery of earlier periods, but it is in the idiom of the Eighteenth Dynasty that the interpretation is most lifelike and most elegant. In addition to the figure vases, other fanciful forms became popular—ring vases (see cat. 88) and imitations of vases in stone or leather (see cat. 85). The skill and virtuosity of the potters who made these vases is easy to take for granted, because they strove to remove all external traces of their work. What resulted are small pottery sculptures, which happen also to be containers. Exploiting the plasticity of the clay medium to the full, they created a wide range of vases, varied both in subject and in treatment. The conventions of formal art, produced to satisfy the needs of funerary or temple rituals, do not apply. These vases were made for everyday use, and it was only as treasured personal possessions (see cat. 90) that they were placed in a tomb.

The figure vases in the catalogue fall into three subject categories: female figure vases, handled flasks with a woman's head, and "animal" figure vases. The women in the first group are all servants or personal attendants; there is even a musician. Though the vases were not funerary in inspiration, there was a special advantage to be gained by placing them in a tomb, since by magic the figures could become animated, like the servant figures placed in Middle Kingdom tombs,[1] to serve the deceased in the next world. The animals include a hedgehog and an ibex; a *bolti* fish is depicted on another vase, while a grasshopper is carefully modeled in a figure vase in Cairo (fig. 30). All are

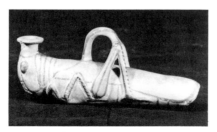

Fig. 30. Grasshoppers are a common motif in jewelry and amulets but this vase is a rarity; the insect is even modeled on the underside, which would not normally be visible (Cairo JE 27048).

represented many times in tomb scenes of hunting in the desert or in the marshes of the Nile, and illustrate the Egyptian artist's sympathy for natural forms. The hedgehog vase (see cat. 89) surely also illustrates his sense of humor.

The contents of these small elaborate vases were almost certainly cosmetics of some kind, possibly expensive oils[2] such as that pressed from the nut of the moringa tree.[3] (The head of Bes, who often appears on cosmetic items [see cats. 216 and 288] decorates an example in Cairo [fig. 31]). As many tomb paintings show, oils like this

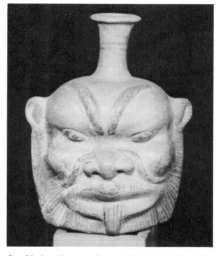

Fig. 31. A pottery amphora with an inscription of Horemheb provides good dating evidence for this red polished vessel decorated with a Bes-image (Cairo JE 46996).

were used to anoint the head and face at banquets or festivals. To be sweet smelling was an important attribute of beauty in both men and women.

These vases have been said to be foreign imports[4] or at least of foreign inspiration. At present there is no evidence to confirm their foreign manufacture. Compared with Eighteenth-Dynasty tomb paintings they show an unequivocally Egyptian style. The thick red slip covering the surface of most of them and the absence of fresh breaks make visual assessment of their fabric difficult, and for only a few has spectrographic analysis been applied to the clay.[5] However, with the exception of cat. 366, the impression is of a general homogeneity of fabric, certainly not Nile silt, but equally certainly not one of the well-known foreign wares in circulation at that time. The fabric was evenly fired to

a light reddish brown and burnished, where unslipped, to a yellowish red. It is hard and very dense, containing many small, and sometimes also large white (possibly limestone) inclusions, sand, other fine unidentifiable gray grits, and sometimes a little coarse chaff. Until further work is done, more cannot be said than that the fabric does not closely resemble that of any of the contemporary pottery, though this is not surprising since these vases must have come from specialist workshops. Fragmentary examples indicate that the figure vases were modeled by hand or molded in sections.

While the vases may not have been imported into Egypt, the vogue for them does coincide with the beginning of the period of Egypt's greatest expansion into the Near East. The tribute that Syrians are shown bringing to the king, in scenes in the tombs of high officials from the reign of Hatshepsut onward, contains fantastically shaped vases of precious metals with ornate animal-shaped spouts and handles. If these are what created a demand for such vessels, it was one that the Egyptian artist-potter was more than able to satisfy.

<div align="right">J.D.B.</div>

1. Winlock 1955.
2. Helck 1963, p. 700.
3. Lucas 1962, pp. 331-332.
4. Knobel et al. 1911, pp. 40-46, pls. xxiv-xxv; MacIver and Mace 1902, pp. 72-75.
5. Payne 1966, pp. 176-178.

84

Flask
Provenance not known
Dynasty 18, reign of Thutmose III
Height 14.5 cm.
Agyptisches Museum, Berlin (13156)

On the woman's head that forms the neck of this ovoid flask sits a tall spout, suggesting, perhaps, the cones of scented wax placed on the heads of guests at banquets. The head is schematically modeled, the brows and eyes outlined and the wig painted black. The wig divides at the sides and back into long curls, two meandering down the handle of the vase, which runs from the back of the head to the shoulder. Around the neck, painted in black, is a design of a lotus flower framed by two buds. It is out of scale with the head but, standing in place of a necklace, appropriately fills the blank space on the surface of the vase.

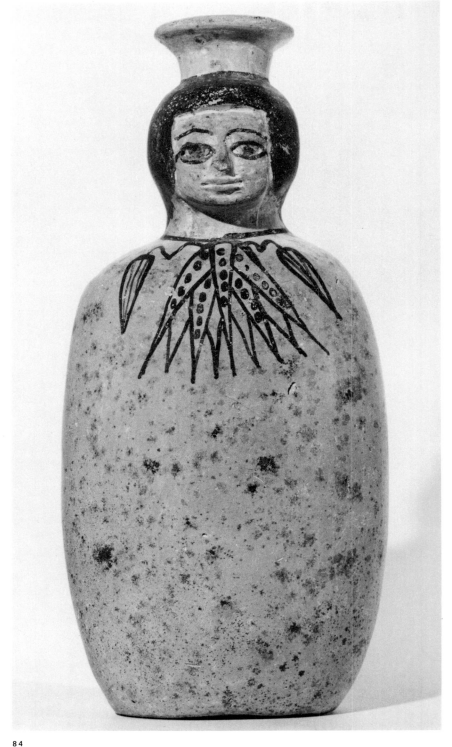

84

This piece belongs to a group of molded vases far more consistent in shape and decoration than other figure vases. Whether this means they were made for a special purpose we do not know.

A vase of the same type in the Ashmolean Museum comes from Abydos tomb E178; the intact burial is datable by pottery and scarabs to the reign of Thutmose III.[1] A second example was found during the first archaeological survey of Nubia[2] in a tomb that was used first during the reign of Thutmose III. Still another, now in the Metropolitan Museum,[3] came from the debris of an Eighteenth-Dynasty cemetery at Saqqara. There are examples in the British Museum and in the Brooklyn Museum[4] but these are without provenance.

J.D.B.

1. Garstang 1901, p. 27, pl. 19.
2. Reisner 1910, p. 341, fig. 322.
3. Hayes 1959, p. 195, fig. 110.
4. E.g., 61.49.

Bibliography: Wolf 1930, p. 52, fig. 4; Krönig 1934, p. 153; Kayser 1969, no. 675; Hornemann 1969, no. 1923; Brunner-Traut 1970b, p. 155; Brunner-Traut 1974, pl. 20a,b; Höhr-Grenzhausen, Rastel Haus 1978, no. 273.

85
Vase

From Sedment tomb 254
Dynasty 18, late reign of Thutmose III
Height 12 cm.; width 9.9 cm.
University Museum, Philadelphia. Gift of Egypt Exploration Fund (E. 15426)

The potter imitated in meticulous detail a vase with a leather body, reproducing the thick side seams in two bands of raised relief, ornamented with the pattern of the stitching in black paint. The bands terminate in two carrying loops. Around the shoulder, again in black paint, is the blanket stitch joining the shoulder to the side pieces. No such leather vase has survived, but one may guess that it would have been provided with a neck of clay like this one, which would have been inserted into the leather body. The strap handle and the two thin relief belts on the neck are features adapted from Cypriote base-ring juglets (see cat. 65) imported into Egypt, examples of which were found in Sedment tomb 254.[1] A stopper, composed of a small ball of string

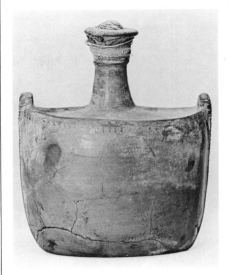

85

wrapped in linen, remains in place, as do fragments of the linen that once covered the mouth of the vase. The original contents are still inside.

The craftsmanship of this handmade vase is of the highest order. The fabric is a fine Nile silt; careful burnishing and painted decoration on top of a thick red slip cover all the potter's joins and tool marks. The vase was found inside one of five baskets in a coffin containing the undisturbed burials of three adults and a child, a group dated to the reign of Thutmose III.[2] The size, narrow mouth, quality, and careful sealing of the vase indicate that it contained a valuable commodity used in small quantities. Its find spot—in a basket containing toilet objects and prophylactics — suggests that the contents were used for cosmetic or medicinal purposes, rather than for food. Apart from a fish found in one of the baskets, no food for the burial was found inside the coffin.

Vases of this kind are rare, the only other known being a simplified version retaining only the relief bands, lugs, and elliptical shape. Two in the Ashmolean Museum are from Sedment tomb 53[3] and Abydos tomb E178,[4] and one in the Metropolitan Museum[5] is probably from Thebes. A copy in alabaster was found in tomb S66 at Aniba,[6] and a second alabaster example of unknown provenance is in Toulouse.[7] Other objects found with the vases suggests a date range between the reign of Thutmose III and the beginning of the reign of Amen-

hotep III. Much of the Egyptian pottery that would provide further criteria for dating remains to be studied. One relevant question is the date of the appearance and evolution of pilgrim vases in Egypt (see cat. 63).

J.D.B.

1. Merrillees 1974, p. 38.
2. Merrillees 1968a, pp. 62-64; Merrillees 1974, pp. 12-40.
3. Petrie and Brunton 1924, p. 24.
4. See also Garstang 1901, p. 14, pl. 19.
5. Hayes 1959, p. 207, fig. 123.
6. Steindorff 1937a, p. 146, pl. 95:1.
7. Guillevic and Ramond 1971, pp. 14-15.

Bibliography: Petrie and Brunton 1924, p. 24, pls. 55:12, 57:33; Merrillees 1968a, pp. 62-64; Merrillees 1974, p. 38, fig. 25; Schneider 1977, fig. 15:11c.

Literature: Bourriau 1981, no. 144.

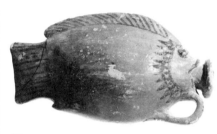

86

86
Fish vase

From Semna tomb S502
Dynasty 18, reign of Thutmose III
Length 16.8 cm.; width 8.8 cm.
Museum of Fine Arts. Harvard University—Museum of Fine Arts Expedition (24.1785)

Every Egyptian must have been familiar with the sight of *tilapia nilotica*[1] (cf. cat. 138), one of the most common fish in the Nile, sucking on a lotus flower. Instead of a flower, this fish holds the spout of a vase in his mouth, but the effect is the same. Except for the applied neck and handle, the vase was modeled by hand in two parts, joined along the long sides. The surface was covered in a red slip and burnished, with details added in black pigment. (For fabric and possible contents, see pp.101-102.) The vase was found in a rock-cut tomb containing, it seems, a single burial with objects datable to the reign of Thutmose III.

Vases depicting *tilapia nilotica* are relatively common at this time, but they vary considerably in details of decoration and in quality. A vase in

Toronto[2] has scales painted on the body and the handle placed in front of the dorsal fin; another in Oxford[3] has a spout in the form of a lotus. Fish vessels were also made in faience and glass (see cat. 155) and these eventually became more popular than the pottery version. The burial in Semna tomb S502 also contained a serpentine vase of the same shape as cat. 116.

J.D.B.

1. Gamer-Wallert 1970, p. 24.
2. 936x188.
3. 1921.1291A, from Sedment tomb 263; unpublished.

Bibliography: Dunham and Janssen 1960, p. 76, fig. 33.

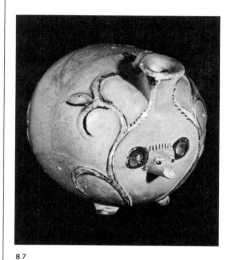

87

87

Hedgehog vase

From Abydos tomb D11
Dynasty 18, reign of Thutmose III
Height 7.4 cm.; diameter 22.5 cm.
Ashmolean Museum, Oxford. Gift of
Egypt Exploration Fund (E. 2775)

The anonymous artist who made this vase was clearly amused by hedgehogs. He reduced for effect the size of the stumpy feet, and applied the spout, ears, and nose directly to the spherical body that forms the vessel. At the same time he embellished the body surface with a beautifully disciplined design of lotus flower scrolls. This is a sophisticated example of a combination of ideas — a humorous, even grotesque animal form decorated with stylized foliage patterns, earlier expressed by the faience hippopotami of the Middle Kingdom.[1] The flowers and stems are executed in raised relief, and details — the hairs on the stems,

the ears, eyes, brows, and fur of the hedgehog — are painted in black. The surface was covered with red slip and carefully burnished, leaving few tool marks. The unslipped burnished surface visible on the hedgehog's stomach is a yellowish red,[2] and to the eye the fabric, with many white inclusions, looks like that of the majority of the figure vases (see p. 102). The spout, which has a tiny handle for suspension, is incorporated (as in cat. 86) into the overall design here by the tendrils of the foliage.

The vase was found in a shaft tomb with five interconnecting chambers and an elaborate superstructure. Burials took place there during Dynasties 18 to 26, but all the Eighteenth-Dynasty material seems to belong to the period up to the end of the reign of Thutmose III. (Despite the conclusions of J.L. Myers, who first published the vase in 1902,[3] no evidence has since appeared to prove that it came from outside Egypt.)

In the debris of a Middle Kingdom cemetery at Lisht were found fragments, only the spouts and snouts, of hedgehog vases.[4] The fabric is different, though certainly Egyptian, and the snout was applied to the body of the vase in the same way.

The form of the lotus motif, with curling stems and fleur-de-lis-like flowers on the present example, is unlike the typical Egyptian pattern, but it is also found on a sherd[5] from the shoulder of a large, wheel-thrown vessel from the same tomb. The decoration of the latter is incised and white filled, and the fabric, which varies in color from pale yellow to dark gray, is a very hard, dense, gritty Egyptian marl clay. The same ware occurs in early Eighteenth-Dynasty (unpublished) contexts at Saqqara and Karnak North.

J.D.B.

1. Hayes 1953, fig. 142.
2. Boston 1905: Munsell 5YR 6/6.
3. MacIver and Mace 1902, pp. 73-74.
4. Oriental Institute 15.3.984.
5. Ashmolean E.2776.

Bibliography: J.L.Myers in MacIver and Mace 1902, pp. 73-75, pl. 50; Knobel et al. 1911, pp. 44-45, pl. 25:68; Moorey 1970, p. 50. fig. 22; von Droste zu Hülshoff 1980b, p. 121; Bourriau 1981, no. 51.

Literature: Muscarella 1974, no. 230.

88

88

Ring vase

From Abydos tomb E233
Dynasty 18, reign of Thutmose III to
Thutmose IV
Height 15.5 cm.
University Museum, Philadelphia. Gift of
Egypt Exploration Fund (E. 6761)

This whimsical product exemplifies the skill and creativity of potters working during the period that begins with the reign of Thutmose III. The neck is wheel thrown, the rest handmade; the fabric is Nile silt fired to a reddish brown. A thick red slip was applied to the surface and heavily burnished; then, rather carelessly, strokes of black pigment were painted with a brush along the sides and around the vessel rim. Perhaps the potter was inspired by the netting in which many pots were carried.

No information exists concerning the character of the tomb from which this ring vase comes (although it was presumably of the shaft and chamber type), or the relationship of the vase to the other objects found. However, despite the excavator's suggestion,[1] the group appears homogeneous.

Ring vases of this kind,[2] which occur also in alabaster (see cat. 124), seem to be a short-lived variant of pilgrim vases, appearing in the middle of Dynasty 18, perhaps as early as the reign of Thutmose III, but disappearing before the Amarna Period.[3] All the known excavated examples from Abydos,[4] Sedment,[5] and Sawama[6] belong to this period. The example

closest to the present ring vase is a fragment from Sedment tomb 132. Unfortunately, no details of the context of the objects from this group are given. It contains four objects[7] whose type disappears before the beginning of the reign of Amenhotep III.

J.D.B.

1. Garstang 1901, p. 15.
2. Bourriau 1981, no. 142.
3. But see Bourriau 1981, no. 149.
4. Garstang 1901, pl. 21; MacIver and Mace 1902, pl. 50.
5. Petrie and Brunton 1924.
6. Bourriau and Millard 1971, fig. 6, p. 97.
7. Petrie and Brunton 1924, pl. 59:10, 13, 16, 17.

Bibliography: Garstang 1901, p. 15, pl. 21:E.233.

89
Ibex vase

From Dra Abu el Naga
Dynasty 18, reigns of Thutmose III to Amenhotep III
Height 10 cm.; width 15.5 cm.
Musée du Louvre, Paris (E 12659)

This exceptionally fine, elaborate vase is in the form of a reclining ibex with two young fawns. The spout of the vase is inserted into the mouth, and a curious spur, running from jaw to chest, may have provided a means for attaching a suspension cord. The hooves, horn, and ear (one of each is missing) are shown in meticulous detail, and the two fawns lie sprawled against their mother with complete naturalness. One of the heads is broken away at the base of the neck, and the other has lost most of its face, showing that they were applied to the body of the vase. The surface of the vase was covered in a thick red slip and burnished; the fabric and techniques used in its manufacture are not clear. It was found in a badly robbed shaft without associated objects.

An ibex vase of comparable elaboration, but of inferior quality, in Berlin[1] shows a young child in the act of climbing onto the back of a standing ibex.

J.D.B.

1. Kayser 1969, fig. 100.

Bibliography: Chassinat 1906a, p. 84; Gauthier 1908, pp. 144-145, pl. 3; Bénédite 1908, p. 17; Ecole du Caire 1981, pp. 226-227.

89

90

90
Feminoform vase

From Abydos tomb W1
Dynasty 18, reign of Amenhotep III or somewhat later
Height 21.5 cm.
Ashmolean Museum, Oxford (E 2431)

The vase was found with the apparently intact burial of a young girl of not more than fourteen and is datable by the associated pottery to the reign of Amenhotep III or a little later. Representing a woman attendant wearing a long black wig and a close-fitting skirt reaching from her hips to her ankles, the figure was clearly intended to be grasped around the lower body, since there is no handle. Broad lines, suggesting straps, are painted in red across the chest (over the right hand), around the hips, and over the shoulders. Just below the hip girdle is a clumsily painted black semicircle representing an enlarged pubic triangle. The face is sharply incised and there are two blobs of clay representing the enormous ear plugs then fashionable (see cat. 301); a necklace is indicated by an incised line. The basket is supported on the woman's left arm, while her right arm lies across her breasts. The base, right arm, and basket are all applied to the main body of the vase.

Baskets such as this one with conical lids attached by a string passing

105

around the knobs on lid and basket, were common and were imitated in pottery and faience (see cat. 159). The basket is hollow and the lid removable, so it too could have been used as a container.

Red paint applied over a small chip on the spout protruding from the head may represent an attempt to repair for deposit in the tomb a vase that had suffered a little in the course of its everyday use.

Closely resembling this example, and possibly from the same workshop, is a figure vase, now in Copenhagen,[1] of a serving woman carrying a bird in her right hand, in addition to a basket in her left. On both vases cutting rather than modeling is used to delineate the features, and tool marks are visible all over the surface, coarsening the elegant outline. The attenuation of the figure and the pose with the right arm across the chest recalls that of female-figure mirror handles of the period (see cat. 218).

J.D.B.

1. See Mogensen 1930, pl. 70:A522.

Bibliography: Ayrton et al. 1904, pp. 49-50, pl. 16:3; Knobel et al. 1911, p. 44, pl. 25:65.

91
Bottle

From Abydos tomb P.β.
Dynasty 18, reign of Amenhotep III
Height 24.5 cm.; width 5.2 cm.
Museum of Fine Arts. Gift of Egyptian Exploration Fund (11.1468)

The shape of this bottle was clearly much admired and copied in glass, faience (cat. 150), and alabaster. A clue to its function may lie in the tiny bronze strainer found inside a similar bottle from Nubia.[1] Perhaps it contained spices or herbs in solution, such as were used to flavor wine. The vestigial handles are purely decorative, and the vase may have been carried in a net or suspended from a loop tied around the neck.

Composed of a fine, dense, hard marl clay containing sand, fine grits, and a few large white (possibly limestone) particles, the vase was carefully made and wheel thrown. Above the handles the surface was coated in red slip, and on the neck burnishing strokes were applied in a triangular pattern. All tool

91

marks were obliterated by the burnishing, which darkened the pink surface to reddish yellow.

Though made of a particular ware to suit their specialized function, bottles of this kind are not rare. The site at which this example was found was a robbed shaft and chamber tomb containing many burials from the late Eighteenth and Nineteenth Dynasty. Another example from an intact burial at Abydos is dated by a scarab of Akhenaten.[2] Others from a single intact grave with a scarab of Thutmose III are datable to late Dynasty 18.[3] At present there is no evidence to support the suggestion that these bottles are imports from Syria.[4]

J.D.B.

1. Firth 1912, p. 189, pl. 42a:1-3.
2. Ayrton et al. 1904, p. 49, pl. 15:15.
3. Firth 1912, p. 189, pl. 42a.
4. Peet 1914, p. 105.

Bibliography: Peet 1914, p. 105, pl. 21:7.

Literature: Engelbach 1915, pl. 14, 63; Brunton and Engelbach 1927, pl. 26:38; Blackman 1937, pl. 16:2.

Food and Drink

The remnants of the funerary feast for the burial of Tutankhamen affords some clue as to what might be a typical menu for a dinner party among the well-to-do during the New Kingdom. The eight guests present consumed nine ducks, four geese, and several cuts of beef and mutton, accompanied no doubt by bread, various fruits and vegetables, and wine.[1] A last meal interred in the tomb of an elderly woman more than a thousand years before Tutankhamen consisted of barley and emmer breads, a porridge made from ground barley, fish, pigeon stew, roast quail, kidneys, ribs and legs of beef, stewed figs, jujubees, cheese, small honey cakes, and wine.[2] From the evidence of these and many other remains and tomb paintings, a fairly complete picture of Egyptian culinary offerings may be assembled.

Cattle were kept as far back as civilization can be traced in Egypt,[3] and the slaughter of cattle for sacrifice or for food is depicted on many monuments. Literary evidence indicates that roast meat was more common than its portrayal would suggest; the roasting of whole beefs on spits over charcoal is rarely shown[4] and the cooking method most commonly depicted was boiling. From the time of the Old Kingdom cattle were fattened artificially, force-fed by herdsmen who pushed balls of dough into their mouths. They were regarded as ready for slaughter when so big and heavy that they were practically incapable of walking.[5]

Large herds of goats and cows were kept for the milk, butter, and cheese they provided, as well as for meat. Milk, regarded as a great delicacy,[6] was kept in pots stoppered with bunches of grass to keep out insects without making the jars airtight.[7] It was served hot, made into butter and cheese,[8] and used in cooking;[9] butter was clarified like the Indian ghee.[10] Herds of pigs are depicted in Theban tombs[11] (fig. 32) with cattle, horses, donkeys, goats, and sheep, and later taboos notwithstanding, pork was a common element of the diet.[12] Amenhotep III offered pigs to the temple of Ptah at Memphis[13] and Seti I allowed pigs to be raised inside the temple of Osiris at Abydos,[14] while Ramesses III included pigs in his list of offerings to Ptah-Sokar at Medinet Habu.[15] It is

known that pigs were eaten by the workers and artisans of the Ramesside Period at Deir el Medineh, as large numbers of pig bones were found in their trash heaps.[16] The Egyptians were also fond of the meat of a number of wild species, including the hyena (see p. 46), which might not seem palatable to modern tastes.

A tomb painting in the British Museum represents the counting of geese on an Egyptian farm, the goose-herds placing the geese in wickerwork handled baskets for transport.[17] Pigeons or doves were raised in cotes both for food and as a source of fertilizer.[18]

Egypt is a land of water-birds, and in the migration season in the autumn the lagoons of the Delta, the banks of the Fayum, the canals, ponds, and flooded fields are crowded with thousands of them. In ancient times, ibises, pelicans, cranes, cormorants, herons of all kinds, and fourteen species of wild ducks and geese were all trapped with the clap-net[19] and put into fowl houses for fattening.[20]

Roast quail was found in a Second Dynasty tomb at Saqqara and dressed quail were identified from a royal burial dated to the reign of Amenhotep I at Thebes.[21] Herodotus claimed the Egyptians ate quail, ducks, and other small birds uncooked, merely first salting them.[22] However, there is very little evidence that meat, fish, or fowl were salted, pickled or subjected to any type of preservative process in pharaonic Egypt other than drying in the sun.[23]

Water birds, especially pelicans[24] (fig. 33), were a source of fresh eggs, which were stacked neatly in earthenware vessels with green grass above and below to keep them secure.[25] Cocks and hens were not known before the New Kingdom, but domesticated fowl were imported at this time from Asia, perhaps as novelties (see cat. 18), for it is doubtful that they provided eggs on a daily basis before the Late Period.[26]

While the eating of particular varieties of fish was explicitly prohibited for superstitious reasons in certain villages or districts,[27] fish in general formed an important part of the Egyptian diet and was supplied in abundance by the state to the workmen at Deir

Fig. 32. Pigs treading grain (the young pig striped dark and light along the body) and a boar mounting a sow (from Theban tomb 24).

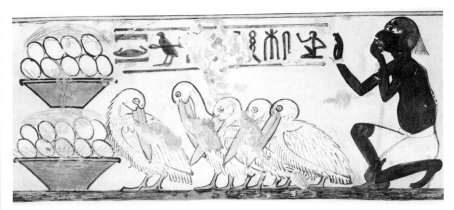

Fig. 33. The pelicans and their keeper have a comical appearance in this painting (from the tomb of Horemheb, Theban tomb 78).

el Medineh.[28] Among those eaten were mullet, mormyr, catfish, batensoda, large *bolti* fish, and giant perch so big that two men were needed to carry them on a long pole through their gills and laid across the bearers' shoulders with the tail of the fish brushing the ground.[29] Fish were also used for payment of taxes.[30]

Fish were caught by seines, trawl nets, hand nets, traps, dropline hooks, and poles.[31] Fish hooks in the New Kingdom were frequently of bronze with a flat, notched end around which a string was tied.[32] On shore the fish were scaled and gutted, then broiled or boiled in stews. The majority were probably slabbed and sun-dried to preserve them for later use.[33] A preserved slabbed fish fillet was discovered at the workmen's village of Deir el Medineh.[34] Some tomb scenes seem to show the extraction of roe

from mullet, so the ancient Egyptians may have eaten the equivalent of caviar.[35]

Bread was made from barley and emmer[36] and came in assorted shapes and sizes. There are over fifteen words for bread in the Old Kingdom offering lists, and the culinary vocabulary of the New Kingdom included more than forty words for breads, biscuits, and cakes. They probably represent differences in the type of flour used, in shape, in the method of baking, or in the ingredients they contained— honey, milk, fruit, eggs, fat, or butter.[37]

A popular bread was tall and conical and baked in a mold[38] (see cat. 97) but other loaves were roughly ovoid or circular[39] and marked with slashes to allow the gases formed during rising and baking to escape. There were also triangular loaves, semi-

circular loaves,[40] a round loaf that had at its center a crater surrounded by a raised or everted lip of dough (see cat. 95), and even a variety of bread that resembles an acacia pod in shape.[41] Other loaves were sprinkled with flour or seeds or overlaid with fresh dough after a preliminary baking and rebaked.[42] In the New Kingdom special loaves and cakes were rolled into spirals or other fancy forms in the shape of geese, cows, or female figures,[43] and the tomb of the architect Kha contained bread or cakes in an assortment of fanciful types.[44] Honey was incorporated into cakes and pastries,[45] and dates were chopped and mixed with barley to make cakes.[46] There were also imitations of foreign breads, including "Nubian" bread and "loaves of the Asiatics"[47] like modern "French" or "Italian" bread.

Flour in ancient Egypt was ground on saddle-stones or querns of granite, syenite, mica schist, quartzite, limestone, or basalt, with the result that many small abrasive particles of stone are present in actual examples of Egyptian bread. These abrasive particles, along with windblown sand, would account for the attrition seen on the teeth of Egyptian mummies; otherwise, tooth decay was relatively uncommon in ancient Egypt.[48] Bread was baked on an open fire, over ashes or in pre-heated molds, on low braziers, or in open cylindrical ovens of clay with a round or square fire door.[49] In the latter case, the round loaves were pressed against the inside of the heated walls when the fire had gone out.[50]

Breadmaking and brewing are frequently shown together in tomb scenes,[51] and it seems likely that ancient Egyptian beer was manufactured in the same way as the *bouza* beer of the modern Sudan: a very coarse barley bread was slightly baked so as not to kill the yeast and then the loaves were broken up and mixed with water and malted barley and allowed to ferment. The mixture was then pushed through a sieve into a jar with a spout at the rim to draw off the dregs and decanted into beer jars.[52] An analysis of the contents of several beer jars from Thebes yielded a previously unknown type of yeast (now *Saccharomyces Winlocki*) after the

American Egyptologist who discovered it).[53] The beer produced probably had an alcoholic content of between 6.2 and 8.1 percent like modern *bouza*[54] compared to 6 percent, the average alcoholic content of ordinary American beers. In addition to native Egyptian brews of the New Kingdom, beer was imported from the land of Kedy.[55]

Also imported in the New Kingdom was a Mesopotamian invention[56] (see fig. 34), the drinking siphon or tube, which prevented any chaff or nonedible particles from the bread from being consumed along with the beer.

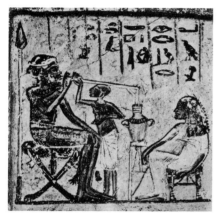

Fig. 34. A Syrian mercenary drinks from an angulated drinking tube in this stele from Amarna, while his Egyptian wife looks on (Berlin 14122).

Metal fittings for a drinking siphon, the rest of which probably consisted of two reeds, were found in a house at Amarna: a narrow mug with pointed top and bottom, a tube jointed at right angles strengthened by a crossbar (the angle being filled by a floral motif in openwork), and a strainer with a cylindrical socket.[57]

The other principal alcoholic drink known to the Egyptians, wine, was more expensive, and was restricted to court circles and the upper classes. Wine was not, for example, part of the regular deliveries to the workmen at Deir el Medineh,[58] although it may have been distributed to the populace on special occasions. The best domestic wines came from estates in the eastern, central, and western Delta and from the oases[59] and wine was also imported as tribute or commercially from Arvad, Djahi, and Retjenu in Asia.[60] It is generally presumed that the wine of the ancient Egyptians was red; however, since white grapes are shown in the tombs along with

red, pink, and green grapes, it is possible the Egyptians knew white wine.[61] Blended wines were known but the mixing was done just before serving at banquets.[62] Of the three dozen wine jars in Tutankhamen's tomb, only four were labeled "sweet."[63] Perhaps this indicates a clear preference on the part of the young king for dry wines; on the other hand, it may indicate that the wine was sweetened.[64] Honeyed wine was imported from Retjenu,[65] while it was said of the mellow wine of the vineyard Ka-en-Kemet that it surpassed honey in its sweetness.[66]

There are no signs of the resins used in Egyptian wines of the Greco-Roman period[67] and from all we know about Egyptian wines it seems they would have been much more to our taste than the resinated, oil-covered, burned, and diluted concoctions served by the ancient Greeks and Romans.[68] Wines from good vintage years were prized, and there is some evidence for the long-term storage of wine.[69]

The ancient Egyptians consumed a wide variety of vegetables, green and otherwise. In their wanderings toward the Promised Land the Hebrews looked back nostalgically to the plentiful cucumbers, watermelons, leeks, onions, and garlic of Egypt.[70] Squash-like cucumber and melons are often seen on offering tables in temple reliefs and tomb paintings. A large green-striped watermelon (e.g., *bedduka*) is depicted with other offerings in the Old Kingdom tomb of Iy-mery at Giza.[71] The halved watermelons in the painting from the tomb of Userhat[72] contain more rind than their modern counterpart, but the seeds and pink flesh are clearly depicted. They may represent a species of small inedible watermelon (*Citrullus vulgaris Schrad.*, var. *Colocynthoides Schweinf.*) raised exclusively for its seeds, which are chewed in modern Egypt and whose cultivation goes very far back in time.[73]

Ancient Egyptian onions were green with small white bulbs like modern scallions or shallots. They had an extremely thin and tender skin and like their modern descendants were probably sweet, lacking the bitter taste of the European onion.[74] Pliny claimed garlic and onions were invoked by the

Egyptians when taking an oath,[75] and the rituals of the Sokar festivals held at Memphis in connection with the winter solstice prescribed wearing circlets of onions around the throat and smelling onions in the sacred procession,[76] a peculiar custom depicted in Theban tombs.[77] Bunches of onions and long stems of garlic with leaves and flowers were found in the tomb of the architect Kha at Deir el Medineh.[78] Egyptian garlic was and is smaller than its European counterpart; it often has as any as forty-five pods and its taste is not as strong.[79] Clay models of garlic were found at Mahasna in the predynastic cemetery.[80]

Lettuces were sacred to the ithyphallic Min, god of procreation and vegetation, perhaps because they grew straight and tall and exuded a milky white juice when pressed. In view of its sexual association, it is interesting to find lettuce recommended in the medical papyri to cure impotence.[81] It was probably eaten as it is in modern Egypt, that is, uncooked with oil and salt.[82]

Legumes play a significant role in the diet of the modern Middle East and were probably a staple in ancient times. When a pupil of the Ramesside Period built his old teacher a comfortable home[83] he stocked its storerooms with chick peas, cowpeas, lentils, and ordinary peas. Mashed lentils were found in graves of the Middle and New Kingdom at Dra Abu el Naga and Deir el Bahri.[84] The broad bean was agreeable to both men and gods, probably just as they are eaten today: stewed or as a special purée fried in balls.[85]

Oil-producing crops formed an important part of Egyptian agriculture. Sesame was cultivated for its oil at least by the time of the New Kingdom. One of the most common items in the daily diet of the workmen's village at Deir el Medineh, sesame oil, was distributed among the workmen by the administration. Another oil, made from the fruit of the horseradish tree (*Moringa aptera*), seems to have been used rarely by the workmen, perhaps because it was too expensive.[86]

Representations of cooking scenes on tomb walls[87] provide a glimpse into the daily activities of meal production. At Amarna the kitchens were

placed on the eastern side of the house and connected with the main structure by a service corridor.[88] Cooking equipment consisted of cylindrical clay ovens about three feet in height, with an opening at the bottom to create a draft and to allow the ashes to be removed.[89] Since there was no coal in Egypt or any of the neighboring countries, cooks had to make do with charcoal, wood, and dung.[90] A two-handled saucepan (see fig. 35), slightly wider than the opening at the top of the oven and of varying depth, stood on top. Clay braziers and clay or metal stoves resembling low boxes without bottoms were also used, the fuel being spread on a surface in which holes were pierced.[91] On occasion the stove was dispensed with and the pans balanced on a tripod over a fire.[92] Otherwise, kitchen equipment consisted of saucepans, basins, pitchers, and jars of earthenware, as well as jugs and baskets for carrying provisions, and three- or four-legged tables for carving and dressing meat or fish. For making fires, there was the "fire drill" (see cat. 29).

It is surprising, since archaeological collections contain so many different kinds of pottery vessels suitable for serving, that dishes, plates, and bowls are conspicuously absent from party scenes on tomb paintings.[93] The Egyptians ate a great deal with their fingers, as is attested by a depiction of King Akhenaten munching a shoulder of beef and his queen gnawing a whole bird held in her right hand. In an adjacent scene, King Akhenaten and his family drink from cups and goblets.[94]

E.B./P.L.

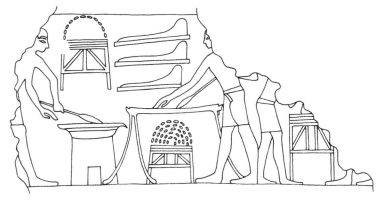

Fig. 35. A cook stirs the contents of a saucepan set over the fire in a cylindrical clay oven, while a companion works at a tripod table (from Theban tomb 93).

1. Winlock 1941.
2. Emery 1962.
3. Ruffer 1919, pp. 1ff.; Epstein 1971, pp. 227ff.
4. See Darby et al. 1977, pp. 151-152, fig. 3:44.
5. Darby et al. 1977, pp. 119-120; Ruffer 1919, p. 9.
6. Lefebvre 1960.
7. Montet 1962, p. 82.
8. Lucas 1962, p. 330.
9. Fischer 1976, pp. 97-99.
10. Lucas 1962, p. 330.
11. Porter and Moss 1960, p. 467.
12. Kees 1961, pp. 91-92; Darby et al. 1977, pp. 173ff.
13. Newberry 1928, p. 211.
14. Ibid.
15. Nelson and Hölscher 1934, p. 59.
16. Kees 1961, p. 92; Darby et al. 1977, pp. 188-189.
17. Davies and Gardiner 1936, pl. 67.
18. Kees 1961, p. 95.
19. Dunham 1937, pp. 52-54.
20. Kees 1961, pp. 93-95.
21. Hayes 1959, p. 52.
22. Book II, 77: Godley 1921, p. 365.
23. Hayes 1951, p. 92.
24. Davies and Gardiner 1936, p. 83.
25. Ibid.; Brack and Brack 1980, pl. 24b.
26. Darby et al. 1977, pp. 301-309.
27. Montet 1962, p. 79.
28. Janssen 1975, p. 348.
29. Montet 1962, p. 79.
30. Davies 1943, pl. 30.
31. Bates 1917; Darby et al. 1977, pp. 337ff.
32. Bates 1917, pp. 246-249, pl. 11.
33. E.g., Davies 1927, pl. 30; Davies 1943, pl. 46.
34. Darby et al. 1977, fig. 7:37.
35. Keimer 1939; Vandier 1964b.
36. Leek 1973; Währen 1963.
37. Montet 1962, p. 86.
38. Kemp 1979a, p. 11; Cooney 1965a, no. 46, pp. 73-74.
39. Darby et al. 1977, figs. 12:12, 13.
40. Ibid., figs. 12:15, 16.
41. Säve-Söderbergh 1957, pp. 22; Täckholm 1974, pl. 93c.
42. Grüss 1932.
43. Darby et al. 1977, p. 522.
44. Schiaparelli 1927, p. 151, fig. 135.
45. Erichsen 1933, p. 62 (556, 2).
46. E.g., BM 5346, 5353; Hayes 1951, p. 95.
47. Caminos 1954, pp. 205, 217.
48. Leek 1972.
49. Bruyère 1939, pp. 72-73.
50. Rosellini 1834, pl. 85; Borchardt 1932a.
51. Helck 1971.
52. Lucas 1962, pp. 10ff.
53. Ibid., pp. 15-16.
54. Lucas 1928, p. 2.
55. Caminos 1954, p. 570.
56. Kantor 1979, p. 35.
57. Griffith 1926, pp. 22-23.
58. Janssen 1975, pp. 350-352.
59. Hayes 1951, p. 59.
60. Lucas 1962, p. 20.
61. Ibid.
62. Lesko 1977, p. 31.
63. Černý 1965, p. 4.
64. Lesko 1977, p. 22.
65. Sethe 1907b, p. 670, l. 8.
66. Caminos 1954, p. 74.
67. Lucas 1962, pp. 19-20.
68. Lesko 1977, p. 31.
69. Helck 1954a; Lesko 1977, p. 23.
70. Numbers 11:5.
71. Smith 1949, fig. 206.
72. Theban tomb 51.
73. Täckholm 1961, p. 31.
74. Ruffer 1919, p. 74.
75. Ibid., p. 76.
76. Keimer 1951.
77. Davies 1927, pp. 11-12, pls. 5, 12.
78. Schiaparelli 1927, p. 162, fig, 146.
79. Darby et al. 1977, p. 657.
80. Ayrton and Loat 1911, pl. 16.
81. Darby et al. 1977, p. 680.
82. Montet 1962, p. 81.
83. Caminos 1954, pp. 164-165.
84. Ruffer 1919, p. 73.
85. Darby et al. 1977, pp. 683-684.
86. Janssen 1975, p. 330.
87. Wreszinski 1923, pls. 221, 286, 325-326.
88. Pendlebury 1935, p. 111.
89. Ibid.
90. Montet 1962, pp. 82-83; Caminos 1954, p. 167.
91. Montet, 1962, p. 83.
92. Wreszinski 1926, p. 10, figs. 31, 33.
93. Montet 1962, p. 89.
94. Davies 1905b, pl. 6.

Literature: Keimer 1956b; Währen 1963.

92

92

Grill

From Deir el Medineh house northwest 19
Dynasty 19
Length 22 cm.; width 21.3 cm.
Musée du Louvre, Paris (E 16324)

The limestone grill with its bottom
hollowed out was found in a house-
hold context and has traces of burning
and grease on the top.

A similar grill from Memphis, now in
the Metropolitan Museum,[1] belonged
to the chief steward Amenhotep. The
offering formula inscribed along the
sides shows that it was intended for
ritual use. It has been suggested that
the four ridges on the upper surface
represent loaves of bread,[2] an inter-
pretation that would apply equally
well to the present example.

J.K.M.

1. Hayes 1959, p. 274.
2. Petrie 1909b, p. 8, pls. 9, 18.

Bibliography: Bruyère 1939, p. 296, fig. 166;
Letellier 1978, p. 31, no. 31.

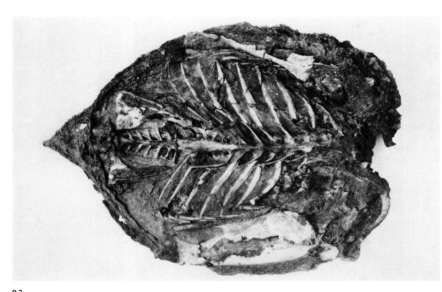

93
94

93

Prepared duck or pigeon

From Deir el Medineh
Dynasty 18, reign of Hatshepsut
Length 15.2 cm.; width 11.5 cm.
Musée du Louvre, Paris (E 14551)

To judge from the large number of
scenes of domestic fowl that have
survived from Egyptian paintings,[1]
their flesh was an important source of
protein that complemented, along
with fish and meat, the Egyptians'
diet of cereals, vegetables, and fruits.
The preferred method of cooking fowl
was either boiling or roasting on a
spit.[2]

This duck was prepared for cooking
following the method that is still used
in Egypt: it was split in two, spread
and pressed for grilling.

J.K.M.

1. Porter and Moss 1960, p. 468d.
2. Darby et al. 1977, p. 278.

Bibliography: Letellier 1978, no. 32.

94

Case with mummified pigeon or quail

From Deir el Bahri tomb of Seniu
Dynasty 18, reign of Amenhotep I
Length of case 17.5 cm.; length of fowl
10 cm.
Museum of Fine Arts. By exchange with
the Metropolitan Museum of Art
(37.552a-c)

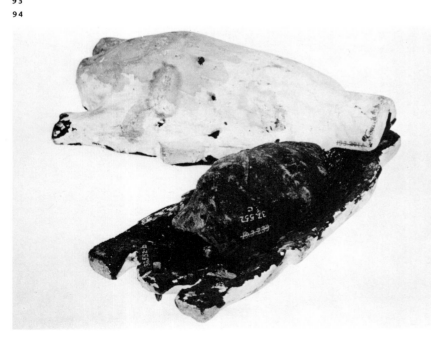

The wooden case, which was plastered on the outside and lined inside with bitumen, contains a small "mummified" fowl, probably a pigeon or quail wrapped in linen strips. In anticipation of the needs of the deceased, offerings of food and drink were placed in the tomb during the latter part of the Old Kingdom. Limestone models of dressed meats and fowl were common, as well as limestone food cases in the shape of trussed geese, trussed ducks, legs of beef, or the like,[1] used to contain dressed fowl or cuts of meat. Later these were carved from wood, like the present example.

J.K.M.

1. Hayes 1953, p. 118.

Bibliography: Lansing 1920a, p. 7.

95

95

Round bread with central cavity

From Deir el Medineh eastern cemetery
Dynasty 18, reign of Hatshepsut
Diameter 17.5 cm.
Musée du Louvre, Paris (E 14673)

It can be determined from surviving examples of Egyptian bread, offering lists, representations, and texts that the ancient Egyptian baker produced dozens of different sorts of bread for various occasions, even such fancy forms as cookies in the shape of animals.[1] Of the various shapes, the triangular, the conical, and the round were the most common. This round loaf, portions of which have been restored with wax, has a large cavity punched in the center, probably used to hold a garnish of some sort such as meat.[2] The loaf is paralleled by others also from the eastern cemetery at Deir el Medineh.[3]

J.K.M.

96

1. Schiaparelli 1927, p. 151, fig. 135.
2. Borchardt 1932a, pp. 73-78.
3. Bruyère 1937b, fig. 52, p. 106.

Bibliography: Letellier 1978, p. 32, no. 34.

Literature: Währen 1963; Wild 1975, cols. 594-598.

96

Round bread

From Deir el Medineh eastern cemetery
Dynasty 18, reign of Hatshepsut
Diameter 10.6 cm.
Musée du Louvre, Paris (E 14554)

Bread was one of the dietary staples of the ancient Egyptians of all economic levels, and the high proportions

97

of inorganic matter found in samples of their bread (see p. 108) have been shown to have resulted in tooth attrition and associated dental infections.[1] Almost all the stages in processing, from harvest to baking the finished product, contributed to its contamination, and inorganic materials such as fine sand or earth may even have been added to hasten the process of reducing grains to flour.[2]

Portions of this round loaf, examined radiologically at King's College Dental Hospital, London, show that it contains, in comparison with other ancient Egyptian and modern samples, only a moderate proportion of such impurities (more than the bread fed to dogs on one excavation in Egypt in the last decade, but fewer than those in bread samples from periods earlier than the New Kingdom).[3]

S.K.D.

1. Leek 1972.
2. Ibid., pp. 131-132.
3. Ibid., pp. 129-130, graphs.

Bibliography: Leek 1972, p. 129, chart; Letellier 1978, p. 32, no. 36.

Literature: Wreszinski 1926; Drenkhahn 1975.

97

Conical loaf of bread
Provenance not known
Probably Dynasty 18
Height 16 cm.; diameter 5.5 cm.
Museum of Fine Arts. Hay Collection, Gift of C. Granville Way (72.4757c)

This loaf, a portion of which has been broken away, is made of a coarsely ground grain. The purplish tinge could be explained by the addition of the flour of sweet figs,[1] but a more likely cause is the presence of small, reddish seeds of some sort.

Loaves of this shape and color have been found in several New Kingdom burials. The tomb of Kenamen shows a basket heaped with red, conical loaves,[2] and any of the loaves found in the eastern cemetery at Deir el Medineh had the same hue.[3] In the tomb of Rekhmire is depicted a heap of variously shaped loaves, each one given a hieroglyphic label.[4] The shape that corresponds most closely to the present example is called *herset,* which from other contexts is known to have meant carnelian or, more generally, a designation for some shade

98

of red.[5] The ancient Egyptians may therefore have understood *herset* as a general term for any loaf of this composition, just as we understand black bread to be made of very dark rye.

J.K.M.

1. Bruyère 1937b, p. 107.
2. Davies 1930, pl. 58.
3. Bruyère 1937b, p. 100.
4. Davies 1943, pl. 38.
5. Gardiner 1952, p. 13; Harris 1961, p. 120.

Bibliography: Hay 1869, p. 123.

98

Dom-palm nuts
Provenance not known
Date uncertain
Length 7 cm.; width 5.7 cm.
Museum of Fine Arts. Hay Collection, Gift of C. Granville Way (72.4748)

Two varieties of palm were known to the Egyptians: the date and the *dom.* Although the fruit of the *dom.* palm has a tough, fibrous exterior, the pulp is edible (said to taste like gingerbread);[1] it may also have been prescribed as a medicine for intestinal complaints.[2] The wood of the *dom* palm, one of the few native sources of wood for the Egyptians, was much valued for its strength, particularly in the construction of roofs. Readily identifiable by its distinctive forked trunk, the *dom* palm was frequently pictured in the tombs of the New Kingdom[3] and on ostraca.[4] An ostracon from Stockholm shows a monkey grabbing at a sack of palm

fruit,[5] and a similar scene is portrayed in the Theban tomb of Rekhmire.[6]

In Papyrus Sallier I, 8, 4[7] the god Thoth is equated with the *dom* palm.[8] This text reference, in conjunction with the knowledge that Thoth can appear in the aspect of a baboon, suggests a religious interpretation to the scenes and may help to explain a practice, widespread during the New Kingdom, of placing small baskets loaded with *dom*-palm nuts into tombs.[9]

J.K.M.

1. Hoskins 1835, p. 38; Darby et al. 1977, pp. 730-733.
2. Darby et al. 1977, p. 733.
3. Porter and Moss 1960, p. 161 (11), 175 (30).
4. Vandier d'Abbadie 1936, nos. 2001-2004.
5. Peterson 1973, p. 98, no. 108, pl. 59.
6. Davies 1943, pl. 48.
7. Caminos 1954, p. 321.
8. Bruyère 1937b, p. 108; Keimer 1938a, pp. 42-45; and Vandier d'Abbadie 1946, pp. 15-16.
9. Täckholm 1952, p. 211.

Bibliography: Hay 1869, no. 1075.

99

Pomegranate
From Deir el Medineh tomb pit Dx3
New Kingdom
Height 4.5 cm.
Ägyptisches Museum, Berlin (21530)

The pomegranate was probably imported into Egypt early in Dynasty 18 from western Asia.[1] The oldest text mentioning the tree is in the tomb of Ineni, who served kings Amenhotep I to Thutmose III,[2] and the fruit is pictured among other examples of Asiatic flora that Thutmose III had carved

99

100

upon the walls of his festival hall.[3] Thereafter it appears with increasing frequency in reliefs in the temples and paintings in the tombs of nobles. In the Theban tomb of the royal butler Djehuty, among gifts of flowers and fruits brought to Queen Hatshepsut, is a single huge pomegranate;[4] thirteen pomegranates tied in a chain and bunches of grapes are held by an official of the household of Sebek-hotep, major of the Fayum under Thutmose IV, in his tomb at Gurna.[5]

The distinctive turning-back of the outer husk at the end makes the pomegranate easily identifiable.[6] Imitations were made in many materials, including pottery, wood, faience,[7] glass[8] (cats. 87 and 188), and metal, for use as vases and, in miniature, as pendants to earrings.[9] Chased on the neck and shoulder of a silver or electrum pomegranate from the tomb of Tutankhamen[10] are garlands of lotus petals and a band of cornflowers and leaves.

The pomegranate was used not only as a food and an offering but also as a vermifuge or deworming agent.[11] There is evidence that its juice was added to color and flavor some wines just as grenadine is today.[12]

J.K.M.

1. Darby et al. 1977, p. 742.
2. Boussac 1896, pl. 9; Wreszinski 1923, pl. 60a; Sethe 1906, p. 73.
3. Wreszinski 1935, pl. 28.
4. Davies 1932, p. 282.
5. Davies and Gardiner 1936, pl. 44.
6. Keimer 1924, pp. 180-181.
7. Daressy 1902, pl. 30.
8. Nolte 1968, p. 173.
9. MacIver and Mace 1902, p. 90, pl. 50.
10. Edwards 1976a, p. 165.
11. Wreszinski 1913a, p. 15.
12. Darby et al. 1977, p. 616.

Bibliography: Anthes 1943, p. 53.

100

Raisins

Provenance not known
Date uncertain
Length 1-1.5 cm.
Agyptisches Museum, Berlin (7004)
Formerly in the Passalacqua Collection

Raisins are known as a sweet fruit in modern Western cultures and they may have been so regarded in ancient Egypt, or they may have been added to stuffings for savory meat dishes or to grains, much as they are today in Syria and Lebanon.[1] They were also

one of a host of remedies for intestinal ailments[2] and in the treatment of epilepsy and stroke.[3] The presence of raisins in a basket of toiletries has led to speculation that they were used in the manufacture of cosmetics.[4]

A basketwork bottle discovered in the tomb of Tutankhamen[5] was filled with raisins.

J.K.M.

1. Darby et al. 1977, pp. 139, 794.
2. Ibid., p. 716.
3. Ebbell 1937, pp. 104-105.
4. Bruyère 1937b, p. 109.
5. Carter 1933, p. 150 and pl. 80b.

101

101
Segmented bowl
Provenance not known
New Kingdom
Diameter 10.3 cm.
Museum of Fine Arts, Boston. Hay Collection, Gift of C. Granville Way (72.4310)

Carved of a single block of wood, this bowl is divided into three compartments. Three other such examples are known: another smaller bowl in Boston[1] and two in the Petrie collection.[2] By contrast, the segmented bowls depicted in numerous New Kingdom tomb scenes are commonly divided into two or four parts.[3] The contents are usually shown as though viewed from the top, and each compartment is filled with a different fruit or berry.[4]

G.L.S.

1. MFA 1979.557.
2. Petrie 1927, p. 45, pl. 40:44.
3. Two divisions: Davies and Davies 1923, pls. 54, 58, 63; Davies 1933, pls. 20, 28, 33; four divisions: Farina 1929, pl. 137.
4. Keimer 1924, pp. 118, 184, nos. 6-11.

102
Cucumber-shaped bottle
From Sedment tomb 2010
Dynasty 19-20
Length 16.6 cm.; width 4.8 cm.
University Museum, Philadelphia. Gift of the Egyptian Research Account (E. 15436)

The green faience bottle is reconstructed from three large fragments. Its black markings are too indistinct to allow certain identification of the species. Although the bottle could be said to resemble more closely a squash than a cucumber, gourds and squashes, which belong to the genus *Cucurbita,* were not known in the ancient world. Squash-shaped vegetables were regularly included in the funerary repast of the deceased and are a common feature in the scenes of offering tables piled high with meats, fowl, and vegetables for the enjoyment of the departed.

A similar faience bottle was found at Gurob, among a group of objects dated to the reign of Amenhotep III.[1]

102

Small bottles and flasks of this sort may have been used to hold additives for beer and wine.

J.K.M.

1. Petrie 1891, p. 17:11.
Bibliography: Petrie and Brunton 1924, p. 32.
Literature: Keimer 1924, pp. 13-17.

Metal Vessels

The Egyptians of the New Kingdom were accomplished metalsmiths, elaborating on and perfecting designs and techniques already long practiced. The objects in this catalogue show the range of metals most often used for vessels at this time: gold, silver, copper, and bronze.[1]

Egypt had always had abundant resources of gold in the Eastern Desert;[2] during the Middle Kingdom, she began receiving supplies of it from her Nubian territories, and in the Nineteenth and Twentieth Dynasties from Libya and Asia as well, in the form of booty and tribute.[3] Copper, too, could be found in abundance in the Eastern Desert, although it had to be mined from ores such as malachite.[4] In the Eighteenth Dynasty, additional supplies of copper were imported from Syria and Western Asia, and bronze, the alloy of copper and tin, came into extensive use.[5] Silver was lacking from Egypt's natural resources, appearing natively only as an element in other ores such as gold.[6] Indeed, it was long considered a kind of gold by the Egyptians, who called it "white gold" and valued it very highly. But by the beginning of Dynasty 18, even that lack was remedied, as large quantities were imported from Syria, Asia, and Libya.[7]

The equipment available to the New Kingdom smith was limited and fairly crude, and had apparently evolved but little from its predynastic and Old Kingdom beginnings. True, the blast furnace with foot-operated bellows had replaced the old pottery bowl over a bed of coals, blown with reed pipes with clay nozzles,[8] but the craftsmen still lacked proper shears and had to cut the metal sheets by punching out lines with a chisel, then bending the sheet along the line until it parted.[9] Tomb paintings and reliefs from the New Kingdom show that polished stones held in the hand were still being used to hammer sheets of metal and burnish finished vessels.[10] This may, however, have been a convention showing an out-of-date practice, for two hammerheads of New Kingdom date, one limestone and the other bronze, are similar in shape to those used by modern metalsmiths.[11]

Primitive as the tools of his trade might be, the New Kingdom metalsmith's repertoire of techniques was modern and complete, including soldering,[12] burnishing, engraving, chasing, and repoussé. Both solid and cire perdue, or lost wax, casting was practiced,[13] as well as other, more technical processes.[14] The bodies of the vessels were usually cold hammered, often from a single sheet of metal, over wooden stakes,[15] or over forms made of pottery, wood, stone, or metal, which would be removed once the vessel had taken shape.[16] Other parts, such as a handle (see cat. 109) or openwork decoration (see cat. 106), were often cast by the lost-wax method, in which beeswax was molded over a core of sand and clay, and a pottery form shaped over that; when the molten metal was poured in, the wax melted and ran out, leaving a thin shell of metal.[17] Joins might be riveted or soldered (see cats. 112 and 113); details of decoration might be added by repoussé, chasing, or engraving. Repoussé work is done on the back side to form raised relief on the front; chasing is essentially the opposite process, and the two are often used together, the chasing adding sharper outline and details to the repoussé (see cats. 107 and 113). It has been suggested[18] that the "engraving" done at this time was probably rather a very fine chasing (see cat. 107), since the sharp, hard edge needed to prevent damage to thin and malleable metals such as gold can be achieved only on iron or steel tools, which did not appear in Egypt until the Late Period.

Decoration of metal vessels became increasingly elaborate during the New Kingdom; even the most commonplace and mundane of objects received its share (see cat. 106). Fluting is one common trait that begins to appear with increasing frequency in Dynasty 18;[19] later it becomes patterned, as on the belly of cat. 112. Another typical motif is described under the same entry: a rosette on the bottom of a vessel and fluting or lotiform petaling up the sides. The rosette has, in fact, a long history in Egyptian vessel decoration; one in the form of an open lotus appears on the bottom of an alabaster vase of Teti, thus dating the motif to at least the Old Kingdom.[20] The rosette on the

bottom of cat. 107 is functional in that it is a raised ombo, but this is by no means always the case; the rosette on the bottom of a faience bowl of the Late Period is, in fact, a hindrance, preventing the vessel from standing upright.[21] The form of the rosette may be a simple marguerite-like fluting, as on cat. 112, or more in the form of the sharper-petaled blue lotus blossom, as on the bottom of cat. 107. The fluting that rises from the rosette up the sides of the vessel becomes increasingly elaborate as well; even if the form remains simple, the relief work is deeper as the Eighteenth Dynasty progresses,[22] but more often fluting is replaced altogether by alternating large and small lotus petals, pointing upward.[23] In fact, the lotus, particularly the blue lotus, appears not only on the sides of bowls and jugs but commonly on the tops of handles, where it may be either incised (see cat. 110) or cast in openwork (see cat. 109).

The palmette, a stylized depiction of a tree, begins to appear as a motif

Fig. 36. "Tree-of-life" motif from a jar stand (detail of cat. 106).

(fig. 36) on a variety of New Kingdom artifacts: the earliest examples of it occur on the funerary equipment of Amenhotep III;[24] others include the handle of a wooden cosmetic spoon of Dynasty 18[25] and Eighteenth-Dynasty scarabs,[26] the embroidered panels on a tunic from the tomb of Tutankhamen,[27] and two gold armbands of Ramesses II.[28] Two animals, goats, gazelles, or antelopes, leaping up against the palmette in a symmetrical design, are often an element of this motif. They appear as early as Dynasty 17 on a game board from Thebes[29] and can be seen in the New Kingdom on the end panel of a funerary box,[30] an openwork ring

stand (cat. 106), and the engraved registers around the necks of two silver jugs from the Tell Basta treasure.[31] It may be that the palmette is actually a stylized "tree of life" and that the motif is Syrian in origin;[32] however, the reverse is equally possible: that the appearance of this motif in Syrian art is due to Egyptian influence.[33] It has also been suggested that the development of the palmette can be traced back as far as the Old Kingdom.[34] A small version of the palmette was sometimes used as a space filler, as seen on cat. 106 between the backs of the two animals, and on a chair from the tomb of Yuya and Thuya.[35]

G.L.S.

1. Lucas 1962, p. 253.
2. Ibid., p. 224.
3. Ibid., p. 227.
4. Ibid., pp. 199-201.
5. Ibid., pp. 209, 220.
6. Ibid., p. 245.
7. Ibid., pp. 247-248.
8. Davies 1943, pl. 52; Aldred 1971, pp. 67-68.
9. Aldred 1971, p. 71.
10. Ibid., pl. 55.
11. Hayes 1959, p. 216, fig. 129; Aldred 1971, p. 69.
12. Davies 1943, pl. 53.
13. Ibid., pl. 52.
14. Lucas 1962, pp. 230-231.
15. Davies 1943, pl. 55; Aldred 1971, pp. 68-69.
16. Aldred 1971, p. 85.
17. Ibid., pp. 114-115.
18. Ibid., p. 72.
19. Petrie 1900, p. 34, pl. 24:2, 3.
20. Joseph Pilsudski University 1937, pl. 17.
21. Brooklyn Museum 1956, pl. 64:42.
22. Ibid., pl. 72.
23. Ibid., pl. 73.
24. Smith 1958, p. 137.
25. Kayser 1969, pl. 294.

103

26. Newberry 1908, pl. 20:4, 7.
27. Crowfoot and Davies 1941, pls. 20, 22.
28. Boreux 1932, pl. 45.
29. Mariette 1889, pl. 51.
30. Capart 1947, pl. 757.
31. Simpson 1959, figs. 4, 8.
32. Boreux 1932, p. 341; Montet 1937, pp. 142-147.
33. Steindorff 1937b, p. 122.
34. Smith 1965, p. 113.
35. Quibell 1908b, pl. 33

103

High-necked bowl

From Dra abu el Naga
Dynasty 18
Height 10.5 cm.
University Museum, Philadelphia. Eckley B. Coxe Junior Expedition (E. 14237)

The shape of this bowl, with its tall, slightly concave neck and rounded shoulder, first appears in the New Kingdom and continues well into Greek and Roman times, becoming increasingly stylized. The form may derive from stone bowls with short, recurved necks and round bodies from the Third Dynasty. These may be, in turn, copies of even earlier pottery bowls.[1] The form as it appears in the New Kingdom has a longer neck, either straight or concave, and a more defined shoulder. Late examples, such as a silver bowl dated to around 200 B.C. in the Brooklyn Museum[2] or a silver bowl from Mendes, now in Cairo,[3] show a more stylized form, with a taller, more concave neck and

a shoulder more sharply defined; often a band runs around the shoulder to separate it from the neck even more definitively. These late bowls are usually decorated elaborately, with a rosette on the bottom and either fluting or lotus petals extending up the sides to the shoulder.

The Philadelphia bowl is a relatively simple example of the form, and its outer surface is burnished but not decorated. A close parallel to it in the Metropolitan Museum was found nested in a group of metal bowls in a house in the New Kingdom town of Lisht.[4]

G.L.S.

1. Petrie 1937, p. 7, pl. 23:384-387.
2. Brooklyn Museum 1956, pl. 75.
3. Möller 1924, pl. 38.
4. Mace 1922, p. 15, figs. 18, 20.

104

Flask

From Semna
Dynasty 18
Height 21 cm.; diameter of rim 7.7 cm.
Museum of Fine Arts. Harvard University—
Museum of Fine Arts Expedition (29.1204)

Round- and pointed-bottom vessels were common throughout Egypt's history. The graceful form illustrated by this bronze flask began to appear by the end of the Middle Kingdom: the widely flared rim, with a rolled edge, flows into a tall, concave neck; the body is piriform. Hammered from a single sheet of metal (probably by means of a long, narrow *repoussé* hammer), the vessel was then scraped to remove the hammer marks.

The flask was found within the Semna Fort under the mud-brick temple of Taharqa. Two mirrors found with the vessel (cats. 215 and 216) are datable to Dynasty 18 by the form of their handles: one is in the shape of a girl holding a papyrus umbel over her head (cat. 215) and the other shows the Bes-image on a papyrus column (cat. 216). Two bronze ring stands (cat. 105) and a bronze bowl[1] were also found in this group.

Vessels of this graceful shape were common during the New Kingdom and appear in many materials, including pottery,[2] stone,[3] and glass.[4] A close parallel to the Boston flask, although perhaps somewhat earlier, is in the Kestner Museum. It is a slightly

104-105

smaller bronze flask (with a matching ring stand) from el Bersheh in Middle Egypt.[5] Another bronze flask, in London is inscribed "*wab* priest and sandalbearer of Amen, Djehuty-hotep" and has been dated to Dynasty 18, although no provenance is given.[6] Finally, a copper flask, in poor condition but originally of the same shape as the Boston flask, was excavated from a New Kingdom cemetery near Dakka, in the stretch of the Second Cataract in Nubia.[7]

G.L.S.

1. Dunham and Janssen 1960, p. 54, pl. 130d.
2. Steindorff 1937a, pl. 71a, b.
3. Petrie 1937, pl. 34:881.
4. Corning Museum 1957, pl. 1.
5. Kayser 1969, fig. 167.
6. Petrie 1937, p. 27, pl. 39:15.
7. Firth 1915, pl. 21.

Bibliography: Museum of Fine Arts 1952, p. 113, fig. 71; Dunham and Janssen 1960, p. 54, pl. 130d.

105
Ring stand

From Semna
Dynasty 18
Height 9 cm.; diameter 13.4 cm.
Museum of Fine Arts. Harvard University—Museum of Fine Arts Expedition (29.1201)

Vessels such as cat. 104 obviously cannot stand unsupported. In the absence of sand to set the vessel in, or a net to hold it, or a handle to hang it by, the simplest means of such support is a ring stand, a hollow circle of material usually shaped like a spool with flaring rims. Ring stands are as ubiquitous in Egypt as the round-bottomed vases they supported, and were made in as many materials: pottery (see cat. 54), stone,[1] faience,[2] metal, and even basketwork.[3]

This stand is hammered from a sheet of bronze. It was found beneath the Taharqa temple in the Semna Fort, together with a group of Eighteenth-Dynasty objects, including a bronze flask (cat. 104), which probably belongs with it. A second bronze ring stand, slightly smaller, was also in the group.

Containers supported on ring stands were so common a sight that they became a popular motif: vessels came to be made in the shape of a vase and stand all in one piece. One of the earliest examples of this is in the shape of a cup sitting on a short ring stand; it is carved from stone and dated to

the Early Dynastic Period.[4] This motif appears again in stone during the New Kingdom and becomes quite common, especially in the form of an amphora on a ring stand (e.g., cat. 116).[5] Of particular interest is a metal vase found in the tomb of the scribe Neferkhaut and his family in western Thebes, datable to the first half of Dynasty 18. This curious vessel was shaped to appear like a flask similar to cat. 104 sitting on a ring stand, all hammered from a single sheet of bronze.[6]

G.L.S.

1. Petrie 1937, pl. 14.
2. Wallis 1898, pl. 1.
3. Schiaparelli 1927, fig. 126.
4. Petrie 1937, pl. 14:143.
5. Ibid.
6. Hayes 1935, fig. 16.

Bibliography: Dunham and Janssen 1960, p. 54, pl. 130d.

106
Openwork ring stand and flask

Provenance not known
Dynasty 18
Height of stand 7.2 cm.; diameter of lower rim 9.5 cm.; height of flask 16 cm.
Field Museum of Natural History, Chicago (30177a, b)

An illustration of the New Kingdom trend toward the elaborate decoration of objects of everyday use, this bronze ring pot stand was made by the *cire perdue* method of casting.[1] In openwork, two goats leap up against a palmette; on the other side of the stand, a small version of the palmette fills the space between the goats' backs. On the bottom rim of the stand appears a short inscription: "What the helmsman of his majesty, Pa-aam, made."[2] On the body of the flask is an identical inscription placed between two horizontal lines, and just above it are partially erased remains of another, perhaps earlier, dedication.

Examples of the openwork casting of large objects, as opposed to jewelry and small pieces, are rare before the beginning of the New Kingdom.[3] Among the earliest New Kingdom examples are bronze ax heads dated to Dynasty 18,[4] obviously used for ceremonial purposes since they could hardly stand up to strenuous practical use. Other examples of openwork are a bronze mirror handle found at Thebes and now in Cairo,[5] and a few

openwork bronze pot stands, all dated to Dynasty 18. Two pot stands, now in Leipzig, were found in the tomb of the scribe User and his wife Tenefret at Aniba in Nubia.[6] One is an elongated version of the ordinary ring stand and is decorated with openwork registers showing birds in papyrus thickets around the top rim, men leading horses around the bottom, and plant forms around the middle. The second stand is in the form of a tripod with a flared ring top, and the openwork decoration shows people at a feast. A third ring stand, now in Turin, is from the tomb of Kha at Deir el Medineh.[7] Its openwork decoration consists of plant forms.

The fact that these other known openwork pot stands are securely dated to Dynasty 18 supports that dating for the Chicago stand.

G.L.S.

1. Aldred 1971, p. 114.
2. Steindorff 1937b, p. 123.
3. Aldred 1971, p. 114.
4. E.g., Smith 1958, pl. 98a, b.
5. Bénédite 1907, pl. 4.
6. Steindorff 1937a, pl. 96.
7. Schiaparelli 1927, fig. 126.

Bibliography: Steindorff 1937b, pp. 122-123, pl. 12; Capart 1947, pl. 698; Smith 1958, p. 137, pl. 99a.

Literature: Kühnert-Eggebrecht 1969, pls. 20-29.

107
Bowl

From the tomb of Djehuty (Theban tomb 11)
Dynasty 18, reign of Thutmose III
Diameter 18 cm.; height 2.2 cm.
Musée du Louvre, Paris (N. 713).
Formerly in the Drovetti Collection

The inner surface of this gold bowl was elaborately worked by means of alternate *repoussé* and chasing. The figures were first hammered into raised relief, then the forms outlined and details added with an incising tool. Six fish (*tilapia nilotica*) swim around a central rosette, and are in turn encircled by fifteen papyrus umbels. The central rosette is in fact a raised ombo, intended to allow the user to grasp the bowl more firmly by putting a finger in the hollow underneath. Thutmose III presented the bowl to one of his generals, Djehuty, probably as a reward for his war exploits. The bowl was interred with

106

Djehuty, and was found filled with a variety of funerary objects. A hieroglyphic inscription, neatly engraved around the circumference of the vessel, reads: "Given through the favor of the king, the king of Upper and Lower Egypt, Men-kheper-re [Thutmose III], to the hereditary prince and noble, the god's father, the beloved of the god, who is trusted by the king in all the foreign lands and the islands that are in the midst of the Great Green [the Mediterranean], who fills the storehouses with lapis lazuli, silver, and gold, the overseer of the foreign lands, the general, whose *ka* acted for [?] the lord of the two lands, the king's scribe, Djehuty."[1]

The vessel is a representation in gold of a popular New Kingdom style commonly made of blue faience.[2] Flat faience bowls were often decorated on the inner surface with river birds, water plants, and fish to appear as though one were looking into a pond (see cats. 138, 139, 140, 142; see p. 141). This motif became more complex, especially in metal vessels, incorporating boats, swimming figures, and often entire marsh scenes.[3] The simple fish motif, as represented on Djehuty's gold bowl, was also symbolic of procreation, and thus was associated in Egyptian belief with life and the continuance of life after death (see cat. 138). This, together with the fact that it was a physical symbol of his pharaoh's esteem, made the bowl doubly appropriate for inclusion in the tomb after Djehuty's death.

107

The Louvre bowl was found with the fragments of a second bowl, of silver, which, although in poor condition, appears to be much like the gold bowl.[4] The silver bowl, too, carries an inscription that describes it as a gift of the king's favor to the "king's scribe and overseer of the northern foreign lands, Djehuty."[5] Djehuty was one of the favored generals of Thutmose III and is known today not only for the objects in his tomb[6] but also from an account of his capture of the Palestinian city of Joppa. Through a clever ruse reminiscent of *Ali Baba and the Forty Thieves*, he hid his soldiers in baskets and had them carried into the city.[7]

G.L.S.

1. Sethe 1907b, p. 999.
2. Kayser 1969, p. 187.
3. See Daressy 1901, fig. 10; Desroches-Noblecourt 1976, pl. 71.
4. Boreux 1932, p. 348.
5. Sethe 1907b, p. 1001a.
6. Ibid., pp. 1000-1001.
7. Goedicke 1968, pp. 219ff.

Bibliography: Maspero 1889, p. 308, fig. 275; Sethe 1907b, p. 999; Vernier 1907, pl. 20; Möller 1924, p. 21, pl. 36; Schäfer and Andrae 1925, p. 689, pl. 412; Steindorff 1928, p. 94, pl. 297; Boreux 1932, pp. 341-342, pl. 45 (lower); Capart 1947, p. 24, no. 669b; Porter and Moss 1960, pp. 23ff.; Kayser 1969, p. 187, pl. 159; Seipel 1975, pp. 379-380, pl. 379.

108

Bowl with Hathor cow

Provenance not known
Dynasty 18
Height 11.48 cm.; width 21.5 cm.
Musée du Louvre, Paris (E 3163). Formerly in the Anastasi Collection

In the center of this bronze bowl a small metal statue of a divine cow stands on a narrow bridge that raises her above the bottom of the vessel. The bowl is undecorated except for the inscription: "that which the Lady Nefert-her made [? for] Hathor, Mistress of the West." The cow and bridge were cast in one piece and fastened to the bottom of the bowl with a rivet at either end of the bridge. Between the cow's horns is the sun disk.

Similar to this bowl are three found at Thebes, two of which are in Cairo and one in New York.[1] They differ slightly from the Louvre bowl in size and in the decoration of their cows. The inner surface of the New York bowl has apparently been treated with an

108

acid and salt solution to give it a matte texture[2] and the cow and bridge are of pot metal, a mixture of lead and other base metals. Two temples to Hathor were built in the vicinity of Thebes during Dynasty 18, and many votive objects have been found in that area; these three bowls were probably intended as such.

It has been suggested that vessels such as the Louvre bowl may have been used to contain flowers: the thick stems of the water lily or lotus might be held in place under the bridge.[3] The effect would recall the image of Hathor in her familiar form as a cow wandering through a thicket of water plants. Since Hathor was supposed to have nursed the infant Horus on Chemmis, an island in the marshes of the Delta, this scene would be particularly appropriate as a votive offering, and the dedicatory inscription on the Louvre bowl would support such a conclusion. The Egyptians were exceedingly fond of flowers, as is shown by tomb paintings and reliefs depicting bowls of flowers on feast tables, flowers among offerings and tribute, and flowers bedecking men, animals, and objects.[4] A flower bowl that served as a votive offering, or vice versa, would be a pleasure as well as a religious duty. On the other hand, since the three Theban bowls bear no dedication, they may well have served as flower bowls in a private home, where Hathor would have presided with equal propriety in her role as goddess of human joys. Later, the bowls may have been offered to Hathor on some special occasion, as apparently often happened with appropriate household objects.[5] Pottery bowls containing pottery cows have been found north of Thebes. Two were excavated at the Eighteenth-Dynasty site of Deir el Ballas.[6] A third was found at Diospolis Parva.[7]

G.L.S.

1. Winlock 1936a, pp. 148, 150-152 n. 6.
2. Cf. Hayes 1959, p. 65.
3. Winlock 1936a.
4. Davies and Davies 1923, pl. 5; Davies and Gardiner 1926, pls. 9, 36; Davies and Davies 1933, pls. 26, 30, to name a few examples.
5. Winlock 1936a, pp. 155-156.
6. Now in the Lowie Museum of Anthropology: 6-8661 and 6-8290.
7. Petrie 1901, pl. 35:103.

Bibliography: Winlock 1936a, p. 155, n. 16.

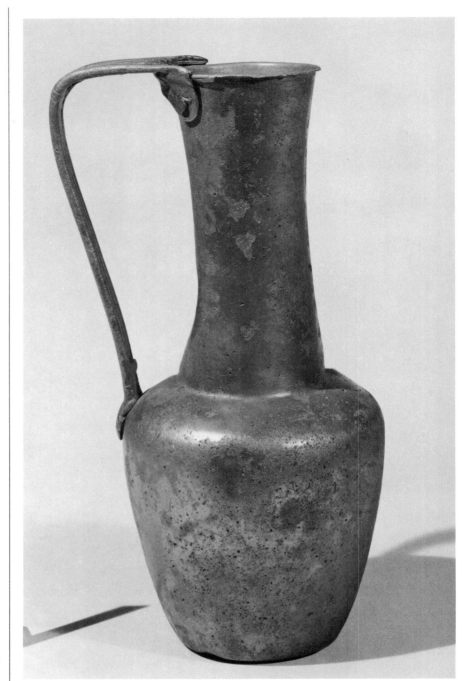

109

109

109

Tall-necked jug with lotus handle

Provenance not known
Dynasty 18-19
Height 19.3 cm.; diameter 8.8 cm.
University College, London. Petrie
Museum (8448)

This bronze jug is similar in shape to cat. 110, but it has a much taller, slightly concave neck. After the body was beaten from a single sheet of metal, the handle was cast, then fastened to the jug at the rim with three rivets on the inside, and at the base with two small rivets. The top of the handle is decorated with an openwork lotus blossom; the "stem," in three parts, flows down to end in a small plant form.

An alabaster jug with a similar tall neck and a papyrus design at the base of the handle[1] was found in the tomb of Yuya and Thuya in the Valley of the Kings; an undecorated, tall-necked jug of blue paste, also found in the Valley of the Kings, has been dated to Dynasty 18.[2] There is a similar jug in bronze, found in Meroitic tomb 101 at El Kurru, which differs somewhat in its proportions, the body being more globular and the neck wider than the London jug;[3] however, the handle is much the same: a lotus blossom at the top and a tripartite stem that flows down to end in a small plant form. Another tall-necked jug, this one with proportions more like those of the London vessel, was found at Matmar and dated by associated pottery to Dynasty 19 or 20;[4] the handle differs from that of the London vessel in that it is soldered on, rather than riveted, and the lotus blossom is incised rather than openwork. A third metal tall-necked jug, again of differing proportions — the neck becomes wider as it slopes down to meet the shoulder — is datable to around the time of Amenhotep III. The handle of this jug differs from that of the London vessel in that it has no decoration and was attached during the casting.[5]

G.L.S.

1. Davis et al. 1907, p. 31, pl. 26; Quíbell 1908, p. 49, pl. 26.
2. Daressy 1902, p. 24, pl. 6:24057.
3. Dunham 1950, p. 110, pl. 41d.
4. Brunton 1948, pp. 67-68, pl. 49:1.
5. Petrie 1890, pl. 18.

Bibliography: Petrie 1937, p. 27, pl. 39:16.

Literature: Bonnet and Valbelle 1980, p. 7, fig. 5.

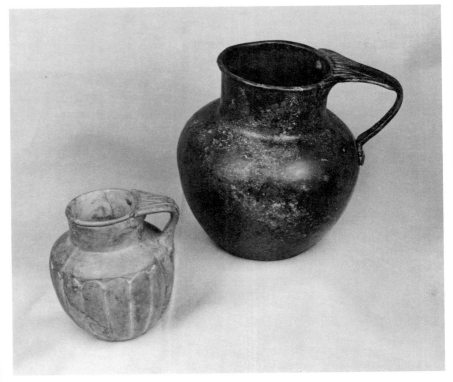

110, 111

110

Jug with lotus handle

Provenance not known
Dynasty 18-19
Height 13.7 cm.
Detroit Institute of Arts (48.142)

The shape of this squat bronze jug, with its rolled rim, short neck, broad shoulder, flat base, and handle, began to appear during Dynasty 18. It is a very functional shape, probably used for pouring liquids. The jug was hammered from a sheet of metal, and the handle, incised with the design of a blue lotus, was fastened to the rim with three rivets on the inside.

Very common during the New Kingdom, three jugs like the present example have been found at Abydos alone.[1] All three have an openwork lotus on the handle and date to Dynasty 18. Another very similar jug, in the Hildesheim Museum, dates to Dynasty 19.[2] A Nineteenth-Dynasty bronze jug, found at Dendera, has an undecorated handle, and its body shows the fluting that first became popular during the Eighteenth Dynasty.[3]

The single-handled jug, with its standard shape and decoration, became so

common during the New Kingdom that it was occasionally imitated in other media (see cat. 111).

G.L.S.

1. MacIver and Mace 1902, pls. 44, 46, 47.
2. Kayser 1969, pl. 161.
3. Petrie 1900b, pl. 24:3.

Literature: Bissing 1901, p. 49.

111

Faience jug with lotus handle

Provenance not known
Probably New Kingdom
Height 9.3 cm.
Detroit Institute of Arts (48.143)

A close imitation of the bronze lotus-handled jugs common to the New Kingdom (see cat. 110), this faience vessel displays the fluting often found on metal jugs, such as that from Dendera.[1] The top of the handle is decorated with an "incised" lotus blossom, and three little faience "rivets" can be seen on the inside of the mouth, as if fastening the handle to the jug.

A parallel in blue glass, now in Belfast, was found in Qau tomb 4990 and dated to Dynasty 25.[2] Although of later date than the Detroit jug — it has

the narrower fluting common to the Third Intermediate Period and later[3]— the glass jug too shows many of the details commonly found in, and functional only for, metal jugs: the lotus on the top of the handle, and three "rivets" on the inside of the rim.

G.L.S.

1. Petrie 1900b, pl. 24:3.
2. Brunton 1930, pl. 47:18.
3. Brooklyn Museum 1956, pl. 72.

112
Bowl with ring handle
Provenance not known
Dynasty 18-19
Diameter 11.3 cm.; height 3.6 cm.
University College, London. Petrie Museum (8539)

The pattern incised on the outer surface of this bronze bowl is typical of the New Kingdom: a fluted rosette on the bottom, a register of petal-like fluting extending up the sides, and a final garland of lotus petals around the rim. A ring of hammered wire hangs through a holder riveted to the rim of the bowl.

Vessels with a ring handle and of this simple shape, with or without decoration, are common during the New Kingdom. Two undecorated bowls are dated to Dynasty 18 or 19[1] and an undecorated bowl with a ring handle similar to that of the present example, now in the British Museum, was acquired in Thebes.[2] Another two bowls were found under a house in the New Kingdom town of Lisht.[3]

The pattern of decoration exemplified on the London bowl occurs on a variety of vessels during the New Kingdom and later, including jugs and high-necked bowls,[4] and becomes increasingly elaborate. The rosette on the bottom may retain the simple form it has on the London bowl, or it may appear more like lotus petals. In either case, it is more likely to be *repoussé* work than incised. The fluting around the middle often takes the form of lotus petals rising from the bottom rosette in later examples, or even alternating large and small whole lotus buds with stems, again, deeply embossed rather than incised.[5] Simple fluting still occurs on some vessels of late date, but it too is deeply indented.[6]

G.L.S.

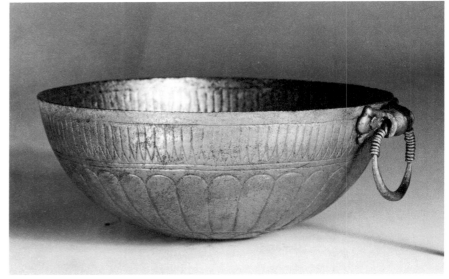

112

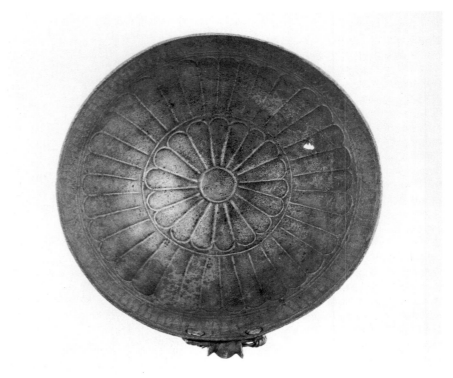

112

1. Petrie 1937, pl. 40:39, 40.
2. Wilkinson 1883b, p. 8, fig. 275:1, 2.
3. Mace 1922, figs. 18, 20.
4. Brooklyn Museum 1956, pls. 73, 75.
5. Möller 1924, pl. 38.
6. Lansing 1938, fig. 1, upper row; Oliver 1977, no. 7.

Bibliography: Petrie 1937, p. 27, pl. 39:14.

113
Flask with face
Purchased at Hawara
Probably New Kingdom
Height 10.3 cm.
University College, London. Petrie Museum (28052)

This gold flask is similar in shape to the round-bottomed vessels of the New Kingdom, such as cat. 109: it has a tall neck with a slightly flared rim and a rounded shoulder. An obvious

point of difference is the ring base that it possesses instead of a round bottom. The neck and body of the flask were made separately, hammered from sheets of metal and then soldered together at the shoulder. Two suspension loops, one on either side, through which a carrying cord would be passed, were soldered on afterward. The relief bust on front and back consists of a human face down to the shoulders, surrounded by crosshatching. Two arms hang from the shoulders and bend at the elbows; the fingers of the hands meet below the neck.

Vessels with human faces modeled or painted on the sides are common in Egyptian ware. Usually it is possible to identify the face as belonging to a god, often Bes,[1] a goddess such as Hathor, or occasionally a foreign captive, as on the pilgrim flask in the West Berlin Museum,[2] or simply a human figure, usually female (see cats. 84, 366). This last possibility is suggested by the position of the hands, similar to that on feminoform vases, where they cover breasts (see cat. 50). Another clue is to be found in the curled, somewhat hunched position of the arms and the crosshatching that surrounds the face and covers the vessel up to the shoulder; these are paralleled in the many hedgehog vases that proliferated at this time.[3] Here the difficulty is that the face and hands are definitely human, and no other examples of a hedgehog and human combination are known. It has been suggested also that the face is meant to represent Hathor,[4] but the head lacks the cow ears typical of Hathor depictions.

The closest parallel to the face appears on scarabs of the Second Intermediate Period, New Kingdom, and later (see cat. 356).[5] The back of this type of scarab is divided in half, the upper half filled with crosshatching, while the lower is composed of a human face. The face on the London flask differs from that on the scarabs in that it has a more domed forehead and the crosshatching extends farther down around the face. In addition, the scarab faces possess no arms. A similarly shaped flask of glass, with a similarly vague face modeled on the side, was found at Gurob and dated to Roman times.[6] The fact that the London flask has a ring base, together

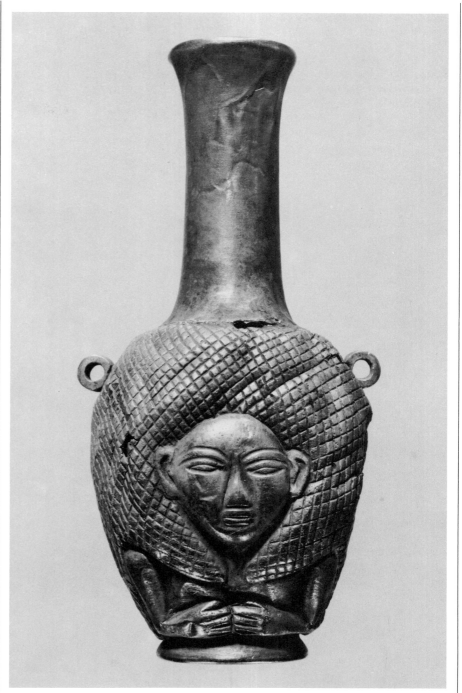

113

with its similarity to the scarabs, suggests a date for it in the New Kingdom.

G.L.S.

1. Höhr-Grenzhausen Rastel Haus 1978, p. 173, no. 275.
2. Kayser 1969, fig. 108.
3. See, e.g., Kayser 1969, fig. 121.
4. Petrie 1937, p. 27.
5. See also Hall 1913, pl. 121:1240-1241; Petrie 1917a, pl. 68:75.
6. Petrie 1891, pl. 33:7.

Bibliography: Petrie 1937, p. 27, pl. 39:24.

Stone Vessels

By the early Dynastic Period, the Egyptians were accomplished stone-workers. More numerous and skillfully made vessels have been found in tombs from that time than from any other in Egypt's history. Starting with crude bowls and dishes of basalt during early predynastic times, the Egyptians gradually added almost every available stone — hard or soft, compact or brittle—to their repertoire. All of the stones used were native except obsidian, which may have been acquired in trade from Abyssinia.[1] Certain stones were always favored above others in the making of vessels, namely limestone, basalt, and alabaster, followed by breccia, marble, and serpentine.[2]

By the end of the Old Kingdom, the number of stone vessels made decreased, and many types of stone were dropped from the stoneworker's repertoire, especially the harder varieties, leaving alabaster as the principal stone used for vessels. Alabaster is a fairly soft stone that polishes well. It is white or a yellowish white in color, often striped or veined like marble, and almost translucent when cut thin. Egyptian alabaster is actually calcite (crystalline calcium carbonate, not to be confused with Roman alabaster, which is calcium sulphate); it occurs in the Sinai and the Eastern desert. All but three of the seventy-nine stone vessels found in Tutankhamen's tomb were of alabaster; the remaining three were of serpentine, which, like alabaster, is a fairly soft stone and is found throughout the Eastern Desert. In color it is a mottled dark green to almost black. Some stones, such as breccia, apparently continued to be admired for their color or appearance, since they were even imitated in paint on wood.[3]

Tomb paintings and reliefs, together with what remains of the actual tools, indicate that stoneworking equipment of the New Kingdom was little different from that of the Old Kingdom. First, the block of raw stone would be cut out, probably with a copper-edged saw. A chisel was then used to dress the soft stone into rough shape; a drill probably had to be used on harder stone. The shape would then be smoothed and finished with blocks of stone, probably granular sandstone, held in the hand, in a vertical move-

ment, from top to bottom.[4] Only after the completion of the exterior of the vessel was the interior hollowed out. This order of process is illustrated by an amethyst vase that was completely finished on the outside before a flaw was discovered that prevented the completion of the hollowing out.[5] Hollowing was achieved with a drill (fig. 37), set with stone bits that were usually made of flint (but occasionally of sandstone, limestone, or diorite) and were either round or half-moon-shaped.[6] They came in different sizes to accommodate different types of vessels;[7] a pointed head may have been used to start the hole.[8] More

Fig. 37. Workman adjusting the drill with which he is hollowing out a stone vase (from Theban tomb 100).

common was the copper tubular drill, which "cut out" cylindrical cores that could easily be chiseled or hammered free, thereby saving a great deal of time and energy. In some cases, vases may have been hollowed out in sections, then cemented together.[9] The actual cutting agent was the abrasive powder fed into the drill, which was weighted with rocks.[10] This powder was once thought to be emery,[11] but it was more probably native quartz sand, which would be sufficiently hard to grind any stone used by the Egyptians during the New Kingdom.[12]

Several of the stone-vessel types popular during the New Kingdom were of foreign origin, or were heavily influenced by foreign wares — not surprising, considering the increase in direct contact between Egypt and her neighbors during the Second Intermediate Period and the foreign wars of Thutmose III, and the resulting cosmopolitan atmosphere of the New Kingdom. Cypriote base-ring pottery was one of the major influences on Egyptian stoneware. The ring foot can

be seen on many otherwise Egyptian vessels, such as cat. 121, which usually occurred with a flat base.[13] The bulbous body, as well as the ring base of Cypriote ware, is exemplified by cat. 118, although the ribbon handle of the latter is typically Egyptian. The pilgrim flask (see cat. 63) and its variant, the ring vase (see cat. 124), on the other hand, were inspired by imported pottery. Originally occurring with a short neck, the pilgrim flask in Egypt gradually lengthened in body and neck during Dynasty 19.[14] The inspiration for the dish on a stand, or "tazze" (cat. 120), may be foreign imports, in this case from Syria.[15] Some long-standing Egyptian stone-vessel styles continued during the New Kingdom, often acquiring fashionable new details. Tripartite ribbon handles, as seen on cat. 109 and in stone on cat. 118, were added to the simple bowl shape of cat. 125. Ring stands came to be carved in one piece with their vessels, as in cat. 116, and some vessels that had previously been made in pottery began to appear in stone, such as cats. 114 and 122.

G.L.S.

1. Lucas 1962, p. 416.
2. Ibid., p. 421.
3. Hayes 1959, pp. 154, 228.
4. Bonnet 1928, p. 11.
5. Quibell 1935, p. 77.
6. Bonnet 1928, p. 12.
7. Lucas 1962, p. 423.
8. Davies 1943, p. 49.
9. Ibid., p. 49.
10. Davies 1922, pl. 23; Davies 1925b, pl. 11; Bonnet 1928, p. 12; Davies 1943, pl. 54; Hartenberg and Schmidt 1969.
11. Petrie 1937, pp. 2-3.
12. Bonnet 1928, p. 13; Lucas 1962, pp. 42-43, 73.
13. Petrie 1937, p. 13, pl. 34:869-872.
14. Ibid., p. 14, pl. 36, nos. 915-919.
15. Ibid., p. 12.

Literature: Rieth 1958; Goyon 1970.

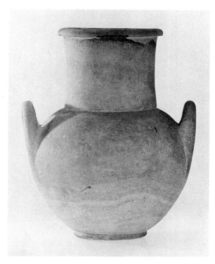

114

114
Amphora

Provenance not known
Reign of Hatshepsut to late Dynasty 18
Height 26.5 cm.; diameter 19 cm.
Museum of Fine Arts. Hay Collection, Gift of C. Granville Way (72.555)

Like cat. 115, this alabaster amphora was originally equipped with a lid. Amphoras of this general shape seem to appear first in pottery during the reign of Hatshepsut[1] and to continue into the Amarna Period. The stone version occurs from the reign of Thutmose III onward. A vase of similar shape now in Cairo[2] is inscribed with the name of Thutmose III and its capacity. This is given in *hin,* a measure used principally for liquids, and the vase still contains part of its original contents described as "brown ointment."[3]

Apart from the handles and shallow ring foot, the amphoras are clearly related in shape to cats. 117 and 118, which were in circulation at the same time. Versions also exist in pottery and glass.

J.D.B.

1. See Daressy 1902, pl. 5.
2. Bissing 1907b, pp. 156-157, pl. 4.
3. Petrie 1937, p. 13.

Bibliography: Hay 1869, cat. 248.

115
Amphora

From Abydos tomb D115
Dynasty 18, reign of Thutmose III to Amenhotep III
Height 14 cm.; width 12.7 cm.
Museum of Fine Arts. Gift of Egypt Exploration Fund (01.7273a, b)

This serpentine amphora from a shaft and chamber tomb at Abydos still retains its original cover. The other New Kingdom objects found with it suggest a date range between the beginning of the reign of Thutmose III and that of Amenhotep III.

J.D.B.

Bibliography: MacIver and Mace 1902, p. 89, pl. 47.

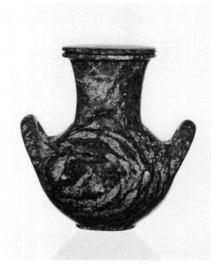

115

116
Amphora

Provenance not known
Dynasty 18, reign of Hatshepsut to Amenhotep III
Height 21 cm.; 7.9 cm.
Rijksmuseum van Oudheden, Leiden. Anastasi Collection (A AL 26/H385/E. xlii 139)

This elegant alabaster vessel was almost certainly used for the storage of scented oil (see cat. 114). A set of four limestone vases, including one of this type, was made for the burial of Yuya, the father-in-law of Amenhotep III.[1] Also comparable, though of a different shape, are the elaborate vases filled with oil that were provided for the tomb of Tutankhamen, whose contents were valued by thieves as

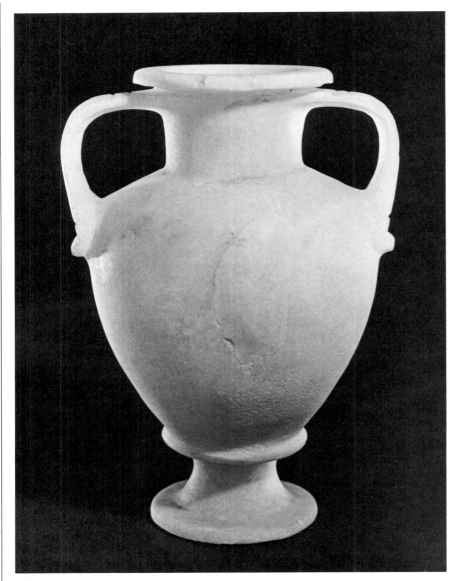

116

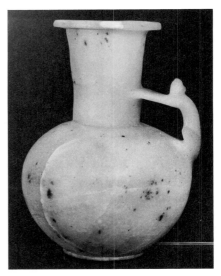

117

other vase of New Kingdom date with monkey handle from Abusir is in the Cairo Museum[3] and an additional example was found at Saqqara.[4] A fragment of another example without provenance, formerly in the Hornblower Collection, is now in the Fitzwilliam Museum.[5]

J.D.B.

1. Peterson 1973, pl. 56; Brunner-Traut 1979, pl. 17.
2. Hayes 1953, p. 128, fig. 78; p. 245, fig. 157.
3. Bissing 1907b, p. 64, pl. 5.
4. Quibell and Hayter 1927, p. 38, pl. 20.
5. E.202.1939; see Petrie 1937, pl. 27:548, for a second such piece.

Bibliography: Capart 1931, pl. 79a; Hornemann 1969, no. 1944.

118

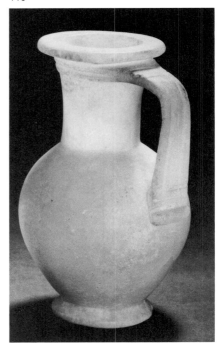

much as the gold burial equipment. There is a version without handles[2] that seems to be of an earlier date, ranging from the end of the reign of Amenhotep I to the reign of Thutmose III. The amphora seems to occur first during the reign of Hatshepsut[3] and to disappear after the reign of Amenhotep III.

The base of this vessel, which copies the shape of the ubiquitous pot stand (see cat. 54), is carved in one piece with the body; in other examples[4] the base was a separate element and is now missing.

J.D.B.

1. Quibell 1908b, p. 48, pl. 24; Davis et al. 1907, pl. 29.
2. Carter 1916, pl. 22:14; Petrie et al. 1912, pl. 16.
3. See Daressy 1902, pp. 12-13, pl. 4.
4. E.g., MFA 44.30.

117
Vase

Provenance not known
Dynasty 18, reign of Thutmose III to Amenhotep III
Height 21 cm.; diameter 11.6 cm.
Musées Royaux d'Art et d'Histoire, Brussels (E. 4991)

This alabaster vessel has a handle formed by the figure of a squatting monkey with outstretched arms. The animal's pose, with his head turned back, recalls the scene, to be found on tomb walls and in artists' preparatory sketches,[1] of a tame monkey climbing a palm tree to shake down the fruit. Animal forms, whether whole vases or details such as a handle, lid, or spout, are common in Dynasty 18, although monkeys often appear earlier.[2] An-

118
Pitcher

Provenance not known
Dynasty 18, reign of Thutmose III to
Amenhotep III
Height 14.7 cm.; diameter of rim 6.3 cm.
Fitzwilliam Museum, Cambridge. Gift of
E. Towry Whyte (E. 426.1932)

The distinctive shape and decoration
of this alabaster pitcher was copied
from Cypriote base-ring ware (see cat.
65), which was imported into Egypt
from the late Second Intermediate
Period until the reign of Akhenaten.[1]
Curiously enough, the alabaster ver-
sion is almost as common in Egypt as
the Cypriote jugs it imitated; a pitcher
in Boston[2] provides a close parallel.
Another, in the Cairo Museum, is from
the tomb of Maiherperi, a high official
who served Queen Hatshepsut[3] (cf.
cat. 199). Imitations exist also in
faience and glass. Since the imitations
do not continue to appear after the
base-ring ware itself ceased to be im-
ported, the popularity of the shape
may not have been due simply to
fashion but may have owed something
to the identification of the container
with its contents. It has been sug-
gested[4] that the vessels were filled
with honey containing opium, and that
the opium poppy seed pod was the
inspiration for the pottery's shape and
particular decoration. Thus the con-
tainer was thought to contribute to
the effectiveness of the drug, which
was used for a wide variety of me-
dicinal purposes. It is likely that this
pitcher contained a scented oil or fat
used as a cosmetic, rather than an
opium mixture. Results of analyses of
such fats that have been preserved
have proved unsatisfactory so far,
owing to the evaporation or deteriora-
tion of the original substance,[5] but
almond oil and scented animal fats
are possibilities.

The pitcher is carefully made and the
surface polished to remove tool marks.
Both the container and its contents
would have been costly items, to be
found only in the homes of the
wealthy.

J.D.B.

1. Merrillees 1968a, passim.
2. MFA 11.1479.
3. See Daressy 1902, pl. 4.
4. Merrillees 1962b.
5. See Lucas 1962, pp. 327-329.

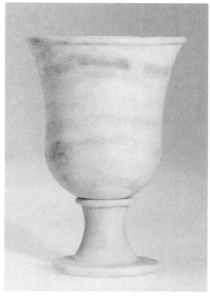

119

119
Goblet

Provenance not known
Dynasty 18, reign of Thutmose III
Height 11.4 cm.; diameter 7.6 cm.
Museum of Fine Arts. Hay Collection,
Gift of C. Granville Way (72.516)

Small stemmed cups or goblets be-
came fashionable as drinking cups
from the middle of the Eighteenth
Dynasty until the end of the New
Kingdom. They appear frequently in
banqueting scenes in wall paintings.
Made usually of alabaster[1] and also of
glass (see cats. 173 and 174), hard
stone, precious metals, and faience,
they hardly ever occur in the cheapest
material of all — clay. This example
is made of a fine-grained alabaster;
the foot was carved as a separate
piece into which the doweled cup fits.

A close parallel, in the Metropolitan
Museum of Art, comes from the burial
of the three wives of Thutmose III, and
is fitted with a gold band around the
rim.[2]

J.D.B.

1. MacIver and Mace 1902, pl. 51; Bissing 1907b,
 pl. 6; Petrie 1937, pl. 32; Dunham 1978, pl. 31.
2. Winlock 1948, pl. 35b, right.

Bibliography: Hay 1869, no. 277.

120
Dish on stand

Provenance not known
Dynasty 18-19, reign of Amenhotep III to
Ramesses II
Height 14 cm.; diameter 18.5 cm.
Cleveland Museum of Art. Gift of the
John Huntington Art and Polytechnic
Trust (14.625)

This alabaster *tazze* or dish on a stand
was probably used to dispense the
scented ointment worn at feasts.[1] The
stand was made separately and, al-
though it may not belong with this
particular dish, is of the traditional
shape.

The dish first appears under Thutmose
III with two ribs and little or no foot.[2]
Dishes with three ribs and a separate
foot begin to appear under Amen-
hotep III, and a fourth rib is added
later. Examples in faience also exist[3]
and the shape suggests that it was de-
rived from a metal prototype.[4] Stone
was undoubtedly a more satisfactory
material for the preservation of an oily
substance such as ointment.

Perhaps the earliest and latest datable
examples are from the burnt deposits
from Gurob[5] from the time of Amen-
hotep III (or a little later) and Rames-
ses II, respectively.

J.D.B.

1. Davies 1925b, pl. 7.
2. Petrie 1937, p. 12, pl. 33:820-837.
3. Scott 1973, fig. 24.
4. Cf. Petrie 1937, pls. 39:21-22, 40:31.
5. Petrie 1891, pls. 17:10, 18:23.

Bibliography: Williams 1918, pp. 166-167, pl. 26:3.

120

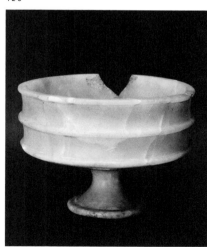

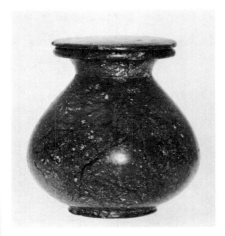

121

121
Jar

Said to be from Akhmim
Early Dynasty 18
Height 9 cm.; diameter of rim 6.5 cm.
Museum of Fine Arts. Emily Esther Sears
Fund (04.1882a, b)

This small ointment jar with matching
lid is made of black serpentine. It
belongs to a large class of pear-shaped
jars with flat bases, introduced at the
beginning of the Eighteenth Dynasty
and lasting throughout the New King-
dom.[1] This is an early example and its
shallow ring base and atypical rim
relate it to kohl pots[2] and to a lime-
stone jar in the Metropolitan Museum
from an early Eighteenth-Dynasty
burial at Thebes[3] (for the jar's possible
contents see cat. 114).

The material is unusual at a time when
alabaster was favored above all stones
for cosmetic jars, but the mottled ap-
pearance of serpentine must have
been admired since it was imitated in
paint and applied to vases made of
wood.

J.D.B.

1. Petrie 1937, pl. 34:869-872.
2. Ibid.: 692, 694.
3. Hayes 1959, fig. 35.

122
Vase

Provenance not known
Mid-to late Dynasty 18
Height 7 cm.; diameter 5 cm.
Museum of Fine Arts. Hay Collection,
Gift of C. Granville Way (72.571)

Like cat. 123, this serpentine vase rep-
resents the most common class of
Eighteenth-Dynasty stone vessels. Its
trumpet-shaped base may have been
inspired by the Cypriote base-ring
ware juglets (see cat. 65). A pottery
vase of the same shape was found at
Zawiyet el Aryan in a basket with
toilette articles (see cat. 67), and an-
other in Egyptian blue from a burial at
Rifeh[1] is now in Boston.[2]

E.B.

1. Petrie 1907, pl. 37a.
2. MFA 07.549.

Bibliography: Hay 1869, no. 275; New Orleans
Museum of Art 1977, no. 60.

Literature: Monnet-Saleh 1970, p. 122, no. 539.

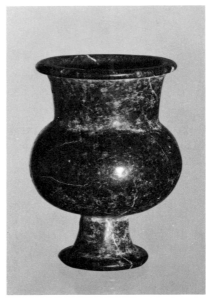

122

123
Vase

Said to be from Sheikh Ali
Mid-to late Dynasty 18
Height 10.5 cm.; diameter 9 cm.
Museum of Fine Arts. Emily Esther Sears
Fund (04.1868)

This alabaster vessel typifies the most
common class of stone vase in use in
the Eighteenth Dynasty. The shape
occurs also in glass (cat. 175), faience,
and metal. While the proportions of
the vessel and the form of its base may
vary, the combination of flat ledge rim
and long, slightly concave neck set off
from a globular body is common to
the whole class. This example has the
traditional pot stand-shaped base,
whereas cat. 122 has a trumpet-
shaped base. Both vessels show drill-
ing lines on the inside of the foot and
marks of smoothing and polishing on
the interior. They were probably used
to store perfumed oils and fats, and
may be compared with gold, silver,
and glass examples from the burial
equipment of the three wives of
Thutmose III.[1]

J.D.B.

1. Winlock 1948, pls. 35-36.
Literature: Bissing 1907b, pl. 4:18363.

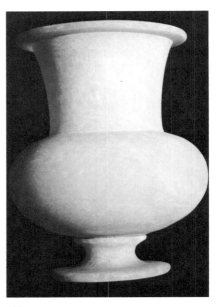

123

124
Ring flask

From Abydos tomb D16b
Dynasty 18
Height 12.6 cm.; diameter 4.5 cm.
Manchester Museum [England]. Gift of
Egypt Exploration Fund (2950)

True pilgrim flasks in alabaster are
common, but ring vases are scarce,
and for the present one may assume
that they have the same time range as
pottery ring vases (see cat. 88). Prob-
ably used to store a cosmetic oil, this
example was originally tightly sealed
by tying a piece of linen over the
mouth.

The familiar "pilgrim flask" shape of
the vase has a central hole around
which concentric circles were usually
painted or incised. This example has
a circle in brown paint outlining the
hole. A relief band joins the handles.

A small ivory pilgrim flask with an in-
cised line around its center, dated to
the reign of Thutmose III,[1] has a similar
raised band joining the two handles.[2]
Cat. 125, a stone bowl, also comes
from this tomb.

J.D.B.

1. Fitzwilliam E. 13.1901.
2. MacIver and Mace 1902, pl. 44, D108. Abydos tomb D16b was a shaft-and-chamber tomb, but no information on the number of burials or the precise association of the objects is given. The limestone *ushebti* of Huy-May from the tomb (Randall MacIver and Mace 1902, pl. 39) belongs to Schneider's type VA, and carries version IVD of the spell, which he dates to the Eighteenth or Nineteenth Dynasty (Schneider 1977, part 1, pp. 102-104).

Bibliography: MacIver and Mace 1902, pl. 44, D16b.

125

Bowl

From Abydos tomb D16b
Dynasty 18
Height 6 cm.; diameter 17 cm.
Manchester Museum [England]. Gift of Egypt Exploration Fund (2954)

Borrowed from a metal prototype,[1] the ribbed handles of this alabaster bowl enliven its simple shape. Two bowls in the Cairo Museum[2] are slightly carinated on the bottom, while the ribbon handles have a similar incised decoration. Grooved handles still appear in a wooden version of Dynasty 19 date.[3] This example was found at Abydos with cat. 124.

J.D.B.

1. Schiaparelli 1927, fig. 125, p. 172.
2. JE 52362, JE 89317.
3. Petrie and Brunton 1924, pl. 66:12.

Bibliography: MacIver and Mace 1902, p. 88, pl. 44.

126

Bottle

Provenance not known
Dynasty 18-19
Height 19.1 cm.; width 4.9 cm.
Museum of Fine Arts. Gift of Mrs. Horace L. Mayer (1981.281)

The shape of this long, slim alabaster bottle, with its short neck and pointed bottom, is a common one in the New Kingdom.

Alabaster bottles of this sort have been found at Riqqeh,[1] Abydos,[2] and Gurob;[3] in the Petrie Collection in London there is another example, unfortunately of unknown provenance.[4] Besides stone, these bottles were made of faience (cat. 150) and pottery (cat. 91). They may have been used to

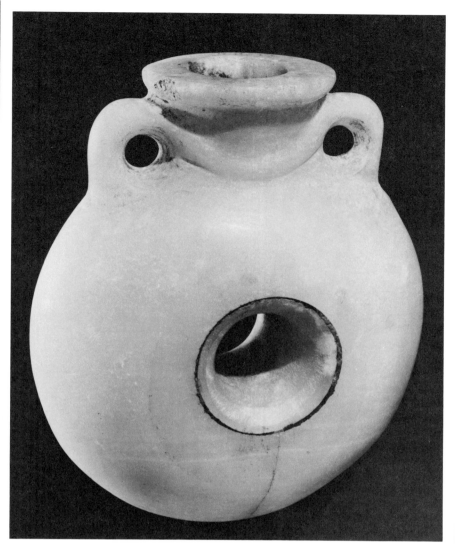

124

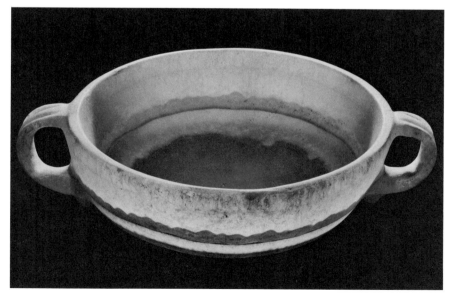

125

131

pour spiced liquids or to contain perfume.[5]

G.L.S.

1. Engelbach 1915, pl. 14:S63.
2. Peet 1914, pl. 10:17.
3. Brunton and Engelbach 1927, pl. 26:38.
4. Petrie 1937, pl. 34:878.
5. Hayes 1959, p. 323.

126

127

127

Mortar and pestle

From Abydos tomb D115
Dynasty 18, reign of Thutmose III to Amenhotep III
Height of mortar 9.8 cm.; height of pestle 10.9 cm.
Museum of Fine Arts. Gift of Egypt Exploration Fund (01.7268–7269)

Until recently a pestle and mortar with lug handles like this one were part of the standard equipment in any kitchen; they were as common in the Eighteenth Dynasty and almost every large cemetery of the period has produced comparable examples.[1] The shape varies little during the New Kingdom. Found in the same tomb were a serpentine amphora (cat. 115), a lotiform chalice (cat. 145), a double ivory kohl tube and stick (cat. 278), and a cylindrical ivory cosmetic container (cat. 26), all datable between the reigns of Thutmose III and Amen-

128

hotep III. The alabaster mortar, broken in half with two large chips missing from its rim, has been restored in wax; the pestle is of limestone or alabaster. While such mortars could be used to grind spices, nuts, or dried fruits, they probably served also for grinding the ores used for eye paints.

J.D.B.

1. E.g., Peet 1914, pl. 14:20; Engelbach 1915, pl. 14:S64.

Bibliography: MacIver and Mace 1902, p. 89, pl. 47.

128

Goblet and cylindrical vase
Said to be from Sheikh Ali
Late Dynasty 18
Height 8.8 cm.; length of support 11 cm.
Museum of Fine Arts. Emily Esther Sears Fund (03.1536a-d)

The alabaster goblet and vase stand on a low support of the same material, carved to fit them. The rounded base of the goblet fits into a circular depression, and the vase, without a base of its own, fits neatly around a raised circle on the support. It has a well-fitting domed lid. No similar set of stone vessels is known, so one can only speculate as to its function. Perhaps the lidded vase was used to store spices, which were added to wine before drinking (a custom we know was practiced), or the set may have been for cosmetics.

The vase may be compared with a group of cosmetic vessels of late Middle Kingdom date, which are similar in every respect except that they are freestanding.[1] It is interesting to compare the goblet, made in one piece, with cat. 119.

J.D.B.

1. See Vandier d'Abbadie 1972, no. 530.

Baskets and Basketry

Among the domestic arts of ancient Egypt, basketry is of the very greatest antiquity. Some of the oldest artifacts from the Nile valley are the coiled baskets and woven grain bin liners recovered from the Fayum A neolithic settlement.[1] In manufacturing their baskets, the Egyptians used native plants and fibers.[2] Reeds, palm rib, and heavy grasses usually served as the foundation strands, while palm leaf, halfa grass, and flax were used to bind the whole together. Of the four known fabrication techniques[3] the coil with overcast sewing strip was by far the most common. It is still used in modern Nubian baskets, which differ in no fundamental respect from ancient examples.[4] The body of the basket is built up of a continuous coil of vegetable matter, then successive revolutions of the coil are sewn together by means of a strip cast over one coil and just through the topmost portion of the coil immediately beneath. By varying such factors as the width, color, and arrangement of the stitches, quite elaborate patterns could be achieved. For example, by arranging successive passes of the sewing strip in between stitches on the coil below, an echelon effect was produced. It was also common, especially when using a broad palm leaf as sewing strip, to split the stitch on the lower coil (called a "furcate" stitch), thus creating a chevron pattern. Dyed sewing strips, judiciously hidden at intervals along the inner surface of the basket, could be worked to produce very elaborate designs such as the human figures on the baskets depicted in the tomb of Rekhmire[5] (fig. 38).

A second method employed by the ancient Egyptians was that of twined basketwork. In this, the primary strands usually run vertically and are tied at intervals by wrapping two strings about the fibers, twisting them around one another whenever they intersect. The twine is frequently a two-ply flaxen cord. A large interval between twining strands results in an open matrix suitable for bags for transporting such things as tools but not granular substances. Twining closely produces a tough, dense mesh, ideal for such things as chair seats and mats. By passing the twining strands about every second, third, or fourth fiber and by staggering the sequence

Fig. 38. Elaborate figured baskets from the storehouse of Amen (pictured in Theban tomb 100).

from one row to the next, a characteristic diagonal pattern or "twill" emerges.[6]

The sewing together of plaited strips, used only rarely in Egypt, supplanted the coil technique in Roman times.[7] Wickerwork, on which so much modern basketry depends, was unknown in ancient Egypt.[8]

While specimens of ancient Egyptian basketry have survived from the Predynastic Period[9] and the Eleventh Dynasty,[10] the preponderance of finds is from Eighteenth-Dynasty Theban tombs of Meryet-Amen,[11] Tutankhamen (of 116 baskets, almost all are unpublished), and the workmen's tombs at Deir el Medineh.[12] These finds comprehend a great variety of shapes, including such exotic forms as the basketwork bottle from the tomb of Tutankhamen.[13] The baskets were used for storage of linens, food offerings, toiletries, and even embalming materials.[14]

By using slightly modified basketry techniques, the ancient Egyptians were able to make chair seats, mats, sieves, strainers, and pot stands. Our knowledge of how such items were used is vastly supplemented by servant statues, models of daily life, and, most important, tomb reliefs and paintings from the Theban necropolis.[15] The oldest representation of a basket is on the great scorpion mace head from Hieraconpolis;[16] three-dimensional depictions in wood and stone are fairly common. Baskets have also been imitated in stucco,[17] pottery,[18] gold,[19] and faience (see cat. 157).

J.K.M.

1. Caton-Thompson and Gardner 1934, pp. 42-44, pls. 25-26.
2. Lucas 1962, pp. 128-133.
3. Crowfoot 1954, pp. 413-447.
4. Sterns 1918, pp. 194-196, pls. 1-3.
5. Davies 1935, pl. 13.
6. See, e.g., Petrie 1913, pl. 8.
7. Petrie 1898, p. 33.
8. Lucas 1962, p. 132.
9. Brunton and Caton-Thompson 1928, pls. 30, 31.
10. Garstang 1907, figs. 113, 114.
11. Winlock 1932b.
12. See e.g., Bruyère 1937b, p. 53, fig. 26.
13. Carter 1933, pl. 80.
14. Winlock 1942, pl. 94.
15. See, e.g., Porter and Moss 1960, p. 188(2); p. 192 B(a); p. 344 (1).
16. Quibell 1900, pl. 26c, no. 4.
17. Bruyère 1937b, p. 56, fig. 27.
18. Smith 1958, pl. 81a.
19. Lansing 1934, fig. 37.

129
Mat

From Deir el Medineh tomb 1389
Dynasty 18, reign of Thutmose III
Length 1.75 m.; width 75 cm.
Musée du Louvre, Paris (E 14446)

This example of ancient Egyptian matting is beautifully preserved. It is made of reed stalks tightly woven through a cord wrap. Undoubtedly designed for domestic use, the mat was probably brand new when it was put in the tomb.[1]

Mats were important household articles and were used for a variety of purposes. In the banqueting scenes of the New Kingdom hosts and guests are often shown resting comfortably on mats,[2] and labeled representations of reed matting occur in Theban tombs.[3] Mats were also used as hangings, some of them extraordinarily elaborate and colorful.[4]

J.K.M.

129

1. Bruyère 1937b, p. 197.
2. Davies 1935, pl. 19; Schäfer 1974, p. 168.
3. Davies 1943, pls. 30-31.
4. Ibid., pl. 9; Perrot and Chipiez 1882, pls. 13-14.

Bibliography: Bruyère 1937b, pp. 197, 199, fig. 114; Letellier 1978, no. 8; Ecole du Caire 1981, p. 199.

Literature: Hayes 1959, p. 85, fig. 47.

130
Hamper

From Deir el Medineh tomb Dx2
Dynasty 18
Height 29 cm.; diameter 54 cm.
Agyptisches Museum, Berlin (20995)

The hamper, made from a coil of reed fibers oversewn with palm leaf stripping, differs from the other coiled baskets in this catalogue by virtue of the herringbone ribs sewn into the basket wall and lid at regular intervals. The effect is similar to that achieved by using the split feathered stitch.[1] Normally the basketmaker would carry the sewing strip over two full coils. Then, on the next pass of the sewing strip on the coil above, he would once more wind the strip over

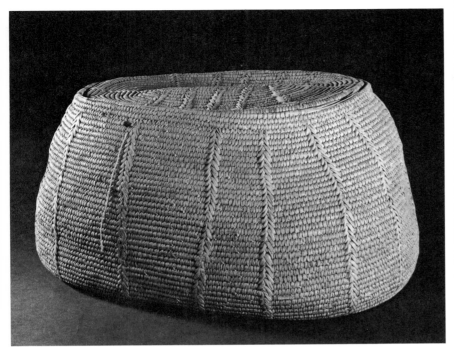

130

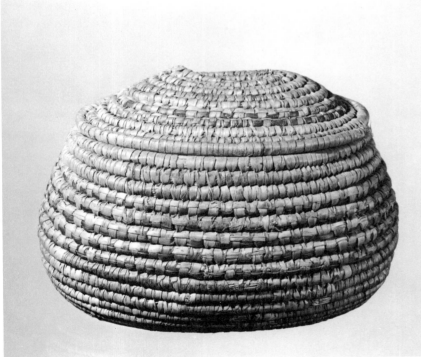

131

two coils and split the top of the longer stitch beneath. After a sufficient number of turns, a chevron pattern would emerge, the apexes of the triangles pointing downward. In this example, however, the herringbone pattern points upward. The basketmaker accomplished this by darning in the ribs, proceeding from bottom to top, after the basket was finished, giving it added rigidity and strength. The hamper was closed by means of eight two-ply cords, traces of which remain. These were knotted through the basket wall and were drawn up over the top to form a sort of harness above the lid.

When this basket was found, it contained an infant burial. The use of amphorae, hampers, and small chests for the inhumation of infants was not at all uncommon in ancient Egypt.[2] In fact, the most ancient coffins surviving from Egypt were made simply of lashed reeds.[3] But in this instance it is likely that the hamper was originally designed for some household purpose and its use as a coffin may have been for reasons of economy.

J.K.M.

1. Bruyère 1927, p. 57, fig. 48.
2. Bruyère 1937b, pp. 11-13.
3. Petrie 1913, pl. 25.
Bibliography: Anthes 1943, pp. 52-53.

131

Oval basket with lid
Provenance not known
New Kingdom
Height 14 cm.; length 20 cm.
Museum of Fine Arts. Hay Collection,
Gift of C. Granville Way (72.4738a-b)

This basket is of very simple design and fabrication. The body and the lid are built from a continuous coil of rush or straw. The coil is fairly thick and is of uniform diameter throughout. Two heavier vertical coils are sewn to the underside of the lid. The circuit of these is a shade larger than the mouth of the basket so that when the lid is pushed in place it fits very snugly.
Natural, undyed palm leaf was used as the sewing strip and this has produced a monotonous design. But the basketmaker tried to enliven the work somewhat by incorporating a checker-

board pattern into six rows of the basket and two rows of the lid. This was done by darning halfstrips of palm leaf alternately over and under successive wrapping stitches. To heighten the contrast, he used a stained leaf when darning over the lower portion of the coils.

The two stubs of coil visible on the lid suggest that originally there was a loop handle. Although there is no exact parallel for the lid with a loop, modern Nubian examples do preserve this feature.[1] Ancient Egyptian examples show the same locking mechanism and decoration.

J.K.M.

1. E.g., Peabody Museum, Harvard University, 62254.

Bibliography: Hay 1869.

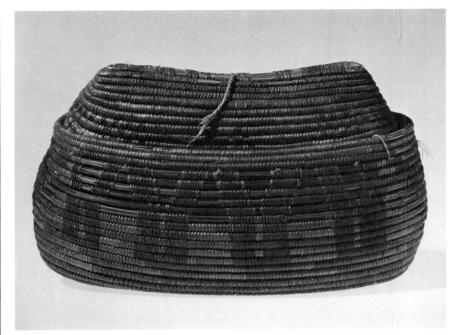

132

132

Elliptical basket with lid

From Heracleopolis Magna
Dynasty 18
Height 15 cm.; width 13 cm.
Museum of Fine Arts. Gift of Egypt
Exploration Fund (91.141a-b)

This well-preserved basket is a fine example of the great delicacy of ancient Egyptian basketry. The body is composed of a skein of reed or split straw. The ten coils of the base were purposely made thicker than those of the sides so as to support the weight of the loaded basket. Two thick coils were sewn to the inside just below the lip of the basket to form a shelf for the support of the lid. These surfaces, which bear more stress than the rest of the basket, were whipped with palm leaf for added strength. The sides of the basket and all of the lid were wrapped with strands of the much finer halfa grass.

Not readily apparent here, owing to the thinness of the grass, is the fact that the coils are bound together by a furcate stitch. Instead, the stitches of successive rows seem to have been placed between rather than through those on the coil beneath, thus conveying the illusion of an echelon pattern. Three types of halfa grass were used: a light brown, a reddish brown, and a dark brown. The reddish-brown strip was introduced on the fifth row of the side and the dark brown grass was incorporated in rows ten through fifteen. By hiding the

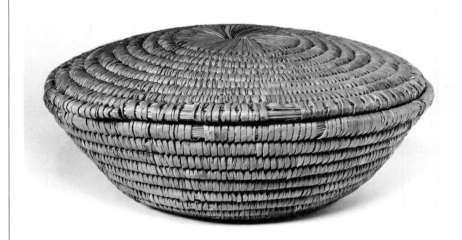

133

sewing strips on the interior and bringing them out only at specific points, the patterns of Y's and triangles were formed. The sets of opposed triangles (seven on each side) and the twin chevrons on either end of the basket were originally filled with the dark brown strip, vestiges of which may be glimpsed on the interior. But owing to some peculiarity of the dye used, the dark brown halfa grass has not survived as well as the red and buff varieties. To a lesser degree, patterning was used on the lid: two small chevrons and a checkerboard motif were worked into the sides and ends, respectively.

The lid of the basket was held loosely in place by means of fourteen two-ply flaxen cords that were knotted through the side of the basket, just below the third coil. They were then drawn over the lid and were tied to a slightly thicker cord set into the very center of the lid. A good example of such a closure may be seen in a basket from the tomb of Hatnefer and Ramose.[1]

A basket of similar elliptical form but with a somewhat flatter lid was found in the tomb of Meryet-Amen.[2] The pronounced ridge on the lid of the Boston basket is probably due to shrinkage of the fiber coil.

It is possible that this basket is to be identified with one of two described in a publication concerning the necropolis of Heracleopolis Magna,[3] both of which contained an assortment of toiletry articles.

J.K.M.

1. Lansing and Hayes 1937, p. 32, fig. 38.
2. Winlock 1932b, pl. 32.
3. Naville 1894, p. 12.

133

Circular basket with lid
Probably Deir el Medineh tomb 1388, east cemetery
From Dynasty 18, reign of Thutmose III
Height of basket 4 cm.; diameter of basket 27 cm.
Musée du Louvre, Paris (E 14482)

This basket is made of a reed coil oversewn with golden brown halfa grass. The sewing strip was wrapped eccentrically about the first few coils of the lid, producing a spoke-like pattern.

134

Several similar baskets were recovered from this site. They were ordinarily used to hold sweet fruits such as dates, grapes, and pomegranates.

J.K.M.

Bibliography: Bruyère 1937b, p. 93, figs. 26, 109.

134

Pot stand
From Deir el Bahri
Dynasty 18
Height 4 cm.; width 19 cm.
Museum of Fine Arts. Gift of Egypt Exploration Fund (95.1420)

The ancient Egyptians made pot stands of both pottery (see cat. 54) and natural fiber. Numerous pottery examples have survived; those in basketwork are less common.

For storage purposes jars might be set in rigid pottery stands.[1] But for everyday use, to keep a jar from over-turning during the sieving of beer mash, for example, it was customarily nestled in the ground or poised atop either a grass ring[2] or a basketwork stand.[3] Comparison of drawings from the Theban tombs of Suemniut[4] and Khaemwaset[5] show that the basketwork stands could have been either shallow saucers or deeper, rounded baskets.

This example, one of the shallow variety, is made up of a six-tiered coil of split straw oversewn with palm leaf. The coils are bound together very loosely and are only intermittently joined by the sewing strip. Unearthed during excavations at Deir el Bahri in 1895, this stand and ten others formed part of a foundation deposit that also contained a scatter of model tools.[6]

J.K.M.

1. Wreszinski 1923, pp. 295-296.
2. Davies 1930, pl. 83; Wreszinski 1923, pl. 22b; Peet and Woolley 1923, pl. 21:2.

3. Davies and Gardiner 1936, pl. 27; Breasted 1948, pl. 29b, no. 6.
4. Porter and Moss 1960, p. 188(2).
5. Ibid. p. 344(1).
6. Naville 1908, p. 9, pl. 168.

Bibliography: Naville 1908, p. 9, pl. 168.

135
Sieve

Provenance not known
Probably Dynasty 18-19
Height 7 cm.; diameter 44.3 cm.
Musée du Louvre, Paris (N.1376)

The sieve is made in two sections: a body composed of a coil oversewn with palm leaf and, sewn to that, a gridwork formed of reed stalks loosely bound together with five twining strands. For added support two palm ribs were attached to the bottom. Presumably this sieve would have been used for sifting grain, flour, or any granular materials;[1] there were other types for straining liquids,[2] especially in the preparation of beer.

J.K.M.

1. Breasted 1948, pl. 26a.
2. Wild 1966, pl. 11.

Literature: Peet and Woolley 1923, pl. 22:2; Hayes 1959, p. 85, fig. 47.

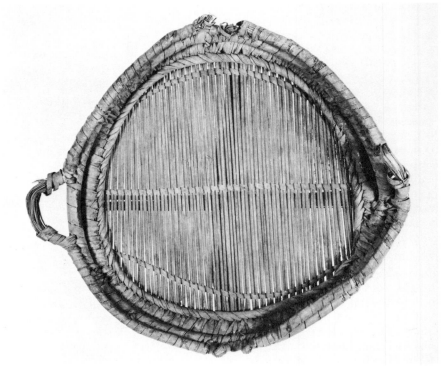

135

136
Small basket

Provenance not known
New Kingdom
Length 20 cm.
Agyptisches Museum, Berlin (6913).
Formerly in the Minutoli Collection

Made of a loose network of twined rushes, the basket exemplifies a type that occurs frequently in New Kingdom tomb scenes of sowers, gleaners, and tradesmen. In the tomb of Sennedjem at Deir el Medineh the wife of the deceased is shown sowing seed from a small openwork basket with the slight, characteristic splay toward the bottom.[1] In the tomb of Menna gleaners carry similar small net baskets.[2] A much enlarged version of this basket, with loop handles, filled with tools, occurs in the tomb of Ipuy.[3] This form of basket goes back at least as far as the Archaic Period. For example, a stone basket imitating loose mesh work and having two handles or grips was recovered from First-Dynasty levels at Abydos.[4]

J.K.M.

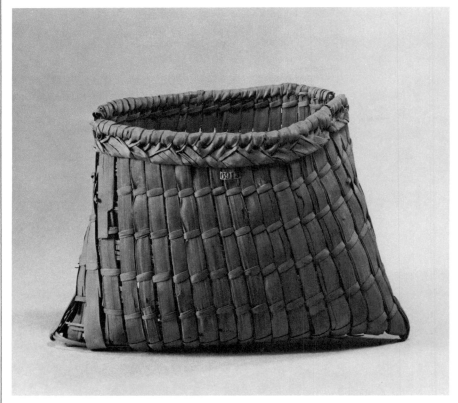

136

1. Mekhitarian 1954, p. 149.
2. Wreszinski 1923, pl. 231.
3. Davies 1927, pl. 38.
4. Seipel 1957, fig. 352a.

137

Broom

From Deir el Medineh
Dynasty 18-19
Length 66.5 cm.
Musée du Louvre, Paris (E 16414)

The broom is made of a stiff fiber, perhaps from the palm, that has been lashed together with a continuous strand of two-ply cord. The handle contains a wooden core for additional strength.

Scenes of a servant sweeping the palace courtyard with a short-handled broom very similar to this one are common in the art of the Amarna Period.[1] In a few instances a servant is shown sprinkling water in front of the sweeper so as to lay the dust[2] and in at least one case a servant appears to be performing both functions.[3]

The representation of brooms is not confined to scenes of daily life in ancient Egypt. In the morning ritual of *inet-red* the officiant trails a long broom behind him, signifying the banishing of evil spirits from the sanctuary.[4]

J.K.M.

1. Cooney 1965a, p 73.
2. Davies 1905a, pl. 19; Davies 1908b, pl. 19.
3. Davies 1903, pl. 11.
4. See Nelson 1949, pp. 82-87; Altenmüller 1971, pp. 146-154.

Bibliography: Letellier 1978, p. 20, no. 10; Ecole du Caire 1981, p. 200.

Literature: Peet and Woolley 1923, pl. 21:3; Wreszinski 1923, pls. 47, 96b.

137

Faience Vessels

Faience, Egyptian blue, and glass are among many New Kingdom ceramic types that share a common technology. The natural inorganic substances from which these materials are formed are silica, calcite, a mixture of alkalies, and colorants such as copper and iron oxide.[1] Some of the more refractory silica materials include quartz pebbles and sand: feldspar is also present in trace quantities.[2] The prime source of alkali is natron, which is gathered in the low-lying desert areas where evaporation of flood or rain water has left a residue of sodium salts in the form of carbonates, sulfates, and chloride.[3]

The structural differences among faience, Egyptian blue, and glass result from various chemical combinations of soda, lime, and silica and from differences in processing. Glass, for example, appears in cross section to be quite homogeneous in texture; Egyptian blue, known principally as a pigment is homogeneous as well, but is composed of numerous fine particles sintered or fused at the edges by heating; faience, on the other hand, exhibits a multiple-layer structure in which a glassy coating or glaze coats a core of different composition. The core is frequently composed of more than one layer.[4]

Faience and Egyptian blue were developed during the Predynastic and early Dynastic Periods, respectively, whereas glass vessels first appear as indigenous products during the New Kingdom.[5] Many technological advances in this tradition occurred during Dynasty 18; for instance, the color range of the ceramic palette was enlarged to include red, yellow, light green, purple, and opaque white.[6] In the earlier palette blue and green objects colored by copper compounds were decorated with small areas of brown, black, or violet consisting predominantly of manganese dioxide.

In both Egyptian blue and faience raw materials are ground to the desired range of particle size. These particles are then sintered or heated together to form a new polycrystalline substance that appears rough and opaque. A greater degree of sintering at a higher temperature or a longer firing time fuses the particles more completely. Firing temperatures range from 800 to 1,000 degrees Centigrade.

An extensive literature has accumulated since the latter nineteenth century in attempts to explain the processing of Egyptian faience.[7] Only a few objects are discovered to have been turned on a wheel in the manner of pottery. Because of the lack of plasticity of faience, one expects and finds the processes of modeling by hand and a wide variety of molding techniques. Several thousand small one-piece pottery molds were collected at Amarna, some with faience material still present. Faience would have been pressed into these porous molds, removed, and set aside to dry.[8] Inspection of the interior surfaces of specific examples has suggested that ovoid or spherical faience vessels were molded over a core that burned out during firing.[9] Occasionally two molded halves of a sphere were joined together with a glue-like slurry of faience; likewise, prefabricated loops were joined with this slurry onto molded beads (see p. 244). The occasional uneven wall thickness and faceting of the bottom of open faience bowls supports the contention that they were shaped over a simple convex mold. The thinness of certain vessel walls and tubular beads has led to the proposition that forming over armatures or cores was done by dipping the core into a thick slurry of faience.[10]

Microscopic observation of faience glazes shows that the thin glaze coating has no sharply defined inner surface and appears gradually to dissolve into the body. Surface decoration consisted of painting, or of incising and inlaying lines or areas with faience of a different color. There are examples of painting of a thick slurry of faience mixed with pigment as well as thin pigment washes.

Three very different techniques have been proposed to account for the glaze. They include the application of a wetted powder as a slurry by dipping, pouring, or painting.[11] With this technique a layer of uneven thickness is likely to be produced. Second, a method of self-glazing has been proposed in which the migration of soluble alkaline salts from the body to the surface occurs by capillary action

as water evaporates from the body during drying. The alkalies effloresce on the surface, where they melt during firing to fuse with the fine quartz and lime particles.[12] During drying, efflorescent salts cannot form where there is no evaporation, and therefore objects glazed by this process should have no glaze where they rested during drying. In other words, they should exhibit drying marks. A third method has been proposed in which the faience object is embedded in a glazing powder.[13] This powder may be applied wet or dry around the objects. During firing the soda in the glazing powder melts and wets the quartz particles on the surface of the object, forming a glaze. The unmelted lime component of the powder pulls away from the surface, remaining as a friable powder that upon cooling can be easily broken away from the objects. An ethnographic study has documented the contemporary use of a similar process employing a glazing powder for the production of blue donkey beads in Qom, Iran.[14]

P.V.

1. Binns et al. 1932; Caley 1962; Sayre 1965, pp. 145-154; Chase 1968; Wulff et al. 1968; Noble 1969; Kiefer and Allibert 1971.
2. Kiefer and Allibert 1971.
3. Lucas 1962, pp. 171-172, 263-267; Noble 1969.
4. Lucas 1962, p. 161.
5. Petrie 1910, pp. 107-119; Stone and Thomas 1956.
6. Petrie 1910, p. 111.
7. See Petrie 1892a; Binns et al. 1932; Beck 1934b.
8. Petrie 1910, pp. 115-116.
9. Reisner 1923b, p. 137; Noble 1969.
10. Kiefer and Allibert 1971.
11. Petrie 1910, pp. 107-119.
12. Binns et al. 1932; Noble 1969; Kiefer and Allibert 1971.
13. Kiefer and Allibert 1971.
14. Wulff et al. 1968.

Literature: Burton 1912; Kiefer and Allibert 1968; Kühne 1969; Aspinal et al. 1972; Williamson 1974; Kingery et al. 1976; Vandiver 1982.

Bowls

In the New Kingdom, a series of attractive blue bowls with black painted designs appear among the many different objects made of blue-glazed faience. The quality of the drawing varies enormously according to the skill of the craftsman, and not infrequently the inside decoration is noticeably finer than the outside, which was probably done by an unskilled apprentice.

The decorated bowls seem to have evolved from small cups decorated on the outside only with the petals of the blue lotus blossom. These are occasionally found in Middle Kingdom tombs[1] and in shape, color, and decoration imitate a lotus flower. In the following period larger, deeper bowls appeared and, although they retained the original lotus petal design on the base, the walls and interior were then decorated with motifs of marsh and pond life—lotus and papyrus plants, *tilapia* fish, and birds. During the Eighteenth Dynasty, as the bowls became shallower, the interior was the most important area of decoration, with increasingly complex designs of pools, fish, plants, and other motifs such as the Hathor head and Hathor cow. The original association with the lotus did not disappear completely, however, as the outside is usually decorated with the petals of the lotus flower; occasionally, a marguerite replaces the lotus.[2]
The principal motif on the early bowls is the blue lotus flower, which, because it opens each day at sunrise and closes again in the evening, was associated with the birth of the sun god every morning,[3] and thus became a symbol of regeneration and transformation of the dead in the afterlife. The *tilapia* fish has a similar significance[4] (see cat. 138). The frequent symbols of the goddess Hathor support this idea that the main theme of decoration was rebirth, since she was the goddess of the West (the land of the dead) and, as the Celestial Cow, she nourished and protected the dead and assisted them in their transformation and rebirth.[5] Apart from Bastet, with whom she is identified, she is the only deity mentioned by name on these bowls, and many fragments were found at her shrines and temples at Deir el Bahri, Faras (Nubia),

Serabit el Khadim, and Timna (Sinai). At Serabit, she was worshiped as Lady of Turquoise and elsewhere she is called Lady of Faience,[6] so it seems that she had a special connection with both the color and the material of faience.

The popularity of these bowls was at its peak in the early part of the Eighteenth Dynasty but waned in the late New Kingdom, and after the late Eighteenth Dynasty the shape and style of their decoration change. They become more rounded in profile and have no external decoration. The designs on the inside change completely; the white lotus now appears more often than the blue, and instead of pond life, humans and animals are depicted—playing the lute or double flute, dancing, punting in the papyrus marshes, and bearing offerings.

The introduction of new motifs may indicate a change in the function of the bowls during the second half of the New Kingdom; the restricted range of decoration on the earlier bowls implies a special significance. With the exception of the bowls found in the Harim Palace at Gurob,[7] they are hardly ever found in a domestic context but come from tombs and temples. The few inscribed bowls do not indicate what, if anything, they had contained; wine[8] and milk have been suggested, but at least one example from an undisturbed tomb contained a solid substance.[9] Certainly they could not all be drinking bowls, as has been proposed, as some of them are much too large; one example from Deir el Bahri is nearly thirty-two centimeters in diameter.[10] Perhaps the importance of these earlier bowls lay more in the decoration, with its theme of regeneration and transformation, than in any specific contents, and, as the majority of them come from tombs and temples, it is likely that their main purpose was to hold offerings and libations.

The later bowls, with their wider range of motifs, are more difficult to interpret; the finds from Gurob may indicate a domestic use, and a group of shallow saucers of this period are the right size and shape for drinking bowls. However, the fact that they were still placed in the tombs during the second half of the New Kingdom

is perhaps an indication that they had not lost their significance as symbols of rebirth for the dead, and indeed, some of the motifs can be interpreted as different images of this theme. For example, the decoration of one of the Gurob bowls[11] shows a calf in a papyrus thicket, which may have symbolized the morning sun, born each day from the cow goddess Mehet Weret. Similarly, the musicians depicted on several bowls[12] may have meant more than just a wish that the dead would continue to enjoy all the pleasures of this life in the afterlife. This profession was under the patronage of Hathor and Bes, both of whom had erotic associations.[13] The goddess Hathor combines the distinct personalities of the Goddess of Love and Fertility and the Mistress of the Dead—expressing different aspects of the basic generative forces essential to procreation and birth in this world, as well as to transformation and rebirth in the next.

A.J.M.

1. Quibell 1896, p. 3, pl. 3:18.
2. Liverpool 1977.109.1.
3. Clark 1959, pp. 66-67, 239.
4. Desroches-Noblecourt 1954, pp. 33-42; Dambach and Wallert 1966, pp. 283ff.
5. Bleeker 1973, pp. 42ff.
6. Harris 1961, pp. 223-224.
7. Petrie 1891, pp. 16-19, pls. 17-20.
8. Rogers 1948, pp. 154-160; Bruyère 1937b, pp. 89-90.
9. Schiaparelli 1927, p. 167, fig. 153.
10. Winlock 1922, p. 35, fig. 25.
11. Petrie 1891, pl. 17:14.
12. Wallis 1898, pl. 12:42, 43; Brooklyn Museum 1968, p. 44, pl. 10:42.
13. Naville 1913, p. 31; Vandier d'Abbadie 1938, p. 34; Bleeker 1973, pp. 39ff.

Literature: Krönig 1934; Strauss 1974.

138

Rilled cup
Provenance not known
Dynasty 17-18
Height 5.8 cm.; diameter 12.2 cm.
Kofler-Truniger Collection, Lucerne
(K 2700 A)

The outside of this deep bowl is modeled to resemble the horizontal ridging of basketwork, with a decoration of two rows of black dots zigzagging around the bowl. Below the black rim runs a frieze of birds, lotus flowers, and papyrus plants. On the base are more papyrus and lotus, the pond weed *Potamogeton lucens L.*,[1] and *tilapia* fish, one of which is nibbling a papyrus umbel.

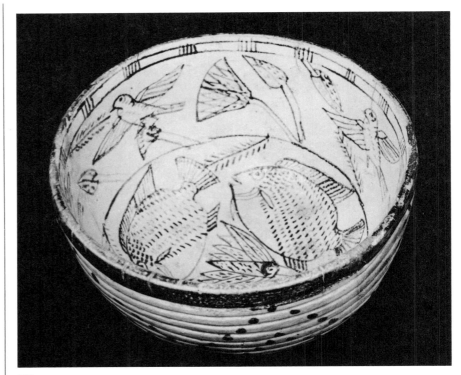

138

The ribbing on the outside of the bowl is an unusual feature found only on a few examples of the Second Intermediate Period and early Eighteenth Dynasty. Several fragments from similar bowls were found at Kerma[2] and one from Uronarti,[3] both sites in Nubia. The Uronarti piece is not dated, but the Kerma fragments must date to the Second Intermediate Period or early Eighteenth Dynasty before the destruction of the site by the Egyptians. Apart from one example from Lisht,[4] all examples of ribbed faience vessels seem to come from Nubia, and it may have been a form peculiar to that area.

The inner decoration of fish and birds is very similar to that on a bowl from Qau,[5] dated by the pottery in the grave to the Second Intermediate Period, and thus in accordance with the general date of the Kerma fragments. Both bowls are decorated with exceptionally fine drawings, especially in the detail of the fishes, where rows of fine dots represent the scales. The scene inside the bowl shows a pool with lotus flowers growing out of it and birds flying above. The choice of motif is significant: *tilapia* fish were

associated with transformations of the dead and with the goddess Hathor and were symbols of fertility and of rebirth.[6] These associations were no doubt due to the strange spawning habits of these fish, who take up the newly laid eggs into their mouth until they are hatched.[7] The appearance of the young fish from the mother's mouth must have suggested self-propagation to the Egyptians and hence the association with rebirth. (For other aspects of the role of the *tilapia* or *bolti fish* see cats. 140 and 352.) This fish motif was very popular in the New Kingdom, and it appears on pottery and faience vessels and on many of the small toilette objects.

A.J.M.

1. Keimer 1927, pp. 182-197.
2. Reisner 1923b, pp. 153-169, pls. 45-47.
3. Dunham 1967, fig. 3.
4. Metropolitan Museum 22.1.1134-5.
5. Brunton 1930, p. 9, pl. 33:1, 2; Petrie 1930, pl. 16:5, 6.
6. Gamer-Wallert 1970, pp. 109ff.
7. Dambach and Wallert 1966, p. 276.

Bibliography: Kunsthaus Zürich 1961, no. 320; Kunsthaus Zürich 1964, no. 131; Müller 1964, no. A131, p. 92; Kayser 1969, fig. 116, p. 129; Schlögl et al. 1978, no. 167.

139

Bowl

Provenance not known
Dynasty 18
Height 3.8 cm.; diameter 15.7 cm.
Museum of Fine Arts. William E.
Nickerson Fund (1977.619). Formerly in
the H. J. P. Bomford Collection

The exterior of this repaired bowl is
decorated with the dotted sepals and
petals of the blue lotus, which radi-
ate up from the base. Inside, in the
center, three concentric squares rep-
resent a pool from which lotus buds
grow; four *tilapia* fish swim around
the pool carrying more lotus buds in
their mouths.

This design of pool and lotus was one
of the most popular decorations
found on early faience bowls. The
present example, very similar to one
now at Eton College,[1] which must
have come from the same workshop,
can be dated by its likeness to other
well-dated examples to the middle of
the Eighteenth Dynasty. The pool and
lotus motif is found on three bowls
from tomb 729 at Thebes, dated to
the time of Thutmose III,[2] and frag-
ments of a similar bowl with *tilapia*
fish, found in the tomb of Tjanuni at
Thebes are dated to the time of Amen-
hotep II and Thutmose IV.[3]

The design is careful and symmet-
rical, with four fish evenly spaced
around a pool, which is represented
by a small square in the center. How-
ever, the depiction of fish and plants
outside the square seems to indicate
that the whole inner surface of the
bowl represents a pool. The notion of
fish carrying lotus blossoms is a reaf-
firmation of the theme of rebirth (see
cat. 138), as the lotus is associated
with the daily birth of the sun god in
the form of a young child from the
primordial waters of Nun[4] and was
thus an expression of the self-genera-
tive powers of the sun.

A.J.M.

1. D34: Burlington Fine Arts Club 1922, p. 58,
no. 11, pl. 38; Krönig 1934, fig. 21.
2. Hayes 1935, pp. 17-36.
3. Brack and Brack 1977, p. 72, fig. 23.
4. Clark 1959, pp. 66-67, 239.

Bibliography: Museum of Fine Arts 1978,
pp. 26, 44.

Literature: Christie et al. 1980, p. 47.

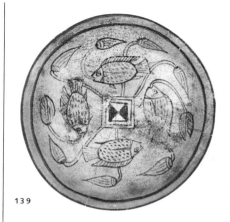

139

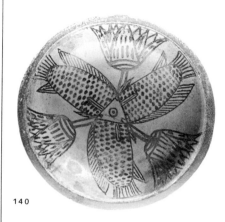

140

140

Bowl

Provenance not known
Early to mid-Dynasty 18
Height 3.5 cm.; diameter 10 cm.
Agyptisches Museum, Berlin. Passalacqua
Collection (4562)

The petals of the lotus flower enclose
the outside of this bowl. Inside, three
tilapia fish are arranged symmetrically
with their bodies converging in a
single triangular head in the center, a
single dot serving as the eye of each
fish.

Several bowls of similar shape bear
this design, but none of them is se-
curely dated. The form, the design of
lotus petals on the outside, and the
style of drawing suggest a date in the
early to mid-Eighteenth Dynasty, cer-
tainly not much later.

This bowl is one of the best examples
of its kind; the drawing is precise and
evenly spaced, and the details of the
fish, especially the fins and the
scales represented by dots, are
clearly shown. The design is a playful
variation on a motif that goes back to
the Prehistoric Period, showing sev-

eral *tilapia* fish gathered around a
ball.[1]

The idea seems to have come from
the breeding habits of the fish; unlike
the subspecies that hatches its eggs
in its mouth (see cat. 138), another
type of *tilapia* gathers its eggs into a
ball on the river bed and watches
over them until they are hatched.[2]
In the scene here, the ball of eggs
appears to have merged into the
single head of the three fish. The
lotus flowers emerging from the cor-
ners of the head are doubtless in-
tended to be held in their mouths.

A.J.M.

1. Glanville 1926, pl. 19:1, 3.
2. Dambach and Wallert 1966, p. 275.

Bibliography: Pietschmann 1894, p. 134; Krönig
1934, pl. 23a; Kayser 1969, no. 605; Strauss 1974,
p. 19, fig. 14.

141

141

Bowl

Provenance not known
Late Dynasty 18
Height 3.3 cm.; diameter 16.5 cm.
Museum of Fine Arts. William E. Nickerson
Fund (1979.204).

Only the inside and the rim of this
bowl are decorated, the rim with a
series of black dots, the center with a
medallion of a bull leaping through a
clump of papyrus. A band of lotus
petals encircles the central design.
The bowl has received modern
cosmetic repairs.

The lack of external decoration and
the dotted rim are typical features of
bowls of the period after the mid-
Eighteenth Dynasty. An almost iden-
tical bowl found at Idalion in Cyprus[1]

is, unfortunately, undated; the two bowls certainly came from the same workshop if not from the same craftsman. The motif of a bull in a papyrus thicket was very popular at Amarna and is found on the painted pavements and the polychrome tiles there.[2] One of the painted pavements from the palace at Amarna depicts a large pool with lotus and fish inside and around the edge young bulls and calves against a background of different plants. The combination of lotus pool and the young bulls is a link between the designs on earlier bowls and that of this bowl, suggesting that neither group is far removed in time from the Amarna pavement.

A.J.M.

1. Wallis 1898, pl. 12, fig. 41; Cesnola 1903, pl. 108:5.
2. Petrie 1894, pp. 13-15, pls. 2-4.

Bibliography: Vermeule 1981, p. 194, fig. 6.

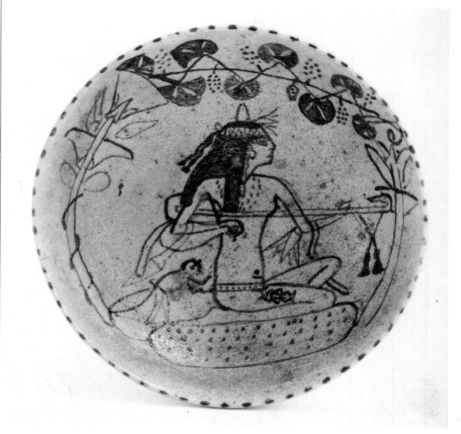

143

142

142

Bowl

Provenance not known
Late New Kingdom
Height 4.1 cm.; diameter 15.8 cm.
Museum of Fine Arts. Hay Collection, Gift of C. Granville Way (72.1522)

This fragmentary bowl has an extraordinary bright blue glaze and is exceptionally well made with thin, even walls. It is decorated on the inside only, with a band of flying birds around the edge and a white lotus flower in the center. The white lotus appears as a decoration on vessels of different types from the Sixth Dynasty[1] until the Late Period; it appears on the faience bowls of both the early group from Kerma and those of the late New Kingdom. This bowl can be dated by other elements in its design—the lack of external decoration and the band of birds—to the late New Kingdom. About two-thirds of the bowl is original; the remainder has been restored.

A.J.M.

1. Joseph Pilsudski University 1937, pl. 17:2.

Bibliography: Hay 1869, no. 817.

143

Bowl

Provenance not known
New Kingdom
Diameter 14 cm.
Rijksmuseum van Oudheden, Leiden (AD 14/H118/E.xlii.38). Formerly in the Anastasi Collection

The glaze of this bowl is a light blue and free from the greenish tinge of earlier bowls; the shape and decoration likewise belong to bowls of the second half of the New Kingdom. It has a dotted rim and no exterior decoration. In the center of the bowl, a young girl is seated on a cushion, playing the lute; behind her is a small monkey. She is naked except for her jewelry—earrings, a necklace, and a girdle. On her head is a perfumed cone and a lotus flower held in place with a headband. More lotus blossoms are looped over each arm. In her right hand, she holds a plectrum attached to the lute by a cord; her other arm is extended along the lute, which ends in a duck's-head terminal. On her right thigh she has a tattoo of the dwarf god Bes. On either side, papyrus and lotus pillars support a trellis of vine leaves and bunches of grapes. The treatment of the leaves and grapes is very like that on a faience plaque of Eighteenth-Dynasty date in the Metropolitan Museum.[1]

The design is executed carefully, but the posture of the woman is rather rigid when compared with other depictions of this subject. A plate in the Louvre[2] shows a similar lutist, although with less detail, and an ostracon from Deir el Medineh depicts another seated lute player in a very realistic and graceful manner.[3] Standing lute players are also found on decorated spoons[4] and on several bowls,[5] one of which shows Bes playing this instrument.[6] Bes was closely associated with music and dancing

and his image is sometimes found tattooed on the thighs of female musicians and dancers, as it is on this lute player.[7] This may be explained as an invocation of the god's protection; it may also have been a mark of a courtesan.[8] The monkey may have an erotic association also;[9] on this bowl he appears to be untying the woman's girdle. The theme of the lutist and her monkey companion is also found on a ring bezel from Amarna.[10]

The excellent state of preservation of this bowl makes it extremely likely that it came from a tomb, and the suggestive nature of its decoration places it in the same category as the so-called *concubines du morts* figurines of the Middle Kingdom, which were buried in the tombs of that period.[11]

A.J.M.

1. Hayes 1959, cover.
2. E 22554.
3. Vandier d'Abbadie 1937, pl. 55:2391.
4. Vandier d'Abbadie 1972, pp. 16-17:2, pp. 18-19:29.
5. Wallis 1898, pl. 12, figs. 42, 43; Brooklyn Museum 1968, p. 44, pl. 10:42.
6. Wallis 1898, pl. 12, fig. 43.
7. Keimer 1948a, pp. 104-105, pl. 21:2; Vandier d'Abbadie 1938, pp. 27-35.
8. Keimer 1948a, p. 96ff.
9. Derchain 1975, p. 69.
10. Frankfort and Pendlebury 1933, pl. 49:I.D.16; K. Bosse-Griffiths 1980, pp. 70-74, pl. 10:2.
11. Desroches-Noblecourt 1953, pp. 7-47.

Bibliography: Leemans 1842, p. 54; Wallis 1898, p. 10, fig. 11a; Wreszinski 1923, pl. 76; Steindorff 1928, pl. 275b; Keimer 1948a, pl. 21:2; Kayser 1969, p. 129, fig. 117; Peck 1978a, pl. 15; Schneider and Raven 1981, pp. 26, 105, no. 102.

144
Bowl

Provenance not known
New Kingdom
Height 3.4 cm.; diameter 11.2 cm.
Musée du Louvre, Paris (E 14372)

This small saucer is one of a group characterized by their shallowness and dark glaze; unfortunately, none is well dated. In the center of the bowl, two men are fishing; a naked man is carrying a basket slung on a strap from his head, while his kilted companion is drawing a net with a fish in it out of the water. The water is indicated by vertical zigzag lines, and plants, possibly lotus flowers, are shown on the bank. Below the rim is a frieze of water birds and papyrus

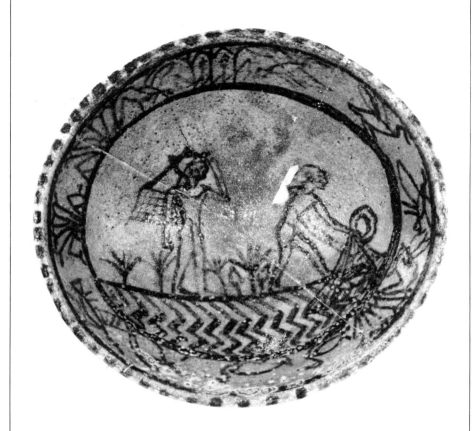

144

plants, drawn very sketchily in outline only. The whole design is rather clumsily drawn and badly spaced.

Similar fishing scenes are found on other objects of the late New Kingdom, notably on some of the metal vessels from the Bubastis treasure, which date to the late Nineteenth Dynasty.[1] These show various marsh activities—bird-netting, fishing, and punting—that reappear in the Twenty-second Dynasty on faience relief chalices[2] and bowls.[3] The vessels of precious metals probably served as prototypes for these designs.

A.J.M.

1. Edgar 1925, pp. 256-258, pl. 1:2; Simpson 1949, p. 62.
2. Tait 1963.
3. See, e.g., Simpson 1959, pp. 37-38, pls. 13, 14.

Bibliography: Rogers 1948, p. 160.

Chalices

Both the blue and the white lotus are represented in a series of faience chalices that are among the most fanciful products of the New Kingdom ateliers. The Egyptians' name for the blue-lotus chalice was the same as for the natural flower, *seshen*.[1] It emerges at the beginning of Dynasty 18 with little or no apparent development, a fact that has given rise to the notion that the form was introduced from some other land.[2] However, no appropriate foreign prototype presents itself and the motif is typically Egyptian.[3] Because of the sparsity of excavated examples, the early development of the blue-lotus chalice is unclear, but there is enough evidence to suggest a probable sequence of style. Early chalices are heavy, wide-mouthed, and low-stemmed with thick walls and a thick, dark glaze that ran into the deep grooves of the leaves and petals.[4] A chalice in Eton College[5] and the gold-rimmed, blue glass chalice of one of Thutmose III's three Syrian wives[6] are representative. In later chalices the spaces between the

petals and leaves are cut back, leaving them in low relief and subtly modeled, sometimes with a grooved vein up the leaves and central petals.[7] One such chalice (cat. 145) was found in a grave at Abydos, datable by its pottery to the period from Thutmose III to Amenhotep III.

The latest in the series of New Kingdom chalices are slender, trumpet-shaped goblets; the modeling of the sepals and petals is more subtle, the grooving is lighter, the cup is cut back sharply at the top to leave the petals in pronounced relief, and carefully modeled veins run up both leaves and central petals.[8] They are more elaborately conceived and worked. At the end of the New Kingdom the blue-lotus decoration is reduced to a narrow band at the bottom of the cup, and the main rim bands of the cup are ornamented with narrative relief scenes.[9]

Although extant chalices nearly all represent the blue lotus, a number of faience chalices imitating in form the white lotus do survive (for the difference between the two types, see pp. 37–38), for example, a blue-glazed white-lotus chalice with a group of objects of Amenhotep III dating from Gurob[10] and, in the Metropolitan Museum, a blue-glazed fragment of a white-lotus cup that may have had a stem with incised petals and the personal name of Amenhotep III in a cartouche on a sepal.[11] There exist also, from Sinai, fragments of more than one green-glazed chalice with white-lotus petals and sepals in high relief. One fragment, now in Philadelphia, is incised with the popular sobriquet of Ramesses II, Sisu.[12] From tombs at Aniba came two intact lotus chalices with leaves and petals in relief (see cat. 146), one in polychrome, the other of light green faience.

Both types of lotus were imitated in metal[13] and stone. Of four exant alabaster white-lotus chalices[14] fragments of two were found in the turquoise mining settlement of Sinai.[15] In both the leaves and petals are carved in low relief and the incised titles of Amenhotep III are filled with red pigment.[16] Another alabaster chalice in the Metropolitan Museum[17] is incised in low relief like the Sinai chalices but has the cartouches of Akhenaten and Nefertiti. The fourth chalice was found in the tomb of

Tutankhamen and represents a single bloom of the white lotus between handles formed by buds and blossoms of the blue lotus.[18] Akhenaten, Tutankhamen, and Seti II are all shown drinking from white-lotus chalices, and the evidence indicates that from the Amarna period on white-lotus chalices were used as stately vessels for drinking.[19]

The suggestion has been made that the blue-lotus chalice is never shown in scenes of drinking and therefore was a cult vessel used only in temples or for the ritual of the dead.[20] However, there are three bits of evidence indicating that blue-lotus chalices were used for drinking. A piece of inscribed linen of Ramesside date is painted with a picture of the lady Kakay[21] holding a crudely sketched blue-lotus chalice before her in her right hand. In a second representation inside a faience drinking bowl,[22] an elaborately dressed, seated official holds out a blue-lotus chalice into which a woman pours a libation. The costumes and complex lattice bracing of the official's chair (see p. 72) suggest a date in the Ramesside Period or somewhat later. Very much in the same genre is a fragmentary drinking bowl found in Tumulus 1 at El Kurru,[23] the earliest of the ancestral tombs of the kings of Napata who conquered Egypt in Dynasty 25. In the interior of this bowl an official in similar garb seated on a virtually identical chair raises a blue-lotus chalice to his lips. The blue-lotus chalices that do appear in ritual contexts probably represent larger chalices of alabaster,[24] metal, or pottery.[25]

E.B.

1. Wreszinski 1935, pl. 336.
2. Montet 1937, p. 59.
3. Tait 1963, p. 98 n. 6.
4. Ibid., p. 101.
5. Ibid., pl. 12:1.
6. Winlock 1948, p. 58, pl. 35.
7. Tait 1963, p. 101.
8. Ibid.
9. Ibid., pp. 103ff.
10. Petrie 1891, pl. 17:8.
11. Tait 1963, p. 97.
12. Petrie 1906b, p. 151, pl. 156:5.
13. Möller 1924, pl. 35; Pendlebury 1932, pl. 14:5; Petrie 1937, pl. 39:18; Montet 1951, pl. 70.
14. Tait 1963, p. 97.
15. Petrie 1906b, p. 138.
16. Leeds 1922, pl. 1.
17. Hayes 1959, fig. 181.
18. Carter and Mace 1923, pl. 46.
19. Tait 1963, pp. 95-96.
20. Ibid., pp. 98-99.
21. Bruyère 1933, fig. 1.
22. Sotheby 1922, pl. 8, lot 266.
23. Dunham 1950, pp. 13, 14, fig. 1b.
24. See MFA 05.86.
25. Nagel 1938, pp. 199ff.

145

145

Blue-lotus chalice

From Abydos tomb D115
Dynasty 18, reign of Thutmose III to Amenhotep III
Height 14 cm.; diameter 10.5 cm.
Museum of Fine Arts. Gift of Egypt Exploration Fund (01.7396)

The sepals and petals of this blue-glazed faience chalice are lightly modeled with grooved outlines. The space between the petals and leaves is cut back, leaving them in low relief. A grooved vein runs up the sepals.

The earliest of the excavated blue-lotus chalices, this specimen was found with a second chalice[1] in the same grave at Abydos; they are datable by the tomb pottery to the period from Thutmose III to Amenhotep III (see cat. 127). The second example is simpler in design, thicker walled, and without the veining on the sepals; otherwise, both chalices are wide-mouthed, straight-sided, and low-stemmed and resemble more than later chalices the actual flower of the blue lotus. However, whereas five sepals and thirty-five petals are represented in this chalice, the blue lotus has four green sepals or leaves and twelve to sixteen petals. For other objects from Abydos tomb D115 see cats. 26, 115, 127, 261, and 278.

E.B.

1. MFA 01.7397.

Bibliography: MacIver and Mace 1902, pp. 72, 89, pl. 47; Nelson 1936, p. 501 n. 2; Museum of Fine Arts 1942, p. 113, fig. 71; Museum of Fine Arts 1952, p. 113, fig. 69; Tait 1963, p. 101.

146

146
White-lotus chalice

From Aniba tomb SA30
Dynasty 18
Height 10.7 cm.; diameter 8.2 cm.
University Museum, Philadelphia. Eckley
B. Coxe Expedition (E 11156)

The relief chalice of white, green, black, and red faience emulates in form a blossom of the white lotus. Each flower has four rounded leaves with pronounced veins and these are indicated by deep grooves in the faience. The green faience of the leaves is mostly faded to white. The color of the eight red petals is peculiar since the *Nymphaea lotus* is usually pure white, but it may be the rose-colored variant that is intended.[1] The black-glazed elements between the sepals look more like buds than petals[2] and it is possible that the maker has incorporated lotus buds into his design.

The chalice was found at Aniba in a tomb datable to Dynasty 18.[3] From a Nineteenth-Dynasty grave at the same site came another white-lotus chalice in light green faience not dissimilar in design.[4] In light green faience also are several fragments of a lotus chalice in Philadelphia with the nickname of Ramesses II.[5]

E.B.

1. Spanton 1917, p. 2.
2. Cf. Davies 1927, pl. 25.
3. Steindorff 1937a, pp. 231-232.
4. Ibid., pp. 180-181, pl. 91:4.
5. Petrie 1906b, pl. 156:5.

Bibliography: Steindorff 1937a, pp. 142, 232, pl. 91:3.

147
White-lotus chalice

Provenance not known
Dynasty 18-19
Height 12.5 cm.; diameter 8.8 cm.
Musées Royaux d'Art et d'Histoire, Brussels (E. 4138). Formerly in the MacGregor Collection

The inspiration for this chalice appears to be the white lotus with its familiar veined leaves. Its maker cut off all the ovoid leaves of the white lotus at the same height, forming a scalloped circle with an even lip or border. In order to steady the vase, the base of the stem was enlarged, and the artist could not resist drawing another floral motif on the base. The effect is illogical but nevertheless charming and foreshadows the work of Louis Comfort Tiffany, who adopted the lotus form for his ceramic fantasies over three millennia later.[1]

A similar chalice in the British Museum[2] is straight sided without the flaring outline of this example and has tall ribbed stems or leaves on the base, like cat. 148. Two parallels lack the sculptured stem and have a small rounded foot. The first, from an Eighteenth-Dynasty tomb at Abydos, has six lobes and an even lip or border.[3] The second chalice has a scalloped rim and a six-lobed lip.[4]

E.B.

1. Eidelberg 1968, fig. 2.
2. Capart 1927, pl. 83a.
3. MacIver and Mace 1902, pl. 46.
4. Sotheby 1922, pl. 7, lot 194.

Bibliography: Musées Royaux 1934, no. 69; Musées Royaux 1958, no. 24.

147

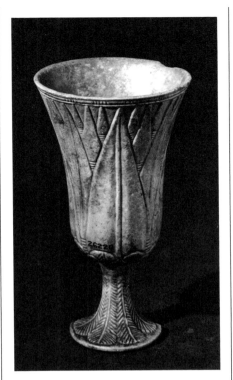

148

148
Blue-lotus chalice

Said to be from Tuneh el Gebel
Probably Dynasty 20-21
Height 15.5 cm.; diameter 9.2 cm.
British Museum, London (26226)

This chalice is more elaborately worked than earlier examples of its kind. Incised veins run up the leaves and central petals, and horizontal lines are lightly incised below the petals. A narrow block border adorns the rim. Beneath the leaves, instead of the usual lobes, are eight papyrus umbels with five smaller umbels between them; inverted palm leaves ornament the slender stem and widely expanding foot.[1]

This is the latest of the lotus chalices in this catalogue, but it is not certain how late. The narrow block border on the rim occurs in the Twenty-second-Dynasty chalices with relief scenes. The horizontal lines below the petals are frequent in representations of the two lotus types in Dynasty 18 but they also occur later,[2] for example, in a chalice of similarly slender shape found outside the head end of a coffin in a late New Kingdom group containing a scarab of Seti II.[3] The palm leaves on the stem and foot appear in two earlier chalices with relief scenes[4] in lieu of the inverted blue lotus blos-

soms and buds or inverted papyri on the stem and foot of most of the relief chalices. However, in one of these, the original stem is missing; a stem belonging to another chalice is glued in its place.[5] In the photograph of the other, published in the sale catalogue of the MacGregor Collection, it looks as though its stem too may originally have belonged to another chalice.[6]

P.V.

1. Tait 1963, pp. 101-102.
2. Ibid., p. 103 n. 4.
3. Quibell 1908a, pl. 25:1.
4. Tait 1963, nos. 4, 19.
5. Ibid., p. 117.
6. Sotheby 1922, frontispiece.

Bibliography: British Museum 1922, p. 144; Capart 1927, pp. 63-64, pl. 83b; Capart 1947, p. 37, pl. 736; Tait 1963, pp. 101-102, pl. 12:3.

Fancy Forms

The manufacture of faience reached its most brilliant development under Amenhotep III and IV.[1] The techniques of decoration remain essentially the same as those of Middle Kingdom artisans, but more elaborate effects are achieved during the New Kingdom. Besides the shades of blue and green previously used, there are now purple blue and violet, apple green, bright yellow and lemon yellow, crimson red, brown red, and milk white.[2] Designs were painted in black or manganese brown onto the body of the vessel or inlaid in a second color, the latter effect achieved by cutting out the desired pattern in broad lines or patterns while the object was still moist, and filling these incisions with a paste of a different color from that of the background.[3] Often the colorant was added directly to the body. A wide range of shapes typical of other materials were copied in faience with a more extensive use of molds and cores and consequently a greater variety of shapes with thinner walls.

E.B.

1. Petrie 1910, p. 111.
2. Ibid.
3. Reisner 1923b, p. 138.

149

149

Long-necked vessel
From Abydos tomb K2
Dynasty 18
Height about 23.5 cm.
Museum of Fine Arts. Gift of Egypt Exploration Fund (09.376)

The elegant form of this long-necked faience vessel is particularly characteristic of the New Kingdom (see cat. 104). It is closely paralleled by a pottery wine bottle with a highly polished haematite slip and bands of floral decoration in black, blue, and red paint used at the funerary banquet of Tutankhamen.[1] The faience vessel is decorated with a floral collar painted bright blue with details picked out and the individual elements outlined in brown. The same color extends to the neck, which widens into a papyrus umbel whose spathes are indicated in brown paint. Three lines in blue encircle the neck high up. About two-thirds of the lower body of the vessel is missing and is partly restored in plaster. The body was probably piriform like the Tutankhamen bottle. Below the floral collar the body is white with three partially preserved

floral swags once pendant from the collar outlined in brown and painted in blue and brown.

The vessel was molded around a core and the neck added or built up on a stick, as evidenced by a thick ring on the interior at the base of the neck.

E.B.

1. Winlock 1941, pl. 5; Hayes 1959, fig. 187.

Bibliography: Museum of Fine Arts 1942, p. 113, fig. 71; Museum of Fine Arts 1952, p. 113, fig. 69.

Literature: Peet 1914, p. 54.

150

Bottle
From el Ahaiwah
Probably Late Dynasty 18
Height 14.5 cm.; width 4 cm.
Lowie Museum of Anthropology, University of California, Berkeley (6-22231)

This piece is one of three such faience bottles known. An exact duplicate in the Metropolitan Museum was formerly in the collection of Lord Carnarvon, patron of Howard Carter, the discoverer of the tomb of Tutankhamen.[1] The third, lacking its neck, was found in a plundered New Kingdom cemetery at Sesebi in the northern Sudan[2] and is now in the British Museum.[3] Like its Metropolitan counterpart,[4] this bottle is of white faience decorated with friezes of bluish-green lotus petals outlined in black. Another lotus with black details and flanking buds is suspended beneath each of the two small vestigial handles. The markings on the collar surrounding the handle differ slightly in the British Museum example and this one. Nevertheless, the similarity of all three pieces would point to a single workshop as the source for these luxury items.

The shape of this bottle was much admired and copied both in pottery (see cat. 91) and in alabaster (see cat. 126).

D.N.

1. Blackman 1937, p. 151.
2. Ibid., pl. 16:2.
3. British Museum 1964b, fig. 75.
4. Hayes 1959, p. 323, fig. 204.

150

151

153

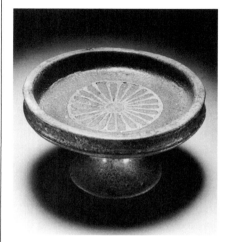

153

151
Lentoid flask
From el Ahaiwah
Late Dynasty 18
Height 8.8 cm.; diameter of body 6.7 cm.,
of neck 4.5 cm.
Lowie Museum of Anthropology, University of California, Berkeley (6-22230)

This lentoid flask in white faience is decorated with a collar of petals from the blue lotus, executed in green and black. The marguerite in the center is also painted in green and black. Below each handle is a lotus flower with buds. The polychrome decoration on three other faience vases (see cat. 150) parallels this piece very closely.

D.N.

152
Bowl
From Medum
Dynasty 18
Height 3 cm.; diameter 9.3 cm.
Musées Royaux d'Art et d'Histoire,
Brussels (E. 3102)

Drawn on the bottom of this polychrome faience bowl is an open blossom of the white lotus. (For a discussion of the development of this motif, see cat. 142.) The background is white, the floral design green with brown highlights.

E.B.

Bibliography: Keimer 1926b, pp. 238, 242, fig. 49; Musées Royaux 1934, pl. 68 (center); Strauss 1974, p. 14, fig. 2.

152

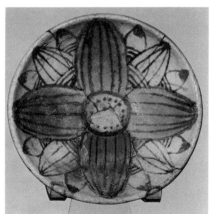

153
Footed dish
Provenance not known
Late Dynasty 18
Height 4.7 cm.; diameter 7.6 cm.
Walters Art Gallery, Baltimore
(48.1608a, b)

The form of this faience footed dish or *tazze* — flat with a low rim and two ribs around the circumference — is common during the first half of Dynasty 18. The distinct, separately made foot, however, is found more frequently later.

At the center underneath, the saucer comes to a point, which fits into a corresponding hole in the stand. A dark blue glaze covers both parts of the vessel, and the color is enhanced by a marguerite blossom in a lighter blue circle inside the dish. The marguerite can be seen on the bottom of a bronze bowl (cat. 112). A footed dish very similar to the one presented here, even to the marguerite decorating the bottom of the saucer, but with what appears to be a basketwork stand, is held in cat. 239 by a Nubian

girl who balances the stand on a monkey's head.

The footed dish is also represented in this catalogue in glass (cat. 181) and in alabaster (cat. 120).

G.L.S.

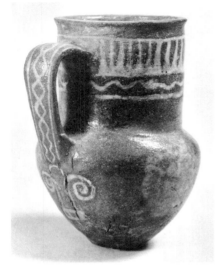

154

154
Jug
Provenance not known
Dynasty 18, probably reign of
Thutmose III
Height 10. 9 cm.; diameter 6.7 cm.
Staatliche Sammlung Agyptische Kunst,
Munich (1576)

This deep blue-violet faience jug has a single handle, a high neck, and a gentle carination rather high on the body. Inlaid in white around the neck is a band composed of a stylized lotus garland and a wavy line, and a helical design on the handle with a pattern beneath that resembles a fleur-de-lis.

There is in Boston an excavated parallel in pottery from tomb D115 at Abydos.[1] Although the material differs, the treatment of rim, neck, handle, carination, and base are all reminiscent of the Munich piece.[2] The objects from that Abydos tomb are consistent with a date in the reign of Thutmose III.

J.K.M.

1. MFA 01.7399.
2. MacIver and Mace 1902, pl. 55:55.

Bibliography: Höhr-Grenzhausen Rastel Haus 1978, no. 227.

155
Fish
Provenance not known
Probably Dynasty 18
Length 16.8 cm.; width 7.5 cm.
Walters Art Gallery, Baltimore (48.1534)

Like many glass and pottery fish bottles (see cats. 179 and 86), this glazed stone figure represents a *bolti* fish or *tilapia nilotica*. A symbol of life and rebirth (see cat. 138), the *bolti* was used as a decorative motif on ointment spoons,[1] cosmetic dishes,[2] faience drinking bowls (see cat. 138), and also as an element in jewelry (see cats. 312 and 352). The deep green glaze is the same as that on an openwork kohl pot (cat. 268).

S.K.D.

1. Dambach and Wallert 1966, p. 290.
2. Ibid., p. 286.

Literature: Dambach and Wallert 1966, pp. 273-294; Gamer-Wallert 1970, pp. 24-27, 53, 109-113.

155

156
Amphora
Provenance not known
Dynasty 19-20
Height 26.3 cm.; diameter 12.4 cm.
Musée du Louvre, Paris (A.F. 8276)

The shape of this blue faience amphora, with its high neck and handles

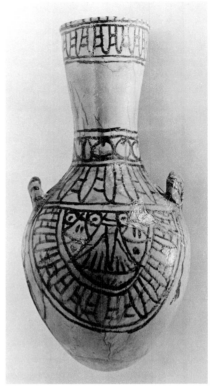

156

set low on the shoulder, is quite common to the New Kingdom from the late Eighteenth Dynasty on. Decorated with a band of lotus petals around the rim and mandrake around the base of the neck, this vase also has a collar of lotus petals covering its shoulder and a "swag" of inverted lotus blossoms and mandrake bordered by lotus petals pendant over the body. In form and decoration, it is very similar to a pottery amphora of Ramesside date from the Louvre (cat. 83).

Several pottery amphorae of the same shape as the present vessel were found in late Eighteenth- to Nineteenth-Dynasty contexts at Gurob, one undecorated[1] and five decorated with a floral garland around their necks and a large floral swag over their bellies.[2] Yet another amphora found at Gurob provides an even closer parallel, although its base is flat and the neck somewhat shorter; it is covered with a blue glaze and painted with similar floral garlands.[3]

G.L.S.

1. Petrie 1891, pl. 21:7.
2. Brunton and Engelbach 1927, p. 16, pls. 29, 38:46s.
3. Petrie 1891, pl. 20:2.

Bibliography: Wallis 1898, p. 48, fig. 98.

157
Basket with lid
Probably from Tuneh el Gebel
Probably New Kingdom
Height 14.2 cm.; diameter 11.1 cm.
Walters Art Gallery, Baltimore (48.426a, b).
Formerly in the MacGregor Collection

This faience vessel imitates a coiled basket. Against a dark blue background rosettes, lotus flowers, foliage, and hounds are drawn in dark brown paint. Around the lip of the basket are a series of perforations through which lashings were passed to keep the lid in place; there are numerous examples of actual baskets closed by identical means (see cat. 132). Neither this basket nor the only known parallel, a piece in the British Museum with somewhat less representational design,[1] is from excavated contexts; however, it is primarily during the New Kingdom that such fancy forms in faience occur and New Kingdom basketry frequently makes use of the sort of elaborate patterning that cat. 157 imitates (see p. 133).

J.K.M.

1. 15667.

Bibliography: Wallis 1900, pl. 14; Burlington Fine Arts Club 1921, p. 85, no. 16; Sotheby 1922, p. 37, no. 270, pl. 8.

157

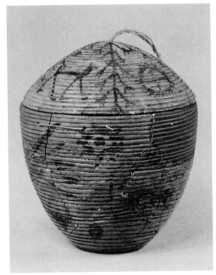

158
Blue-green pyxis with domed lid
Provenance not known
Dynasty 18
Height 6.6 cm.; diameter 7.5 cm.
Staatliche Sammlung Agyptischer Kunst, Munich (1575)

158

The decoration of this faience pyxis or basket resembles closely the ornamentation on the interior of a rilled cup in the Kofler-Truniger Collection (cat. 138). The slashed bands at the top and bottom of the pyxis recur around the rim of the cup, and the frieze of birds, pond reed, and papyrus in both is executed with deft, playful strokes. It is not too far-fetched to presume that the two were painted by the same person. The lower portion of the pyxis has an additional design of crosshatchings, a watercourse perhaps, or a bird net. A faience pyxis in Cleveland[1] provides a close parallel from the standpoints of form and design.

Like cat. 159, the basket may reflect in form an African hut. The lid is ornamented with an inverted blue-lotus motif.

E.B.

1. 14. 609.

Bibliography: Staatliche Sammlung Agyptischer Kunst 1976, p. 108, no. 75; Höhr-Grenzhausen Rastel Haus 1978, p. 151, no. 223.

159
Rounded basket with conical lid
Provenance not known
Probably New Kingdom
Height 15 cm.; diameter 12 cm.
Musée du Louvre, Paris (E 3610). Formerly in the Fould Collection

The body of the faience basket is decorated in black and blue and includes two figures, with an inscription between them reading: "Thoth, the lord of Hermopolis. May he give goodness and life to the *ka* of the scribe of the harbor Hori." The background is composed of a checkered pattern and a zigzag motif imitative of water. The lid, with a hole pierced in the center, is decorated with a lotus pattern now badly faded.

Baskets with domed or conical lids and bearing decoration similar to that on this piece have a long history. Early examples are the painted pottery baskets from the Second Intermediate Period tumuli of Kerma.[1] A stucco basket contemporaneous with the Louvre piece was excavated at Deir el Medineh.[2] It, too, carries a checkerboard motif on the body and a lotus motif on the lid. Painted on a pottery basket of New Kingdom date from Sedment are patterns in red and yellow, diamonds on the body, and an inverted lotus pattern on the lid.[3] The form, possibly in imitation of an African hut with a slightly overhanging roof,[4] survives in modern baskets from Nubia.[5]

J.K.M.

1. Wenig 1978b, p. 160.
2. Bruyère 1937b, p. 56, fig. 27.
3. Petrie and Brunton 1924, pl. 65:2.
4. Wenig 1978b, p. 161, no. 68.
5. Peabody Museum 62255.

Bibliography: Wallis 1900, p. 11, fig. 20.

159

Egyptian Imitations of Aegean Vases

In the long and fruitful relations among the Egyptians, the Minoans on Crete, and the Mycenaean Greeks on the mainland, the manufacture of faience played a special role. The Minoans learned early from the Egyptians how to make the material and adapted it to special uses, often grand and ambitious. The faience plaques that compose the Town Mosaic at Knossos may belong to the seventeenth century B.C., and the extraordinary range of faience votive objects contained in the Temple Repositories of Middle Minoan III B suggest that the material was highly prized in sacral contexts. The figurines of the snake votaries, votive robes with flowers, faience plaques of agrimi (wild Cretan goats) or cow with calf, flying fish, seashells, and vases with applied sprays of flowers are among the most prized of all surviving Minoan palace objects.[1]

The Minoans passed this technique north to the Mycenaeans at the beginning of their cultural exchange. Faience is highly visible in both Grave Circles at Mycenae: the cup with a spray of flowers from the older Circle B[2] or, more renowned in Circle A, the ostrich-egg rhyta with diving faience dolphins, the sacral knots and ewers, the cups based on Egyptian models, the Triton shell, the gaming board and disks, the sketches of armed warriors, and the ruined haunch of a predatory animal.[3] While there are no true Egyptian objects in the Mycenaean Shaft Graves,[4] it is there that a series of mainland rhyta begins, including both conical rhyta in silver and animal-headed examples in silver and gold. These, with the Procession Fresco at Knossos,[5] offer the most visible parallels to the metal rhyta carried by "Keftiu" in fifteen Theban tombs.[6] Most of the rhyta in the paintings illustrating the remarkable gifts of the northerners to Egypt are picturesque animal-headed pieces: lionesses, leopards, griffins, dogs, jackals, rams, and bulls. Some have good analogues in metal and clay in the Aegean proper and in faience in the eastern Mediterranean at Enkomi and Ugarit.[7] Such curious pieces are naturally popular and were embellished in tomb paintings, but they seem to have been copied less often than the conical rhyton. Egyptian versions of this simple, effective vase, which may also have sacral and royal connotations, may begin as early as the end of the Second Intermediate Period and continue through Dynasty 18.[8] Egyptian versions of the Aegean stirrup jar come later, and are made not only in faience but also in glass, alabaster, metal, and pottery.[9]

The Rhyta

The conical rhyton or ceremonial vase for liquid appears in Crete in the later Middle Minoan Period, and in Greece the type is set with the Silver Siege Rhyton of Shaft Grave IV at Mycenae.[10] That piece is not very tall and is densely figured, and the lower part is covered with the tricurved elaboration of the scale pattern (see cat. 169) that becomes congenial to Egyptian painters rendering the type in the hands of the Keftiu[11] (fig. 39). The Aegean desire to decorate special rhyta with active figures persists through the famous serpentine examples from Haghia Triadha, Knossos, and Zakro in Crete to the late faience and ivory rhyta from Kition and Athienou in Cyprus, both harking back in shape and register decoration to models like the Boxer Vase.[12] None of the rhyta in Egyptian tomb paintings is figured, although one in the tomb of Rekhmire may have a palm

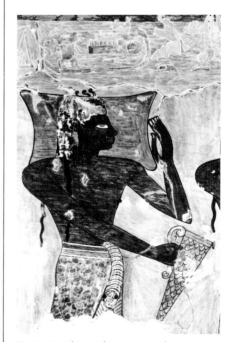

Fig. 39. Man from Keftiu carrying a rhyton decorated with a scale pattern in a procession of Minoan tribute bearers (from the tomb of Rekhmire, Theban tomb 100).

tree[13] like a clay Mycenaean export at Gurob.[14] This raises the question in regard to the sources and workshops of the faience rhyta found at Mycenae itself. Egyptian faience found in the Aegean is generally monochrome, pale blue or green with dark blue, brown, or black patterns in thin lines.[15] Minoan faience may be polychrome, as in the Town Mosaics and Temple Repositories, or monochrome, if the beautiful pale blue ovoid rhyton with oblique spiral decoration found in the House of Shields at Mycenae is Minoan rather than Mycenaean; it was accompanied, however, by faience stemmed goblets, one with Egyptian lotus flowers, and a baggy alabaster Egyptian bowl, as well as by the polychrome pieces with active armed warriors and the griffin-and-lion fragment, which seem much more in the vein of local fantasy.[16] Polychrome faience in Egypt reached its height during the reign of Amenhotep III and the Amarna Period;[17] with the exception of the tiles of foreigners and prisoners, it is not often pictorial, and it is always of higher quality than such crudely pictorial efforts as the bird and date palm on a conical rhyton from Ugarit.[18] The eight known Egyptian faience versions of the Aegean conical rhyton are abstractly decorated and monochrome, with spirals or pendant triangles as the favored motifs. Painted examples are either covered with metallic scale pattern or are vertically grooved, like the rhyton in the Procession Fresco at Knossos.[19] The alabaster version, from an unknown context, has an unusually straight, deep handle,[20] while the faience versions prefer the loop handle of the best Late Minoan I A gilded stone examples. It is not known why the sacral Aegean rhyton was occasionally wanted in Egyptian tombs, but one at least is shown, not in the hands of foreigners but among the vases necessary to funeral cult, in the tomb of Sebekhotep, under Thutmose IV.[21]

The Stirrup Jars

Faience stirrup jars are slightly later in date and far more numerous than the rhyta. The stirrup jar formed a high percentage of the real exports to Egypt from the Mycenaean world, as they are a standard feature of trade with Cyprus, Syria and Palestine; they are, however, less common at Amarna than at Gurob and other Late Helladic III B sites[22] or in the eastern Mediterranean.[23] The larger examples, more common from Troy to Cyprus, were probably used to export olive oil; the smaller ones, and their faience imitations, for perfumed unguents and valuable liquids, since the peculiar construction of the stirrup jar makes it possible to stop the flow from the spout with the thumb, while the second and third fingers control the two sides of the stirrup handle.[24] (There is reason to doubt an early analysis of the contents as coconut oil;[25] see cat. 165). The faience versions are usually very small, and may be presumed to function as containers of luxury liquids.

In contrast to the rhyta, stirrup jars in Egyptian tomb painting are known only in the tomb of Ramesses III,[26] at a period when the import of real stirrup jars was down. Faience imitations began at the start of Late Helladic III B; there is an early blue example from Gurob,[27] and the early compilers of lists of these faience versions note alabaster copies too, as well as a glass one from the same tomb of Ramesses III[28] (see cat. 166) and a metal one at Dendera.[29] Since the painted stirrup jars of this tomb were associated with Canaanite jars, the component of eastern trade makes it less surprising to find high numbers of faience stirrup jars in Cyprus,[30] mostly in the south and east, at Enkomi, Kition, Hala Sultan Tekké, and Kourion, as well as inland near Idalion.[31] Egyptian faience stirrup jars tend to be monochrome, but polychrome examples were made in some Western Asiatic workshops, with brown, white, yellow, and blue decoration. In both cases, the Mycenaean shape being imitated is of a thirteenth-century type[32] with a rounded shoulder, perked up or squat. The designs do not, on the whole, bear any relation to Mycenaean designs and are usually spots, arcs, stripes, wavy lines, and zigzags; the pictorial design of cat. 167 is most unusual.

E.T.V.

1. Evans 1921, pp. 301-314, 486-523.
2. Mylonas 1973, p. 27, pl. 16b,d.
3. Karo 1933, pp. 114ff., 242ff., 315ff.
4. Vermeule 1975, pp. 18ff.
5. Evans 1928, pp. 704ff.
6. Bissing 1898b, pp. 242ff.; Fimmen 1924, pp. 181ff.; Evans 1928, pp. 736ff.; Hall 1928a, pp. 198ff.; Pendlebury 1930a, pp. 75ff.; Kantor 1947, pp. 41ff.; Furumark 1941, pp. 203ff.; Smith 1958, pp. 145ff.; Vercoutter 1956a, pp. 311ff.; Porter and Moss 1960, p. 464, no. 5.
7. Karo 1911; Doumas 1968; Murray and Walters 1900, p. 33, fig. 61:1212, p. 34, fig. 63:1217; Schaeffer 1949, pp. 220ff.
8. Merrillees 1968a, pp. 27-28.
9. Bissing 1898b, pp. 260ff.; Nelson 1936, p. 504; for correlations of Egyptian and Aegean dates, see Hankey and Warren 1974, pp. 142ff.
10. Evans 1930, pp. 81ff., 96, figs. 50-56; Karo 1933, p. 175ff., no. 481; Furumark 1941, pp. 71-72.
11. Vercoutter 1956a, pl. 42, nos. 302, 304-306.
12. Müller 1915, pp. 247ff.; Evans 1930, p. 224, fig. 157; Zervos 1956, figs. 544-547; Dothan and Ben-Tor 1972, pp. 201-208; Peltenburg 1974, pp. 116ff.
13. Davies 1943, pl. 18; Vercoutter 1956a, pl. 42:303.
14. Petrie 1891, pl. 19:37; Stubbings 1951, p. 94.
15. Peltenburg 1973, pp. 129ff.
16. Wace 1954, p. 237; Wace 1956, pp. 109ff.
17. Peltenburg 1974, p. 130.
18. Schaeffer 1936, p. 115, fig. 8b; Peltenburg 1974, fig. 3e.
19. Evans 1928, pl. 12.
20. Forsdyke 1911, p. 117, fig. 5; Hall 1928a, p. 222, fig. 92; Warren 1969, P 465-468, 471.
21. Vercoutter 1956a, p. 324, pl. 43:307.
22. Pendlebury 1930a, pp. 87ff.
23. Kantor 1947, p. 80; Stubbings 1951, pp. 92ff.; Hankey 1973, p. 131; Merrillees and Winter 1972, pp. 122ff.
24. Furumark 1941, p. 78; Raison 1968, pp. 33ff.; Cadogan 1969, pp. 152ff.
25. Gill 1906, pp. 300ff.; Lucas 1962, pp. 328ff.; Merrillees and Winter 1972, p. 125.
26. Champollion 1845, pl. 258; Hall 1901, pp. 59ff., figs. 26-27; Fimmen 1924, pp. vi, 209, fig. 202; Vercoutter 1956a, pl. 59:438-441.
27. Hankey 1973, p. 131.
28. Bissing 1898b, pp. 262, 263.
29. Bissing 1899, p. 57.
30. Vercoutter 1956a, p. 354.
31. Peltenburg 1973, pp. 129ff.; Peltenburg 1976, pp. 104ff.
32. Furumark 1941, S173; Peltenburg 1976, p. 104.

Literature: Bissing 1898b, pl. 8; Bissing 1902, nos. 3676, 3677; Hall 1901, pp. 185, 190; Hall 1928a, p. 221; Fimmen 1924, pp. 207ff.; Gjerstad et al. 1934, pl. 78.1.109; Pendlebury 1930a, pp. 87ff.; Schaeffer 1952, pls. B,43.1; Smith 1965; Schachermeyr 1967, pl. 56, pp. 205-206; Hankey 1967, pl. 37; Peltenburg 1973, p. 134; Peltenburg 1976, p. 104; Buchholz 1974, p. 458.

160

160
Conical rhyton
From Tuneh el Gebel
Dynasty 18
Height 23 cm.; diameter 13 cm.
British Museum, London (22731)

This tall straight-sided rhyton has an offset concave lip and a slightly crooked vertical loop handle at the rim. The body is divided into seven abstract decorative registers: vertical lines below the lip, a band of horizontal slashes, four rows alternating solid pendant triangles and solid lozenges framed by two thin lines, and sharp spotted lotus petals rising one third of the way up. There are dots on the sides of the handle. The faience is pale blue, with dark blue designs and black outlines; the inside is unglazed.

This is the most published of the faience rhyta. The decoration is straight Egyptian, with analogies also in Cyprus but not generally in the Aegean ceramic repertory, although the well-known fragment of fresco from the palace at Tiryns, showing an animal drinking from a conical rhyton, has thin alternating pendant and up-right triangles in the zone around the handle root.[1] It is a natural design for the shape; the broader faience rhyton from Saqqara has a double band of pendant triangles in the handle zone, with the vertical lines, reminiscent of

the grooved metalwork in the Theban paintings or the Procession Fresco at Knossos, reserved for the lower body.[2]

Similar systems of triangles decorate the broad baggy rhyton from Kubban at the rim[3] and the bulging clay rhyton from Arminna, painted in red and black on a cream buff surface, with bands of dots above and long crude pendant triangles in the handle zone.[4] It is a sign of the full absorption of the foreign vessel form into local Egyptian production, and was also extended to an "Aegean" krater in the tomb of Huya at Amarna.[5] The other faience conical rhyta come from Saqqara, Sedment, Kubban, and from unknown sites (now in Brussels, at Eton College, and in the Fitzwilliam Museum); there is a well-known neckpiece at Ashur and a possible rim fragment from the island of Kythera.[6]

E.T.V.

1. Rodenwaldt 1912, pl. 16:4; Evans 1928, p. 769, fig. 501; Peltenburg 1974, p. 118, fig. 2c.
2. Peltenburg 1974, p. 119, fig. 3b.
3. Firth 1927, p. 63, pl. 27c:3.
4. Simpson 1963, pl. 15:24.
5. Vercoutter 1956a, pl. 51:375.
6. Peltenburg 1974, pp. 126-127.

Bibliography: Wallis 1900, p. 10, fig. 18; British Museum 1922, p. 143, no. 36; Hall 1901, p. 186, fig. 53; Hall 1928a, p. 222, fig. 291; Fimmen 1924, p. 208; Evans 1928, supp. p. 24.20; Bossert 1937, no. 569; Nelson 1936, p. 502, fig. 2; Schachermeyr 1967, pl. 41:154; Peltenburg 1974, p. 119, fig. 3c; Buchholz 1974, p. 458r.

161
Rhyton
From Abydos tomb D11
Early Dynasty 18
Height 17.5 cm.; diameter 7.5 cm.
Museum of Fine Arts. Gift of Egypt Exploration Fund (00.702)

The broad, baggy funnel-shaped "filler," mended from four fragments, has one low vertical loop handle at the rim, slightly off center; the outside of the handle bulges. The bottom of the rhyton is pierced with an off-center hole. It is made of blue faience and decorated with lustrous black glaze, thinly and unevenly applied. Decoration consists of two black lines running around the rim and across the handle, a row of solid pendant triangles below the rim, a single large uneven running spiral band under the handle zone, with two crooked black lines below, and a line

and a band around the opening at the bottom.

This is one of six known Egyptian faience imitations of the Aegean conical rhyton; its combination of decorative motifs, the local triangle border, and the more Aegean-looking spiral scroll epitomize the hybrid character of the group, like the following small faience stirrup jars. The curiously broad, squat proportions of the Egyptian vases contrast both with the standard conical rhyta known in clay in the Minoan and Mycenaean worlds and with the elegant forms of those carried by the Keftiu in Theban tomb paintings;[1] they are closer to the shape made in the Cycladic islands of Melos and Thera, or found in Cretan coastal towns like Gournia.[2]

The conical rhyton is conservative in shape in the Aegean proper, as is normal in sacral vessels, so that late thirteenth-century luxury examples decorated in registers, like the faience rhyton from Kition in Cyprus or the ivory rhyton from nearby Athienou,[3] consciously go back to such models as the Boxer Vase from Haghia Triadha in Late Minoan I A.[4] None of the rhyta in the Egyptian tomb paintings is shown with figured registers; most are covered with scale pattern or vertical grooves to suggest gold and silver metalwork, but one example from the tomb of Men-kheper-re-seneb has a spiral register like this,[5] similar to many "Aegean" vases of other shapes. The spiral was familiar in Egypt long before, from Kerma vases to the ceilings of many New Kingdom tombs, but in this wavering and unskillful form seems to represent the artisan's feelings for what was "proper" in the best tradition of luxury Late Minoan I A vessels.

E.T.V.

1. Evans 1928, supp. pl. 24; Vercoutter 1956a, pp. 323ff., pls. 42-43.
2. Evans 1928, supp. pl. 24:1-3; Marinatos 1971, pl. 86b; Marinatos 1972, pl. 64; Marinatos 1974, pl. 6a.
3. Peltenburg 1974, pp. 116-117; Dothan and Ben-Tor 1972, pp. 201-208; Dothan and Ben-Tor 1974, unnumbered plate.
4. Müller 1915, pp. 247-248; Evans 1930, p. 224, fig. 157; Zervos 1956, figs. 544-547.
5. Davies and Davies 1933, pl. 5; Vercoutter 1956a, pl. 43:308.

Bibliography: MacIver and Mace 1902, p. 90, pl. 50; Nelson 1936, p. 502:1, p. 502:3; Merrillees 1968a, p. 27.

161

162
Rhyton
Provenance not known
Late Helladic III A:2, mid-14th
century B.C.
Height 26 cm.; diameter of rim 10.2 cm.
Museum of Fine Arts. Seth K. Sweetser
Fund (1970.9)

This tall conical rhyton with everted
rim, narrow body, and pierced base[1]
is of buff clay with red-chestnut glaze
paint. Decoration consists of zigzags
under the rim, obliquely vertical wavy
bands framed in fine lines in the han-
dle root zone, and alternating bands
and fine lines on the body; the interior
is glazed solid and the base is solid.
Part of the rim and all of the handle
have been restored.

This is a good taut example of the
kind of vase after which the baggier
Egyptian faience rhyta were modeled,
and it accords well with the slenderer
versions in Egyptian tomb paintings.
The decoration is in characteristic
"Amarna" style of the mid-fourteenth
century. There is a conical rhyton at
Amarna[2] and a fancier version with
palms and crocuses from Gurob.[3] The
numbers of such rhyta imported into
Egypt seem, on present evidence,
smaller than the number of imitations.

E.T.V.

1. Furumark 1941, S199.
2. Hankey 1973, p. 134, fig. 1.
3. Petrie 1891, pl. 19:37; Benson 1963, pl. 19.

Bibliography: Münzen und Medaillen 1969, no. 27;
Vermeule 1971, pp. 40ff., no. 3.

162

163
Stirrup jar
Purchased at Tuneh el Gebel
New Kingdom
Height 7.5 cm.; diameter 22 cm.
Ashmolean Museum, Oxford (1922.77).
Formerly in the MacGregor Collection

This small, globular vase, with a flat
disk on the false neck, handles
grooved along the edges, a flaring
spout, and a raised base, is made of
blue-green faience with black, thin-
line designs. The decoration is not
unified, as so often occurs on these
vases: a circle on the disk, concentric
arcs with dots on the two front quad-
rants with a cross under the spout, a
cross in a circle of dots on the rear,
and a broad belt of filled alternating
triangles around the waist. Except for
a few chips from the left front rim of
the spout, it is intact.

A fragmented stirrup jar in the Ash-
molean Museum, from the Hathor
temple at Deir el Bahri, has a more
Aegean spiral band.[1]

E.T.V.

1. Fimmen 1924, p. 208.

Bibliography: Sotheby 1922, no. 1800.

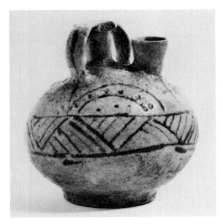

163

164
Stirrup jar
Provenance not known
Dynasty 19
Height 6 cm.; diameter 5.9 cm.
Museum of Fine Arts. Anonymous loan
(143.64). Formerly in the Garstang and
Rea Collections

This is a small globular stirrup jar of
yellowish-white, slightly veined ala-
baster, the false neck and handle tilted
toward the rear, the spout rimmed and
with a concave profile, and a flat base
with rolled edge.

This Egyptian stone version of the
later Mycenaean shape is close to
most faience examples and under-
scores the versatility of the Egyptian
craftsman in copying foreign forms.
An alabaster vase was found at
Illahun;[1] there is another in Berlin[2] and
glazed and calcite versions from
Gurob,[3] as well as the metal and glass
examples mentioned above.

E.T.V.

1. Petrie 1891, pl. 19:27.
2. Buchholz 1974, p. 458.
3. Hankey 1967, pl. 37.

Bibliography: Hall 1928a, p. 221, fig. 289;
Vermeule 1964, pl. 45; Buchholz 1974, p. 458.

Literature: Hall 1901, p. 190, fig. 56.

164

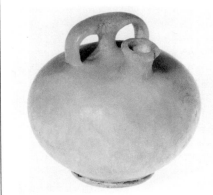

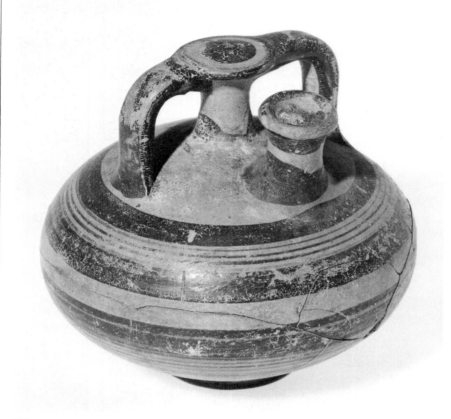

165

166
Stirrup jar
Provenance not known
Dynasty 18
Height 14.9 cm.
St. Louis Art Museum (177.1925). Gift of
the Bachstitz Gallery

This tall faience stirrup jar, with sunken disk, has strap handles taller than usual and a long spout with flared rim, a concave false neck, a globular body, and a flat base. The thin-line decoration consists of a series of long tongue-like patterns filled with irregular dots, pendant from the base of the neck, three on each side of the spout, overlapping the framing line below the handle roots, and lotus leaves spreading upward from the base.

Unlike the usual low globular form imitated in faience, this stirrup jar has more in common with the tall forms of the painted examples in the tomb of Ramesses III.[1] It should be relatively late in the series, and the decoration underlines how far these vessels have become independent of any Aegean prototype.

E.T.V.

1. Perhaps following Furumark 1941, Shape 180.
Bibliography: St. Louis Art Museum 1975, p. 19.

166

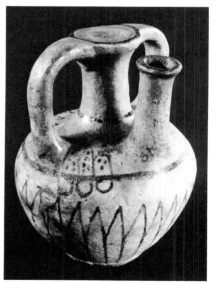

167
Biconical flask
From Gurob
Late Dynasty 18-Dynasty 19
Height 9 cm.; diameter 10.5 cm.
Manchester Museum [England] (659).
Formerly in the Haworth Collection

165
Mycenaean stirrup jar
Provenance not known
Late Helladic III B, 13th century B.C.
Height 10.8 cm.; diameter 10.8 cm.
Museum of Fine Arts. Hay Collection,
Gift of C. Granville Way (72.1482)

The jar has a low, biconical body, a spout with a marked rim tilted forward, vertical handles and false neck, a flaring disk with slight nipple, and a raised foot with a straight edge. It is of gray-buff clay with dark brown paint. The center of the disk is painted solid and ringed at the edge; the top and root of the spout are ringed, as is the false neck; the handles are glazed entirely but unevenly. The decoration is typical of lower-grade export pottery from the Amarna Period onward: alternating, wide bands filled with thin stripes (four on the shoulder, three on the belly).

The spout of the stirrup jar is still plugged with solidified material, an aromatic oil of some kind. An old analysis identifying the substance as coconut oil is now doubted.[1] The splay of the spout accords well with the exaggerated splay in the tomb representations of Ramesses III (see p. 153). This modest piece has the characteristic "Amarna" decoration of Late Helladic III A:2,[2] although the general shape and slightly raised nipple on the disk suggest a thirteenth-century date. Numbers of such stirrup jars were found at Amarna and Gurob. The sites from which the Hay-Way Collection in Boston was gathered are not known; however, Mycenaean stirrup jars of the later fourteenth and thirteenth century are attested at Abydos, Amarna, Assiut, Balabish, Buhen, el Arish, the Fayum, Gurna, Gurob, Heliopolis, Mostai, Naqada, Rifeh, Riqqeh, Saqqara, Sedment, Sesebi, Tell el Daba, Tell el Yahudiyeh, and Thebes.[3]

E.T.V.

1. Gill 1906, p. 300; Merrillees and Winter 1972, p. 125.
2. Hankey 1973.
3. Stubbings 1951; Merrillees 1968a; Buchholz 1974.

Bibliography: Gill 1906, pp. 300ff.; Fairbanks 1928, p. 27; Vermeule 1964, pl. 45A; Buchholz 1974, p. 457, no. 24; Merrillees and Winter 1972, p. 125; Art Museum of South Texas, p. 10, fig. 9.

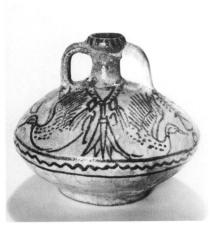

167

The body of this jar is low spreading and biconical with handles attached to the short neck under the mouth; the shoulder is broad and the under-body and base narrow. It is of blue-green faience with black thin-line decoration. There are slashes on the rim and a narrow pair of framing lines around the greatest circumference, enclosing a wavy line. On the shoulder, in each quadrant, is a duck represented trussed as though suspended from the jar neck tail to tail with wings raised, separated by pendant lotus buds with scattered trailing weeds in the field.

This is the most ambitiously decorated of all the faience jars. The theme of waterbirds and blossoms was traditional in Egypt and made its influence felt early in the Aegean world in metalwork, as on the "Nilotic" dagger from the Shaft Graves;[1] in paintings, as on the Thera naval fresco;[2] and on pottery, the three-handled jar from Argos being the most beautiful surviving example.[3]

While the mechanism of the interchange is still unknown, the related Tell el-Yahudiyeh bird-and-lotus vase was exported to Cyprus in the late Middle Bronze Age,[4] and the jug from Tomb 879 of the North Pyramid at Lisht suggests, in its unique combination of water birds and dolphins, reverse influence from the Aegean.[5]

The Gurob flask seems clearly in the Egyptian rather than the Aegean tradition and is closely connected with the interest in waterfowl on the painted floors at Amarna or the reliefs of trussed ducks common to that period.[6] Aegean pictorial renderings of birds in this period are far more formal and abstract: flamingoes or herons marching in narrow repetitive friezes, or, in a different sphere, birds and fish caught up in octopus tentacles on late thirteenth- and early twelfth-century stirrup jars. The closest Aegean analogies to this design come on the Phaistos baggy alabastra (see cat. 168) with ducks springing among plants and feeding[7] or the Minoan jar with heraldic ducks and weeds found at Hala Sultan Tekké on Cyprus.[8] There are no stirrup jars with this kind of suspended duck-and-lotus theme, certainly not among the many imported stirrup jars found at Gurob. The connection with Amarna period design seems strengthened by the similar relationship between the prancing calves in thickets of the Amarna and Malkata palaces and by the similar themes on faience bowls and on two-handled jars of ultimately Aegean inspiration, which are related to stirrup jars.[9]

E.T.V.

1. Karo 1933, no. 765, fig. 56, pl. 94; Vermeule 1975, p. 21.
2. Marinatos 1974, pl. 8.
3. Vollgraff 1904, p. 377; Evans 1935, p. 332; Deshayes 1953, p. 73.
4. Negbi 1978, p. 144.
5. Kantor 1965, p. 23, fig. 6; Smith 1958, p. 119; Schachermeyr 1967, pl. 35:135; Prag 1973, p. 128.
6. Bissing 1941, pls. 3-8; Smith 1965, pp. 159-160; Aldred 1973, no. 142.
7. Evans 1935, p. 337, fig. 280.
8. Åström et al. 1976, pl. 79:163.
9. See, e.g., Cesnola 1903, pls. 108:5, 109:1; Wallis 1898, p. 48, fig. 100.

Bibliography: Petrie 1891, p. 19, pl. 20:1; Wallis 1898, p. 48, fig. 101.

168

Alabastron

Provenance not known
New Kingdom
Height 19 cm.
British Museum, London (22730)

This tall bag-shaped vase has a large flat rim, a narrow neck, and a body swelling toward the bottom, resting on a flattened base. Made of blue faience, it is adorned with black glazed designs. A round cover (not in photograph) with a rosette design closes the opening of the vessel, while the body is embellished with registers of triangles, filled lozenges, lotus blossoms, and running spirals.

The shape of the vase is characteristically Egyptian and many similar

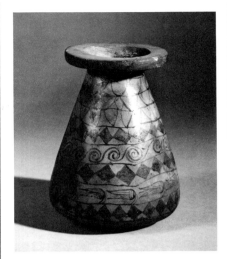

168

vessels are known in pottery, alabaster, and faience; there is a particularly close variant in the Louvre[1] in yellow faience bearing cartouches of Amenhotep III and Tiye, as well as several comparable pieces in alabaster.[2] Alabaster vessels of this general shape were exported to the Aegean at an early date, however,[3] and there is a close parallel between the clay alabastron with Aegean designs of foliate bands, scale triangles, rosettes, and zigzags found in Grave 137 at Sedment[4] and an alabastron from a Late Minoan I house at Mochlos on the north coast of Crete. The "Nilotic" feeling of these vases in the Aegean is evident in the duck-and-plant design on the baggy alabastron from Phaistos in Crete;[5] the triangular pattern may relate ultimately to the veining of the alabaster prototypes.[6] The interchange is conspicuous, with the adaptation of the shape in the Aegean, and the Aegean designs in Egypt. There is, however, nothing obviously Aegean about the set of patterns here, in spite of the band of loose running spirals. The triangles and lozenges are used in other combinations on other faience vases (see cat. 160), as they are independently on hundreds of Cypriote white painted vases.

E.T.V.

1. Vandier d'Abbadie 1972, no. 240.
2. Ibid., nos. 304-307.
3. Furumark 1941, p. 39; Warren 1969, pp. 112, 114.
4. Evans 1935, p. 270, fig. 200.
5. Ibid., p. 337, fig. 280.
6. Warren 1969, P 606, 609, 610, 614.

Bibliography: Wallis 1900, pp. 10-11, fig. 19.

169

169
Cup

Provenance not known
Dynasty 18
Height 10.1 cm.; diameter 8.6 cm.
Museum of Fine Arts. Hay Collection,
Gift of C. Granville Way (72-1415)

The heavy rolled rim of this small cup
is beveled beneath, the ridged torus
foot has a flat base, and the sides
taper steadily inward from below the
rim to just above the foot, when it
splays out again; the shape is that of a
beaker. It is of blue faience with a
black glaze; rim and foot are glazed
solid, and the body is covered with an
uninterrupted connected scale pat-
tern, the scales hanging downward,
their points rounded.

The scale pattern and its elaboration,
the tricurved arch, were used widely
in the Aegean on metalwork, ivory,
and stone, and on painted and ivory
versions of textiles.[1] Its Aegean con-
nection in Egyptian eyes appears
early as an overall design on the rhyta
carried by the "Keftiu" in Theban
tombs (see p.152). The shape of this
cup is derived from Egyptian stone
vessels of the Old Kingdom and their
later analogues in the Aegean, but the
cup may well be imitating a metallic
model. A close parallel of Egyptian
manufacture in alabaster, probably
dating to Dynasty 6, was exported to
Crete and was found in an unclear
context at the northwest corner of
the palace at Knossos[2] and it is ap-
parent that the Minoans were im-
itating the shape as early as Middle
Minoan II B,[3] although most copies are
Middle Minoan III to Late Minoan I.

The scale pattern is understandably
never used on the Minoan stone vases
of this shape, and among stone vases
in general it may be limited to the
famous fragment of a conical rhyton
from Knossos, where it forms a back-
ground for the crouching bearded
archer, a serpentine analogue to the
Silver Siege Rhyton at Mycenae.[4] If
there is any Aegean ceramic reflection
of the imported and imitated Egyptian
stone conical cups, it might be the
so-called Vapheio cup, a shape that
marks the transition from Middle to
Late Bronze and then has an honorable
independent life. It is usually broader
and lower than the Egyptian cup, with
a single strap or loop handle. On the
mainland it also usually has a midrib.
Such cups are often shown being
carried by the Keftiu in Theban paint-
ings, although none are covered with
scale pattern like the rhyta;[5] there is a
clay version, however, that is com-
pletely decorated with a scale pattern
very like this,[6] but such a scheme is
more usually reserved for three-
handled jars and kraters.[7] Since the
shape, technique, and parallels to this
cup are Egyptian,[8] perhaps the search
for an Aegean inspiration for the dec-
oration is unnecessary, except as a
general reflection of a motif absorbed
into Egypt as "Aegean" in the period
of the Keftiu paintings to mark north-
ern luxury goods, especially since the
scale pattern had such a long history
in Egypt, where it was used for both
feathers and fish scales as well as
abstract pattern[9] (cf. cat. 296). There
is a faience chalice from Kubban in
Nubia covered with a cruder all-over
scale pattern with points downward,
which demonstrated the predilection
for the association of scale pattern
with shapes that have ritual tradi-
tions.[10] However, a third cup of the
flat-bottomed Boston shape, in the
British Museum, has a markedly
Aegean decoration of nets of vertical
hooked spirals.[11] Perhaps the missing
link will yet appear.

E.T.V.

1. Kantor 1947, pp. 99ff.; Poursat 1977, pt. 2,
 pp. 83ff., pl. 25:278a, b.
2. Evans 1935, pp. 123-124; Warren 1969, P 600.
3. Warren 1969, P 416-426, and for Egyptian
 comparison P 410-415.
4. Evans 1930, p. 100, fig. 59.
5. Vercoutter 1956a, pls. 35-36.
6. Blegen 1921, pl. 4:4.
7. Furumark 1941, Motifs 42.3, 70.
8. Petrie and Brunton 1924, pl. 63; example at
 Eton College.
9. E.g., Aldred 1973, no. 154.
10. Firth 1927, p. 96, pl. 27c:1.
11. Wallis 1900, fig. 21.

Egyptian Blue Ware

As the first synthetic pigment and the principal paint or pigment used by the Egyptians, "Egyptian blue" was known to the Roman architect Vitruvius, who called it *caeruleum* and said it was invented at Alexandria, although it was used 2,000 years before Alexandria was built.[1] Similar in chemical composition to faience (see p. 140), Egyptian blue can be fired and ground as a pigment or if powdered finely and mixed with water can be molded or modeled, dried, and fired. Egyptian blue was made into beads, amulets, and other small objects at an early period[2] and was used more ambitiously in the New Kingdom for vases (cat. 170), cosmetic dishes (cat. 171), and the like.

Egyptian blue is fired to a lower temperature than that required for glass.[3] Many materials called "Egyptian blue" are inhomogeneous and contain quartz, calcite, or sometimes colorants other than copper. In these cases, a more general term "frit" should probably be used.

P.V.

1. Lucas 1962, p. 340.
2. Ibid., p. 343.
3. Chase 1968.

Literature: Petrie 1892a; Hodgson 1936; Saleh et al. 1974.

170

170

Vase and cover
Said to be from Luxor
Mid-Dynasty 18
Height 12.7 cm.; diameter of cover 9.7 cm.
The Walters Art Gallery, Baltimore
(47.1a,b)

High-necked and footed alabaster vases like this Egyptian blue example had a brief career, the known examples dating to the reigns of Hatshepsut and Thutmose III.[1]

The body of this vessel is baggier than some of the alabaster vases and the shoulder is more sharply accentuated. The form is paralleled closely in an unpublished alabaster vessel from Sedment grave 1723.[2] Scarabs from this grave with nicks on the wing cases indicate that the date of the grave cannot be earlier than Hatshepsut and is probably no later than Thutmose III. Two similar frit vessels excavated at Aniba[3] have a green cast that indicates the presence of iron compounds,[4] and a third, found at Rifeh,[5] displays the same green color. A high-necked and footed gray serpentine vase like these was found in the debris of a New Kingdom burial at Semna; it is complete with a cover like the Baltimore vessel.[6]

E.B.

1. Petrie 1937, p. 13.
2. Information provided by J. Bourriau.
3. Steindorff 1937a, pp. 166, 177, pl. 91:9,10.
4. Lucas 1962, p. 341.
5. Petrie 1907, pl. 27a.
6. S532: Dunham and Janssen 1960, fig. 48, pl. 118a.

Bibliography: Brooklyn Museum 1968, p. 104.

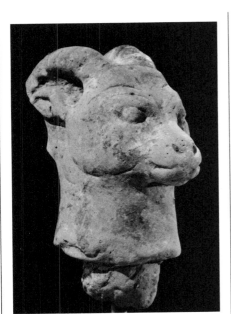

171

Glass

171
Ibex head

Provenance not known
Dynasty 18
Height 5.5 cm.
Museum of Fine Arts. William Stevenson
Smith Fund (1979.159)

From parallels in other materials[1] it
seems likely that the head was fitted
as a terminal to a cosmetic dish in the
form of an ibex body. The color is a
light blue.

E.B.

1. Cf. Petrie 1927, p. 43, pl. 38:38,39.
Bibliography: Museum of Fine Arts 1979, p. 23.

Glass was as precious as rubies and
gold in Egypt and the Near East, ac-
cording to the Bible. Objects of faience
(e.g., cat. 378) were worn and coveted
in the third millennium B.C.; however,
it was not until the middle of the
second millennium, sometime after
1500 B.C., that vessels were made en-
tirely of glass. The transition from
glazing stone and manufacturing
faience in the late fifth or early fourth
millennium B.C.[1] to the fabrication of
complete glass vessels is still unclear.
Glassmaking appears to have been a
natural if not accidental development
of this ancient faience industry.[2]

Although present in differing propor-
tions, the raw materials used to manu-
facture both faience and glass are
soda, lime, and silica. The practice of
applying molten glass to a removable
core may have been derived from
observing the difference between the
skin of alkaline glaze and the fine
crushed quartz core of fired faience.
The production of faience required
dipping the core into the glaze or
firing the unglazed elements in a
special self-glazing mixture;[3] in con-
trast, the glassmaker would have ap-
plied hot glass over a removable clay
and dung core. Perhaps this transition
in technology occurred when a crafts-
man tinkered with a faience object by
scraping out the friable core, pro-
ducing a fragile and delicate glass
form. This hypothetical "experimen-
tal" vessel would have had a rather
thick layer of core material adhering
to the interior. Obviously, a consider-
able amount of refinement would have
been required to develop a proficient
technique that would allow craftsmen
to produce glass vessels of consistent
form and quality.[4] Despite all of the
differences between faience and glass
manufacturing, these basic similarities
should not be ignored.

Current research, both epigraphical
and archaeological, continues to sup-
port a Western Asiatic, not an Egyp-
tian, origin for glassmaking.[5] The
Mitannian region has been suggested
as the location of the earliest
workshops.[6]

It is primarily the numerous examples
of glass vessels preserved in Egypt and
the evidence of manufacturing sites[7]
that continue to promote the popular
theory that glassmaking began in
Egypt. One need only compare the
heavily weathered and often frag-

mentary glasses of Nuzi and Nimrud with the intact and glistening vessels of Eighteenth-Dynasty Egypt to see why an Egyptian origin was readily accepted.

After its early beginnings in the Near East, the industry did not take long to distribute vessels abroad. Glassmaking may have been introduced to Egypt with the expansion of her empire during the Eighteenth Dynasty, possibly under Thutmose III, who extended the boundaries to Syria in the East (cf. cat. 173). We shall probably never know if the glassmakers were prisoners of war or if they returned with the armies to cultivate a wealthy and promising market. There is also the question of imported artisans or locally trained craftsmen under foreign supervision. Although the glass vessel shapes are Egyptian, the quality of the glass and the skill in manufacture suggest a long tradition of working this difficult material.

A likely fabrication technique, thought to have been refined from the faience industry to produce glass vessels and jewelry, is core forming. It consisted of fashioning a clay and dung core over a metal rod. Glass was probably trailed or pulled onto the core by means of a second tool, as it is unlikely that the core could have been dipped into hot glass without gathering too much from the furnace. Once it was on the core, the glass was marvered or smoothed on a flat surface. Trails of contrasting color were wound on the vessel and marvered smooth. Afterward, the trails were dragged up or down in a feather or festoon pattern with pointed instruments. Handles, feet, and rims were fashioned from thick trails of glass and added to the form. The finished vessel was removed from the rod and annealed. Finally, the core was scraped out and the vessel was ready to be used.

Another technique of glassmakers in the second millennium B.C. was casting in open or multiple-part molds. Glass does not have a melting point but rather softens and becomes a viscous fluid when heated. Thus, close analogies of glass and metal casting should be avoided, since ancient craftsmen did not have the extremely high temperatures needed to make glass flow easily into a complicated mold. It is more likely that hot glass was pressed or pushed into open

molds to form pendants or simple pieces. For more complex objects glass may have been crushed or powdered and added to the mold continuously as it melted.[8] This process, or a variation of it, must have been used to fabricate the well-known glass headrest of Tutankhamen[9] now in the Cairo Museum, as well as the head of Amenhotep II in the Corning Museum of Glass.[10] The headrest was probably cast in two pieces, each in a two-part mold. The two pieces were annealed and finished by grinding, polishing, and joining the separate parts together. The gold band around the center covers the place where the two pieces join.

Unlike the headrest, the Corning head was lost-wax cast in a more complicated and time-consuming process. The head was probably part of a kneeling figure that was carefully retouched and polished once it was removed from the mold. Fragments of cast objects, varying in complexity and technical refinement, exist in many museum collections. They suggest that the technique of casting glass was used extensively, although the products were not as numerous as those made by core forming.

A third process, that for creating mosaic glass, was contemporary with casting and core forming. Often called *millefiori* (the Italian term for "a thousand flowers," used to describe paperweights) and known from early sites in the Near East[11] such as Tell al Rimah, 'Aqar Qūf, and Marlik, it is the most complicated of the three techniques (see cat. 176). A series of monochrome rods of different colors was prepared and fused together to form a cane of multicolored design. When such a cane was softened and drawn out so that the diameter became smaller, the design remained the same throughout the length. Once the cane was cooled, it was cut up into the desired lengths and arranged in a mold. A cover or insert held the canes in place[12] and kept them from shifting during firing. The rough blank, removed from the mold, required extensive grinding and polishing before it was completed. The glassmaker had to be familiar with the furnace and the qualities of the glass in order to produce such vessels successfully. Too little heat and the

elements would not fuse; too much heat and the glass would flow together, destroying the design. It is not surprising that objects made by this technique in antiquity were rare. Through the centuries, both ancient and modern consumers have prized this type of glass above others.

By means of these three manufacturing processes, Egyptian craftsmen produced a wide range of objects for wealthy patrons. Along with containers, sculptures in the form of freestanding figures, *ushebtis*, and miniature pendants[13] were fashioned by casting. Dedicatory implements, decorative tiles, and architectural elements were also made in this way. Much of the furniture of Tutankhamen is embellished with wood, stone, bone, and glass inlays. Some of these inlays are cast, while others are mosaic glass compositions. This technique was used extensively in jewelry and furniture, but few vessels of this type are preserved.

The overwhelming majority of vessels still remaining from the Eighteenth through the Twenty-first Dynasty are core formed. Although some of these forms, mainly bowls and cups (see cats. 173, 174, and 181), were appropriate for drinking, most glass containers probably held perfumed unguents, scented oils and salves, and kohl. A few larger one-handled flasks (see cats. 178 and 184) might have been used for oil at the table but, other than the series of vessels from the tomb of Amenhotep II,[14] none seem sufficiently large to have been suitable for wine or storage. Many pendants, rings, earplugs, and beads of glass were also core formed. As the end of the Bronze Age approached, the quality of glassmaking seems to have declined in Egypt. The simple beakers found in the tomb of Neskhons, the wife of Pinodjem I[15] were core formed but made of inferior glass and poorly decorated when at all.

Although glassmaking technology was not completely lost in Egypt, it was not until the founding of Alexandria in 332 B.C. that it flowered again as it did during the Eighteenth Dynasty. In spite of the sparse archaeological evidence for glassmaking at Alexandria, the praise of ancient authors over the quality and quantity of Alexandrian glass has ensured Egypt's

importance in the history of glass in
the Hellenistic and Roman world.

<div align="right">S.M.G.</div>

1. Stone and Thomas 1956, pp. 39-44; Brooklyn
 Museum 1968, p. 2; Harden 1969, p. 48.
2. Goldstein 1979b, p. 25.
3. Wulff 1966, p. 167; Wulff et al. 1968.
4. Goldstein 1979a, pp. 25, 27ff.
5. Beck 1934a, p. 19; Oppenheim et al. 1970;
 Harden 1969, pp. 46-48; Goldstein 1979a,
 pp. 34-35.
6. Barag 1962; Oppenheim et al. 1970,
 pp. 137-153.
7. Petrie 1894; Newberry 1920.
8. Schuler 1959, p. 49.
9. Desroches-Noblecourt 1963, p. 303.
10. Goldstein 1979b.
11. Von Saldern 1966; Harden 1967; Harden 1969.
12. Schuler 1959.
13. Cooney 1960b.
14. Nolte 1968, pp. 54-55.
15. Ibid., pp. 76-77.

Literature: Brooklyn Museum 1968; Nolte 1968;
Auth 1976; British Museum 1976a; Fitzwilliam
Museum 1978; Goldstein 1979a.

172

Glass manufacturing waste

From Amarna
Dynasty 18, reign of Akhenaten
Length 4 cm. or less
University College, London. Petrie
Museum (22909-20)

Manufacturing wastes and vessel
fragments from glass manufacturing
sites such as Malkata and Amarna in
the Eighteenth Dynasty and later ma-
terial from Lisht and Menshiyeh still
need extensive study and interpreta-
tion. The selection of material in this
small group from Amarna shows the
quality of Eighteenth-Dynasty glass-
making as well as some of the rich
colors available to the craftsmen. The
droplets are probably excess from
tools that were used to remove hot
glass from the furnace. This may have
occurred during the initial stages of
forming the vessel on the core or
while preparing trails or rods for
subsequent decoration. The straight
sections of rods or monochrome canes
may indicate the type of material for
decoration of the vessel, either as
applied trails or as the first stage in the
manufacture of spirally wound canes
(see cat. 186) or multiple-element
handles (see cat. 185). Such canes,
often rather complex and puzzling in
cross section, would have been suit-
able for the manufacture of beads or
amulets.

<div align="right">S.M.G.</div>

Bibliography: Petrie 1894, pp. 25ff.; Pendlebury
1935, p. 95, 142; Nolte 1968, pp. 23-24, pl. 35:1-3.

Literature: Lucas 1962, pp. 191ff.; British Museum
1976a, pp. 125-130; Goldstein 1979a, p. 64,
nos. 33, 34.

172

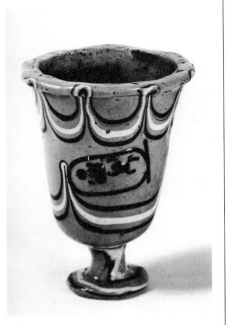

173

173
Goblet
Said to be from Thebes
Dynasty 18, reign of Thutmose III
Height 8.1 cm.
Staatliche Sammlung Agyptischer Kunst,
Munich (630). Formerly in the Drovetti
Collection

Core formed and tooled, this opaque light blue goblet was decorated with trails of deep blue and yellow below the rim and at the foot and lower portion of the body. Both registers were dragged upward to create simple festoon patterns and a wide undecorated central band. In this space is the prenomen of Thutmose III, applied in deep blue trails.

This vessel is a most important document in the history of glass. It is one of three objects that retain the name of Thutmose III, the others being a goblet in the Metropolitan Museum[1] and a jug in the British Museum, London.[2] Although there is no evidence that these early glass pieces belonged to the pharaoh personally (they were found in the tombs of princesses or minor wives), they may have been an attempt to honor the pharaoh as the founder of the industry in Egypt.[3] The application of the cartouche is of great interest, the sure lines and the clearly preformed elements within it suggesting that there may have been an alternative to the technique of trailing on this decora-

tion. Although no evidence exists in the literature of early technology for lampworking glass, it is a tempting explanation. The localized application of intense heat from a portable source was known in metalworking and it is possible that such a technique was adopted by glassworkers to soften and form the cartouche and apply it to the preheated surface of the goblet. Until this vessel can be closely studied, along with some fragments in the Cairo Museum, this hypothesis cannot be confirmed.

S.M.G.

1. Scott 1973, no. 25; Hayes 1959, fig. 77.
2. British Museum 1976a, no. 764, pl. 6.
3. Harden 1969; Goldstein 1979a, p. 35.

Bibliography: Rosellini 1834, pl. 62:6; Christ-Dyroff 1901, p. 117, no. 630; Bissing 1908, p. 213; Kisa 1908, p. 67, fig. 3; Newberry 1920, p. 155, pl. 16; Breasted 1936, fig. 287; Scharff 1939, pl. 100:4; Fossing 1940, p. 9, fig. 2; Vávra 1954; Müller 1960, p. 631, pl. 396; Haberey 1961; Villa Hügel 1961, p. 116, no. 149; Neuberg 1962a, p. 32, pl. 1a; Tait 1963, p. 110; Kämpfer 1966, fig. 1; Agyptische Sammlung des Bayerischen Staates 1966, p. 37, pl. 37; Nolte 1968, pp. 48-49, no. 6, pl. 1; Harden 1969, p. 48, pl. 1d; Kayser 1969, p. 152, fig. 140; Staatliche Sammlung Agyptisches Kunst 1976, p. 104, no. 73; Goldstein 1979a, p. 35.

Literature: Maspero 1915, p. 385.

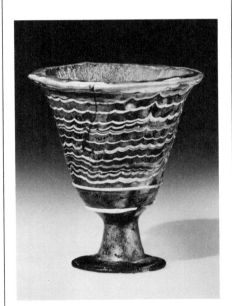

174

174
Goblet
Provenance not known
Dynasty 18, reign of Thutmose III to
Amenhotep III
Height 9.1 cm.; diameter of rim 7.6 cm.
The Corning Museum of Glass, Corning,
New York (59.1.7). Formerly in the
R. W. Smith Collection

Core formed and tooled, this translucent deep blue goblet has a rim highlighted by a turquoise trail left in relief. The body is decorated with festoons of opaque yellow, opaque white, and turquoise. The bottom of the bowl and the foot are also highlighted with relief trails of white, yellow, and turquoise.

This vessel is closely related to an inscribed Thutmosid goblet (cat. 173); however, the decorative technique suggests a somewhat later date.

S.M.G.

Bibliography: Corning Museum 1957, p. 23, no. 4; von Saldern 1962, p. 26, fig. 2; Nolte 1968, p. 99, no. 17, pl. 11; Goldstein 1979a, pp. 52-53, pl. 2:10.

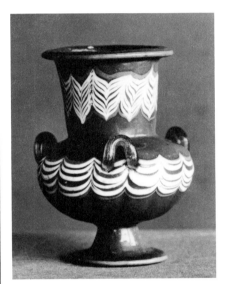

175

175
Krateriskos
Provenance not known
Dynasty 18, reign of Thutmose IV to
Akhenaten
Height 6.4 cm.; diameter 5 cm.
Victoria and Albert Museum, London
(1011-1868)

The rim and foot of this core-formed jar of translucent medium blue glass are highlighted with a single opaque yellow trail. The feather pattern on the neck and the festoon pattern on the body are opaque white framed by yellow trails; all are marvered into the surface. There are three small translucent blue-green handles applied to the shoulder.

S.M.G.

Bibliography: Nesbitt 1878, p. 7; Burlington Fine Arts Club 1895, p. 107, no. 7, pl. 2; Honey 1946, p. 17, pl. 1b; Nolte 1968, p. 84, no. 8, pl. 3.

176

176
Shallow dish

Said to be from Malkata
Dynasty 18, reign of Amenhotep III
Diameter 10.5 cm.; height 1.8 cm.
The Brooklyn Museum, Brooklyn, New
York. Charles Edwin Wilbour Fund
(48.162). Formerly in the Brummer, Hearst,
and MacGregor Collections

A mosaic glass technique was used
for this vessel: irregular chips of
colored glass (translucent deep blue
and turquoise and opaque red and
white) were probably cast in a two-
part mold and finished by rough
polishing. The shallow lens-shaped
disk was not highly polished but was
probably ground smooth after casting.

The Brooklyn dish is the largest and
most complete example of this rare
group. The glassmaker must have
crushed various colored rods or ingots
of glass and arranged the chips in a
two-part mold. Some fragments of
these vessels suggest that more
regular segments of preformed rods
were used to build the form. A frag-
ment at Corning[1] and two others in
Boston[2] are composed of elements cut
from a cane of square section and
arranged in the mold. A smaller dish
of this type in the British Museum[3]
and numerous fragments from Mal-
kata there and in the Metropolitan
Museum suggest that the form and
technique were a well-represented
product of the palace workshop of
the first half of the fourteenth
century B.C.

S.M.G.

1. 64.1.222.
2. 65.1783.
3. British Museum 1976a, p. 145, no. 1748, pl. 3.

Bibliography: Burlington Fine Arts Club 1922,
p. 42, no. 10, pl. 47; Sotheby 1922, p. 118, no. 911,
pl. 29; Steindorff 1928, pp. 88, 279b; Fossing 1940,
p. 18; von Saldern 1966, p. 20, fig. 14, no. 39;
Nolte 1968, p. 66, no. 6, pl. 29; Oliver 1968, p. 69,
no. 25; Brooklyn Museum 1968, pp. 95-96, no. 16,
pl. 3; Oppenheim et al. 1970, p. 182 n. 160; British
Museum 1976a, p. 145, pl. 3: 1748; Goldstein
1979a, p. 65, no. 37, pl. 9:37.

177
Amphoriskos

Provenance not known
Dynasty 18, reign of Amenhotep III or
Akhenaten
Height 12.3 cm.; diameter 6 cm.
Toledo Museum of Art. Gift of Edward
Drummond Libbey (51.405)

The rim, neck, base of body, and foot
of this translucent greenish-blue core-
formed, tooled *amphoriskos* are high-
lighted with applied and marvered
trail decoration in opaque white and
yellow. Two thick handles of slightly
darker blue glass were applied to the
shoulders.

The footed *amphoriskos* was an early
form that seems to have been a fa-
vorite of Eighteenth-Dynasty glass-
makers. Later workshops at the end
of Dynasty 18 preferred the open
krateriskos form (cf. cat. 175) or the
lentoid flask (cf. cat. 185).

S.M.G.

Bibliography: Riefstahl 1961, p. 27, fig. 1; Neuberg
1962a, fig. 2; Neuberg 1962b, no. 6; Riefstahl
1967, p. 428, fig. 1; Toledo Museum 1967, p. 16;
Nolte 1968, p. 103, no. 6, pl. 12; Jones 1970, p. 10;
Grose 1978, p. 70, fig. 2.

177

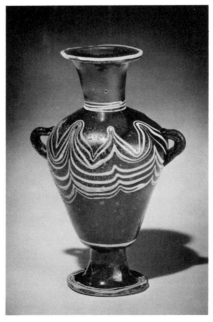

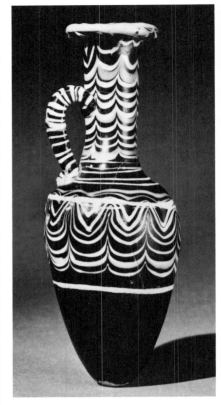

178

178
One-handled flask

Said to be from Amarna
Dynasty 18, probably reign of Akhenaten
Height 14.3 cm.; diameter at shoulder
5.4 cm.
The Corning Museum of Glass, Corning,
New York (55.1.59). Formerly in the
R. W. Smith Collection

The long cylindrical neck on this core-
formed flask of translucent deep blue
glass is decorated with trails of opaque
white and opaque yellow dragged in
a festooned pattern; it ends in a thick
rim. The elongated ovoid body has a
similar festooned pattern, highlighted
above and below with a white trail
left somewhat in relief. A single rec-
tangular handle, wrapped with white
and yellow trails, was applied after
the flask was decorated.

The shape of this vessel is closely re-
lated to two similar forms excavated
at Amarna in the main city site.[1] Al-
though the form is unusual in glass
examples, it is known in Eighteenth-
Dynasty alabaster and ceramics
(cat. 62).

S.M.G.

1. Nolte 1968, pp. 69-70, nos. 3,4, pl. 13.

Bibliography: Corning Museum 1957, p. 21, no. 1;
von Saldern 1962, p. 26, fig. 2; Nolte 1968, p. 106,
no. 17, pl. 13; Goldstein 1979a, pp. 56-57, pl. 3: 18.

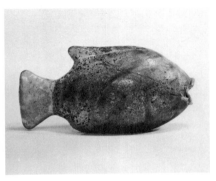

179

179
Fish-shaped flask

Said to be from Saqqara
Late Dynasty 18
Height 5.3 cm.; length 10.7 cm.
The Brooklyn Museum, Brooklyn, New
York. New-York Historical Society,
Charles Edwin Wilbour Fund (37.316E)

The inside of this core-formed fish seems to have been decorated with scale patterns in blue powdered glass and opaque yellow and blue, over which colorless glass with a trace of greenish-yellow was wound and worked. Dr. Robert H. Brill, of the Corning Museum of Glass, examined a large fragment of the body and noted that the blue bubbly material is pressed down into the interior surface of the fish. The easiest explanation of this phenomenon would be that the powdered blue glass in the core was of sufficiently high relief that it distorted and deformed the surface during the shaping and marvering process. This would not be unusual, as considerable pressure is required to move the softened glass around the core. It becomes increasingly difficult when the desired form is not symmetrical, as in the case of the fish. Once the form was completed, details such as the blue eyes with opaque yellow centers and a yellow mouth were trailed on; the tail was worked out from the body.

An analysis of the yellow glass and subsequent isotope determination of the lead by Dr. Brill confirms an Eighteenth-Dynasty date for the fish. Additional investigation should be undertaken to determine if the scales are indeed deposits of crushed glass or some other pigment that would retain its blue color given the prolonged high temperatures involved. The cloudy surface of the fish is due in part to weathering and also to devitrification of the glass, which became partially crystallized as it cooled from the molten state.

S.M.G.

Bibliography: Bonomi 1846, p. 9, no. 19; Abbott 1853, p. 45, no. 617; New-York Historical Society 1873, p. 45, no. 617; New-York Historical Society 1915, p. 40, no. 624; Riefstahl 1948, p. 3, fig. 1; Nolte 1968, p. 134, no. 59, pl. 28; Brooklyn Museum 1968, pp. 98-99, no. 30, pl. 7; Riefstahl 1972, pp. 10-14; Aldred 1973, p. 213; Brill et al. 1974, pp. 9-27.

180
Shell-shaped dish

Said to be from Saqqara
Late Dynasty 18
Length 11.7 cm; width 6.6 cm.
The Brooklyn Museum, Brooklyn, New
York. New-York Historical Society,
Charles Edwin Wilbour Fund (37.599E)

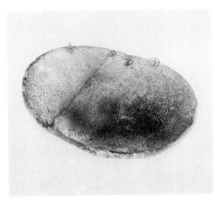

180

This vessel was probably core formed but it could also have been cast in a two-part mold and finished by fire polishing. The undecorated surface is heavily pitted with a thick brown weathered crust.

The glass appears to have been originally a translucent light blue. There is a similar shell in the British Museum[1] and fragments of others in the Victoria and Albert Museum and the Antiquities Department storehouse at Giza.

As shells and their imitations were used in ancient Egypt for mixing cosmetics, it would not be inappropriate for a wealthy noblewoman to have had a glass plate in this shape to complement a set of kohl tubes and unguent containers made of glass.

S.M.G.

1. British Museum 1976a, p. 146, no. 1752.

Bibliography: Bonomi 1846, p. 9, no. 19; Abbott 1853, p. 33, no. 454; New-York Historical Society 1873, p. 33, no. 454; New-York Historical Society 1915, p. 29, no. 460; Brooklyn Museum 1968, p. 99, no. 31, pl. 7; Nolte 1968, p. 138, no. 6, pl. 29.

181

181
Footed dish

Provenance not known
Dynasty 18
Height 3.5 cm.; diameter 7.7 cm.
Musées Royaux d'Art et d'Histoire,
Brussels (E 8420)

The technique of fabrication for this vessel is difficult to determine. The open form could have been shaped by casting or softening the glass over a flat domical form. However, the rim and base carination appear to have been heavily tooled and the foot seems to have been made separately as well. Although it would have been a difficult form to manipulate, the vessel may have been core formed. This deep blue glass dish is one of three examples preserved in this medium; there are two related dishes in the Metropolitan Museum.[1]

Similar dishes without feet seem to have been an Eighteenth-Dynasty form imported from Syria; an example in alabaster was excavated from a tomb at Abydos dated to the time of Thutmose III.[2] Footed parallels of alabaster are known from the time of Amenhotep III and have horizontal ribs on the body (see cat. 120). This continues to be a representative form in the Amarna Period.[3]

S.M.G.

1. Nolte 1968, p. 137, nos. 3,4, pl. 29.
2. Peet and Loat 1913, pl. 10:6.
3. Petrie 1937, p. 12, P. 33:829.

182

182
Palm-column flask and kohl stick
Provenance not known
Late Dynasty 18-19, reign of Amenhotep
III to Ramesses II
Height 10.5 cm.; height of stick 13.2 cm.
Museum of Fine Arts. Pierce Fund (99.450, 99.451)

Core formed and tooled, this translucent dark blue flask has a short rounded rim, below which are eight rounded leaves worked out of blue glass added to the body. They are highlighted with opaque white and yellow trails, with light blue and yellow trails left in relief below the capital. The long, almost cylindrical body is decorated on the lower portion with feathered trails of white and yellow; the base has a thick relief trail of light blue.

The palm-column flask is the most well-represented glass form from Eighteenth- and Nineteenth-Dynasty Egypt, with over seventy examples preserved in public and private collections.[1] The vessels contained kohl, as did their counterparts in other material such as ivory, metal, stone, faience, and wood (cf. cats. 262-288). The earliest known example is from Deir el Medineh.[2] Most seem to be from the Ramesside Period, although it is nearly impossible to establish a

chronology based on stylistic evidence at this time.

S.M.G.

1. Vandier d'Abbadie 1972, pp. 58-60.
2. Tomb of Kha; Schiaparelli 1927, pp. 109, 111, fig. 92; Nolte 1968, p. 67, no. 2, pl. 31.

Bibliography: Nolte 1968, p. 144, no. 22, pl. 32.

183
Palm-column flask
Said to be from Amarna
Late Dynasty 18-19
Height 9.8 cm.
Fitzwilliam Museum, Cambridge. Gift of
Percy Newberry (E.1.1938)

Core formed and tooled, this translucent blue flask has a short cylindrical rim highlighted with a trail of medium blue; below the rim are rounded palm leaves with the same highlight. The underside of each leaf is bisected with a single opaque white trail that winds down the neck along with a medium blue trail. The lower portion of the body is decorated with the same colored trails dragged up and down in a feather pattern. A heavy trail of white left somewhat in relief emphasizes the base.

The form of this flask differs from that of other examples in that the column appears more architectural in the sharply tapering capital and in the slightly spreading body (cf. cat. 182).

S.M.G.

Bibliography: Murray 1963, p. 245, pl. 86:5; Nolte 1968, p. 148, no. 42; Fitzwilliam Museum 1978, p. 14, no. 9.

183

184

184
One-handled flask
Said to be from Tuneh el Gebel
Late Dynasty 18-19
Height 17.5 cm.
The Metropolitan Museum of Art, New
York. Gift of Edward S. Harkness
(26.7.1176). Formerly in the Carnarvon
Collection

Core formed and tooled, this elegant long-necked turquoise vessel is trail decorated, its horizontal rim highlighted with a thick trail of purplish blue. The neck and elongated ovoid body are both ornamented with spaced festooned decoration in purplish blue and white. On the pad foot is a wide trail of white and the preformed handle, roughly rectangular in cross section, is striped with a repetitive series of purplish blue, and opaque yellow and white trails.

The extraordinary preservation of this flask is complemented by the grace and elegance of the form (compare the fabrication and decoration of this handle to a flask of the Amarna Period: cat. 178). Rather than being wound around a thick coil and fashioned into a handle, the individual trails on this vessel handle seem to have been applied as separate strips, precut and wrapped around three sides of the handle. They were subsequently reheated and marvered into the surface.

S.M.G.

Bibliography: Burlington Fine Arts Club 1922, p. 48, no. 37; Lythgoe 1927, p. 36, Capart 1931, pp. 75-76, pl. 80d; Winlock 1936b, p. 4, color plate, center; Steindorff and Seele 1942, p. 198, fig. 71, left; Metropolitan Museum 1944, fig. 16; Capart 1947, pl. 759, middle; Kac̆alov 1959, p. 57, fig. 11, middle; Nolte 1968, p. 113, no. 8, pl. 16; Scott 1973, fig. 23.

185

Lentoid flask

Provenance not known
Late Dynasty 18-19, reign of
Tutankhamen to Ramesses II
Height 11.5 cm.
Victoria and Albert Museum, London
(1006-1868)

The rim of this core-formed and tooled flask of medium or sky-blue glass is highlighted with a spirally wound coil of opaque white and deep blue, while the neck and body are decorated with simple trails marvered into the surface and dragged into festooned and feather patterns. The two handles are each composed of three separate deep blue trails fused together and applied to the neck and shoulder.

The lentoid flask was a popular form during this period. Although the features of the London flask are not as refined in profile and proportion as other existing forms, the unusual medium blue makes it one of the brightest and most colorful examples of its type.

S.M.G.

Bibliography: Nesbitt 1878, p. 6, pl. 2; Burlington Fine Arts Club 1895, p. 107, no. 2, pl. 2:13; Fossing 1940, p. 15, fig. 7; Honey 1946, p. 17; Nolte 1968, p. 114, no. 9, pl. 16.

185

186

186

Krateriskos

Provenance not known
Dynasty 19-20
Height 11.4 cm.
Staatliche Sammlung Agyptischer Kunst, Munich (2945). Formerly in the von Bissing Collection

The large open body of this core-formed and tooled opaque grayish-white jar is highlighted with two trails of translucent purplish-blue glass spirally wound with opaque white and applied to the rim and foot. The handles were tooled of thick coils of grayish-white glass marvered roughly square in cross section and applied to the vessel.

A comparison of this *krateriskos* with an example from Dynasty 18 illustrates the growing popularity of monochrome wares with sparse highlights but somewhat larger forms. Less attention tends to be paid to details such as handles (cf. cat. 175).

S.M.G.

Bibliography: Müller 1960, pl. 631: 396, middle; Villa Hügel 1961a, p. 282, fig. 58; Zurich 1961b, p. 117, no. 151, figs. 149-151; Neuberg 1962a, p. 17, pl. 1b; Agyptische Sammlung des Bayerischen Staates 1966, p. 37, pl. 37, right; Nolte 1968, pp. 130-131, no. 18, pl. 24; Staatliche Sammlung Agyptischer Kunst 1976, p. 104, no. 73.

187

Pomegranate flask

Provenance not known
Dynasty 19-20
Height 10.5 cm.; width 7.8 cm.
Musée du Louvre, Paris (E 11224)

This opaque green glass flask was core formed and tooled in the shape of a pomegranate. The foliations of the fruit were cut, tooled, and reheated, then highlighted with the application of an opaque yellow trail.

The pomegranate was introduced into Egypt from the East in the Eighteenth Dynasty. Whether its interest was as a novelty fruit or as a ritual offering, it was reproduced in many media such as glass, faience, and precious metals. Scholars believe that some glass pomegranates, usually those more heavily weathered and with heavy trail decoration, came from centers outside Egypt. However, the color of the Louvre pomegranate and its rounded foliations suggest a vessel produced in Egypt. The monochrome color is typical of late Nineteenth- or Twentieth-Dynasty workshops (cf. cats. 186, 188, and 189).

S.M.G.

Bibliography: Boreux 1932, p. 545; Fossing 1940, p. 22; Nolte 1968, p. 133, no. 40, pl. 27; Vandier d'Abbadie 1972, pp. 183-184, no. 809.

187

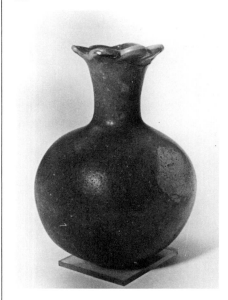

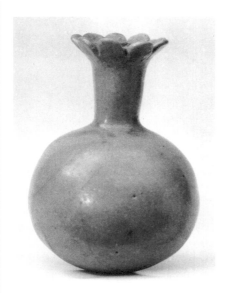

188

188
Pomegranate flask

Said to be from Menshiyeh
Dynasty 19-20
Height 12 cm.; width 7.9 cm.
The Metropolitan Museum of Art, New
York. Gift of Edward S. Harkness,
Carnarvon Collection (26.7.1180)

This core-formed, tooled pome-
granate-shaped flask of opaque yellow
glass has a long, narrow cylindrical
neck that has been cut and tooled,
then reheated to form the spreading
foliations at the rim.

S.M.G.

Bibliography: Burlington Fine Arts Club 1922,
pp. 14, 46, pl. 48: no. 27; Winlock 1936b, p. 3,
fig. 2; Hayes 1959, p. 403, fig. 255; Nolte 1968,
p. 76, no. 6, pl. 27; Scott 1973, fig. 24.

189

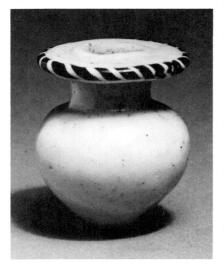

189
Apodal vase

Provenance not known
Dynasty 19-20
Height 3.5 cm.; diameter 2.8 cm.
Ashmolean Museum, Oxford (1959.438)

The simple body of this core-formed
vase of opaque yellow glass is em-
bellished by a contrasting coil of
opaque white and black glass. The
coil was formed by twisting a white
trail around a black trail and reheating
the element to smooth the surface.
The coil was then applied to the rim,
the excess cut away, and the slight
overlap smoothed by marvering and
reheating.

Diminutive vessels of glass are known
from early Eighteenth-Dynasty
Amarna and Ramesside contexts.
However, the simple form of this vase,
the coil highlighted on the rim, and
the solid bright color suggest a rela-
tively late core-formed vessel of
Dynasty 19 or 20.

S.M.G.

Bibliography: Moorey 1970, p. 51, fig. 23, center.

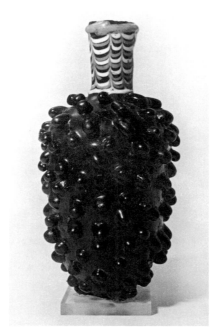

190

190
Bottle in the form of a bunch of grapes

Said to be from Akhmim
Dynasty 19-21, reign of Merneptah to
Pinodjem II
Height 19 cm.; diameter 9.2 cm.
Musée du Louvre, Paris (E 11610)

The body of the core-formed vessel
was covered with short canes of dark
blue glass that were reheated exten-
sively and left in relief. The neck was
trail-decorated with opaque white,
yellow, and medium-blue glass.

This vessel is one of the more extraor-
dinary products of the glassmakers
of New Kingdom Egypt. The swelling
and supple surface is unparalleled (see
also cat. 12).

S.M.G.

Bibliography: Boreux 1932, p. 545, pl. 71; Capart
1947, p. 41, pl. 758; Nolte 1968, p. 126, no. 25,
pl. 22.

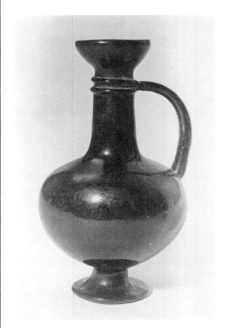

191

191
Bilbil

Provenance not known
Dynasty 19-21, reign of Ramesses II to
Pinodjem III
Height 10.5 cm.; diameter 6 cm.
Musée du Louvre, Paris (A.F. 2624)

The foot and handle of this core-
formed and tooled vessel were sep-
arately fashioned and then joined to
the opaque deep blue glass body.
Around the neck where the handle is
attached, thick trails or coils of the
same glass were applied horizontally
and left in relief.

The shape of this vessel, not a native
Egyptian form, was derived from
Cypriote ceramics.[1] These base-ring
juglets, as they are also called, were
imported widely, early in the Eight-

eenth Dynasty, and may have contained opium (cf. cat. 65).

The simple, elegant profile and the lack of contrasting trail highlights suggest a date in the Nineteenth Dynasty or later.

S.M.G.

1. Cyprus Museum 1961, p. 146, no. 2.

Bibliography: Deville 1874, p. 10, pl. 5c; Sambon 1906, p. 7, fig. 6; Fossing 1940, p. 21; Vávra 1954, pl. 4, middle; Nolte 1968, p. 132, no. 29, pl. 25; Vandier d'Abbadie 1972, pp. 187-188, no. 826.

192

192

Light blue bead

Provenance not known
Dynasty 18
Height 1.3 cm.; width 1.3 cm.
Museum of Fine Arts. Gift of Mrs. Horace L. Mayer (1978.691)

This square glass bead is incised with the prenomen of Ahmose, first king of the Eighteenth Dynasty, on one side, and that of Amenhotep I, second king of the same Dynasty, on the other. An incised square surrounds the prenomen of each king. The carver did not leave enough room for the second "t" in the prenomen of Ahmose so it had to be inserted in a smaller size to the right of the lion's head. On the other side, the extended arm holding the *nehbet* wand and the *ka* sign are intentionally broadened to fill the available space. The bead is pierced vertically. An indentation, perhaps to hold a gold setting, runs along the edge and across the two holes.

The bead becomes the fourth piece of evidence for a possible co-regency between Ahmose and his son Amen-

hotep I. The other three[1] are an amulet, a fragmentary stela (each with the two kings' cartouches) and a quarrying inscription that calls Ahmose Nefertari, Ahmose's queen, both "Great King's Wife" and "King's Mother." While it is prudent to use caution in interpreting juxtaposed cartouches alone as evidence for co-regency,[2] the additional evidence of the quarrying inscriptions provides an adequate base upon which to place evidence.[3]

An elemental analysis by means of x-ray spectrometry yielded findings consistent with the analysis of known Eighteenth-Dynasty parallels. If the bead is contemporary with the time of the two kings whose names are inscribed on it, then it is a very early example of glass manufacture.

A.G.

1. Murnane 1977, pp. 114-115.
2. Redford 1965, pp. 116-117.
3. Vittman 1974, pp. 250-251; Murnane 1977, pp. 114-115, 230.

Literature: Schmitz 1978, passim.

193

Inscribed bead

Provenance not known
Dynasty 18, reign of Hatshepsut
Length 2 cm.; diameter 1 cm.
Merseyside County Museums, Liverpool. Gift of Joseph Mayer (M 11568)

This swirled bead in turquoise and dark blue glass bears a short incised inscription with the throne name of Queen Hatshepsut and her steward Senenmut: "the good god, Maatkare, beloved of Hathor, resident in Thebes, who presides over Djeser-djeseru [and] the hereditary prince and steward Senenmut." Senenmut is often described as the architect who designed Djeser-djeseru, the queen's funerary temple at Deir el Bahri, but it is more likely that his association with the building of the temple was purely administrative.[1] This is only one side of Senenmut's career that has recently been examined with a view to revision.[2]

M.E.-K.

1. Helck 1958, pp. 362-363.
2. Schulman 1970, pp. 29ff.

Bibliography: Gatty 1879, pp. 56-57, no. 358.

Literature: Hall 1913, p. 52, no. 490.

193

194

Scarab

Provenance not known
Dynasty 18-19
Length 1.8 cm.
Fitzwilliam Museum, Cambridge (E.460.1939)

Two monkeys scamper up a palm tree on this scarab molded of white glass. This decorative motif was a common one in Egyptian art of the New Kingdom, and it occurred on numerous scarabs and scaraboids during Dynasties 18 and 19 (see cat. 356).

The material of the scarab—opaque glass—is indicative of its date. Glass was first used for beads at the beginning of the Eighteenth Dynasty[1] and scarabs of light blue and dark blue glass imitating turquoise and lapis lazuli began to appear around the middle of the dynasty.[2] These blue colors often tend to fade to white, however, after exposure to moisture.[3] Glass continued to be used for scarabs past the New Kingdom, but its use was most common during this time.[4] A dark blue glass frog-shaped amulet in the Brooklyn Museum is dated to late Dynasty 18 (cat. 353), and a green-blue glass scarab in the Corning Museum is dated to Dynasty 19.[5]

G.L.S.

1. Petrie 1917a, p. 8.
2. Hall 1913, p. xxviii.
3. Petrie 1917a, p. 9.
4. Hall 1913, p. xxviii.
5. Goldstein 1979a, p. 86, no. 160.

194

195

195

Glass duck bead

From Saqqara
Probably New Kingdom
Height 0.8 cm.; width 1.6 cm.
The Brooklyn Museum, Brooklyn, New
York. New-York Historical Society,
Charles Edwin Wilbour Fund (37.1444E)

Deep blue glass inlaid with threads of
white glass was used to form this bead
in the shape of two resting ducks. The
object is pierced for suspension
through the bodies and wings.

Much controversy exists concerning
the dating of the bead. Because the
technique of inlaying a contrasting
color on a monochrome field, begun
in the Eighteenth Dynasty, continued
through Islamic times, some scholars
have been inclined to date such pieces
to the Roman period or later.[1]

Excavated New Kingdom parallels do,
however, exist for these ducks. Tomb
492 in the main cemetery at Gurob
contained, along with New Kingdom
pottery, a similar twin-duck bead.[2]
In two other tombs in the same ceme-
tery similarly shaped but single glass
ducks[3] were found, although they may
be a later intrusion.[4] A blue and yellow
glass duck bead in the Corning
Museum is attributed to the New
Kingdom on the basis of its yellow
color, a shade not found in Islamic
glass.[5] As the duck form is basic to
Egyptian iconography and omni-
present in Egyptian art (cats. 218,
258, and 260), it is not unlikely that
the bead is indeed Eighteenth
Dynasty.

R.E.F.

1. Cooney 1960b, p. 20; Ettinghausen 1962, figs. 2,
 3.
2. Brunton and Engelbach 1927, pl. 42, item 3r.
3. Ibid., p. 42, item 3n.
4. British Museum 1976a, p. 20.
5. Goldstein 1979a, pp. 83-84, no. 152.

Bibliography: New-York Historical Society 1873,
p. 48, no. 685; New-York Historical Society 1915,
p. 43, no. 692; Cooney 1960, fig. 11, p. 20.

Literature: Goldstein 1979a, pp. 83-84, no. 152.

Costume

Loose draping, rather than fine tailor-
ing, characterized ancient Egyptian
fashion throughout the dynasties,
according to the evidence provided to
us by painting and sculpture. Gar-
ments for both men and women were
generally wrapped around the body
and either tied in place or held with
straps. Adjustments were made with
only a small amount of sewing, if
any.[1] White was the main color worn,
and the material was universally
linen. The occasional streaks of yellow
appearing in the area of the shoulders
and chest of figures in New Kingdom
tomb paintings probably resulted
from the melting of scented fat from
the cosmetic cone.[2]

Throughout Egyptian history, there
was a tendency for dress to become
more elaborate, although occasion
and occupation also influenced the
style worn.[3] Women's fashion was
usually more conservative than men's.
Accordingly, in any given period in
Egyptian history, a man had more
styles to choose from.

In the Old Kingdom, men commonly
wore a skirt or kilt made from a rec-
tangular piece of material wrapped
around the hips and tied in one of a
number of ways (fig. 40).[4] A version
of the same garment is seen on the
First-Dynasty Narmer palette and
contemporary monuments.[5] The
length of the kilt in the Old Kingdom
varied from just above the knee to
mid-calf. Although usually tied
tightly around the torso, its lower end
could also be extended to a point,
perhaps through the use of starch, to
form a triangular projection.[6] Noble-
men sometimes had their kilts pleated
in horizontal, vertical, or even herring-
bone pleats.[7] Occasionally laborers
wore what seems to have been only a
sash looped around the waist leaving
long flowing ends in front; often they
went naked.[8] Men's cloaks covering
both shoulders were unknown in the
Old Kingdom, or at least do not seem
to have ever been represented. How-
ever, there are a few instances, going
back as far as Early Dynastic times,
where men were depicted in long
garments draped over one shoulder.[9]

Women in the Old Kingdom, and
later traditionally, wore a plain sheath
dress that covered the body from
breast to shin (fig. 41). This was made
from a single piece of linen folded

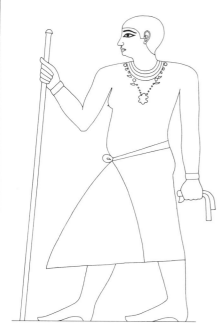

Fig. 40. An Old Kingdom man of distinction wears the wrapped kilt (from the tomb of Meresankh III at Giza).

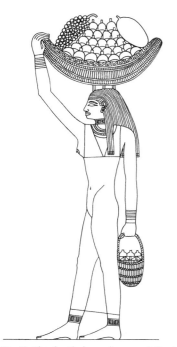

Fig. 41. The sheath dress often reveals the body underneath (from the tomb of Ti at Saqqara).

in half and hemmed up the side with shoulder straps holding it in place. Representations show this garment clinging closely to the contours of the body, although in reality, by the nature of the tailoring, it was probably a bit less form-fitting. Brightly colored clothing was frequently depicted in tomb paintings,[10] but no actual examples have survived.[11] Over their sheath dresses, from time to time, women of the Old Kingdom and earlier wore cloaks that sometimes had one or both shoulders starched to a point.[12] Sleeved tunics appear in linen lists as early as the Early Dynastic period,[13] but the only representation of a sleeved garment actually being worn prior to the New Kingdom is found in a Fifth-Dynasty tomb at Deshasheh, where it clothes a young girl.[14] The same cemetery yielded ten tunics with sleeves, all from female burials, but these garments are too narrow to have ever been worn.[15] Female burials from a few other sites contained dresses with sleeves, which were somewhat larger and showed definite signs of wear. It appears that in the Old Kingdom sleeved garments were worn only by women.[16]

In the Middle Kingdom, the short skirt or kilt continued to be the main item of clothing worn by men, often as a second garment under a longer transparent outer skirt. This new outer skirt reached halfway down the calf and often hung lower in front than behind;[17] it was sometimes pleated.[18] High-waisted kilts also came into fashion[19] and occasionally a number of them were worn at the same time. We have several actual examples of another type of garment in the Middle Kingdom, the so-called bag tunic, a rectangle of material folded in half and seamed up each side, leaving an ample opening for the arms. In order for it to be passed over the head, a keyhole-shaped opening was cut in the center.[20] (This fashion seems to be first represented in the New Kingdom, when it becomes the standard male attire.[21]) In the second half of the Middle Kingdom, a long cloak or mantle draped over one or both shoulders frequently enveloped the body like a blanket (fig. 42).[22] Its selvedged upper edge sometimes created a fringe-like effect.[23]

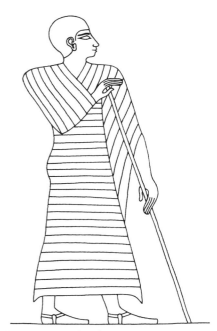

Fig. 42. Man enveloped in a long mantle (from the tomb of Djehutyhotep at Bersheh).

During the early part of the New Kingdom, fashions from earlier eras were often elaborated upon. In the Eighteenth Dynasty, clothing for the upper part of the body became more stylish than ever before. Men are often shown wearing the bag tunic described above in combination with the usual kilt (fig. 43).[24] (Occasionally these are found in tombs.[25]) The shortest are knee length, while the longest brushed the ankles. For the latter, a piece of linen as large as 142 centimeters long and 89 centimeters wide was needed.[26] The garment must have been rather bulky, since it was closely woven from fairly heavy flax.[27] Occasionally a transparent shawl draped over the left shoulder and tied in the back was added to this outfit (fig. 44).[28] One example from Thebes, made of fine, loosely woven linen, measured approximately 188 centimeters in length and about 58 centimeters in width.[29] Later in the New Kingdom, mantles covering both shoulders were worn as well.[30] The restrained and simple tastes of the early New Kingdom gave way to a fussiness and frivolity in the late Eighteenth Dynasty. From that time on, a long bag tunic, either pleated or plain and reaching to the ankles, is the rule, and to this, long sewn-in sleeves were sometimes added, perhaps in colder weather.[31] (For the

Fig. 43. The bag tunic worn in conjunction with a shorter, wrapped kilt (from Theban tomb 101).

shorter cap sleeve, created by the spill-over of excess material from the shoulder, see cat. 196.) The tunic was worn in combination with an apron-like sash, made from a second piece of material, also pleated, which was wrapped around the buttocks and tied in front (fig. 45). Its free ends formed a triangular apron, and fringes on the bottom enhanced its decorative effect.[32] Each generation had its own ideas of high fashion; by the Ramesside Period, the outer skirt was loosely tucked up at the bottom to show the skirt beneath.[33] A formal wig, sandals, a walking stick, and staff of office completed the attire of the elegant New Kingdom citizen. Throughout the New Kingdom, soldiers, laborers, and poor folk usually wore only a version of the basic kilt, a cool and comfortable garment well suited to the work they performed.[34]

Women in the early New Kingdom typically wore sheath dresses similar in style to those their ancestors had worn. Occasionally, they seem to have donned bag tunics not unlike those of their male contemporaries.[35] The woman's garment became increasingly elaborate around the

middle of the Eighteenth Dynasty and, in outward appearance, hers resembled his, although it was constructed differently (see fig. 46). A typical woman's dress was made from a rectangle of linen at least 200 centimeters long and 100 centimeters wide, often pleated and fringed.[36] This large sheet was first wound around the lower torso, then draped over the shoulders, and finally held in place by a sash tied under the breasts.[37] Thus, without any sewing at all, the Egyptian woman created a loose-fitting, billowy frock[38] both elegant and comfortable under the hot Egyptian sun.

The question of how the ancient Egyptians pleated their garments has never been fully resolved. The folds may have been made mechanically by pressing the cloth onto a board with concave grooves and fixing the ridges formed in the material with a gelatinous sizing.[39] Alternately, it is possible that the pleats were fashioned entirely by hand when the cloth was wet and then redone after each washing. This time-consuming method, requiring no sizing, is still used for pleating folk costumes in Central Europe.[40]

R.E.F.

1. Riefstahl and Chapman 1970, pp. 244-246.
2. Davies 1927, pp. 44-45; see also p. 199 of the present catalogue.
3. Cartland 1916a, p. 166.
4. Staehelin 1966, pl. 3.
5. Asselberghs 1961, pls. 95, 98, 101.
6. Hayes 1953, p. 109.
7. Riefstahl and Chapman 1970, p. 249, fig. 7.
8. Cartland 1916a, pp. 166-167; Staehelin 1975b, cols. 385-386.
9. Quibell and Green 1902, pl. 57; Staehelin 1966, pp. 32-33; Bianchi 1978, pp. 97-98, 100.
10. Hayes 1953, p. 109.
11. See p. 180.
12. Dittmann 1939, pl. 26a,c; Staehelin 1966, pp. 170-172, pl. 16.
13. Bianchi 1978, p. 95; Hall 1980, pp. 32-33.
14. Petrie 1898, pl. 9; Hall 1980, p. 33.
15. Landi and Hall 1979, p. 142.
16. Hall 1980, pp. 33-34; Hall 1981, p. 34.
17. Cartland 1916a, p. 170; Erman 1971, pp. 205-206.
18. Blackman and Apted 1953, pl. 18.
19. Evers 1929, pl. 142; Staehelin 1975a, cols. 230-231.
20. Hayes 1953, p. 240; Riefstahl and Chapman 1970, pp. 253-254; Hall 1981.
21. See below.
22. Evers 1929, p. 97b; Blackman and Apted 1953, pl. 18.
23. Evers 1929, pl. 97b; Bianchi 1978, p. 97.
24. See cat. 196.
25. Schiaparelli 1927, figs. 67-69; Mond and Emery 1929, pp. 56-57; Bruyère 1937b, p. 60, fig. 31; Hayes 1959, p. 187, fig. 103.
26. Hayes 1953, p. 240; Hayes 1959, p. 187.
27. Riefstahl and Chapman 1970, p. 254.
28. Mackay 1924, p. 41, pl. 9.
29. Hayes 1959, p. 187.
30. Wilkinson 1883c, pl. 67, opp. p. 446; Erman 1971, p. 209.
31. Janssen and Hall 1981, p. 24.
32. Cartland 1916b, pp. 212, 214, fig. 3; Riefstahl and Chapman 1970, p. 254; see also p. 180.
33. Erman 1971, p. 207.
34. See cats. 197 and 199; Staehelin 1975b, cols. 385-386.
35. Riefstahl and Chapman 1970, pp. 254-256.
36. Bruyère 1937b, p. 58; Riefstahl and Chapman 1970, p. 246.
37. Bruyère 1937b, p. 59; fig. 30; see cat. 196.
38. Bianchi 1980, p. 11 n. 7.
39. Wilkinson 1883a, p. 185; Staehelin 1966, p. 169.
40. Riefstahl 1975, pp. 28-29.

Fig. 44. Man wearing a transparent rippled shawl (from the tomb of Menkheper, Theban tomb 79).

Fig. 45. Amenhotep Huy wears a pleated tunic with triangular apron.

Fig. 46. The woman's garment of the later New Kingdom was wrapped around the body and tied under the breasts (from the tomb of Neferhotep, Theban tomb 49).

196

Statue of Amenemopet and Hathor

Said to be from Deir el Medineh tomb 265/215
Dynasty 19, reign of Ramesses II
Height 33.2 cm.; width 18 cm.
Agyptisches Museum, West Berlin (6910).
Formerly in the Cassis Faraone Collection

This statue of the Royal Scribe, Overseer of Works in the "Place of Truth" (the tomb of the King, in this case Ramesses II), and his wife represents a continuation and stylization of the fashions and tastes of the time of Amenhotep III. Amenemopet is seated on a lion-footed chair and beside him, on a flared-leg stool (see cat. 40), sits his wife, who bears the name of one of the most prominent Egyptian goddesses, Hathor. The entwined arms of the loving couple are a common feature of these "pair" statues.

The attire that Amenemopet and Hathor chose to be clad in for eternity is their finest and does not necessarily reflect their daily wear. Amenemopet wears a double wig (see cat. 198), with the sections of hair resting on the chest longer and more squared off at the ends than at the time of

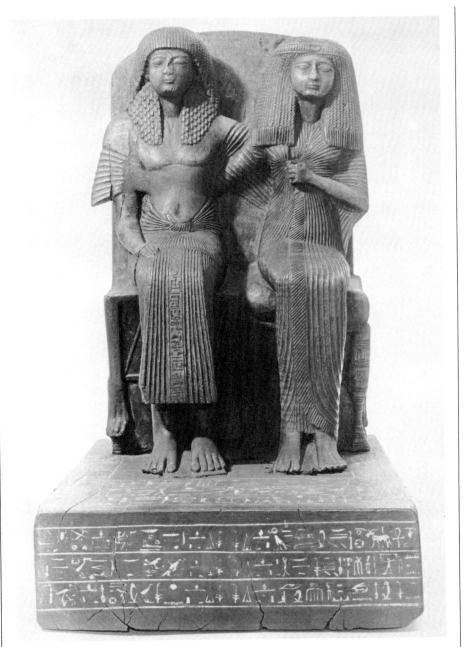

196

Amenhotep III. His costume, specifically New Kingdom, consists of three main pieces: a shirt, a long skirt, and a shorter overskirt, all of which would have been made of fine white linen. It is thought that a finer linen was used during the New Kingdom than in previous periods, thus lending itself to and perhaps encouraging the elaborate draped styles. The sack-like shirt, or bag tunic, has an opening at the top for the head, frequently with a vertical slit that could be tied closed with a pair of cords, and openings at the sides for the arms. The fan-shaped sleeves are created by the surplus fabric at the top, dropping over the shoulders. The shirt, worn by officials and courtiers from the time of Amenhotep III onward, differs in the later versions, such as the present statue, only in that more pleats are added to the sleeve edges. The short skirt worn over the long underskirt is especially elaborate, with a decorated selvage at the waist edge and fringe on the uppermost of the two pleated front sections. The sculptor chose the long front section as a convenient spot to place an inscription that gives the titles and name of Amenemopet.

The Mistress of the House, Hathor, wears an enveloping wig of long crimped locks that fall from a center part and are twisted at the ends. Her fillet, in the form of a garland of lotus petals, is ornamented with one mandrake fruit above the center of the forehead. The elaborately draped and fringed gown consists of a single panel of linen, probably white, that is wrapped around the body and tied under the right breast. This robe is a more developed form of the diaphanous gown of the late Eighteenth Dynasty.

Just behind Hathor's legs, taking what appears to be a very subordinate position, is an incised representation of her son, the scribe Semenmes. He carries his scribe's palette under his arm and wears a simpler version of his father's skirt. The small monkey eating figs under Hathor's stool may have been a household pet.

B.F.

Bibliography: Barguet 1953, p. 106 n. 3; Basel Kunsthalle 1953, no. 124; Kees 1956, p. 54; DeWit 1957, p. 33 n. 9; Schott 1958, p. 142; Barucq 1963, pp. 66, 90, 99, 139, 148, 185, 186, 187, 190, 193, 233, 238, 240, 242, 326, 378, 392-395, 396, 399, 402; Wente 1963, pp. 32, 34 n. 11; Otto 1964, p. 13 n. 10; Agyptisches Museum 1967, no. 778; Barta 1968, pp. 120 n. 10, 121 n. 1, 127 n. 7, 133 nn. 5, 14; Desroches-Noblecourt and Kuentz 1968, p. 141; George 1970, pp. 110, 174; de Meulenaere 1971, p. 232 n. 3; Tefnin 1971, p. 39 n. 1; Cerný 1973a, passim. (See Porter and Moss 1960, p. 346, for additional references.)

196

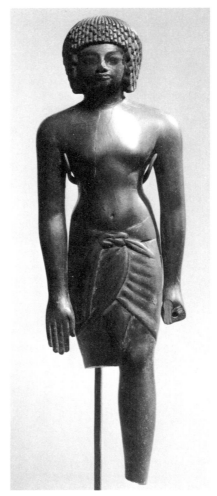

197

197

Statue of a man
Provenance not known
Dynasty 18, reign of Amenhotep III
Height 21.2 cm.
The Brooklyn Museum, Brooklyn, New York. Charles Edwin Wilbour Fund (57.64)

This is one of the finest of a small group of New Kingdom wooden statues representing men wearing the so-called military kilt.[1] The large, elegantly slanted eyes and the full mouth are to be found in likenesses of Amenhotep III, thus suggesting an approximate date. Two less subjective criteria that are particularly indicative of the time of Amenhotep III are the short Nubian wig and the kilt.

The wig, shoulder length or short, cut up at the back of the neck, is a version of the hair style traditionally worn by Nubian soldiers. First adopted by Egyptians during the Eighteenth Dynasty, it is worn by King Amenhotep II on several occa-

sions, even in combination with Nubian costume.[2] Most frequently it is found on soldiers, policemen, and officials, but the Nubian cut is not restricted to males: at Amarna, Queen Nefertiti, her daughters, and her better-placed female servants favored this essentially military hair style.[3] Although the popularity of the Nubian wig decreases after the Amarna Period, it still does appear occasionally, for example, on a statue inscribed for Ramesses III of Dynasty 20[4] and on a statue of Osorkon I of Dynasty 22,[5] where the long version of the wig is worn.

Represented from the beginning of pictorial history in ancient Egypt, a kilt consisted of a single piece of fabric whose final appearance was determined by the length of the fabric and the way in which it was draped or wrapped. The type of kilt seen in the Brooklyn statue, distinguished by the pointed end piece at the front and the belt with the long sash ends, was popular in the Eighteenth Dynasty. When its color is preserved it is white and we may assume it was made of linen. Although this kilt may indeed have had a military origin, it seems to have been worn by men in all walks of life.

In Theban tomb paintings we find servants and soldiers wearing a kilt with a pointed center section but with no indication of the draping so evident in this example. Around the time of Amenhotep III the draped kilt was frequently worn by officials in combination with long skirts and a shirt. Occasionally an additional fan-shaped panel of fabric was doubled at the front.[6] One would expect that these more elaborate versions of the kilt were reserved for gala occasions.

Once painted, the statue still bears traces of black paint on the wig and the eyes. Related examples are to be found in a number of museums.[7]

B.F.

1. Vandier 1958, p. 493.
2. Aldred 1957, passim.
3. Aldred 1973, pp. 109, 110, 126, et passim.
4. Vandier 1958, pl. 131:3.
5. Louvre A.O. 9502.
6. Agyptisches Museum 1967, pp. 73, 777.
7. Medelhausmuseet, Stockholm, N.M.E. E. 306; Agyptisches Museum, West Berlin, 14134 and 10269; Ernest Erickson Collection, New York; Museum Meermanno-Westreeniamum, The Hague, 76.

Bibliography: Brooklyn Museum 1960, p. 32.

Literature: Aldred 1957; Sotheby 1964, lot 113.

198

198

Head of a man

Provenance not known
Late Dynasty 18
Height 31 cm.; width 24.7 cm.
Field Museum of Natural History, Chicago
(31718)

This limestone head is marked by its soft, almost velvety surface, a characteristic of the Post-Amarna period.[1] The eyes are incised rather than modeled into the stone. The left is horizontal, with a pronounced downward tilt to the inner canthus. The right eye, larger and slanting slightly upward, lacks the attenuated inner canthus. The upper lid bulges slightly and is emphasized by an incised fold line.

Although fragmentary, this limestone head offers a particularly detailed example of the elaborate so-called double wig. Prefigured during the time of Thutmose III, with short echeloned curled sections beneath and behind the ears,[2] this wig first appears in sculpture in the round, with lengthened hair sections falling forward over the shoulders, during the reign of Amenhotep III; it was a favorite of officials and courtiers well into the Ramesside Period. In this sculpture and in representations of the wig in relief and painting (though probably not in actuality), the wig consisted of two separate parts. The upper part, falling from the crown of the head to mid-forehead in the front, cuts back at an angle from the tem-

ples, leaving the earlobes free, and reaches to the shoulders in the back. It consists of crimped locks of hair that are given a tight twist at their ends. Crimped locks, sculptured as zigzag lines, became popular in the time of Amenhotep III and continued into the Nineteenth Dynasty (see cat. 196). The sculptor of this head gave the curls a more realistic appearance by drilling the ends. The second part of the wig is formed by two masses of tightly twisted echeloned curls that fall forward over the shoulders from under the wig's upper section. Although part of the shoulder sections are missing here, comparison with cat. 196 permits us to imagine how the wig appeared in its original state.

The ears are pierced but, as usual in representations of males in sculpture, earrings are not indicated. Pierced ears do not appear in male sculpture before the reign of Akhenaten.

B.F.

1. Seidel and Wildung 1975, pl. 15, figs. 199-200.
2. Vandier 1958, p. 507, pl. 143, fig. 1.

199

199

Gazelle-skin loincloth

From the Valley of the Kings tomb 36
Dynasty 18, probably reign of
Thutmose III
Height 85 cm.; width 89 cm.
Museum of Fine Arts. Gift of Theodore
M. Davis (03.1035)

In the Eighteenth Dynasty Nubians and Sudanese were commonly found in Egypt as soldiers and police. Many appear to have enjoyed the status of free citizens and a few, like the fan bearer Maiherperi, attained positions of wealth and influence.[1] Only Maiherperi was awarded the considerable honor of a burial in the Valley of the Kings at Thebes,[2] a site usually reserved for royalty. A cartouche of Queen Hatshepsut's[3] was found on Maiherperi's mummy cloths, and his burial is sometimes assigned to her reign.[4] The style of his anthropoid coffins[5] and of a glass vessel found in the tomb[6] suggest, however, a slightly later period, probably the independent reign of Thutmose III.

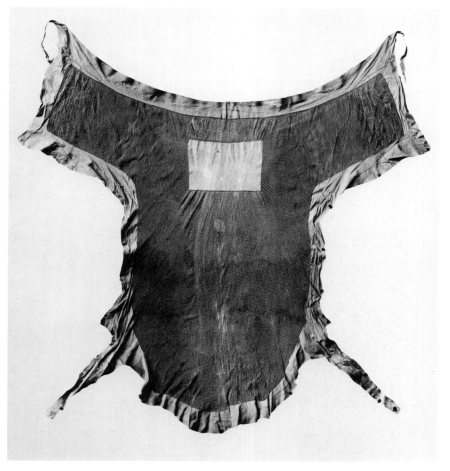

Maiherperi went well provided to the next world (see cat. 200); his mummy was carefully unwrapped in 1901[7] and resides today in the Egyptian Museum. Maiherperi was a strikingly hand-home man with dark skin and fine features. He was certainly at least part Nubian;[8] but what appear to be tight corkscrew curls on Maiherperi's head actually represent a wig of black human hair. The likelihood of his Nubian connections is strengthened by the great similarity of the leather objects of Maiherperi with finds made at Kerma in the Sudan.[9]

Maiherperi is one of the first known holders of the title "fan-bearer."[10] Later the title was one of high distinction and became fixed as "the fan-bearer on the king's right hand," a dignity often borne by the viceroys of Kush. The title reflected a close personal relationship with the pharaoh, for the recipients had the duty and privilege of carrying a long feather fan alongside the king at public ceremonies.[11] It is likely that the designation was originally a service title and, as the men who carried the insignia also bore an ax,[12] it is possible that they served as the king's personal bodyguards. Maiherperi certainly saw military service abroad, being "a royal follower in his [the king's] footsteps in every southern and northern foreign land,"[13] and perhaps he was distinguished by his valorous actions in battle; indeed, his Egyptian name, Maiherperi, means "a lion on the battlefield."

Whatever Maiherperi's relationship with the king, it probably dated to his childhood for, as his title "child of the harim"[14] indicates, he grew up and was educated with the royal children in the private quarter of the palace. To ensure the loyalty of his newly conquered vassals in Syria and Palestine, Thutmose III carried off their eldest sons with him as hostages to Egypt, where they were educated and so treated as to engender friendly feelings toward Egypt; if a vassal died one of his sons would be dispatched from Egypt to take his place.[15] Maiherperi's title is evidence that the custom may have been an older one that extended to Africa as well, and that Maiherperi may have been the son of an African king brought to Egypt to receive an Egyptian education.

In a small hollow in the rock above Maiherperi's tomb, Howard Carter, the excavator of the tomb of Tutankhamen, found this and a second loincloth.[16] They were packed tightly in a small wooden box painted yellow and inscribed in blue paint with Maiherperi's name and titles (cat. 200). The loincloths are of two types, both so delicate and finely worked that they may have been more ornamental than serviceable,[17] although this example, which has very small holes formed by cutting out tiny squares from the leather, shows signs of use. The cutting was done with such precision and regularity that the strands are broken in only a few places.[18] The other loincloth was cut in a large, loose rhomboidal net pattern.[19] Both types are depicted in Theban tomb paintings of the New Kingdom, worn by sailors, soldiers, agricultural laborers, and workmen engaged in various crafts or activities.[20]

The plain section of leather was placed over the buttocks and the garment tied around the waist; the rounded section was drawn up between the legs and fastened at the waist in front. In some instances the loincloth seems to have been worn over a linen kilt.[21] A troop of soldiers in the tomb of Tjanuni[22] wear their loincloths loose over a simple kilt with the tails of some feline animal attached to the loincloth and to garters at the knees.

Clothing of pierced leather was found in male graves at Kerma[23] and in other Second Intermediate Period graves in Nubia[24] and the suggestion has been made[25] that this Nubian fashion of wearing pierced leather kilts may have been the origin of the New Kingdom pierced leather loincloths.

Other loincloths are to be found in Cairo,[26] Florence, Frankfurt, London, Oxford, and Toronto.[27]

D.N.

1. Hayes 1959, p. 116.
2. Daressy 1902.
3. Ibid., pl. 12.
4. See Porter and Moss 1964, pp. 556-557.
5. Daressy 1902, pls. 1,2.
6. Ibid., pl. 7; Nims 1965, pl. 90.
7. Daressy 1902, pls. 16, 17, pp. 58ff.
8. Ibid., p. 59.
9. Säve-Söderbergh 1941, p. 238.
10. Reisner 1920b, p. 81.
11. Ibid., pp. 81-83.
12. Ibid., pp. 80-81, pls. 9-10.
13. Daressy 1902, p. 54.
14. Ibid., passim.
15. Breasted 1905, p. 293.

16. Stolen from the Field Museum of Natural History, Carter 1903, pp. 46-47; Porter and Moss 1964, p. 557.
17. Museum of Fine Arts 1960, p. 126.
18. Ibid., pp. 124-126, figs. 76-77.
19. Carter 1903, pl. 7r.
20. Davies 1926, pls. 5, 13, 18, 32; Davies and Gardiner 1936, pl. 45; Davies 1943, pls. 50, 58, 61, 68.
21. Wainwright 1920, p. 29.
22. Davies and Gardiner 1936, pp. 90-91, pl. 45.
23. Reisner 1923b, pp. 303ff.
24. Wainwright 1920, p. 29 nn. 1-2, pl. 10:2.
25. Ibid.
26. Jéquier 1910, p. 174.
27. 910.105.

Bibliography: Museum of Fine Arts 1903, p. 25; Museum of Fine Arts 1904, pp. 7-8; Wolf 1930, p. 139; Waterer 1946, p. 30; Capart 1947, p. 26, pl. 676; Museum of Fine Arts 1960, p. 124.

Literature: Faulkner 1941, p. 14 n. 2; Säve-Söderbergh 1946, pp. 75, 77 n. 4; Schulman 1964, p. 19 nn. 1-2.

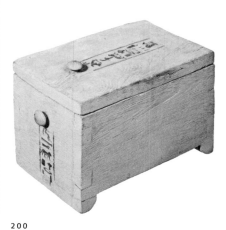

200

200

Painted box of Maiherperi

From the Valley of the Kings tomb no. 36
Dynasty 18, probably reign of Thutmose III
Height (with lid) 13.5 cm.; length 19.7 cm.
Museum of Fine Arts. Gift of Theodore M. Davis (03.1036a-b)

The box is constructed of five dovetailed pieces of cypress wood with two pegged-on shoes for legs. In profile, the rounded inner sides of the shoes resemble bracket feet and form an attractive detail. Diagonal saw marks are visible on the bottom board, which is attached by two dowels on each of the long sides. The inscription on the face, below the knob, reads: "Child of the royal nursery, Maiherperi." A single line of hieroglyphs down the top of the lid, carved in sunk relief and painted blue, names the "fan bearer Maiherperi" (see cat. 199). In addition to identifying its owner, the hieroglyphs ornament the box with a contrast of blue on yellow.

On the underside of the lid are two cleats, each fastened with two wooden dowels. The rear cleat is cut to fit a wedge-shaped groove on the inside back edge of the box, thus helping to "lock" the lid in place. On the outside of both the box and the lid are the typical wooden knobs around which a string was tied to fasten the lid shut. Such knobs, in addition to various bolts and locking devices, appear on chests and boxes of all sizes and shapes.

The box originally contained two finely cut and perforated gazelle-skin loincloths, one of which is cat. 199.

P.D.M.

201

201

Basketry sandals
Provenance not known
Probably New Kingdom
Length 21.5 cm.
Museum of Fine Arts. Emily Esther Sears Fund (03.1720/21)

The modern shoe consisting of sole and uppers appeared relatively late in ancient Egypt.[1] Prior to the Late and Ptolemaic Periods, the Egyptians wore sandals made of leather or natural grasses woven or plaited together. During the New Kingdom, the soles of basketry sandals were either woven on a diagonal, as here, or made of a tight mesh of reeds wrapped with thin strips of grass.[2] Normally a thong running between the first and second toes and connected to a strap passing over the instep formed a Y-shaped harness. In some cases another strap was added behind the heel, so forming a loop-shaped harness. Papyrus or reed sandals would have been too fragile for extended use in or outside the home; thus, sandals made of leather or of a grass coil[3] were undoubtedly worn for rough outside terrain.

It is often said[4] that the Egyptians disliked the constraints of footwear, preferring to go barefoot. However, the wayfarers Weni encountered on his journey to Palestine had sandals;[5] the quarrymen who cut quartzite for the monuments of Ramesses II received sandals as part of their regular allotments of food, clothing, and oil;[6] in "The Tale of the Two Brothers," Anubis takes his staff, cloak, and sandals with him when he sets out to look

202

for his brother in the Valley of the Pine.[7]

According to etiquette, sandals were removed in the presence of a superior.[8] This practice may help explain the boast of the king in the Pyramid Texts that the gods remove their sandals in his presence.[9] By extension, it was an honor to carry the sandals of a great man. The title of "sandal bearer" was expressed pictorially on the First-Dynasty Narmer Palette,[10] where the sandal bearer stands in attendance behind the king.

The soles of the Boston sandals are made from a core of papyrus pith plaited with palm leaves and strengthened with three coils of grass around the edge. The papyrus and palm leaf harness over the instep is paralleled by a strap seen in sandals from the Eighteenth-Dynasty tomb of Yuya and Thuya,[11] while the plaited sole is very similar to that on a pair in Berlin.[12]

J.K.M.

1. Agyptisches Museum 1967, no. 598; Erman 1971, pp. 226-227.
2. See Davies 1935, pl. 13.
3. Petrie 1927, pl. 54.
4. Wilkinson 1883b, p. 336; Jéquier 1921, p. 29; Montet 1962, pp. 72-73; Erman 1971, p. 226.
5. Sethe 1903, p. 102, 1.13.
6. Hamada 1938, p. 228.
7. Simpson et al. 1973, p. 103.
8. Fischer 1976, p. 99 n. 15.
9. Sethe 1910, I. 1197d.
10. Quibell 1900, pl. 29.
11. Davis et al. 1907, pl. 44.
12. Wilkinson 1883b, p. 336, fig. 444.

Bibliography: Carter 1903, pp. 46-47, fig. 1.

202

Basketry sandals with upturned toes
Provenance not known
Late New Kingdom
Length 33 cm.
Agyptisches Museum, Berlin (6931)

The sandals are made of plaited palm leaves and grass with toes turned back and attached to the loop passing over the instep.

The sandal with upturned toe seems to be an innovation of the Ramesside Period, one of the earliest pairs being

177

from the toilet box of Tutu, wife of Any.[1] A model silver sandal of the same design from a funerary deposit of objects belonging to Seti II and Queen Tawosret of the Nineteenth Dynasty was recovered from tomb 56 in the Valley of the Kings.[2] In the High Gate at Medinet Habu, Ramesses III and the princesses who attend him wear upturned sandals[3] and, in the vignette accompanying the Great Harris Papyrus, Ramesses III stands before the Theban triad in the same footwear.[4] Yet another example of the sandal occurs in a depiction of a mother nursing her child, on an ostracon from Deir el Medineh.[5] Representations of sandals with the toe attached to the strap are known from Dynasty 21 and Dynasty 22.[6]

J.K.M.

1. Baker 1966, fig. 223.
2. Davis et al. 1908, p. 44, pl. [20b].
3. Oriental Institute 1970, pls. 594, 598, 603, 605, 607, 608, 609, etc.
4. James 1972, opposite p. 48.
5. Bruyère 1939, p. 131, fig. 51; Vandier d'Abbadie 1946, fig. 43.
6. Petrie 1909b, pl. 31, p. 13; Carnarvon and Carter 1912, pl. 41, p. 49.

Bibliography: Staatliches Museen 1899, p. 216; Agyptisches Museum 1967, no. 593; Erman 1971, p. 228.

203
Walking stick

Provenance not known
Dynasty 18-19
Length 134.5 cm.; diameter 2 cm.
Museum of Fine Arts. Hay Collection, Gift of C. Granville Way (72.4343)

Walking sticks in ancient Egypt formed one part of the very much larger class of staves and scepters. Their characteristic shapes and names have been discussed in several studies[1] and they have been shown to reflect status in Egyptian society. The deceased is frequently depicted in Theban tombs with a scepter and walking stick while surveying his estates; in daily life a staff was an important item of apparel, to be taken up along with sandals and cloak when setting out from the house.[2]

Walking sticks were included among the grave goods of king and commoner for another reason, which seems to lie in the notion that the passage of the deceased to the hereafter was an actual journey for which a walking stick was appropriate. Texts inscribed on

203

the sticks are taken from the religious literature of the Old and Middle Kingdoms.[3] The phrase inscribed on a walking stick in Cairo, for example, one of nine inscribed walking sticks and canes of diverse form found in the family tomb of Sennedjem at Deir el Medineh, reads: "Accept, thou, old age in silence within the place of truth, so that you may follow Amen whenever he appears."[4] The texts place walking sticks among the objects of daily use that doubled as amulets to help revivify the deceased through sympathetic magic and restore his capacity for movement (see p. 250).

The design of this polished wood walking stick, with the fork of a branch left at the top and a slight swelling toward the bottom, is typical of the New Kingdom.[5] Earlier walking sticks and canes often have a pommel of metal, alabaster, faience, or glass.[6]

J.K.M.

1. Mace and Winlock 1916, pp. 76-103; Jéquier 1921, pp. 159-194; Hassan 1976.
2. Simpson et al. 1973, p. 103; Davies 1930, pl. 36.
3. Hassan 1976, pp. 114-122.
4. Ibid., p. 138.
5. Jéquier 1921, p. 164.
6. Hayes 1959, p. 215.

Bibliography: Hay 1869.

Literature: Hassan 1976; Fischer 1978a, 1978b.

204
Staff

From Thebes
Dynasty 18
Length 104 cm.
Agyptisches Museum, Berlin (14348)

This walking stick with a forked top is decorated with a band of birch bark and a long silver sleeve on the end. Elaborate walking sticks from the Eighteenth Dynasty often include decorative bark and, to a lesser extent, stained ivory inlay.[1] One of the followers of the nobleman Kenamen is shown in the latter's tomb carrying a walking stick identical to the present example, with fork, marquetry, and long ferrule.[2]

The length of this staff suggests that it was never intended for actual use. Instead it probably served a symbolic or magical function. The stick was broken in antiquity, possibly by design, as bows and staves included in Middle Kingdom burials were intentionally broken[3] to alter their function or render them useless.

The text on the walking stick includes two names: Senenmut, the steward of Amen, and Tusy, the overseer of the farmers of Amen. It is highly unlikely that the two men shared the stick;

204

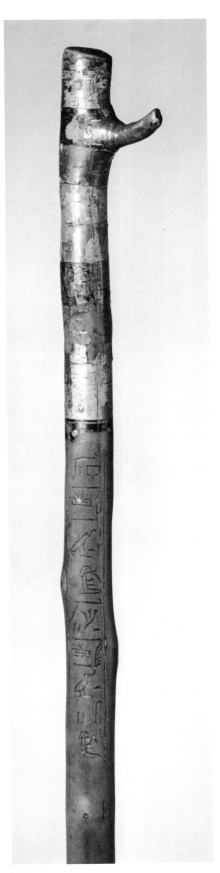

perhaps it was a gift from Senenmut to a friend, relative, or employee.

J.K.M.

1. Carter 1933, p. 135; Hayes 1959, p. 215.
2. Davies 1930, pl. 36.
3. Hassan 1976, pp. 122-123.

Bibliography: Hassan 1976, p. 139, pl. 8:7.

205

Fan handle
Provenance not known
Probably Dynasty 18
Length 44 cm.
Museum of Fine Arts. William Francis Warden Fund (49.1918). Formerly in the Brummer Collection

Atop the palmiform terminal of the tapered wooden fan handle are four holes that may originally have contained ostrich feathers (as shown in a representation in the tomb of the vizier Ramose, for instance).[1] They might also have held leaves or even flowers.[2] Palmiform fans are represented as early as the Old Kingdom, but it is only from the New Kingdom on that the actual item is preserved.[3] A scene etched on the gold surface of a fan from Tutankhamen's tomb shows the young king chasing ostriches, and the inscription explains that he hunted the birds in the deserts bordering the Nile valley; ostrich feathers are also included in tribute from Nubia.[4]

A painting depicting a carpenter's workshop in the tomb of Men-kheper-re-seneb shows two fan handles among other examples of the carpenter's art,[5] and fans have been found in other domestic contexts.[6]

R.E.F.

1. Davies 1941, pl. 37.
2. Fischer 1975b, col. 81.
3. Ibid.
4. Davies 1943, pl. 18.
5. Davies and Davies 1933, pl. 11.
6. Petrie 1890, pl. 18; Carnarvon and Carter 1912, p. 72, pl. 65:1; Bruyère 1929, pl. 8.

Bibliography: Sotheby 1949, lot 50.

Literature: Reed and Osborne 1978, pp. 273-276.

205

Textiles

Owing to the fragile nature of their fibers and to the adverse effects of the elements on them, the number of existing textiles from all parts of the world datable to the pre-Christian era is extremely small in relation to most other categories of archaeological materials. Fortunately for the Egyptologist, the majority of the pre-Christian textiles that have survived are those preserved in Egyptian tombs and burying grounds, protected by the extremely dry climate. These textiles are especially useful as indicators of "ordinary" or everyday objects, as they served no ritualistic function in the burial, nor were they created for the express purpose of clothing the deceased. Rather, they were selected from whatever stores of textiles were at hand, for use in wrapping the body and padding out the coffin.

Virtually all excavated fabrics dating from dynastic times in Egypt are made up entirely of linen yarns. This is not surprising because, although no wild form of flax has been found in Egypt, it was cultivated there from the earliest times and was used for the production of linen fabrics as early as the Neolithic Period.[1] The texture of these weavings is occasionally coarse, but in other examples it is quite often extremely fine. In fact, linen textiles datable to approximately 3000 B.C. were produced with as many as sixty-five warp yarns and fifty weft yarns per centimeter, a count finer than today's linen handkerchiefs.[2] Made into garments, these lightweight, even sheer, fabrics were well suited to the hot Egyptian climate.

Few surviving New Kingdom textiles are patterned or ornamented in any way except for the use of warp or weft fringes (see cat. 207). Certain important exceptions[3] are self-patterned by means of varying the usual plain cloth weave, as in cat. 210 and in a group of intriguing "ripple-striped" textiles depicted in numerous New Kingdom tomb paintings (see fig. 44).[4] Still others depend on dyed yarns for their patterns. Chief among these are embroidered and tapestry-woven objects from the tomb of Tutankhamen and the warp-patterned belt or girdle of Ramesses III.[5] However, linen accepts dyestuffs less readily than the other common natural fibers (wool, cotton, and silk), and the Egyptians

of dynastic times never developed the art of dyeing to a high level.[6]

Although wool accepts dyes beautifully, the ancient Egyptians apparently made little use of this fiber. They did possess large flocks of sheep, but the wool from these animals may not have been well suited to weaving. In only a handful of instances has wool — either woven into cloth, spun but not woven, or in its natural state — been found in dynastic tombs.[7] Many New Kingdom tomb paintings depict foreigners wearing highly patterned garments and there is sound circumstantial evidence suggesting that dyed wool yarns played a part in their decoration.[8] Certainly wool weaving was well advanced in many areas neighboring Egypt prior to its adaptation in that country.[9] Eventually Egyptian weavers did begin to use wool in their textiles, and they became accomplished in incorporating dyed woolen yarns in their weavings by Roman and Christian times. However, the exact period that this fiber came into general use in Egypt remains unknown. The fact that few dynastic woolen textiles have come out of excavated tombs does not necessarily mean that they were not used at that time. One possible reason for their absence is given in the following observation, reported in the fifth century B.C. by Herodotus: "They [the Egyptians] wear a linen tunic fringed about the legs and called *calasiris,* over this they have a white woolen garment. Nothing woolen, however, is taken into their temples or buried with them as their religion forbids it."[10] Of course, Herodotus' statement pertains only to the very end of Pharaonic times.

The earliest example of cotton cloth found in Egypt is of Roman date[11] and the first documented use of silk in Egyptian textiles dates from the Ptolemaic Period;[12] both were unknown in New Kingdom times. Cotton is known to have been produced in India as early as the fourth millennium B.C.[13] and when it was introduced to Egypt it came either from that source or from Nubia or the Sudan.

The type of loom most frequently used to weave textiles in New Kingdom Egypt was the horizontal ground loom, employed from predynastic times and illustrated in Middle Kingdom tomb paintings[14] and models.[15] A second

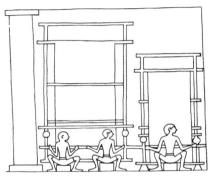

Fig. 47. Weavers working vertical looms in the house of Djehutynefer (from Theban tomb 104).

type of loom, the vertical two-beamed loom, was brought to Egypt from Syria or other areas of the Near East, and it appears in New Kingdom tomb paintings[16] (fig. 47). It is not known how quickly its use spread throughout Egypt, but it by no means displaced the horizontal loom. Although the vertical loom was apparently used to weave large cloths and sheets, its special advantage was the ease with which tapestry-woven fabrics could be produced on it, and it may well have been the type of loom on which were created textiles with tapestry decoration such as those found in the tomb of Tutankhamen.

The introduction of the vertical loom into Egypt during the New Kingdom period made possible a much greater variety of decoration to the weavers, but they continued to produce mainly plain linen cloths for use as sheets, towels, tunics, and other garments.

L.S.

1. Caton-Thompson and Gardner 1934, p. 46.
2. Riefstahl 1944, p. 1.
3. Ibid.
4. Mackay 1924, pp. 41-43, pl. 9, figs. 1-3.
5. Riefstahl 1944, figs. 35, 36, 38.
6. See Lucas 1962, pp. 150-154.
7. Ibid., p. 147.
8. Riefstahl 1944, pp. 18-19.
9. Bellinger 1951.
10. Herodotus II, 81: Godley 1921, p. 367.
11. Lucas 1962, p. 148.
12. Ibid., p. 149.
13. Marshall 1931, pp. iv, 33, 194.
14. Roth 1913, figs. 1-7.
15. Bellinger 1959, pl. 2.
16. Roth 1913, figs. 9, 16.

Literature: Roth 1913; Riefstahl 1944; Crowfoot 1954; Lucas 1962, pp. 128-154.

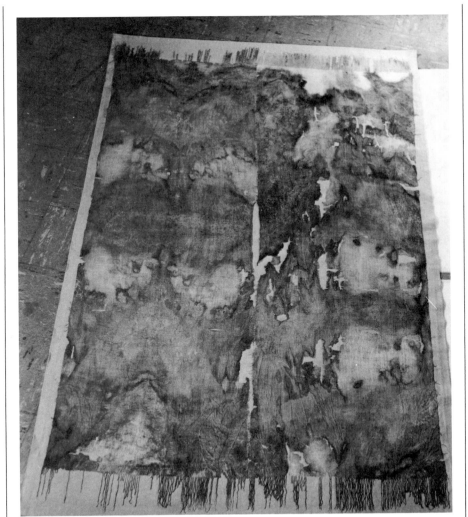

206

206
Festival tunic
From Deir el Bahri
Late Dynasty 19—Dynasty 20
Length (open) 2.54 m.; width 1.2 m.
Royal Ontario Museum, Toronto
(910.4.35)

White linen yarns, now yellowed, constitute the warp and weft of this garment, woven in plain cloth weave. Characteristic of New Kingdom festival costume, this tunic is made up of a large rectangle folded in two along the short axis. The fullness was probably taken up in an arrangement of deep pleats in front, held in place with a tightly wrapped sash extending from the middle of the ribcage to below the hips; the circular neck opening has a finely rolled hem (see fig. 48).

The garment was used as a wrapping for the body of Nakht, a weaver in the funerary cult of Setnakht.[1] One of a random selection of textiles found

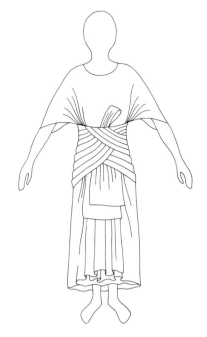

Fig. 48. The festival tunic of Nakht as it might have looked when worn with a sash.

with this body, it has several missing sections and shows considerable wear. This evidence suggests that the tunic did not belong to Nakht, but was more likely part of a supply of old textiles on hand at the mortuary to be used in wrapping bodies for burial.

L.S.

1. Lewin et al. 1974, pp. 18-19.

Bibliography: Lewin et al. 1974, pp. 18-19.

207
Bed sheet
From Gurna
Dynasty 18, reign of Queen Hatshepsut
Length 4.9 m.; width 1.5 m.
The Oriental Institute, The University of Chicago. By exchange with The Metropolitan Museum of Art, New York (18284)

This undyed linen sheet is plain woven with a long fringe at one warp end, which may have been created by removing the cloth beam from the finished product. A short side fringe indicates that the sheet was probably woven on a horizontal ground loom rather than a vertical loom.[1] Near the end with the long fringe the sheet is marked with two hieroglyphic signs

207

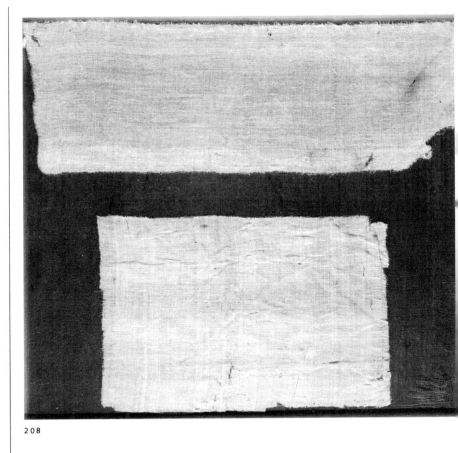

208

that may read "ruler of truth."

Used originally as bed sheets, textiles like this one were typically called into service to wrap bodies being prepared for burial. Usually they were not new but were gathered from family supplies saved for the day of need, procured from friends and relatives, or even bought for the occasion. Great numbers were used to wrap, pad out, and shape the body, and were wadded up to fit between the body and the casket walls. This sheet may have come from the mummy bundle of Hatnefer, mother of Senenmut, a favorite of Queen Hatshepsut.[2] In her coffin eighteen shawls and sheets formed an outer covering for the body, while fourteen more sheets were included in the wrappings, along with eighty bandages, twelve pads, and four sets of trussing tapes.

L.S.

1. Bellinger 1959, pp. 3-4.
2. Lansing and Hayes 1937, pp. 18-20.

Bibliography: Lansing and Hayes 1937, pp. 25-26.

208
Fragments of a garment
From Deir el Bahri
Said to be Dynasty 18, reign of Thutmose
Length (a) 12 cm.; width (a) 35 cm.
(before mounting)
Length (b) 15 cm.; width (b) 26 cm.
(before mounting)
Museum of Fine Arts. Gift of Mrs. Horace Mayer (1978.565)

These two finely woven linen fragments are typical of sheer fabrics produced throughout dynastic times for use as garments. Their thread count (approximately forty-five warps and forty wefts per centimeter) is greater than that of modern fine linens, all the more remarkable in that the weave is open, with space between adjacent warp and weft yarns. The yarns are not plied and are s-spun.

L.S.

209

210

209
Fragments of lace

From Thebes
Probably New Kingdom
Height 36 cm.; width 38 cm.
Museum of Fine Arts. Gift of Mr. Stuart
P. Anderson (57.152)

The network and four-petaled flowers along the lower border of this linen fragment are formed in the knotted-lace art form known as macramé. Although this textile is the earliest known example of macramé, the design is sufficiently sophisticated to suggest that the maker was working in a well-established technique. It appears to differ in construction from Middle Kingdom pot nets excavated at Kerma[1] and from Roman Period women's turbans,[2] which are created through a network of plaited warps. The use of this object is not known, but it may well have served as a decorative overgarment.

L.S.

1. Reisner 1923b, pp. 301-303, and pl. 64:65.
2. Scott 1939, pp. 229-230, figs. 2-4.

Bibliography: Macramé 1971.

210
Cover

From Deir el Medineh tomb no. 1370
Dynasty 18, reign of Queen Hatshepsut and Thutmose III
Height 55 cm.; width (max.) 1.3 m.
Musée du Louvre, Paris (E14500)

This textile from the tomb of Madjar is constructed of undyed linen. The weaving technique, with supplementary weft yarns looped or knotted to produce a pile on one side approximately five centimeters high, creates a design of triangles and bands on the other face. Pile textiles have a long tradition in Egyptian art, with the earliest known examples from Deir el Bahri tombs datable to Dynasty 11,[1] and with other examples occurring upon occasion well into the Christian era. The pile is sometimes ordered to create a design in itself or to give more body to the textile, but frequently in the case of costume material it appears to be intended to provide added warmth for the wearer. This rectangular textile is most likely intended to be an article of clothing or a saddle blanket, as a pattern is worked into the weaving, visible only from the side that has no pile. Used in this manner,

the pile would have been turned toward the wearer, and the patterned side worn as the face.

L.S.

1. Winlock 1942, p. 206, pl. 37.

Bibliography: Bruyère 1937b, p. 61, fig. 31, no. 5; Letellier 1978, p. 36, no. 41; Ecole du Caire 1981, p. 194.

211

212

211
Needle
From Abydos
Dynasty 18
Length 10.2 cm.
Royal Ontario Museum, Toronto. Gift of Egypt Exploration Fund (905.2.103)

212
Thread
From Deir el Bahri
Dynasty 20-21
Diameter .5 mm.
Royal Ontario Museum, Toronto. Gift of Egypt Exploration Fund (907.18.45)

Egyptian garments were typically woven flat and then hemmed, seamed, and occasionally embroidered with needle and thread. The linen thread is two-ply, z-spun and s-plied. This is unusual, as linen rotates naturally in an "s" direction when drying, and the vast majority of two-ply Egyptian textiles are s-spun and z-plied.[1]

L.S.

1. Bellinger 1950, n.p.

Mirrors

Metallic mirrors were made in Egypt at least as early as the Old Kingdom, and had functional as well as religious and funerary uses. Reflecting the image of a person, the mirror disk was associated with vitality, generation, and regeneration. The shape of the papyrus stalk, so often used as a handle, in fact points out this association, as do the features of Hathor, a goddess of vitality and beauty. Solar, and to a lesser extent lunar, associations were also present in the mirror, again an understandable association when one considers the shape and light-giving quality of a disk.

The shape of the disk changed from oval with short broad tang (pierced for a rivet to hold the early New Kingdom metallic handles) to cordiform (with elongated tang) to round (with somewhat stockier tang). The number of preserved handles seems to be especially great from the New Kingdom, but to some extent this is because metal handles were popular then, while more perishable wood and ivory ones were common in other periods. Representations of mirrors usually show a handle accompanying the disk; on the other hand, certain types of handles — the figurative ones, for example — were never represented as far as we know. This exhibition illustrates all but one of the major handle types of the Empire Period.

C.L.

Literature: Loret 1902; Schäfer 1932, pp. 1-7; Hickmann 1956b; Munro 1969, pp. 92-109; Evrard-Derriks 1972, pp. 6-16; Evrard-Derriks 1975-1976, pp. 223-229; Husson 1977; Lilyquist 1979.

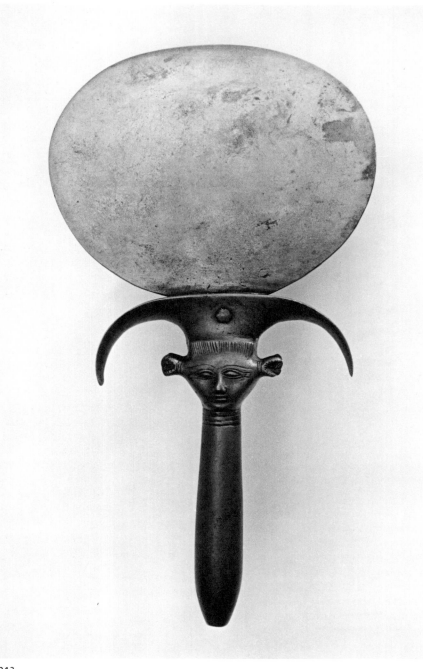

213

Mirror with Hathor faces
Provenance not known
Early Dynasty 18
Height 25.4 cm.; width of disk 13.3 cm.
Agyptisches Museum, Berlin. Passalacqua
Collection (2774)

The thick oval disk with golden re-
flective surface is attached to a sturdy
handle by means of a rivet. Two
Hathor faces, placed back to back,
separate umbel and shaft. Each face is
triangular and has the usual cow ears
and fringe of hair along the forehead.
Below the heads are ties of the column
shaft; dried spathes are incised near
the flattened base. The detail of the
handle was presumably created in the
model before casting; the area be-
tween the ears was left unfinished.
The material of the entire object is
probably bronze.[1]

The size, weight, proportions, and
material of this object make it typical
of a class of mirrors from early
Dynasty 18; similar examples have
been recovered at Thebes with objects
that date to the late Seventeenth or
early Eighteenth Dynasty.[2] Further-
more, there is an example in the
Oriental Institute, Chicago, of a handle
inscribed with the name of Queen
Ahmose Nefertari.[3] The papyriform
column here is the most popular shape
for Egyptian mirror handles, and the
attenuated umbel is usual in this
period. The Hathor faces occur in a
particularly satisfying design; handles
from the Middle Kingdom with Hathor
faces are less successful,[4] as are nearly
contemporary ones from Kerma.[5]

C.L.

1. See also Passalacqua 1826, pp. 159, 238, 659.
2. Ibid.; Hayes 1959, fig. 32.
3. Hughes 1959, fig. 8.
4. Lilyquist 1979, figs. 31, 35, 64, 74.
5. Ibid., figs. 84, 87.

Bibliography: Königliche Museen 1895, pl. 35;
Agyptisches Museum 1967, no. 585.

214

Mirror with falcons
From Semna tomb S552
Early Dynasty 18
Height 21.9 cm.; width of disk 12 cm.
Museum of Fine Arts. Harvard University—
Museum of Fine Arts Expedition (27.872)

The mirror has a cordiform disk that
was originally fastened by a rivet to a
cast-metal handle. The shaft of the

papyriform column is decorated with four equidistant vertical ribs separated by four undulating "threads." Two falcons perch on the flaring umbel tips, each facing outward. Cloth impressions remain on one side of the handle and disk and a smooth dark gray patina lies below the disk's corrosion. Objects from this tomb confirm the observation that the mirror came from the "Dynasty 18" level.[1] This type of handle occurs in the south of Egypt,[2] but more exact parallels for the decorated shaft are known from Thebes,[3] Abydos,[4] and Kom Abu Billu.[5] The decoration seems to reflect current interest in metal casting rather than traditional mirror iconography; its prototype may be in the leather and other non-metallic items found in cemeteries of the Kerma culture.[6] Like the lions on a group of Second Intermediate Period mirrors,[7] the falcons on this bronze mirror handle may be solar symbols.

C.L.

1. Dunham and Janssen 1960, p. 92.
2. Lilyquist 1979, p. 45, figs. 82-86; Vercoutter. 1970, p. 232; Dunham and Janssen 1960, pl. 130b.
3. Hayes 1959, fig. 32.
4. MacIver and Mace 1902, pl. 51.
5. Farid 1973, pl. 8.
6. Cf. Reisner 1923, pp. 4-5, pl. 66.
7. See Steindorff 1935, pl. 69; Schäfer 1932, pp. 1-7.

Bibliography: Dunham and Janssen 1960, p. 93, no. 24-3-444, pl. 129c.

Literature: Reisner 1923b, pp. 178-179, pl. 48.

214

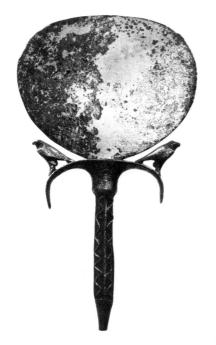

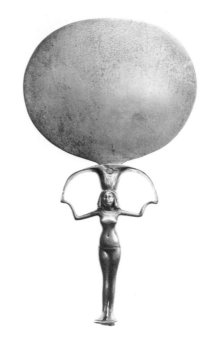

215

215
Mirror with Egyptian figure
From Semna
Early to mid-Dynasty 18
Height 22.5 cm.; width of disk 12.2 cm.
Museum of Fine Arts. Harvard University—
Museum of Fine Arts Expedition (29.1197)

The papyriform-column handle is modified here to include a nude female figure, whose raised arms are contiguous with the umbel, thus creating a handle pleasing to look at and convenient to hold. The figure belongs to the best series of metal statuettes preserved from Dynasties 18 and 19. The disk has a golden red patina, the rivet is in place, and the calyx and certain details of the body are engraved: braids, broad collar with counterpoise, girdle, and pubic triangle. The right foot is slightly advanced; the feet rest on a small base roughened on the bottom. It is likely that, as with other metallic handles, this spot is the point from which the figure was cast. The nose was worn when found.

The mirror was excavated from the middle level below the Taharqa temple, along with a second mirror (cat. 216), two metal vessels and stands, and a wooden kohl stick. A mid-Eighteenth-Dynasty date for the group seems reasonable, especially as it is reinforced by other mirrors of this type and date from Qustul,[1] Buhen,[2] Aniba,[3] Semna,[4] and Abusir.[5] All of the latter fall within the Hatshepsut-Amenhotep III period. The nudity of these figures (except for jewelry and wigs), their youthfulness, and their occurrence with objects of daily use suggest that they may be servants (see cat. 218).[6]

C.L.

1. Seele 1974, fig. 8.
2. MacIver and Woolley 1911, pl. 62, left.
3. Steindorff 1937a, pl. 62, above.
4. Dunham and Janssen 1960, pl. 129c.
5. Bonnet 1928, pl. 36.
6. Cf. Evrard-Derriks 1972, pp. 13ff.

Bibliography: Dunham and Janssen 1960, p. 54, pl. 128c, d; Dunham 1958, pl. 70.

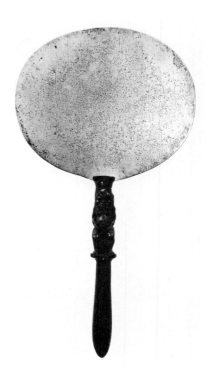

216

216
Mirror with Bes-image
From Semna
Early to mid-Dynasty 18
Height 22.1 cm.; width of disk 11.25 cm.
Museum of Fine Arts. Harvard University—
Museum of Fine Arts Expedition (29.1198)

The thin oval-shaped disk has a reddish corrosion over "gold" and gray reflective layers. It is attached by two rivets to a handle of light wood partially coated with a beige layer. Atop a support—possibly a simplified papyrus shaft — stands the figure of Bes, his head surmounted by either a

modified umbel or a feather head-dress. The tongue is out, the hands held on the belly. There are small lion ears, a lion tail between the legs, and a mane hanging below the face and down the back.

This mirror was found with cat. 215 and should be dated accordingly. It is unusual for, though the Bes-image is associated with household items and with birth (thereby vitality) and though he is commonly represented on Late Period mirror disks, this mirror is the only excavated example with a Bes-image on the handle. Moreover, there are few occurrences of him on handles where it is certain that the object was made for a mirror.

<div style="text-align:right">C.L.</div>

The figure lacks many details we would expect on Bes-images fashioned during and after the reign of Amen-hotep II, including veining on the limbs, a skirt, and indications of the rib cage.[1] Thus, the mirror belongs to the first half of the Eighteenth Dynasty, probably to the reign of Thutmose III, when Egyptian activity at Semna reached a peak in the New Kingdom.

<div style="text-align:right">J.F.R.</div>

Bibliography: Dunham and Janssen 1960, p. 54, no. 28-13-70, pl. 129a, b.

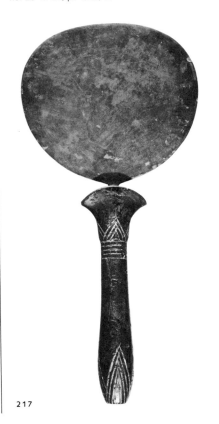

217

217

Mirror with papyriform handle
From Amarna house U.35.17
Late Dynasty 18
Height 26.8 cm.; width of disk 12.5 cm.
Manchester Museum [England]. Gift of Egypt Exploration Fund (8598)

The cordiform disk has a dull ocher surface partially covered by pinkish corrosion. Its tang, five centimeters long, is held in the handle by friction. The handle is dark wood, possibly ebony, with calyx, ties, and spathes incised and filled with pigment; the color was once reported to be blue but is now yellowish white. The umbel is flattened laterally, but the shaft is fully rounded.

The provenance of Amarna indicates a date in the late Eighteenth Dynasty, and indeed another example of similar shape was found at that site.[1] A metal example, however, was in the Maket group, which is sometimes dated earlier than that time.[2] The papyrus column being the most common mirror handle shape, it is interesting to find here a contracted version more like Old and Middle Kingdom examples.

<div style="text-align:right">C.L.</div>

1. Peet and Woolley 1923, pl. 20.
2. Petrie 1891, pl. 26.

Bibliography: Frankfort and Pendlebury 1933, p. 36, no. 29/215.

218

Mirror with Nubian figure
Provenance not known
Late Dynasty 18
Height 22.2 cm.; width of disk 12.25 cm.
The Brooklyn Museum, Brooklyn, New York. Charles Edwin Wilbour Fund (60.27.1)

The slightly cordiform disk is held in place by a rivet that passes through a stylized flattened umbel or head-dress. The disk has a golden reflective surface, and bits of linen adhere to dark green corrosion. The shaft is composed of a Nubian female, her right hand against her side and her left holding a bird at her waist. She is nude except for crossties, waist-band, armlets, and bracelets; these are indicated by incised lines, as are the creases at neck, knees, and belly, the pubic triangle with hair, stylized Bes tattoos on the thighs, and tattoos and dimples above the buttocks. Tufts

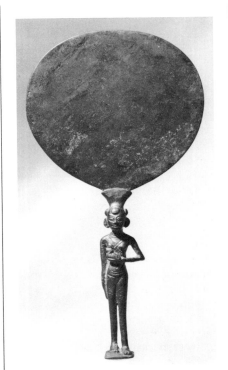

218

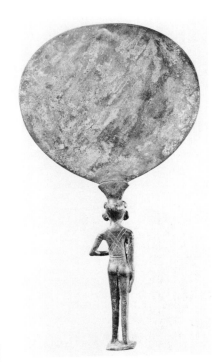

218

of hair protrude on the axial points of the head, these also being incised. The large pierced ears have the re-mains of one earring. The figure stands on a flat rectangular base, left leg advanced.

Although mirrors with youthful nude females are well known, only one with this particular handle type is known to

come from an excavated context.[1] This bronze example is dated only by the shape of the "capital" (cf. cat. 217) and the type of figure. The subject has Nubian characteristics, her tubular limbs, angular position of arms, and large ears contrasting markedly with the Egyptian features in cat. 215. The bird-carrying pose is sometimes found on young noblemen's daughters,[2] but such an attribution is impossible here. The identity of all such nude females on mirror handles is uncertain; their similarities to figures on other classes of objects and to objects from foreign cultures, as well as their relationship to other figurative mirror handles and to mirror iconography, have yet to be established.

C.L.

1. MacIver and Woolley 1911, pl. 62, right.
2. Evrard-Derriks 1972, p. 15.

Bibliography: Cooney 1960a, pp. 40, 42, 69; Fazzini 1975, no. 72.

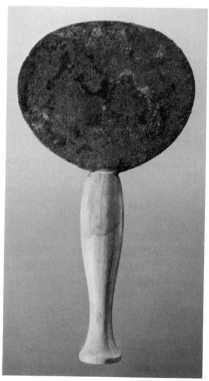

219

219

Mirror with club handle

Provenance not known
Probably Dynasty 19
Height 28.3 cm.; width of disk 14.2 cm.
Fitzwilliam Museum, Cambridge. Bequest of R. G. Gayer Anderson (EGA 4572.1943)

The slightly cordiform disk, undoubtedly with elongated tang, is fitted with a bone or ivory handle. The handle type is commonly identified with a hieroglyph recognized as a club, and pronounced "hem."[1] Since the Egyptian word for "servant" is expressed by this same hieroglyph, and is likewise pronounced "hem," it would seem that a mirror handle was thought to be the "servant" of the disk.

Club-shaped handles are known from the Middle Kingdom[2] and are commonly used in conjunction with Late Period disks inscribed with cult scenes and in Ptolemaic-Roman temple scenes where the king presents mirrors to a goddess.[3] Several mirrors with club handles are dated to Dynasty 18;[4] the Cambridge mirror is closest in shape and material to an example excavated by the Metropolitan Museum at Lisht[5] in a cache sealed with a scarab thought to name Tutankhamen.

C.L.

1. Griffith 1896, p. 17, no. 44; Borchardt 1899, p. 82.
2. Lilyquist 1979, fig. 73, pp. 62 n. 708, 144.
3. Cf. Munro 1969, passim; Husson 1977, passim.
4. Quibell 1908b, pl. 50; Vandier d'Abbadie 1972, no. 756, with rounded base.
5. Mace 1922, fig. 19.

Razors

For the ancient Egyptians, shaggy beards and overall hairiness were symptomatic of uncleanliness and neglect; the face, neck, limbs, armpits, chest, and pubic regions were regularly shaved. In the many representations of daily life that have survived in tomb paintings and reliefs people of hirsute appearance rarely occur and when they do, they are usually foreigners or belong to the lowest classes of society. Men and women of standing as a rule wore their natural hair close-cropped, attiring themselves with wigs on public occasions. With the infrequent exception of a thin mustache or short neatly trimmed beard, the men were clean shaven, facial stubble being allowed in public only in special circumstances such as at times of mourning. For reasons connected with ritual purity, shaving was even more strictly demanded of priests. From the earliest time it was required of certain categories that their heads be shaved completely bald, and this seems to have been an increasingly general practice from the New Kingdom on. In view of these conventions, it is not surprising that artisans with special tonsorial training and skills, the equivalent of modern-day barbers, played an important role in Egyptian society. Called chaku, a name derived from the verb chak ("to shave"), and meaning literally "shavers," they were attached to the permanent staff of royal and noble households, of temples, and also, it would seem, of the army. There were, in addition, practitioners of a more itinerant variety, who served the populace at large. It is, however, unlikely that people would always have found it necessary to have recourse to professional barbers. More probably, shaving and depilation of a routine, straightforward nature were carried out by individuals using their own personal implements. The well-to-do were fortunate to own razors, knives, and tweezers made of copper and bronze. The poorer, no doubt, made do with knives and scrapers of flint.

The razor has a long history in Egypt, metal implements that may be reasonably identified as razors occurring by the late Predynastic and Protodynastic Periods. There appear to have been two types: an asymmetrical variety with a single cutting edge at the side[1] and a symmetrical spatula-like type with parallel sides and rounded cutting edge.[2] Both forms had metal tangs extending from the center of the butt onto which handles of a different material were fitted. The asymmetrical type soon fell out of use, but the spatula type survived to become the predominant head and body razor of the Early Dynastic Period and Old Kingdom.[3] Though it differs widely from it in form, it is, in fact, the original ancestor of the curiously shaped New Kingdom razor (see cats. 220, 221, and 222). The evolution of the one from the other began toward the end of the Old Kingdom, with a change in the shape of the blade from one with parallel sides to one with splayed sides.[4] From this form, in turn, there emerged during the Middle Kingdom a variant with its cutting edge protruding laterally, effecting a change of axis between haft and edge, which is the crucial developmental link; the New Kingdom razor is essentially an elongation of this lateral protrusion coupled with a separate haft of wood or metal, which is now curved rather than straight.[5] It is thought that the spur at the rear had a practical function in the manipulation of the blade, but it would also have served as a useful counterweight to ensure a proper balance in the handling. The basic form and composition of this razor, with its convex cutting edge at the end of a hatchet-like blade, curved handle attached by rivets, and spur at the butt, appear to have remained more or less unchanged throughout the New Kingdom.[6] Unlike its earlier predecessors, however, which are well represented in barbers' scenes,[7] the exact mode of handling and method of working have not yet been established beyond doubt. The razor could probably be handled in more than one way, depending on tonsorial requirements. For the cutting of hair, to be effected by a sawing action, it has been suggested that the middle of the blade was held between thumb and finger with the little finger and third holding the spur and vibrating it to and fro.[8] For close shaving, requiring a firm scraping action, the handle might have been held with the motive force supplied by rotation of the wrist. Like the word for barber, the name for this razor was derived from the verb chak ("to shave"). Earlier forms were called

chaket[9] or *mechaket*,[10] the New Kingdom type, *mechak*.[11]

Egyptian toilette equipment seems always to have included more than one type of razor. In the Old Kingdom, in addition to the primary spatula type, there existed a rectangular implement of relatively thick section with one face entirely flat and the other beveled on the four sides.[12] Each of its four edges could be sharpened. Its form seems to have been derived from similarly shaped flint implements of the Early Dynastic Period, which are commonly referred to as "scrapers."[13] Its Egyptian name was *hesbet*[14] and it does not appear to have survived in any recognizable form beyond the Middle Kingdom. The major supplementary razor of the First Intermediate Period and Middle Kingdom was a flat four-sided implement with a slanting cutting edge that was pointed or squared at the top. A number of varieties are found—on some the cutting edge is straight; on others it is convex or even slightly concave.[15] By the end of the Middle Kingdom, the point at the top was replaced in one variety by a rounded protuberance,[16] which develops into a lateral cutting edge, the slanting edge underneath now reduced to an indentation or notch.[17] In this notched variety we recognize the immediate ancestor of the scalpel-like razor that was to become one of the most characteristic toilette implements of the New Kingdom (cat. 223). This was a multifunctional razor with a hooked cutting edge at one end and a sharp chisel-shaped butt at the other. There is no direct evidence as to how it was used, but it seems probable that it was intended for cutting and shaving of a kind requiring a little more delicacy and precision than could be readily achieved with the larger hafted *mechak* razor. That their functions were indeed distinct is strongly suggested by the fact that the two types are often found side by side as items in the same shaving equipment.[18] Cat. 223 has a form most typical of the first half of the Eighteenth Dynasty. Thereafter, somewhat fancier forms develop with markedly curved hooks at the top and with flared butts that become fully winged by the Ramesside Period.[19] The name of this razor and its earlier prototypes was *dega*.[20]

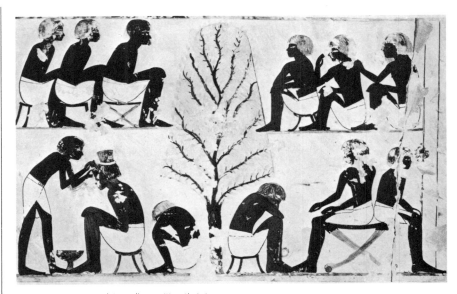

Fig. 49. Army recruits dejectedly awaiting their turn with the barber (from the tomb of Userhet, Theban tomb 56).

The remaining implements (e.g., cat. 224) represent a minor form of toilette knife or razor of the Eighteenth Dynasty, almost invariably with ornamented handles. Their small size and delicacy suggest that they were women's razors. Their chisel-like edge is very like that on the butt of the *dega* razor and it may be surmised that they performed a similar function.[21]

While there is some evidence that dry shaving was practiced by the Egyptians (the barbers in the scenes of the Old and Middle Kingdoms are shown with none of the accoutrements, in the form of ewers or basins, that one might have expected to be present if wet shaving were taking place), it seems unlikely that people of substantial means would have subjected themselves to regular shaving without finding some means to render it relatively painless. Since they lacked the equivalent of soap or a proper lathering substance,[22] they may have had recourse to oil or unguent to soften the skin and hairs of the areas to be shaved. Ewers for holding a liquid of some kind, possibly oil, are shown in a barber's scene of the Eighteenth Dynasty[23] (fig. 49).

As a precaution against sharp edges, as well as for simple convenience, razors were kept in containers when not in use. For this purpose, the well-to-do had special boxes (one such was found in Tutankhamen's tomb) with insides carefully designed to accommodate the various items of equipment.[24] More usually, razors were stored either collectively, sometimes with other toilet implements, in baskets or bags of leather or linen,[25] or individually, in simple sheaths made of bone or wood, which were often worked to the shape of the razor.[26]

W.V.D.

1. MacIver and Mace 1902, pp. 27, 40, pl. 12:9; Garstang 1903, pl. 16:14; Brunton 1927, p. 17, pls. 20:66, 22; cf. Baumgartel 1955, p. 16.
2. Brunton 1927, p. 17, pl. 20:67; Bonnet 1928, p. 48, pl. 32:5.
3. Petrie 1892a, pl. 15; Quibell 1913, pp. 33-34, figs. 14-15, pl. 21:65, 67; Hassan 1936, pl. 55:2; Junker 1944, p. 59, fig. 24, top middle; Hassan 1948, p. 43; Reisner 1955, p. 45, fig. 45, pl. 40a,c,d; Moussa and Altenmüller 1977, pl. 24, fig. 10; Simpson 1978, pl. 47d.
4. Newberry 1893b, pls. 4, 13; Chassinat and Palanque 1911, pl. 23:3; Petrie 1917b, pl. 61:21-22; Joseph Pilsudski University 1950, p. 192, pl. 21:2-3; Vandier d'Abbadie 1972, pp. 163-164, 735.
5. Garstang 1901, pl. 16 (E225, middle); Lacau 1904, pl. 41:217; MacIver and Woolley 1911, p. 161, pl. 63 (10325a); Petrie 1917b, pls. 60:25, 61:23-24; Brunton 1920, pl. 10; Jéquier 1921, p. 125; Engelbach 1923, pls. 15:9, 23:10; Reisner 1923a, pp. 180-183, pl. 49:2; Hayes 1953, p. 243, fig. 155.
6. Petrie 1891, pls. 18:44, 19:40; Garstang 1901, pl. 16; MacIver and Woolley 1911, p. 154, pl. 64; Petrie 1917b, pls. 60:80-81, 61:75-79; Schiaparelli 1927, p. 76, fig. 40; Brunton 1948, p. 70, pl. 49:7; Vandier d'Abbadie 1972, pp. 164, 737-741.
7. See Newberry 1893b and Moussa and Altenmüller 1977.
8. Petrie 1891, p. 50; for a possible representation of this process, see Wreszinski 1923, pl. 44, but for a different interpretation of the scene see Davies 1926, pp. 13-14, fig. 11.
9. Montet 1931, pp. 178-189.
10. Erman and Grapow 1928, pp. 133-138.
11. Ibid.; Janssen 1975, p. 299.
12. Davies 1977, p. 110 n. 29.
13. Peet 1914, p. 3, pl. 9:1; Garstang 1903, pl. 24, bottom right; Emery 1954, pp. 67-68, fig. 96, no. 6, pl. 34; Emery 1958, p. 85, pls. 101a, 125:9.

14. Davies 1977, p. 110 n. 30; probably Quibell 1913, p. 32, pl. 21:61.
15. Petrie 1900b, pl. 22, middle; Lacau 1904, pl. 41: 225; Petrie 1917b, pls. 60-64, 61:65; Brunton 1927, pl. 38:19; Brunton 1937, p. 108, pl. 61:11, 13; Brunton 1948, p. 52, pl. 35:20; Davies 1977, p. 110, pl. 17:2.
16. Brunton 1920, pl. 11:7; Engelbach 1923, pls. 15:8, 23:9.
17. Petrie 1901, p. 44, pls. 29, 32:31; Reisner 1923a, p. 184, pl. 49:1.
18. Garstang 1903, pl. 16; Schiaparelli 1927, p. 76, fig. 40; Hayes 1935, pp. 28-29, fig. 10; Davies 1977, pp. 107-111.
19. Petrie 1917b, pls. 62:23-24, 26, 63:46-47; Brunton and Engelbach 1927, pl. 53.
20. Davies 1977, pp. 107-111.
21. Petrie 1917b, pl. 61:66-67; Hayes 1959, pp. 268-269, fig. 164; Gout-Minault 1976, pp. 95, 97, fig.7; Velter and Lamotha 1978, pp. 26-27.
22. Assertions to the contrary based on the mistranslation of an Egyptian word (see Davies 1977, p. 110 n. 32).
23. Wreszinski 1923, pl. 44; Davies 1926, pp. 13-14, fig. 11.
24. Hayes 1953, pp. 243, 245, fig. 155; Davies 1977, p. 111, pl. 17:1.
25. Jéquier 1921, pp. 127-128; Schiaparelli 1927, p. 76, fig. 40, p. 105, fig. 78; Frankfort and Pendlebury 1933, p. 16 (26/391); Bruyère 1937b, pp. 72ff.; Hayes 1953, p. 64, fig. 33.
26. Petrie 1891, pl. 18:3; Borchardt 1905a, p. 79; MacIver and Woolley 1911, p. 63 (10310); Wreszinski 1923, pl. 44; Reisner 1923b, pl. 49:2; Schiaparelli 1927, p. 105, fig. 79; Brunton 1948, pl. 43:41.

Literature: Kaplony 1975, cols. 617-619; Monica 1975, pp. 121-122; Lloyd 1976, pp. 152-154, 165-166; Müller 1977, col. 924; Weeks 1979, pp. 130-133.

220

220

Razor

From Amarna
Late Dynasty 18
Length 16.5 cm.
Royal Ontario Museum, Toronto.
Gift of the Egypt Exploration
Society (929.52.13)

The two-piece bronze razor has a large quinquelateral blade of thin metal with a narrow handle extending down from the point of juncture of the lower sides. The blade, in front of the handle, has near-symmetrical, slightly incurved sides and a moderately convex cutting edge. The shorter rear end is in the form of a bilateral spur, which curves upward away from the handle, its longer lower side convex, its upper concave. The tip is rounded. In hafting, the blade was inserted in a split in the handle and the attachment secured by two metal rivets. The handle, cylindrical in section with a rounded knob at the end, curves quite sharply toward the razor's cutting end. Two similar razors were found at Amarna.[1] W.V.D.

1. Frankfort and Pendlebury 1933, pl. 34:1.

Bibliography: Frankfort and Pendlebury 1933, p. 35 (29/254).

221

221

Razor

Provenance not known
New Kingdom
Length 18.1 cm.; width 5.2 cm.
Fitzwilliam Museum, Cambridge.
Gift of E. Towry Whyte (E. 152.1932).
Formerly in the Forman Collection

The thick wooden handle curves only very slightly toward the cutting end; its stem tapers a little from top to bottom and terminates in a large rounded knob. It is decorated with a pattern of wavy striations that spiral around the haft and are bordered at top and bottom by concentric bands.

W.V.D.

Bibliography: Sotheby 1899, lot 194.

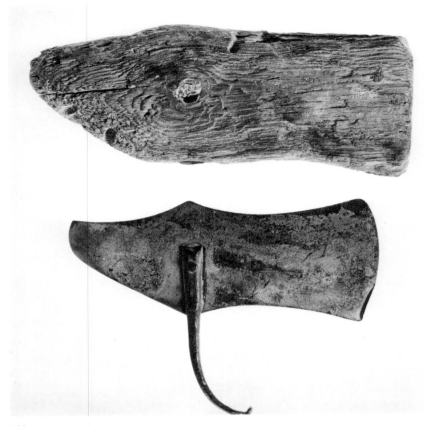

222

223

Razor

From Semna tomb S704
Dynasty 18
Length 10.1 cm.; width 2.75 cm.
Museum of Fine Arts. Harvard
University—Museum of Fine Arts
Expedition (24.1787)

The razor, probably bronze, has a flat
slender shaft with a sharp flared con-
vex butt, narrow neck, and asym-
metrical head so shaped and worked
as to form on one side a slanting, out-
ward curving cutting edge. This edge
curves back sharply into the neck to
create a hook at its lower end and is
also turned over a little at the top.

W.V.D.

Bibliography: Dunham and Janssen 1960, p. 106,
pl. 130a (bottom, second from left).

224

Razor

Provenance not known
Probably Dynasty 18
Height 9.4 cm.; width 2.7 cm.
University College, London. Petrie
Museum (30135)

This bronze razor or toilette knife has
a flat crescentic head and decorative
handle in the form of an ape standing
on a pillar. The ape wears a collar and
belt and holds a bunch of *dom*-palm
nuts;[1] his facial features — nostrils,
mouth, eyes, and ear — together with
the ruff under his neck are neatly
modeled and tooled, and the hair of
his body is indicated by a series of
lightly punched indentations. Despite
the decoration, there is no doubt that
the piece was designed to be func-
tional, since the head was hammered
thin and then lightly ground to form
a sharp edge. X-ray fluorescence
spectrometry has determined the
bronze to be constituted of copper
with approximately ten percent tin
and three percent lead.

W.V.D.

1. Keimer 1938a, pp. 42-45; Vandier d'Abbadie
1966, pp. 194-198.

223

222

Razor

Provenance not known
New Kingdom
Length 12.7 cm.; width 4.7 cm.
The Oriental Institute, The University
of Chicago (1058/2)

This razor, probably of bronze, has a
less elongated blade than those of
cats. 220 and 221. The metal handle
tapers markedly from top to bottom,
its lower half sharply curved; there is
no terminal knob. The razor is accom-
panied by a crude wooden sheath,
roughly shaped to accommodate the
body of the razor while allowing the
handle to protrude.

W.V.D.

Bibliography: Hughes 1959, p. 174, fig. 7.

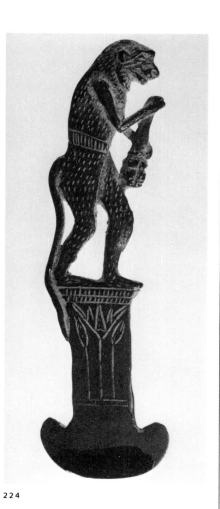

224

Toilette Implements

"Scissors,"[1] "tweezer-razors," and "hair-curlers"[2] are among the many names variously ascribed to implements of this type. Each consists of two metal elements pegged together with a pin. One element is straight: on one end, the working end, there is a narrow slot, while the opposite end, the handle, tapers to a sharp point. As the working end of the second element, there is a flat blade that fits into the slot of the first element. Its opposite end is angled slightly upward from the hinged joint. This angled portion may be shaped as a knife (cat. 225) or a razor,[3] or it may be a purely decorative handle taking the form of a human or animal figure (cats. 226 and 227). The decorative and functional aspects of the handle may be combined as in cat. 226, where the tail of a cheetah fans out into a flower, with the edge of the flower being used as a razor.

These curious implements, in all likelihood, served a multiplicity of purposes. It has been suggested that they were used mainly as hair curlers. One possibility would be to heat the working ends slightly and then wind hair from a wig or beard tightly around both elements.[4] The two ends would then be spread apart by forcing the opposite ends together and the curl would be set in that manner.[5] Another possibility would be to wind the hair around the blade end only and then force blade and hair into the slot. However, if that was how it was used it would have been possible to curl only a small amount of hair at once, since blade and slot fit together rather snugly. Needless to say, this would have been an awkward way to curl one's hair, especially in the examples where the "handle" of the second element is actually a razor. If the objects are hair curlers, they must have functioned without heat since none appear to have been subjected to flame. It is possible that they were used as eyelash or beard curlers; such a tool is effective for crimping a small amount of hair, even if not heated. However, one problem with this theory is that the instruments are relatively common, whereas beards were rarely grown, and there is nothing in any of the paintings, reliefs, or statues to suggest that the Egyptians ever curled their eyelashes. Nevertheless, some sort of cosmetic

function must be attributed to such pieces because they are often found together with toilette articles like razors, whetstones, and tweezers.[6] They are also suitable for hair removal, although the Egyptians had several types of tweezers that fulfilled that function admirably (see cat. 228).

Paradoxically, although these instruments were obviously used for several purposes, we can be certain of only one: their use as razors. We do know that they were popular from the end of the Old Kingdom until the Late Period,[7] and that their form changed somewhat. The pointed end was often longer than the handle during the Middle Kingdom, while in the New Kingdom it is frequently the same length or shorter[8] and the handles are usually decorated.

R.E.F.

1. Reisner 1923b, p. 184.
2. Hayes 1959, pp. 21-22.
3. Garstang 1901, pl. 16.
4. Petrie 1917b, p. 49.
5. Ibid.
6. Hayes 1935, fig. 10; Garstang 1901, pl. 16; Schiaparelli 1927, fig. 41.
7. Petrie 1917b, p. 49.
8. Reisner 1923b, p. 185.

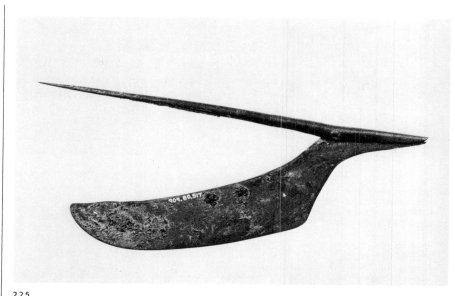

225

225

Toilette implement with blade handle
Provenance not known
Dynasty 18-19
Length 12.7 cm.
Royal Ontario Museum, Toronto
(909.80.517)

The broad, flat end of this two-part copper instrument slightly concave on the inner surface, is clearly a knife and may have been used to cut hair either on the face or on the scalp. The other end of the same piece tapers to a flat point that fits into the narrow trough on the corresponding end of the second piece. The latter tapers at its other end to a sharp point slightly longer than the blade; the point might have been used as an aid in arranging hair on a wig. The two elements are hinged together with a pin placed about a quarter of the distance down their length.

The earliest occurrence of the blade and trough implement with the large knife is at Kerma and thus is datable

to the late Second Intermediate Period or the early New Kingdom.[1] In Egypt these implements are first found in slightly later tombs, datable to the first half of the Eighteenth Dynasty.[2]

A close parallel to the Toronto specimen comes from an Eighteenth- or Nineteenth-Dynasty context at Gurob.[3] A second example from the same site, datable to the reign of Seti II, is smaller and has shorter blades.[4]

R.E.F.

1. Reisner 1923b, pl. 49.
2. Garstang 1901, pls. 16, 18.
3. Petrie 1890, pl. 17:43.
4. Petrie 1891, pl. 19:33.

226

226

Toilette implement with feline
Provenance not known
Dynasty 18
Length 9.8 cm.; width 2.8 cm.
University College, London. Petrie Museum (30134)

The identification of the sleek animal on the handle as a leopard or cheetah is based mainly on the overall stippling of the body and the exaggerated slimness of the torso and legs. Leopards differ from cheetahs in having retractable claws, a detail impossible to ascertain in view of the scale of this representation. As leopards and cheetahs were extinct in Egypt by the New Kingdom,[1] they had to be imported from Africa for use in hunting.[2]

A lotus flower with stylized tendrils extends back as a continuation of the legs. The tip of the flower has a sharpened edge and acted as a razor (see cat. 223). An extension at the front legs fits into the trough formed by one end of a piece of metal hinged to the animal by a bronze rivet.

R.E.F.

1. Edwards 1976a, p. 112.
2. Porter and Moss 1960, p. 468, 19c.

Bibliography: Petrie 1917b, p. 49, pl. 61:15.

227

227

Toilette implement in the shape of a horse

Provenance not known
Dynasty 18, reign of Thutmose IV or
Amenhotep III
Length 5.3 cm.; width 3.1 cm.
University College, London. Petrie
Museum (26935)

A horse in flying gallop with legs fully extended (see also cat. 236) forms the handle of this copper toilette implement. The forelegs of the animal taper to a thin blade that fits into the trough formed by a second piece of metal hinged to the horse at the juncture of foreleg and torso. This second piece originally tapered to a narrow point, as in cat. 226. A circular disk surmounted by three plumes forms the headgear. Trappings and details of the torso are indicated by incised lines and dots.

Although horses are represented on these toilette objects with some frequency, most of the examples are without context. An example of a toilette implement with a horse-shaped handle was found in the tomb of the architect Kha, who served Amenhotep II, Thutmose IV, and Amenhotep III.[1] This example stands apart from the other specimens in the amount of incised detail shown. That a royal horse is represented is clear from the plumes on the head.[2] The closest parallel is the horses represented on the chariot of Thutmose IV in Cairo,[3] where the horizontally striated plumes emerge directly from a single large disk and bend slightly backward at the tip as they do on the toilette implement. Later examples show a different treatment of the headgear, which usually consists of a series of disks set in a matrix and feathers bent throughout their length, not only at the tip.[4] The combination herringbone and linear patterning of the tail, the tufts of hair on the legs,

and the shape and decorative motif on the blanket are directly comparable with the horses on the chariot. While the diamond motif on the legs does not appear on the chariot horse of Thutmose IV as it does on the toilette implement, it does occur on the hind leg of the griffin on the inside of the chariot.[5]

R.E.F.

1. Schiaparelli 1927, p. 77, fig. 41.
2. Schulman 1957, p. 263.
3. Wreszinski 1935, pl. 1.
4. Ibid., pl. 47; Edwards 1972, no. 23; Aldred 1973, no. 143.
5. Wreszinski 1935, pl. 3.

228

Tweezers

From Abydos tomb D116
Mid-Dynasty 18
Length 8 cm.
Museum of Fine Arts. Gift of the Egypt
Exploration Fund (01.7317)

The Egyptians made tweezers with both blunt and sharp ends, which suggests a differing function for each type. It may be that the first variety was for pulling hair and the second for extracting thorns.[1] This bronze example has a blunt-end and, in addition, a pinched top. Although tweezers are found as early as the First Dynasty,[2] the pinched-top variety seems to begin only in the Eighteenth Dynasty.[3]

R.E.F.

1. Petrie 1917b, p. 51.
2. Ibid.
3. Reisner 1923b, p. 186.

Bibliography: MacIver and Mace 1902, p. 88, pl. 46.

228

Wigs and Hair Accessories

From the evidence of sculpture relief and painting, the ancient Egyptians wore wigs for festive occasions as well as for ordinary daily activities. It is likely that every Egyptian nobleman and noblewoman owned at least one, and wigs are often included in tombs as part of the equipment for a successful afterlife. Analysis shows that in the New Kingdom human hair rather than animal hair or fiber was used,[1] for example, in an Eighteenth-Dynasty woman's wig found in a tomb at Thebes and now in the British Museum[2] (fig. 50). The top of the wig is composed of a mass of brown curls, each about a half inch in diameter. Around the bottom of the wig and extending from ear to ear are several hundred tightly braided strands about fifteen inches long.

Fig. 50. An Eighteenth-Dynasty woman's wig showing the net foundation, tight curls, and long braided strands (British Museum 2560).

To make the wig, a foundation of tightly plaited hair was woven into a mesh with rhomboidal openings. About 300 individual strands of hair were used for the wig, with each strand consisting of about 400 hairs. Each strand was anchored by first dipping it into a mixture of warm beeswax and resin, and then looping it over the mesh matrix. Then a bit of the strand was sectioned off and used to wrap around the looped-over area. The hardened wax served as a glue and held the curls in place.

Scenes of hairdressing first appear in the First Intermediate Period on coffins and stelae,[3] although the office of hairdresser is known through inscriptional evidence as early as the Old Kingdom.[4] At that time, the hairdresser was a person of importance and might have fulfilled a ritual function as well.[5] Representations of hairdressing invariably show the attendant (neshet) as a woman in the Middle Kingdom and New Kingdom, although in the Old Kingdom similar positions were filled by men.[6] Typically, the hairdresser sits or stands behind the person whose hair she is fixing.[7] The latter frequently holds a mirror or a lotus flower. In a scene from the tomb of Neferrenpet the hairdresser may be using a comb[8] and, if so, this is the only instance where a comb is represented.

On a satirical papyrus of Dynasty 20 in Cairo, a mouse wears a wig similar to the example described above (fig. 51), while a cat serves as her hairdresser. The feline attendant has a switch of hair fastened to her head by means of a hairpin, which was also used to arrange the curls on wigs.[9]

Fig. 51. A cat plays hairdresser to a mouse, from a satirical papyrus of the Twentieth Dynasty (in the Cairo Museum).

Switches of hair were added to wigs or to natural hair to add fullness or, in the case of an early Eighteenth-Dynasty queen, to conceal a bald patch at the top of her head[10] An entire basket of switches was found in the tomb of Queen Meryetamen.[11] Hairpieces were included in burials dating back to predynastic times.[12]

One can imagine that wigs and hairpieces were made in a studio such as the one recently excavated at Deir el Bahri, where wigs in all stages of production, as well as an awl, bone hairpins, and a wooden model head were found. Such discoveries offer a rare

insight into what must have been an important ancient Egyptian industry.[13] (For a dscussion of specific wig types, see cats. 196, 197, and 198.)

R.E.F.

1. Lucas 1930, p. 196; Eisa 1948.
2. Cox 1977, pp. 67ff.
3. Gauthier-Laurent 1935-1938, p. 673.
4. Riefstahl 1952a, pp. 11-12.
5. Ibid.
6. Ibid., p. 14.
7. Gauthier-Laurent 1935-1938, p. 688.
8. Ibid., pp. 682-683, fig. 7.
9. Laskowska-Kusztal 1978, p. 116; Gauthier-Laurent 1935-1938, p. 689, fig. 9.
10. Smith and Dawson 1924, p. 90.
11. Winlock 1932b, p. 9, pls. 13, 33.
12. Lucas 1962, p. 31.
13. Laskowska-Kusztal 1978, pp. 84ff.

Literature: Haynes 1977, pp. 18ff.

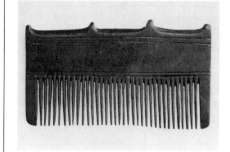

229

229
Comb

Provenance not known
Dynasty 18
Length 8.2 cm. width 4.7 cm.
Museum of Fine Arts. Hay Collection, Gift of C. Granville Way (72.4341)

The teeth of this flat rectangular wooden comb are evenly spaced and of equal width, except for the two outermost, which are thicker, as in modern combs. Four trapezoidal tangs project from the top. Two parallel incised lines set off the teeth and another two are engraved beneath the tangs.

Four-tanged combs with proportions similar to the present example have been found in both Egypt and Nubia in tombs datable to the Eighteenth Dynasty.[1] Frequently combs are found in baskets that also contain other cosmetic articles such as kohl pots, ointment jars, or hairpins.[2] At Deir el Medineh, all the combs were found in tombs of women.[3] Wood is the most common material, although ivory examples are also known.[4] While most combs are flat, occasional examples are curved, suggesting that they may have been used as hair ornaments as well.

R.E.F.

1. Petrie and Brunton 1924, pls. 42, 55, 63; Schiaparelli 1927, p. 109, fig. 89; Bourriau and Millard 1971, pl. 18:2.
2. Petrie and Brunton 1924, pls. 42, 55; Carnarvon and Carter 1912, pl. 70:2.
3. Bruyère 1937b, p. 80.
4. Ibid.

230
Comb with ibex

Provenance not known
Dynasty 19 or 20
Height 6.3 cm.; width 5.6 cm.
Musée du Louvre, Paris (N. 1359).
Formerly in the Salt Collection

Combs were decorated with figures of ibexes as early as predynastic times.[1] However, the crouching ibex, on combs and otherwise, appears first in the Eighteenth Dynasty.[2] In spite of the small size of this acacia-wood comb, anatomical details like the striations on the horns or the structure of the legs are carefully indicated. With its head resting on bent leg and with hind quarters raised, the figure of the ibex just fills the available space. The same sensitivity to design is evident in the depiction of a horse on a comb from Gurob, found in a tomb containing objects dated to the reign of Ramesses II.[3]

Fragments of ibex combs were found at Deir el Medineh in pits containing dated material from the Nineteenth and Twentieth Dynasties.[4] Both the position of the animals and the rendering of their bodies are comparable to the Louvre comb. Found with the Deir el Medineh pieces were combs with depictions of feeding horses similar to the Gurob example mentioned above.

While the vast majority of New Kingdom combs have teeth that form a straight edge, this example has a convex outline.[5]

R.E.F.

1. Asselberghs 1961, pl. 47, fig. 72.
2. Cooney 1974, no. 190.
3. Petrie 1891, pl. 18.
4. Bruyère 1953, pp. 28-59, 65-66, fig. 15.
5. See Schäfer and Andrae 1925, pl. 407, for a comb with a double convex outline.

Bibliography: Bénédite 1924, pl. 35; Boreux 1932, p. 608, pl. 76; Daumas 1965, pl. 235; Vandier d'Abbadie 1972, p. 141, no. 598.

230

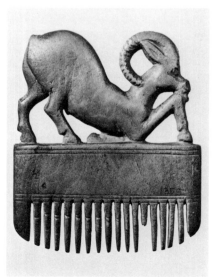

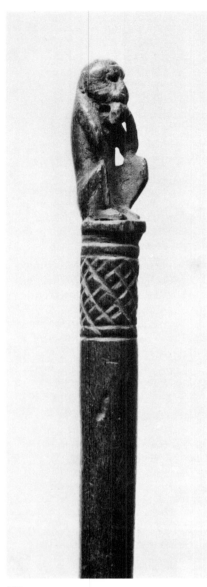

232

Although monkeys are represented in Egyptian art throughout, they achieve their greatest popularity in the Eighteenth and Nineteenth Dynasties.[1] More than a dozen statuettes of monkeys were found at Amarna,[2] of which a number assume the same crouching position and nibble on food[3] as on the one on the Louvre hairpin.

The crosshatching bordered by incised lines on the upper area of the pin is another feature that suggests a late Eighteenth-Dynasty date for this piece. A similar decoration was found on hairpins from the tomb of Toutiy at Gurob, dated to the reign of Amenhotep III[4] and in Eighteenth-Dynasty contexts at Lahun,[5] Sedment,[6] and Deir el Medineh.[7]

R.E.F.

1. Vandier d'Abbadie 1966, pp. 143ff.
2. Samson 1972, p. 37.
3. Frankfort and Pendlebury 1933, pl. 31; Samson 1972, p. 39, fig. 17.
4. Chassinat 1901, p. 232, fig. 3.
5. Petrie 1927, p. 25.
6. Petrie and Brunton 1924, pl. 61:69.
7. Letellier 1978, no. 55.

Bibliography: Vandier d'Abbadie 1972, p. 149, no. 633.

231

231
Hairpin with monkey
Provenance not known
Late Dynasty 18
Length 17.8 cm.
Musée du Louvre, Paris (N. 1715).
Formerly in the Drovetti Collection

A crouching monkey with his elbows on his knees eagerly clasps a nut or fruit to his mouth on the top of this wooden hairpin (see also cats. 196 and 380). His tail extends down the length of the shank. On the upper part of the pin is a design of crosshatched lines bordered on either side by two parallel horizontal lines.

The Egyptians decorated hairpins with figures of animals in predynastic and early dynastic times, and then not again until the Eighteenth Dynasty.

232
Hairpin with suckling calf
Provenance not known
New Kingdom
Length 14.3 cm.
Fitzwilliam Museum, Cambridge. Bequest of R. G. Gayer Anderson (EGA 125.1949)

In only one centimeter of space, an ibex turns her head with motherly concern to observe her feeding calf. The ebony composition rests on the top of a papyriform capital that forms the head of the hairpin; the shaft is made of ivory.

The suckling motif appears frequently in tomb scenes from the Old Kingdom on and recurs in New Kingdom tombs.[1] It was also used as a hieroglyph,[2] and in the ancient Near East it was popularized in ivory.[3] The combination of ivory and ebony is seen on another hairpin found in an Eighteenth-Dynasty context at Gurob.[4]

R.E.F.

1. Vandier 1969, figs. 126, 137.
2. Gardiner 1957, p. 458.
3. Decamps de Mertzenfeld 1954, pls. 90-92.
4. Petrie 1927, p. 24, pl. 19:8.

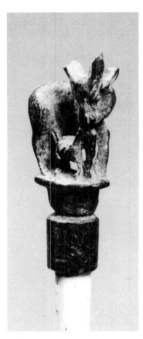

232

Cosmetic Arts

Vanity, health, religion, and magic together account for the importance of the cosmetic arts in ancient Egypt. The Egyptians had remedies for dandruff, gray hair, baldness, unwanted hair, unpleasant body odor, and skin problems.[1] A sure-fire cure for wrinkles was a ground-up mixture of frankincense, wax, fresh balanites oil, and rush nut mixed in viscous fluid and applied to the face every day, but if that did not work, a number of other potions were available.[2]

Cleanliness was important to the Egyptians and they bathed often.[3] Indeed, priests were required to wash three times daily.[4] In the absence of soap, animal or vegetable oils mixed with powdered limestone served as cleansers.[5]

Under the hot Egyptian sun oils were needed to keep the skin from drying and cracking.[6] Unguents, known in as many as thirty different varieties, were rubbed on the body as a basic part of the daily toilette of all classes.[7] The rich imported oils from the Levant and scented them with costly myrrh or frankincense from Africa, resins, or fragrant flowers;[8] castor bean oil was affordable to those of more modest means.[9] In fact, oil was so important to the Egyptians that necropolis workmen at Deir el Medineh went on strike in part for lack of it.[10]

To counteract the drying effect of the sun on hair, it was treated with a moisturizing cream placed in a lump on top of the head (see fig. 52; modern Nubian tribesmen anoint their hair with oil or fat for the same reason[11]). Called *bit* by the Egyptians,[12] this "cosmetic cone" was made of tallow impregnated with myrrh.[13] A popular embellishment of the New Kingdom and later, it frequently adorns the wigs of both men and women, and it is portrayed in painting, relief, and sculpture.[14] It was certainly not restricted to nobility, as scenes from the Theban tombs show. At banquets, for instance, it is worn not only by the guests but by musicians and servants as well.[15]

Early in the Eighteenth Dynasty (Amenhotep I to Thutmose III) it takes the form of a low semicircular lump,[16] often with a bumpy outline.[17] During the reign of Thutmose IV the mass becomes larger and higher[18] and by the next reign assumes a tall conical

Fig. 52. A maidservant adds more scented fat to the cosmetic cone of her mistress (from Theban tomb 181).

shape.[19] The cone is most often whitish with streaks of orange brown running down from the top, and this brown may represent the fragrant substance with which, according to literary sources, the animal fat was impregnated.[20] The streaky yellow or orange color seen on garments in tomb paintings may represent runoff from the cosmetic cone when it melted.[21] Eyes were painted as early as predynastic times, and the custom continued throughout Egyptian history.[22]

To color their cheeks the Egyptians used red ocher, a naturally occurring iron oxide, in a base of animal or vegetable fat and gum resin.[23] In the Middle Kingdom rouge pots were sometimes included with jars of kohl in cosmetic kits.[24] Actual remains of the cosmetic are known from the New Kingdom: little pieces of rouge were reportedly found in a Nineteenth-Dynasty tomb at Sedment,[25] and red ocher was found near a palette in a tomb in Nubia that may date from the late New Kingdom.[26] In a unique representation of the subject[27] a woman on a stela fragment of the Eleventh Dynasty applies what would appear to be rouge to her face with a pad. While tomb representations of Nefertari, the wife of Ramesses II, show a reddish tint on her cheeks, the presence of the same coloring on her nose, chin, neck, and

arms[28] suggests that this was only a convention employed by the artist to highlight those areas rather than a representation of rouge.

Red ocher in an oil or fat base may have been used for lipstick as well as for rouge.[29] The main evidence for the use of lipstick in the New Kingdom comes from a drawing in an erotic papyrus (fig. 53). In one hand a jewel-bedecked woman poises a brush or tiny spatula in front of her lips, while in the other she holds a mirror to view the procedure.[30] Red color was applied to the lip area on the linen wrappings of a female mummy of the Old Kingdom,[31] and the title "painter of her mouth" is known in a Middle Kingdom context.[32]

Fig. 53. A woman appears to apply color to her lips as she glances at her reflection in a mirror; in the hand with the mirror she also holds a cosmetic container (Turin 55001).

Henna, another red pigment, is thought to have been found on the palms, soles, nails, and hair of mummies,[33] although other opinion has it that the red coloring may be only a discoloration caused by the embalming material.[34] A tomb at Gurna that may date as early as Dynasty 20 contained flowers and twigs of the henna plant.[35] In any case, the copper-red color of the hair of Henut-ta-mehu, a woman of the Eighteenth Dynasty, certainly resulted from a henna dye[36] and several Old Kingdom statues have a reddish coloring on the fingernails and toenails that may well represent henna.[37] The colorant was applied as a paste made from the leaves and root of the henna plant (*Lawsonia alba* or *Lawsonia inermis*).

Tattooing, a permanent form of personal adornment, may date back as far as predynastic times, although the earliest indisputable evidence we have for that practice dates to the Middle Kingdom. Mummies of dancers and royal concubines of the Eleventh Dynasty had geometric designs tattooed on their chests, shoulders, arms, abdomens, and thighs.[38] Men had themselves decorated as well, although not as extensively.[39] In the New Kingdom dancers, musicians, and servant girls occasionally had a tiny representation of the Bes-image (see p. 307) tattooed on the upper part of each thigh (cat. 143), an enlistment of his protection and good graces, as well as a seductive charm. A painting of one such dancer-musician decorated the wall of a house at Deir el Medineh[40] and another musician reclines on a cushion on the bottom of a drinking bowl (cat. 143).

R.E.F.

1. Deines et al. 1958, pp. 296-304.
2. Ebbell 1937, pp. 101-102.
3. Herodotus II, 37: Godley 1921, p. 319.
4. Caminos 1954, p. 51.
5. Winlock 1948, p. 53.
6. Brooklyn Museum 1943, p. 2.
7. Forbes 1954, p. 287.
8. Brooklyn Museum 1943, p. 2; Forbes 1954, p. 289.
9. Strabo XVII: 2, 5: Jones 1932, pp. 151-152.
10. Hughes 1959, p. 165.
11. Keimer 1953, p. 343; Hoskins 1835, p. 184.
12. Keimer 1953, p. 372.
13. Faulkner 1936, p. 131; Hamada 1938, pp. 223, 228-229; Caminos 1954, pp. 334, 345; Simpson et al. 1973, p. 307.
14. For a rare example of a cosmetic cone in a sculpture, see Musées Royaux 1934, pl. 54.
15. Davies and Gardiner 1936, pls. 36, 37, 70.
16. Boussac 1896, pl. [5].
17. Davies and Gardiner 1936, pl. 26.
18. Ibid., pl. 37.
19. Ibid., pl. 61.
20. Faulkner 1936, p. 131; Simpson et al. 1973, p. 307.
21. Keimer 1953, p. 367; see also Psalm 133:2.
22. For a discussion of substances used to enhance the beauty of the eye, see pp. 216-217.
23. Winlock 1934, p. 67.
24. Ibid., p. 69; Hayes 1953, pp. 242-243, fig. 155.
25. Petrie and Brunton 1924, p. 32.
26. Firth 1927, p. 157.
27. Edwards 1937, p. 165, pl. 20.
28. Thausing and Goedicke 1971, figs. 30, 32, 46, 137.
29. Lucas 1962, p. 84.
30. Omlin 1973, pl. 13; for a dissenting view, see Fischer 1976, p. 78 n. 61.
31. Smith 1949, p. 24 n. 6.
32. Posener 1969, pp. 150-151.
33. Lucas 1962, p. 310.
34. Smith 1912, p. 61.
35. Keimer 1924, p. 52.
36. Smith 1912, p. 19.
37. Borchardt 1897, pp. 168-170.
38. Keimer 1948a, pp. 1-6, 13-15.
39. Lange and Schäfer 1902, pls. 12:20138 and 86:465.
40. Vandier d'Abbadie 1938, pp. 27-28, fig. 1.

Literature: Capart 1907.

Boxes

Judging from the contents of their small boxes, the ancient Egyptians appear to have been collectors of both trash and treasure. Boxes have been found to contain everything from cosmetic unguents (see cat. 236) and jewelry,[1] to objects with a significance quite indiscernible today, like the two balls of hair wrapped in linen found in an alabaster casket in Tutankhamen's tomb.[2] Others, such as the box belonging to Senenmut's sister (see cat. 233), held personal memorabilia, i.e., a drop-shaped ornament of faience, a lump of bright blue pigment, a chunk of rock salt, and five purple berries.[3]

The rectangular box with flat sliding lid was the most popular type of small casket in ancient Egypt. It functioned primarily as a jewelry box[4] but seems occasionally to have held a solid form of cosmetic or fragrance as well.[5] This simple yet ingenious way of constructing a closed container was devised in predynastic times[6] and used into the Late Period.[7]

A slightly different type of rectangular box had a gabled lid. To open it, one side was swung out from the top. Larger versions of the gabled lid type were used at least as early as the Old Kingdom.[8] In at least one instance the sliding lid type and the gabled lid type were whimsically combined in the same piece (cat. 235). Boxes with arched lids are also known.[9] Rectangular boxes were most often made of an inexpensive wood such as cypress but often inlaid with costlier woods or ivory (cats. 233 and 234) with their component pieces held together by simple miter joints (cat. 234), butt joints, and dowels (cat. 235). Less often stone was used for rectangular boxes.

Zoomorphic boxes are also known, like the delicate gazelle in fig. 54[10] or a grasshopper box (fig. 55) turned up by Cecil Firth's dog when playing in the sand at Saqqara.[11] Both probably contained scented unguent.

Cylindrical wooden caskets seem to have been used mainly to hold cosmetic unguents in the New Kingdom (cat. 236). Many are subdivided into tiny compartments. The origin of the shape is to be found in stone and ivory vessels of the Middle Kingdom.[12]

The Egyptians used a simple yet effective method to close and lock their boxes. A cord was wound alternately around a knob projecting from the body of the box and from a corresponding place in the lid. A dab of wet clay embossed with the owner's mark completed the seal.

R.E.F.

1. Carnarvon and Carter 1912, pp. 64, 80, pl. 69.
2. Edwards 1972, no. 5.
3. Hayes 1959, p. 196, fig. 111.
4. Carnarvon and Carter 1912, pp. 64, 80, pl. 69; Williams 1924, pp. 212-213, pls. 11, 33.
5. Petrie 1909b, p. 7, pl. 26.
6. Petrie 1914b, p. 9, pl. 3.
7. Petrie 1927, p. 36, pl. 33.
8. Baker 1966, p. 58, fig. 57.
9. Edwards 1976a, no. 9.
10. Maspero 1912, p. 200, fig. 385; cf. Prisse d'Avennes 1847, pl. 50.
11. Keimer 1932, pp. 129ff. The grasshopper has been thought to date to the Old Kingdom because of its findspot between the Sixth-Dynasty pyramids of Queens Khuit and Iput, but a parallel in the Brooklyn Museum, from the collection of Howard Carter, is believed to have been found in an important tomb of Dynasty 18 at Thebes. On that basis the Cairo example can be assigned to the New Kingdom.
12. Garstang 1901, pl. 14:3; Downes 1974, p. 7, fig. 73.

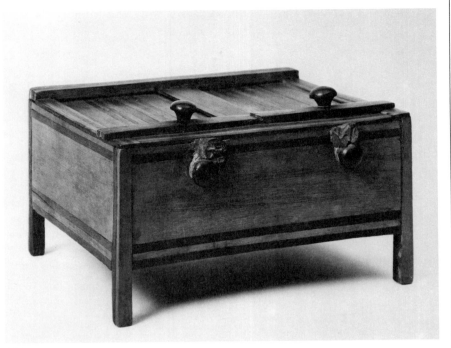

233

Fig. 54. The horns of this wooden gazelle box, probably made of a different material, are now missing; in their absence the identification of the animal is based on the facial markings. Its unusual position, with the left hind leg tucked under the body and forelegs bent back on each side is seen also in a pottery flask in the form of an ibex (cat. 89) (Cairo JE 44744).

Fig. 55. The striated outer wings of this grasshopper cosmetic box pivot outward on a peg at the base of the neck to reveal a hollow cavity running the length of the insect's body (Cairo JE 56931).

233
Trinket box
Provenance not known
Dynasty 18
Height 8.5 cm.; length 16 cm.
Royal Ontario Museum, Toronto (931.55)

Three different kinds of wood were used in the construction of this double box, which was probably intended to hold cosmetics or small trinkets. The body is of cypress wood, the inlaid strips are boxwood, and the four knobs used to secure the lids are ebony. When open, the lids slide beneath the crosspiece at the back. To hold them in place, a dab of wet clay was used to fasten a cord wound alternately around the knobs. On the clay was impressed the owner's scarab seal, which shows a standing man who grasps what is either a branch or a crocodile in each hand.[1] A scarab with a similar motif was found at Tell el Yahudiyeh.[2]

While compartmented boxes with two sliding lids are known to have existed in the Middle Kingdom, the compartments were either perpendicular to one another[3] or arranged end to end.[4] The parallel arrangement seems to have become fairly common in the New Kingdom (see cat. 235). A box similar to this one, although made entirely of cypress rather than a combination of woods, was found at Thebes and may have belonged to Senenmut's sister (see p. 200). The combination of three woods in the same box is not unique. Renefer, who lived in Thebes around the time of Hatshepsut, owned a casket made of tamarisk, cypress, and boxwood.[5]

R.E.F.

1. Cf. Petrie 1925, p. 26, pl. 14:962.
2. Ibid., p. 26, pl. 19:1561.
3. Winlock 1926, p. 5, fig. 1.
4. Lansing 1920b, p. 16, fig. 6.
5. Hayes 1935, p. 29, fig. 12.

Bibliography: Needler 1967, pp. 146, 148, fig. 4.

234
Box with sliding lid
Provenance not known
Dynasty 18
Length 20.4 cm.; width 10.2 cm.
Museum of Fine Arts (1981.282)

This wooden box is handsomely inlaid with alternating ebony and ivory squares in a checkerboard pattern. The lid slides into a groove beneath the rim of the box and was secured by a cord wound alternately around the knob on the lid and a second knob (restored) on the side of the coffer. The joints are of the simple miter type.

The present example of this popular type of box is datable to the Eighteenth Dynasty chiefly on the basis of the checkerboard pattern of inlays, which is also found on a box from a Sedment tomb datable to the

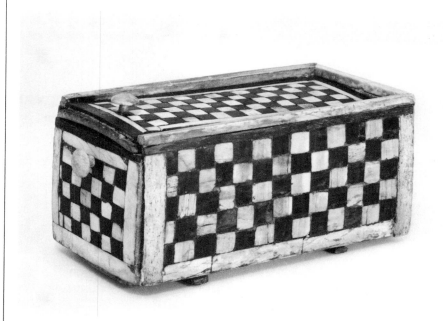

234

end of the reign of Thutmose III[1] and on others with a painted pattern imitating checkerboard marquetry from the tomb of Kha.[2]

R.E.F.

1. Petrie and Brunton 1924, p. 24, pl. 57; Merrillees 1968, pp. 62-64; Merrillees 1974, pp. 12-40.
2. Schiaparelli 1927, pp. 124-125.

235

Multi-compartmented box

From Sedment tomb 254
Dynasty 18, reign of Thutmose III
Height 5.8 cm.; length 9.4 cm.
University Museum, Philadelphia. Gift of British School of Archaeology (E. 14198)

This four-legged rectangular box has two sliding lids and a hinged, gabled lid, all secured by means of cords wound around the knobs. The pieces are assembled with butt joints. Strips of a darker wood serve as trim and are held in place by tiny dowels.

The box was found with a set of baskets that also contained a second box and a variety of pottery (see cat. 85) and stone vessels[1] datable to the end of the reign of Thutmose III.[2] The unique shape is actually a combination of the gabled-lid casket and the sliding-lid type (see cat. 234), double in this case. An example of the former is the second box found in the same tomb,[3] while another tomb at Sed-

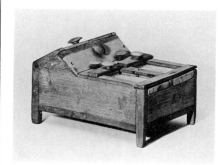

235

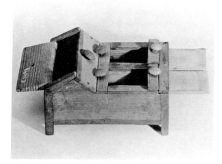

235

ment contained a box with parallel sliding lids (see cat. 233).[4]

R.E.F.

1. Petrie and Brunton 1924, p. 24, pl. 57.
2. Merrillees 1968, pp. 62-64; Merrillees 1974, pp. 12-40.
3. Petrie and Brunton 1924, pl. 57.
4. Ibid., pls. 48, 63.

Bibliography: Petrie and Brunton 1924, p. 24, pl. 57; Ranke 1950, p. 79, fig. 48; Merrillees 1974, p. 24, fig. 10.

236

Casket with animal-combat motif

Provenance not known
Late Dynasty 18
Length 13 cm.; width 6.1 cm.
Staatliche Sammlung Agyptischer Kunst, Munich (473)

The cylindrical acacia-wood casket is divided inside into four separate compartments that probably once contained a solid cosmetic. The underside is decorated in raised relief with bands of flower petals or lozenges framing a panel in which appears a calf attacked from above by a panther and from below by a Saluki dog. Similar geometric motifs on the lid surround a panel showing a calf attacked by a lion. Clumps of foliage above and below the calf act as filling motifs and were once inlaid with colored paste. The box was closed by means of a sliding lid and fastened by a cord wound around one peg on the side of the box and a second on the lid (now missing).

This is an example of a type of cosmetic vessel popular in Egypt in the late Eighteenth to early Nineteenth Dynasty.[1] Though this type occurs in Egypt as early as the First Intermediate Period,[2] an Aegean origin has been postulated for the motif of the flying gallop, in which animals are shown in a bounding leap, their legs outstretched forward and back in a virtual horizontal line.[3] It appears on a number of objects from Tutankhamen's tomb[4] and as far away as Syria on a newly restored frieze above an Egyptianizing ivory bed panel from Ras Shamra.[5]

A similar box found at Sedment contained traces of a cosmetic or unguent,[6] and an analysis performed on the contents of another in 1898 indicated that it held beeswax, "fragrant rosin," and plant oil.[7]

R.E.F.

1. Borchardt 1932b; Cooney 1953, p. 8.
2. Smith 1952, p. 78.
3. Kantor 1947, pp. 69-70.
4. Ibid., n. 68.
5. Schaeffer 1954, pp. 52-53, fig. 4.
6. Petrie and Brunton 1924, p. 31.
7. Gowland 1898, p. 269.

Bibliography: Staatliche Sammlung Ägyptischer Kunst 1966, 63:473; Villa Hügel 1961, no. 170.

237

Cylindrical box

From Saqqara
Late Dynasty 18
Height 11.2 cm.; diameter 7.4 cm.
The Brooklyn Museum, Brooklyn, New York; New-York Historical Society, Charles Edwin Wilbour Fund (37.600E)

The cylindrical wooden box has a lid that swivels horizontally on a knob. A connecting string wound around the second knob on the lid and another on the side of the box would effectively secure the lid. Around the circumference of the vessel is a band of incised decoration showing a seated figure of Ipuy, the owner, attended by a girl who presents him with liquid refreshment, as five scantily clad female musicians and dancers entertain him. In a band of inscription above, Ipuy is instructed, "Deck [yourself] with garlands, anoint [yourself] with oil, spend the day merrily!" —a phrase taken from the Song of the Harper.[1] Incised below the register of figures are five horizontal lines and a series of vertical lines reminiscent of brick niching, the so-called "palace-facade" motif.

The theme of musicians at a banquet caught up in the rapture of their performance became popular in the Eighteenth Dynasty, when it appears frequently in Theban tombs.[2] It is often accompanied by the harper's song, which laments the passing of life and urges its enjoyment while it lasts.[3] A box similar in shape and motif is in the Louvre.[4]

R.E.F.

1. Lichtheim 1945, pp. 178ff.
2. Davies and Davies 1923, pls. 5, 18; Davies 1933, pl. 66.
3. Lichtheim 1973, p. 193.
4. Vandier d'Abbadie 1972, p. 41, no. 110.

Bibliography: New-York Historical Society 1873, p. 32, no. 455; New-York Historical Society 1915, p. 29, no. 461; Brooklyn Museum 1943, p. [21], fig. 11 (bottom); James 1974, p. 173, pl. 84.

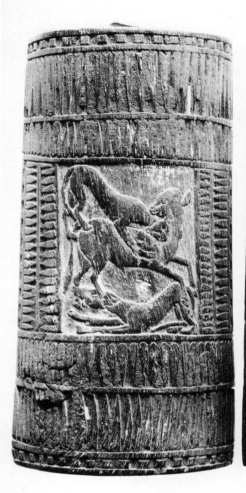
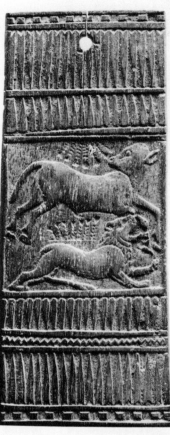

236

237

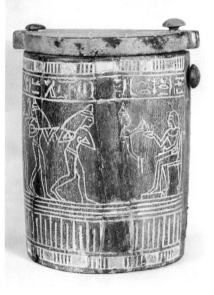

Figures Carrying Vessels

Unlike the swimming girls whose association with the toilette has been questioned (see p. 205), servants carrying vessels are much more convincing as cosmetic containers. The contents of some of the vessels have been analyzed, and the results indicate that they contained some sort of wax or grease, which was perhaps a component of the cosmetic cones or one of the many medicinal, apotropaic, and rejuvenative creams described in the medical papyri (see pp. 199-200). The shape of the vessels they carried further supports this interpretation (cats. 122, 123, and 239), since actual containers of these forms have been found with cosmetic unguent inside and such vessels are frequently associated with groups of toilette objects in tombs.[1]

R.E.F.

1. See, e.g., Petrie and Brunton 1924, pl. 63, bottom; Winlock 1934, p. 67; Bruyère 1937b, pp. 82 (fig. 41), 83; Winlock 1948, pp. 52-53, pl. 31; Vandier d'Abbadie 1972, p. 112, nos. 456, 458, 459.

238
Servant girl with amphora

Provenance not known
Late Dynasty 18
Height 18.7 cm.; width 4.1 cm.
Rijksmuseum van Oudheden, Leiden
(A 116A/F 176/E. xix). Formerly in the
Anastasi Collection

The entire body of this nude serving maid turns to accommodate the weight of a large, two-handled jar on her left shoulder. Her right shoulder is lowered, the hip thrust out, and the leg bent at the knee in a *contrapposto* pose; her long hair follows the S-curve of her back. Partial nudity was common among young Egyptian children and servant girls, but this figure is totally naked, devoid even of the shell girdle usually seen on serving maids.

In contrast to the smooth, soft planes of the girl's body, the wooden jar is decorated on both neck and shoulder with an incised petal and checkerboard motif. Like cat. 239, this vessel presumably contained a cosmetic cream. Similar amphorae are known in stone and in pottery in the New Kingdom.[1]

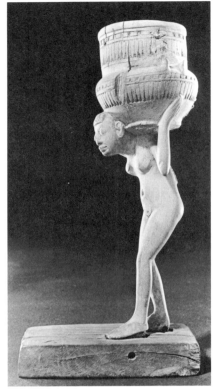

238

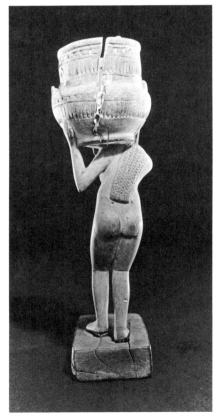

238

The statuette is fastened to the base by means of tenons extending from the soles of the feet and pegs (now missing) inserted in the sides of the base.

1. Petrie 1937, pl. 34: 879.

Bibliography: Leemans 1842, pl. 32; Capart 1907, p. 11, fig. 5; Fechheimer 1921, pl. 146; Boeser 1925, pl. 10: 51; Breasted 1936, p. 290; Badawy 1954, pp. 275ff., fig. 14; Wolf 1957, figs. 412-414; Schneider and Raven 1981, pp. 24, 104, no. 95.

239
Nubian girl and monkey with ointment dish

Purchased at Thebes
Late Dynasty 18
Height 17.5 cm.; length 8.5 cm.
University College, London. Petrie
Museum (14210)

A graceful Nubian girl balances a footed dish on the head of a cooperative monkey in this ebony composition. Her round face has heavily lidded eyes gazing slightly downward and a wide, somewhat pouting mouth. Her hair is gathered into four circular tufts in a style popular for Nubian children (see cat. 218). The soft curves of her breasts, belly, and thighs lend an air of nascent sensuality to the nude figure. Around the lip of the vessel is a band of zigzag; a marguerite with dotted petals is incised on the inside, and incised circles decorate the splayed foot.

This type of bowl (represented by cats. 120 and 153 in blue faience and in alabaster) is often shown filled with ointment in Theban tomb paintings. In one register in the tomb of Nebamen and Ipuki a slave girl holds such a vessel in one hand and, with the other, pats some of the substance on the cosmetic cone on her mistress's wig (fig. 52). A similar vessel in the register above is held by another slave girl, who rubs the shoulder of her master as if anointing him.[1]

The figure is fastened to the base by means of a peg extending down from her foot. Another peg is inserted perpendicular to the first through the side of the base.

R.E.F.

1. Davies and Gardiner 1936, pl. 61.

Bibliography: Capart 1905, pl. 68; Capart 1907, p. 12, fig. 6; Petrie 1910, p. 43; Petrie 1915a, p. 29, no. 416; Petrie 1931, p. 167; Page 1976, no. 88, p. 81.

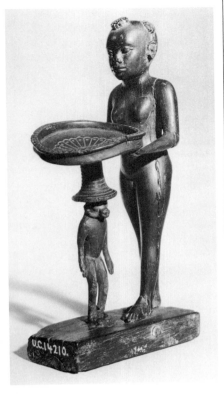

239

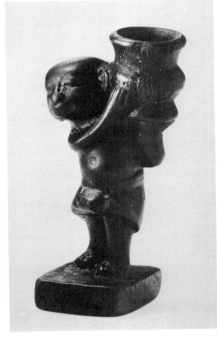

240

240

Dwarf bearer

Said to come from Amarna
Dynasty 18, reign of Akhenaten
Height 5.9 cm.; length 2.6 cm.
Museum of Fine Arts. Helen and Alice
Colburn Fund (48.296)

A common attitude of the ancient Egyptians is summed up in the *Teaching of Amenemopet,* which states emphatically, "Do not laugh at a blind man, nor tease a dwarf!"[1] Dwarves were featured in Egyptian art as early as Dynasty 1;[2] they were shown fulfilling various offices and duties, sometimes of an important kind.[3] Often dwarves served in the household, and it is perhaps in this capacity that this dwarf carries a huge jar nearly half his size on his shoulder, forcing him to sway to one side to balance its weight.

A late Eighteenth-Dynasty date is established for this boxwood piece by the two faintly incised cartouches bearing the names of Akhenaten and Nefertiti;[4] also characteristic of the period is the naturalistic pose of the dwarf and the shape of the vessel.[5]

Cosmetic articles frequently bear royal cartouches indicating they were a royal gift (see p. 222), so the dwarf need not have been the personal property of Akhenaten or Nefertiti.

R.E.F.

1. Pritchard 1950, p. 424.
2. Bothmer 1949, p. 10.
3. Dawson 1938, pp. 186-189; Silverman 1969, pp. 55-59.
4. Bothmer 1949, fig. 4.
5. Petrie 1937, p. 13.

Bibliography: Bothmer 1949, pp. 9ff.; Keimer 1949a, p. 139 n. 10; Museum of Fine Arts 1960, p. 134, fig. 89; Terrace 1968, pp. 49-56.

Swimming-Girl Spoons

The function and meaning of cosmetic spoons in the form of a swimming girl have never been satisfactorily resolved. Many examples exist in wood, ivory, stone, and even faience, usually consisting of a handle in the shape of a young maiden whose feet are extended straight behind her and whose outstretched arms hold a container. The container may be a circular or rectangular bowl or a cartouche-shaped dish; it may take the form of a duck, gazelle, fish, or a bouquet of flowers. The maiden, either Egyptian or Nubian, usually has an elaborate coiffure but wears only a girdle or a collar. Only occasionally are men represented instead of women.[1] The type appears to begin early in the Eighteenth Dynasty[2] and continues into Early Christian times.[3] Examples are also found in the Sudan in the Napatan Period.[4]

While most have been found in graves, swimming-girl spoons are occasionally excavated in houses and palaces.[5] The traditional interpretation is that they functioned as a container for cosmetics,[6] whether perfume[7] or an ointment.[8] Although none of their contents are still preserved, an example in the British Museum once contained traces of "incrustation in green paste,"[9] while another had remains of "wax."[10] Possibly they were also used to hold myrrh or wine for use in rituals connected with the cult or burial, a suggestion made primarily on the basis of a ritual interpretation of the motifs.[11]

R.E.F.

1. Pavlov and Khogash 1959, p. 133, pl. 47.
2. Petrie and Brunton 1924; p. 24, pl. 54.
3. Wallert 1967, p. 66.
4. Wenig 1978b, p. 177.
5. Wallert 1967, p. 20.
6. Keimer 1952, p. 59.
7. Cooney 1974, no. 198.
8. Kayser 1969, p. 313.
9. Frédéricq 1927, pp. 8-9.
10. Morant 1939, p. 36.
11. Wallert 1967, pp. 66-68.

241

Spoon in the form of a swimming girl

Provenance not known
Late Dynasty 18
Length 33 cm.; width 6.5 cm.
Musée du Louvre, Paris (N. 1725a)

The figure, nude except for an incised belt and floral collar, is shown in the

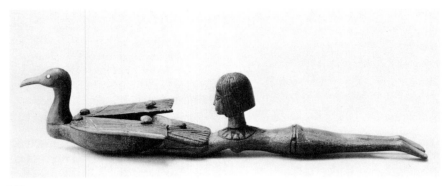

241

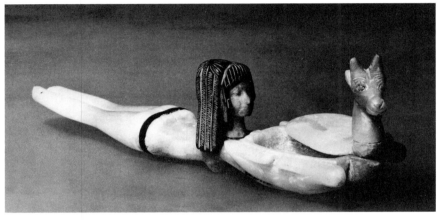

242

Spoon in the form of a swimming girl

Provenance not known
Dynasty 18, reign of Akhenaten or
slightly later
Length 22.5 cm.
The Metropolitan Museum of Art,
New York. Rogers Fund (26.2.47)

The alabaster figure in the out-
stretched pose of a swimmer holds a
gazelle by its underbelly. The head
and upper body of the animal serve
as the cover of a dish formed by its
lower body and folded legs. The girl
is clad in only a girdle (restored).
Her layered wig, made separately out
of metamorphic schist, has ringlets
of hair arranged in a side lock, an
indication that she is little more than
a child. Both the head of the girl and
the head of the animal were made
separately and cemented in place,
the circular tenon of the latter serving
also as a pivot for the lid.

Excavations at the palace of Amen-
hotep III at Malkata produced a head
of a "swimming girl" (now also in the
Metropolitan Museum) that, like the
present example, is made of alabaster
and has a separately carved, layered
wig of metamorphic schist with a
single curl of hair forming a side lock.[1]
On the basis of this evidence, both
pieces have been thought to date to
the reign of Amenhotep III.[2] While the
Malkata head has the elongated eyes
with arching brows so characteristic
of that reign, the eyes on this example
are less attenuated, less stylized, and
slightly three-dimensional. Their
shape suggests that this piece post-
dates the reign of Amenhotep III, and
other features suggest that it was
made during the reign of Akhenaten
or slightly later.

Bobbed or layered wigs (the so-called
Nubian wig; see cat. 197)[3] coupled
with multiple ringlets gathered in a
side lock are common on young girls
shown in Amarna reliefs[4] as is the
hair style worn by Princess Sitamen,
daughter of Amenhotep III and Tiye
in a representation on the back of her
chair.[5] Younger children at Amarna
sport a side lock and multiple ringlets
but not the layered wig.[6] The sweet
and sensitive modeling of the facial
features of the girl on the present
example is comparable to those on
the head of the canopic jar that be-
longed originally to Meryetaten,

attitude of a swimmer. Her out-
stretched arms clasp the underside of
a duck, the creature that most fre-
quently accompanies swimming girls.
The body of the bird was hollowed
out to form a dish, while the wings act
as a cover and pivot individually on
pegs at the base of the neck. They
could be secured by means of a cord
wound around two additional pegs
at the tip of the wing and another on
the tail. Except for the eye of the duck,
which is ivory surrounded by a narrow
rim of ebony, the composition is made
of tamarisk wood. The short wig,
eyes, and jewelry of the girl are
painted black. As is usual with this
kind of object, the head was made
separately and attached.[1]

Although the only complete figures
of swimming girls with ducks come
from tombs, fragmentary examples
have been found in private houses
and palaces.[2] The earliest datable
context for these objects is the reign
of Akhenaten;[3] however, it is not
unlikely that there are earlier
examples.

It has been suggested that the com-
position was meant to show a girl
seizing a duck to present it as an
offering,[4] but there is never any im-
pression of violence.[5] A second hy-
pothesis that the swimmer pushes the
duck[6] is also unlikely, since the
position of the arm and hand are not
appropriate.[7] In all likelihood what is
represented is a swimming girl being
towed through the water by the
duck.[8]

R.E.F.

1. Cooney 1974, no. 198.
2. Wallert 1967, p. 20.
3. Ibid.
4. Keimer 1952, pp. 60, 71.
5. Wallert 1967, p. 21.
6. Frédéricq 1927, p. 9.
7. Wallert 1967, p. 21.
8. Capart 1907, p. 17.

Bibliography: Perrot and Chipiez 1882, p. 763,
fig. 512; Wreszinski 1913b, p. 194, fig. 34; Vandier
d'Abbadie 1952, p. 26; Wallert 1967, p. 138;
Vandier d'Abbadie 1972, p. 11, no. 1.

daughter of Amenhotep IV.[7] The marked plasticity in the head of the gazelle, especially around the area of the nose and mouth, is paralleled on representations of ibexes from Amarna (cat. 17). The multiple incised lines above the eyes also appear on Amarna ibexes, as well as in a representation of a calf from the same site.[8]

Further confirmation of a late Eighteenth-Dynasty date may be found by examination of a barque with head and prow in the shape of gazelle heads from the tomb of Tutankhamen.[9] The boat is steered by a dwarf in alabaster, who wears a schist wig with side lock of multiple ringlets, and an alabaster princess wearing a schist wig without side lock sits in the prow. Although the tradition of combining schist and alabaster is maintained, the modeling of both human and animal heads is not quite as naturalistic or as sensitive as the New York dish or the Amarna pieces. This represents a slight degeneration from the previous reigns, and would argue for an earlier dating of the present examples, namely during Akhenaten's reign.

R.E.F.

1. Phillips 1941, p. 173.
2. Ibid., p. 174.
3. See Aldred 1957, pp. 141ff.
4. Aldred 1973, fig. 50, nos. 129, 130.
5. Davis et al. 1907, p. 38, fig. 1.
6. Aldred 1973, nos. 16, 17, 33, 34, 49, 116, 130.
7. Aldred 1957, pp. 141-142.
8. Aldred 1973, no. 77.
9. Carter 1933b, p. 231, pl. 74.

Bibliography: Lansing 1928, pp. 160-161, fig. 5; Phillips 1941, pp. 173ff., fig. 3; Metropolitan Museum of Art 1944, fig. 29; Pijóan 1950, p. 358, fig. 486Y; Hayes 1959, pp. 267-268, fig. 162; Aldred 1961, pl. 47; Wenig 1967, p. 49, pls. 50, 51a.

Spoons and Dishes

Grouped under the heading "cosmetic spoon" are a number of diverse items ranging from objects with an obvious spoon shape[1] to more decorative pieces not immediately recognizable as spoons. Often hidden in the design is an *ankh,* the hieroglyphic sign for life (see cat. 246) or a cartouche (see cat. 251). Zoomorphic representations are common as well, including such diverse animals as leopards (cat. 249), oryxes (cat. 254), and dogs (cat. 377). Spoons with decorative handles and bowls existed as early as predynastic times,[2] but the greatest variety of forms occurred in the New Kingdom, and many types continue into the Late Period[3] (cat. 243 and 245, for example). Bone, wood, schist, alabaster, and bronze are among the more popular materials. In "cosmetic dishes," the lower part of the body of an animal such as a duck (cat. 260) or gazelle (fig. 54) is often hollowed out to form a container and its cover is carved in the shape of the upper body.

The identification of the spoons and dishes as cosmetic utensils goes back to the first half of the nineteenth century.[4] (Other authors had previously suggested that they were intended for ritual use,[5] and both theories have found support in recent years.[6]) Their delicacy of form and manufacture brings to mind the kind of bauble a wealthy Egyptian would have possessed, at least as seen through our modern eyes.[7] However, while some of the spoon and dish shapes are indeed either elegant or fanciful in nature, others incorporate representations of bound animals (cat. 254) or detached limbs,[8] subjects more likely to appear in temple or tomb offerings than in domestic contexts.

The archaeological evidence is unfortunately ambigious as far as the function of these objects is concerned. By far the majority of the excavated examples were found in tombs belonging to both men and women. Some of those tombs also contained objects with a clear cosmetic function, such as combs and hairpins; however, no "cosmetic spoon" or "cosmetic dish" has been found inside containers within the tomb holding these or other known cosmetic items.[9]

Temples are another source of spoons and dishes, suggesting that they were considered sacred for their material or for other properties. At Qau and Matmar groups of bone spoons were buried in pits with other objects of the same material.[10] Some of the accompanying items, such as *djed* pillar amulets and representations of gods, are decidedly religious in nature;[11] the function of others is unclear. Both deposits contained tubes for kohl, a substance that served both a cosmetic and a religious function (see p. 216).

One type of spoon, with a long handle terminating in the recurved head of a duck, is shown in a representation from the tomb of Menna transferring a substance from a bowl into a fire.[12] The substance is most likely incense, and the ceremony performed is probably religious in nature. Nevertheless, two examples of the same type of spoon were found in houses at Amarna[13] and this would imply that they had a domestic use as well.

If the material contained in these spoons and dishes could be analyzed, the question of their function would surely be answered. However, in the few instances where contents were once preserved,[14] they were removed before proper analyses could be performed.[15]

R.E.F.

1. Wallert 1967, pl. 6.
2. Ibid., pp. 5-9, pl. 1.
3. Ibid., pp. 37-46, pls. 35-39.
4. Wilkinson 1837, p. 358; Prisse d'Avennes 1846, p. 740.
5. Champollion 1827, p. 70; Rosellini 1834, p. 355.
6. Wallert 1967, passim; Vandier d'Abbadie 1974, pp. i-iv.
7. Vandier d'Abbadie, 1974, p. iv.
8. Wallert 1967, pl. 5:B35.
9. Ibid., pp. 53-54.
10. Brunton 1948, p. 65.
11. Ibid., pl. 53; Brunton 1930, pl. 36.
12. Wallert 1967, p. 57, fig. 4.
13. Hermann 1932, p. 100, figs. 10, 11, n. 3. See also Wallert 1967, pl. 7: M1; Hayes 1959, p. 253.
14. Wallert 1967, p. 49.
15. Vandier d'Abbadie 1974, p. iv. (One example is said to have contained wax or ointment [Frédéricq 1927, p. 9, pl. vii].)

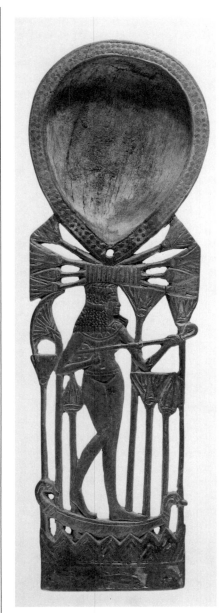

243

243
Spoon with a figure of a girl playing a lute

From Sedment
Dynasty 18
Length 21 cm.
University College, London. Petrie Museum. Gift of Egypt Exploration Fund (14365)

This openwork carving shows a nude young woman playing a lute. The boat on which she stands, resting on a stylized water design, in a thicket of lotus and papyrus, has prow and stern terminals in the shape of duck heads; the lute neck also terminates in a duck head. The woman wears a heavy wig decorated with a lotus garland and contained by a band or ribbon; she wears a broad collar and beaded girdle. Placed horizontally above her head is a tied bunch of lotus blossoms and buds, four to the right and four to the left. The lower torso of the figure is shown in a near frontal position, a pose known from Theban tomb paintings of female musicians. The ovoid wooden spoon bowl, which has lost its cover, is decorated with a double dotted band on the rim. Early photographs of this spoon show that the bowl contained a dried residue, which has been removed.

An interesting comparison for this piece[1] depicts a male lute player on a duck-head boat in a thicket. The spoon in the latter case takes the form of a rectangular pond of water. Similar in general form is a spoon in the Louvre[2] with a nude female lute player, who stands on a reed mat rather than a boat. The London spoon was found with scarabs of Thutmose III and Amenhotep III.

W.H.P.

1. Vandier d'Abbadie 1972, pp. 18-19, no. 29.
2. Ibid., pp. 16-17, no. 22.

Bibliography: Capart 1905, pl. 70; Wallert 1967, p. 122, pl. 21.

244
Spoon with figure of a girl gathering blossoms

Provenance unknown
Dynasty 18
Length 18 cm.; length of bowl 7 cm.
Musée du Louvre, Paris (N. 1750).
Formerly in the Salt Collection

One of the most remarkable of this series of spoons with elaborate handles, this example depicts a genre scene transformed into a stunning design. Pulling long lotus flowers, a young woman stands in front of other stalks and flowers that form an openwork pattern. She wears a short skirt knotted at the waist with a sash that flows freely to one side and her hair is dressed in an elaborate wig that falls below her shoulders on both sides. The contrast of the graceful figure against a rhythmic background is balanced by the heavy element of the spoon bowl. The shape of the bowl and the horizontal element below are a subtle allusion to the *ankh* form.

The bowl of the wooden spoon is ovoid with a zigzag pattern around the rim; the cover, for which the pivot hole exists, is missing. The stalk of the left-most plant is broken away and there is a small chip out of the rim of the bowl. Faint traces of color can be seen on the wig and in areas of the background.

W.H.P.

Bibliography: Prisse d'Avennes 1878, pp. 153-154; Perrot and Chipiez 1882, p. 844, fig. 585; Fechheimer 1921, p. 140; Bénédite 1924, pl. 35; Capart 1947, pl. 716; Keimer 1948b, p. 95, fig. 3; Desroches-Noblecourt 1962, p. 64, fig. 76; Wallert 1967, p. 142, pl. 20; Wenig 1967, pl. 48; Michalowski 1968, fig. 784; Vandier 1970, pl. 21; Vandier d'Abbadie 1972, p. 17; Seipel 1975, fig. 372b.

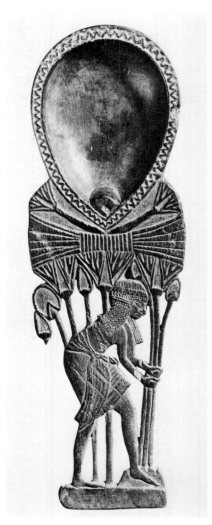

244

245
Spoon with figure of a Syrian carrying a jar

From Gurna
Dynasty 18
Length 23.5 cm.; length of bowl 9.5 cm.
Musée du Louvre, Paris (N. 1738)

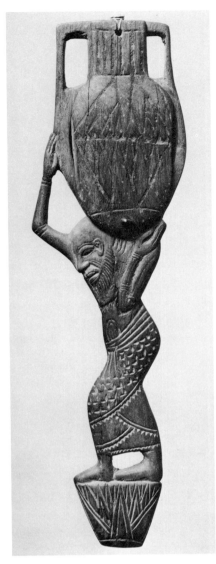

245

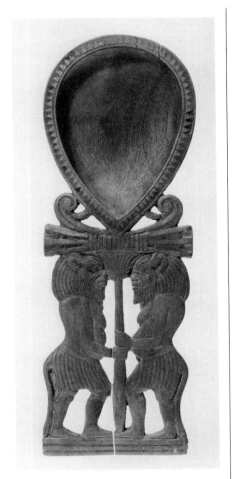

246

A bald and bearded Asiatic carries on his shoulder a large two-handled jar with a petal pattern on the body. The bend of his legs suggests that his load is heavy, and the contortion of the left shoulder implies that he is a hunchback, although this is not clearly indicated. He wears a long-sleeved undergarment, and a decorated shawl is wound around his body from the waist downward, a feature common to both Syrian and Egyptian portrayals of Syrian people;[1] beneath his feet is a lotus-blossom pedestal.

Syrians were one of the nine traditional enemies of ancient Egypt. While they are shown in subservient postures in temple reliefs or beneath the feet of the king on statue bases well before the New Kingdom, it is primarily in the New Kingdom that they enter the minor art repertoire. Tutankhamen owned a walking stick, one end of which was carved in the shape of a Syrian prisoner, and one of his unguent jars rests on the head of a Syrian.[2] A bound Syrian was incorporated into the leg of a chair of Ramesses III.[3]

The spoon is of acacia wood with a small button of ivory and traces of blue in the incisions. Parallels have been found as far away as Sanam in Nubia.[4]

<div align="right">R.E.F./W.H.P.</div>

1. Wreszinski 1935, pl. 1.
2. Desroches-Noblecourt 1963, pls. 18, 43.
3. Prisse d'Avennes 1878, pl. 85.
4. Griffith 1923, pl. 31:5.

Bibliography: Champollion 1889, pl. 167:4; Wallis 1900, p. 11, fig. 4; Fechheimer 1921, p. 140 (P 13), pl. 25; Pijóan 1950, p. 355, fig. 481; Vandier d'Abbadie 1972, p. 18.

246

Ointment spoon with double Bes-image

From Sedment
Dynasty 18, reign of Amenhotep III
Length 17.3 cm.
University College, London. Petrie Museum (14366)

This spoon has a handle in the form of two confronting Bes-images shown in profile standing upon three horizontal lines and holding a stem of papyrus plant between them. Their bodies are carved with large flaccid breasts, distended abdomens, and protruding buttocks; both wear knee-length skirts with vertical stripes.

The discovery of this wooden piece with a ring bearing the name of Amenhotep III provides a firm date for the spoon and for the two Bes-images on its handle. Pairs of Bes-images occur only during two New Kingdom reigns, those of Amenhotep III[1] and Akhenaten (see cat. 334).[2] In none of these examples, however, do the two Bes-images appear in a strict heraldic scheme as on the London spoon. The fact that Egyptian artisans normally eschewed such "mirror imagery" suggests that the inspiration for the design was foreign.

<div align="right">J.F.R.</div>

1. See also Quibell 1908b, pl. 39.
2. See also Peet and Woolley 1923, pl. 18:3.

Bibliography: Burlington Fine Arts Club 1895, pl. 5; Capart 1905, pl. 70; Wallert 1967, p. 122.

247

Spoon in the form of a formal bouquet

From Saqqara
Dynasty 18
Length 29.5 cm.; width 7.8 cm.
The Brooklyn Museum, Brooklyn, New York; New-York Historical Society, Charles Edwin Wilbour Fund (37.605E)

The decoration of this wooden spoon includes lotus blossoms and papyrus flowers, marguerites, poppy buds, and a mandrake fruit. The use of the lotus throughout the range of these decorative objects is an allusion to the beauty of the flower and also a symbolic reference to life.[1]

The lower part of the handle would have been decorated with the stalks of the flowers, but some of the ivory and paste inlay is missing. The lotus flowers retain bits of blue-green paste, now mostly black, with the lowest register having the most preserved color. The flanking flowers on either side of the largest lotus (the spoon bowl) are broken off and lost.

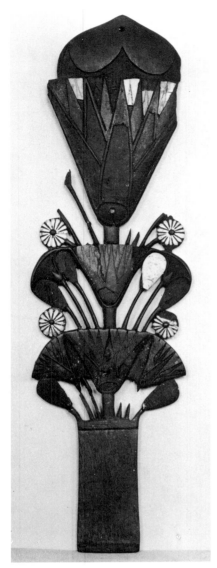

247

in the form of a lotus flower, lotus buds, and a mandrake. The incised lines of the flowers and fruit are filled with green coloring, and the leaves of the lotus blossom are inlaid with green paste; a large chip has fallen out in recent years. The base of the blossom and buds is painted red. The lotus shape is admirably suited to use as a cosmetic spoon, and here the addition of the two buds and the mandrake results in a compact design with the appearance of a completely functional object. The simple device of three stalks bound together for the handle suggests that the artist-craftsman gave careful consideration to the limitations of his material. The lid, which is formed by the lotus flower and the mandrake, pivots at the bottom. The interior of the spoon is divided into two compartments. (For a discussion of the symbolism of the lotus, see cat. 138.)

W.H.P.

Bibliography: Frédéricq 1927, p. 11, pl. 4; Wallert 1967, p. 115, pl. 29.

248

Inlay is missing from almost all the flowers and the mandrake fruit.

W.H.P.

1. Fazzini 1975, p. 90, no. 75.

Bibliography: Abbott 1853, p. 34, no. 459; Prisse d'Avennes 1878; New-York Historical Society 1915, p. 30, no. 465; Brooklyn Museum 1943, pl. 16; Capart 1947, pl. 715; Cooney 1948, p. 9; Wallert 1967, p. 83, pl. 28; Fazzini 1975, no. 75.

248
Spoon in the form of a bunch of flowers

Provenance not known
New Kingdom
Length 27.5 cm.
British Museum, London (5966)

In the category of wooden spoons of floral shape, this example is one of the simplest and most satisfying designs,

249

249
Spoon in the form of a leopard biting a leaf

Provenance not known
Late Dynasty 18
Length 22 cm.; width 5.4 cm.
Merseyside County Museums, Liverpool.
Gift of Joseph Mayer (M13516)

Biting a leaf that forms the bowl of the wooden spoon is an elongated figure of a leopard, its left forepaw extended and resting on the edge of the leaf. The ribs of the leaf are carved in relief and the spots of the animal are indicated by incision; an incised collar implies that he is a pet. There are cracks running through the leaf and some chips of wood are lost.

A similar spoon in the Metropolitan Museum[1] was found in a domestic context at Malkata, and it is on the basis of this parallel that a late Eighteenth-Dynasty date is assigned to the Liverpool piece.

W.H.P.

1. MMA 11.215.715.

Bibliography: Gatty 1879, p. 63, no. 457; Keimer 1947, p. 39, fig. 37; Wallert 1967, p. 112, pl. 16: L16.

Literature: Wallert 1967, pl. 16: N4.

250

Spoon in the form of a shell and hand

Provenance not known
New Kingdom
Length 9.3 cm.
Museum of Fine Arts. Morris and Louise Rosenthal Fund (1974.2)

Mussel shells were used as early as predynastic times as containers for eye paint, and continue to function for the same purpose today.[1] (Spoons in the form of a hand were known in predynastic times.[2]) Hand-held shell spoons begin in the Middle Kingdom in an elongated form, such as an example in Berlin, which provides one of the few instances of an inscription on this type of object. The phrase, "It is to the beloved of Horus and the beloved of the city god that I have given incense," implies that this was a ritual spoon.[3] On the other hand, a New Kingdom frit spoon of larger size (19 cm.) in the Metropolitan Museum contains traces of red paint of the type used by artists and scribes.[4] This suggests that smaller spoons like the present specimen might have been utilized for mixing eye paint.

This ivory shell is supported by the palm, thumb and extended fingers. In a wooden example in Boston[5] the thumb embraces the side of the shell, and in another wooden spoon in the same collection[6] only the index finger supports the shell from underneath, while the thumb is hooked over the rim of the shell and the other three fingers are folded. A large piece is broken off the open end of the shell and a smaller chip is missing from the rim.

W.H.P./R.E.F.

1. Wallert 1967, p. 64.
2. Fischer 1963, pp. 32-33, fig. 8c.
3. Wallert 1967, p. 77, pl. 8 bottom.
4. Hayes 1959, pp. 29, 220, 304, 409, 410, fig. 260.
5. MFA 88.1047.
6. MFA 11.1519.

250

251

251

Dish in the form of a cartouche

Provenance not known
New Kingdom
Length 11.8 cm.; width 5.4 cm.
The Brooklyn Museum, Brooklyn, New York; New-York Historical Society, Charles Edwin Wilbour Fund (37.608E)

The interior of the wooden dish contains an incised design of two Nile fish facing two lotus flowers, the outlines filled with blue frit. The handle is decorated with a flat relief of a crouching desert hare; the incised areas around the hare and lotus are filled with blue frit. Three chips of wood are missing from the inner surface and there is a large chip from the edge of the cartouche. A close parallel to this object, in the British Museum, has an interior incised design with two fish and two lotus flowers, drawn with more detail; its handle is the shape of a crouching gazelle.[1]

The association of the fish *(tilapia nilotica)* with lotus blossoms occurs frequently in Egyptian art of the New Kingdom (see cats. 107, 139, and 252).

W.H.P.

1. Wallert 1967, pl. 19.

Bibliography: Brooklyn Museum 1943, pl. 12; Dambach and Wallert 1966, p. 289; Wallert 1967, p. 83, pl. 20.

Literature: Wallert 1967, pls. 18-20.

252

Dish in the form of a cartouche

Provenance not known
Dynasty 18
Length 13 cm.; width 5.2 cm.
Norbert Schimmel Collection, New York (199). Formerly in the David Weill Collection

The cartouche form occurs as early as the Old Kingdom;[1] it adapts well as a dish or tray, affording a flat space for further decoration. The surrounding rope is delineated in a chevron pattern; the tie at the bottom has interspersed lotus flowers. The handle of this stone dish is decorated with a duckling in raised relief sitting on a water pattern. Behind the duckling's head are lotus flowers and buds. The interior of the tray has an elaborate incised design composed of a papyrus thicket, lotus buds and flowers, a star-shaped flower, and a marguerite. Small birds nest in the thicket and a *bolti* fish is placed incongruously

among the papyrus stalks (cf. cats. 138 and 251).

W.H.P.

1. Wallert 1967, p. 17.

Bibliography: Hôtel Drouot 1971, no. 4; Cooney 1974, no. 199.

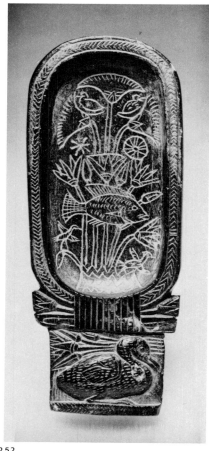

252

253
Dish in the form of an ape sitting on a ball
Said to be from near Zagazig
Possibly Dynasty 18
Length 12.8 cm.
Kofler-Truniger Collection, Lucerne (411F)

Squatting monkeys nibbling or touching food were a popular motif of the New Kingdom (see cat. 231). Monkeys and apes were trained as fruit gatherers, so the object on which this one sits may be a stylized piece of fruit; however it is not impossible that it is a balancing ball. The sphere forms the bowl of the dish, and the ape is carved on both sides with careful attention to detail of anatomy. Its waist is encircled by a belt that has a loop inserted on one side. The dish is made of schist with blue paste inlays.

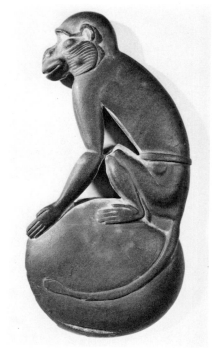

253

On the concave side of the bowl about one third of the rim has been broken away, causing the right forepaw of the animal to be lost.

The date of this piece is subject to some question.[1]

W.H.P.

1. See Wallert 1967, p. 126; Müller 1964, pp. 84-85.

Bibliography: Müller 1964, pp. 84-85, no. A121; Wallert 1967, p. 126.

254
Dish in the form of a bound oryx
Provenance not known
Dynasty 19-20
Length 13.5 cm.; width 6 cm.
Musée du Louvre, Paris (E 3217);
Formerly in the Anastasi and MacGregor Collections

This spoon is in the shape of a bound oryx, the body hollowed out for the bowl. The detailing of horn, binding rope, and hooves are indicated with care. The use of faience dictated certain details of handling, as in the filling of the space between horn and neck for added strength. Similar examples are known in stone, wood, and ivory.

W.H.P.

Bibliography: Lenormant 1857, p. 76, no. 872; Wallis 1898, p. 25, fig. 48; Boreux 1932, p. 591; Vandier d'Abbadie 1972, p. 30, no. 69.

255
Dish in the form of a bound oryx
From Qau el Kebir tomb 562
New Kingdom
Length 15.4 cm.; width 6.2 cm.
Ashmolean Museum, Oxford. Gift of Egypt Exploration Fund (1923.622)

The ivory dish was found in a two- to three-ton mass of human and animal bones thrown randomly into the mouth of a Second-Dynasty tomb, probably during the Nineteenth Dynasty.[1] Other ivory objects in this curious deposit included kohl tubes, mirror handles in the shape of female figures, and bound-animal dishes.

Spoons of this type were made in a considerable range of materials: faience, steatite, wood, and ivory. A close parallel in Berkeley, also in ivory, was excavated at the New Kingdom site of el Ahaiwah.[2] A bound oryx with the horn, ear, and legs carved in openwork forms the shape of this example. The material lends itself to carving of detail such as the indentations of the horn and the binding rope.

The dish has been broken and repaired; cracks run through the body and the neck.

W.H.P.

1. Brunton 1930, pp. 18-19.
2. LMA 6-22232.

Bibliography: Brunton 1927, p. 12; Brunton 1930, p. 18, pl. 36; Moorey 1970, p. 59, fig. 28.

256
Dish in the form of a bound oryx
Provenance not known
Dynasty 18
Length 9.5 cm.; width 4.5 cm.
Toledo Museum of Art (53.152)

This glazed steatite dish illustrates, in comparison with cats. 254 and 255, the variety to be found in representations of the same subject. The head here is upturned and space has been left behind it. Although the general form is conventional, the maker of this example chose to emphasize different details, such as the ribs, which, like the indentations of the horn, are indicated by incision. The front of the neck is serrated and the horns, ear, and back of the head are carved as openwork.

W.H.P.

Bibliography: Whitaker 1967, p. 17, fig. 4; Luckner 1971, fig. 7.

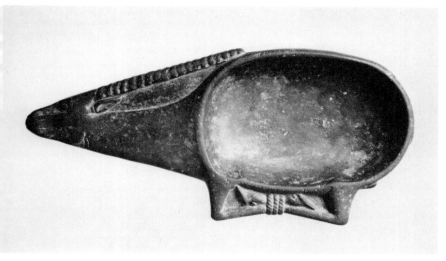

254

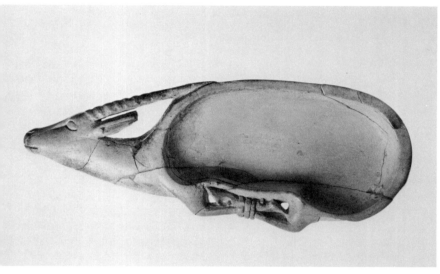

255

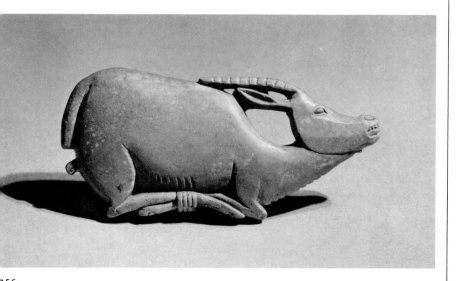

256

257

Dish in the form of a bound ibex
From Gurob
Dynasty 18, reign of Amenhotep III
Length 18.5 cm.; width 8 cm.
Musée du Louvre, Paris (E 11124)

The bound ibex turns its head back in this wooden dish. The fore and hind legs are crossed rather than parallel; the binding rope is indicated in carved relief. Traces of black remain on the horn, red on the tongue and feet, and green on the body.

As in cat. 255, in ivory, this spoon in wood is skillfully carved with great attention to detail. The legs are carved on the container side as well as on the back.

W.H.P.

Bibliography: Vigneau 1936, p. 71; Capart 1947, pl. 713; Vandier d'Abbadie 1972, no. 65.

258

Dish in the form of a trussed duck
Provenance not known
New Kingdom
Length 10.5 cm.; width 5.5 cm.
Musée du Louvre, Paris (N. 1749)

The head of this duck is turned back, its bill touching one shoulder. On the underside, the two webbed feet and the first joint of the wings are indicated in relief. It is possible that there were once two small inlaid pieces at the outer corners of the eyes.

The form of the trussed duck for such wooden ointment containers was very popular and many examples exist; this is one of the finest. A near parallel to the Louvre duck is in Boston,[1] the head of the latter being included within the oval silhouette of the bird.

W.H.P.

1. MFA 72.4306.

Bibliography: Vandier d'Abbadie 1972, p. 31, no. 75.

259

Dish in the form of a fish
From el Arabah
Dynasty 18
Length 15 cm.
University Museum, Philadelphia. Gift of Egyptian Research Account (E. 9260)

Cosmetic dishes are often in the form of the Nile fish *tilapia nilotica* (see cat. 138), which is easily distinguished

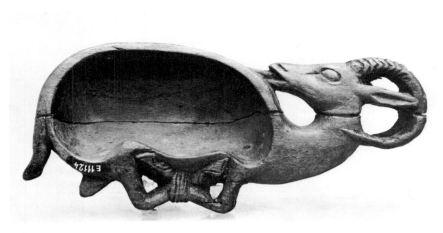

257

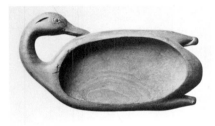

258

Fig. 56.

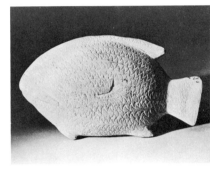

259

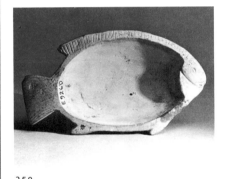

259

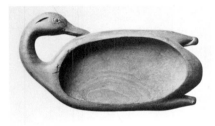

260

by its arrangement of fins as well as its general shape. In some examples the dish has a hinged lid, but this seems not to be the case in the present example of limestone. The entire body is hollowed out as the container; on the reverse side are incised fish scales.

The fish has long been associated with cosmetic objects. In predynastic times, slate palettes for grinding eye paint were often fish shaped.[1] Cat. 251 has an incised fish on the bottom of a cosmetic dish.

W.H.P.

1. Asselberghs 1961, pl. 53.
Bibliography: Garstang 1901, pl. 21, p. 15.

260

Duck-shaped dish

Provenance not known
Mid-Dynasty 18
Length 21 cm.; width 8.2 cm.
Rijksmuseum van Oudheden, Leiden
(AH 148/H 546/E. xxvi 2). Formerly in the
Anastasi Collection

The shallow dish is formed by the hollowed-out body of a duck in wood. Its back serves as the cover and is made from a separate piece attached by means of a peg, which also acts as a pivot. Tiny triangles of ebony and ivory marquetry ornament the margins of the body and lid. Markings on the duck's head were probably also inlaid. The head is attached by means of a tenon.

Ducks were a favorite motif for Egyptian artists as early as predynastic times, when they are represented on pottery, combs, and slate palettes. This fusion of a duck's body and dish shape, which turns a decorative motif into a functional object, seems to have occurred first in the Old Kingdom.[1]

Although the head now looks forward, it may originally have faced inward;[2] duck dishes where the head clearly faces forward usually either were made with covers[3] or have divided covers, where each wing pivots separately.[4] The duck dishes with clearly incurved heads looking behind them[5] all have one-piece oval covers very similar to the present example. Some have, in addition, ducklings perched atop them.[6]

214

In the "backward-looking" group, the back of the neck is decidedly convex,[7] as is true of the Leiden duck. The neck of this example is rather short, and it is possible that it was originally lengthened by the addition of a separate piece of wood (now lost) in much the same manner as in a "backward-looking" duck dish excavated at Ras Shamra.[8]

A parallel to the Leiden dish exists in painting in the tomb of Kenamen from the reign of Amenhotep II[9] (see fig. 56). The Kenamen duck has its head turned to look at a duckling resting on its back. Like cat. 260 it has an oval bowl and a triangular motif around the lip. A lid found at Sedment in a tomb dated no later than Thutmose III (on the basis of the kohl pots)[10] is also oval and has a similar triangular inlay decoration. The Leiden dish is therefore datable on the basis of these two parallels to the middle of Dynasty 18, a date supported by its smooth, simple lines and lack of body modeling.

R.E.F.

1. Petrie 1900a, p. 27, pl. 37:1.
2. Hermann 1932, pp. 96-97.
3. Reisner 1910, pl. 64k; Petrie and Brunton 1924, pl. 54; Bruyère 1927, p. 33, fig. 17.
4. Smith 1958, fig. 153b; Vandier d'Abbadie 1972, pp. 44-45, nos. 117, 118.
5. Quibell and Hayter 1927, pl. 20; Hermann 1932, pl. 99; Schaeffer 1932, pl. 8.
6. Hermann 1932, pl. 9a,b.
7. Ibid., pl. 9b; Schaeffer 1932, pl. 8; Quibell and Hayter 1927, pl. 20.
8. Schaeffer 1932, pl. 8.
9. Davies 1930, pl. 18.
10. Petrie and Brunton 1924, p. 23, pl. 48.

Bibliography: Schneider and Raven 1981, p. 104, no. 97.

261

Cylindrical vessel

From Abydos tomb D115
Mid-Dynasty 18
Height 7 cm.; diameter 4 cm.
Museum of Fine Arts. Gift of Egypt Exploration Fund (01.7355)

This cylindrical cosmetic container is the smaller and better preserved of two from the same burial, a rich tomb that also contained four other items in this catalogue (cats. 115, 127, 145, and 278). The slightly tapered body of the vessel is made of one piece of ivory, and the base made of a second; the two were cemented in place. A centimeter-wide panel is carved under the rim around most of the perimeter of the vessel, except for a strip be-

261

neath the area where a tiny peg (restored) fastens the lid. The lid has a corresponding narrow rectangular projection. To close the vessel, a cord was wound alternately around the large ivory "button" on the lid and around a similar one (now missing) on the body.

The form of the vessel is frequently represented in tomb reliefs and paintings.[1] Viewed from the side, the shape with its slightly tapered body, separately delineated panel with vertical strip, and button closing on the lid, approximates the *bas* jar hieroglyph, a sign used as a determinative in the words for unguent and ointment.[2] One problem with this identification is that representations of the jars show vessels that are more tapered.[3] Analysis of the contents of some *bas* jars from Deir el Medineh has identified an animal or vegetable fat, beeswax, and an aromatic substance (cyprus, poppy, or aloe wood).[4] It is therefore likely that this vessel once contained a similar substance, although it was empty at the time of discovery.

A similar vessel in wood from Saqqara has a recessed panel decorated with carved zigzag and parallel lines in three horizontal bands.[5]

Abydos tomb D115 is datable to the middle of the Eighteenth Dynasty on the basis of other objects found in it (see cat. 127).

R.E.F.

1. See, e.g., Davies and Gardiner 1936, pl. 35.
2. Gardiner 1957, p. 527.
3. Jéquier 1921, p. 142, figs. 373-377.
4. Bruyère 1937b, pp. 83-84.
5. Quibell 1908a, p. 79, pl. 34.

Bibliography: MacIver and Mace 1902, p. 89, pl. 47.

Kohl and Kohl Containers

As far back as Badarian times (ca. 4000 B.C.) the ancient Egyptians used cosmetics to enhance their facial features. Malachite *(uadju)*, a copper oxide of light green color, and red haematite were ground on slate palettes in geometric or animal shapes with brown jasper pebbles and the resultant powder was mixed with fat or resin to serve as a cosmetic.[1] A large head of the Predynastic Period from Mahasna,[2] made of yellow clay and baked, shows that green paint was used around and under the eyes. The face was painted dark red with the eyebrows almost black, while the eyelids were outlined with a broad light green band, the space within being colored black or very dark red.[3] The use of kohl or black eye paint *(mesdemet)* also goes back to that remote age, as evidenced by a small bag containing galena, a dark gray ore of lead and the chief ingredient for making kohl, found near the hands of a skeleton in a predynastic grave at Mostagedda.[4]

The custom of painting the eyes with green eye paint was popular during the Old Kingdom, for example, on a mummy of Dynasty 4 at Medum the eyes and eyebrows of the outer wrappings were painted with green.[5] Indeed, the liberal application of green eye paint from the eyebrow to the base of the nose is an archaic feature characteristic of the transitional period at the end of Dynasty 3 and the beginning of Dynasty 4.[6] As late as Dynasty 4 or 5 in reliefs at Dendera, green eye paint appears on the face around the eye and below it.[7]

Both green and black eye paints are mentioned in offering lists in the Old Kingdom; only the green appears to have acquired symbolic meaning, being mentioned in the Pyramid Texts.[8] In the Middle Kingdom green eye paint continued to be used for the brows and corners of the eyes,[9] but by the New Kingdom it was succeeded in ordinary use almost entirely by black eye paint, which was originally used only for the rims and lashes of the eyes.[10] However, green eye paint has been found in kohl tubes in contexts as late as the Nineteenth Dynasty[11] and in representations of Nakht in his tomb at Gurna.[12]

The lining of black eye paint certainly made the eyes appear larger and more luminous. It may also have had a prophylactic function, the lining around the eyes stopping the glare of the desert, just as the Eskimo blackens the skin to save the eye from the brightness of the snow[13] or as football players now smear grease under their eyes to protect them from glare.

The multiple kohl tubes of the New Kingdom (see pp. 223-224) suggest that several kinds of eye preparations were used. Often three tubes were inscribed with the names of the seasons, a fourth with the general prescription "eye paint for everyday" (see cat. 280). Fuller texts on other containers imply that the contents of the three tubes were drugs or medicinal powders for treating specific eye ailments at different seasons of the year[14] (fig. 57).

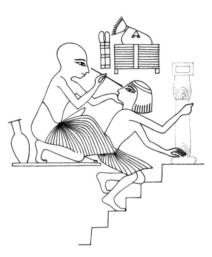

Fig. 57. A man applying kohl to the eyes of a workman (from the tomb of Ipuy, Theban tomb 217).

From the predynastic age onward shells were used to mix ground malachite or galena with fat or resin to make eye paint[15] and the prepared form of both malachite and galena has been found in shells of the Old Kingdom (cf. p. 211).[16] There were traces of green malachite paste in an ivory vase in a grave at Badari,[17] and malachite was found in a duck-shaped toilet dish of ivory from Abydos.[18]

In the Old Kingdom eye paint was stored in a variety of containers.[19] A blue-glazed pot of a squat unattractive form used for kohl was found in a grave at Hû[20] datable to the late Old Kingdom; it is reminiscent of similar forms in drab pottery used for eye paint at Gurna in Dynasty 11.[21] During the Middle Kingdom kohl was almost invariably kept in a small jar or pot of

special design with a flat bottom, wide rim, tiny mouth, and flat disk-shaped lid. Occasionally in the Middle Kingdom, as later, kohl pots were mounted on a small, four-legged stand, either made separately or carved in one piece with the jar.[22]

Kohl pots of the New Kingdom differ from Middle Kingdom vessels in showing a marked concave profile under the rim. Middle Kingdom kohl pots, in addition, often have the interior hollowed out to conform to the contour, distinguishing them in general from Dynasty 18 examples, which have a tubular hole only.[23]

During both the Middle and New Kingdoms the great majority of kohl jars were carved in Egyptian alabaster (calcite), but they occur in a wide range of other stones and materials, including diorite, diabase, serpentine, breccia, obsidian, slate, feldspar, haematite, limestone, anhydrite, faience, glazed steatite, pottery, wood, and even dried mud;[24] anhydrite, or blue marble, was less common for kohl pots in the New Kingdom but examples do occur.[25] Glazed steatite and blackened limestone used in combination with yellow incised decoration became very popular for toilette articles in Dynasty 18 (see cat. 285). The glass kohl pots that occur in the New Kingdom[26] were sometimes banded in gold (see cat. 265).

Prior to the Middle Kingdom, both green and black eye paint are presumed to have been applied with the fingers. In the Eleventh Dynasty or somewhat earlier kohl sticks or pencils — slender sticks with one bulbous end used in applying the cosmetic to the eyes — began to appear, sometimes tied to the necks of the jars.[27] Wooden kohl jars of New Kingdom date sometimes have lid, rim, and shoulder drilled to accommodate a kohl stick or two.[28] The kohl sticks, more often than not of ebony, cedar, or other hardwoods, but also of bronze, haematite, obsidian, and glass, often attained the status of finely made jewelry,[29] sometimes inscribed (see cat. 270) or banded in gold.[30] Bronze kohl sticks of the New Kingdom (see cat. 273) often have a spatula end for mixing the paint or even a tiny circular bowl at one end, which could be used as a cosmetic spoon.[31] An ivory kohl

stick from Abydos (cat. 272) is surmounted by a uraeus.

As containers for their eye salves and cosmetics, the Egyptians of the New Kingdom used tubes made of lengths of hollow reed, sometimes bound together in pairs or larger groups with cord, rushes, or strips of cloth.[32] The individual reeds are often inscribed in ink with labels identifying their contents[33] or enigmatic formulas (cat. 274). Both individual reeds and reed bundles were reproduced in faience and other materials.[34]

Single kohl tubes in faience and wood may have a cut around the tube to imitate the joint in a section of reed.[35] Small white or blue faience tubes inlaid or painted with the names of kings Amenhotep III or Tutankhamen were probably for distribution as favors on the occasion of festivals and court functions (cat. 277). Double tubes in blue faience frequently bear informal designs in black glaze;[36] a specimen once in the Hoffmann collection[37] has twice repeated the name and titles of the High Priest of Ptah, Dedia.

Multiple kohl containers reproducing clusters of hollow reeds are typical of the New Kingdom (see cats. 279, 280, and 281). Double,[38] triple,[39] quadruple,[40] quintuple (cats. 280 and 281), and even sextuple[41] or septuple[42] specimens are known. They are often carved from blocks of light wood with inlays and lids of ebony or from blocks of ebony trimmed with ivory[43] and sometimes also in gray veined steatite, glazed steatite, and alabaster. The lids swivel horizontally on a single peg and are commonly fastened shut by a kohl stick that passes through a hole or slot in the cover into a tubular hole or slot in the side or center of the block when not in use.[44]

Another type of container in blue faience (cat. 282), wood (cat. 283), or ivory (cat. 284) consists of tubes of equal height represented as if enclosed within a wide, flat binding that extends two-thirds of the way up their lengths[45] and is decorated on the front and back with figurative or geometric motifs incised and painted or in relief (see cats. 283 and 284). Examples are known with two,[46] three (cat. 283), and four tubes (cat. 284).

A type of kohl tube that first appears in the New Kingdom, and continued to be popular thereafter, has the form of a miniature palm column with the characteristic tapering shaft and flaring, foliate capital.[47] This type was most commonly produced in opaque, polychrome glass adorned with festoons of dragged decoration (cat. 182). The glass columns range in date from the reign of Amenhotep III to Ramesside times,[48] but many faience specimens were found in the tomb of Thutmose IV,[49] and even earlier wooden[50] and ivory examples are known. An ivory tube from Medum has a copper loop in the lower part and a slot in the upper for the accommodation of the kohl stick and still retains the peg of the cover, although the cover has disappeared.[51]

Ivory or bone kohl tubes in the form of a papyrus bud column are also common in New Kingdom graves.[52] Cat. 278, a double ivory column of this sort on a separate base, derives from an Eighteenth-Dynasty grave at Abydos.

In Dynasty 18 little squatting or standing figures of monkeys (in faience [cat. 286], blackened limestone [cat. 285], glazed steatite,[53] or wood[54], holding kohl tubes are quite common. Monkeys adorned toilette articles as early as the Old Kingdom[55] and cling in relief to the sides of blue marble or anhydrite toilette jars during Dynasty 12;[56] the tradition continued during the New Kingdom.

Human figures sometimes replace the monkeys, for example, in a wooden kohl container in Boston (cat. 287) fashioned in the form of a naked and rather grotesque female figure. Numerous other containers in the form of the Bes-image were produced in the New Kingdom in stone,[57] faience, ivory,[58] and wood (cat. 288).

Superseded by such containers, the traditional stone kohl jar lost its popularity and was gradually replaced after the reign of Thutmose III.[59]

E.B.

1. Baumgartel 1960, pp. 81ff.
2. Ayrton and Loat 1911, pp. 28-29, pl. 15:1.
3. Ibid., pp. 28-29.
4. Brunton 1937, p. 45.
5. Petrie 1892a, p. 18; Smith 1914, pl. 31:2.
6. Smith 1949, p. 142 n. 1.
7. Petrie 1901, p. 20.
8. Baumgartel 1960, pp. 52-53.
9. Firth and Gunn 1926, p. 36, pl. 32d; Hayes 1953, p. 242.

10. Hayes 1953, p. 242.
11. Petrie 1892a, pp. 42-43; Brunton 1930, p. 19; Hayes 1959, p. 22.
12. Davies 1917, pl. 12.
13. Petrie 1901, p. 20.
14. Feigenbaum 1958, pp. 131-140.
15. Brunton 1927, p. 63.
16. Quibell 1923, p. 36; Junker 1947, p. 107.
17. Brunton 1928, p. 31, pl. 26.
18. Petrie 1900a, p. 27, pl. 28; Petrie 1901, p. 21.
19. See Brunton 1927, pp. 62-63, pl. 27:80-89; Reisner 1955, p. 93.
20. Petrie 1901, p. 39, pl. 28.
21. Petrie 1909b, pl. 16; Petrie 1927, p. 26.
22. Hayes 1953, p. 242.
23. Brunton 1930, p. 17.
24. Emery and Kirwan 1935, p. 225, fig. 239:2.
25. Terrace 1966, p. 58 (5) n. 3.
26. Nolte 1968, pp. 47-48.
27. Brunton 1927, p. 63; Hayes 1959, p. 242.
28. Jéquier 1933, pl. 10; Vandier d'Abbadie 1972, p. 91, no. 359.
29. Hughes 1959, p. 169.
30. Brooklyn Museum 1943, fig. 4.
31. Hayes 1959, pp. 22-23.
32. Bénédite 1911, pl. 11; Hayes 1959, p. 191.
33. Quibell 1901, p. 143; Hayes 1959, p. 191; Vandier d'Abbadie 1972, no. 206.
34. Hayes 1959, p. 191.
35. Bénédite 1911, pp. 26-27, pl. 12; Hall 1928c, p. 74, pl. 9; Vandier d'Abbadie 1972, p. 63, no. 200.
36. Petrie 1891, pl. 18:8; Ayrton et al. 1904, pl. 17:14; Firth 1927, pl. 27e.
37. Legrain 1894, p. 61, no. 195.
38. Bénédite 1911, pp. 37-40; Petrie 1927, pl. 22:18; MacIver and Mace 1902, pl. 47; Winlock 1932b, p. 16, fig. 14.
39. Bénédite 1911, p. 41; Petrie 1937, pl. 31:752, 753.
40. Bénédite 1911, pp. 41-43; Petrie 1927, pl. 22:16.
41. Petrie 1927, pl. 22:15.
42. Hayes 1959, p. 81, fig. 43.
43. Ibid., p. 191.
44. Ibid.
45. Ibid., pp. 191-192.
46. MacIver and Mace 1902, pl. 46; Petrie 1927, pl. 22:9.
47. Hayes 1959, p. 192.
48. Nolte 1968, p. 140.
49. Carter and Newberry 1904, pp. 126-127, pl. 26:1; Petrie 1937, p. 11; Hayes 1959, p. 150.
50. Petrie 1891, pl. 27:9; Dunham and Janssen 1960, pl. 130.
51. Petrie et al. 1912, pl. 21:6.
52. See, e.g., MacIver and Mace 1902, pl. 48.
53. Engelbach 1915, p. 15, pl. 1.
54. Vandier d'Abbadie 1972, p. 60, nos. 183, 184.
55. Hayes 1953, p. 128, fig. 78.
56. Terrace 1966, pp. 57ff.
57. Frankfort and Pendlebury 1933, p. 35, pl. 38.
58. Vandier d'Abbadie 1972, pp. 55-57, nos. 161, 162, 163, 164, 166.
59. Petrie 1937, p. 11; Hayes 1959, p. 193.

262

262
Kohl pot

Provenance not known
Early Dynasty 18
Height 5.1 cm.; diameter 5.9 cm.
Manchester Museum [England] (11172).
Formerly in the Robinow Collection

Red breccia, which consists of angular white fragments of stone in a red matrix, occurs along the west bank of the Nile and in the Eastern Desert.[1] Although popular earlier and still common in the early Eighteenth Dynasty, it is a rare material for vases in the New Kingdom. There is an identical smaller kohl pot in Liverpool[2] inscribed with the cartouche of Queen Ahmose-Nefertari, and the French mission found another at Deir el Medineh,[3] its linen seal still intact, filled with galena. Traces of "kohl" were found inside this example. The pot has a matching, carefully fitted lid and a cylindrical hole inside.

J.D.B.

1. Lucas 1962, pp. 407-408.
2. Merseyside County Museums 1973-1-216.
3. Letellier 1978, p. 30, no. 30.

Literature: Engelbach 1915, pl. 14: S43.

263
Kohl pot

From Zawiyet el Aryan tomb 278
Dynasty 18, reign of Thutmose III
Height 6.35 cm.; diameter 5.8 cm.
Museum of Fine Arts. Harvard University—
Museum of Fine Arts Expedition
(11.2425a, b)

This pot in red-veined alabaster has a close-fitting lid and a tubular hole inside. The tomb in which this piece was found is datable by the pottery to the reign of Thutmose III.[1]

J.D.B.

1. Dunham 1978, pp. 56-57.

Bibliography: New Orleans Museum 1977, cat. 40; Dunham 1978, pp. 56-57, no. 4, pl. 44.

263

264
Kohl pot

Provenance not known
Dynasty 18
Height 4 cm.; diameter 3.3 cm.
Merseyside County Museums, Liverpool
(44.12.17)

Blackened limestone, used in combination with yellow incised decoration, became very popular for toilette articles in Dynasty 18. Kohl pots, beakers,[1] or figures of squatting monkeys holding tubular kohl receptacles (cat. 285) are stained black and decorated with animals, plant forms, and mythological creatures; linear and geometric patterns, including running spirals, also appear frequently. The blackened limestone and colored paste may have been in imitation of ebony with gold inlay,[2] but it is possible that the decoration was inspired by the attractive glossy black pottery with incised and paste-filled decoration of Hyksos times and later. Many vessels of this class derive from the cemeteries at Abydos,[3] one example comes from the town of Ahmose at the same site,[4] and a few have been

264

found at other places.[5] The pots have been dated to the reigns of Hatshepsut and Thutmose III,[6] but they may have occupied a longer span of time.[7]

The decoration on this kohl pot consists of a simple linear pattern around the body of the pot and a schematized floral design on the lid.[8]

E.B.

1. MacIver and Mace 1902, pl. 44.
2. Ibid., p. 71.
3. Ibid., pls. 44, 46, 47, 48, 50, 51; Garstang 1901, pl. 21.
4. Ayrton et al. 1904, pl. 15.
5. Brunton and Engelbach 1927, pl. 22:48; Steindorff 1937a, pl. 59:6; Downes 1974, p. 100.
6. Petrie 1937, p. 11.
7. Brunton and Engelbach 1927, pl. 22:48.
8. Smith 1958, fig. 22.

265

265
Kohl pot and lid

Provenance not known
Dynasty 18, probably reign of
Thutmose III
Height 6.3 cm.; diameter 6.4 cm.
British Museum, London (24391)

Bands of gold adorn the lid, the rim, and the foot of this kohl pot in sky-blue glass. A similarly banded black and white breccia kohl pot inscribed with the name of Thutmose III was found in the tomb of three of his wives.[1] Since the London pot was purchased in 1892, it cannot come from the same tomb, which was discovered and plundered in 1916[2] but, judging from its similarities, it belongs to the same period.[3]

A glass kohl pot of the same form and sky-blue color was excavated at Riqqeh,[4] and the lid of a kohl pot in lapis-lazuli colored glass was found in the tomb of Thutmose III (see cat. 269, a glass kohl pencil of the same sky-blue color).[5]

E.B.

1. Winlock 1948, p. 51, pl. 30:4.
2. Ibid., pp. 7-12.
3. Nolte 1968, p. 47, no. 5.
4. Engelbach 1915, p. 16, pl. 12:14; Nolte 1968, pp. 48 (no. 6), 178l, pl. 1:3.
5. Ibid., p. 47, no. 4.

Bibliography: Budge 1925, pp. 262, 391; Haberey 1957, fig. 5; British Museum 1964, p. 202; Nolte 1968, pp. 47 (no. 5), 178l, frontispiece b, pl. 1: 1; British Museum 1976a, no. 1760, p. 148, pl. 6.

266
Kohl pot

From Abydos tomb D10
Dynasty 18, reign of Thutmose III
Height 3.8 cm.; diameter 3.8 cm.
Museum of Fine Arts. Gift of Egypt
Exploration Fund (00.701 a, b)

The earliest glazed material from ancient Egypt is steatite,[1] beads of which were very plentiful in the Badarian civilization. Thereafter, beads, scarabs, small statuettes, and small vases were often cut from steatite. Because of its softness and the ease with which it can be cut, the silicate steatite is a very suitable material for carving into small objects; being fine grained, it also makes a satisfactory base for glazing, may be heated without cracking, and becomes very hard after heating.[2]

Carved around the body of this green-glazed kohl jar are figures in low relief —an engaging and typically Egyptian[3] mixture of desert animals and foliage with magic symbols of power and protection. A hound and a hare shown in the air to indicate the perspective of distance,[4] an antelope and ibex, a second hare, and the animal of the goddess Mafdet on a standard are preceded by a head of Hathor, goddess of love and beauty, and a design

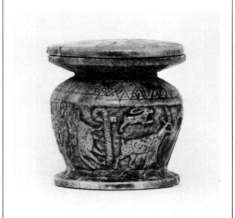

266

composed of the hieroglyphs for dominion and life. The lid is incised with a daisy or marguerite motif. The rounded forms and vigorous, informal composition suggest a date early in the Eighteenth Dynasty, which the shape of the pot confirms.

The tomb in which the kohl pot was found was a large one, with an elaborate superstructure and two burial shafts.[5] Although the pot could be as early as the reign of Amenhotep I,[6] the tomb is unlikely to have been built before the middle of the Eighteenth Dynasty. A kohl pot in the same style in the British Museum is inscribed "Amenhotep." Since the name is flanked by a cobra and a vulture,[7] it may be assumed to be a king's name. The provenance of this and of a similar pot once in the MacGregor Collection[8] is unknown.

J.D.B.

1. See Beck 1934b, pp. 69-83.
2. Cf. Lucas 1962, pp. 155-156.
3. Pace Terrace 1968, p. 56.
4. Davies 1913, pl. 22.
5. MacIver and Mace 1902, pl. 24.
6. Terrace 1968, p. 56.
7. Wallis 1898, fig. 31.
8. Ibid., fig. 14.

Bibliography: MacIver and Mace 1902, p. 86, pl. 38; Appel 1946, fig. 4; Museum of Fine Arts 1946, p. 109, fig. 65; Museum of Fine Arts 1952, p. 110, fig. 65; Terrace 1968, p. 56, fig. 17.

267

267
Kohl pot

Provenance not known
Dynasty 18, reign of Thutmose III
Height 5.6 cm.; diameter of rim 3.3 cm.
Fitzwilliam Museum, Cambridge
(E. 72.1932). Formerly in the
E. Towry-Whyte Collection

The figures carved in the panels around this pale green-glazed steatite openwork kohl pot are deities whose concerns reflect those of the pot's owner: beauty, love, and the birth and rearing of children. The apotropaic Bes image is followed by a cat, symbol of Bastet, the benevolent counterpart of the lion-goddess Sekhmet, and in the same panel is the curved stem and flower of the upper Egyptian plant. Then comes the head of Hathor and finally the figure of the hippopotamus goddess Taweret, protectress of women in childbirth. This pot illustrates clearly how the form or decoration of a container magically reinforces the value of its contents.

The pot fits into a separately made openwork stand, imitating a low table,[1] on the underside of which, completely hidden, is a carving of a marguerite. The scroll border is an early Eighteenth-Dynasty feature.[2] The sequence of figures on this pot and cat. 266 recalls those incised on the magical knives of the Middle and New Kingdoms.[3] The surface glaze has worn in patches, and there has been a little modern retouching in brown paint.

J.D.B.

1. Cf. Kayser 1969, fig. 166.
2. Compare the decoration of a double kohl tube in the Metropolitan Museum: Hayes 1959, fig. 107.
3. Petrie 1927, pp. 39ff., pls. 36-37; Steindorff 1946, pp. 41-51.

Literature: Bissing 1907b, pp. 124-125, pl. 9; Bénédite 1911, pl. 22; Vandier d'Abbadie 1972, pp. 72-73, no. 243.

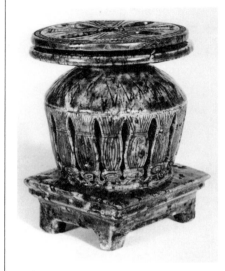

268

268

268
Kohl pot

From Riqqeh cemetery E265
Reign of Amenhotep III or IV
Height 7.5 cm.; diameter 5.7 cm.
Ashmolean Museum, Oxford. Gift of Egyptian Research Account (1913.480)

This glazed steatite jar in a separately made openwork shell, allowing a glimpse of the tube for kohl within (see p. 217), is ornamented with a frieze made up of the hieroglyphic sign *kheker*, which means "ornament" — a play on words popular with the Egyptians. As a decorative element in architecture, *kheker* friezes exist from the Archaic Period onward[1] and painted friezes occur frequently in New Kingdom tombs.[2] The sign, as the delicately carved detail suggests, probably represents a bundle of reeds tied together.[3]

The pot sits on a low stand, which copies the design of tables of the period. Pot and stand were manufactured separately, the two pieces fused together by the glazing. The lid is elaborately carved and incised with the familiar floral motif of the marguerite. Of the objects found with the pot, the only others published are beads, which are dated to the reign of Akhenaten, and scarabs and plaques, which include two with the name of Amenhotep III.[4]

This piece belongs to a small group of finely carved glazed steatite kohl pots with heraldic designs. A fragmentary specimen in Hannover[5] incorporates the cartouche of Thutmose I into the design, while a similar kohl pot in Baltimore[6] bears the name of the "King's Daughter, Mer[et]-nub,"[7] assigned variously to the Hyksos Period and to Dynasty 18.[8] Two other examples with heraldic designs are in London[9] and Philadelphia.[10] A bronze kohl pot with an openwork design of *ankh* signs and *hes* jars was recovered from a New Kingdom burial at Saqqara.[11]

The deep green glaze of this group of kohl pots is characteristic of Dynasty 18 and occurs also in cats. 266 and 267. A related class of glazed steatite kohl pots features an openwork frieze of mythological animals (see cat. 267). Yet another departure from the norm is a kohl pot in the Louvre with an openwork design of bound prisoners, glazed in deep blue.[12]

J.D.B.

1. Smith 1949, fig. 51, p. 136.
2. Mackay 1920, pp. 111-122.
3. Petrie 1895, pp. 100-103.
4. Engelbach 1915, p. 15, pl. 17: 67-72.
5. Kestner Museum 1976, pp. 278-279.
6. Wallis 1898, pl. 8:8.
7. Cf. Petrie 1917a, pl. 24.
8. Gauthier 1912, p. 151; Wallis 1898, p. 13.
9. Wallis 1898, fig. 19; Beck 1934b, p. 72, fig. 9a.
10. Ranke 1950, fig. 48.
11. Firth and Gunn 1926, p. 70, fig. 79.
12. Vandier d'Abbadie 1972, pp. 74-75, no. 244.

Bibliography: Engelbach 1915, p. 15, pl. 11: 1.

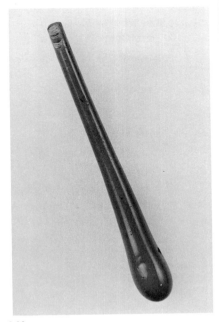

269

Kohl stick
Said to be from the Fayum
New Kingdom
Preserved height 7 cm.; diameter 0.8 cm.
Royal Ontario Museum, Toronto
(910.165.773)

The top of this glass kohl stick in sky-blue glass with a small bulbous end is broken off. A close parallel comes from a New Kingdom tomb at Saqqara.[1]

E.B.

1. Hayes 1959, p. 191.

270

270

Kohl stick
Provenance not known
Dynasty 18
Height 10.8 cm.; diameter 0.9 cm.
Museum of Fine Arts. Hay Collection,
Gift of C. Granville Way (72.788)

The black opaque haematite kohl stick with a metallic luster is inscribed for the "High Priest of Ptah, Ptahmose." Several individuals named Ptahmose bore that designation in Dynasty 18[1] and the stick might have belonged to any one of them. This particular haematite was employed as early as the Predynastic Period and was used by the ancient Egyptians for beads, amulets, kohl sticks, and small ornaments.[2]

E.B.

1. Anthes 1936.
2. Lucas 1962, p. 395.

Bibliography: Hay 1869; New Orleans Museum 1977, no. 49.

271

Kohl stick
Provenance not known
New Kingdom
Height 14 cm.; diameter 0.7 cm.
Museum of Fine Arts. Hay Collection,
Gift of C. Granville Way (72.4330)

Of fine dark brown wood with a polished surface, this kohl stick is distinguished by its flawless condition.

E.B.

Bibliography: Hay 1869.

273 272 271

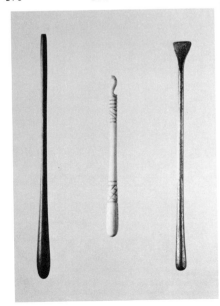

272

Kohl stick
From Abydos tomb D11
Dynasty 18, reign of Thutmose III
Height 9.2 cm.; diameter 0.6 cm.
Museum of Fine Arts. Gift of Egypt
Exploration Fund (00.713)

With incised decoration in two zones, this ivory kohl stick is surmounted by a uraeus.

E.B.

Bibliography: MacIver and Mace 1902, p. 90, pl. 50.

273

Kohl stick
From Abydos tomb D77
Dynasty 18
Height 15 cm.; diameter 0.5 cm.
Museum of Fine Arts. Gift of Egypt
Exploration Fund (01.7324)

This bronze kohl stick was found with an ivory or bone kohl tube in the form of a papyrus bud column. It has a spatula end for mixing the kohl.

E.B.

Bibliography: MacIver and Mace 1902, p. 91, pl. 51.

Literature: MacIver and Mace 1902, pl. 46; Peet and Loat 1913, pl. 11.

274

Kohl tube
Provenance not known
Dynasty 18
Height 19 cm.; diameter 2 cm.
British Museum, London (51068)

Formed of a single reed, this kohl tube bears an enigmatic inscription referring to black eye paint. Lengths of hollow reed, sometimes bound together in pairs — or larger groups with cords, rushes, or strips of cloth — were commonly used for eye paint in the New Kingdom.[1]

E.B.

1. Bénédite 1911, pl. 11; Hayes 1959, p. 191.

Bibliography: Budge 1925, p. 259; Hall 1928c, p. 74, pl. 9: 3.

275

Kohl tube
Provenance not known
Dynasty 18
Height 13.1 cm.; diameter 1.6 cm.
British Museum, London (66824)

This faience kohl tube (like cats. 276, 277 and 282) reproduces the form of

a reed. The design, composed of a garland of lotus petals toward the top and a zone of diaper pattern below, is in brown paint on a white background. The same combination of white and manganese brown appears in a kohl tube in the British Museum inscribed with the names of Tutankhamen and his wife.[1]

E.B.

1. Hall 1928c, p. 74, no. 2, pl. 9:1.

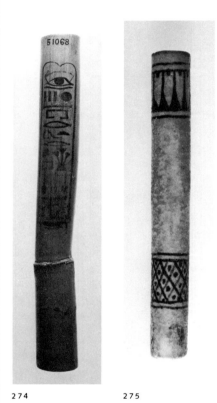

274 275

276
Kohl tube

From Sedment tomb 2010
Dynasty 19-20
Height 13.5 cm.; diameter 1.75 cm.
University Museum, Philadelphia. Gift of Egyptian Research Account (E. 14187)

The distinction of this unembellished faience kohl tube is its brilliant blue color and simple design in imitation of a reed.

J.K.M.

Bibliography: Petrie and Brunton 1924, p. 32.

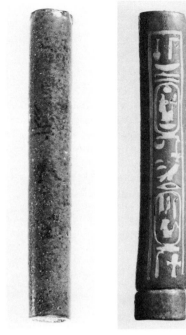

276 277

277
Kohl tube with names of Amenhotep III and Queen Tiye

Provenance not known
Dynasty 18, reign of Amenhotep III
Height 13 cm.; diameter 1.7 cm.
Lowie Museum of Anthropology, University of California, Berkeley (5-2100)

Small blue, white, or yellow faience kohl tubes with royal names inlaid in lighter blue and blue or black faience[1] were probably distributed as favors by kings Amenhotep and Tutankhamen on the occasions of festivals and court functions. Two other examples from the British Museum come from the reign of Tutankhamen: one a white faience tube painted in manganese brown with the prenomen of Tutankhamen and the name of his queen[2] and the other of deep blue faience painted in black.[3]

While the blue of the kohl tubes from the reign of Amenhotep III is often a blue-violet color, the Berkeley tube is gray-blue with the hieroglyphs inlaid in pale green.

E.B.

1. Petrie 1891, pp. 16-17, pl. 70:20; Loat 1905, pl. 4; Jéquier 1933, pl. 10; Hayes 1951, p. 235, fig. 35d; Hayes 1959, p. 257, fig. 155; James 1974, p. 107, no. 244, pl. 63.
2. Hall 1928c, p. 74, no. 2, pl. 9:1.
3. Ibid., p. 74, nos. 2, 3, pl. 9:1, 2.

Literature: Hayes 1959, p. 257; Vandier d'Abbadie 1972, pp. 66-67, no. 223; Cooney 1974, no. 201.

278
Double kohl tube and stick

From Abydos tomb D115
Dynasty 18
Height 13.6 cm.; width of base 8.5 cm.; height of stick 14.2 cm.
Museum of Fine Arts. Gift of Egypt Exploration Fund (01.7318, 01.7353)

Only the outer two of three octagonal columns of ivory on a common stand were receptacles for kohl, while the center one served as a carrier for the accompanying bronze kohl stick. Single tubes of identical form are common in graves of the New Kingdom.[1] The columns are summarily rendered, but more detailed examples[2] indicate that a papyrus bud column was intended. Part of the front of one of the tubes is missing.

Two square lids swivel horizontally on pegs set in a corner of each column. A small ivory pin driven into the front of one tube near the top is the vestige of an ivory knob like the knob on the lid; they were connected by a string, thus securing the lid. A small hole occurs in the appropriate spot on the other tube. Two pinholes on the inside of the tubes are more difficult to explain but indicate perhaps a miniature architrave like an elaborate parallel in the British Museum: two ivory bud columns are separated by a third with an open

278

papyrus flower on which the archi-
trave rests, steadying the whole.[3]

E.B.

1. See, e.g., MacIver and Mace 1902, pls. 45, 51.
2. MacIver and Mace 1902, pl. 48.
3. British Museum 1904, pp. 272 [fig. 2], 273.

Bibliography: MacIver and Mace 1902, pp. 72, 89, pl. 47.

279

279

Quadruple kohl tube and stick

Provenance not known
Dynasty 18
Height 7.3 cm.; width 4.2 cm.
Merseyside County Museums, Liverpool.
Gift of Joseph Mayer (M 11187)

Carved from a block of ebony and
covered and trimmed in ivory, this
kohl tube of quadruple cylinder type
with five separate wells was inscribed
on a plinth at the front for its owner,
the "*wab* priest of Amen in the second
phyle, Nefer-em-heb." Its ivory lid
swivels horizontally on a single ebony
knob. A connecting string wound
around an ivory knob on the lid and
another knob at the side of the block
would attach the lid; the kohl stick
also secured the lid as it passed
through a hole in the cover into a
tubular hole in the top of the block.
Three metal staples at the side were
doubtless to retain additional kohl
sticks. The ivory lid is chipped and two
bronze staples are missing. The tubes
contain remnants of kohl.

E.B.

Bibliography: Gatty 1879, p. 55, no. 327; Edwards 1888, p. 132.

280

Inscribed quintuple kohl container

Possibly from Thebes
Dynasty 18, reign of Thutmose III
Height 9 cm.
British Museum, London (5337)

Although this wooden kohl container
appears externally to have only four
wells, a fifth is concealed in the center.
A post on which the missing lid would
have swiveled projects from the top of
the plinth and on the outside of one
tube is a knob for tying the lid shut.
Between two of the tubes is a metal
loop, in which the stick was probably
stored.

Kohl tubes inscribed with information
regarding the use of the contents are
unusual. Sometimes, as on this ex-
ample, these inscriptions specify the
contents for use during a particular
season of the year. On other tubes,
the contents are identified as effective
for a specific purpose, for example,
the relief of watery eyes, or inflam-
mation.[1] Medical papyri provide con-
siderable information of this kind
since, owing to frequent sandstorms
and hot climate in Egypt, eye diseases
have always been a problem.[2]

The inscription on the plinth of this
tube consists of a prayer invoking the
god Amen-Re to give "every good and
pure thing to the *ka* of the Overseer
of Works and Scribe Ahmose." On the
tube to the left of the plinth is the
label "Fine eye paint for every day."
Remaining inscriptions specify the
contents of the other wells for use
from "the first month of Inundation

280

until the fourth month of Inundation,"
from "the first month of winter until
the fourth month of winter," and from
"the first month of summer until the
fourth month of summer."[3]

The owner of this container, Ahmose,
was an assistant to Peniati, Overseer
of Works under Hatshepsut and Thut-
mose III, and was appointed to some
of Peniati's posts after his death.[4]

S.K.D.

1. Feigenbaum 1958, pp. 134 [fig. 7], 136-137;
 Hayes 1959, p. 191; Mez-Mangold 1971, p. 23;
 James 1974, p. 54, no. 127.
2. Ebbell 1937, p. 74.
3. Budge 1925, pp. 260-261; Glanville 1928,
 p. 297.
4. Glanville 1928, p. 297; Helck 1958, p. 351.

Bibliography: Budge 1925, pp. 260-261; Glanville
1928, pp. 296-297, pl. 30; Feigenbaum 1958,
p. 137, fig. 8.

Literature: Grapow et al. 1956, p. 42; Van de Walle
and de Meulenaere 1973, pp. 67-69; Brunner 1975;
Helck 1975a; Helck 1975c; Westendorf 1975;
Schneider and Raven 1981, p. 105, no. 99.

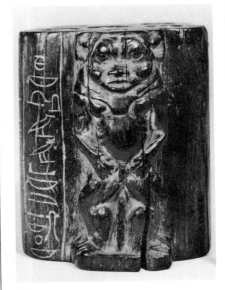

281

281

Quintuple kohl tube of the Scribe It

Provenance not known
Dynasty 18, reign of Amenhotep III
to that of Tutankhamen
Height 8.2 cm.; width 6.6 cm.
Petrie Museum, University College,
London (30136). Formerly in the Grenfell
and Wellcome Collections

The quintuple kohl tube of the Scribe
It is a critical piece of evidence for
understanding the origin and develop-
ment of the Bes-image. The inscrip-
tion identifies the figure as Aha ("the
fighter"), one of a host of minor
deities depicted by the Bes-image.[1]

Aha also appears as a lion-man on numerous carved ivory amulets called "magic knives" in the Middle Kingdom and Second Intermediate Period.[2] The early version of Aha is quite lion-like, with a long mane and tail, ribs common to Egyptian representations of lions, and a sleek feline body.

The present example carved in mid-Dynasty 18, demonstrates how much the figure of the lion-man had changed since the Middle Kingdom. For an unknown reason, Egyptian artisans working just prior to the reign of Amenhotep III chose to stress the human rather than the animal aspects of the Bes-image:[3] his limbs lost their long claws, he assumed more animated postures, he adorned himself with a headdress and skirt, and his body took on many of the characteristics of the sub-Saharan Bushman.

Yet the craftsmen who created this new type of Bes-image did not disassociate it completely from its original leonine aspect.[4] Thus, even in late Dynasty 18, we encountered Bes-images with stylized lachrymal discharges common to the great jungle cats (cat. 75) and pronounced folds of flesh across their faces, perhaps alluding to the strained muzzle of a snarling lion. We also find Bes-images with hair that is rough and tufted like a lion's and continues onto the figure's chest precisely like the so-called ventral mane of the male lion (cats. 48, 49, and 350). Even the figure's bent-leg attitude seems to refer to the Bes-image's link to the animal world since, when a lion or other great cat stands on its hind paws, it must keep those legs flexed. Egyptian artists could depict legs bent in that manner only by showing them in profile, exactly as they appear in Bes-images shown frontally.

Once the leonine aspects of the Bes-image become apparent, we no longer have to search outside of Egypt for its origin. Lion-men are known in Egyptian art as early as the Old Kingdom. Two Fifth-Dynasty reliefs, one in the British Museum[5] and another from the mortuary temple of King Sahure at Abusir[6] depict lion-headed humans ancestral to the familiar Bes-image of Dynasty 18. Far from being a late import, the Bes-image is clearly an early, autochthonous creation of the Egyptian imagination.[7]

The University College kohl tube is carved from ebony. The Bes-image at its front is naked and stands, as often, facing front with hands on hips, knees bent, and feet turned out. The head has large feline ears, eyebrows arcing over large round eyes, a broad nose, and open mouth. In this instance, the tongue is not indicated. A curved beard covers the cheeks and a mane falls onto the shoulders and continues in a horizontal line across the chest. The torso and limbs are thick and muscular, the genitals indicated, and the tail shown between the legs. At the left side of the container a monkey squats with forepaw raised, holding a fig or *dom* palm nut to its mouth.

Eight columns of hieroglyphs cover the rest of the container. The inscription reads:

I am the Good One, who applies black
 eyepaint for the owner, the Scribe it,
[I am] the One who vanquishes tears.
I am Aha, who gurds by means of the
 sa amulet for the owner every day.
Remedy for *dehat* (an eye ailment)
An offering that the king gives Amen-
 Re, lord of Karnak, that he may grant
 a good life, favor, and love to the
 spirit of the liege man of his lord,
 the Scribe It, may he live again.

The inscription engraved directly over the head of the female monkey, identifies her as "the Good One" and presents a prayer for the spirit of the deceased owner.

Most representations of the Bes-image can be associated with the feminine portion of ancient Egyptian society, appearing on women's beds, mirrors, and the like. But the figure was not without its male devotees. This piece, for example, belonged to the Scribe It. The inscription also relates that at least one of its five tubes originally held a prescription to treat an affliction of the eyes (see cat. 280).

<div align="right">J.F.R.</div>

1. Romano 1980, p. 39.
2. Steindorff 1946; George 1980.
3. Romano 1980, p. 46.
4. Ibid., p. 48.
5. James 1961, pl. 25:3.
6. Borchardt 1913b, pl. 22.
7. Romano 1980, p. 48.

Bibliography: Burlington Fine Arts Club 1895, p. 38, no. 18, pl. 6; Sotheby 1917, p. 7, no. 52.

282

282

Double kohl tube with stick

Provenance not known
Dynasty 18
Height 10.2 cm.; width 4 cm.
The Brooklyn Museum, Brooklyn,
New York. Museum Collection Fund
(11.671.1-2)

Molded in blue faience, this kohl container consists of two tubes of equal height joined together with bands of the same material. The tubes are decorated with three vertical black lines on each side and one black band around the neck of each tube. The necks are stopped up with small balls of linen tightly wedged in place. The bronze kohl stick is inserted in an opening between the tubes.

A kohl tube of virtually identical form from Abydos[1] is decorated with a design of floral chaplets and the figure of a woman in black glaze.

<div align="right">E.B.</div>

1. Bissing 1902, pp. 85-86.

Literature: Giorgini 1961, pl. 26; Björkman 1971, p. 81, no. 95, pl. 22.

283

Triple kohl tube

Provenance not known
Dynasty 18
Height 15.8 cm.
Agyptisches Museum, Berlin (6772)

The binding of the wooden cylinders is decorated at the top and bottom with a band of geometric ornament — straight lines and wavy lines. Identical

examples in ivory or bone are in Paris and Berkeley;[1] other parallels are decorated with animal motifs.[2]

E.B.

1. Vandier d'Abbadie 1972, pp. 67-68, no. 224; LMA 6-18474; see also Ayrton et al. 1904, pls. 15-16.
2. MacIver and Mace 1902, pl. 46; Petrie 1927, pl. 22:10.

Bibliography: Agyptisches Museum 1967, no. 578.

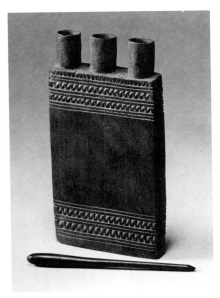

283

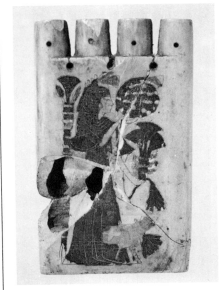

284

284
Quadruple kohl tube
Said to be from Thebes
Dynasty 19
Height 14.6 cm.; width 8.5 cm.
The Brooklyn Museum, Brooklyn, New York. Charles Edwin Wilbour Fund (49.51)

Carved from a single block of ivory, the four tubes, spaced slightly apart, are represented as if enclosed within a wide, flat binding, which extends some three-quarters of the way up their lengths. Each tube is pierced by a hole near the top, while the binding near the top on the front is pierced with three larger holes. A similar (triple) kohl tube in the Metropolitan Museum[1] has three small ivory pins driven into the front of each tube near the top, evidently for a cord from the missing stopper. A double kohl tube in limestone from a plundered New Kingdom grave at Saqqara, similarly pierced, has two dome-shaped stoppers in the tubes.[2]

The figures of a fashionably dressed man and woman are executed on the front of the triple New York tube in a style that, in its heaviness, heralds the approach of the Ramesside Period.[3] The front of the Brooklyn container is decorated with the incised and colored figure of a lady dressed like the stylish ladies in the tomb of Userhat under Seti I at Thebes[4] or the fashionably attired woman from a Ramesside tomb at Saqqara.[5] The Brooklyn lady stands before a formal bouquet with a tray of fruit and flowers. At her feet marches a sacrificial calf. On the reverse is a formal floral arrangement of papyrus, lotus, and pomegranates with four brace of ducks; the formal bouquet resembles that held by the Ramesside lady from Saqqara.

The Brooklyn kohl tube was reassembled from several fragments. A large section that exposes the depth of the tubes is missing from the lower left side of the front and small fragments along other breaks are missing. The ends of two tubes are chipped. The entire surface of the object is covered with an unidentified brown varnish-like substance that may be ancient. There are remains of kohl in the tubes.

E.B.

1. Hayes 1959, pp. 315-316.
2. Quibell 1908a, p. 5, pl. 34:2.
3. Hayes 1959, pp. 315-316.
4. Davies 1927, pls. 5-8.
5. Quibell 1912, pls. 67:2, 72.

Bibliography: Sotheby 1924, pl. 4, lot 79.

285

285
Monkey holding a kohl tube
Provenance not known
Dynasty 18
Height 6.5 cm.; width 2.1 cm.
Fitzwilliam Museum, Cambridge (E.14.1901)

The monkey so familiar to the New Kingdom, and Dynasty 18 especially, grasps this kohl tube of blackened limestone with yellow-filled incised decoration (see also cat. 264). The decoration consists of the figure of the hippopotamus goddess, probably Taweret (next to the monkey on one side) and a Bes-image on the other; on the front of the tube appears a jackal head on a stand, a common motif on vessels of this class.

Unlike a similar composition (cat. 286), only the head and shoulders of the monkey and the top of the tube are fully carved; the rest is left a block of stone, on the surface of which the monkey's body is incised, its sketchy forepaws holding the tube and its tail trailing between its legs. A very close parallel to this vessel, also dated to Dynasty 18, is in London;[1] the monkey is not carved fully away from the tube it grasps; its body is incised, as is the figure of the hippopotamus goddess decorating the front.

G.L.S.

1. Petrie 1937, p. 11, pl. 31:755.

Bibliography: MacIver and Mace 1902, pl. 44.

Literature: MacIver and Mace 1902, pls. 46, 48, 50; Bissing 1907b, pl. 9; Vandier d'Abbadie 1972, p. 60, no. 185.

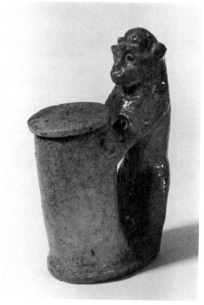

286

286
Monkey holding a kohl tube
Provenance not known
Dynasty 18
Height 18.3 cm.
Fitzwilliam Museum, Cambridge
(E.343.1954)

Molded of blue faience, this fully modeled monkey stands holding a kohl tube (cf. cat. 285). The tube is undecorated and is equipped with a flat lid.

Monkey handles appear on numerous vessels of the New Kingdom, including stone vases (cat. 117) and kohl tubes

of a variety of materials, such as cat. 285, the present example in faience, and a wooden monkey holding a rectangular kohl container from an early New Kingdom tomb at Deir el Medineh.[1]

G.L.S.

1. Bruyère 1948, pp. 5-7, figs. 1-2.

Literature: Vandier d'Abbadie 1972, p. 60, nos. 183-184.

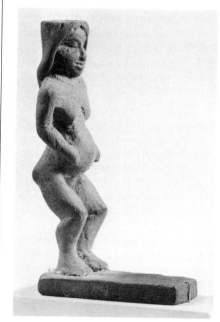

287

287
Kohl tube in the form of a nude woman
Provenance not known
Late Dynasty 18 or early Dynasty 19
Height 12.8 cm.
Museum of Fine Arts. Hay Collection, Gift of C. Granville Way (72.4158)

Regardless of their age or social status, women in ancient Egypt were represented with elegant bodies and delicate features. In rare instances this ideal of beauty was not upheld. Such is the case in this example, where the body of a woman with sagging breasts, protruding belly, and rolls of fat is hollowed out to form a container for kohl. Strikingly similar to medicine containers in the form of pregnant women,[1] this wooden kohl tube may likewise represent a woman in advanced pregnancy. Lavish use of black paint to highlight a large pubic triangle and nipples further enhances the fertility aspect of this piece. Black paint was also used to emphasize her large eyes and flowing tresses, which

fall below her shoulder to mid back. Remains of yellow paint around her neck suggest she once wore a broad collar. The awkward squatting position she assumes is reminiscent of that of Taweret and the Bes-image, both deities who played a role in ensuring a safe pregnancy and childbirth.[2] The latter also serves as a receptacle for eye paint. Kohl containers in anthropomorphic and zoomorphic shapes became popular in the late Eighteenth Dynasty.

Two pairs of tiny holes on her back at shoulder and waist level may have been part of a device to hold a kohl stick.

R.E.F.

1. Brunner-Traut 1970b, pp. 35ff.; see cat. 404.
2. See cat. 288.

Bibliography: Hay 1869, no. 487.

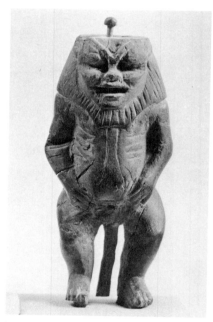

288

288
Kohl tube in the form of a Bes-image
Provenance not known
Dynasty 18, reign of Amenhotep III to Tutankhamen
Height 13 cm.; width 5.2 cm.
Museum of Fine Arts. Hay Collection, gift of C. Granville Way (72.4308)

The naked Bes-image stands frontally with his legs slightly bent and his hands on his swelling abdomen. On his face, straight eyebrows meeting at the root of the nose rise obliquely

over small eye cavities that were once inlaid. Cosmetic lines extend from the outer canthi. Beneath a small nose is an extremely broad, open mouth, which once held an inlaid tongue. The mane falls over his shoulders and extends horizontally across his chest. An incised rib cage and median line are visible on the thick torso; his tail falls between his legs. The body, drilled to contain kohl, has a pivot on top of its head for a lid (now missing). Although this wooden container reflects neither the charm nor the high degree of technical accomplishment of many of its contemporaries, it is a rare example of a toilette article that once belonged to a member of Egypt's middle class.

The indication of the ribs suggests a date within the seven decades separating the coronation of Amenhotep III and the burial of Tutankhamen. This dating is confirmed by the open mouth and deep eye cavities that once contained inlays in another material such as colored glass. Inlaid Bes-images of this kind appear very infrequently in Egyptian history; only one firmly dated example can be cited from Dynasty 18, a highly stylized cosmetic container from Amarna, Akhenaten's capital.[1]

J.F.R.

1. Frankfort and Pendlebury 1933, p. 35, pl. 88:1-3.
Bibliography: Hay 1869.

Jewelry

Earrings

Earrings became popular in Egypt in the course of Dynasty 18, after sporadic appearances considerably earlier, during the Middle Kingdom. An ivory doll wearing spiral earrings, excavated from a grave at Hû,[1] probably dates from Dynasty 12, and there are two finds of earrings from burials at Sheikh Farag that have been assigned to the Middle Kingdom.[2]

Some scholars believe the Egyptians adopted earrings from their neighbors to the south;[3] others suggest an origin in the Near East, where earrings are known as early as 2100 B.C. in the Royal Cemetery of Ur.[4] Allowing that there may well be validity in both theories, it has been proposed that parallels from the south may have undergone Near Eastern influence during the Hyksos Period (Dynasty 15).[5]

Men, women, and children of both sexes wore earrings during the New Kingdom. The men who are depicted wearing earrings all belong to the highest echelon of the bureaucracy. They also wear the *shebyu*, a special gold necklace (see cat. 316) bestowed ceremonially by the king on favored officials, suggesting that earrings, like the necklace, could be awarded for meritorious service.[6] Confirmation comes in a scene from the Memphite tomb of General (later King) Horemheb: among the jewelry that Horemheb received from his sovereign at the ceremony "Awarding the Gold of Honor" were two pairs of earrings (see fig. 1). Unlike other types of ancient Egyptian jewelry, earrings seem to have had no amuletic function, although of course motifs employed in their design might have amuletic significance.

In design and material Egyptian earrings show considerable variety. Included in this catalogue are four types: penannular—or hoop—earrings, tube-and-boss earrings, ear studs, and ear plugs.

M.E.-K.

1. Petrie 1901, p. 43f., pl. 26.
2. Reisner 1923b, p. 280.
3. Andrews 1976, p. 44; Bakr 1977, pp. 55ff.
4. Aldred 1971, p. 142; Edwards 1976b, p. 15.
5. Wilkinson 1971, p. 121.
6. Bakr 1977, p. 59.

289

290

291

289
Spiral ornament
From Semna, grave S716
Dynasty 18
Height 1 cm.; diameter 2.3 cm.
Museum of Fine Arts. Harvard University—
Museum of Fine Arts Expedition (24.1788)

To make the spiral the craftsman twisted a gold wire tightly around a rod. Ornaments of this kind have not to date been found in place on a mummy in Egypt. However, in the Royal Cemetery of Ur in Mesopotamia, gold spirals were discovered beside the skulls of women, suggesting their use as either hair rings or earrings. The ivory doll from Hû (see p. 227) evinces similar ornaments that are clearly earrings. Others occur in burials of the so-called Pan-Grave people, dating to the Second Intermediate Period.[1] The excavators have customarily described them as finger rings.

A pair of spiral rings of gold-plated copper were found at Kerma in a burial datable to the Hyksos Period or, at the latest, to the very beginning of Dynasty 18.[2] The association of such ornaments with the south—this example comes from Semna—continued through the New Kingdom and even into the Napatan Period.[3]

M.E.-K.

1. Bietak 1966, p. 29.
2. Reisner 1923b, p. 281, pl. 44:1, 16.
3. Wenig 1978b, p. 249, no. 180.

Bibliography: Dunham and Janssen 1960, p. 108.

290
Penannular earring
Provenance not known
New Kingdom
Diameter 2.5 cm.
Fitzwilliam Museum, Cambridge
(EGA 224.1947). Formerly in the R. G. Gayer Anderson Collection

Penannular earrings such as this example in alabaster are simply a hoop with a narrow opening. Such earrings might be clipped directly onto the ear or worn by passing a pin (as in cats. 295 and 296) or a wire through two loops attached to the ring and simultaneously through a hole in the earlobe.

Cleft hoops of this type in stone (see cat. 291), ivory, shell, glass, or gold (see cat. 292) are sometimes described as hair rings, rather than earrings, because the narrowness of the cleft would seem to preclude fitting such rings onto the earlobe. It has been postulated that hair was introduced through the cleft and packed into the hoop. But evidence is lacking, both from representations and from burials, that the Egyptians wore such rings in their hair. Excavation of a New Kingdom cemetery at Balabish[1] turned up a mummy wearing stone earrings of this type, but with a larger cleft. To account for the examples where the cleft is too narrow to have been slipped onto the ear, a strictly funerary function has been suggested, i.e., that the earrings were never worn in life but simply deposited as token jewelry with the mummy.[2]

M.E.-K.

1. Wainwright 1920, p. 55, pl. 19:2.
2. Williams 1924, p. 116.

Literature: Engelbach 1915, pl. 16; Wainwright 1920, pl. 20; Peet and Woolley 1923, pl. 13; Bakr 1977, pp. 59-60.

291
Penannular earring
Provenance not known
Dynasty 18
Diameter 2.8 cm.
Royal Ontario Museum, Toronto
(979 x 2.45)

Cleft hoops of carnelian and jasper of graduated circumference and width, varying from barrel-shaped to a narrow ring, are very common in New Kingdom graves and museum collections. This red jasper barrel-shaped hoop with a wide gap is paralleled by many excavated specimens in gold, jasper, and faience.[1] The serrated ridge on the perimeter of the earring probably imitates the braided wire decoration found in the gold examples.

M.E.-K.

1. Petrie 1891, pl. 26:6; Daressy 1902, pl. 9; MacIver and Mace 1902, pls. 49, 50; Engelbach 1915, pls. 16, 51; Steindorff 1937a, pl. 57; Bourriau and Millard 1971, figs. 8, 9, 10.

292

292
Penannular earring
Provenance not known
Dynasty 18-19
Diameter 2 cm.
The Brooklyn Museum, Brooklyn, New York. New-York Historical Society, Charles Edwin Wilbour Fund (37.744 E)

Except for a few dents and scratches, the electrum earring is perfectly preserved. It was probably made in two pieces, the two parts then soldered together, and the seam very carefully polished and burnished so that now it can scarcely be detected. The open ends were closed with pieces of sheet metal, in one of which a hole was punched to allow the escape of gases generated in soldering the joints.

In Theban tomb 15 of early Dynasty 18, Tetiky wears heavy hoop earrings,[1] in another tomb Sennefer, mayor of Thebes under Amenhotep II, wears a type of heavy gold earring similar to the present example.[2]

Royal examples of Dynasty 19 often have small rings soldered to the lower arc of the hoop from which hang pendants in other materials.[3]

E.B.

1. Carnarvon and Carter 1912, pl. 6.
2. Lange and Hirmer 1968, pl. 23.
3. Davis 1908, pl. [15]; Aldred 1971, p. 234, pl. 131.

Bibliography: Williams 1924, p. 117, no. 44, pl. 15a, b.

Literature: ·Petrie 1891, pl. 26:7, 11; MacIver and Mace 1902, pl. 46.

293

293

Pair of penannular ribbed earrings
From Abydos tomb 941, A.09
Dynasty 18
Diameter 3.3, 3.4 cm.
Merseyside County Museums, Liverpool.
Bequest of Lt.-Col. J. R. Danson
(1977.108.6a,b)

Earrings of this type vary greatly in size, so much so that the large examples were once believed to be bracelets,[1] but they were all made in the same manner. The prototype consists of four, five, or six gold rods, one or two being longer than the others. Each rod is hollow and triangular in section. The jeweler bent the rods into a penannular shape and soldered them together with the longer rod or rods

in the center. The narrow cleft just allowed the central rod or rods to be inserted through the pierced earlobe.

The earliest examples of this type of penannular earring date to Dynasty 17.[2] In the reign of Thutmose III they became popular and continued in vogue throughout Dynasty 18.[3] A wooden statuette of a naked woman of New Kingdom date in London wears earrings of this type,[4] and an x-ray of the mummy of Meryet, the wife of Kha, an architect under Amenhotep III, shows that two pairs of such earrings might be worn simultaneously, a pair in each ear.[5] A variation of this earring in the Metropolitan Museum, from the excavations of Lord Carnarvon at Thebes, is decorated with small lapis-lazuli beads threaded around the rim.[6] Earlier examples include a pair of earrings in a Theban burial of Dynasty 17 with four rings each made hollow but not as thin as the later earrings[7] and at least two pairs in the treasure of Queen Ahhotep.[8]

M.E.-K.

1. Garstang 1909, p. 129.
2. Petrie 1909b, p. 9, pl. 29; Aldred 1971, p. 198, fig. 48; Mariette 1872, pl. 31; Maspero 1915, p. 429, fig. 123.
3. MacIver and Mace 1902, p. 89, pls. 46, 53; Petrie 1906a, p. 16, pl. 13; Engelbach 1915, pp. 31-32, pl. 51:3; Dunham 1978, p. 45, pl. 35.
4. Bakr 1977, fig. 4.
5. Curto and Mancini 1968, p. 79b, fig. 3, pl. 13:2.
6. Hayes 1959, p. 186, fig. 102; Wilkinson 1971, p. 126, fig. 52.
7. Petrie 1909b, p. 9, pl. 29; Aldred 1971, p. 198, fig. 48.
8. Mariette 1872, pl. 31; Maspero 1915, p. 429, fig. 123.

Bibliography: Garstang 1909, pp. 128-129, pl. 15; Bourriau 1979, p. 151, pl. 26:1.

Literature: Schäfer 1910, pp. 26-27, pl. 5: 21, p. 58, pl. 14: 90; Vernier 1927, pp. 132-133, 136-137, pl. 32; British Museum 1978, p. 62, no. 55c, d.

294

Pair of penannular ribbed earrings
Provenance not known
Dynasty 18
Diameter 2.8 cm.
British Museum, London. Franks Bequest (54317-8)

Little inlaid flowers with five rounded petals ornament these penannular gold earrings, a variant of the type represented by cat. 293. The flowers are attached at the point where the outer tubes end, and they presumably rested against the earlobe. The central of five triangular tubes is longer than

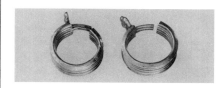

294

the others and on either side of it gold wire was soldered. The earrings are very like five pairs found in the treasure of three wives of Thutmose III buried at Gurna,[1] of which four pairs are decorated with circular cloisonne inlaid with glass and a fifth is surmounted by a lily flower.

E.B.

1. Winlock 1948, pp. 17-18, pls. 6, 8b.

Bibliography: Andrews 1976b, p. 14; British Museum 1978, p. 62, no. 55d.

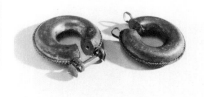

295

295

Pair of penannular earrings
From Abydos tomb 941, A.09
Dynasty 18
Diameter 2.5 and 2.7 cm.
Merseyside County Museums, Liverpool.
Bequest of Lt.-Col. J. R. Danson
(1977.108.9a,b)

The locking pin is missing from one of these gold penannular earrings. The undisturbed burial in which they were found also included some stone and alabaster vases of considerable delicacy and beauty, two pottery figure vases and a blue faience fish bowl,[1] a collar of gold pendants (cat. 313), six gold ribbed earrings (see cat. 293), a gold ring and gold-mounted scarabs (cat. 329), a pair of blue and yellow glass earrings of penannular type, a glass ear stud, some small pendants of gold and lapis lazuli, and two fly decorations.[2]

Each of these earrings was made from sheet metal cut into two circles and raised by beating to form one side of the hoop. The two halves were soldered together, the join being masked on the outside by a plaited rope pattern of gold wire.[3] As in cat. 292, there is a hole in each end closure to allow the escape of soldering gases. The earrings were worn by passing the locking pin through a hole in the earlobe. Queen Ahhotep took a pair of gold earrings of this sort with her to the grave,[4] and still in place on the mummy of Kha in Turin, who died in the reign of Amenhotep III, is a pair of such earrings.[5] Other examples have been found at Saqqara and Zawiyet el Aryan.[6] A pair from the tomb of Tutankhamen are similar but more elaborate, with tassels.[7]

The Liverpool earrings, along with much of the contents of the tomb mentioned above, belonged to the donor's father, F. C. Danson, who subscribed to a number of Garstang's excavations and received a share of the finds.

E.B.

1. Garstang 1909, p. 129, pl. 16.
2. Ibid., p. 129, pl. 15.
3. British Museum 1978, p. 62, no. 55b.
4. Mariette 1872, pl. 31; Maspero 1915, p. 429, fig. 123.
5. Curto and Mancini 1968, p. 79e, pl. 12:1.
6. Vernier 1927, p. 126, no. 29.
7. Desroches-Noblecourt 1963, p. 23, color plate 3b.

Bibliography: Garstang 1909, p. 129, pl. 15; Bourriau 1979, p. 151, pl. 26:1.

296
Penannular earring with locking pin
Provenance not known
Dynasty 18
Diameter 2.5 cm.
The Metropolitan Museum of Art, New York. Gift of Miss Helen Miller Gould (10.130.1540). Formerly in the Murch Collection

The analogous design of earrings securely dated to the later Eighteenth Dynasty by their archaeological context suggests a similar dating for this piece (see cat. 293). The gold hoop is inlaid with lapis lazuli in an imbricated pattern that is probably intended to reproduce the appearance of feathering.

M.E.-K.

Bibliography: Mace 1911, p. 26, fig. 19; Hayes 1959, p. 186, fig. 102; Wilkinson 1971, p. 126, fig. 53.

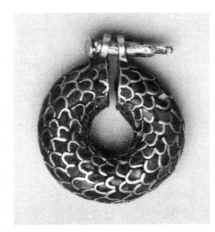

296

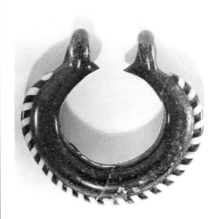

297

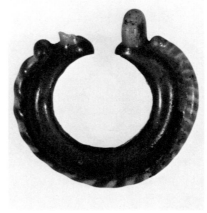

297

297
Penannular earrings
a. Deep blue glass earring with blue and white twisted trail
Provenance not known
New Kingdom
Height 2.8 cm.
Fitzwilliam Museum, Cambridge. Gift of G. D. Hornblower (E.320.1939)

b. Turquoise, white, and yellow glass earring
Provenance not known
New Kingdom
Height 2.1 cm.
The Corning Museum of Glass, Corning, New York (59.1.44)

These glass earrings are of the same penannular form as cats. 295 and 296. They were manufactured by drawing a glass thread or cane into an open-ended circle and forming the ends into two vertical loops; the glass might be two twisted threads of different colors and an elaboration of the basic design could be achieved by pressing another thread—either plain or bicolored[1] into the perimeter of the hoop.[2]

Glass earrings of this type were presumably attached to the earlobe by means of a metal wire hoop, as evidenced by an earring in the British Museum.[3] The vertical loops are often not aligned, prohibiting the use of a pin as in cat. 295.

Numerous glass earrings of similar form, but without the vertical loops, were excavated from the palace of Amenhotep III at Malkata and at Amarna, as well as from the tomb of Tutankhamen.

M.E.-K.

Bibliography: Goldstein 1979a, p. 180, no. 129.

1. Fitzwilliam E. 320.1939.
2. British Museum 1978, pp. 92-94.
3. Ibid., p. 93.

Literature: British Museum 1978, pp. 93-95.

298
Ear studs
a. White and dark blue glass ear stud
Provenance not known
Dynasty 18
Height 2.6 cm.; diameter 2.2 cm.
The Brooklyn Museum, Brooklyn, New York. Charles Edwin Wilbour Fund (58.28.6)

b. Opaque red glass ear stud
Provenance not known
Dynasty 18
Height 2.1 cm.; diameter 1.8 cm.
Royal Ontario Museum, Toronto (909.80.17)

c. Turquoise glass ear stud with yellow trail
Provenance not known
New Kingdom
Height 2.8 cm.; diameter 1.5 cm.
Fitzwilliam Museum, Cambridge. Gift of G. D. Hornblower (E.322.1939)

d. Black glass ear stud with red, white,
 and yellow trails
 Provenance not known
 New Kingdom
 Height 3 cm.; diameter 1.7 cm.
 Fitzwilliam Museum, Cambridge. Gift of
 G. D. Hornblower (E.324.1939)

In form, ear studs resemble a mush-room. The shape of the shaft, which
was inserted through a hole in the
earlobe to display the circular head on
the outside, varies from short and
bulbous to long and straight. The head
may be either flat or domed.

The vast majority of these ear orna-ments were manufactured in glass or
faience (cat. 299), although studs
made of other materials such as bone,
ivory, gold, alabaster, or even wood
(cat. 300) are known. The earliest ex-cavated ear studs, found at Kerma,
are of faience and ivory and date to
the Hyksos Period.[1] Many excavated
glass ear studs come from Malkata,
the site of the immense palace com-plex built at the order of Amenhotep
III. Most of the examples from other
sites are of ivory, bone, or alabaster,[2]
but one pair of opaque red glass studs
was found at Amarna[3] and a badly
weathered glass stud was found at
Zawiyet el Aryan,[4] while there are a
number of glass ear studs, said to
come from Memphis, in the Salt col-lection in the British Museum.[5] Their
popularity began to wane with the
decline of glass production toward the
end of Dynasty 19.

A decorative effect was often created
in glass quite simply by using two
twisted threads of different color for
the shaft and edging the monochrome
head with the contrasting color. In the
Brooklyn ear stud (cat. 298a), the
edging of the head is created from
two twisted threads.

M.E.-K.

Bibliography: Fitzwilliam Museum 1978, no. 5b.

1. Reisner 1923b, pp. 257-258.
2. Loat 1905, pl. 4; Engelbach 1915, pl. 16; Peet
 and Woolley 1923; Dunham 1978, pp. 70, 71.
3. Samson 1972, p. 75, fig. 45i.
4. MFA 11.2685.
5. British Museum 1978, pp. 92ff.

Literature: British Museum 1978, pp. 92-94.

298a

298b

298c

298d

299

299
Ear stud
Provenance not shown
Dynasty 18-19
Height 2.8 cm.; diameter 1.7 cm.
Fitzwilliam Museum, Cambridge. Gift of
G. D. Hornblower (E.383h.1939)

The heads of faience studs, like ear
plugs (see cat. 301), often bear a
pattern in the form of a marguerite
in red, white and blue colors.

M.E.-K.

300

300
Ear stud
Provenance not shown
New Kingdom
Height 4 cm.; diameter 2 cm.
Fitzwilliam Museum, Cambridge. Bequest
of R. G. Gayer Anderson (EGA 281.1947)

It is quite unusual to find an ear stud
of this sort in wood. The head of the
stud is divided by four incised lines
radiating from a central point.

E.B.

301
Ear plug
Provenance not shown
Probably Dynasty 18
Diameter 6.5 cm.
Fitzwilliam Museum, Cambridge. Bequest
of R. G. Gayer Anderson (EGA 2600.1943)

Ear plugs are disks with a grooved
edge that were worn in a hole in the
earlobe. Usually only one convex
face of the plug is decorated, but late
examples bearing a different design on
each face are known. The marguerite
is the source for the floral design in the
center of this piece.

It has been suggested that the ear
plug form was derived from the ear
stud toward the end of Dynasty 18,[1]
but a black stone ear plug excavated

303, 301

302

304

305

304

306

at Kerma,[2] and datable to the Hyksos Period, strongly suggests that ear plugs, like ear studs (see cat. 298), originated early in the south. Plain ear plugs in stone,[3] ivory,[4] and pottery,[5] as well as decorated faience plugs, have been found in burials of the New Kingdom, for example, a pair of simple black pottery plugs from Abydos,[6] which are identical in form and much the same size as the Fitzwilliam specimen.

In the tomb of Kenamen, a contemporary of Amenhotep II, a pair of ear plugs decorated with a marguerite pattern is included, along with two bracelets, in a display of products from the workshop of the temple of Amen at Thebes.[7] Beginning in the reign of Amenhotep III women are shown in sculpture in the round, as well as in relief and painting, wearing large ear ornaments that are probably plugs, although they could be abnormally large studs.

Because of their large diameters, ear plugs have sometimes been described incorrectly as bobbins. However, female mummies with holes stretched to enormous proportions in their earlobes have been excavated,[8] so that doubt as to the use of large disks no longer exists.

The material most commonly used for the manufacture of decorated plugs is faience, but the present example is said to be made of Egyptian blue; in Edinburgh there is an elaborately fashioned gold ear plug thought to come from the royal tomb at Amarna.[9]

M.E.-K.

1. Aldred 1971, p. 144.
2. MFA 13.4243.
3. Petrie 1891, pl. 18:47.
4. Ayrton et al. 1904, pl. 17:9.
5. Ibid., pl. 16:7.
6. Ibid.
7. Davies 1930, pl. 19.
8. Winlock 1942, pl. 87.
9. Aldred 1971, p. 144, pl. 68, top, center.

302

Ear plug

Provenance not shown
New Kingdom
Diameter 3.3 cm.
The Metropolitan Museum of Art, New York. Gift of Edward S. Harkness (26.7.1142)

This ear plug of yellow, blue, and white glass is of characteristic New Kingdom shape, for which numerous

ivory and alabaster parallels are known,[1] but an excavated example in polychrome glass was found at Abydos in a tomb that also contained an inscribed bead of the high priest Pinodjem of Dynasty 21,[2] so the present example might be slightly later than the Empire Period.

E.B.

1. See, e.g., Petrie 1891, pl. 18:47; Ayrton et al. 1904, pl. 17:9.
2. MacIver and Mace 1902, p. 88, pl. 45.

Literature: British Museum 1976a, no. 1834.

303

Openwork ear plug
Provenance not known
Probably New Kingdom
Diameter 2.8 cm.
Fitzwilliam Museum, Cambridge. Gift of R. G. Gayer Anderson (EGA 2591.1943)

This faience ear plug is less than half the size of cat. 301 but by modern standards still very large for insertion into a pierced ear. Like the Egyptian blue ear plug, it also has a rosette motif in the center, a design common for this type of earring; in this case it is executed in pierced openwork. The technique is known at least as early as the Second Intermediate Period[1] and gained popularity in the New Kingdom (cats. 267 and 268).

A similar ear plug datable to the New Kingdom was found at Lisht.[2] The type continues into the Late Period, when it also appears in the Sudan.[3]

R.E.F.

1. Newberry 1933, p. 54, pl. 10:2-5.
2. Gautier and Jéquier 1902, pp. 106-107, fig. 142.
3. See, e.g., Dunham 1950, p. 87, pl. 51a,b; Dunham 1970, p. 69, fig. 45, pl. 56b.

304

Tube-and-boss earring
Provenance not known
New Kingdom
Diameter about 5.5 cm.
Rijksmuseum van Oudheden, Leiden, (Ao1e/653-54/E.xl. 122). Formerly in the Anastasi Collection

Tube-and-boss earrings consist of two halves identical in design: a cylindrical tube attached to the underside of a button-like boss. One tube is slightly smaller in diameter, allowing it to fit inside the other. The tubes are sometimes ribbed so that the two halves grip each other and the pierced ear-lobe through which they are to be inserted. When worn, only one boss is visible from the front, therefore it is common to find only a single boss decorated. This is not the case, however, with the present gold earring, one of a pair, whose bosses both bear the same flower-like design reproduced in *repousse*.

A wooden sculpture from Tutankhamen's tomb depicting the head of the newborn sun god upon a lotus blossom displays half of a simple tube-and-boss earring through the left earlobe;[1] three complete pairs of tube-and-boss earrings were also recovered from the tomb. The form may be a variant of the ear stud (see cat. 298); it is also related to a further elaboration of the type of penannular earring illustrated by cats. 295 and 296.[2]

M.E.-K.

1. Silverman 1978, p. 29.
2. Aldred 1971, pp. 229-230; Edwards 1976a, pl. 16.

Bibliography: Leemans 1848-1850, pl. 39:53a-b.

305

Leech-type earrings
From el Ahaiwah tomb 543
New Kingdom
Height 1.5 cm; width 1.2 cm.
Lowie Museum of Anthropology, University of California, Berkeley (6-22915a,b)

In conformity with their modest appearance, hoop earrings of "leech" or "boat" type were comparatively easy to manufacture. In this case, a thin sheet of gold was formed over a core of sandy paste, which was left inside.[1] The earring was worn by passing the bent wire attached at the top through a hole in the earlobe.

The design of leech-type earrings was widely distributed throughout the ancient Mediterranean world. The earliest securely dated earrings of this type known in Egypt were excavated from a tomb at Abydos that also contained a scarab inscribed with the name of Hatshepsut.[2] The same tomb contained beads and a leopard-head slide from a string tie (see cat. 320).

M.E.-K.

1. Williams 1924, pp. 118ff.
2. MacIver and Mace 1902, pp. 71, 91, pl. 53.

Literature: MacIver and Mace 1902, p. 89, pls. 46, 51; Peet 1914, pl. 15:14; Williams 1924, p. 119; Steindorff 1937a, pl. 58.

306

Pair of earrings
Said to be from Thebes
Dynasty 18-19
Height 3.3 cm.; width 3.3 cm.
The Brooklyn Museum, Brooklyn, New York. Gift of Dr. Louis Keimer (52.149a-b)

The design of these opaque red glass earrings is related to that of the simple ear studs illustrated by cats. 298-300. Each earring is formed as a lotus flower at the end of a bent stem, which was threaded through a hole in the earlobe and hung down behind while the blossom was visible from the front. The petals of the half-opened lotus flowers are indicated by triangular inlays of blue glass in two shades, now much damaged.

Earrings of analogous design are documented in reliefs and paintings beginning in the late Eighteenth Dynasty. For example, on a gold shrine from Tomb 55 in the Valley of the Kings,[1] Queen Tiye is depicted wearing similar earrings, as is Queen Nefertari, a great Royal Wife of Ramesses II, in her tomb in the Valley of the Queens.[2] The owner of these inexpensive glass earrings probably enjoyed a considerably less exalted status.

M.E.-K.

1. Davis et al. 1910, pl. 29.
2. Thausing and Goedicke 1971, pl. 37.

Bibliography: Brooklyn Museum 1956, pp. 35-36, pl. 63; Brooklyn Museum 1968, pp. 42, 101.

Beaded Collars

Ancient Egyptian linen garments, whether a simple sleeveless chemise or an elaborately pleated kilt and matching tunic, served as neutral foils for the brilliant color of deep beaded collars made of quantities of faience beads. The ancient name for this most characteristic type of Egyptian jewelry was *usekh,* meaning simply "the broad one." According to one theory, the broad collar, like other kinds of beaded neck ornaments, evolved from a necklace composed of a single charm strung on a cord.[1] Alternatively, the prototype of the *usekh* was a garland of flowers, leaves, and berries sewn onto a backing of papyrus or palm leaves.[2] However, actual examples of floral garlands incorporating fruit, as well as imitations of them in faience (like cat. 308), are first known only many centuries after the earliest beaded collars were made.

The beaded collars in this catalogue were made late in Dynasty 18, when the manufacture of multicolored faience had been perfected to an astonishing degree. Costume jewelry in faience was then in demand for a variety of customers from low-ranking officials to the royal family. Several faience collars quite similar to cat. 308 were excavated from the tomb of King Tutankhamen.

M.E.-K.

1. Aldred 1971, pp. 144ff.
2. Feucht 1977b, cols. 933ff.

Literature; Clark 1949-1950, pp. 154ff.; Aldred 1971, pp. 144ff., 231; Feucht 1977b, cols. 933ff.

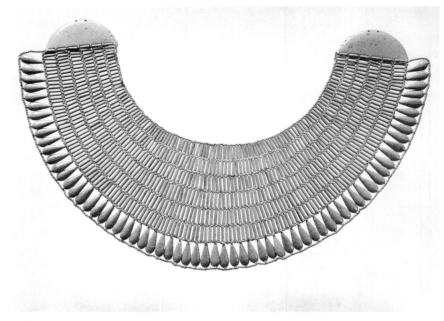

307

307

Broad-collar necklace

From Thebes
Dynasty 18, reign of Tutankhamen
Length 36.6 cm.; width 11.3 cm.
The Brooklyn Museum, Brooklyn, New York. Charles Edwin Wilbour Fund (40.522)

Broad-collar necklaces of this type, made of plain tubular beads, were already known by the early Old Kingdom.[1] Such traditional collars consist of two or more (here six) rows of tubular beads woven together vertically with an outer row of drop beads. The terminals are simple semicircular plaques. There can be no doubt that such broad collars had an amuletic function, for they are depicted beside other types of amuletic jewelry on Middle Kingdom coffins.[2]

M.E.-K.

1. Firth and Gunn 1926, pls. 34-35.
2. Jéquier 1921, pp. 62ff.

Bibliography: Riefstahl 1948, p. 14, fig. 13; Brooklyn Museum 1968, pp. 31, 99, 100, pl. 9:32; Tefnin 1971, p. 37 n. 1; Fazzini 1975, cat. 73.

308

Broad collar

From Thebes
Dynasty 18, reign of Tutankhamen
Length 43 cm., width 4.5 cm.
Musées Royaux d'Art et d'Histoire, Brussels (E. 7534)

This typical late Eighteenth-Dynasty collar made of imitation floral elements, including mandrake fruits and the petals of the blue lotus, has terminals of polychrome faience in the form of the blue lotus flower (see cat. 9). The plain tubular beads of the traditional *usekh* collar (see cat. 307) are replaced here by pendant-like elements produced in molds in the same manner as the bezels of faience rings. Before glazing, small circular beads were pressed into the upper and lower edges of the molded fruit and petals while they were still moist, providing a means for stringing the various elements together.

In the tomb of Tutankhamen was found an actual floral collar incorporating real mandrake fruits sliced in half lengthwise and blue lotus petals.[1]

M.E.-K.

1. Carter 1927, pp. 191-192, pl. 36.
Bibliography: Musées Royaux 1958, no. 20.

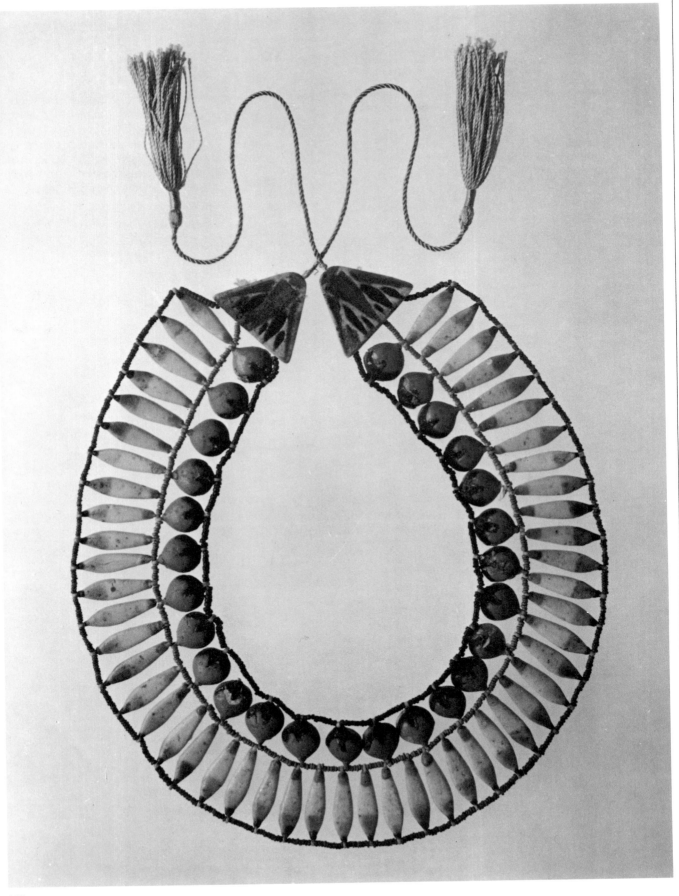

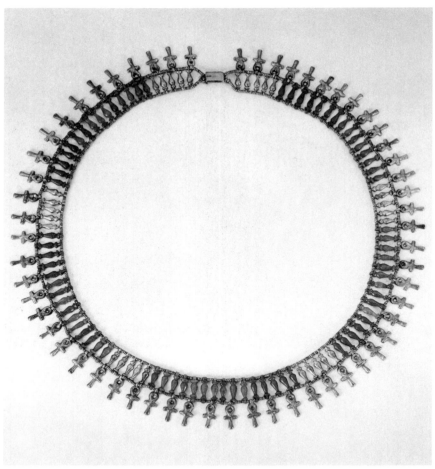

309

309

Necklace of *hes* jars and *ankh* signs

Provenance not known
Probably Dynasty 18
Length 45.7 cm.; width 2.4 cm.
St. Louis Art Museum (16.1940)

The composition of the necklace includes elements in carnelian, cobalt blue glass, and turquoise glass. The 164 principal beads are clearly recognizable as *hes* vases, the characteristic ancient Egyptian water jar, and *ankh* pendants, which represent the sign of life.

M.E.-K.

Bibliography: St. Louis Art Museum 1975, p. 19.

Necklaces

A string of beads, with or without pendants, was the most common type of jewelry worn in pharaonic times; bead necklaces made of shell, stone, glazed steatite, and copper, were known in the Nile Valley long before the unification of Upper and Lower Egypt around 3100 B.C. Egyptian beads come in many forms, including disks, rings, balls, cowroids, cylinders, barrels, and others of complex figural design; often they have amuletic significance. For example, a string of greenish faience beads may have served to protect the wearer from the "evil eye," since the color alone was believed to possess apotropaic power.

M.E.-K.

310

Nefer pendants and disk beads

Possibly from Sedment tomb 254
Dynasty 18, reign of Thutmose III
Length of string 18.5 cm.; average length of *nefer* pendant 9 cm.
University Museum, Philadelphia. Gift of Egypt Exploration Fund (E. 15789)

This necklace is made of fifty hollow gold pendants with flat backs and disk beads used as spacers. The pendant shape represents the hieroglyphic sign *nefer,* embodying notions of well-being and beauty (see cat. 311).

M.E.-K.

Literature: Aldred 1971, pp. 115ff.; Van der Sleen 1973.

311

Nefer pendants and beads

Provenance not known
Dynasty 18
Length of string 39.9 cm.; height of jackal 1.4 cm.
Museum of Fine Arts. Anonymous Gift (45.969)

Twenty-four electrum pendants and blue glass beads make up this necklace. The pendants are in the form of the hieroglyph *nefer,* which might describe appearance ("beautiful" or "fair"), condition ("young"), or character ("kind" or "good"). In addition to the *nefer* pendants, the composition also includes an openwork jackal amulet in electrum.

M.E.-K.

Bibliography: Merrillees 1974, p. 16, fig. 6.

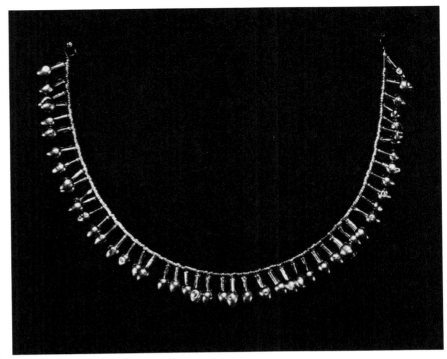

310

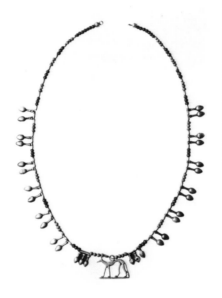

311

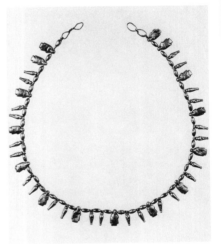

312

312

Fish and vase pendants

Provenance not known
Dynasty 18
Length of fish 1.2 cm.
Royal Ontario Museum, Toronto
(910.81.6)

Bolti fish alternate with *hes* vases in this necklace of thirty-nine gold pendants. There are two vases between each two fish and a barrel-shaped bead between every two pendants. A disk bead separates each element. The fish pendants clearly depict the *bolti* fish (see cat. 138). The *hes* vase pendants resemble in form the characteristic ancient Egyptian water jar (see cat. 71).

The fish- and vase-shaped pendants were formed of sheet gold over a core, which was then removed, leaving the element hollow. The edges were soldered together; on the back can be seen the vent hole through which the gases escaped during the soldering process. Finally, a thread hole was punched through the top of each pendant. The barrel-shaped

beads were punched out of thick sheet gold with a die to form hemispheres. Two hemispheres were soldered together to form each bead; then a thread hole was punched through and the outside of the bead burnished.

G.L.S.

Bibliography: Needler and Graham 1953, p. 28, no. 22, pl. 3.

Literature: Gamer-Wallert 1970, pp. 24-27, 109-113.

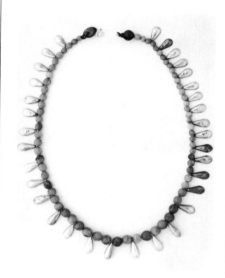

313

313
Ball and teardrop beads

From Abydos tomb 941. A.09
Dynasty 18
Length of string 41 cm.; length of gold bead 1.5 cm.
Merseyside County Museums, Liverpool, Bequest of Lt.-Col. J. R. Danson (1977.108.4)

The gold teardrop beads are of a type also incorporated into broad collars (see cats. 307 and 308). Their color forms a striking contrast to the carefully graduated carnelian ball beads.

The necklace was found with several pairs of earrings (cats. 293, and 295), rings, amulets, and a large group of vessels of various materials in an undisturbed tomb deposit of the Eighteenth Dynasty.

E.B.

1. Garstang 1909, pp. 128-129, pl. 15:16.

Bibliography: Garstang 1909, pp. 128-129, pl. 15; Bourriau 1979, p. 151, pl. 26:1.

314
Ball beads and cornflower pendants

From Semna tomb S563
Dynasty 18-19
Length of strings 70 and 63 cm.; height of pendants 1.3 cm.
Museum of Fine Arts. Harvard University—Museum of Fine Arts Expedition (27.895, 27.896)

The elements of these necklaces were found in a disturbed tomb; thus it cannot be determined with certainty which elements belonged together originally. The 480 ball beads and 80 cornflower pendants are made of carnelian. Unlike the pomegranate, which was purposely transplanted to Egyptian soil (see cat. 99), the cornflower, indigenous in the Near East, was probably introduced accidentally with grain that was shipped to Egypt from Syria during Dynasty 18. Cornflowers were woven into floral garlands and used in bouquets. The actual blossom is blue, but beads and pendants made for jewelry come in a variety of colors, including red, yellow, and green, as well as shades of blue.

M.E.-K.

Bibliography: Dunham and Janssen 1960, p. 99.

Literature: Engelbach 1915, p. 6, pls. 1 and 11:2; Wainwright 1920, pp. 56-57, pl. 20; Keimer 1924, pp. 8-10, 49, 181:21-23.

314

315
Fly pendants

Said to be from the Valley of the Kings
Dynasty 18
Length 42.2 cm.; length of flies 1.1 cm.
Museum of Fine Arts. Lent by Dr. Dean Crocker (52.1978)

The necklace is composed of twenty gold flies regularly interspersed between ball beads of garnet and gold ring beads, which are formed of three contiguous rings of gold granules. The gold flies are cast solid, the underside flat.[1]

The granulation technique was introduced from the Aegean toward the end of the Twelfth Dynasty. Since granulated beads similar to these come from the burial of three minor queens of Thutmose III and from the tomb of Tutankhamen, it is possible that this necklace, too, derives from a royal burial of the New Kingdom.

Fly pendants, documented from late predynastic times down through the end of the New Kingdom, were very popular in ancient Egypt; perhaps they were worn as talismans to ward off the bothersome insects. Or, like the scarab, they may have been valued for their regenerative powers.[2] Fly amulets adorned with the head of a lion (perhaps to be identified as the lion goddess Sekhmet, who was supposed to ward off sickness), have been excavated from Meroitic graves; also found there were necklaces made up simply of fly-shaped beads.[3] According to New Kingdom textual sources, the king presented courageous soldiers with a gold medal in the form of a fly.

M.E.-K.

1. Cf. British Museum 1978, pp. 58-59, no. 49b.
2. Hornung and Staehelin 1976, pp. 111ff.
3. Dunham 1963, pp. 9, 12, figs. 133u, 117e.

Literature: Weber 1977, cols. 264ff.

316
Disk beads

Provenance not known
New Kingdom
Diameter of beads 1.2 to 1.6 cm.
Royal Ontario Museum, Toronto (922.8.56)

Large lenticular or disk beads in blue faience strung on stout cords to form one or a series of short necklaces, or chokers, and worn two, three, or even

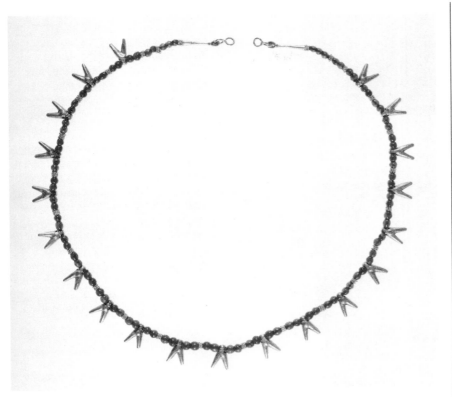

315

316

four strings at a time were exceedingly common in Dynasty 18 and continued to be popular down to Ramesside times.[1] Enough lenticular beads were recovered from the burials of three wives of Thutmose III to form strings totaling over five feet in length.[2] Many are not well made; some are thin while others are fairly thick, and their colors range in general from a pale to a rich dark blue. The Toronto example, composed of 140 disk beads of blue faience, is an inexpensive imitation of massive originals made of gold.

Gold necklaces of this type were called *shebyu* in ancient Egypt and were part of a standard reward known as the "Gold of Honor," bestowed by the king on outstanding courtiers. The complete ensemble included one or more *shebyu* necklaces, broad collars, a pair of double armlets for the upper arms, two bracelets of different form (one for the left and one for the right wrist), earrings, and signet rings.[3] Officials who had received the "Gold of Honor" might include a depiction of the awards ceremony in the decoration of their tombs; others were content to have themselves depicted wearing the necklace and bracelets. Beginning in the second half of Dynasty 18, the king himself was sometimes shown wearing the *shebyu*. Two outstanding examples are a statuette of Amenhotep III in Boston, a rare three-dimensional depiction of a king wearing the "Gold of Honor,"[4] and a three-string *shebyu* composed of yellow and red gold and blue faience beads found tied onto the gold mask covering the head of Tutankhamen's mummy.[5]

M.E.-K.

1. Hayes 1959, p. 179.
2. Ibid., p. 131; Winlock 1948, pp. 24-25.
3. Feucht 1977a, cols. 731-734.
4. Simpson 1970, pp. 260ff.
5. Carter 1927, p. 87, pl. 25.

Literature: Petrie 1907, pl. 37a.

317

317

Candy-striped beads

From Deir el Bahri
Dynasty 18
Length of string 95 cm.; length of beads 1.7 cm. to 6.7 cm.
University Museum, Philadelphia. Gift of Egypt Exploration Fund (E 2470)

These twenty-six candy-striped faience beads in dark blue and black glaze were perhaps among the votive offerings dedicated by Eighteenth-Dynasty pilgrims to the Hathor shrine of Thutmose III at Deir el Bahri.[1] Some of the beads found in the rubbish heaps of the Hathor shrine retained their original strings, but these have been restrung in recent years.

To make such beads a linen thread was coated with a mixture of sand paste and colored glaze, then cut into units of the desired length. When fired, the thread burned away to leave a perforation for stringing. The black glaze was probably added before a final firing.

E.B.

1. See Naville 1907, p. 17.

318

318
Drop bead
Provenance not known
New Kingdom
Length 3.6 cm.; diameter 1 cm.
Museum of Fine Arts. Gift of Horace L. Mayer (67.1134)

Inscribed beads are comparatively rare. The text incised on this blue-glazed steatite drop bead reads "the scribe of the treasury, Huy." (Huy was a nickname borne by men with the common New Kingdom name Amenhotep.) In the treasury where Huy worked accounts of the yearly income of the crown were kept.[1] A slightly smaller but otherwise identical bead in Brooklyn bears the same inscription.[2]

M.E.-K.

1. Helck 1958, pp. 182ff.
2. James 1974, p. 86, no. 198, pl. 50.

Literature: Petrie 1925, pl. 26.

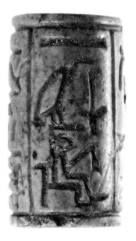

319

319
Cylinder seal of Senenmut
Provenance not known
Dynasty 18, reign of Hatshepsut
Height 2 cm.; diameter 1 cm.
Museum of Fine Arts. Gift of Horace L. Mayer (67.1137)

Egypt adopted the form of the cylinder seal from Mesopotamia, where contracts, letters, receipts, and other documents, written with a stylus on mud tablets, were legalized by rolling personal seals of the concerned parties or witnesses over the still-moist clay. Cylinder seals were also used for safeguarding merchandise in Mesopotamia and were rolled many times over the clay stoppers of pottery jars filled with wine, beer, oil, or honey as a sign of ownership.[1]

The Egyptians wrote on papyrus, not on clay tablets, and it was for the latter purpose that cylinder seals were utilized in Egypt. The majority of early seals in black steatite, serpentine, ivory, or wood bear the names and titles of the private individuals,[2] but massive seals of gold, silver, or hardstone bearing the king's name were conferred on high officials who acted on behalf of the king.[3] In the Old Kingdom they were mounted in metal or wood frames and worn as pectorals.[4]

Cylinder seals continued in general use until the late Middle Kingdom, when they were almost entirely supplanted by seals in the form of the scarab beetle;[5] they were exceedingly rare by the New Kingdom. Royal examples in bronze, faience, glazed steatite, or carnelian are known[6], as well as a few private seals bearing the names and titles of officials.[7] Seals of the New Kingdom resemble cylindrical beads, and it is difficult to believe they were functional. Perhaps the form, hallowed by tradition, had amuletic associations.

This fine green-glazed cylinder is inscribed for "the Great Steward of [the king, or Amen], the Overseer of the cattle of Amen, Senenmut." Another cylinder seal of Senenmut is in the Petrie Museum.[8] It is possible that the Senenmut cylinders were mounted as pectorals. On the other hand, the seals may have been capped in gold at each end and set in a massive finger ring as a bezel (like a lapis-lazuli colored glass cylinder in the British Museum).[9]

E.B.

1. Frankfort 1939, pp. 1-3.
2. Hayes 1953, pp. 38-39.
3. Aldred 1971, p. 20.
4. Hayes 1953, p. 38, fig. 27.
5. Ibid., p. 38.
6. Newberry 1908, pl. 8; Hall 1913, p. 271, nos. 2645, 2646; Hayes 1959, pp. 124, 184.
7. Hall 1913, p. 55, fig. 32.
8. Newberry 1908, p. 47, fig. 24, pl. 8:4.
9. Andrews 1976, p. 12.

Literature: Newberry 1908, pp. 43-56; Frankfort 1939; Kaplony 1977.

320
Necklace with leopard spacer
From el Ahaiwah tomb A525
Dynasty 18
Length of string 82 cm.; height of spacer 2 cm.
Lowie Museum of Anthropology, University of California, Berkeley (6-22018). Hearst Egyptian Expedition

The necklace resembles a "string tie" but the leopard-head "slide" is fixed and cannot be slipped up and down over the beads. The beads are of two types: simple ring beads in yellow and red faience and star-shaped beads in blue-green faience; the floral terminal imitate jasmine blossoms.

The role of the panther, or leopard, in ancient Egyptian religion is disputed. One speculation asserts that the leopard was a primeval sky goddess, with the stars being the spots on her coat. A protective, apotropaic function for the leopard may be traced back to the Old Kingdom, when a leopard skin was some-

320

times represented in relief on top of stone sarcophagi.[1] The leopard-head motif in the form documented in this example makes its first appearance in the design of jewelry in the Middle Kingdom[2] and continues in the New Kingdom.[3]

The necklace was one of three excavated from the New Kingdom cemetery at el Ahaiwah. A fourth, discovered in an Eighteenth-Dynasty grave at Abydos was restrung in accordance with the arrangement of one of the el Ahaiwah examples found actually in position.[4]

M.E.-K.

1. Roveri 1969, p. 123, pl. 40.
2. Aldred 1971, pp. 191-192, pl. 36; Wilkinson 1971, pp. 81-82, pl. 13.
3. Winlock 1948, pl. 7.
4. MacIver and Mace 1902, pp. 88-89, pl. 46.

Literature: Petrie 1891, pl. 26:18; Peet 1914, pl. 37; Brunton and Engelbach 1927, pl. 28: 12; Cooney 1974, p. 41, no. 362; Walters Art Gallery 1980, p. 25, no. 36.

321
Double frog beads

Provenance not known
New Kingdom
Length of string 29.4 cm.; length of frogs 1.5 cm.
The Metropolitan Museum of Art, New York. Gift of Mrs. Frederick F. Thompson (15.6.47)

Twenty-four glass beads in the shape of frogs and numerous small ring beads have been strung together in the composition of this necklace.

In ancient as well as in modern times, the watery thickets along the Nile were populated with large colonies of frogs. Huge numbers appeared each year after the recession of the inundation, evidence of the frog's ability to procreate in quantity and thus accounting for its association with fertility, pregnancy, and childbirth. According to legend, the goddess Heket, who could be depicted either as a frog or as a woman with a frog's head, assisted at the birth of the king.[1] Amulets in frog form were intended not only to guarantee the fertility of the living but also to ensure the rebirth of the dead to a new life in the netherworld.[2]

M.E.-K.

1. Kákosy 1977, cols. 1123-1124.
2. Hornung and Staehelin 1976, pp. 112ff.

Bibliography: Hayes 1959, p. 179, fig. 101.

321

322

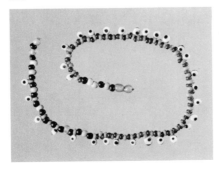

322
Eye and ring beads

From Abydos cemetery G
New Kingdom
Length of string 30 cm.; diameter of beads .3-.5 cm.
Fitzwilliam Museum, Cambridge. Gift of Egypt Exploration Fund (E.176.1900)

The earliest glass beads, dating to the early Middle Kingdom, seem to have been made accidentally as a by-product in the firing of faience. Not until the middle of the Eighteenth Dynasty was their manufacture perfected (see p. 161).

The thirty black and white eye beads in this necklace are combined with blue and yellow ring beads in a modern stringing. Other excavated examples are known, including a necklace with eye beads from Gurob datable to the reign of Ramesses II.[1]

M.E.-K.

1. Petrie 1891, p. 18, pl. 18:30.

Bibliography: Fitzwilliam Museum 1978, p. 12, no. 4b.

Literature: Northampton et al. 1908, pl. 9.

323
Ball and drop beads

From Sedment tomb 2017
Dynasty 19
Length of string 86.7 cm.; length of drop beads 3.3 cm.
Ashmolean Museum, Oxford (1921.1309)

Alternating ball and drop beads were strung together in necklaces as early as the Middle Kingdom,[1] but it is first in the New Kingdom that glass was used rather than semiprecious stones (see cat. 318). The beads in this necklace are silver and gold colored glass.

Found on a mummy of Ramesside date were three strings of ball and drop beads of stuccoed and gilded wood and blue glass.[2]

E.B.

1. Wilkinson 1971, pl. 16.
2. Letellier 1978, p. 73, no. 104.

Bibliography: Petrie and Brunton 1924, p. 32.

324
Fly beads

Provenance not known
Dynasty 18
Length of string 11.5 cm.; length of beads 3.3 cm.
Fitzwilliam Museum, Cambridge. Gift of G. D. Hornblower (E 67a. 1939)

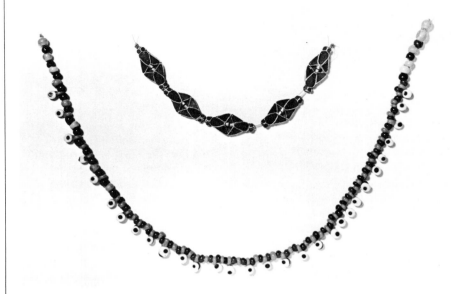

324 322

323

These five pieces represent all that is preserved of a necklace composed of double fly beads. For each bead, two *cloisonné* flies in gold with blue glass bodies and red jasper inlaid eyes were joined end to end to form a truly luxurious ornament for an elegant lady of the New Kingdom.

Cloisonné work in Egyptian jewelry was done by soldering strips of metal, bent to shape, onto a base plate to form settings. Colored glass, gems, paste, or some other form of inlay material was cut to fit these settings and cemented in. The surface of the finished piece was then polished.[1]

M.E.-K./E.B.

1. Aldred 1971, p. 113.

Bibliography: Fitzwilliam Museum 1978, no. 3.

Girdles

The girdles that women wore in ancient Egypt seem to have had no practical function similar to the belts that men buckled around their waists to secure kilts. Girdles were worn underneath a simple dress or, exclusive of any other garment, slung low around the hips. Apparently the girdle belonged to the professional equipment of dancers, musicians, and servants, who are frequently depicted wearing it while at work (see fig. 58). The larger beads of preserved girdles often contain pellets that rattled when the wearer moved, creating an erotic effect. Although there are no depictions of women of elevated status wearing girdles, excavated burials prove that they too possessed them.

M.E.-K.

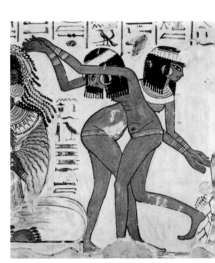

Fig. 58. Young dancers wearing only elaborate beaded girdles (British Museum 37984).

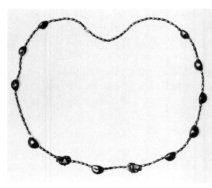

325

325

Girdle

Provenance not known
Dynasty 18
Length 59 cm.; length of duck
heads 1.5 cm.
Museum of Fine Arts. Gift of
Henry L. Higginson (18.219)

Strung together in modern times, the
silver beads of this ornament did not
all necessarily belong originally to a
girdle; truncated bicone beads were
often included in the stringing of
bracelets and necklaces as well.
Similarly, the two beads in the shape
of ducks with turned-back necks may
be unique for a girdle, although the
motif itself is not unknown in the
composition of ancient Egyptian
jewelry.[1] However, the large beads of
peculiar form are known only as
girdle elements. They may represent
disk-shaped pieces of leather folded
in half and stitched around the open
edge — hence the designation "wallet
beads."[2] Another interpretation of the
form suggests that they depict stylized
cowrie shells,[3] a motif occurring in
the design of girdles since the Middle
Kingdom, whereas the earliest "wal-
let" beads date to the beginning of
the Theban ascendancy at the end of
the Second Intermediate Period.[4] They
come in a variety of materials — not
only silver but also gold, electrum,
lapis lazuli, glass, and faience. Queen
Ahhotep possessed twenty-seven
"wallet" beads, varying in size, that
were undoubtedly part of a girdle;
some lapis "wallet" beads still adhered
to the back of Queen Meryetamen's
mummy, and there were many of them
in the treasure of the three wives of
Thutmose III.[5] A girdle incorporating
glass (or faience) "wallet" beads is
visible in x-ray, slung low around the
hips of the mummy of Meryet, wife
of the architect Kha.[6]

M.E.-K.

1. Hermann 1932; Hickmann 1957, p. 100.
2. Petrie 1909a, p. 9.
3. Wilkinson 1971, p. 134.
4. Petrie 1909a, p. 9, pl. 29.
5. Wilkinson 1971, p. 134.
6. Curto and Mancini 1968, p. 79, fig. 4.

Bracelets

One of the two bracelets in this cata-
logue is a "bangle," a rigid circlet
slipped over the hand and worn either
loose around the wrist or snug on the
arm just below the elbow. Bangle
bracelets are the earliest type of
ornament for the arm known in an-
cient Egypt; examples in shell, bone,
and ivory have been excavated from
predynastic burials.[1] Another type of
rigid bracelet worn in the Nile Valley
consists of two semicircles joined by a
hinge and a clasp.[2] Flexible bracelets
made of beads such as cat. 327 are
indistinguishable in design and manu-
facture from anklets, a type of
ornament.[3]

M.E.-K.

1. See, e.g., Hayes 1953, pp. 24-25, fig. 18.
2. Wilkinson 1971, p. 101.
3. Aldred 1971, pp. 157-159.

Literature: Aldred 1971, pp. 157-159; Wilkinson
1971, pp. 99-108.

326

326

Bangle bracelet

Provenance not known
Dynasty 18
Height 1.9 cm.; diameter 11.9 cm.
British Museum, London (66840)

Queen Ahhotep possessed two pairs
of gold bracelets very like this except
for braided gold ropes about their
upper and lower margins.[1] One of
two identical bracelets, this bangle
was made of thin sheet gold beaten
into shape on a wooden ring. The two
ends were joined to form a three-
sided hoop with an open internal face
onto which was soldered a thin sheet-
gold strip.

E.B.

1. Vernier 1927, pp. 38-39, pl. 10.

Bibliography: Andrews 1976, p. 10, no. EA42b.

Literature: Wilkinson 1971, p. 101.

327

327

Flexible bracelet

Provenance not known
Probably Dynasty 18
Diameter 6.7 cm.; height 4 cm.
Musée du Louvre, Paris (N.1960a)

This bracelet is composed of fifteen
rows of lapis lazuli beads held to-
gether by gold spacer bars. Ten sec-
tions of lapis beads alternate with
nine spacers.

First occurring in the Middle Kingdom
in the treasures of Dahshur and Lahun,
this type of bracelet survives virtually
unchanged into the New Kingdom. Its
locking mechanism, a gold pin in-
serted through the hollow interlock-
ing elements in the terminal gold
clasps, resembles more the system in
a flexible bracelet of Queen Ahhotep
than the clasps of most Middle
Kingdom examples.[1]

E.B.

1. Wilkinson 1971, pp. 63, 100-101, pl. 26b; Aldred
1971, p. 158, fig. 34.

Rings

The earliest rings known from ancient Egypt, simple bands of stone, shell, or precious metal, derive from predynastic burials. Similar rings have been excavated from Early Dynastic and Old Kingdom tombs as well. These early rings were probably worn simply as ornaments, for they have no discernible amuletic properties nor could they have functioned as signets.

The earliest scarab rings, dating to the Middle Kingdom, were unpretentious affairs: a gold wire was threaded through the longitudinal hole in a scarab and the ends of the wire twisted together. In the course of the New Kingdom other means were devised for securing the scarab to a separately made shank (see cats. 328 and 329). The various mounts have in common the property of permitting the scarab to rotate, revealing the underside with its inscription, and thus allowing it to be used as a signet ring for identifying the owner and his goods.

At the beginning of Dynasty 18 Egyptian goldsmiths cast the first heavy rings in solid metal. The so-called stirrup ring (see cats. 333 and 336) with a decorated bezel is the most characteristic form. Since it could be employed effectively for sealing documents, the stirrup ring may thus be described as a true signet (fig. 59) and it remained in use as such down to Roman times.[1] Lighter-weight variants

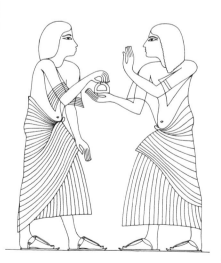

Fig. 59. The Viceroy Huy receives Tutankhamen's signet ring (from a scene in Huy's tomb at Thebes).

of the type were also produced (cats. 331, 334, 335, and 337), and signets of entirely different form — such as cat. 332, with its square bezel—are known. In all likelihood the bezel design was not produced in the casting process but was subsequently engraved and punched out.

By far the most common type of ring preserved from the New Kingdom is made of faience (see cats. 341-348). The faience rings represented by this group were all mass-produced in the same manner, using two molds, one for the shank and another for the bezel. Cat. 343 is an example of a mold that produced a bezel of the type in cat. 344. After a die had been pressed into a small lump of clay, the resulting molds were baked. Then, in order to make rings like cats. 342-346, a craftsman packed lumps of paste into the molds for bezel and shank. The two molded elements were then pressed together while still moist. When dry, the rings were dipped in powdered glass and fired to produce the shiny glaze. The selection of rings grouped together here documents the wide variety of colors known and a sampling of the motifs employed.

Faience rings of this type, as well as the molds required for their manufacture, have been excavated in great quantity from the palace complex of Amenhotep III at Malkata and at Amarna. They were obviously mass-produced items of "costume" jewelry. True signets were apparently used to make the molds for the bezels bearing royal names, but it is unlikely that the faience products like those included here were ever used as seals. Quite possibly they were distributed by the monarch among the populace as "favors" or mementos on occasions such as festivals and state processions.[2]

Rings are seldom included in depictions of men and women in relief, painting, or statuary, but mummies attest that both sexes possessed them and that rings could be worn on any finger of either hand. Apparently only in the case of scarab rings was a convention observed as to which finger was appropriate: scarab rings have been found consistently on the third finger of the left hand.[3]

M.E.-K.

1. Schäfer 1910, no. 78; Hall 1913, p. 276; Brunton and Engelbach 1927, pl. 27:29; Brunton 1930, pl. 34:7; Wilkinson 1971, p. 130.
2. Hayes 1951, p. 231.
3. Hayes 1935, p. 28.

Literature: Petrie 1894, p. 28; Williams 1924, pp. 76ff.; Müller 1969, pp. 359ff.; Aldred 1971, p. 160f.; Wilkinson 1971, pp. 11f., 20, 44, 76ff., 128ff., 158f.; British Museum 1978, pp. 239ff.; Taylor and Scarisbuck 1978.

328

328
Scarab ring

Provenance not known
Dynasty 18
Height 1.7 cm.; length of bezel 1.8 cm.
Museum of Fine Arts. Gift of H. H. Richardson (62.810)

The bezel of this ring, a glazed steatite scarab bearing the throne name of Thutmose III, is attached by means of a gold wire to a gold shank with spherical terminals. Because the setting encroaches on the design of the scarab's underside, it is likely that either the scarab was not intended to be used as a seal or that the setting is not original. The motifs on the underside include a reclining sphinx with the Blue Crown, the so-called war helmet,[1] and a winged uraeus hovering behind the sphinx's head.

M.E.-K.

1. Müller 1955, pp. 46-68.

Literature: Petrie 1889, pl. 18.

329
Scarab ring

Provenance not known
Probably Dynasty 18
Height 2.2 cm.; length of bezel 1.5 cm.
Merseyside County Museum, Liverpool. Bequest of Lt.-Col. J. R. Danson (1977.108.2)

The base of this glazed steatite scarab bears a cartouche of Thutmose III. Its back is composed of gold cloisons inlaid with stone, a feature known as early as Dynasty 12.[1] Set in a gold mount ornamented with twisted gold wire on its perimeter, the scarab has a midsection of green jasper and wing cases inlaid with red jasper.

Since the ring forms part of the same bequest as cats. 293, 295, and 313, it is possible that it derives from the same Abydos tomb.

E.B.

1. Winlock 1933, p. 137; Winlock 1934, pp. 55-56.

Literature: Garstang 1909, p. 129; Bourriau 1979, p. 151, pl. 26:1.

330

331

329

330
Ring with cowroid

Provenance not known
New Kingdom
Height 2.2 cm.; length of bezel 1.4 cm.
Fitzwilliam Museum, Cambridge
(E.13.1947)

This jasper cowroid is quite plain. Had the mounting been lost, it would probably have been identified as a bead. The mounting is similar to that of cats. 328 and 329. Like scarab rings, to which they are related, rings of this type became common in the later Eighteenth Dynasty. Often the cowroid bore an inscription or an emblematic device on one face and thus could have been used, like the inscribed scarab, as a signet.

M.E.-K.

Literature: Hayes 1959, p. 478.

331
Signet ring with name of Amenhotep II

From Thebes
Dynasty 18, reign of Amenhotep II
Height 2 cm.; length of bezel 1.6 cm.
The Brooklyn Museum, Brooklyn, New York. New-York Historical Society, Charles Edwin Wilbour Fund (37.725E)

The circular shank and oval bezel of this gold ring were made separately and then soldered together. The latter is inscribed with the throne name of Amenhotep II and the epithet "Son of Amen-re" in carefully executed signs probably made with a punch. The ring is said to have been found in a small wooden box with a sliding lid,[1] a type that commonly contained jewelry.

M.E.-K.

1. Williams 1924, p. 89.

Bibliography: Bonomi 1846, p. 32, no. 3; Prisse d'Avennes 1846, p. 733; Prisse d'Avennes 1847, pl. 47: 3; Abbott 1853, no. 1085; Lepsius 1897, p. 10, no. 17; Gauthier 1912, p. 284, no. 34; Abbott 1915, no. 1081; Williams 1924, pp. 89-90, no. 25, pls. 8, 10.

332
Signet ring with smiting scene

From Saqqara
Dynasty 18, reign of Amenhotep II
Height 2.1 cm.; length of bezel 2.2 cm.
The Brooklyn Museum, Brooklyn, New York. New-York Historical Society, Charles Edwin Wilbour Fund (37.726E)

The square bezel of the silver ring bears a depiction of the king, identified by the inscription as Amenhotep II, who is about to deliver a death blow with his mace to a cowering foreigner. An *ankh* sign behind the king completes the decoration of the bezel. The "smiting" motif is traditional in royal iconography; its origins can be traced back to before the unification of Egypt around 3100 B.C., but its occurrence in the decoration of a signet ring is unusual.[1] Other military motifs referring to the triumph of the king over Egypt's adversaries are not uncommon on signets beginning in the reign of Amenhotep II's father, Thutmose III, and the popularity of this theme continued into the reign of Amenhotep II himself.

M.E.-K.

1. Williams 1924, pp. 90-91.

Bibliography: Bonomi 1846, p. 32, no. 12 (?); Abbott 1853, no. 984; Lepsius 1897, p. 10, no. 18 (?), also p. 185, under no. 30; Abbott 1915, no. 980; Williams 1924, pp. 90-91, no. 26, pls. 8, 10.

Literature: Hornung and Staehelin 1976, p. 63.

332

333
Stirrup ring

Provenance not known
Late Dynasty 18
Height 2.4 cm.; length of bezel 2 cm.
British Museum, London (32723)

The suggestion has been made that the design on the bezel of this pale gold ring incorporates a portrait of Akhenaten.[1] The central figure is that of a king seated on the ground like a child, with his knees drawn up and holding the feather of Maat, emblem of the goddess of truth. Faience amulets of like form are exceedingly common at Amarna.[2] An identification with the child Horus has been suggested, but the figures wear the customary pleated kilt and the Blue

Crown or other royal headdress, leaving little doubt that this is meant to be the pharaoh as a child.[3] The hieroglyphs on the ring could be grouped in several meaningful combinations, which might represent the throne names of Amenhotep III or Tutankhamen.

E.B.

1. Wilkinson 1971, p. 129.
2. Petrie 1894, pl. 17: 271-273; Frankfort and Pendlebury 1933, pls. 28:6, 29:5.
3. Hayes 1959, p. 291.

Bibliography: Hall 1913, p. 278, no. 2688.

Literature: Frankfort and Pendlebury 1933, pl. 50:220, 274; Pendlebury 1951, pl. 100:11, 27-31; Hayes 1959, p. 292; Aldred 1971, p. 211, pl. 70; Edwards 1976a, no. 19.

333

334

334

Signet ring with Bes-images

Said to be from Amarna
Dynasty 18, reign of Amenhotep III or Akhenaten
Height 2 cm.; length of bezel 1.7 cm.
Merseyside County Museums, Liverpool. Bequest of Sir H. Rider Haggard (56.20.576). Formerly in the Norwich Castle Museum and the H. Rider Haggard Collection

The oval bezel is decorated with two schematically rendered Bes-images flanked by crudely formed *ankh* signs. Both gods wear extremely wide flaring headdresses and carry knives in each hand; other knives project from their feet.

The purported findspot of this gold ring, the royal tomb of Akhenaten at Amarna, would provide clear evidence of its date. Unfortunately, the early history has been reconstructed from hearsay and, despite some scholars' acceptance of the story linking the ring to Akhenaten's intended burial place,[1] such claims cannot be conclusively proven.

Nevertheless, the presence of two Bes-images in the same figure scene does narrow considerably the range of possible dates for the ring. Pairs of figures appear only during two New Kingdom reigns, those of Amenhotep III and Akhenaten (see cat. 246).

J.F.R.

1. Most recently, Martin 1974, p. 77, no. 277, pl. 50.

Bibliography: Blackman 1917, p. 45:8, pl. 13:8; Martin 1974, p. 77, no. 277, pl. 50.

335

Signet ring with the name of Ramesses IV

Provenance not known
Dynasty 20
Height 2.3 cm.; length of bezel 2.3 cm.
The Brooklyn Museum, Brooklyn, New York. New-York Historical Society, Charles Edwin Wilbour Fund (37.727E)

A human-headed falcon or *ba* bird dominates the design of the bezel. Above the falcon is a sun disk with pendant uraeus; in front is a depiction of the goddess Maat and, behind a scepter, the hieroglyph *heka*. If the bird and sun disk are taken together as constituting the name of the sun god Re, then the four signs could be read Heka-maat-re, the throne name of Ramesses IV. But the qualifying epithet "Chosen one of Amen," which regularly accompanies that king's throne name, is absent from the text. The other hieroglyphs engraved on the bezel are: two *djed* signs ("stability"), two *hes* vases ("praise"), a single *hetep* sign ("peace"), and at the bottom a *neb* basket. The material of this ring is a silver-tin alloy.

A *neb* sign was often added to the design of an oval bezel or scarab

335

simply because its shape conveniently filled the space at the bottom of the oval. It may be that all the hieroglyphs on the bezel of cat. 335 do not constitute a meaningful text but rather were employed in the design simply for their decorative and amuletic values.[1]

M.E.-K.

1. Williams 1924, pp. 92-93.

Bibliography: Bonomi 1846, p. 32, no. 11 (?); Abbott 1853, no. 1090; Abbott 1915, no. 1086; Williams 1924, pp. 92-93, no. 27, pl. 8.

336

336

Stirrup ring

Provenance not known
Late Dynasty 18
Height 2.8 cm.; length of bezel 1.6 cm.
Musée du Louvre, Paris (AF 2352).
Formerly in the Salt Collection

Jasper is an impure, opaque, compact variety of silica that may be colored red, green, brown, black, or yellow by compounds of iron.[1] Green jasper, of which this ring is made, was cut into beads and amulets as early as the Badarian Period.

The bezel of this stirrup ring is engraved "Ptah, whose favors are endur-

ing." Rings with the loop and bezel made in one piece of semiprecious stone were uncommon before the Amarna Period.

The semicircular depression below the bezel on either side also occurs in a silver stirrup ring of Akhenaten in the British Museum.[2]

E.B.

1. Lucas 1962, p. 397.
2. Hall 1913, p. 276, no. 2678.
Literature: Petrie 1891, p. 23, pl. 26:19.

337

337

Ring with sistrum and lotus
Provenance not known
Dynasty 18
Height 1.8 cm.; length of bezel 1.6 cm.
Fitzwilliam Museum, Cambridge.
Bequest of R. G. Gayer Anderson
(EGA 30.1947)

The gold ring was probably cast in one piece, like cat. 333, but is of lighter design. The bezel is decorated with a sistrum, the cult instrument of the goddess Hathor, flanked by two uraei. The sistrum takes the form of a shrine-shaped box that sits atop a human head with cow ears and horns. Two lotus blossoms on the sides, a motif common in faience rings at Amarna,[1] are, like the sistrum, often associated with Hathor. The combination of sistrum and uraei also occurs in scarabs and scaraboids.[2]

The dating of the ring is suggested by excavated parallels.[3]

M.E.-K.

1. Petrie 1894, pl. 16.
2. See, e.g., Petrie 1891, pl. 26:41; Frankfort and Pendlebury 1933, pl. 47:4b; Dunham 1978, pl. 26.
3. See Brunton and Engelbach 1927, pl. 26:8, 16.
Literature: Williams 1924, pp. 94-95; Walters Art Gallery 1980, pp. 47-48, no. 129.

338

Ring with reclining lion
Provenance not known
New Kingdom
Height 2.2 cm.; length of bezel 1.8 cm.
Fitzwilliam Museum, Cambridge.
Bequest of R. G. Gayer Anderson
(EGA 103.1947)

Carved from a single piece of stone, the carnelian ring has a tiny modeled lion bezel. Lions were incorporated into jewelry as early as the Twelfth Dynasty.[1] Being royal symbols they may have been presented by the king as rewards for valiant actions.[2] The ends of the hoop terminate in papyrus umbels.

A similar ring in Baltimore has a frog bezel.[3]

E.B.

1. Firth and Gunn 1926, p. 59, pl. 37.
2. Wilkinson 1971, p. 64.
3. Walters Art Gallery 1980, pp. 49-50, no. 147.

338

339

Inlaid ring
Provenance not known
Dynasty 18
Height 1.6 cm.; length of bezel 0.9 cm.
Walters Art Gallery, Baltimore (57.1475)

Opposing lotus blossoms, an ever-popular motif, are joined to a central band to form the bezel of this colorful ring. The petals and central element, made of lapis and carnelian, are set into cloisons of gold. The band is made of a tripartite loop of gold and joined to the bezel by means of five decoratively wrapped gold wires.

Unlike true *cloisonne*, where powdered glass is fused by heat into separate gold cells,[1] the glass inlays here

have been used like precious stones, each piece being cut, shaped to fit its cell, and cemented in position. The earliest instance of true *cloisonne* in ancient Egypt is thought to have been among the jewels of Tutankhamen.[2]

A lotus-blossom design virtually identical with that on the bezel of this ring occurs in a blue-glazed faience ring from Amarna.[3]

E.B.

1. Aldred 1971, p. 128.
2. Ibid.
3. Petrie 1894, pl. 16: 219-221.
Bibliography: Canby 1980, pp. 45-46, no. 124.

339, 340

340

Inlaid ring
Provenance not known
Dynasty 18
Height 1.3 cm.; length of bezel 1 cm.
Walters Art Gallery, Baltimore (57.1474)

A pair of slender-petaled lotus blossoms made of dark and light glass fitted into gold cloisons forms the oval bezel of this ring. White glass flecked with purple fills the space between the petals, and the bezel is surrounded by delicate granulation. The band is made up of a sheet of gold rolled on each side, creating the effect of a double wire.

A Middle Kingdom date has been suggested for the ring,[1] but the combination of lotus blossoms and buds is a common motif in decorative arts of New Kingdom date (cats. 150, 151, and 347), and rings of a similar, albeit more elaborate, construction were found among Tutankhamen's treasures.[2]

E.B.

1. Walters Art Gallery 1980, p. 46.
2. Edwards 1976b, no. 18.
Bibliography: Randall 1966, p. 76; Canby 1980, pp. 45-46, no. 122.
Literature: Schäfer 1910, no. 63.

341

341
Ring with the name of Amenhotep III

Provenance not known
Dynasty 18, reign of Amenhotep III
Height 2.3 cm.; length of bezel 2.1 cm.
Museum of Fine Arts. Egyptian Special
Purchase Fund (1979.47)

A total of 451 ring bezels bearing the
name of Amenhotep III were found at
his palace at Malkata; 356 of them
were inscribed in the same manner as
this example with his throne name,
Neb-maat-re.[1] This apple-green
faience ring dates from a time when
the type was first mass-produced; it
is more solidly made than later
specimens (cf. cats. 342-346). The
apple-green color is not as common
as shades of blue or even violet, but
it is known from Malkata.[2]

E.B.

1. Hayes 1951, pp. 231-232.
2. Ibid., p. 232 n. 401.

342
Ring with the name of Ay

Provenance not known
Dynasty 18, reign of Ay
Height 2 cm.; length of bezel 2 cm.
Museum of Fine Arts. Gift of Mrs.
Laurence E. Eastman (1978.303)

The oval bezel of this greenish-blue
faience ring is inscribed with the
personal name of King Ay, "the god's
father Ay, the god-ruler of Thebes."
Rings bearing Ay's coronation name,
Kheper-kheperu-re Ir-maat, have been
found at Gurob and Riqqeh,[1] and a
cache of faience rings with Ay's per-
sonal name and the names of
Amenhotep III, Tutankhamen, Queen
Mutnedjmet, and Seti I was dis-
covered in debris on the floor of
Street 7000 at Giza,[2] along with others
identical to cats. 344 and 346a.

E.B.

1. Petrie 1891, pl. 23:28-30; Engelbach 1915, pl. 16.
2. Giza Object Register 26-1-742 – 753.

343
Mold for faience ring

From Amarna
Dynasty 18, reign of Akhenaten
Length 3.2 cm.; width 3 cm.
Museum of Fine Arts. Gift of University
College, London (36.493)

The circular mold, crudely made of
clay, has an oval-shaped depression

containing a raised design of a lotus
flower flanked by two buds. It was
used to make the bezel of a ring
similar to cat. 344.

E.B.

Literature: Petrie 1894, p. 28, pl. 16:213.

344
Lotus ring

Provenance not known
Dynasty 18, reign of Akhenaten
Height 1.8 cm.; length of bezel 2 cm.
Museum of Fine Arts. Gift of Horace
L. Mayer (57.444)

The bezel of this faience ring, dec-
orated with a lotus flower and two
buds, was made from a pottery mold
essentially identical to cat. 343. Floral
designs were a popular motif for
faience rings; like those in the same
material inscribed with royal names
(see cat. 342), they were mass-
produced from the reign of Amen-
hotep III until at least that of
Ramesses II.[1] Bezels or molds with
the same motif were found at Amarna[2]
and at Gurob.[3]

E.B.

1. Petrie 1891, pl. 23.
2. Petrie 1894, pl. 16:213.
3. Petrie 1891, pl. 23:86; Brunton and Engelbach
 1927, pl. 41:95.

Literature: Petrie 1894, p. 28.

342

344, 343

345

345

Ring with Bes-image

Provenance not known
Late Dynasty 18
Height 2.2 cm.; height of bezel 2.1 cm.
Mustum of Fine Arts. Hay Collection,
Gift of C. Granville Way (72.2915)

The greenish-blue faience ring shows
a profile Bes-image in relief on the
bezel. He wears a feathered headdress,
and a knife projects from his front
foot.

Similar rings or bezels have been
found at Amarna[1] and other sites.

E.B.

1. Petrie 1894, pl. 16:180; Frankfort and
 Pendlebury 1933, pl. 49, I.D.31.

Uadjet eye rings

346

a. Deep blue faience ring

Provenance not known
Dynasty 18
Height 2 cm.; length of bezel 2 cm.
Museum of Fine Arts. Hay Collection,
Gift of C. Granville Way (72.2875)

b. Violet and white faience ring

Provenance not known
Dynasty 18
Height 2.1 cm.; length of bezel 2.0 cm.
Fitzwilliam Museum, Cambridge.
Gift of R. G. Gayer Anderson (6375.1943)

c. Apple-green faience ring

Provenance not known
Dynasty 18
Height 2.3 cm.; length of bezel 2.1 cm.
Fitzwilliam Museum, Cambridge.
Gift of R. G. Gayer Anderson (6376.1943)

346 a

346 b

346 c

346 d

d. Violet and white faience ring with
 white band

Provenance not known
Dynasty 18
Height 2.2 cm.; length of bezel 1.9 cm.
Fitzwilliam Museum, Cambridge.
Gift of R. G. Gayer Anderson (6374.1943)

The openwork bezels of the four
faience rings are formed as *uadjet*
eyes, the "sacred eye of Horus," com-
bining a human eye and brow with
falcon face markings (see cat. 349).
The four rings grouped here document
the range of colors in use late in
Dynasty 18.

M.E.-K.

Literature: Klasens 1975.

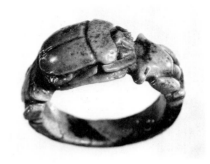

347

347

Scarab ring

Provenance not known
Late New Kingdom
Height 2.7 cm.; length of bezel 1.5 cm.
University College, London. Petrie
Museum (27746)

The blue faience ring has a bezel in
the form of a scarab set between a
pair of lotus flowers and buds (see
cat. 340), all molded in the round. A
similar ring, once in the Murch collec-
tion, is now in the Metropolitan
Museum.[1]

E.B.

1. Hayes 1959, p. 397, fig. 249.

Literature: Walters Art Gallery 1980, p. 46, no. 128.

348

Openwork ring

From Giza
Late New Kingdom
Width 1.8 cm.; diameter 2.5 cm.
Museum of Fine Arts. Harvard
University—Museum of Fine Arts
Expedition (11.982)

Bands with complex openwork or pierced designs were the last type of faience ring to be developed. First documented toward the end of Dynasty 18, they continued to be popular through the Third Intermediate Period. In the best examples, the glazing is carefully and thinly applied so as not to clog the openings between the design elements.[1]

Exactly how such rings were made in faience is a matter of conjecture. It is possible that the figural elements were molded separately, a time-consuming task, and then pressed together between two simple rings on a rod. If lightly fired before the glaze was applied, the elements would have fused together.
The pattern of this ring includes a lotus blossom and a squatting figure of the falcon-headed sun god, complete with sun disk and *Maat* feather.

M.E.-K.

1. They may well imitate costly originals in precious metals. An openwork ring of electrum from an Eighteenth- or Nineteenth-Dynasty grave at Gurob includes in its decoration winged scarab beetles, a figure of the moon god with falcon head, and a *uadjet* eye.

Literature: Brooklyn Museum 1968, pp. 104ff.

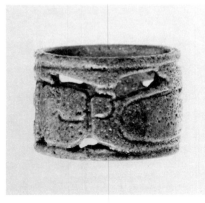

348

Amulets

There have been many attempts to classify Egyptian amulets. Those in the form of figures depicting divinities or animals associated with divinities usually present no problem of identification, but the exact connotation of other talismans cannot be determined with certainty in many instances, for example, those in the form of animals, fish, birds, and insects not positively associated with any particular deity. Perhaps the wearer of such a talisman wished to acquire the strength or courage characteristic of the creature in question or, in the case of dangerous or hostile animals, to placate or propitiate them. Amulets in the form of parts of the human body may have been worn as "strengtheners" or perhaps as substitutes for the members represented. Other amulets might serve to ensure the general health and well being of the wearer. Still others defy classification and cannot be assigned a specific function.

G.L.S.

Literature: Reisner 1907; Petrie 1914; Reisner 1958; Hayes 1959, p. 180; Klasens 1975, cols. 232-236.

349
Uadjet-eye amulet
From Semna Fort
New Kingdom
Length 3.7 cm.; width 2.65 cm.
Museum of Fine Arts. Harvard University—Museum of Fine Arts Expedition (27.884)

In this blue faience amulet, the white of the eye and the spaces between the cheek markings are filled with what appear to be glass inlays. The space between the eye and brow is incised with crosshatching and the eye cosmetic line is decorated at the end with an incised braid pattern. The usual falcon-cheek markings beneath the eye are transformed into an arm that holds an *ankh* sign, the symbol of life. The white inlay of the eye originally had another overlay for the pupil; it and the red inlays below the eye are fixed with some sort of bitumen adhesive. The amulet is perforated laterally for suspension on a necklace or bracelet. A similar *uadjet* amulet, without any inlays but with its necklace, was found in the tomb of Tutankhamen.[1]

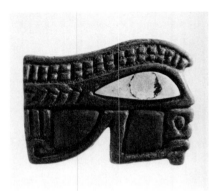

349

The eye of the falcon god Horus *(uadjet)* is a symbol of soundness or totality and, as an amulet, is second in popularity only to the scarab.[2] A human eye compounded with the facial markings of the falcon, the name derives from the ancient Egyptian verb *uadja* ("to prosper, be sound").[3] The importance of the eye originates from the myth about a conflict in which the eye of Horus is injured by his uncle Seth in a struggle for hegemony over Egypt. Because the eye is later restored by the god Thoth, it came to be known as the "sound eye of Horus."[4] The power of this amulet is graphically represented by the arm, which offers the symbol of life to the wearer.

L.H.H.

1. Edwards 1976b, no. 27; see also Davies 1927, pl. 25.
2. Edwards 1976b, p. 33.
3. Erman and Grapow 1928, vol. 1, p. 399.
4. Mercer 1942, pp. 150ff.

Bibliography: Dunham and Janssen 1960, p. 17.

Literature: Walters Art Gallery 1980, p. 34, no. 82.

350
Amulet in the form of a Bes-image
Said to be from Thebes
Dynasty 18, reign of Amenhotep III to Tutankhamen
Height 3.6 cm.; width 1.7 cm.
The Brooklyn Museum, Brooklyn, New York. New-York Historical Society. Charles Edwin Wilbour Fund (37.710E)

This beaten gold amulet with a suspension loop at the top of the head probably hung from a necklace or bracelet belonging to a wealthy woman living in the second half of Dynasty 18. It translates into gold a type of faience amulet commonly found at Malkata, Amenhotep III's Theban palace, and at

Amarna, the city of Akhenaten. Young women frequently adorned themselves with these amulets, perhaps during crucial rites of passage in their sexual development. A wooden cosmetic vessel of the same period carved in the form of a naked servant girl, today in the collection of the Durham Museum,[1] shows such an amulet suspended from a cord tied around the woman's neck.

Both the pronounced veining and the indication of the ribcage permit an attribution of this Bes-image to the reign of Amenhotep III, Akhenaten, or Tutankhamen[2] (see cat. 48).

<div align="right">J.F.R.</div>

1. Porter and Moss 1964, pp. 670-671.
2. Romano 1980, p. 45.

Bibliography: New-York Historical Society 1915, p. 61, no. 1021; Williams 1924, pp. 66-67, no. 10, pl. 5.

350

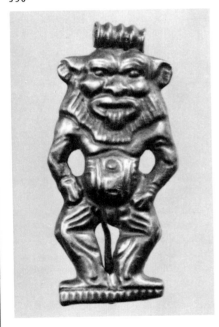

351

Amulet of Senenmut

Provenance not known
Dynasty 18, reign of Hatshepsut
Height 2.1 cm.; width 1.7 cm.
The Brooklyn Museum, Brooklyn, New York. Charles Edwin Wilbour Fund (61.192)

This red carnelian amulet in the form of a head of the goddess Hathor bears on the top and back an inscription in five lines naming "the good god, Maatkare [Hatshepsut], beloved of

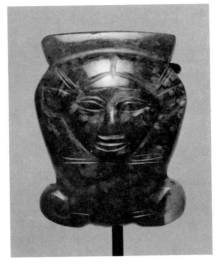

351

Iunyt" and "the hereditary prince, steward of Amen, Senenmut." The serpent goddess Iunyt was one of the three deities worshiped at Armant, a town in Upper Egypt,[1] where she seems to have been syncretized with the cow goddess Hathor. Senenmut had close associations with Armant and dedicated two fine statues of himself in the sanctuary there.[2]

Carnelian, the material of the amulet, is a translucent red chalcedony, the color being due to the presence of a small amount of iron oxide. It occurs abundantly as pebbles in the eastern desert of Egypt and in at least one locality in the western desert. It was much used from predynastic times onward, for beads, amulets, finger rings (see cat. 338), and small vessels, and for inlay for jewelry, furniture, and coffins.[3]

<div align="right">D.N.</div>

1. James 1974, p. 78.
2. Bothmer 1970.
3. Lucas 1962, p. 391.

Bibliography: Bothmer 1970, p. 126 n. 5, figs. 9-11; James 1974, p. 78, no. 179, pl. 48.

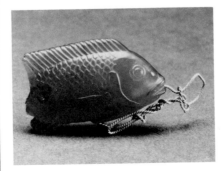

352

352

Bolti pendant

Provenance not known
New Kingdom
Preserved length 2.5 cm.
Walters Art Gallery, Baltimore (42.196). Formerly in the Amherst and Carmichael Collections

Carefully carved in translucent carnelian, this small *bolti* fish has a twisted gold wire imitating a tow rope inserted through a hole in the right side of the mouth and extending through to the belly. The external part of the wire was twisted into a suspension loop in front of the mouth, and the rest was tied into intricate knots so that only one end is visible. In addition to the usual associations of the *tilapia nilotica* (see cat. 138), it also acted as a guide and helped pull the heavenly ship of the sun god Re, who was said to pass across the sky every day in his boat. A blue faience frog of Eighteenth-Dynasty date from Gurob was similarly fitted out, with a stiff twisted copper wire running through its body.[1] (The frog, like the bolti fish, is associated with the solar bark of Re.[2])

<div align="right">E.B.</div>

1. Brunton and Engelbach 1927, pl. 24:22.
2. Thomas 1959.

Bibliography: Sotheby 1926, lot 233; Walters Art Gallery 1980, pp. 40, 42, no. 111; Canby 1980.

Literature: Phillips 1944, p. 188; Gamer-Wallert 1970, pp. 13, 24ff., 53ff., 109ff., 124ff.

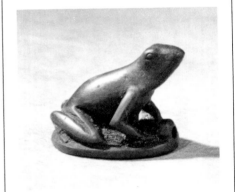

353

353

Frog amulet

Provenance not known
Dynasty 18
Height 1.5 cm.
The Brooklyn Museum, Brooklyn, New York. Charles Edwin Wilbour Fund (59.18)

The opaque blue glass amulet in the form of a frog is pierced lengthwise for suspension. The surface has a slightly matte finish and the form of the frog is carefully modeled with front legs fashioned in the round; the front and rear feet are merely suggested. Within the body of the glass are minute red and light blue inclusions. The ovular bottom of the amulet is inscribed with a brief protective text: "Around [the goddess] Mut there is no fear."

The motif of the frog was very common in ancient Egypt, especially with objects of domestic use, where it was identified with the goddess of childbirth, Heket.[1] The worship of Heket is attested before the beginning of the third millennium, and during the Eighteenth Dynasty representations of her with the body of a woman were included in scenes depicting the divine birth of the king at the temple of Queen Hatshepsut at Deir el Bahri in Western Thebes.[2] The function of this amulet would have been to provide protection for the owner during childbirth, and its power is reinforced by the reference to Mut, goddess of motherhood. The frog goddess also assisted the rebirth that took place after death, the frog hieroglyph being a cryptogram for the phrase *wehem ankh* ("repeating life"), an epithet applied to deceased persons from the Middle Kingdom onward.[3]

L.H.H.

1. Kákosy 1977, cols. 1123-1124.
2. Naville 1896, pls. 49-51.
3. Jacoby and Spiegelberg 1903, p. 217.

Bibliography: Cooney 1960b, pl. 138, no. 2; Brooklyn Museum 1968, p. 97, no. 22; James 1974, no. 277.

Literature: Cooney and Simpson 1976, p. 209 n. 2.

354
Lion-headed aegis

From el Ahaiwah tomb 553
Late New Kingdom
Height 2.5 cm.
Lowie Museum of Anthropology, University of California, Berkeley (6-22882)

This gold amulet is fashioned in the form of an aegis with a head of the lion goddess Sekhmet mounted above a large broad collar. The head is surmounted by a solar disk and uraeus and the lappets of Sekhmet's divine wig frame her face. The individual

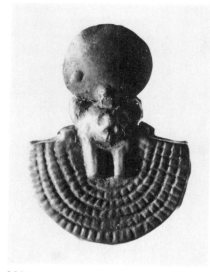

354

beads of the broad collar are indicated only by chased lines, and the falcon-head terminals are merely suggested. This amuletic figure was suspended from a necklace by means of a gold loop on the back.

Aegis heads were used to identify the divine owners of ritual equipment such as sacred barks, furniture, and ritual jewelry. An aegis in Baltimore[1] provides a close parallel to this example.

L.H.H.

1. Walters Art Gallery 1980, p. 22, no. 32.
Literature: Walters Art Gallery 1980, pp. 21-22.

355

355
Scarab

From Semna room W. 105
Dynasty 18
Length 1.45 cm.; width 1 cm.
Museum of Fine Arts. Harvard University—Museum of Fine Arts Expedition (29.1151)

The naturalistic form of this bluish-colored faience scarab, with the head

and legs well modeled and small notches on the wing cases, is typical of Eighteenth-Dynasty scarabs.[1] A hole runs lengthwise, and the base is inscribed with "Amen-Re," surrounded by an *usekh* collar. The scarab was found in an area that has a date range of Dynasty 18 to 20.

The Egyptian scarab was modeled on the *scarabaeus sacer,* or dung beetle. This insect has the curious habit of laying its eggs in a pellet of dung, then rolling the pellet along with its forelegs until it has accumulated a huge ball of dung and burying the ball in the sand to hatch. The image of the beetle rolling its ball of dung was equated by the Egyptians with the concept of the god Kheper rolling the ball of the sun across the sky. It has been suggested that the sight of the young beetles emerging from the dung caused the ancient Egyptians to believe that the scarab beetles were self-creating — which implied, by extension, that the god of the sun was self-created. The emergence of numerous beetles from the earth may have been taken as reflective of life after death, and thus the scarab became a symbol of personal resurrection.

A blue-green glazed scarab in New York was found in deposits from Hatshepsut's tomb,[2] and in the Cairo Museum are several similar scarabs, all dating to Dynasty 18.[3]

The inscription on the base is common to this time (see cat. 359), and the *usekh* collar appears in the base design of other Eighteenth-Dynasty scarabs.[4] The combination of the two elements is unusual.

G.L.S.

1. Newberry 1908, p. 75; Hall 1913, pp. xxx-xxxi; Martin 1971, p. 4, pl. 52.
2. Hayes 1959, p. 88, fig. 48.
3. Newberry 1907, pl. 8, nos. 36504, 36694, 37224.
4. Hayes 1959, p. 87, fig. 48.

Bibliography: Dunham and Janssen 1960, p. 57, no. 28-1-389, fig. 6.

Literature: Ward 1902, pp. 3-4; Newberry 1908, pp. 62-64; Hall 1913, pp. xvii-xviii; Dunham and Janssen 1960, pls. 120:6, 7, 12, 121:24.

356

356
Scaraboid with human face
Provenance not known
Dynasty 18 or 19
Length 2.4 cm.; width 1.9 cm.
Museum of Fine Arts. Gift of Mrs. Horace Mayer (1978.521)

The back of this off-white steatite scaraboid is incised with a human face topped with crosshatched hair; the base shows four monkeys climbing a palm tree. A hole below the chin and at the top of the head, but not piercing the entire length of the scaraboid, indicates that it was probably once set as a ring.

The human face begins to appear on scarabs at the end of the Middle Kingdom. One of the earliest datable occurrences is on a Twelfth-Dynasty scarab inscribed with the name of Amenemhat IV.[1] The popularity of the motif reached its height during the Second Intermediate Period, but it continued in use into the New Kingdom and beyond.[2]

Steatite, or soapstone, the material of which the Boston scaraboid is made, was a favorite material for scarabs of all types between about Dynasties 12 and 20.[3] It is a soft stone, easily carved, and compact enough to withstand considerable use. However, its natural color apparently did not appeal to the Egyptians, and they usually fire-blackened or glazed it; rarely is an unglazed steatite scarab, such as this example, to be found.[4]

The motif on the base of the Boston scaraboid—monkeys climbing a palm tree—is fairly common in Egyptian tomb painting of the New Kingdom. It also occurs on the base of numerous Eighteenth- and Nineteenth-Dynasty scarabs, for example four in the Cairo Museum[5] and one in Liverpool.[6] In the

Zagreb Museum in Yugoslavia is a scarab with two monkeys climbing a palm tree, underneath which is a figure of the Bes-image flanked by two captives.[7] The monkeys and palm tree constitute a cryptogram: *nefer renpet,* meaning "good year"—in effect, a new year's greeting.[8]

G.L.S.

1. Martin 1971, p. 5.
2. Hayes 1959, p. 37; Hall 1913, p. xiv; Brunton and Engelbach 1927, pl. 21:7.
3. Newberry 1908, p. 84.
4. Hall 1913, p. xxv.
5. Newberry 1907, pls. 10, 15.
6. Newberry 1908, pl. 42:28.
7. Saleh 1970, p. 81, no. 288; see also cat. 194.
8. Wallert 1962, p. 99.

Literature: Hall 1913, pp. 121, 189, nos. 1238-1241, 1884; Keimer 1938a; Von Droste zu Hülshoff 1980b, p. 185, no. 223, pl. 17.

357

357
Scaraboid in the form of a hedgehog
Provenance not known
Dynasty 18-19
Length 0.8 cm.; width 0.6 cm.
Museum of Fine Arts. Hay Collection, Gift of C. Granville Way (72.2620)

No larger than a ladybug, this tiny hedgehog is modeled in light green steatite. The base is inscribed with a *Maat* feather and a uraeus, or cobra. The small size is not unusual among Egyptian scarabs and amulets. Numerous examples have been found measuring between .5 and .75 centimeters in length.[1]

From the Old Kingdom to Greco-Roman times, the hedgehog appears on vases, as figurines, and in tomb reliefs depicting desert scenes, as well as in numerous other representations. It was evidently regarded by the Egyptians as a humorous figure (see cat. 87), but the hedgehog's supposed power to resist poison made it valuable as an amulet. One early example, found at Gurob and bearing the name of Senusert II, dates to Dynasty 12.[2] Hedgehogs became more popular dur-

ing the New Kingdom and were a favored device on the backs of Eighteenth-Dynasty and Ramesside seals.[3]

The feather-and-cobra device on the bottom of the Boston scaraboid can be found on a number of scarabs in the Cairo Museum, all dating to Dynasty 18,[4] and on a cat-shaped scaraboid of Dynasty 18 in the Langton collection.[5]

G.L.S.

1. Dunham and Janssen 1960, p. 21, no. 24-2-1167, fig. 6, p. 52, nos. 28-1-327, 28-1-429, pl. 120; p. 92, nos. 24-3-366, 24-3-367, pl. 122.
2. Petrie 1925, p. 30, pl. 24.
3. Hayes 1959, pp. 126, 184, 399.
4. Newberry 1907, p. 15.
5. Langton 1940, p. 50, no. 206, pl. 14.

Literature: Langton 1940, p. 52, no. 215, pl. 14; Von Droste zu Hülshoff 1980b, pp. 151ff.

358

358
Hathor-head seal
From Deir el Bahri
Dynasty 18
Length 1.4 cm.; width 1 cm.
Museum of Fine Arts. Gift of Egypt Exploration Fund (06.2493)

This blue-glazed steatite seal has the head of Hathor carved on one side and the name Amenhotep, in blocky glyphs, on the other. A shallow hole appears at either end, indicating that the seal may once have been set in a ring.

Flat, square seals such as this were popular from the beginning of Dynasty 19, and then again at a later date.[1] Parallel examples also bear the same name or the king's prenomen.[2]

G.L.S.

1. Hall 1913, p. xiv.
2. Ward 1902, pl. 2:32; see also pl. 6:422; Hall 1913, p. 40, nos. 365, 366; Brunton and Engelbach 1927, p. 12, pl. 21:46.

359

359

Scaraboid in the form of a fish

Provenance not known
New Kingdom
Length 1.1 cm.; width 0.8 cm.
Museum of Fine Arts. Hay Collection,
Gift of C. Granville Way (72.2611)

This green-glazed steatite seal is carved in the shape of a *bolti* fish, a common decorative motif (see cat. 138 on Egyptian seals and amulets (see cat. 352). Early examples are seldom as well executed or as numerous as New Kingdom seals, nor are they as clearly intended to be *bolti* fish.[1] Eighteenth- and Nineteenth-Dynasty parallels have been found at Badari,[2] at Gurob,[3] and at Sawama, near Akhmim.[4]

The inscription appearing on the back of the Boston seal, "Amen-Re" between two *neb* signs (meaning "lord"), also found on several scarabs in the Cairo Museum,[5] and on an Eighteenth-Dynasty cat-shaped scaraboid in the Langton Collection,[6] is common to Dynasties 18 and 19.

G.L.S.

1. Brunton 1928, pl. 96:35; Petrie 1925, p. 25.
2. Brunton 1930, pl. 34:73.
3. Brunton and Engelbach 1927, p. 14, pl. 21:57.
4. Bourriau and Millard 1971, pp. 34-35, fig. 7, no. 30.
5. Newberry 1907, pl. 8.
6. Langton 1940, p. 50, no. 207.

Literature: Newberry 1908, p. 87, fig. 90; Hall 1913, p. 40, nos. 371, 372; Rowe 1936, pp. 243, 248, 255, pls. 27:S-3, 50, 28:69a; Schlögl et al. 1978, p. 76, no. 244.

360

Monkey scaraboid

Provenance not known
Dynasty 18-19
Length 1.5 cm.; width 1 cm.
Museum of Fine Arts. Hay Collection,
Gift of C. Granville Way (72.3885)

A seated monkey, its hands to its mouth, adorns one side of this green-

glazed scaraboid; on the back is carved a goose between two lotus blossoms.

The meticulously carved design on the back — even lines for the goose's feathers are depicted — is exceptional. The material, the carving technique, and the treatment of the monkey, however, are all very similar to cat. 359. Both show the same markings over the body, representing scales on the fish and hair on the monkey.

A late Eighteenth-Dynasty scaraboid in the British Museum is carved with a seated ape, hands to mouth; the back shows the prenomen of Thutmose III[1] and a monkey exactly like the present example appears on a scaraboid in the Petrie Collection;[2] on its back is carved "Amen-Re" between two *neb* signs.

G.L.S.

1. Hall 1913, p. 119, no. 1219.
2. Petrie 1925, pl. 9, no. 310.

Literature: Brunton and Engelbach 1927, pl. 40:27.

360

361

Uadjet **eye amulet**

From Amarna
Dynasty 18
Length 1.4 cm.; width 1 cm.
Museum of Fine Arts. Gift of Mrs. S. D. Warren (94.254)

The *uadjet* eye that forms this blue-glazed steatite amulet (see cat. 349) is molded in openwork, and a hole runs through its length. The base is inscribed "Neb-maat-re."

An openwork sacred-eye amulet was found in a tomb at Gurob dated to the reign of Thutmose III,[1] and three similar openwork amulets were once in the collection of John Ward.[2] The first, somewhat more detailed than the Boston example, is inscribed

361

"Maatkare" and dated to the reign of Hatshepsut. The other two, very similar to the present piece, are inscribed "Men-kheper-re" and come from graves datable to the reigns of Thutmose III and Amenhotep II, respectively. A green-glazed steatite sacred eye, inscribed with the name of Tiye, wife of Amenhotep III, is now in Basel.[3]

Neb-maat-re, the name inscribed on the back of cat. 361, was the prenomen of Amenhotep III and can be found on many late Eighteenth-Dynasty scarabs.[4] One found in the Eighteenth-Dynasty level of excavation under the Taharqa Temple at Semna shows the same unusual arrangement of glyphs that make up the throne name of Amenhotep III.[5] Thus, this type of amulet seems to date between the reigns of Hatshepsut and Amenhotep III.

G.L.S.

1. Brunton and Engelbach 1927, pl. 40:27.
2. Ward 1902, pls. 2:234,425 and 4:236.
3. Schlögl et al. 1978, p. 77, no. 251.
4. Newberry 1907, pl. 4:36208, 36209, 36211, 36214, 36215, 36217, 36220, 36222-36225.
5. Dunham and Janssen 1960, fig. 6, no. 28-1-383.

Music

Of all the ancient civilizations, Egypt has left the greatest testimony as to the role and importance of music. The documents that permit the recovery of Egyptian music are both numerous and varied, including paintings from Theban tombs depicting female orchestras (fig. 60), representations from temples and tombs illustrating musical rites, stelae and statues of musicians, objects of daily life embellished with musical scenes, actual instruments, and so forth. Surprisingly, for a people who developed an independent system of writing, it seems that the Egyptians, unlike their Babylonian neighbors, were unaware of any system of musical notation; we therefore know nothing of their musical theory. In the absence of explicit documentation, we are forced to conclude that in ancient Egypt, as is the case in the countryside today, there existed a musical tradition that was transmitted orally from father to son or from teacher to student. Perhaps one day the study of documents that are not well understood, such as magical or mathematical papyri, will reveal to us the secret of Egyptian music. Ancient Greek voyagers were impressed by the serenity and harmony of the Egyptian melodies and attributed the invention of music and its theory to the Egyptian funerary god Osiris.[1]

It is essentially through the study of instruments from the pharaonic period that one gains an idea of what ancient Egyptian music was like. Fortunately, there are numerous examples in museums, and some of them, resting for millennia in the tombs of their owners, have been recovered intact by archaeologists. Their range is quite varied during the New Kingdom, when the Egyptians adopted many instruments originating in the Near East, with which contacts were very close. The ancestors of most modern instruments are found in Egypt: harps, lutes, and lyres among the stringed instruments; flutes, clarinets, oboes, and trumpets among the wind instruments; and drums, tambourines, and castanets among the percussion instruments. Instruments as varied as the Celtic harp, the Egyptian *zummara,* and a type of lyre still played in the high plateaus of Ethiopia seem to derive from instruments used during the pharaonic period.[2] However, the way of playing many of these was entirely different from modern methods: for example, the bow and the drumstick were unknown. Other instruments, such as the sistrum with shrine-shaped head, were indigenous to the Nile Valley. Through study of facsimiles modeled on the design of ancient instruments, acoustical experts and Egyptologists have reached certain conclusions regarding the timbre of harps, lutes, lyres, and trumpets. In addition, comparison with instruments

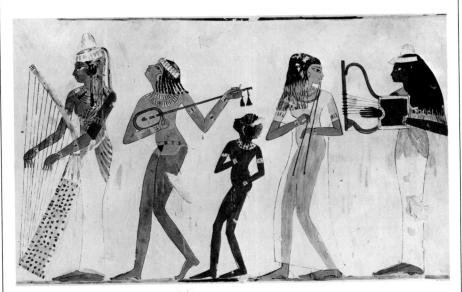

Fig. 60. Female musicians, playing (from left) a harp, lute, double oboes, and a lyre, entertain the guests at a banquet while a young girl dances (from the tomb of Djeserkareseneb Theban tomb 38).

played in Africa today has been very useful, and the study of contemporary Egyptian musical folklore substantiates certain survivals from the pharaonic period, such as the simultaneous clapping of hands and stamping of feet.

Some instruments could be played solo or in duets, as was the case with the trumpet, but most were used in small orchestras. These were often pictured in the tombs of the Theban notables, particularly in banquet scenes showing family members clustered together, wreathed with flowers, perfumed with unguents, and listening to music while drinking. As a rule, the harp, lyre or lute, double oboe, and occasionally the tambourine appear in these scenes. Very often vocalists accompanied themselves on instruments. This was the case with the singer-harpists so popular at banquets in the New Kingdom. Naturally, the relationship between music and dance was extremely close, and young female performers who attended banquets often played on either the lute or oboe while dancing.

The definitive study of Egyptian musicians remains to be done, and at the moment little is known about their lives or social status. Families of court musicians are known from the Pyramid Age; they seem to have been veritable dynasties that transmitted their offices to other family members, like the Bachs and Couperins, and enjoyed a privileged status. During the New Kingdom, the situation became more complex. If music was still practiced as a family diversion, the scenes depicting such activity were no longer shown. By this time, too, the musical profession seemed to have lost some of its prestige, and certain moralistic instructions of the age put youth on their guard against emulating the behavior of musicians.[3] Alongside court musicians such as Harmose,[4] who was attached to the household of Senenmut, the favorite of Queen Hatshepsut (see cats. 193 and 351), one finds many itinerant musicians whose status was near that of slavery. Certain of them, captured in Asia during the course of military campaigns, were later given as rewards to the soldiers; others formed part of the entourage of the foreign princesses who resided in the pharaoh's harem. The Memphite stele of Amenhotep II informs

us that the king brought back no fewer than 270 Asiatic musicians, together with their instruments of gold and silver, all of whom he later offered to a temple.[5]

Each sanctuary possessed a troop of priests or musicians who played the harp, the lute, the flute, the drum, and so forth. They participated in the divine cult and their role was particularly important at the time of festivals and processions. Thus, the celebrated reliefs of Luxor illustrating the festival of Opet[6] show groups of musician-priests escorting the sacred barque. At their side were soldiers carrying drums, trumpets, and clappers, and also women shaking sistrums. It was, in fact, stylish for the women of Theban high society to participate in the cult of Amen and to belong to the "god's harem." However, unlike the "chantresses of the residence of Amen," who were sworn to celibacy, the female musicians of Thebes apparently led entirely normal lives with their families.

Although the documentation is more informative with regard to the sacred than the secular arts, music was ubiquitous in Egyptian daily life; feasting, mourning, and work all took place amid song and the sound of the most diverse instruments. It is not always easy to distinguish scenes of private life from religious ones. Accordingly, the joyous musical soirées that charmed the nobles of Thebes are at times interpreted as funerary ceremonies. Similarly, the representation of a shepherd accompanying the harvesters to the sound of his flute[7] or an Old Kingdom scene showing clapper players accompanying vintners[8] can be taken as the expression of a musical rite in honor of agricultural divinities.

Music and religion were intimately joined in ancient Egypt. In its magical aspect, music appeased the anger of the gods and banished forces of evil. Certain gods were especially associated with this function. Thus, the young women represented beating time, called the *Meret* of Upper and Lower Egypt, were considered as the protectresses of song and liturgical music. Hathor of Dendera, helpful to the dead, goddess of joy, love, and fecundity, was also the patroness of music and dance, and mistress of

noisemaking collars *(menat;* cf. cat. 418), sistrums, clappers, and drums. Her son was the young god of music Ihy. Frequently shown shaking the sistrum with shrine-shaped head, he acted as the protector of choristers. The Bes-image, grotesque but likable, was often shown playing the harp and tambourine; dancing girls were occasionally tattooed with his image or wore Bes amulets (see cats. 143 and 350). Other divinities like the falcon god Horus the Elder, a patron of harpists, were associated with a particular instrument.[9]

C.Z.

1. Sachs 1921, p. 10.
2. Megevand 1974; Jenkins 1969.
3. Caminos 1954, p. 182; Schott and Krieger 1956, p. 122.
4. Scott 1944, pp. 159-163.
5. Helck 1955, p. 1305 ll. 6ff.
6. Hickmann 1956d, pls. 24-25.
7. Ibid., pl. 38.
8. Moussa and Altenmüller 1971, pl. 9.
9. Hickmann 1954a, pp. 31-59.

Literature: Sachs 1921; Wegner 1950; Hickmann 1953; Sainte Fare Garnot 1955; Hickmann 1956c; Hickmann 1956d; Laffont 1973; Manniche 1975; Ziegler 1979.

362

Relief with blind harpist

Provenance not known
New Kingdom
Height 47 cm.; width 36 cm.
Frederick Stafford Collection, New York (courtesy of the New Orleans Museum of Art)

This fragmentary limestone relief shows a blind singer seated on the ground and playing the harp. Harps are frequently adorned with royal or divine heads, in this case with a head of the pharaoh; on the bottom of the sound box is a stylized rosette recalling the rings of the wood in which it would have been sculpted. A column of hieroglyphs incised above the harpist give a portion of the text of his song, expressing his adoration for the sun. The person depicted in the lower register is probably a priest in the process of completing the funerary rites.

Representations of blind harpists appear occasionally during the Middle Kingdom. The reason may lie partly in the fact that there was no musical notation then; therefore the blind were relatively less handicapped in the musical profession.

The texts of songs interpreted by the musicians are quite varied. Most cele-

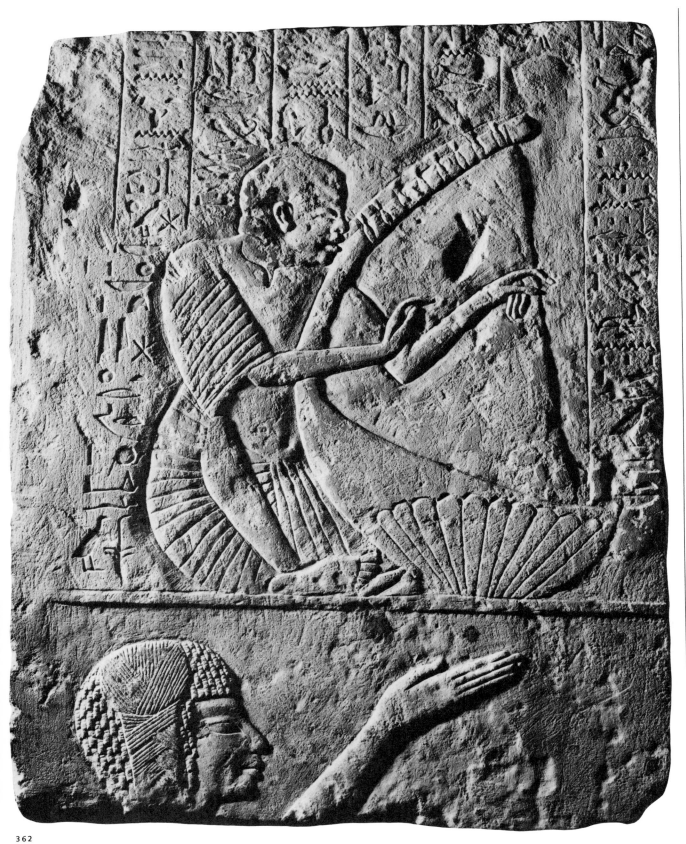

362

brated are those describing the melancholy of the harpist's reflections on the transitoriness of life, expressing skepticism of immortality. Other songs, however, served a religious function and borrowed prayers from funerary literature to guide the deceased on the road to immortality. It is to this last category that the song of the harpist shown here belongs.

C.Z.

Bibliography: Isaac Delgado Museum 1967, no. 68.

Literature: Boeser 1911, pl. 6; Reisner 1920a; Lichtheim 1945, pp. 178-212; Hickmann 1950; Komorzynski 1951, pp. 3-5; Hickmann 1954b; Leibovitch 1960; Wente 1962, pp. 118-128; Simpson 1969-1970, pp. 49-50; Assmann 1977; Hickmann 1977.

Fig. 61.

363

Shoulder harp
Provenance not known
Mid-Dynasty 18
Height 1.82 m.
Metropolitan Museum of Art, New York.
Rogers Fund (43.2.1)

This harp is made in two parts: a naviform sound box and a sharply curved neck ending in a small head. Sculpted from a piece of black wood, the head is attached by means of a tenon. The cords were fastened around sixteen fixed wooden pegs. Twelve of the strings and nine of the pegs have been restored.

Harps are often decorated with divine or royal figurines. One of the most common is Maat, goddess of cosmic order and justice, whose head is crowned with a feather symbolizing her name. It is quite likely that the head adorning this harp was of Maat; at the top is a small cavity for her headdress.

The harp, a favorite instrument of the Egyptians, made its first appearance during the Old Kingdom and subsequently appears in various forms (fig. 61). It would have been a valuable object because it was carved from a large piece of wood, a very scarce material in the Nile valley. Ancient texts also tell of harps encrusted with gold and silver, which were kept in temples (cf. p. 15). All Egyptian harps belonged to the vertical type with the sound box situated at the base of the instrument. On the basis of reconstructions, it is possible to deduce that the range of such small harps corresponded to that of the violin. They were most often played in unison with other instruments. The appeal of the shoulder harp probably lay in the fact that it was easy to transport.

C.Z.

Bibliography: Hayes 1959, fig. 112, pp. 112, 197-198.

Literature: Hickmann 1954b; Hayes 1959, pp. 197-198, fig. 112; Manniche 1975, pp. 58-62; Ziegler 1979, pp. 105-108.

363

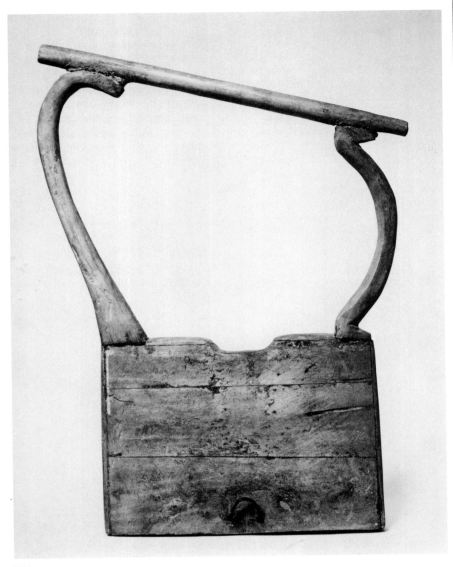

364

364
Asymmetrical lyre
From Deir el Medineh tomb 1389
Dynasty 18, reign of Thutmose III
Height 49.7 cm.; depth 3.8 cm.
Musée du Louvre, Paris (E 14470)

The sound box of this lyre is hollow and open at the base. At the bottom of the box is a small bronze ring that served to secure the strings, and on the solid top is a shallow indentation still bearing the marks of the musician's hand. Surmounting the box are two gracefully curved upright arms of unequal length supporting a crossbar, which still has traces of the leather rings used to hold the original five strings. The harp is made of tamarisk wood and there are traces of red on the sound box.

Archaeologists discovered this instrument placed upon a stool in one of the tombs of the workmen's village at Deir el Medineh.[1] Several lyres have been discovered at the same site; they are all similarly without decoration and have very harmonious lines.

The oldest ancient Egyptian representation of such an instrument is a Twelfth-Dynasty painting showing a caravan of Asiatics who have come to offer their tribute during the reign of Senusert II.[2] However, it is only from the New Kingdom onward that the lyre was adapted from Near Eastern cultures to be used in Egyptian orchestras. It was called a *keniniur*, a name borrowed from the Semitic languages of the Near East.[3]

The asymmetrical lyre was held horizontally, with the sound box either resting against the musician's chest or suspended about the neck on a leather strap. Its gut strings, not numerous and of varying length, were tuned by tightening or loosening the bands that fastened the strings to the yoke.[4] As a rule, the musician sounded the strings with a wooden plectrum. Using a technique still employed in Nubia, he would spread the fingers of his left hand over the strings so as to dampen some, leaving only certain ones free to vibrate. In consequence of the small volume of the sound box, the music must have been muted and, for this reason, the lyre was rarely played alone.

C.Z.

1. Bruyère 1937b, pp. 111-112, 198.
2. Newberry 1893a, pl. 31.
3. Manniche 1975, p. 91.
4. Hickmann 1948b.

Bibliography: Bruyère 1937b, pp. 111-112, 198; Letellier 1978, p. 48, no. 65; Ziegler 1979, p. 118, no. 126; Ecole du Caire 1981, p. 212.

Literature: Hickmann 1949a, p. 155, no. 69417; Ziegler 1979, pp. 118-119.

365
Lyre with horses' heads
From Thebes
Probably Late Period
Height 62.5 cm.
Agyptisches Museum, Berlin (7100)

This wooden asymmetrical lyre has a trapezoidal sound box against which has been fixed a rectangular string holder with thirteen holes. Horses' heads decorate the uprights, which extend through the sound box and are anchored in its base. The transverse bar has an undecorated flower bud at each end.

Although this example is of a period later than the New Kingdom, lyres decorated with animal or vegetable motifs are not rare at that time. In musical scenes one frequently finds such instruments adorned with the head of a duck, ibex, or horse.[1] The famous Turin Papyrus[2] (see fig. 69), which depicts the amorous adventures of a female musician and a priest, contains a representation of a lyre not unlike this one.

C.Z.

1. Davies 1948, pl. 28.
2. Omlin 1973, p. 43, pl. 2.

Bibliography: Sachs 1921, p. 49; Agyptisches Museum 1967, no. 700, pp. 62-63.

Literature: Manniche 1975, pp. 82-83; Ziegler 1979, pp. 116-117.

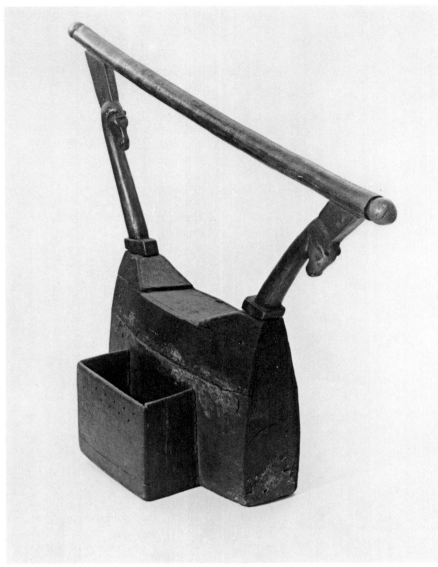

The woman wears a shoulder-length wig with a long plait at the back and bracelets. The face is delicately modeled, with eyes and brows outlined in black. On top of the head is the usual tall spout and behind it a small handle. The figure stands on a separately made round base.

The instrument of the musician, a small lute, is represented very realistically. As is the case with some actual examples,[5] a turtle shell forms the sound box, and the painted striations on the shell are easily discernible, as are the holes in the skin that covered it. Also visible are the eleven frets on the neck, from which two cords with pompoms dangle. In her right hand the musician holds a plectrum.

Playing this type of lute was much like playing the guitar. A musician usually

366

365

366
Vase

Provenance not known
Reign of Thutmose III to late Dynasty 18
Height 21.5 cm.
British Museum, London (5114). Formerly in the Salt Collection

This graceful pottery vase is a three-dimensional version of the lute player who appears among the musicians in so many tomb paintings from the reign of Hatshepsut[1] to the Ramesside Period. In these the girl lutist is often naked;[2] here she wears a close-fitting dress reaching to the ankles, with a v-neck, closed with ties, and short sleeves. There is a narrow fringe along the hem and a line of diagonal strokes in black pigment down each side, which probably represent side seams.[3]

played standing, with the instrument held close to the chest. To change the pitch, the length of a vibrating string was shortened by pressing on it with the fingers of the left hand, while the right hand strummed all the strings with a plectrum. Lutes had either two or three strings and were no doubt tuned according to the vocal range of the singers they accompanied. One of the lower-pitched strings served as a drone, the whole producing notes of a timbre recalling that of the mandolin.

C.Z.

Around the mouth of the vase are black stains, made by the contents (see p. 101). The material of the vase is a fine Nile silt, quite distinct from the fabric of the other figure vases in the catalogue (cats. 84-91). The surface was covered with a thick red slip and carefully burnished vertically. There are figure vases of lutists in alabaster, but all are modeled in a heavy style quite unlike this vase.[4]

J.D.B.

1. Manniche 1975, p. 71 n. 330.
2. Scott 1973, fig. 51.
3. See Riefstahl and Chapman 1970, p. 255, fig. 11.
4. Brunner-Traut 1970a, pl. 6; Wainwright 1920, pl. 20; from a tomb group of late Eighteenth-Dynasty date.
5. Hickmann 1949a, pl. 98.

Bibliography: Knobel et al. 1911, p. 44, pl. 24: 56; Hickmann 1954c, pp. 92-98; Manniche 1975, p. 93; British Museum 1976b, pp. 3-4, fig. 4.

Literature: Hickmann 1952; Manniche 1975, p. 71; Ziegler 1979, p. 123.

367

Double oboe and case

Provenance not known
Ramesside Period
Height of case 63.5 cm.; length of pipe a 53 cm.; length of pipe b 53.5 cm.
Musée du Louvre Paris. Collection Clot Bey (N. 1446, N. 1447a-b)

The original mouthpiece of this instrument — probably made from two split, flattened, and bound sections of reed — is missing. Pipe *a* has three oval holes approximately equidistant, but tube *b* has only one intact hole (two others were destroyed when the pipe was broken). The linen string binding may have been meant to reinforce the pipes at weak points or perhaps created thumb rests, since without some sort of friction, such smooth tubes would have been hard to hold steady while fingering.

367

The case is made from a section of bamboo-like reed. There are pieces of leather and bits of closures at the open end; the bottom is closed naturally by a node in the stem of the plant. The whole surface was painted with geometric designs in black, red, and yellow. In the vignette, a female musician with a long wig and wearing a long gown plays the double oboe before the goddess Mut, who is labeled "Mut, the great one, Lady of Heaven, Mistress of the Two Lands." Above the musician, only her titles are preserved.

Double oboes were extremely popular during the New Kingdom (replacing, to a great extent, the flutes and double

367

clarinets so often seen in the reliefs of the Old and Middle Kingdoms). They were probably imported from Mesopotamia, where they had enjoyed great favor. In all likelihood the melody was played on one tube, while the other acted as a drone. Sometimes the finger holes were temporarily plugged with resin to change the pitch of the instrument for different songs; it is also thought that musicians carried several pairs of tubes, some of which were probably better tuned for certain melodies than others.[1] Although single-tube oboes are known from the Eighteenth Dynasty and later, they were not as popular and are not pictured in reliefs or paintings.[2]

S.K.D./C.Z.

1. Ziegler 1979, pp. 87-88.
2. Ibid., p. 88.

Bibliography: Ziegler 1979, p. 94, no. 113, p. 93, no. 105.

Literature: Closson 1932; Hickmann 1951, pp. 23-27.

368

Pair of clappers adorned with hands

Provenance not known
Dynasty 18-19
Height 19.7 cm.; width 2.86 cm.
Agyptisches Museum, Berlin (9532)

368

1. Ziegler 1979, p. 21.

Bibliography: Sachs 1921, pl. 1:8, p. 19; Agyptisches Museum 1967, no. 708, pls. 705-711.

369

Fragment of a clapper adorned with a Hathor head and a hand

From Semna fort
Dynasty 18 or 19
Height 12.8 cm.; width 3 cm.
Museum of Fine Arts. Harvard University—Museum of Fine Arts Expedition (29.1188)

369

This fragment formed the upper end of an ivory clapper in the shape of a curved arm and hand measuring some thirty centimeters or more. At the wrist is a bracelet and a figure of the goddess Hathor, easily recognizable by her curled wig. Hathor, protectress of the dead and goddess of joy and fecundity,[1] is occasionally called "the hand of Atum," an allusion to one of the episodes in the creation of the earth.[2] There may also exist a relation between the significance of this instrument and the "hand of Fatimah," which is an important element in the religious symbolism of the modern Near East.

There exist numerous ancient Egyptian clappers, sculpted from hippopotamus or elephant ivory. The artist split the tooth in half lengthwise, thus preserving its curved form and making use of the cavity to improve the resonance. Most of the examples dating from the New Kingdom were made in the shape of an arm.

C.Z.

1. British Museum 1976b, pp. 9-22.
2. Hickmann 1956c, pp. 121ff.

Bibliography: Dunham and Janssen 1960, p. 52, pl. 127 I.

Literature: Hickmann 1954a, pp. 31-59; Hickmann 1956a, pp. 67-122; Vandier 1965, pp. 123-124; Ziegler 1979, pp. 19-30.

The instrument is made of two pieces of wood, symmetrically sculpted in the form of a slightly curved forearm. A small fragment is missing from the right-hand clapper and there are no traces of color remaining. A triple-banded bracelet is incised on the wrists and the end of each clapper is pierced so that they can be joined together.

This piece, of relatively crude workmanship, belongs to a type attested in Egypt at least since the Middle Kingdom, but during the New Kingdom it is considerably more common. Its sound replaced the handclapping that had previously punctuated songs and dances, and its form derives directly from this practice (see cat. 369). Egyptian reliefs show several ways of playing them. The musician sometimes held one clapper in each hand and then beat them together vigorously. Sometimes they were placed in pairs between the fingers of the same hand or they might be joined by means of a small tie and suspended from the wrist.[1]

C.Z.

Games

The Egyptians of the New Kingdom seem to have been exceedingly fond of board games; indeed, judging from later tradition, gambling was not uncommon.[1] Unlike their modern counterparts, however, the Egyptians of the New Kingdom did not have a great repertoire of games to choose from, and they rarely invented new ones. In fact they seem to have been content merely to play the few simple games handed down to them by their ancestors from remote antiquity.[2] By far the most popular during this period were the two games whose boards appear on either side of a standard type of game box (see cats. 370 and 371). These reversible boxes were very popular from Dynasty 17 on and can be likened to modern chess-checker and backgammon boards. On one side was a grid for the game called *senet;* on the other was a board for the game called "twenty squares." The pieces were kept in the drawers within.

The Game of Senet

The ubiquitous *senet,* the game of "passing," was unquestionably the board game played most avidly by the ancient Egyptians both in the New Kingdom and throughout their history. It can be traced almost continuously in the archaeological record from predynastic times to the late Roman Period.[3] Even today in Egypt and the Sudan a game bearing astonishing similarities to *senet* is still being played.[4]

Senet equipment was buried with the dead from the earliest dynasties on, and thus much of it survives intact. From the New Kingdom alone, over forty original *senet* sets are known from the graves of commoners, nobles, and kings; other *senet* boards, however, appear as crude grids scratched on pavements or fallen masonry blocks. Still another was drawn in ink on a schoolboy's writing tablet, while two more are found lined on a papyrus in Turin, all of which attests to the game's enormous popularity among Egyptians of all social classes.[5]

Besides the surviving game boards and pieces, evidence for *senet* exists in the form of pictures carved or painted on tomb walls (fig. 62), pictures that depict people actually engaged in playing, seated before their game boards, moving the pieces, or preparing to throw the astragal dice. These same scenes are occasionally accompanied by hieroglyphic texts describing, often at length, the game in progress. With such extraordinary documentation, much has been established about the meaning and play of this game.[6]

Senet was a game for two, played on a board surface marked with thirty squares called *peru* ("houses"), arranged in three parallel rows of ten

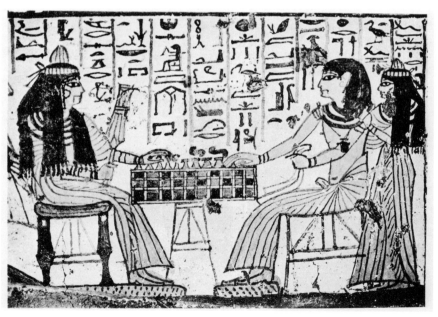

Fig. 62.

squares each. Each player was allotted an equal number of playing pieces called *ibau* ("dancers"), the opposing sides being distinguished by their different size, shape, or color (see cats. 370, 372, and 374). The number of pieces in each camp seems not to have mattered, as long as the two sides were equal, but seven appears to have been the preferred number. Many surviving *senet* sets, however, have as few as five pieces on a side,[7] while others have as many as ten.[8]

The opponents usually effected the movement of their pieces on the board by throws of special flattened marked sticks (cat. 376). An early precursor of cube dice, these implements are still employed today in a variety of Egyptian and Sudanese games, and thus their use is well known. An alternative to the throw-sticks were astragals or "knuckle-bones," which were cast like dice (cat. 375).

To play *senet,* the opponents sat facing each other across the long sides of the board.[9] From certain pictorial and textual evidence it is clear that the three rows of ten squares did not represent a field of battle like a checkerboard but rather a pathway of thirty steps, shaped like a backward S, along which the pieces wound their way single file toward the five final squares of the board, which were usually marked in some way.[10] As suggested by many illustrations, the players seem to have commenced the game by setting up their pieces in alternate squares along the first line. When each player used seven pieces, they would presumably have been lined up alternating to the fourteenth square. The fifteenth of the Berlin board (cat. 371), for example, is inscribed with a blossoming flower, suggesting that this particular square may have been the starting point or first open square in play. By throws of the sticks or rolls of the astragals, players must have tried to move their own pieces forward in order to "pass" (senet) their opponent's pieces, while at the same time trying to block and set the latter back. Although the exact play of the game is uncertain, the object was apparently to remove all one's pieces safely from the board before one's opponent succeeded in doing so.

It seems that the first goal of the players was to achieve square 26, the fifth from the end in the bottom row of the board, which was marked *nefer* ("good"), or some variant thereof. From this position one had to try to leap over the following square, which was clearly a pitfall. Marked ominously "X" (an abbreviation for words meaning both "damage" and "to cross") or, in later boards, *mu* ("water"), this square in gaming scenes of the Old Kingdom is even called the *per heb* ("House of Humiliation") or the *per kesnet* (House of Misfortune").[11] In the later New Kingdom the unlucky player landing here or forced here by his opponent was thought to have "drowned,"[12] and at this point he would perhaps have had the option of either moving his piece back to the start, that is, to square 15, which in the Cairo gaming papyrus is even called the *per wehem ankh* ("House of Repeating Life"),[13] or to remain there, perhaps with all pieces immobilized, until making the particularly difficult throw of "4," which would have removed the piece safely from the board.[14] The next two squares are usually marked with the numerals "3" and "2," respectively, or with symbolic variations of these numbers, while the last square (very rarely marked "1") is normally left blank. Since the "3" and the "2" are frequently mentioned by the individuals depicted in gaming scenes, where their words are written over their heads, it may be that the numerals inscribed on these squares indicated the respective throws of the dice required to remove the pieces positioned thereon from the board.[15]

During the mid-Eighteenth Dynasty the simple signs and numbers traditionally inscribed in the last five squares of the playing surface were replaced by ever more elaborate symbolic equivalents — pictures, inscriptions incorporating the old signs, and even divine images — with the result that the simple secular game of old was given a rich new allegorical meaning that must have dramatically increased its entertainment value.

So long had *senet* games been a feature of tomb regalia, and so long had it been assumed that the dead could enjoy the game in the next world, religious thinkers of the period had

begun to theorize that perhaps the very fate of the dead depended upon their playing a *senet* game in the netherworld against their collective enemies or, indeed, against Fate itself. This contest, played in the presence of Osiris, judge of the dead, was imagined to serve as a substitute for the judgment ordeal, its outcome deciding whether or not the deceased player would achieve immortality.

By the reign of Amenhotep III, the idea of a funerary *senet* game seems to have acquired general acceptance, since it is then that the earliest use can be found of the introductory text to chapter 17 of the Book of the Dead,[16] in which it is implied that the resurrection of the deceased was somehow dependent upon his playing a *senet* game. Certainly by Dynasty 19, this curious notion was a popular one, for now not only were pictures of these underworld contests painted on the walls of tombs or drawn in copies of the Book of the Dead; the last five squares on actual boards of the period (see cat. 372), were given new markings that alluded very specifically to one's desired fate after death. A few surviving boards even bore special amuletic signs and symbols on all thirty squares, although here the designs on the first twenty-five seem to have been no more than good-luck charms, without influence on the actual play of the game.[17] Such playing grids seem to have so caught the public fancy that they even inspired a new genre of funerary text in which the deceased asks for and receives victory in a *senet* game, simulating his perilous passage through the netherworld after death, and in which the moves are reckoned by the designs inscribed on each square.[18] It is from these texts that the most information about the play of the game, its object, and its meaning is derived.

Although it might appear that this bizarre version of the game may have been designed specifically for the dead, and the boards only for burial in the tomb, it is most likely that the funerary *senet* game was also thoroughly enjoyed by the living and permitted them to fantasize about the grim adventure that they expected would await them after death, leading ultimately to the attainment of a blissful afterlife.

The Game of "Twenty Squares"

Once erroneously identified in Egyptological literature as *tjau* ("robbers"), the game opposite *senet* on the standard game boxes of the New Kingdom actually seems to have been called "20" (or "twenty squares")[19] There is reason to believe, however, that this game, which was clearly imported into Egypt from the East, may have been known alternatively as *aseb*, a name possibly of Babylonian origin (see below). Because in Egypt it acquired none of the symbolic or mythological meanings of *senet*, the game did not inspire a literature like its native counterpart and only rarely appeared in art. Thus, other than the mere appearance of the original boards and their accompanying pieces and dice, there is little available external evidence that can suggest how the game was played.

It is certain, at any rate, that it was a game for two players in which each was normally allotted five playing pieces. The dice used were astragals, although occasionally (see cat. 370) a four-sided teetotum or spinning die was used. As in *senet*, the board surface was divided into three rows of squares, but here the row in the middle contained twelve squares and those on either side of it each contained four squares at one end and a long strip the remaining length (see cat. 371). On some surviving boards the playing surface is left completely uninscribed, but on most, every fourth square is marked with a rosette or some good-luck symbol. Occasionally, certain of these squares are inscribed with words or phrases indicating an advantage or disadvantage for a player landing there (see cat. 371).

With the board placed lengthwise between them as in *senet*, the opponents probably started the game with their pieces lined up on the long blank strips of their respective sides of the board. Then, doubtless by some special throw of the dice, each player put his pieces into play one by one upon his own short row of four spaces, moving them toward the corner.[20] From the corner squares, which are marked in many of the known boards, the players moved their pieces out onto the long middle row, where they would now have been moved in the opposite direction. As it would appear that the winner of the game was the player who first managed to move all his pieces safely down this middle row and off the board (into the open drawer of the box), it may be assumed that the principal action of the game would have been the competition of the players for mastery of these twelve squares. Here the adversaries would surely have tried to block or leap one another's pieces, or to capture them and perhaps send them back to the starting position, while at the same time moving their own pieces, if possible via the marked squares or "safe havens," down the row to the end.

It is probably no coincidence that "twenty squares" bears many striking parallels to the Indian game of *pachisi*,[21] for it quite clearly had its origin in western Asia. Several examples of the game dating to the mid-third millennium B.C. are known from Mesopotamia and Iran.[22] During the early and mid-second millennium the game continued to be popular in Babylonia[23] and it also spread westward, since contemporary evidence for it appears in Cyprus and Crete.[24] Numerous examples appear in Canaan[25] and, after the advent of the New Kingdom, it is found in greatest numbers in Egypt, usually opposite *senet* but occasionally alone.[26]

The earliest-known examples of this game in the Nile Valley are of Seventeenth-Dynasty date,[27] but the game must have been common in Egypt long before this time, since it is almost certainly one of two games depicted side by side in each of two early Twelfth-Dynasty tombs at Beni Hasan.[28] In each scene, one of the games is labeled "Playing 3 and 2," and the two players are shown seated before a gaming table on which two sets of seven pieces appear alternating across the top. Obviously this game is *senet*, since "3" and "2" were the numbers engraved on the final squares of *senet* boards (see p. 264 and cat. 370) and seven was the number of playing pieces allotted each player. The second game in each scene, however, is identified as "*aseb*." Here opposing teams of five pieces appear grouped on opposite sides, corresponding precisely to what one would expect in a view of "twenty squares." The name given the game here, however, is problematical, first, since it occurs nowhere else; second, since it means nothing in Egyptian; and third, since even its spelling seems to have been a matter of doubt to the artisans at Beni Hasan. Yet, although the name does not appear again, views of such games do occur well into the New Kingdom, where they would logically be identified as "twenty squares" (see fig. 63). On the basis of a tantalizing text reference in the Amarna correspondence, however, it may be suggested that the name "*aseb*" was not an Egyptian word at all, but rather a metathetic derivation of the Babylonian word *apsu* ("the Deep"), since among the gifts sent by Tushratta, King of Mitanni, to Amenhotep III on the occasion of his daughter's marriage to the latter are listed what seem to be two games called *patti apsu* ("Canal of the Deep") that came with "astragals inlaid with gold."[29]

One humorous scene of the New Kingdom in which "twenty squares" seems to be portrayed is that found in a satirical papyrus in the British Museum (fig. 63).[30] Here a lion and an ibex are shown seated at a table on which a game box has been placed, with opposing pieces grouped on opposite sides of the board. Each animal holds a playing piece and the lion is also shown holding an astragal.

Fig. 63.

In a variant of this game, called "double twenty," known from several boards of the late New Kingdom,[31] players would seem to have started from opposite corners of the board and converged on each other in the middle row. But this game, too, seems to have been a Babylonian invention.[32] The one known view of the "double twenty" game in Egyptian art is a particularly instructive contemporary illustration of the use of the astragal dice, and it has thus been reproduced with cat. 371.

T.K.

1. Herodotus II:122: Godley 1921, p. 423; Plutarch, *De Iside et Osiride* 12; Griffiths 1970, p. 135; Griffith 1900, pp. 30ff.; and cf. Kendall 1978, p. 23, fig. 17.
2. Kendall 1978, p. 3; Swiny 1980, pp. 69ff.
3. Kendall 1978, pp. 7-43; Pusch 1979.
4. Lane 1871, pp. 49ff; Davies 1925a, pp. 145ff; Kendall 1978, p. 5 and addenda for pp. 5, 7-43.
5. Needler 1953, pp. 73ff.; Kendall 1978, pp. 19ff.; Pusch 1979, pp. 207ff., pls. 45ff.
6. See Kendall 1978; Piccione 1980, pp. 55-58.
7. Carter 1933, pl. 42.
8. Reisner 1923b, p. 262, no. 5.
9. Kendall 1978, p. 16, fig. 10; Pusch 1979, pl. 16.
10. Kendall 1978, p. 9, fig. 3, pp. 54ff.
11. Simpson 1976a, fig. 38; Hassan 1975, p. 23, fig. 7; Kendall 1978, p. 10, fig. 5.
12. Pieper 1931, p. 22; Kendall 1978, p. 57.
13. Pieper 1931, p. 21.
14. Kendall 1978, p. 9, fig. 3, pp. 48, 57.
15. Ibid., addenda for pp. 10 n 6, 64, figs. 8, 9.
16. Budge 1898, pp. ixff.; Davis 1908, p. 9.
17. Kendall 1978, fig. 25, pp. 32, 33 n. 17; Pusch 1979, pp. 324ff., pls. 86, 99-102.
18. Pieper 1931, pp. 20ff.; Kendall 1978, pp. 54ff.
19. Pusch 1977, pp. 199ff.
20. Cf. Lane 1871, pp. 49ff.; Davies 1925a, pp. 145ff.
21. Brown 1963-1964, pp. 32ff.
22. Woolley 1934, pp. 274ff., pls. 95-98, 158, 221; IsMeo 1977, p. 455, figs. 17-19.
23. Lenzen 1961, p. 44, pl. 14r.
24. Dikaios 1969, pls. 128, 129; Brumbaugh 1975, pp. 135ff.; Vermeule and Wolsky 1977, p. 87.
25. Grant 1934, p. 34, pl. 20:2, fig. 4; Loud 1939, pp. 49, 50-53; Pritchard 1954, pl. 67, fig. 214, p. 273f.
26. Cf. Letellier 1978, p. 50, no. 67.
27. Mariette 1889, pl. 51j; Hayes 1959, p. 25f.
28. Newberry 1893b, pls. 7, 13.
29. For text, see Knudtzon 1907, p. 166; for Akkadian *kisallu* ("astragal"), see Landsberger 1960, pp. 12ff.
30. Omlin 1973, pl. 20a.
31. Pusch 1977, pp. 199ff.
32. Banks 1912, p. 355.

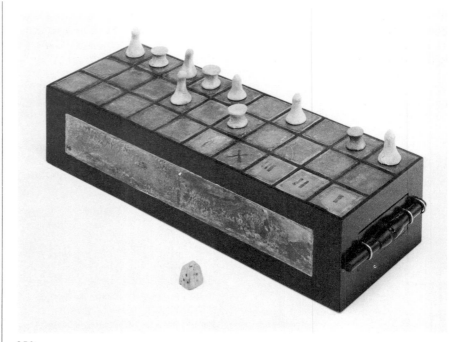

370

370

Game box, playing pieces, and spinning die for *senet* and "twenty squares"

From Grave Z491, Zawiyet el Aryan
Early Dynasty 18
Box: Restored length 35.2 cm.; width 11.1 cm.; height 7.6 cm.
Conical pieces: height 2.3-2.8 cm.
Spool-shaped pieces: height 1.3-1.6 cm.
Die: height 1.5 cm.
Museum of Fine Arts. Harvard University—Museum of Fine Arts Expedition (11.3095-3097)

Although the grave from which this recently reconstructed game box derived contained five adult skeletons, the object was probably associated with the one body that had been interred in a coffin.[1] The box had been placed just outside the coffin at the head end. Apparently, the only other grave goods were a crude pottery bowl and four scarabs. All of the burials, however, had been slightly disturbed.

The original box was found nearly disintegrated; the wood had been so severely damaged by rot or by the action of insects that it was not possible to preserve it. In his unpublished field notes, G. A. Reisner suggested that the wood was ebony, but this identification cannot now be verified since none of the fragments were saved. The present wooden box has been reconstructed according to the drawings and measurements made at the time of discovery.

The box was inlaid on all sides, with faience plaques ranging in color from blue-green to green. Glazed on one side only, these plaques were unevenly colored and possess a mottled surface. On the *senet* side, nine of the thirty squares were missing, including the one marked "X"; they have been restored. The reverse side for the game of "twenty squares" lacked twelve squares (i.e., rectangles), which have likewise been restored. A single plaque belonging to this group appears to have been yellow glazed, and the suggestion might be made that it marked one of the special squares or "safe havens" in that game (see p. 265). Assuming that there were originally fourteen playing pieces, the set seems to be lacking one conical playing piece and three of the spool-shaped pieces. It is very likely, however, that

even at the time of the burial most of these plaques and pieces were lost, and that the game set then was already so old and worn out that the living had no further use for it. All the playing pieces were found inside the remains of the box, as if they had been stored in the drawer. The unusual die was discovered outside the box several feet away. Neither astragals nor throwsticks were found.

The *senet* board possesses crude markings of the early type on the five final squares, suggesting that this game set was manufactured not later than the early fifteenth century B.C.[2] The twenty-sixth square in play, the fifth from the end, bears the carelessly written sign *nefer* ("good") in hieratic script. The next, missing in the original, would have carried the ominous mark "X" (see p. 264). The next three squares are marked with the numerals "3," "2," and "1," respectively, the addition of the last number to the final square being unique on boards of this type. None of the surviving rectangles from the twenty-square board bears a written mark or sign.

Most unusual with this set is the prismatic four-sided ivory teetotum or spinning die, which is paralleled, it seems, only by a contemporary example from Tell Beit Mersim in Palestine,

which accompanied a board for the game of "twenty squares."[3] Presumably this die, whose sides are marked with one, two, three, and four dots respectively, served as a substitute for astragal dice in the same game. It is perhaps the earliest prototype of the cube die known in Egypt.[4]

<div align="right">T.K.</div>

1. Dunham 1978, p. 73.
2. Cf. Needler 1953, p. 73.
3. Pritchard 1954, fig. 214, p. 273f.
4. See Carnarvon and Carter 1912, p. 58; Mackay 1931, p. 459; Bruyère 1933, p. 7.

Bibliography: Dunham 1978, p. 73; Kendall 1978, p. 19 n. 13, p. 25, fig. 19b; Pusch 1979, pp. 241ff., pl. 58.

371
Game box for *senet* and "twenty squares"

Provenance not known
Mid-Dynasty 18, reign of Thutmose III or Amenhotep II
Length 40.5 cm.; width 11.7 cm.
Agyptisches Museum, Berlin (10756)

Similar in form to the Boston game box (cat. 370), this example was carved from a single block of wood of unspecified type. A separately made drawer for the pieces, now lost, would have been inserted into the rectangular hollow chiseled out from one end. Grids for the games of *senet* and "twenty squares" are carved in relief on the upper and lower surfaces, while on the sides short hieroglyphic offering formulae are inscribed. The end opposite the drawer also bears an incised banqueting scene that depicts the owner of the box and his wife

seated, sniffing lotus blossoms, on opposite sides of a table heaped with food. The name of the gentleman is given as Sennefer, who is "the king's follower on water and land in the southern and northern foreign countries. . . ."[1] Since the style of the incised drawing of Sennefer and his wife is typical of the reigns of Thutmose III and Amenhotep II, it is probable that the individual served as a soldier in the foreign wars of one of those kings.

The markings on the *senet* side likewise corroborate this date, since they are transitional between the early type, as represented by the Boston board, and the type common in the later Eighteenth Dynasty.[2] Here, as before, square 26 is marked only *nefer* ("good"), but, as in the later manner, square 27 is marked with the hieroglyph meaning "water," indicating that, by this time, the square was considered a water obstacle. Instead of the numeral "3," square 28 is now adorned with three jabiru birds, the hieroglyph meaning "power." And again, evocative of the numeral "2," square 29 is inscribed with the figures of two squatting men. Square 30 is left blank. Most unusual is the fact that square 15 is specially marked (cf. cat. 268), a characteristic paralleled by only two other published boards (see p. 264 above).[3]

On the reverse side of the box, the board for "twenty squares" also possesses special marked squares. They are the fourth and eighth on the long middle row, which were un-

doubtedly the lucky squares or "safe havens" in the game. The first is inscribed *ankh nefer* ("good life," or perhaps "alive and happy") while the latter was probably to be read *hest[y] mer[ty]* ("You are praised and loved"). Although in the majority of boards for this game these squares are marked only with rosettes, at least three other game boxes preserve meaningful symbols or phrases on the same squares, which are worth noting for comparison. One, found in the tomb of the architect Kha, bears on the fourth square in the middle row the word *petery* ("watch out"), on the eighth the name of the god Amen, and on the twelfth (which is unmarked on the Berlin board) the words *em hebwy* ("in two festivals").[4] Another board, found at Saqqara with the skeleton of a scribe also named Kha, bears the parallel inscriptions *iuty* ("nothing"), *itj in* ("move unceasingly"), and *kha* ("appearing in glory"), which was also the man's name.[5] A third, the large board found in Tutankhamen's tomb, is inscribed in the same squares: *ankh djed was* ("life, stability, and dominion"), *heb sed* ("[thirty-year] Jubilee-Festival"), and *heh* ("million [years]").[6] It is obvious from such inscriptions that an important strategy in the game was to reach or control these squares. As in *pachisi,* they probably made the pieces placed thereon immune from attack by an opponent. The most significant information gleaned from these inscriptions, though, is the way in which players moved their pieces down the central row. For whereas in each case the words in the fourth square suggest uncertainty or illusory happiness, those in squares 8 and 12 suggest confidence and imminent triumph, respectively.

<div align="right">T.K.</div>

1. Roeder 1924, p. 269.
2. Cf. Needler 1953, pp. 73-75.
3. Ibid., p. 72, fig. 2, p. 74, no. 12; Pusch 1979, pls. 52, 60.
4. Schiaparelli 1927, p. 177.
5. Quibell 1909, pl. 59.
6. Pusch 1979, pl. 60.

Bibliography: Pieper 1909, p. 7, fig. 5; Roeder 1924, pp. 269ff.; Pieper 1931, p. 19; Needler 1953, p. 73, no. 7; Agyptisches Museum 1967, p. 56, no. 584; Kendall 1978, p. 25, fig. 19h; Pusch 1979, pp. 261ff., pls. 64, 65.

371

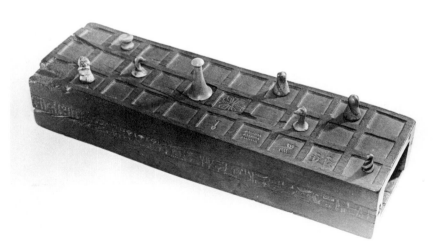

372

Game board and pieces for *senet*
Said to have been found near Tanis
Dynasty 19
Length 33.5 cm.; width 9.7 cm.
Norbert Schimmel Collection,
New York (197)

This pale bluish-green slab of faience, on which a grid for *senet* is neatly incised, is said to have been found with a hoard of at least twenty-four playing pieces that must certainly have accompanied more than this one game. Assuming that the usual two teams of seven pieces were used for the *senet* game, the remaining ten pieces or more would probably have accompanied a matching slab for "twenty squares," now lost. Because the right end of the slab appears to have been deliberately cut down, it might be supposed that it had been trimmed in order to fit conveniently into a container or carrying case. The principal interest in this board lies in the decorative treatment of its five final squares. Here images of gods have replaced the simple signs, numbers, and symbols marked on the earlier boards, and it is completely apparent from their configuration that by this time *senet* had become a kind of funerary fantasy, in which the player's original goal (i.e., getting all of his pieces off the board safely before his opponent) was now construed as a safe passage through the netherworld after death and the achievement of immortality.

Square 26, the traditional *nefer* ("good") square, is here inscribed *per nefer* ("good house") with an image of Osiris seated before the hieroglyphic combination. This square had probably always been known as *per nefer,* for it seems to have been the primary goal of the players near the end of their course and probably the square that had to be attained before one could proceed further and attempt to remove a piece from the board.[1] *Per nefer* was also the name of the place understood mythologically as that where Osiris had been restored to life, with its temporal counterpart of the same name being the place where the dead were prepared for burial. Here the name is perhaps better rendered in English as "House of Rejuvenation."[2] On a somewhat similar faience slab board for *senet* in the Walters Art Gallery[3] the same square bears the design of a mummy lying on a bed. Obviously, in this new symbolic version of *senet* the "good" and primary goal of a player was to achieve mummification.

Square 27, the age-old "House of Misfortune," is no longer inscribed merely "X" ("cross-over," "damage") or *mu* ("water") as it was on the earlier boards. Here it is marked with an image of a Nile god. If it was this square in the traditional *senet* game that the players had to cross safely to attain a position from which to exit from the board, it was here imagined as the Nile, across which the "de-ceased" player was ferried to his tomb on the west bank, which was, in fact, symbolized by square 28, "The House of the Three Gods."[4] Recalling the old numeral "3," the three divinities represented here are Osiris, Lord of the Underworld; Horus, his son; and Hathor, Mistress of the Necropolis.

The following square, evoking the numeral "2," bears images of the sun god in two of his forms, Re and Atum, suggesting the composite sun deity Re-Atum. This was the old sun that was thought to traverse the waterways of the netherworld in a ship, after sunset, with the deceased as a crew member, toward the eastern horizon, where both it and the deceased would be reborn and rejuvenated in the dawn. The sun emerged into the new day as Horus or Re-Horakhty, the deity represented by the falcon on the last square, while the deceased emerged "as a living *ba,*" having gained eternal life, which was the object of the game as stated in chapter 17 of the Book of the Dead.

T.K.

1. Kendall 1978, p. 51f.
2. Donohue 1978, pp. 143ff.
3. Pusch 1979, pl. 84.
4. Kendall 1978, p. 58.

Bibliography: Cooney 1974, no. 197; Kendall 1978, pp. 26ff. and addenda for p. 26; Pusch 1979, pp. 313ff., pl. 82.

372

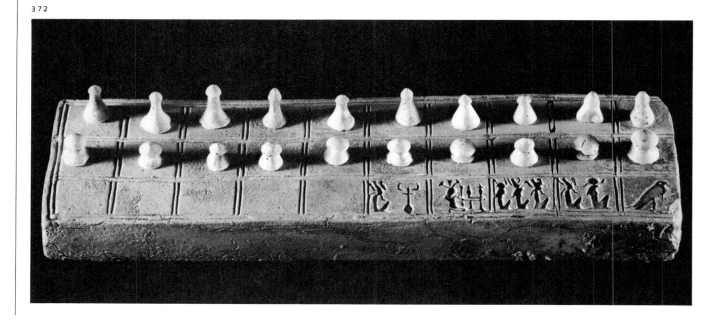

373

373

Game piece in the form of a bound captive

Provenance not known
New Kingdom
Height 3.2 cm.
Royal Ontario Museum, Toronto
(910.100.5)

Game sets of the New Kingdom were always supplied with playing pieces of two distinct types, representing the two opposing sides. Typically, one side consisted of conical pieces that were knobbed at the top, while the opposite were spool-shaped pieces with concave sides (see cats. 370 and 372). As is true with many modern games enthusiasts, however, some Egyptians preferred more finely made or more fanciful pieces than the ordinary, and some quite unusual varieties are known.

This particular piece, in green faience, represents a bound captive, modeled from the waist up, his elbows tied tightly behind his back. His hair was glazed a brownish-black. Somewhat similar pieces in Berlin and New York also depict bound captives, but they differ from this one in that their conical bases are formed from their flaring skirts.[1] Three other examples represent bound naked captives, kneeling.[2] Another type of anthropomorphic playing piece is made in the form of a soldier grasping a bow,

while several others display only human heads.[3]

T.K.

1. Pieper 1909, p. 9, fig. 7; Ägyptisches Museum 1967, no. 584; Scott 1973, fig. 44.
2. Nash 1902, pl. 4:1, 2, 4.
3. Towry-Whyte 1902, pl. 1:1,6, 16.

374

Game pieces

Provenance not known
Dynasty 19-20
Height 4.3 cm.
British Museum, London (24661-24676)

This extraordinary set of molded green faience game pieces (seven jackals and ten Bes-headed figures) almost certainly accompanied an elaborate board, now lost, for the funerary *senet* game (see cat. 372). In this context, the Bes image, which might normally suggest the visage of the dwarfish divine protector of the household, probably recalls the group of mysterious underworld deities known collectively as *Ahau*, the "fighters" (see cat. 281), who were seen as the enemies of all supernatural miscreants and all those inimical to the sun god in the netherworld (see p. 223).[1] As game pieces they would probably have been thought efficacious in defending the "deceased" player in his simulated journey with the sun god through the realms of night on the *senet* board. The jackals, which personify the "souls (or *bas*) of the west" were

likewise viewed as protectors of the dead and of the sun god whose ship they were thought to tow.[2] In the same way they would have been thought appropriate allies of a player. In describing the funerary *senet* game, the Cairo gaming papyrus[3] even attributes the final success of the victorious player to his magical playing pieces, which are said to pull his fingers across the final squares to safety "like the jackals that tow the solar bark" (see cat. 376).

Other pieces with the heads of the Bes-image and jackals are known,[4] and, in the Osireion at Abydos the Pharaoh Merneptah is portrayed seated before his game table in the underworld, on which pieces in the form of seated jackals may be seen set up.[5] By Greco-Roman times, Egyptian game pieces were actually called "dogs," as they are today.[6] In this regard, it is perhaps worth noting that there is also evidence for a Babylonian board game called, after the playing pieces, "Pack of Hounds."[7]

T.K.

1. Allen 1974, pp. 38, 66, 87; Steindorff 1946, pp. 48ff.
2. Heerma van Voss 1955, p. 127.
3. Pieper 1931, p. 21.
4. See Towry-Whyte 1902, pl. I: 3-5; Nash 1902, pp. 345ff., pl. 3: 10-16.
5. Kendall 1978, p. 37, fig. 28.
6. Nash 1902, pp. 346ff.
7. Landsberger 1960, p. 129.

Bibliography: Nash 1902, p. 346.

374

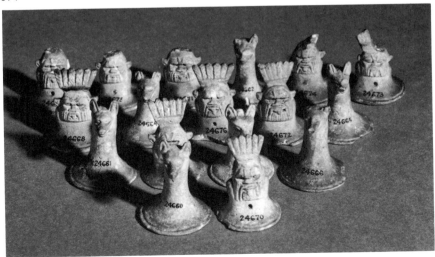

375

375
Astragal
Provenance not known
New Kingdom
Length 3.5 cm.; width 2 cm.
Museum of Fine Arts. Hay Collection,
Gift of C. Granville Way (72.740)

The astragal, more familiarly but incorrectly known as the "knuckle-bone," is a small bone found within the tarsal joint of most hooved animals. As early as the fourth millennium, astragals, particularly those of sheep and goats, may have been used as dice in Eastern Europe,[1] as they certainly were later during the third millennium in Anatolia and Mesopotamia.[2] Although a single astragal is known in Egypt from a royal tomb of the First Dynasty,[3] it is apparently not until the advent of Dynasty 17 that they can be shown to have been used as dice with Egyptian games.[4] Astragal dice may have come into wide use in the Nile Valley only as such foreign games as "twenty squares" became popular there, games whose special dice they seem to have been. This form of dice must have been adapted very quickly to senet as well, since in tombs of the later New Kingdom they are actually depicted, to the complete exclusion of the throwsticks, in gaming scenes painted on the walls, where the illustrated contest is specifically stated in the accompanying text to be senet.[5]

Always readily available from slaughtered animals, astragals must have been commonly saved and dried after banquets in much the same way that we save "wishbones" from roast fowl today. Although these oddly shaped little bones are clearly four-sided, to us, they seem unsatisfactory as four-sided dice because they are so decidedly loaded in favor of two sides. Still, there is reason to suppose that in ancient practice this feature was considered desirable.

If the contemporary Hittites sometimes shaved the sides of astragals or weighted them with plugs of lead or copper to improve the roll,[6] the Egyptians frequently disdained the original bones altogether for more attractive artificial ones that more satisfied their need for aesthetics and symmetry. Probably the simplest of these imitations is represented by this example, which was molded in clay, albeit somewhat less than realistically, and colored with a red slip. It is paralleled by several examples excavated at Thebes.[7] A pair of wooden astragals was found with a game set of early Nineteenth-Dynasty date at Saqqara[8] and a green-glazed faience example was discovered in the debris of a private house at Amarna.[9] Pairs of astragals of ivory and resin were found with two of the game boxes in the tomb of Tutankhamen,[10] and "astragals inlaid with gold" are listed twice among the gifts sent by Tushratta, King of Mitanni, to Amenhotep III (see p. 15).

With Egyptian games, astragals are normally found in pairs, but the pictorial evidence suggests that each player used them singly. While a pair not in use may be seen in the senet game depicted in the tomb of Nebenmaat (Theban tomb 219, see p. 263, fig 62), only one appears in the senet game of Sennedjem (Theban tomb 1), lying at the gentleman's feet.[11] In the game illustrated in the tombs of Neferrenpet Kenro (Theban tomb 178)[12] and Nefersekheru (Theban tomb 296)[13] each of the tomb owners holds what looks like a single astragal poised on the tip of his upturned forefinger as if at the moment of throw.[14] Similarly, in a satirical gaming scene (see fig. 63), only one astragal appears in the lion's paw. Probably the most informative view of these dice, however, is one depicted in a Theban tomb painting (now destroyed) that was recorded in the nineteenth century (see fig. 64).[15] Here again, two astragals are shown, but the player on the left, who would seem to have just thrown the one lying on the top of the game box, is moving his playing piece, while the player on the right, who has not yet made a move, may be seen picking up the other as if to make his first throw.

Possibly the sides of each astragal were valued 1, 2, 3, 4 (or more), with the loaded sides being 2 and 3. Throws of 1 and 4+, being the more difficult to obtain, would probably have entitled the player to a second throw, just as did similarly valued throws of the throwsticks.[16] It should be noted, however, that two perfectly rectangular four-sided Egyptian bone dice are known with sides actually marked 1, 2, 5, and 6, and 2, 4, 3, and 10, respectively. The latter even bears on one end the sign nefer ("good").[17]

T.K.

Fig. 64.

1. Ivanov 1978, p. 58, fig. 23.
2. Schliemann 1881, pp. 263, 426, fig. 531;
 Mackay 1929, p. 135.
3. Hayes 1953, p. 46.
4. Hayes 1959, p. 26.

5. Pusch 1979, pls. 18, 24, 25, 28, 30, 33, 36.
6. Bittel 1933, p. 27; Boehmer 1979, p. 44, pl. 27.
7. Carnarvon and Carter 1912, p. 76; Letellier 1978, p. 51, no. 72.
8. Quibell 1909, p. 114.
9. Frankfort and Pendlebury 1933, p. 25, pl. 29:2.
10. Carter 1933, pl. 42; Murray and Nuttall 1963, pp. 3, 17.
11. Wreszinski 1923, pl. 418.
12. Davies and Gardiner 1936, pl. 94.
13. Pusch 1979, pl. 24.
14. Ibid., pl. 33.
15. Pieper 1931, p. 19.
16. Cf. Davies 1925a, pp. 145ff.; Lane 1871, pp. 49ff.
17. Hilton-Price 1897, p. 355, nos. 2978, 2979.

376

Throwsticks

Provenance not known
New Kingdom
Length 18.2 cm.; width 1.5 cm.
Manchester Museum [England] (6231a-f).
Formerly in the Grenfell Collection

Before the introduction from abroad of astragals, teetotums, and cube dice, the only comparable gaming implements known in Egypt were tabular throwsticks, evidence for which appears commonly even as early as the Archaic Period.[1] These objects were flattened wands, usually somewhat less than a span in length, used in sets of four, five, six, or more, depending upon the game played or upon the regional preference.[2] In their simplest form they were no more than split reeds, and even the finest examples carved from wood or ivory always tended to exhibit this original shape. One side was flat or slightly concave and undecorated, while the other was slightly convex and carved or engraved in some way. When thrown together, the sticks fell randomly, each landing so that either a marked or an unmarked side faced upward. Judging by the way these implements are used today in Egypt and the Sudan, a player in a board game counted the number of unmarked sides after each throw to determine the number of spaces he was entitled to move a playing piece. Throws in which all the marked or unmarked sides faced up were valued the highest, since they were the most difficult to obtain. They also entitled the player to an extra throw, as did a throw of "1."[3]

This particular set consists of six sticks, two of which are fragmentary. Of carved ivory, all have flat undecorated undersides and slightly curving upper surfaces marked on the ends and in the middle with transverse,

376

black-filled, incised lines. Three of the sticks possess squared ends, while each of the remaining three has one end carved in the form of a jackal's head.

Why three of these sticks should have been distinguished from the other three is uncertain. A set of four throwsticks found in a Seventeenth-Dynasty tomb[4] and a like set from Tutankhamen's also consisted of distinctly marked pairs.[5] Two in each set bore the same jackal-head motif on both ends, while the other two had ends carved to resemble fingertips with their nails. In a related set of nine throwsticks in the Metropolitan Museum, varying in length, each stick has a jackal head and a fingertip carved on opposite ends.[6]

The carved fingertips are a common feature that can be traced back to the Old Kingdom.[7] Indeed the sticks actually seem to have been called *djebau* ("fingers"). Since gaming throwsticks and the fingers of the hand were also closely related in function, both as counting aids and as the movers of the playing pieces in a game, the Egyptians, who were always fond of visual puns and double meanings, must have begun to exploit this relationship at a very early date. Thus, when a player in an Old Kingdom

senet game scene from the tomb of Idu at Giza says to his opponent "[I] will cause the finger to lead [you] to the House of Humiliation," he seems to be threatening both a physical action and the throw of the sticks that would have enabled him to seize his adversary's piece and place it on the unlucky square 27 ("X"). A thousand years later in the New Kingdom, the same trite ambiguities were apparently still being uttered over *senet* games, for in the text of the Cairo gaming papyrus the victorious player states at approximately the same point in the contest: "My seven pieces are in front of my fingers like the jackals that tow the solar bark. I seize his [i.e., the opponent's] pieces and throw him into the waters [i.e., square 27] and he is drowned. . . ."[8] Here again, the word "fingers," which seems to refer to the digits, may also be alluding to the throwsticks, especially since jackals are mentioned.

As noted above (p.268), the Egyptians believed that the sun god was towed along the river of night in the underworld by a team of jackals, called variously "the Souls of Hieraconpolis" or "the Souls of the West."[9] In the funerary *senet* game described by the Cairo papyrus the player, too, made a simulated passage through the nether regions with the sun, and his pieces were likened to these jackals, which seemed to pull the player's hand across the final squares to safety (cf. cat. 372). Since jackals' heads are also carved on the ends of throwsticks, in a certain sense they too are "in front of the fingers" (i.e., on the ends of the throwsticks). One can only suppose that these carved images recalled the same protective jackal spirits, whose images here must have been thought to bring luck to a player in this allegorical context.

T.K.

1. Petrie 1900a, p. 23, pl. 17:30, p. 37; Emery 1954, pp. 54ff.
2. Quibell 1913, p. 20, pl. 11; Reisner 1923b, p. 263; Hayes 1959, pp. 26, 200.
3. Davies 1925a, pp. 145ff.; Lane 1871, pp. 49ff.
4. Hayes 1959, p. 26.
5. Carter 1933, pl. 75a.
6. Hayes 1959, p. 200.
7. Cf. an unpublished wooden example excavated by Reisner at Giza, Giza Object Register 12-12-105.
8. Pieper 1931, p. 21; Piankoff 1974, p. 120; Kendall 1978, p. 57.
9. Heerma van Voss 1955, p. 127.

Pets

The fondness of the ancient Egyptians for animals is illustrated in their art throughout Egypt's history. Tomb reliefs and paintings, especially, leave a record of the wide variety of domesticated and wild animals used not only for food but for service and as companions.

The animal first and most often represented in Egyptian art as a companion to man is the dog. It appears in desert and hunting scenes decorating predynastic pottery[1] and combs[2] and, accompanying hunters and wearing collars, in a relief in the Fifth-Dynasty tomb of Prince Re'em-kuy at Saqqara.[3] During the Middle Kingdom, dogs came to be portrayed more frequently than ever before, and with greater variety.[4] A number of distinct types are depicted in paintings in the Twelfth-Dynasty tombs at Beni Hasan: a long, lithe hunting hound with upright, pointed ears and a short, curly tail; a similar hound with lop ears and a long straight tail;[5] a somewhat stockier dog with a large, broad head and lop ears;[6] and, finally, a dog that can only be compared with a Welsh Corgi, with a long body, very short legs, and upright ears.[7] Middle Kingdom figurines found at Lisht show the common village dog, a small mongrel with short legs, a short, wide muzzle, lop ears, and a curly tail[8] and, in an Eighteenth-Dynasty letter, mention is made of large, wolfish, half-wild dogs that roamed the city streets in packs.[9] The remains of at least four different types of dog, dating to the Roman Period, not all the same as those seen at Beni Hasan, have been excavated at Abydos.[10] One, known as the "pariah" dog, had a large head and resembled a jackal or wolf. A second dog, curly-tailed with long legs and face and a high forehead, has been loosely termed the *tjesem* hound, after one of the Egyptian words for dog, although the Egyptians applied that name to more than one kind of dog. A third type, the "Egyptian" dog, stood in size between the "pariah" and the *tjesem* dogs, having a short, wide skull and a large forehead. The fourth dog, known only from a single skull, has been called the Egyptian Spitz, and was similar to, but taller than, the modern Pomeranian Spitz.

The determinative following the Egyptian word *tjesem* depicts the pointy-eared, curly-tailed hound, and from the Predynastic Period until the Middle Kingdom this is the dog most often represented. Lop ears seldom appear during this time, except on puppies. By the New Kingdom, however, the lop-eared, straight-tailed hound (fig. 65) had taken precedence and, although the determinative remains the same, the word *tjesem* was applied to both dogs.[11]

Fig. 65. This lop-eared, straight-tailed hound wears an elaborate collar (from Theban tomb 179).

Unlike the young of many animals portrayed by the Egyptians, which appear often simply as small versions of the adults, puppies, whatever their breed, are frequently given separate treatment, with a whimsical emphasis on their chubby form and youthful vitality. In "The Tale of the Doomed Prince," a New Kingdom literary work, a "greyhound" puppy is called a "young springer," indicating its liveliness.[12] On a limestone relief from the Old Kingdom, two round-headed, lop-eared puppies are shown standing uncertainly.[13] A blue faience figurine from the Middle Kingdom shows a small boy playing with a fat little puppy[14] and a Saluki pup pants, perhaps after a burst of energetic activity, in a small bronze figurine of the New Kingdom.[15]

Dogs were used for a wide variety of purposes in Egypt. They are most frequently represented as hunting dogs,[16] and they may occasionally have accompanied their masters into battle as well;[17] they also acted as shepherds and watchdogs. Perhaps most important, they were amiable companions and pets, as shown by the little dog sitting behind the gardener at work and the dog accompanying the herdsmen and their goats in a painting in the Nineteenth-Dynasty tomb of Ipuy[18] and the seal carving of a man holding a dog that licks his face.[19] Beginning in the Old Kingdom dogs are depicted waiting patiently under the chair of their master or mistress, a tradition that continues in later dynasties.[20]

The dogs of Maiherperi (see cats. 199 and 200) were apparently not buried with their master, but his tomb contained two dog collars. The collar illustrated in fig. 66, composed of layers of pink, green, and white leather, was decorated by cutting shapes out of the upper layers, allowing the various colors to show through. The edges are scalloped, and metal studs are evenly placed around the collar in two rows.[21] The horse depicted on the collar became a major motif in the art of the New Kingdom after the animal first appeared in Egypt during the last years of the Hyksos domination.[22] The second collar from Maiherperi's tomb—made of pink leather, gilded on the outside and decorated with scalloping along the edges and four embossed scenes depicting lionesses or panthers attacking antelopes—was inscribed with the dog's name: "She of the City [Thebes]."

Fig. 66. A dog collar of colored leather decorated with prancing horses (found in the tomb of Maiherperi).

Of the numerous pets known to have been kept by the Egyptians, their dogs are among the few whose names are recorded, most of them common human names. Others refer to the dog's color, such as "Ebony," or a characteristic, such as "Grabber" or "Steering-Oar of the lion" (a reference to the dog's tail), or to the dog's task, such as "The Good Watcher"; some may simply derive from the Egyptian word for the sound of barking, "Abutiu," or from a foreign word.[23] Pets are sometimes simply referred to as the "darling" of their owners.[24] Like other especially beloved pets, dogs were frequently buried in honor, with their masters or separately, sometimes elaborately embalmed and in a coffin.[25] At the very least, their bones, with the bones of other pets, were put in a bone pit—as was done with the harem pets at Amarna.[26]

Cats were probably not domesticated in Egypt before Dynasty 11.[27] Those depicted on Old Kingdom tomb reliefs are wild cats, shown in their natural surroundings.[28] A Middle Kingdom representation from Koptos, once thought to show a dog sitting under its master's chair, is now recognized as depicting a pet cat.[29] A Twelfth-Dynasty tomb at Abydos contained the skeletons of seventeen cats, together with a row of little pots for their food offerings.[30] The serval, or African wildcat, may have been the first type domesticated in Egypt, and there is some textual evidence of their importation from Nubia during the New Kingdom.[31] These cats were probably first used for hunting waterfowl. A relief in a New Kingdom tomb at Thebes shows a cat in the boat with its master on a fowling expedition in the marshes[32] and cats appear, creeping after birds, in many other scenes.[33] During the New Kingdom, they were more frequently depicted as pets, sitting under their owner's chair, snoozing or picking at a fish (fig. 67) or bone,[34] and in one instance a kitten plays on its master's lap.[35] Mummified cats have been found from the Greco-Roman Period.[36]

Fig. 67. Cat avidly devouring a fish (from Theban tomb 52).

Figurines of the New Kingdom and later also depict at least two other distinct types of cat, both native to Egypt—one with long ears, a sharp nose, and a broad tail *(felis chaus)* and the other with short ears, a blunt nose, and a long, tapering tail *(felis ochreata)*.[37] The Egyptian word for all housecats, however, was the onomatopoeic *miu*.

The Egyptians kept rather more unusual animals for pets, as well. Monkeys, for example, presumably acquired through trade with Africa, appear in Egyptian art as early as the Old Kingdom, but representations of them decrease during the troubles at the end of that period and are comparatively less common in the Middle Kingdom, both in number and in variety.[38] The New Kingdom saw a renewed increase in the appearance of monkeys, perhaps because the increased prosperity in Egypt at that time[39] enabled people to acquire them as pets. Their lively agility, amusing resemblance to humans, and propensity for creating trouble made them especially popular in humorous portrayals. Even in otherwise solemn situations, monkeys provide a light touch: in numerous tomb scenes depicting tribute from Asia, Nubia, and the Sudan, they are seen climbing and capering, riding their keepers' shoulders, and eating fruit.[40] In many cases, paintings and statuettes of monkeys (like cats, 379 and 380) appear to serve no function other than to amuse—a characteristic of many New Kingdom decorative objects.[41] A number of limestone figurines depicting monkeys in various antics were found at Amarna.[42] Often they imitate human activities, such as playing a musical instrument[43] (cat. 386), or driving a chariot.[44] Monkeys were especially valued as household pets and were frequently shown standing, leaping, or eating fruit, under their owner's chair.[45] Occasionally a second pet has crept under the same chair—to the monkey's delight and to the detriment of the unfortunate cat or dog.[46]

Monkeys, like cats and dogs, also served the Egyptians in a more useful way. They could be trained to clamber up palm trees and gather nuts for their keepers, an activity that became a common motif in New Kingdom tomb painting.[47] In fact, one representation shows a woman holding a bowl of palm nuts in one hand and in the other the leash of a monkey who is busy gathering more.[48] Monkeys, too, were occasionally so dear to their owners that they were buried with them.[49]

Other unusual pets include the ibex and the gazelle. That the gentle, delicate beauty of the gazelle was appreciated by the ancient Egyptians is shown by such depictions as an Eighteenth-Dynasty ivory figurine from Thebes.[50] Both ibexes and gazelles are shown under a chair in tomb scenes[51] and were occasionally buried in their owner's tomb.[52]

The Egyptians appreciated other animals as well, apparently simply for their exoticism. Tomb reliefs throughout Egyptian history depict all sorts of animals not native to Egypt—giraffes, elephants, lions, etc.—being brought as tribute from Nubia, Punt, Syria, and other foreign lands and presumably destined for the royal zoos or for game parks. Bears are an example of this category of animal. Not native to Egypt, bears were evidently recognized by the Egyptians as one of the natural hazards to be met with in Syria. A wild bear is shown climbing a tree after a man and biting his ankle in a relief depicting the campaign of Ramesses II at Satuna,[53] and a Nineteenth-Dynasty satirical writing, "An Egyptian Letter," refers to the "Chief of the Aser" being found in a balsam tree by a bear.[54] Bears also occur in scenes depicting Syrian tribute from as early as the Old Kingdom. The bears that appear, tied to rings in the ground, in reliefs in the tomb of the Fifth-Dynasty king Sahure have been identified by their form and golden-brown color as Syrian bears[55] and, indeed, people wearing the garb and bearing products of Syria are also shown; they lead elephants and reddish-brown bears[56] in reliefs in the Eighteenth-Dynasty tomb of Rekhmire at Thebes, and a bear on a leash appears in another Eighteenth-Dynasty Theban tomb as well.[57] In a relief depicting tribute from Syria in the Eighteenth-Dynasty tomb of Ineni is a bear of a slate-blue color, possibly meant to be gray.[58]

Lions, too, seem to have been kept in a semidomesticated state.[59] They frequently appear in battle scenes, by the side of the pharaoh against his enemies,[60] and depictions from as early as Dynasty 1 show them wearing collars. They also assume occasionally the typical posture of the Egyptian "pet": lying beside the tent or the chair of their masters. One such lion, gently smiling, is shown lying beside the throne of Ramesses II in a relief at the Beit el Wali Temple; it wears bands around its forelegs, and its name is inscribed nearby: "He who slays his [the king's] enemies."[61]

G.L.S.

1. Petrie 1896b, p. 44, pl. 51:25; Hayes 1953, pp. 17-18.
2. Hayes 1953, p. 28, fig. 20.
3. Ibid., pp. 98-99, fig. 56.
4. Vandier d'Abbadie 1966, p. 143; Fischer 1980a, col. 77.
5. Newberry 1893a, pls. 13, 30; Griffith et al. 1900, pl. 2.
6. Griffith et al. 1900, pl. 3.
7. Newberry 1893a, pl. 30; Griffith et al. 1900, pl. 4.
8. Hayes 1953, pp. 223-224, fig. 140.
9. Phillips 1948, p. [9].
10. Naville et al. 1914, pp. 40ff.
11. Fischer 1980a, col. 77.
12. Simpson et al. 1973, p. 7.
13. Phillips 1948, fig. 20.
14. Hayes 1953, p. 223.
15. Phillips 1948, fig. 17.
16. Davies 1913, pl. 22; Smith 1958, pls. 98b, 99b, 143.
17. Smith 1958, pl. 142; Fischer 1980a, col. 78.
18. Smith 1958, pl. 162b; Porter and Moss 1960, p. 316, no. 5.
19. Petrie 1925, pl. 1c.
20. Aldred 1951, p. 49, no. 27; Davies 1913, pls. 4, 11, 25-28, 39.
21. CG 24076: Daressy 1902, p. 34, pl. 11; Maspero 1915, p. 395, no. 3809; Porter and Moss 1964, p. 557.
22. Hayes 1959, p. 9.
23. Janssen 1958, p. 177.
24. Ibid., p. 176.
25. Phillips 1948, p. [9]; Fischer 1980a, col. 78.
26. Pendlebury 1936, p. 197.
27. Störk 1978, cols. 367-368.
28. Langton 1940, p. 2.
29. Arkell 1962, p. 154.
30. Langton 1940, p. 3; Phillips 1948, p. [11].
31. Störk 1980, col. 368.
32. Wilkinson 1883b, pp. 106-107, fig. 365.
33. Störk 1980, col. 367; Griffith et al. 1900, p. 2, pl. 5; Mekhitarian 1954, pp. 83, 85.
34. Vandier d'Abbadie 1966, figs. 33, 39, and 43; Phillips 1948, figs. 24, 25.
35. Davies 1927, pl. 25.
36. Störk 1980, col. 367.
37. Griffith et al. 1900, p. 2; Langton 1940, p. 3.
38. Vandier d'Abbadie 1965, p. 177.
39. Vandier d'Abbadie 1966, p. 143.
40. Davies 1922, pl. 43; Davies 1935, pls. 6, 7, 14; Davies 1943, pls. 17-20, 29.
41. Aldred 1961, p. 65; Brooklyn Museum 1968, p. 98.
42. Samson 1972, pp. 37-40.
43. Hayes 1959, p. 314.
44. Samson 1972, pp. 37-38.
45. Davies 1913, pl. 4; Davies 1922, pl. 9; Säve-Söderbergh 1957, pl. 11.
46. Davies 1963, p. 15, fig. 4; Smith 1958, pl. 107b.

47. Peterson 1973, pp. 97-98, no. 105, pl. 56; p. 97, no. 106, pl. 55.
48. Vandier d'Abbadie 1966, p. 198, fig. 59.
49. Phillips 1948, p. [12].
50. Ibid., p. [6], fig. 13.
51. Porter and Moss 1960, pp. 467-468, no. 19a.
52. Phillips 1948, p. [8].
53. Smith 1965, pp. 174-175, fig. 219.
54. Pritchard 1950, p. 477.
55. *Ursus syriacus;* Borchardt 1913b, pp. 16, 78, 179, pl. 3.
56. Davies 1935, pl. 12.
57. Wreszinski 1923, p. 269.
58. Müller 1906, pp. 19-20, pls. 8, 10.
59. De Wit 1951, pp. 10-15.
60. Porter and Moss 1972, p. 548, section XA 1.
61. Ricke et al. 1967, pp. 16-17, pl. 15.

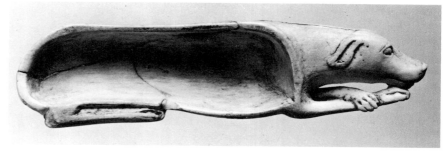

377

377

Ointment dish in the form of a dog
Provenance not known
New Kingdom
Length 9 cm.
Musée du Louvre, Paris (N. 2320).
Formerly in the Salt Collection

This ivory ointment dish is carved in the form of a dog, lying with its chin resting on its crossed forelegs. The kind of hound depicted is difficult to identify, since it seems to have both a curly tail and lop ears, features belonging to two different types of dog (see p.272). Two similar ivory dishes were found in a pit at Matmar, together with various objects datable to the New Kingdom.[1]

Dogs are a common motif in art throughout Egyptian history. They appear on a bow case found in the tomb of Tutankhamen,[2] on game boards, both as decoration[3] and as game-pieces;[4] in figurines;[5] in openwork on a bronze ax head;[6] on furniture;[7] as a toy;[8] and in numerous tomb paintings and reliefs. Running hounds biting fish appear on the handles of wooden ointment spoons of New Kingdom date.[9]

G.L.S.

. Brunton 1948, p. 66, pl. 53:11, 12; see also Hayes 1959, p. 190, fig. 106.
. Carter 1933, pl. 28.
. Hayes 1959, pp. 25-26, fig. 10.
. Hayes 1953, p. 250, fig. 160; Hayes 1959, p. 199.
. Ibid., p. 314.
. Smith 1958, pl. 98b.
. Ibid., pls. 142-143.
. Phillips 1948, figs. 18-19.
. Wallert 1967, pp. 96:K18, 112:L17.

Bibliography: Champollion 1827, p. 70, no. 13; Moreux 1932, p. 538; Vandier d'Abbadie 1972, . 37, no. 96.

378

378

Scaraboid in the form of a cat
Provenance not known
Dynasty 18
Length 1.2 cm.; height 1.1 cm.
Museum of Fine Arts. Gift of Egypt Exploration Fund (06.2498)

A reclining cat, its head turned to one side and its body covered with stippling, is modeled on a flat base of blue-green glazed steatite. On the base is inscribed the name "Amenhotep," and a hole runs lengthwise through the animal.

Although a few have been found dating from the Middle Kingdom or Second Intermediate Period,[1] cat-shaped scaraboids of the type presented here were most common during Dynasty 18, and especially during the reigns of Amenhotep II and III.[2] They were probably used in necklaces, along with other beads, or mounted in rings. A small New Kingdom figurine of a crouching cat with its head turned to one side shows stippling over its body similar to that on the Boston seal; in both cases, it was probably done in an attempt to show fur.[3] Two green-glazed kittens, very similar in shape to the Boston seal, were found at Abydos in a tomb dated to the reign of Akhenaten; with them

were a number of blue beads with which they had once alternated to form a necklace.[4]

G.L.S.

1. Langton 1940, p. 50, no. 213, pl. 14.
2. Newberry 1908, p. 87, fig. 88; Petrie and Brunton 1924, p. 25, pl. 57:23; Brunton and Engelbach 1927, pls. 26:19, 20; 41:49; Langton 1940, pp. 50-51, nos. 204-208, 213, pl. 14.
3. Langton 1940, p. 21, no. 106, pl. 6.
4. Ayrton et al. 1904, p. 49, pl. 16:7.

379

379

Monkey with ball or fruit
Said to be from Amarna
Late Dynasty 18
Height 5.4 cm.; width 2.8 cm.
The Brooklyn Museum, Brooklyn, New York. Charles Edwin Wilbour Fund (48.181)

The small figurine in deep blue faience is in the form of a seated monkey holding a globular object before it with both hands and a foot. The nature of the globe—whether a ball or a piece of fruit—cannot be confirmed with certainty. The monkey's ears are pierced, so it may originally have worn earrings in the form of metal hoops.[1] A depiction of a pet monkey under its owner's chair shows the animal wearing such an earring[2] and

cats, too, are often shown wearing hoop earrings, both in tomb paintings[3] and in figurines.[4]

G.L.S.

1. Aldred 1961, pp. 64-65.
2. Vandier d'Abbadie 1966, p. 171, fig. 28:3.
3. Davies 1927, pl. 25.
4. Langton 1940, pl. 15:220.

Bibliography: Aldred 1951, p. 64, no. 71; Brooklyn Museum 1952, no. 43; Aldred 1952, p. 64, no. 71; Aldred 1961, pp. 64-65, no. 77; Cheney 1968, p. 46, illus.; Brooklyn Museum 1968, pp. 27, 97-98, no. 26, pl. 2; Hornemann 1969, pl. 1776; Fazzini 1975, pp. 88-89, no. 74.

380

380

Monkey with fruit

Provenance not known
Dynasty 18 or later
Height 12 cm.
Museum of Fine Arts. Lent by William Kelly Simpson (148.70)

The wooden monkey stands with its knees slightly bent, busily stuffing a fruit into its mouth. Like a blue faience monkey (cat. 379), this piece illustrates the New Kingdom fondness for amusing gimcracks.

G.L.S.

Bibliography: Simpson 1977, pp. 64, 70, no. 67.

381

Bear

Provenance not known
Probably New Kingdom
Height 5.9 cm.; length 15 cm.
Museum of Fine Arts. Hay Collection, Gift of C. Granville Way (72.4167)

The craftsman has caught the blunt, heavy mass of the bear in this wooden figurine. Its simple form and sturdy construction suggest that it may have been intended as a toy, like a clay model of a donkey carrying a load of sacks,[1] a running hound whose lower jaw moves by means of a lever,[2] and a cat whose jaw opens with the pull of a string.[3] On the other hand, its appeal as an exotic animal may have made it appropriate to the class of New Kingdom figurines that served no function other than to be amusing or appealing to adults or children.[4] To this class also belong wooden and faience monkeys (cats. 379 and 380).

G.L.S.

1. Hayes 1959, p. 26, fig. 11.
2. Phillips 1948, p. [9], figs. 18, 19.
3. British Museum 1930a, p. 104, fig. 38:6.
4. Hayes 1959, p. 313.

381

Wit and Humor

In learning any foreign language, one quickly discovers that, despite intensive study, the ability to comprehend humor can be quite elusive. For a long time it seems that something is always "lost in translation." Even if one is informed in advance as to what should evoke laughter, such an advantage is usually of little help. Acquiring a "foreign" sense of humor involves attaining a developed knowledge not only of the specific language but also of the culture and of the very thought processes of the speakers.

Because ancient Egyptian has not been a living language for about two thousand years, and because it has no direct modern successor, it might appear that it would be difficult to find out what was thought to be humorous in pharaonic times. So much of their material civilization has survived, however, that it is possible to suggest some of the things that may have made the ancient Egyptians laugh. From their writings, both literary and nonliterary, we can often detect evidence of their wit, sarcasm, satire, and humor. Sometimes the use of literary devices such as puns, similes, metaphors, or even artificial etymologies[1] appear to have been used primarily to evoke laughter.

In many Egyptian art forms, such as sculpture in two and three dimensions, and in painting, it is perhaps a bit easier to recognize a gesture, symbol, or image that was intended purely for fun, since they stand apart from conventional representations. Considering the rather consistent hieratic and solemn nature of the majority of Egyptian art, such uncharacteristic scenes would probably be fairly obvious to a viewer, no matter what his background, and their purpose may have been to delight and entertain.

The humor was not always so subtle, however; ribald remarks, satiric comments, and even jests can often be found in the texts.[2] Nonliterary material, such as the speeches of people represented on the walls of private tombs, provides countless examples of these "asides." When one Old Kingdom sculptor at Giza complains that he has been working one whole month on his statue, and it is still not complete, his companion comments with derision that the material that he is using is stone, not wood.[3] An inebriated female guest at a banquet pictured in the Eighteenth-Dynasty tomb of Paheri at el Kab[4] claims that she loves to drink and demands eighteen more cups of wine, while complaining that her "inside" (perhaps throat) is like straw.

In a New Kingdom letter the writer laments that his bad fortune has come about because of a joke that he told to the tax master.[5] Nemty-nakht, the upper-class adversary of the Eloquent Peasant, uses sarcasm against his loquacious opponent when he tells the peasant that the name of a poor man is mentioned only in connection with his lord.[6] We can be relatively sure that the author of one of the Middle Kindom letters from Illahun, apparently feeling some animus toward his correspondent,[7] was exhibiting humor when he altered the normal closing phrase of a letter, "May your hearing be good," to "May your hearing be ill."[8]

Such deviations from the standard can often be amusing and this is perhaps best seen in the numerous sketches Egyptian artists made on flakes of limestone and potsherds. Caricatures especially those of foreigners, sometimes extremely grotesque, were quite common.[9] Animals cast in the role of humans engaged in various activities are a favorite theme in sketches and satirical papyri.[10] Frequently the major roles are played by cats and mice, with the latter being the dominant figures. Both anthropomorphism and role reversal contribute to the humor of such representations. Broader humor can be found in the portrayals of erotic sequences depicted on a papyrus now in the Turin Museum.[11] The paintings of the Turin papyrus picture scenes of animals impersonating humans and a series of sexual episodes involving men and women. The men are usually bald and unshaven, the women scantily clad in the manner of serving girls. Hieratic texts are interspersed among the scenes, and on the verso are several inscriptions. Some color is preserved.

This papyrus has two distinct parts, the smaller, depicting the animals, is often referred to as satiric (fig. 68). There are several separate scenes: a fortress of cats is attacked by mice,

Fig. 68. Animals mimic humans in improbable scenes from a satirical papyrus, including a donkey disciplinarian, mice storming a feline fortress, and a bird attacking a cat with a stick (Turin 55001).

assorted animals play musical instruments, and a bird climbs a ladder to perch in a tree. Satire is manifest by reversing the animal's traditional characteristics, such as the cat who acts as caretaker for fowl or the hippopotamus who sits in the tree. It has been shown, however, that many of the episodes can be related to legends or myths, originally oral, that eventually would have taken written form.[12] In such scenes as the cat and mouse wars pictured in this papyrus, foreign influence has been suggested.[13] On the other hand, the inspiration for later fables that occur in Greece and in the Near East has been thought to originate in these animal actors in Egypt.[14]

The major part of the papyrus, devoted to sexual episodes, has recently been studied in depth.[15] Sometimes called "pornographic" because of the explicit nature of the scenes, the papyrus illustrates various positions of intercourse.[16] In almost all instances the males possess extremely large, erect phalli, (fig. 69). Hieratic texts often reflect the speech of the individuals involved, but it appears that several scribes penned the comments, since the handwriting differs.[17] Because of the state of preservation, these remarks are difficult to restore, but their nature is clear.

It is difficult to know for certain, however, whether the erotic part of the papyrus was composed with or without any parody or satire in mind. These scenes of a sexual nature may allude to those involving deities in mythological papyri. The section showing the bed may refer to part of the myth of Osiris dealing with his

Fig. 69. Pornography is virtually unknown from Egypt before the New Kingdom, when only a few examples occur (Turin 55001).

revivification. It has been pointed out that there are twelve hours of the Amduat ("What is in the Netherworld") and twelve episodes to the papyrus, as well as the fact that binding of the mummy, which is mentioned in a hieratic inscription on the papyrus is also in the Book of Amduat.[19] Comparisons can be found, as well, with representations and texts regarding the deities Geb and Nut, and there appear to be some similarities with dances relating to Hathor.[20]

The two sections, one of which pictures the activities and nature of man (represented allegorically) and the other his religious beliefs (mythology, cosmogony, and eschatology represented erotically) may have been un-

derstood as an entity — a highly satirical and whimsical view of the nature of the world to the ancient Egyptian.

Such representations have been noticed on ostraca, as well,[21] and there are also small sculptures illustrating similar themes.[22] On the walls of a grotto in the cliff north of Deir el Bahri, there are sexually explicit graffiti; depending upon the identity of the figures represented, these drawings may represent not only satire and erotica but political parody as well.

Even temple scenes sometimes provide a bit of comic relief. Anyone viewing the Punt reliefs of Queen Hatshepsut's mortuary temple at Deir el Bahri cannot but be struck by the imposing image of the steatopygous Queen of Punt.[23] She stands behind her rather lean husband, and following her are their children and a small donkey. The humor of the scene has been underlined by a label over the donkey reading "the ass that bears his wife."[24]

Traditional enemies were often the butt of the Egyptians' sense of humor, as they were frequently portrayed on pharaoh's footstool. They were to be "underfoot" as well, when depicted on the soles of the feet (or sandals) of anthropoid coffins.

The Egyptians were capable of producing both art and literature that dealt with obvious sexuality. Their love poetry is highly sensual, and the sexual episodes in both the "Tale of the Two Brothers" and the "Myth of Horus and Seth" are rather explicit. Men and women engaged in intercourse can be found represented on ostracons and in graffiti and statuary, although these examples date primarily to the New Kingdom and later.[18]

Despite our lack of a complete understanding of the ancient Egyptian mind, we can recognize the broad range of their humor, from highly sophisticated literary wit to the low humor of their depictions of erotica.

D.P.S.

1. Van de Walle 1969, pp. 3-4; Guglielmi 1979.
2. Van de Walle 1969, p. 9.
3. Hassan 1936, fig. 219.
4. Tylor and Griffith 1894, pt. 2, pl. 7.
5. Wente 1967, p. 80.
6. Simpson et al. 1973, p. 33.
7. Griffith 1898, p. 76, pl. 32:16.

8. Ibid., pl. 32:16; James 1962, p. 127 n. 3.
9. Van de Walle 1969, p. 16.
10. Ibid., pp. 17ff.
11. Omlin 1973.
12. Brunner-Traut 1955a, p. 29.
13. Omlin 1973, p. 74.
14. Brunner-Traut 1968, pp. 59ff.
15. Omlin 1973.
16. Manniche 1977, pp. 18-23.
17. Omlin 1973, p. 65.
18. Ibid., pls. 28-31.
19. Ibid., pp. 61-62.
20. Brunner-Traut 1955a, p. 31.
21. Manniche 1977, figs. 3, 4.
22. Omlin 1973, pls. 30-31.
23. Naville 1898, pl. 69.
24. Sethe 1906, p. 325, l. 5.

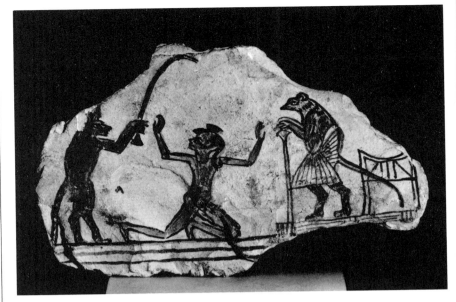

382

382

Ostracon with drawing of cat, mouse, and boy

Provenance not known
Ramesside Period
Length 12.6 cm.; width 7.8 cm.
The Oriental Institute, The University
of Chicago (13591)

The beating of a recalcitrant taxpayer or lazy, unproductive worker is a common theme in Egyptian culture. Representations of corporal punishment are not uncommon in tomb scenes from the Old Kingdom onward[1] and beating is a punishment frequently recorded in texts.[2]

The artist who drew this sketch in red and black ink took advantage of several devices to offer an amusing tableau. For the two most important figures, the noble (or judge) and his servant (or official), the artist pictured a mouse and cat, respectively, thereby employing the technique of parody as well as role reversal. In the position of the punished worker he altered the pattern and drew a small nude boy wearing a sidelock, a symbol of youth.

D.P.S.

1. Campbell 1910, p. 88.
2. Caminos 1954, pp. 247ff.

Bibliography: Wilson 1951, fig. 61a; Brunner-Traut 1955a, fig. 1; Brunner-Traut 1968, p. 14, fig. 9; Peck 1978a, fig. 77, p. 147.

Literature: Brunner-Traut 1955a, pp. 18-25; Brunner-Traut 1956, pp. 88-91; Van de Walle 1969, pp. 18-20; Omlin 1973, pp. 30-31.

383

Ostracon with drawing of mouse and cats

Probably from Thebes
Dynasty 19-20
Height 12.5 cm.; width 10 cm.
Museum of Fine Arts. Mary Smith
Fund (1976.784)

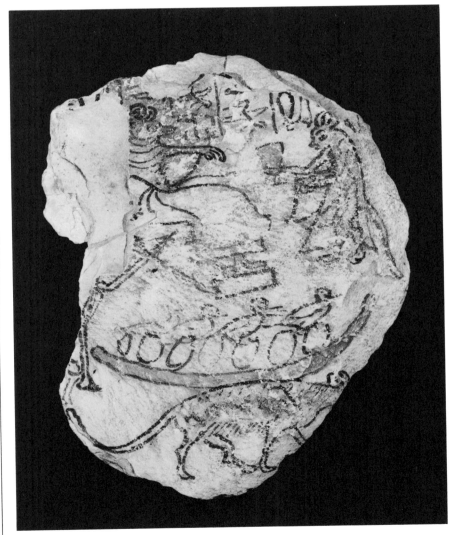

383

279

This limestone ostracon with traces of paint has two separate narrative incidents. The upper scene is a parody of one typically found in tomb paintings: a mouse nobleman is served by one of his staff, a cat. As in similar scenes in the tombs, a hieroglyphic commentary is added, in this case deepening the satire. Unfortunately, the inscription is now almost totally destroyed and only a few words can be read.

Below is another example of role reversal with a cat, a natural enemy of the bird, acting as the porter for a nest in which are eggs and four fledglings. Such a representation is reminiscent of an ostracon from Brussels (cat. 384), where a jackal (or fox) acts as caretaker to the birds, and a similar scene from a Turin papyrus, in which there is a feline "shepherd."[1]

D.P.S.

1. Omlin 1973, pl. 15.

Bibliography: Museum of Fine Arts 1977, p. 41.

Literature: Vandier d'Abbadie 1936, no. 2203; Vandier d'Abbadie 1937, nos. 2264, 2266, 2310; Brunner-Traut 1955a, pp. 18ff.; Brunner-Traut 1968, p. 12; Omlin 1973, p. 30; Peterson 1973, p. 102, no. 129.

384
Ostracon with drawing of jackals and birds
From Deir el Medineh
Dynasty 19-20
Length 5.5 cm.; width 11 cm.
Musées Royaux d'Art et d'Histoire, Brussels (E.6369)

Here, in a typical scene of role reversal, jackals, animals of prey who ordinarily might hunt birds, become caretakers of the flock dressed in human clothing. A similar scene in which cats act as shepherds is found in the Turin Papyrus.[1] Such sketches (see cats. 382 and 383) are sometimes illustrations of stories or myths, and it is possible that this scene refers to a myth of Amen involving geese,[2] but that myth is not common until later periods. Conceivably, the sketches illustrate an oral tradition that would later become a written one. The technique of painting is similar to that of other figured ostraca: outline is of supreme importance, and the quick, easy strokes indicate the artist's considerable ability.

D.P.S.

384

1. Omlin 1973, pl. 15.
2. Brunner-Traut 1956, pp. 81, 89, 91.

Bibliography: Capart 1931, pl. 73c; Brunner-Traut 1955a, p. 21; Brunner-Traut 1968, p. 12:7b.

Literature: Brunner-Traut 1955a, pp. 12-32; Brunner-Traut 1956, pp. 5-6, 81, 89; Van de Walle 1969, pp. 17-20; Omlin 1973, p. 30, pl. 15.

385

385
Statuette of a group of monkeys
Provenance not known
Late Dynasty 18
Length 6.4 cm.; height 6.4 cm.
Royal Ontario Museum, Toronto (948.34.156)

Although the ancient Egyptians frequently depicted scenes that they had observed from nature, representations such as this family of monkeys grooming each other are not very common and may therefore be an attempt at human parody or satire. Carved in limestone, the animals bear traces of black paint. The technique is not of very high quality, with flat modeling and a lack of undercutting. The composition is calculated to show a triangular outline from the side, with the smaller figures in the center. Such

statue groups occur in Amarna,[1] and it has been suggested[2] that the familial affection shown by the animals may have been a parody of that exhibited by the royal family.

D.P.S.

1. Frankfort and Pendlebury 1933, p. 99, pl. 31:2.
2. Samson 1972, pp. 37-40.

Literature: Brunner-Traut 1955a, p. 24, nos. 15-17.

386

386
Figure of a monkey playing a harp
Possibly from Amarna
Dynasty 18
Length 8 cm.; width 5.7 cm.
The Brooklyn Museum, Brooklyn, New York. Gift of the Estate of Charles Edwin Wilbour (16.68)

This sculptured group in miniature shows an adult monkey playing a large harp with a young monkey standing between his knees and the frame of the harp. Traces of red and black paint

remain, and the figure is pierced for suspension. The surface of the group is somewhat weathered. In two similar examples[1] the harp is proportionately smaller.[2]

Twenty-three colored limestone statuettes of monkeys were found at Amarna[3] and the present group may belong to this series. These monkeys play the harp, drive chariots, and play affectionately with their young. It is possible in these statuettes that not only a satirical commentary on human behavior is intended but that some examples, such as the monkeys in chariots, may be caricatures of Akhenaten and the royal family (cf. cat. 385.)[4] Like others from Amarna that have suspension holes, this piece may have been used as a toy or an ornament.

D.P.S

1. Leibovitch 1960, pp. 56-57.
2. See Frankfort and Pendlebury 1933, pl. 31:3.
3. Samson 1972, p. 37.
4. Frankfort and Pendlebury 1933, p. 99; Samson 1972, p. 37.

Literature: Breasted 1948, p. 88, pl. 83a; Brunner-Traut 1955a, pp. 21-22; Vandier d'Abbadie 1966, pp. 143-201; Brunner-Traut 1968, pp. 9-10; Van de Walle 1969, pp. 16-19; Omlin 1973, pls. 11, 14, p. 56.

Writing

Ancient Egyptian writing took the form of recognizable images, many of which were meant to represent the objects or things illustrated. Twenty-four signs were symbols identifying a single sound, like the letters of the Roman alphabet; many others represented two or more sounds. A system resembling Arabic and Hebrew, Egyptian indicated only the consonants. Unlike Arabic and Hebrew, however, which are in use today and whose vowels were eventually indicated graphically, Egyptian hieroglyphic writing hardly survived much beyond the first few centuries of the Christian era, and its exact pronunciation remains today something of a mystery. For this reason ancient Egyptian words when written in English characters, often have a variety of spellings.

Much information about pronunciation and grammar derives from what is considered to be the last stage of the language, Coptic. Beginning in the early Christian era, Coptic Christianity, a Monophysitic sect that originated in Egypt and forms of which still survive throughout the world, used a language descended from that of the past. For consonant and vowel sounds some of the vocabulary, and a few elements of grammar, the Copts borrowed primarily from Greek. For those sounds absent in the Greek alphabet they utilized signs obtained from Demotic, the preceding stage of the Egyptian language. Ancient Egyptian words such as *djebet* (fig. 70), meaning "brick," survived in Coptic as τωωβε. Its modern-day descendant is "adobe."

Fig. 70. The Egyptian word *djebet*, meaning "brick."

A good deal of the language and its written communication fell into the hands of the Egyptian scribe; for the majority of documents, scribes used the cursive form of hieroglyphs, hieratic, a script that seems to have existed simultaneously with hieroglyphic writing from the earliest period and was used chiefly on papyrus. It was necessary for scribes to keep up with the changes in grammar and spelling that occurred as the

language went through its three major stages: Old, Middle, and Late Egyptian, and its two major divisions: literary and non-literary.

For his reed pens, called *ar,* the scribe required a case; he also needed a palette for the two inks he used: red and black. (Around the inkwells the hieroglyph *shen,* meaning "encircle," was often inscribed.) These utensils were combined in a single tool called *gesti* (see cats. 390 and 391) by the Old Kingdom; however the hieroglyphic sign (fig. 71) pronounced *sesh,* indicating the scribe's implements (the palette, a bag with powdered pigment, and a pen holder all attached to a leather cord) still showed them as separate elements throughout the major phases of the language. The

Fig. 71. The *sesh* hieroglyph.

scribe also used a water pot, and he had tools for grinding his own pigment: a pestle and a mortar in the form of a rectangular-shaped stone with a depressed area in the center often in the shape of an oval around which a cartouche was sometimes incised (cat. 393).

Since he was responsible for manufacturing papyrus sheets, the scribe needed knives and burnishers. In the preparation of papyrus, the outer covering of the triangular stem of the plant had to be cut off. The stem was then cut into uniform strips of forty centimeters, each of which was cut longitudinally into thin strips. Several of these strips were set alongside each other with another layer of strips placed on top, at right angles to those below. The two layers were made into one sheet by pounding, and they were then cut, trimmed, and smoothed[1] with a knife called *sha* (see cat. 394). Because of the high cost of papyrus, limestone flakes, potsherds, and plas-

ter-covered boards were used for practice and for the training of young scribes.

Many of the scribe's tools were used by the painter, whose palette and brush case differ only in that there are more pigments to accommodate the wider range of color needed to decorate statuary, relief, pottery vessels, wooden or stone tablets, or the walls of tombs and temples. It was the painter who drew outlines for hieroglyphs and scenes that served as guides for the sculptor.

D.P.S.

1. Lucas 1962, pp. 137-140; Černý 1977, pp. 5-6.

387
Statue of a scribe with the baboon of the god Thoth
From Hermopolis
Dynasty 19
Height 31 cm.
Ashmolean Museum, Oxford (1961.536)

Thoth, manifest here as a cynocephalous (or dog-headed) ape, was scribe of the gods, god of writing, and patron god of scribes. It is not unusual to find him in such a form associated with scribes; however, a composite figure with characteristics of a human and baboon occurs rarely, and usually only in two dimensions.[1] The baboon can be seen frequently sitting on a dais, while the scribe sits cross-legged nearby. Occasionally the baboon perches on the shoulder of a seated or kneeling scribe. This group, showing a standing human figure without any gesture indicating the scribal profession, is therefore quite unusual. The man wears a leopard skin, often associated with priests, over a long pleated kilt.

Among the epithets belonging to Thoth are "Master of Writing," "Ruler of Books," and "He Who Gives Words and Writing,"[2] and these are perhaps the roles indicated here. He may also be thought of as the scribe's protector, since he stands behind him in a position of support, or even as one who dictates to the scribe as he writes.[3]

The lower portion of the figure has been broken off below the apron of the kilt. There are two cartouches, one on the front and one on the back

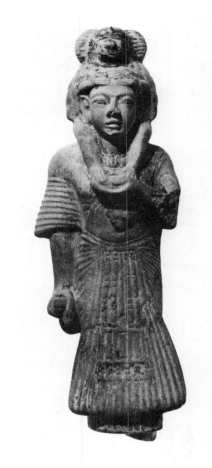

387

of the left shoulder, but their abraded surface makes reading difficult. On the back pillar, in hieroglyphs, is a funerary offering of Thoth for the individual represented, who holds a priestly as well as scribal title. Unfortunately, his name is not preserved.

D.P.S.

1. Bleeker 1973, pp. 108-111.
2. Weber 1969, p. 64.
3. Bleeker 1973, p. 154.

Bibliography: Moorey 1970, p. 55, fig. 26.

Literature: Boylan 1922, pp. 92ff.; Vandier 1958, pp. 449-450, pl. 173; Hayes 1959, p. 380, fig. 287; Bleeker 1973, pp. 108-110; Desroches-Noblecourt 1976, cat. 32; Peck 1978a, pp. 72-75.

388
Brick with stamped text
From Amarna
Dynasty 18
Length 30 cm.; width 15 cm.
Museum of Fine Arts. Gift of Egypt Exploration Fund through the Honorable Robert Bass (37.10)

This mud brick from Akhenaten's capital city undoubtedly came from

388

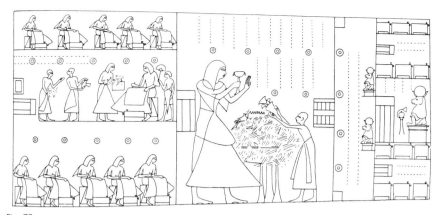

Fig. 72.

pen in hand, surrounded by several scribes. Nearby is a chapel apparently dedicated to Thoth (see cat. 387), wherein can be seen statues of that god in the form of a dog-headed ape.

D.P.S.

1. Q.42.21.
2. Pendlebury 1951, p. 150.
3. Borchardt 1907a, pp. 59-61.

Bibliography: Pendlebury 1951, p. 150: 5, pl. 83v.

Literature: Petrie 1894, p. xlii, no. 19; Fairman 1935, p. 139; Gardiner 1938, pp. 160-161; Pendlebury 1951, p. 114 (21).

389

389

Scribe's equipment box
Provenance not known
Dynasty 18
Height of box 34.5 cm.; length of box 43.7 cm.
Musée du Louvre, Paris (N. 2915)

The wooden casket, which could have been used to hold scribal equipment, has a vaulted lid and a cavetto cornice around the top. The body of the box is painted black, with red-brown rectangular panels bordered by white

the records office,[1] since it is stamped with a hieroglyphic text reading "the place of the correspondence of Pharaoh; may he live, be prosperous and healthy!" While buildings primarily concerned with religion and the afterlife were built of enduring materials such as stone, those used for purposes of daily life were frequently made of mud brick. The records office was located directly to the east of the small temple, with direct access to the room containing the Amarna tablets,[2] recording in cuneiform the correspondence of kings Amenhotep III and Akhenaten with their royal counterparts in Asia and the Aegean.

An indication of what such an office might have looked like is given by a scene from the Theban tomb of Tjay (fig. 72), who lived during the reign of Merneptah.[3] Tjay is shown seated,

and black lines in the center of each side. A similar panel, divided by black and white bands, decorates the top of the lid. The cornice is painted alternately in black and white. A black knob on the top of the lid and one on the end of the box enabled the casket to be tied shut; it was then sealed with a lump of mud.

The shape of this box is common in Egyptian furniture and reflects a design originally used for shrines. Similarly shaped containers with sloping lids, rounded on one edge, had been used since at least the Middle Kingdom for storing cosmetics and other items.[1] During the New Kingdom, such boxes appear frequently among the equipment illustrated on the walls of tombs. Identical boxes can be seen carried in the funeral procession in the tomb of Ramose.[2] Tomb scenes also show scribes recording information with such boxes nearby for their equipment.[3] One of the most elaborate examples of this type of box was found in the tomb of Tutankhamen,[4] but this one is most similar to simpler boxes, like those found in the tomb of Yuya and Thuya, the parents of Queen Tiye, wife of Amenhotep III.[5]

D.P.S.

1. Baker 1966, p. 70, fig. 80.
2. Mekhitarian 1954, p. 114.
3. Davies and Gardiner 1936, pl. 50.
4. Edwards 1976a, no. 51.
5. Quibell 1908b, p. 55, pl. 44.

Literature: Davis et al. 1907, pl. 41; Carter 1933, p. 118ff.; Klebs 1934, p. 17, pl. 11; Davies 1941, pl. 26; Hayes 1959, p. 294.

390
Scribal palette
From Naga-ed-Deir cemetery 9000, tomb N.10,001
Dynasty 18, reign of Thutmose III
Length 38 cm.; width 5.2 cm.
Lowie Museum of Anthropology, University of California, Berkeley (6-15174)

This wooden palette has a slot for storing reed pens and two inkwells, one of which contained red ink, the other black.[1] At the top is inscribed in an oval cartouche "Men-kheper-re," the prenomen of Thutmose III, under whose reign the palette's owner Nebiry lived and worked. Along each side of the top surface are incised prayers, filled in with white pigment. In the prayer on the left, Thoth and Seshat, divinities associated with writ-

390

ing, are invoked to provide such qualities as alertness and power "for the *Ka* of the Deputy in Thinis of the Thinite nome . . . the scribe Nebiry." On the right, an invocation to Onuris, Lord of Thinis, and Mehit, Lady of Heaven, asks for other benefits, including a long life and a good burial for the "scribe and deputy, true confidant of his lord, Nebiry."

S.K.D.

Bibliography: Fazzini 1975, no. 53, p. 74.

Literature: Lucas 1922, pp. 9-14; Lucas 1962, pp. 361ff.; Glanville 1932, pp. 53-61; Hayes 1959, p. 219; Weber 1969; Černý 1977, pp. 11-13.

391
Scribal palette
Provenance not known
New Kingdom
Length 25.2 cm.; width 2.8 cm.
Musée du Louvre, Paris (N.3028)

Similar in design to cat. 390, this ivory example has two round inkwells containing traces of black and red ink and a slot with a lid for pens. The lid of the slot is movable, making the pens more easily accessible.

Ivory palettes and cases were less common than wooden ones. Many of them were models or toys, but examples like this one showing actual use are not unknown.[1] There is no inscription preserved on either surface, and no pens remain in the slot.

D.P.S.

1. Hayes 1959, p. 296; Glanville 1932, p. 56, pl. 4:2, 3.

Literature: Weber 1969, pp. 32ff.; Černý 1977, p. 13.

392
Combination palette and brush holder
Provenance not known
Dynasty 19, reign of Seti II
Length 22.5 cm.; width 8.8 cm.
Field Museum of Natural History, Chicago (31551)

This blue faience palette has four depressions for pigment and a slot for brushes. A protruding knob and the presence of grooves along the sides indicate that there was originally a sliding lid. A hieroglyphic inscription painted in dark blue extends the length of one side.

Early painters used shells and small vessels to hold their pigments;[1] a New

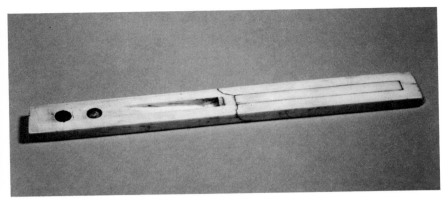

391

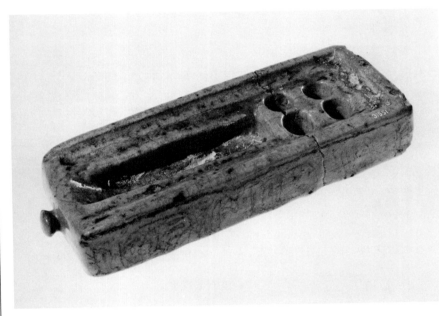

392

393

Kingdom faience painter's palette in the Metropolitan Museum, in the form of a hand holding a shell, recalls its antecedents.[2] As it became necessary to have a more portable apparatus, painters used scribal palettes for drafting and sketching, adding more wells in order to accommodate a wider variety of colors.[3]

Below an emblem of the head of Hathor an inscription reads "The King of Upper and Lower Egypt, Lord of the Two Lands, User-kheperu-re, Setep-en-Re, Beloved of Amen, the Son of Re, Lord of Diadems, Seti-Merneptah [may he be given life] forever." Like a privately owned ivory palette inscribed with the name of Amenhotep III,[4] this example with a royal name is likely to have belonged to a private individual.

D.P.S.

1. Černý 1977, p. 13.
2. Hayes 1959, fig. 260, p. 409.
3. Smith 1949, pp. 351-353; Hayes 1953, p. 291 and 296.
4. Hayes 1959, pp. 255-256.

Literature: Gauthier 1914, pp. 130-139; Davies 1925b, pl. 11; Glanville 1932, pp. 56, 61.

393

Grinding palette
From Semna fort
New Kingdom
Length 16 cm.; width 9.2 cm.; thickness 2.4 cm.
Museum of Fine Arts. Harvard University— Museum of Fine Arts Expedition (29.1206)

In order to prepare the colored inks used by the scribes and painters, it was necessary to grind the pigments and then mix them with a gum or similar medium.[1] In some cases the grinding was done with an adze-like tool called a *kenkenit*[2] that pulverized the pigment. For a surface, the scribe used a grinding stone that was rectangular and had a slightly raised border and a large depression in the center. Often, this depression was ovoid, and in some examples cartouches are incised around it. Accompanying the slab would be a pestle of stone[3] or, in rare cases, a wooden spatula.[4]

D.P.S.

1. Lucas 1922, pp. 9-14.
2. Weber 1969, p. 50.
3. Hayes 1953, p. 296.
4. Černý 1977, p. 13.

Bibliography: Dunham and Janssen 1960, p. 55.

394

394
Scribal knife and papyrus cutter
From Abydos tomb D77
Dynasty 18
Length 22 cm.; width 2 cm.
Museum of Fine Arts. Gift of Egypt
Exploration Fund (01.7325)

Scribes used knives for trimming the
edges of their brushes, for preparing
papyrus stalks before pounding them
into sheets, and for cutting the sheets
into appropriate sizes. The knives were
usually simple, but more elaborate
forms exist, such as this bronze one
with a handle in the form of a duck's
head and an identical example pic-
tured in the tomb of Rekhmire.[1] It
has been suggested that the word
sha may be the designation for this
type of knife.[2] Similar knives have
been found in the Theban tomb of
Hatiay[3] and in Abydos tomb 268.[4]

An inscribed example comes from the
tomb of Neferkhaut at Thebes.[5]

1. Davies 1943, pl. 90.
2. Weber 1969, p. 185 n. 336.
3. Daressy 1901, p. 7, fig. 6.
4. Garstang 1901, pl. 16:268.
5. Hayes 1935, p. 33, fig. 19.

Bibliography: MacIver and Mace 1902, pl. 51.

Literature: Davies 1943, p. 11, pl. 90; Hayes 1959,
pp. 113, 219, 419; Weber 1969, p. 185 n. 331;
Černý 1977, pp. 5-6.

395

395
Burnishing stone
Provenance not known
Dynasty 18 or 19
Height 3.8 cm.; width 8.9 cm.
Museum of Fine Arts. Hay Collection,
Gift of C. Granville Way (72.789)

Elliptical in shape, with convex sides,
this alabaster burnisher is inscribed
with hieroglyphs in a horizontal band
on one of its longer sides. The inscrip-
tion indicates the name and title of its
owner, "The Sem Priest and High
Priest of Ptah, Ptahmose" (see cat.
270). The uninscribed side shows evi-
dence of considerable use.

Besides being used to polish the sur-
face of wood, pottery, or stone objects,
burnishing stones were essential to
smooth fibers and joins in papyrus;
without such preparation, a papyrus
could not accept ink satisfactorily.
The majority of burnishers used on
papyrus either consisted entirely of
wood or ivory or had wooden or ivory
polishing surfaces. Although most of
these burnishers had handles, stones
like this one were held in the hand
directly. Early texts refer to them as
senet.[1] Elaborately carved burnishers
such as the painted ivory one in the
shape of a stylized flower from the
tomb of Tutankhamen were probably
meant only as models.[2]

D.P.S.

1. Weber 1969, p. 57.
2. Edwards 1976a, pp. 44-45.

Bibliography: Hay 1869.

Literature: Hayes 1953, p. 294; Helck 1954b,
pp. 18, 102, 121; Hayes 1959, pp. 216, 218, 219;
Weber 1969, pp. 56-57.

396
Inscribed ostracon
Probably from Abydos
Dynasty 19, year 52 of Ramesses II
Height 12 cm.; width 22 cm.
Museum of Fine Arts, lent anonymously
(226.1974)

Roughly rectangular in shape, this
limestone flake has four horizontal
lines of a hieratic text written in black
ink. The surface of the flake is un-
smoothed, the fairly well-preserved
inscriptions having been written over
flaws and imperfections.

Ostracon, a Greek word used to de-
scribe potsherds used as ballots, here
refers to a piece of limestone, broken
pottery, or, occasionally, wood that
served as a writing surface for ancient
Egyptian scribes and artists. Referred
to in the New Kingdom as *nedjer,*[1]
ostraca were often used for copying
literary material or for artists' practice
sketches. In addition, they served as
the media for many of the records and
accounts that were kept throughout
Egypt to monitor the phases of daily
activities.

This message, recorded in hieratic,
was written on the nineteenth day of
the second month of the summer
season in the fifty-second year of the
reign of Ramesses II. It concerns the
work being done in a temple and lists
the specific quantities of stone blocks
and plaster being used.

D.P.S.

1. Weber 1969, p. 26.

Literature: Gardiner and Černý 1957; Hayes 1959,
pp. 390-394, 432-433; Weber 1969, pp. 25-27.

397
Schoolboy's writing board
From Abydos
Late Ramesside Period
Length 21 cm.; width 19 cm.
Musées Royaux d'Art et d'Histoire,
Brussels (E.580)

Six horizontal lines of hieratic text
in red and black ink are written over
traces of earlier writing on this
rectangular pierced limestone tablet.

396

397

The surviving text is a letter from the scribe Hori to the scribe Paser, urging the latter to behave seriously, abandon his foolish ways, and absorb himself in writing, for scribal activity is foremost among the professions. There are figures of an ibis, engraved twice on the recto and once on the verso, that may be representations of Thoth, the god of writing and scribe of the gods.

Scribal schools kept models of the compositions a scribe might be expected to know. Letters, literary works, and legal and religious documents might be copied by the scribal students onto tablets of wood and alabaster, fragments of limestone and pottery, and, rarely, on papyrus. Often these "practice copies" are all that remain of texts that once were among the apparently extensive collections of the scribal schools.

The word *an* refers to the rectangular tablet usually made of wood, used by the students as a writing board.[1] This limestone example has not only the shape but also the suspension hole at the top that is characteristic of wooden ones. Despite the rarity of examples, limestone may have been the original medium of the scribal tablet.[2]

D.P.S.

1. Weber 1969, p. 21.
2. Ibid.; Van de Walle 1963, p. 119 n. 3.

Bibliography: Amelineau 1899, pl. 3; Capart 1904, p. 91, no. 16; Hôtel Drouot 1904, no. 306, p. 48; Speleers 1923, no. 233, pp. 55, 147; Van de Walle 1963, pp. 118-123.

Literature: Hayes 1953, pp. 294-295; Brunner 1957, p. 74; Weber 1969, pp. 20-27; Bakir 1970, p. 48; Williams 1972, pp. 214-221.

398

Painter's palette

Provenance not known
Dynasty 18, reign of Amenhotep II
Length 21 cm.; width 3.6 cm.
Cleveland Museum of Art. Gift of the John Huntington Art and Polytechnic Trust (14.680)

The rectangular boxwood palette contains five circular depressions in which five original pigments are preserved. Some of the pigments, especially black and light blue, show signs of considerable use, whereas the reddish-orange and green cakes appear untouched.[1] There is a line of inscription inlaid in Egyptian blue at the top,

"Privy to the Secret of the West of Thebes," and another at the bottom, "Mayor and Vizier, Amen-em [Opet]." The former title is also accorded to Amenem opet on a granite stela from the eighth pylon at Karnak,[2] and the latter is on a palette in the collection of the Metropolitan Museum.[3] The individual is undoubtedly the Amenemopet who served as vizier under Amenhotep II and was buried in Theban Tomb 29.

Painting in Egypt was apparently quite popular among the upper classes. Although Old Kingdom representations showing nobles such as Mereruka and Ikhekhi involved in painting may have been religiously motivated,[4] such scenes indicate that painting was a common avocation in the early periods. In the New Kingdom interest in painting did not fade; Akhenaten's daughters Meketaten and Meryetaten possessed miniature painter's palettes.[5]

D.P.S.

1. Analysis of these colors showed that the green cake contains Egyptian blue and green varieties of copper calcium silicate, with the blue cake being composed solely of Egyptian blue and the red cake containing an iron earth compound with quartz and orpiment. The black pigments are made of graphite with a small amount of Egyptian blue; one of these cakes also contains quartz. (Analysis performed by Walter C. McCrone Associates, Inc., Chicago; results provided through the courtesy of Arielle P. Kozloff, Associate Curator in Charge, Department of Ancient Art, The Cleveland Museum of Art.)
2. Helck 1958, p. 439.
3. Hayes 1959, p. 146.
4. Smith 1949, p. 355.
5. Hayes 1959, p. 296; Edwards 1972, no. 19.

Bibliography: Cleveland Museum 1916, no. 10, p. 205; Williams 1918, p. 278; Rhodes 1980.

Literature: Klebs 1934, pp. 92-94; Hayes 1948, p. 60; Helck 1958, p. 439; Hayes 1959, pp. 296-297 and 146.

399

Painter's palette

Provenance not known
New Kingdom
Length 17 cm.; width 6.5 cm.
Kestner-Museum, Hannover (1951. 54)

This rectangular limestone painter's palette has nine oval wells filled with pigments of varying colors. At the top is a short enigmatic inscription.

Although palettes with more than two pigments are often included among descriptions of scribal equipment,[1] it is clear that such implements really belonged to the painter, whose work

398

399

required the use of several colors.[2] Called *sesh kedut* ("outline draftsmen"),[3] painters often held scribal titles as well, and the occupations are not always clearly differentiated.

Although possibly funerary, since there is no brush slot and since the medium is stone rather than wood or ivory, this palette has varying degrees of pigment preservation, indicating that it may actually have been used.

D.P.S.

1. Glanville 1932, pp. 56, 61.
2. Černý 1977, p. 13.
3. Smith 1949, p. 351; Bogoslovsky 1980, pp. 89-116.

Bibliography: Brunner-Traut 1974, fig. 24a.

Literature: Drioton 1944, pp. 18ff., pl. 1; Smith 1949, pp. 351, 353; Hayes 1959, p. 255; Weber 1969, p. 36.

400

Bookplate of Amenhotep III and Queen Tiye

From Amarna
Dynasty 18
Height 6.2 cm.; width 3.8 cm.
British Museum, London (22878)

The rectangular faience plaque with a rounded top is inscribed: "Beloved of Ptah, the king of the Two Lands, the good god Amenhotep III, may he be given life; the wife of the king, Tiye, may she live." At the bottom is the inscription "the book of the moringa tree." The plaque is light blue and the inscription was inlaid in dark blue. There are two holes about .6 cm. apart at the top.

This example and a similar fragment in New Haven were probably used as labels for a box containing papyri.[1] It is possible that wire or string was threaded through the two holes at the top to fix the plaque onto its place on the lid. Another example of a bookplate may be the alabaster tablet now in Berlin,[2] which may designate Akhenaten as the owner. Although it is generally agreed that the London plaque is an "ex-libris," there is considerable discussion as to the nature of the book referred to by the hieroglyphic inscription. Some authorities think that the title refers to a story of foreign origin, while others state that it was probably a native Egyptian tale,[3] and still others believe

400

that two trees are mentioned. One writer felt that the plaque might refer to a scientific book about the properties of the moringa tree and its products; he advanced a parallel suggestion for the Yale plaque, reading its inscription as "book of the pomegranate tree."[4]

The contents of a chest containing papyri could be designated either by plaques like these or by pertinent decoration on the lid.[5]

D.P.S.

1. Bull 1936, p. 31.
2. Weber 1969, p. 219 n. 735.
3. Hall 1926, pp. 31-32; Keimer 1929a, pp. 91-92.
4. Capart 1935, p. 25.
5. Hermann 1957, p. 114.

Bibliography: Bezold and Budge 1892, p. x; Borchardt 1895, pp. 72-73; Keimer 1929a, pp. 90-94; Weber 1969, pp. 118-120; Černý 1977, p. 30.

Literature: Hayes 1959, p. 116.

Medicine

Egyptian medical practice during the pharaonic period was a mixture of pre-scientific rational methods and the most blatant of superstitions. At its most rational, in cases where the cause of injury or disease was observable, we find attempts at systematization and cataloguing of symptoms that are surely the precursors of the Hippocratic system. In the early New Kingdom copy of the Edwin Smith Surgical Papyrus, for example, can be found a series of case descriptions dealing with injuries typical of heavy construction sites or the battlefield, which the compiler has arranged in a logical order, proceeding from injuries to the top of the head downward, from least to most serious, describing in each case the type of examination required depending on the symptoms, suggesting diagnoses, and offering alternative treatments. Cases are categorized according to the ability of the physician to treat them, and the descriptions demonstrate an unusual appreciation for the importance of continued observation, varying treatments for patients of different ages, and constant effort to make the patient as comfortable as possible.[1] Elaborate glosses, added by a later copyist, explain the meaning of many passages for later generations of physicians. Like the Hippocratic physicians of the fourth century B.C., Papyrus Smith shows that the early Egyptians recognized the importance of the crisis period, described by the Egyptians as "[when] he reaches something," and its significance in determining any change in treatment and prognosis.

Another passage in Papyrus Smith, which appears also in the Ebers Papyrus, shows some attempt to understand the inner workings of the body, although this is an avenue that seems not usually to have been pursued by later physicians.

> Beginning of the secrets of the physician: knowing the goings of the heart and knowing the heart [i.e., knowing the way it works and its structure]. There are vessels from it to all the limbs. In regard to these [vessels] upon which any physician, any surgeon [literally, "priest of Sekhmet"], or any magician places his hands or fingers, [namely] upon the head, upon the back of the head, upon the hands, upon the action of the heart, upon the arms, upon all of the legs, [then, if he does this] he examines the heart, because all his [the patient's] limbs contain its vessels. It is the fact that it [the heart] speaks out of the vessels of all the limbs.[2]

Aside from some grammatical difficulties, which render a fluid translation into English extremely difficult, the meaning of the passage is clear. The author has correctly linked the pulse with heart action, although he did not understand that the heart's chief function is as a pump to make the blood circulate in a closed system. Indeed, he regarded the heart as the seat of the "intellect" and the hollow vessels as avenues along which disease moved within the body.

Another part of the rational element in Egyptian medicine was the search for a uniformly applicable theory of the cause of internal diseases. Like the Greeks, with their theory of the humors (which in modified form affected medical theory until a century or two ago), the Egyptians sought to identify a principle upon which all disease could be blamed. They found the root cause of this principle operating in the process of digestion. Food residues, improperly digested, were thought to give rise to internal putrefaction and imbalances, which were spread throughout the body in hollow tubes.[3]

Physicians were trained in schools called "Houses of Life"[4] and had access to numerous reference books. Only gradually came the evolution of basic medical institutions familiar to us, including the medical specialties of surgery, dentistry, gynecology, and ophthalmology. Although much use was made of bandages, splints, poultices, etc., instruments were quite simple and were employed sparingly; an occasional needle or tweezer would probably have sufficed thus many of the instruments could have been borrowed from the nearest cosmetic box. Special surgical tools include the fire drill, used for burning and cauterizing tumors (cf. cat. 29).[5] Since the discovery of germs was millennia in the future, this may actually have been a sterile procedure, if inadvertently so. Papyrus Ebers, of about the same time period as Papyrus Smith, mentions the

occasional use of reed knives, metal knives, and possibly forceps.[6]

Although it was once said of Egyptian prescriptions that "it was . . . necessary that the ingredients should be rare and also, if possible, disgusting,"[7] this is a rather harsh assessment in view of modern scholarship. Plants with a soporific effect such as the opium poppy (cf. cat. 65) may have permitted the patient simply to sleep, always helpful in alleviating discomfort. Even inert ingredients, as long as they were not actively harmful, might have given the patient confidence that "something was being done" while he healed naturally. Honey, often placed by the Egyptians on open wounds, can actively suppress the growth of bacteria, as modern laboratories have shown;[8] copper salts, particularly malachite, often used in preparations of eye makeup or kohl (see p. 216) and employed in a number of other prescriptions, are effective against certain common bacteria.[9] The active ingredients of a number of other drugs prescribed, such as alum (an astringent) and colocynth and aloes (which have laxative properties), were not always known or appreciated.[10] One cannot now justify the excremental additives as even potentially valuable, as some authors have done.[11] Rather, it is in the selection of compounds in ancient Egyptian prescriptions that we see the most obvious recourse to magical means of fending off the unseen forces that caused disease, culminating in the belief that the more disgusting the ingredient, the more likely it was to drive away illness. Indeed, the excrement of numerous animals was widely accepted,[12] occasionally for internal use. Fly dung, for example, when mixed with opium, was used to calm a crying child.[13]

Catering to vanity as well as the needs of personal cleanliness, physicians often dispensed such everyday prescriptions as deodorants, dandruff cures, and wrinkle removers,[14] and even among the ingredients for these simple things we find evidence of a strong belief in sympathetic magic. One sure cure for ridding the house of mice, for example, was to place "fat of cat" in the appropriate nooks and crannies. Another magical prescription, the associations for which are no longer as clear to us as the cat and mouse example, requires carrying vulture feathers and sticks around the exterior of one's home, while reciting incantations designed to rid the area of winds that bring disease.[15]

Evaluating the total effectiveness of Egyptian medical practices is difficult, partly because we cannot identify many of the plant or animal substances named in the prescriptions; nor can we always be sure of the meaning of words used to describe some symptoms or even parts of the body. Whether or not we can ever hope to solve some of these problems is itself a matter of some debate,[16] and our difficulty is increased by the fact that the Egyptians used no standard scientific nomenclature; therefore, the hieroglyphic name of a substance may have no visual or logical relationship to the substance itself. Parallel ambiguities arise also in English usage, where the common name of a plant such as foxglove, from which the medicine digitalis is extracted, gives no clue as to its real identity and is, in fact, misleading if taken literally.

Even if we could evaluate the success of Egyptian treatments, such evaluation invites and implies comparison with our own, and the results would be somewhat unfair, since we have benefited considerably from the experiments and scientific techniques developed over the thousands of years that separate ancient Egypt from the last half of the twentieth century. A more just evaluation is forthcoming when comparing Egyptian medicine with that of other contemporary civilizations at roughly the same stage of development; here, in the literature of their own time, the outstanding reputation of the Egyptian physician rings clear, a reputation confirmed by texts and archaeology, and passed on by classical authors.[17] Some Egyptian doctors traveled over much of the ancient world to see patients, and even Syrians occasionally visited Egypt for their cures[18] (see fig. 73). Homer praised the Egyptians and their physicians highly, saying that in Egypt "every man is a physician, wise above humankind."[19] While early Greeks like Homer complimented Egyptian physicians, later Greeks became their pupils, and the Greek debt to Egyptian medicine is substantial and well documented.[20]

Most of the physical remains of

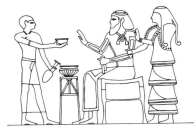

Fig. 73. The physician Nebamen attending a Syrian patient (from Theban tomb 17).

Egyptian medicine, aside from papyri, are associated with pregnancy and childbirth. Alabaster bottles in the form of a pregnant woman probably contained something to make the user more comfortable in the last few months of her term (cat. 404). Likewise, magical significance was attached to the milk of a mother who had borne a male child; it was appropriate treatment in cases of burn or eye diseases, for enhancing fertility, or for making a part of the body more receptive to further treatment.[21] Such milk may have been stored in bottles in the form of a woman carrying a small child (cat. 405), a motif reminiscent of Isis, the mother *par excellence*, and her son Horus. Horn vessels, held by some of the women portrayed by the bottles and also found in various archaeological contexts, may also have contained medicinal preparations (see cats. 402 and 403).

S.K.D.

1. Breasted 1930, pp. 183-185.
2. Ebers 854a ff.: Grapow et al. 1958, pp. 1ff.
3. Ebbell 1937, pp. 114-120; Steuer 1948; Steuer 1961.
4. Gardiner 1938, pp. 157-179; Ghalioungui 1963, p. 42.
5. Breasted 1930, pp. 363-369.
6. Ebbell 1937, p. 127; von Deines and Westendorf, 1962, p. 567.
7. Erman 1971, p. 360.
8. Majno 1975, pp. 116-120; J. W. Estes (personal communication).
9. Estes (see note 8); Majno 1975, pp. 111-115; Jannsens 1970, p. 129.
10. Estes, (see note 8).
11. Thorwald 1962, p. 85.
12. Grapow et al. 1959, p. 358ff.
13. Wreszinski 1913a, p. 191; Ebbell 1937, p. 108; Gabra 1956, p. 53.
14. Ebbell 1937, pp. 100-101.
15. Breasted 1930, pp. 501-502; Ebbell 1937, p. 114.
16. Lefebvre 1956, p. 146; Grapow et al. 1955, pp. 77ff.
17. Pritchard 1950, pp. 29ff.; Sayce 1922, pp. 67-68; Spalinger 1977.
18. Gardiner 1938, p. 157; Pritchard 1950, p. 30; Jonckheere 1958, fig. 14.
19. Odyssey IV, 220ff.: Murray 1945, p. 123.
20. Steuer and Saunders 1959; Saunders 1963, pp. 12ff.; Harris 1971a.
21. Ebbell 1937, pp. 73, 82, 95.

Literature: Ranke 1933, pp. 237-257; Sigerist 1951, pp. 217-371; Grapow et al. 1954-1973; Yoyotte 1968b, pp. 78ff.; de Meulenaere 1975a, cols. 455-459; de Meulenaere 1975b, cols. 79-80; Sandison 1975, cols. 947-950; Sandison 1977, cols. 295-297.

401

401

Vessel in the form of a kneeling woman

Provenance not known
Late Dynasty 18–Early Dynasty 19
Height 9.7 cm.; length at base 5.1 cm.
The Brooklyn Museum, Brooklyn, New York. Charles Edwin Wilbour Fund (49.53)

A naked kneeling figure of green-glazed steatite, her hands and feet tucked beneath her body, holds a small round jar in her left hand and a curved implement in her right. Conventionalized lines appear below her breasts; a long, thick braid at the back of the wig is reminiscent of those on cats. 404 and 405. Hollow and with a rectangular opening at the bottom, this piece could have been used as a vessel only if plugged[1] or fitted to a separate base.[2] For a discussion of the glaze, see cat. 268.

What this vessel represents has been a matter of some debate. The supposition that the figure is a male barber or "surgeon" holding blood-letting equipment[3] is unlikely, since blood-letting was not practiced in pharaonic times. Another theory identifies the piece as a votive object[4] and certainly the position of the figure and the presence of the *nu* jar in the left hand is reminiscent of the numerous kneel-

ing figures presenting wine or water offerings.[5] A third suggestion is that the figure represents a midwife holding her implements.[6] The object in the right hand seems too curved at the small end to represent a horn vessel (cf. cat. 402), although that is surely what one would expect if the figure is to be related to other New Kingdom feminomorphic bottles.

S.K.D.

1. Brunner-Traut 1970b, p. 158.
2. Brooklyn Museum 1968, p. 101, no. 37.
3. Cooney 1965c, p. 47.
4. Brooklyn Museum 1968, p. 100.
5. Hayes 1959, p. 143, fig. 79; Davies 1943, pl. 79.
6. Rand 1970, pp. 209-212; Brunner-Traut 1972, p. 192.

Bibliography: Sotheby 1899, no. 233; Sotheby 1926, no. 273; Hornemann 1966, pl. 1019a.

402

Imitation horn vessel

From Kahun (tomb of Maket)
Dynasty 18
Length 9.8 cm.
Ashmolean Museum, Oxford (1890.823)

Faience and pottery horn-shaped vessels were modeled after examples in actual horn or ivory,[1] which were plugged and capped at the base and often had a small decorative spoon or dish in place of a simple spout, as in this example in green faience (cf. cat. 403). Several of these horns, including the present piece, have been found with other cosmetic objects;[2] more elaborate and larger horns are included in ritual and tribute scenes.[3]

Horns also appear in several medical contexts. A number of medicine

bottles (cf. cat. 405) show a female figure holding a horn vessel[4] and gynecological associations are strengthened by the fact that most horns have been found in women's tombs.[5] Some specific connection with medicinal eye balms and salves has been suggested[6] on the evidence of a horn with a decorative spoon showing the head of the blind Horus.[7] While this evidence is somewhat ambiguous, support for it is found in a letter in which the physician Tjel is requested to prepare for the pharaoh some *mesdemet* (an ingredient in eye preparations; see p. 216) in an elephant tusk.[8] Suggesting that horns had non-pharmaceutical uses as well is an example found with an attached spoon in a basket of carpenter's tools from a Theban tomb (cf. cat. 23).[9]

Examination of the interior surfaces of horn vessels reveals that they contained both powders and liquids.[10] The characteristic narrow orifice of the smaller horns was ideal for dispensing minute quantities of the contents into the spoon or spout, where they were mixed, drunk, sprinkled, or used as a "dip."[11]

S.K.D.

1. Petrie 1927, p. 37, pl. 33.
2. Petrie 1891, p. 22; Petrie 1909b, p. 7, pl. 25.
3. Brunner-Traut 1980a, cols. 8-9.
4. Desroches-Noblecourt 1952, pp. 64ff; Brunner-Traut 1970b, pp. 161ff.
5. With one exception: Deir el Medineh tomb 1389; Bruyère 1937b, p. 85.
6. Bruyère 1937b, p. 85.
7. Junker 1942, passim.
8. Helck 1967, p. 144.
9. British Museum 1964, p. 213.
10. Desroches-Noblecourt 1952, p. 65.
11. Amiran 1962, p. 172.

Bibliography: Petrie 1891, p. 21, pl. 26:50.

402

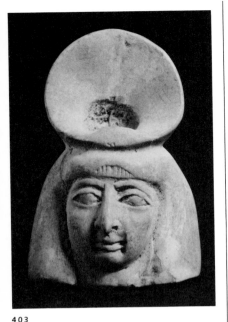

403

403

Decorative spoon from the tip of a horn vessel

Dynasty 18
Length 3.9 cm.; width 2.7 cm.
Merseyside County Museums, Liverpool
(1977.109.20)

Spoons with decorative stems are common on horn vessels. They take many forms, among which are heads of Hathor (represented both as a woman and as a cow),[1] heads of the Bes-image,[2] and heads of rams.[3]

The prevalence of examples showing Hathor, as in this ivory example and a parallel found at Saqqara,[4] may have some relationship to the use of horn vessels in childbirth and nuturing motifs. Syria is apparently the homeland of this motif. An ivory vessel with a simple woman's head on the stem of the spoon came from Megiddo stratum 8[5] and a similar vessel is carried by a Syrian in the tomb of Sebekhotep.[6]

A two-dimensional representation of the motif can be found on an ointment spoon from Dynasty 19,[7] where the head of Hathor in human form acts as a handle for a round dish, suggesting a relationship between the spoons and horns with decorative spouts[8] (see p. 207). A cosmetic function is also indicated by the fact that a bird-headed horn vessel was found in a late Seventeenth-Dynasty burial containing a basket with a razor,

whetstone, and other objects of private use.[9]

S.K.D.

1. Wreszinski 1923, pl. 56b.
2. Prisse d'Avennes 1878, pl. [86].
3. Amiran 1962, p. 165, fig. 3:4.
4. Firth and Gunn 1926, p. xvii: F., pl. 45: F.
5. Amiran 1962, pp. 162ff., 164:1.
6. Wreszinski 1923, pl. 56a.
7. Wallert 1967, pl. 33:L20.
8. Cf. Amiran 1962, p. 173.
9. Petrie 1909a, p. 7, pl. 25.

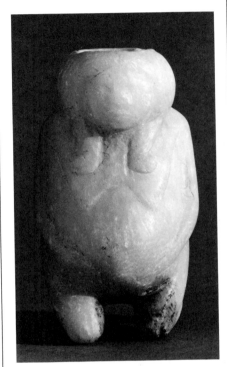

404

404

Bottle in the form of a pregnant woman

Provenance not known
Dynasty 18
Height 12 cm.
Museum of Fine Arts. Gift of the Estate of Mrs. S. D. Warren (02.525)

At the back of this kneeling pregnant figure are the marks of a handle that originally extended from just behind the opening at the back of the top of the head to a point just above a thick short pigtail. Two curled locks of hair fall over her elongated breasts in the front.

The group of alabaster vessels to which this example belongs includes some pieces often thought to be grotesque or demonic because of their coarse, unpleasant facial features and heavy, animal-like hands, feet, and

legs.[1] These features reflect their close association with Taweret, a goddess who took the form of a hippopotamus[2] and who supervised certain aspects of childbirth; the thought of her is apparently so closely entwined with the meaning of these vessels that some of her physical features have intruded into the motif.[3] The hairstyle of the present example is reminiscent of another goddess, Hathor,[4] who also has some relationship to motherhood. Actual Taweret bottles[5] sometimes have an opening at the nipple for pouring the contents, probably milk.

An excavated Eighteenth-Dynasty alabaster bottle in the form of a standing pregnant woman with her hands on her abdomen was found at Abydos in the same tomb as a bottle of the type of cat. 405.[6] The handle of the excavated vessel is in the form of a child.

The contents of bottles such as the Boston example may have been mixed with oil from horn vessels (cf. cat. 402) in order to create an ointment with which a woman might massage herself in the last few months of pregnancy.[7]

S.K.D.

1. Brunner-Traut 1970a, pl. 1; Mogensen 1930, pl. 68.
2. Frankfort and Pendlebury 1933, p. 51, pl. 34.
3. Brunner-Traut 1970a, p. 40 n. 18.
4. Schulman 1967, pp. 155-156; Terrace and Fischer 1970, pp. 73-76.
5. Murray 1911, p. 45:80, pl. 25:80; Wallis 1898, p. 55, fig. 125; Engelbach 1915, p. 15, pl. 9.
6. Garstang 1909, pl. 16; see also Brunner-Traut 1970a, p. 37, nos. 3-4.
7. Brunner-Traut 1970a, pp. 46-47, pl. 7.

Bibliography: Hornemann 1969, pl. 1028; Brunner-Traut 1970a, p. 37, pl. 5b.

Literature: Brunner-Traut 1971, pp. 4-6.

405

Bottle in the form of a woman and child

Provenance not known
Dynasty 18
Height 14 cm.
Agyptisches Museum, Berlin. Deibel Legacy (14476)

The kneeling figure, in red burnished pottery with details in black paint, wears a wig with two long locks falling over her breast (see also cat. 84); another lock, bound into a pigtail, hangs down her back (cf. cat. 366 and

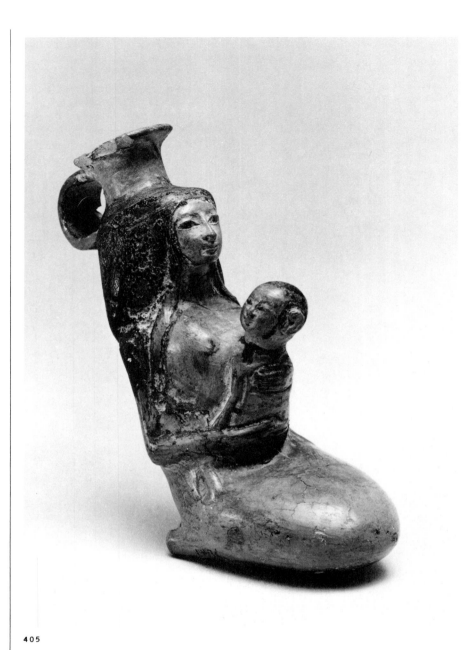

405

pp. 102-103). A small circular handle extends from the rim to the back of the woman's head. The child on the woman's lap has an amulet at its neck.

The group of "mother and child" bottles to which this example belongs has been a subject of much discussion focusing on the child figures, some thought to be depicted as dead and others as alive. Pouring milk from vessels representing dead children to those showing them alive was supposed to signify a resurrection, the milk having absorbed from the bottles the magical qualities needed to create improvement in the condition of a sick child.[1] Such milk would then have been fed to ailing children, probably with the accompaniment of a suitable magical spell.

According to another theory, all the bottles represent living, healthy children, and a mother would hope to attain this state for her child by feeding it milk that had been stored in one of them.[2] A recent study of the bottles[3] describes them as containers for the milk of a mother who has borne a male child, a qualification also made by the previous writers. Such milk is a component of many remedies suggested in medical texts as efficacious for diverse ailments, not all of which are gynecological conditions;[4] thus, any physician might have kept one of them among his equipment.

The mothers represented in this group of bottles may carry a horn vessel (cat. 402) and wear a crescent moon amulet. A secure date in the reign of Thutmose III is provided by the discovery of a similar bottle in an intact burial at Abydos (cf. cat. 84).[5]

S.K.D.

1. Sainte Fare Garnot 1949, pp. 905ff.
2. Desroches-Noblecourt 1952, pp. 49-67.
3. Brunner-Traut 1970b.
4. Ibid., p. 155 n. 20; see above, p. 291.
5. Garstang 1909, pl. 16; Merrillees 1968, pp. 100-102.

Bibliography: Wolf 1930, p. 52, fig. 1; Breasted 1936, fig. 289; Sainte Fare Garnot 1949, p. 911, fig. 3; Badawy 1954, pp. 292ff., fig. 30; Desroches-Noblecourt 1952, p. 51, fig. 3; Hermann 1959, p. 29 n. 88, pl. 5b; Agyptisches Museum 1967, no. 672; Wenig 1967, fig. 47a; Kayser 1969, p. 109, fig. 102; Brunner-Traut 1970b; Miosi 1973, p. 6.

Literature: Brunner-Traut 1971; Bourriau 1981, nos. 48, 50.

406

406

Plate 8 from the Hearst Medical
Papyrus
From Deir el Ballas
Dynasty 18, probably reign of Hatshepsut
Height 17 cm.
Bancroft Library, University of California.
Hearst Egyptian Expedition

Among the extant medical papri, the
Hearst Papyrus is not remembered
either for its organization or for the
empirical nature of its contents. It
is important, however, because it
undoubtedly is a real physician's hand-
book or notebook, and, it contains
assorted prescriptions from various
sources that can actually be identified.
Unlike other medical papyri that
appear to be textbooks or reference
works, or books used for teaching in a
House of Life,[1] the present example
contains no physiological discussions
or theories but has over 250 prescrip-
tions and spells for specific illnesses
or conditions. Among the most

unusual are the prescription to cure
the "bite of a hippopotamus"[2] and the
spell to accompany the selection of a
measuring vessel for ingredients in
medications.[3] It seems clear, since a
large number of these prescriptions
can be found in other textbooks, that
the owner, or someone he had com-
missioned, went to a collection of
medical books and copied out in
random order the most efficacious
texts for his own personal use.

Plate 8 is from a portion of the
papyrus dealing specifically with ail-
ments of the *metou*, or "vessels" (see
p. 290). The enumeration of *metou*
indicates that they were believed to
carry not only blood but urine, air,
and semen. Their maintenance was
thus a matter of the greatest concern,
and plate 8 contains prescriptions for
"cooling," "sweetening," "pacifying,"
and "softening" the *metou*. The titles
of the prescriptions are in red, the
contents in black. Most of the medica-

tions consist of plant material, oils,
perfumes, and fats, which are to be
applied externally to the afflicted area.
The name of the owner and the cir-
cumstances under which he worked
were undoubtedly at the beginning of
the papyrus, which now has eighteen
sheets remaining. It was brought to
the excavator George Reisner while he
was working at Deir el Ballas by a
citizen of that village[4] and has been
dated to a period shortly before the
reign of Thutmose III.[5]

S.K.D.

1. See Gardiner 1938, pp. 157-179.
2. Wreszinski 1912, p. 57, no. 243.
3. Ibid., p. 48, no. 212.
4. Reisner 1905, p. 1.
5. Wreszinski 1912, p. v.

Bibliography: Reisner 1905, p. 10, pl. 8; Wreszinski
1912, pp. v-xiii, pp. 1-133; Leake 1952, pp. 47-97;
Grapow et al. 1955, pp. 92-93, 133-136; Grapow
et al. 1958, passim; Lowie Museum 1966, p. 66.

Literature: Leake 1952, pp. 7-17.

The People's Religion

Reconstructing the abstract beliefs of an ancient people is a very difficult task, even when the material remains of its culture are as plentiful and rich as those surviving from pharaonic Egypt. For the modern observer the apparent obscurity of ancient man's strong belief in certain forces embodied in inanimate objects presents a formidable obstacle toward understanding the spiritual motivation of an ancient faith. There were, in addition, fundamental differences between the beliefs of the secular community and the formal state religion. The common faith was always closely aligned with the natural agrarian cycles of the unique Nilotic environment, while the official religion early evolved away from the same origins and became a formalized institution for the all-powerful royal family and priesthood. The volume of artifacts representing the faith of ordinary people was at least as large as that of the upper classes, but the fragile nature of the materials employed in their fabrication was such that the vast majority of them have perished.

Egypt is a land marked by opposing harmonies, the character of its inhabitants being closely governed by the extreme form of its contrasting desert and river valley environments, which came to represent death and life to them. The Egyptians awareness of the fragility of their existence is clearly visible in their art and religious expressions, which attempt to overcome the fear of death through magic and to ensure continued enjoyment of all earthly pleasures, even after death. The appearance of Egyptian deities is often bewildering to the modern viewer, including beings as diverse in form as insects, reptiles, trees, mountains, and stars. In an attempt to understand natural phenomena, ancient Egyptians personalized the elements of nature and created composite beings, part human and part creature. The animals they worshiped were not considered living gods but were merely imbued with divine power, and even inanimate objects could be given human attributes such as arms or eyes.

There are many sources for studying the religious beliefs of the Egyptian people, among the most important being scenes of everyday activities, which were carved and painted on the walls of the tomb chapels of non-royal persons. Frequently, for example, they depict pastoral scenes on a noble's estate, where agricultural workers labor in the fields and vineyards under the auspices of their patron deity, the cobra goddess Rennutet. Cobras were especially revered because of their habit of seeking shade in the piles of harvested grains, thereby protecting them from attack by rodents. Temple reliefs, on the other hand, often record certain religious festivals when a god left his temple and made an excursion to another district or temple for a celebration in which the local populace took part. For the Festival of Opet,[1] the sacred image of the supreme god Amen left his temple at Karnak to visit the temple of Luxor nearby. During the journey, the people could view the sacred bark and participate directly in a major religious experience. In yet another celebration, the Festival of the Valley, the sacred image of Amen crossed the Nile by boat to visit the great mortuary temples of the monarch and the deceased kings on the west bank. Here, local inhabitants visited the tomb chapels in the cliffs, where they ate, drank, and participated in rituals related to the worship of the souls of deceased ancestors.[2] At the same time, the god might also give an oracle providing an opportunity for the people to resolve disputes and offer petitions, thus presenting a lively demonstration of the god's concern for and authority over the destiny of the entire community.[3]

Perhaps the most informative source of material dealing with the religious attitudes of the Egyptian people is the votive stela.[4] Many have been found in temples and in tombs, especially at the site of the village of royal workmen at Deir el Medineh in Western Thebes. The stelae are decorated with scenes showing the donor worshiping his god. Frequently several large ears adorn the tablet to ensure that the god will hear the prayer inscribed below. These stelae reveal an important element in the religious life of the New Kingdom, the development of a more personal relationship with the gods.[5] The appearance of personal piety in the prayers of the Ramesside

Period is due partly to the spread of literacy and to the fact that many of the artisans had been elevated from the lower strata of society, but another factor was the influence of the universalist philosophy circulating throughout all of the Near East at this time (the period of the Exodus),[6] together with the traditional aspiration of the pious Egyptian to compose and express new and original prayers. Testimony to this new relationship with the gods is to be found in the confession of impiety inscribed on several stelae, one stating: "I am a man who swore falsely to Ptah, Lord of Truth, and he caused me to see darkness in the daytime (i.e., to be blind)" (see cat. 414). In another passage the same man confesses: "[I was] a man, ignorant and foolish, who knew neither good nor evil. I transgressed against the Peak [Western Mountain] and she punished me; I was in her hand by day and by night."[7] These texts are in marked contrast to the traditional bombastic assertions of goodness and purity so frequently found in religious and biographical inscriptions.

A large body of material reflecting religious beliefs comes from amulets,[8] which were worn by and provided protection for everyone. Large numbers have been found in both funerary and secular contexts, including everything from scarabs and seals in stone or faience to pectorals and ornaments in precious metals. Amulets commonly depicted domestic deities such as Bastet, the cat goddess who protected the household; Bes, the bandy-legged dwarf god; and Taweret, the hippopotamus goddess of childbirth. The deities, along with others and a myriad of magical symbols, exemplify the protective forces and beings closest to the hearts and lifestyle of the ancient Egyptians.

Many of the religious ceremonies of the Egyptian people were observed in the home, and the focal point of domestic piety was the household shrine. In a modest house the shrine might consist of a simple niche in one wall of the main living room, containing a painted stone bust of a human being representing, collectively, the souls of deceased relatives (see cat. 409). For the wealthy, the niche would be more elaborate, or, if space permitted, it might be replaced by a separate structure in the garden adjacent to the house and open to the sky. It would have as its main element a finely carved stone tablet with an image of a state god or the deified king and an inscribed prayer (see cat. 407).

The role of the king as a divine intermediary between mankind and the gods is a crucial element for understanding the relationship between the popular and formal religions.[9] The king was considered a mortal human possessing divine essence, the offspring of the union between the supreme god Amen and the king's mother. His physical person was a tangible being to be worshiped as a divine representative on earth, and the existence of shrines dedicated to Thutmose III at Gurob[10] and Ramesses II at Horbeit[11] exemplifies the importance of this element of cultic worship. The primary duty of the monarch was to implement the concept of Maat, an embodiment of natural law, representing the divine worldly order. One of the most important formal rituals enacted in an Egyptian temple was the presentation by the king of an image of the goddess Maat to the cult statue of the supreme god in the sanctuary, symbolizing the king's fullfillment of his most sacred vow.[12] The Egyptian king was simultaneously the protector of social order and the spiritual saviour of his people. It was believed that when he died he became not only Osiris, Lord of the Underworld, who pronounced judgment on the deceased, but also Re, the sun god, who brought light and life to both the earth and the underworld. The principles of Maat and divine kingship allowed a believer to feel himself in a stable environment, divinely sanctioned and maintained constantly by the pharaoh.[13] Cults of former kings and deified sages gave him access through intermediaries to the highest powers.[14]

The religious concepts of the ancient Egyptians were sufficiently adaptive that there was even room for the absorption of foreign beliefs; several deities from the Fertile Crescent and Nubia entered the Egyptian pantheon. Traditionally, the iconography of the Bes-image is considered to be based on an African origin (see p. 76). The Western Asiatic origin of Semitic deities who are found in Egypt is more certain, as they retained their individual character. Interestingly, most of the foreign deities imported from Syria were bellicose deities of battle. Baal ("lord" in Semitic) was an important war god, a personification of the burning heat of the desert sun, and in Egypt was identified with Seth, god of disorder and confusion.[15] The Syrian war god Reshep ("thunderbolt" in Semitic) was depicted on Egyptian stelae as a helmeted man carrying a shield and battle ax and was identified with both Seth and the ithyphallic Min.[16] Astarte, who was well attested in Egypt, was a Syrian war goddess and patroness of battles; she was identified with Isis and Hathor as mother goddess and goddess of love. Qadesh, often associated with Hathor, was a goddess of Syrian origin, perhaps named after the city-fortress of Qadesh attacked by Thutmose III. She was sometimes invoked for protection against noxious insects and animals and was also a divinity of sexual love.[17]

From the earliest periods of Egyptian history, the religious system was based on an elaboration of the pattern of daily life, just as the temple was considered a house for the god, on a grand scale. The king worshiped the gods in his temple on behalf of the entire population and the people in turn prayed to the king in their own domestic shrines; thus the harmonious continuum was maintained at every level of Egyptian society. During the Amarna Period (1363-1347 B.C.), at a time of great internationalism, temples were designed with forecourts filled with hundreds of offering tables, presumably to allow everyone to worship their god with their king. This remarkable innovation indicates a democratization of privilege unparalleled in Egyptian history.

The style of life in the New Kingdom represents a high point of cultural development in pharaonic Egypt, the culmination of two hundred years of commerce and campaigns abroad and internal theological development resulting in in a very high standard of living and an inspired spiritual consciousness, all of which the Egyptians attributed to the munificence of the omnipotent Creator God, about whom

297

the king himself said: "The earth came into being by your hand and it is you who made it; when you rise one lives, when you set one dies, you are a lifetime unto yourself and one lives by means of you."[18]

L.H.H.

1. Wolf 1931.
2. Schott 1952; Wente 1962, pp. 120ff.
3. Parker 1962, pp. 35-48.
4. Vandier 1949, pp. 232-233.
5. Gunn 1916.
6. Oesterley 1927; Simpson 1926.
7. Gunn 1916, p. 86.
8. Petrie 1914a; Bonnet 1952, pp. 26-31.
9. Moret 1902a; Frankfort 1978.
10. Loat 1905, pp. 1-2.
11. Habachi 1969, pp. 28-29.
12. Moret 1902a, pp. 174ff., p. 172, fig. 52.
13. Moret 1902b.
14. Moret 1902a; Wildung 1977; Frankfort 1978.
15. Te Velde 1967.
16. Simpson 1953.
17. Bonnet 1952, pp. 362-363; Vandier 1949, p. 218.
18. Hymn to the Aten, l.12: Davies 1908b, pl. 27, col. 12.

Literature: Kees 1941, Vandier 1949; Roeder 1952; Bleeker 1967; Habachi 1969; Posener 1975.

407

Domestic shrine

From Thebes
Dynasty 18
Height 42 cm.
Cleveland Museum of Art. Gift of the John Huntington Art and Polytechnic Trust (20.2002)

The niche and stela carved from one piece of limestone is probably from a household shrine. The niche is bordered by a torus molding and surmounted by a cavetto cornice. Above and below the niche are horizontal bands of hieroglyphic inscription reading from right to left: "May the Good God live, Lord of the Two Lands, Lord who performs ceremonies, King of Upper and Lower Egypt, Men-kheper-re [Thutmose III], beloved of Amen, may he be given life eternally. Made by the Hearer of Summons of the King, Amenemheb." The round-topped stela set within the niche displays an image of Thutmose III, seated before a table heaped with bread and food offerings; his block throne rests on a *maat* sign, the symbol of truth. Wearing a blue crown, broad collar, kilt, long skirt, bull's tail, and sandals, the king also carries a crook in the left hand and an *ankh*, the sign of life, in the right hand. The six vertical columns of inscription in front of the king read from right to left: "The Good God, Lord of the Two Lands, Lord who performs ceremonies, King of Upper and Lower Egypt, Men-kheper-re, Son of Re, Thutmose, beloved of Amen, may he be given life like Re eternally." Fitted into the curved top of the stela is a winged sun disk with pendant uraei. The sockets that originally held the wooden door leaves covering the stela still remain.

This sort of miniature shrine would have been the religious focal point in a New Kingdom Egyptian home, a humble equivalent to a temple sanctuary. In a town house the shrine would be set in one wall of the main living room, symmetrically opposite a doorway.[1] A more spacious country estate might have a separate open-roofed garden chapel with a larger stela or painted mural depicting the king worshiping the sun god.[2] It was in the Eighteenth Dynasty that the cult of the deified living king originated, formally beginning in the Karnak Red

Chapel of Hatshepsut and culminating in the reigns of Amenhotep III and Akhenaten.[3]

L.H.H.

1. Badawy 1968, p. 94.
2. Ibid., p. 103, pl. 6.
3. Wildung 1977, pp. 3-8.

Bibliography: Cooney 1965, pp. 3ff.

408

Votive stela

Probably from Horbeit
Dynasty 19
Height 14.8 cm.
Roemer- und Pelizaeus-Museum, Hildesheim (380)

The sunken decoration of this round-topped white limestone stela depicts a woman presenting an offering before a statue of a deified king. On the top of her waist-length wig is an incense cone and lotus blossom; she wears a close-fitting inner sheath and an ankle-length transparent flowing outer garment with full sleeves. Her left arm is raised in adoration and in her right she holds out a sistrum, or ceremonial rattle. In front of her is an offering table supporting a metal ewer and a lotus blossom. On the left the figure of the deified king stands on a block base with a vertical line behind indicating the statue's back-pillar; he wears the white crown of Upper Egypt with the uraeus, a long royal beard, and a short kilt, and his hands are clenched around document cases.[1] Above his head is an inscription, "User-maat-Re, the Chosen One of Re, Montu in the Two Lands", identifying the statue as Ramesses II. Above the female figure is inscribed her name and title, "The Singer of Montu in the Two Lands, Isis," indicating that she probably belonged to the staff of a temple of the war-god Montu, perhaps one of the state temples at Per-Ramesses, the Delta capital of Dynasty 19, since a statue with this name is known to have stood before the temple there.[2] A number of very similar stelae have been unearthed at Qantir.[3]

L.H.H.

1. Fischer 1975, p. 20.
2. Habachi 1969, pp. 32-33.
3. Habachi 1952, pls. 30, 33, 34, 38.

Bibliography: Kayser 1973, p. 61, pl. 53.

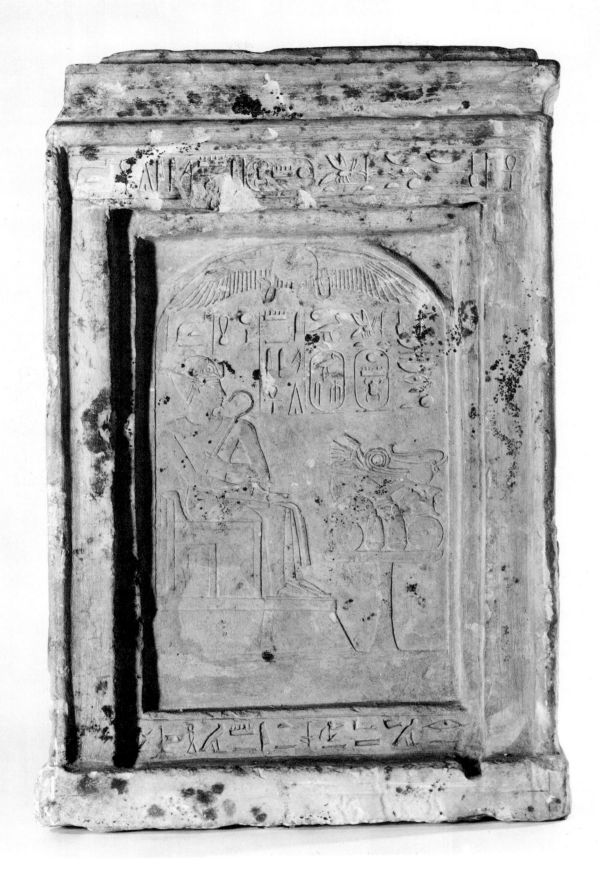

407

408

409
Ancestral bust

From Deir el Medineh
Dynasty 19
Height 26.2 cm.; width 15.5 cm.
The Brooklyn Museum, Brooklyn, New York. Charles Edwin Wilbour Fund (54.1)

The upper torso of this soft white limestone bust is anatomically undetailed, merely serving as a base for the head, which is adorned with a full lappet wig (a mark of divinity) and an undecorated *polos* or platform crown. This early Ramesside face exhibits Amarna characteristics, especially in almond-shaped eyes and full lips. The nose is unusually well preserved and the prominent ears are carefully modeled and pierced. The expression on the face is vague, allowing it to represent either a man or a woman. Originally the bust was brightly painted and traces indicate that the figure wore a very broad collar with polychrome details. In addition there are the remains of blue pigment on the lappet wig and red on the crown; on the back are red ties for the collar.

Almost all of the excavated examples of this type of bust are of Ramesside date and have come from the village of royal tomb workers at Deir el Medineh in Western Thebes. They were usually found near a wall of the main living room, which contained one or more niches, and were presumably situated in a niche.[1] According to one theory, the busts portray the

household deity as a representative of the spirits of the family ancestors; however, there are examples inscribed with the names of private individuals.[2] A figure of this type can be seen accompanying chapter 151 of the Book of the Dead, the "spell of the head of mysteries."[3]

L.H.H.

1. Bruyère 1939, p. 171.
2. Anthes 1943, p. 58; Boreux 1932, p. 397, pl. 63c; Agyptisches Museum 1967, no. 783.
3. Bruyère 1939, pp. 168-169.

Bibliography: Brooklyn Museum 1956, pp. 11-12, pl. 25; Wilkinson 1971, p. 153, fig. 68; Prager 1975, p. 39, fig. 22.

409

410
Votive stela dedicated to Amen-Re

Probably from Thebes
Probably Dynasty 19
Height 33 cm.
Kestner-Museum, Hannover (2938)

This round-topped limestone stela is divided into two registers. The upper part depicts a statue of the supreme god Amen-Re in his aspect as a ram, before which sits an offering table with a metal ewer and a lotus blossom. In front of this group three papyrus umbels arise. Amen-Re is adorned with a sun disk and falcon feather crown, denoting his celestial nature;

410

1. Brovarski 1977, p. 178.
2. Bonnet 1952, pp. 867-871.
3. Keimer 1938b, pp. 297-319.
4. Lacau 1909, pl. 61; Lacau 1926, pp. 199-200.
5. Cf. also MFA 72.697.

Literature; Sethe 1929, pp. 22-25; Cramer 1936, pp. 103-104, pl. 9; Keimer 1938b, pp. 297-331; Bonnet 1952, pp. 867-871.

411

Votive stela

From Deir el Medineh
Dynasty 19
Height 21 cm.; width 15.7 cm.
Ashmolean Museum, Oxford (1961.232)

As was often the case, this round-topped limestone stela was smoothed for painted decoration on one side only and left rough on the back. The black painted decoration, applied over a preliminary red sketch, divides the stela into two registers. The upper scene depicts two cats facing each other over a small pile of bread and vegetable offerings. Above them six short vertical lines of inscription give their names: "The Great Cat, the Peaceful One is his good name, he who belongs to Atum at rest" and "The Good Cat———of Re." The lower register shows the owner of the stela and his wife standing on the right wearing pleated garments. They both have full wigs, with curls terminating in ringlets; hers is waist length and has a headband with a flower at the forehead. In her right hand she holds a vessel, while he offers an incense burner, their left hands are raised in adoration. Like many mass-produced items in ancient Egypt, this stela was probably intended to receive specific identification after purchase. To the left, six vertical columns contain a prayer with blanks left for the names, reading: "Giving adoration to the Great Cat, kissing the earth [for] the herald of Re, the peaceful one who has returned to rest. . . . Reveal to me the vision of your beauty, then peacefully brightness shall return to me. I shall be at peace, knowing [your] beauty. May you give life, prosperity, and health to the soul of———"

Stelae of this type were very common in the New Kingdom, except for the presence of the cat motif. Cats in ancient Egypt were usually associated with the household goddess Bastet[1] by virtue of the fact that they were responsible for ridding the house of

around his neck are a sash and broad collar, and his forelegs are covered by a skirt and his back by a blanket. Over his back is a sunshade, symbolizing the ram's association with an aspect of the soul.[1] At the top center is the god's name, "Amen-Re, Lord of Heaven." The donor of the stela is represented at the lower right, garbed in a long fringed dress, full wig, and ointment cone, with arms raised in worship. Before her is the text of the prayer she speaks, which contains an invocation to Amen-Re of Karnak on behalf of the great singer of Hathor, Re.

The ram in ancient Egypt was associated with many different local gods and had many cult centers; he was known primarily as a symbol of fertility.[2] In the New Kingdom the ram

was identified mainly with the cult of the state god Amen-Re and was considered a living manifestation of the god's soul. The seemingly extraordinary portrayal of this ram with four horns owes its origin to the fact that the horizontal spiraling horns belong to an early species of sheep (*Ovis longipes palaeoaegyptiaca*), which was superseded at the end of the Middle Kingdom by a newer species (*Ovis platyra aegyptiaca*) with horns curving down around the ears;[3] because of the conservative nature of Egyptian religious representation, the animal was thereafter depicted with both sets of horns. A close parallel to this stela is in the Cairo Museum;[4] it dates from the same period and was found at Medinet Habu.[5]

L.H.H.

301

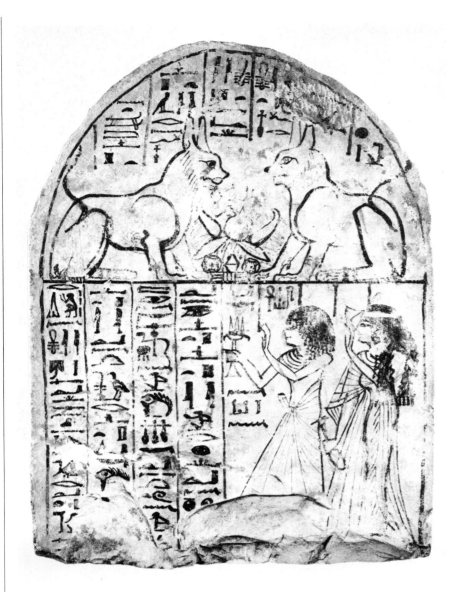

411

insects, rodents, and snakes. However, in the formal religion prior to the New Kingdom, there was an association between the cat and an aspect of the sun god Re based upon paronomasia with the onomatopoeic word for cat, *miu* (cf. p. 274).[2] Because of its domestic associations and its relationship to Re, the cat became a decorative motif on carved window gratings or transoms (see cat. 3).

L.H.H.

1. Otto 1975, cols. 628-630.
2. Book of the Dead, ch. 17, sec. 22; Grapow 1915-1917, pp. 50-54; Allen 1974, p. 30.

Literature: Weigall 1924, pl. 260.

412

Votive statuette of geese
From Deir el Medineh
Dynasty 19
Width 17 cm.
Roemer- und Pelizaeus-Museum, Hildesheim (4544)

Nine Nile geese in white limestone are shown sitting on the ground with their heads close to their bodies; they are divided into three groups: two large, three medium sized and four small. Paint is visible in the inscription on the front of the rectangular base, as well as on each bird's breast and on some of the feathers. The inscription reads: ''Made by the Sculptor of Amen in the Place of Truth, Ken, deceased, who says, 'Be established and enduring on behalf of the geese of Amen.' '' This votive object was found on a wooden base and probably came from the sanctuary of Ptah and Meretseger at Deir el Medineh.[1]

The goose is identified with the sky god Amen, probably owing to the similarity between the words *semen* (goose) and Amen, as well as an association with a primeval creator god called ''the Great Cackler.''[2] The number of geese is significant because there were nine gods in the most important and powerful group of deities in the Egyptian pantheon, the Ennead.[3] Both the Heliopolitan and Hermopolitan creation myths are centered around a body of nine gods.

L.H.H.

1. Porter and Moss 1964, p. 714.
2. Störk 1977, cols. 373-375.
3. Kayser 1958, p. 193.

Bibliography: Kayser 1966, p. 33, pl. 43.

413

Statue of snake goddess
Probably from Saqqara
New Kingdom
Height 35.6 cm.; width 8.5 cm.
The Brooklyn Museum, Brooklyn, New York. New-Yord Historical Society, Charles Edwin Wilbour Fund (37.1749E)

The snake goddess was the patroness of the harvest, and small shrines to her can be seen accompanying harvest and vintage scenes in Theban tombs.[1] The two most important snake goddesses are Rennutet, goddess of nursing and the harvest, and Meretseger, goddess of the Theban necropolis and patroness of the village of royal tomb workers. This red sandstone statue probably represents the latter. (A close parallel in Turin[2] is identified as Meretseger, and a stela in London shows the donor worshiping before just such a statue of Meretseger.[3]) On a rectangular plinth the cobra body coils up to a human head wearing a lappet wig and a crown. Under the crown is a large papyrus blossom. The surface of the stone is superficially pitted over its entire area, and there are traces of red pigment remaining on the hood of the snake, the base of the crown, and the solar disk.

412

413

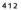

A statue of this type could have been dedicated as a votive offering in a temple or may have been the sacred image in a small shrine. On the head-dress of this sculpture, replacing the usual cow's horns encircling the solar disk, are a pair of raised arms, the pictograph for the Egyptian word *ka* ("nourishment"), which was what the goddess provided.[4] The substitution also transforms the entire headdress into a logogram for the name of the ruler, being read: Maatkare (the ostrich feather, the arms, and the sun disk), the throne name of Queen Hatshepsut. Visual puns of this type are very common from her reign, especially in the statuary of the Great Steward Senenmut,[5] where the serpent represents the goddess Maat.

L.H.H.

1. Davies and Gardiner 1936, pl. 28.
2. Bruyère 1932, p. 225.
3. Vandier 1935, pl. 25; Bruyère 1932, p. 145.
4. Davies and Gardiner 1936, pl. 28.
5. Bothmer 1970, pp. 124-143.

Bibliography: New-York Historical Society 1873, p. 10, no. 93; New-York Historical Society 1915, p. 7, no. 94.

414

Votive stela
From Thebes
Dynasty 19, reign of Ramesses II
Height 39 cm.; width 28 cm.
British Museum, London (589). Formerly in the Belmore Collection

The round-topped limestone stela is inscribed on both sides in shallow sunk relief. The front is divided into two registers; on the upper Ptah, god of craftsmanship, in his usual mummy form, sits on a block throne in a booth adorned with a garland of flower petals. Before Ptah is a table heaped with bread and plant offerings. At the top are four ears, a pair of raised arms, and two eyes, designed to assure the attention of the god and a successful response to the prayer. The lower register displays an image of the donor kneeling with raised arms, pray-ing to the god; the text of the prayer is inscribed in front of the figure in eight vertical columns reading: "Praying to Ptah, Lord of Truth, King of the Two Lands, Youthful of face, who is on his Great Throne, the Unique God who is in the Ennead, he

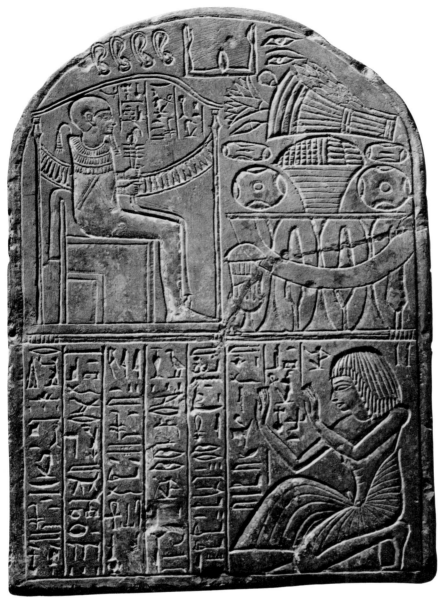

414

This stela is an example of a large class of votive objects placed by pious Egyptians in temples and tombs. Its purpose was to remedy a particular misfortune incurred by the supplicant, in this case blindness, which is referred to twice in the text. Invoking the name of the god falsely was apparently a crime of considerable gravity in view of its frequent mention in stelae of this type. It is interesting to note that "confessions of sin" first appear in the Ramesside Period, when they reflect contemporary notions of personal piety (see p. 297). The comparison of the man with stray dogs in the street is strengthened by the intentional pun between the words *iway* ("dog") and *iwayt* ("wrongdoing").

The same individual dedicated another stela, now in Turin,[1] in which he prays to the goddess of the Western Mountain for a cure for his condition.[2]

L.H.H.

1. Gunn 1916, p. 86.
2. The present stele has been included with monuments belonging to the owner of Deir el Medineh tomb no. 5 (Vandier 1935, p. 49, pl. 26).

Bibliography: Gunn 1916, p. 88; James 1970, p. 36, pl. 31a; Vandier 1935, p. 49, pl. 26.

415

Votive stela

From Deir el Medineh
Dynasty 19
Height 16.6 cm.; width 12.7 cm.
Fitzwilliam Museum, Cambridge (EGA 3002.1943). Formerly in the R. G. Gayer Anderson Collection

The front of this round-topped lime-stone stela was smoothed for decoration and divided into two registers. On the upper the god Reshep is seated on a block throne before a table of offerings, his name inscribed above. His characteristic attributes are a shield, a war club, and a crown resembling the white crown of Upper Egypt but with streamers at the back and a gazelle head at the front. Behind the god is a large *ankh* symbol with outstretched arms holding an ostrich-feather fan and the inscription: "Protection and life are around him." In the lower register the donor of the stela and his son are shown kneeling with arms raised in worship. The accompanying inscription reads:

who is beloved as the King of the Two Lands, that he might give life, prosperity and health, cleverness, praise, and love and that my eyes may see Amen throughout the course of every day, as is done for a righteous man who places Amen in his heart. [Said] by the servant in the Place of Truth, Neferabet, deceased." The text continues on the back with ten vertical lines of inscriptions: "Beginning of the declaration of the powers of Ptah, he who is South of his Wall, by the servant in the Place of Truth in Western Thebes, Neferabet, deceased. He says: I am a man who swore falsely to Ptah, Lord of Truth, and he caused me to see darkness in the daytime. I shall speak of his powers to those who do not know him and to those who know him, to small and to great

people. Beware of Ptah, Lord of Truth, behold he does not overlook the deed of any person. Refrain from pronouncing the name of Ptah falsely. Behold he who pronounces it falsely; he shall be cast down. He caused me to be like the dogs of the street, I being under his control; he caused men and gods to stigmatize me like a man who has become an abomination to his lord. Ptah, Lord of Truth, was just toward me when he made an example of me. Be merciful to me, look toward me when you are merciful. [Said] by the Hearer of Summons in the Place of Truth in Western Thebes, Neferabet, deceased before the Great God."

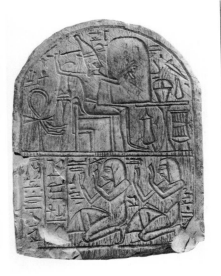

415

"Giving adoration to Reshep, the Great God, that he might give life, prosperity, and health to the servant in the Place of Truth, Pashed, and his son Saen———."

This votive stela is unusual in that it is dedicated to a non-Egyptian god. After the Thutmosid wars of the early Eighteenth Dynasty, when many foreigners came into Egypt, new customs and beliefs were assimilated into Egyptian religion. The cult of Reshep, a Syrian war deity whose name means "thunderbolt"[1] was established in Egypt during the reign of Amenhotep II;[2] it even penetrated into Egyptian Nubia, where a simple rock shrine at Gebel Agg was dedicated to Horus, Lord of Miam (Aniba), Senusert III, and Reshep.[3] Reshep's greatest popularity came during the Ramesside Period, when many stelae of this nature were produced by the community of royal workmen in western Thebes, a fact that may indicate the foreign character of some of these workmen.[4]

A close parallel to this stela in the British Museum was dedicated by a man of the same name, Pashed.[5]

L.H.H.

1. Mercer 1949, p. 221.
2. Simpson 1960, p. 63.
3. Kemp 1978, p. 38.
4. Simpson 1960, p. 71.
5. Janssen 1950, p. 211.

Bibliography: Janssen 1950, pp. 209-212; Porter and Moss 1964, p. 733; Fulco 1976, p. 13; Giveon 1980, p. 146.

Literature: Simpson 1953, pp. 86-89; Stadelmann 1967; Fuscaldo 1972; Fuscaldo 1976; Schulman 1981, pp. 157-166.

416
Prayer stela

From Giza cemetery 7000
New Kingdom
Height 12.5 cm.; width 9.1 cm.
Museum of Fine Arts. Harvard University—Museum of Fine Arts Expedition (27.787)

The decoration of this round-topped limestone stela, incised in shallow sunk relief, depicts a recumbent sphinx wearing the royal *nemes* headcloth, uraeus, and long beard. Above the sphinx is carved a large detailed human ear; there is no inscription.

Stelae such as this one, which might be called "ear tablets," are commonly found in temple contexts,[1] where they were dedicated by ancient worshipers offering a prayer or petition to the god. An essential element of these stelae is an image of the deity being invoked, in this case the well-known great sphinx at Giza, thought by Egyptians during the New Kingdom to be a representation of the sun god Horemakhet ("Horus in the Horizon"). Also included is a representation of an ear or frequently several ears, which symbolized the ears of the god and were intended to ensure that the god or goddess portrayed actually listens to the plea of the supplicant. It is likely that the prayers were directed toward the stela and spoken into these ears.

L.H.H.

1. Hassan 1953, pp. 41-44; Bruyère 1925, pp. 82-84.

416

417
Figured ostracon

Provenance not known
New Kingdom
Height 8 cm.; width 12 cm.
Fitzwilliam Museum, Cambridge (4290.1943). Formerly in the R. G. Gayer Anderson Collection

The limestone ostracon, painted in red, black, and a yellowish-red pigment, is decorated on one side with the figure of a young woman riding a horse. She is naked except for a necklace and a bandolier over one shoulder. Riding bareback and sidesaddle, she supports herself with one hand and holds a spear and a loop of the reins with the other. The horse is rendered very naturalistically except that the base line changes angle under the front legs so that the rear legs are trotting while the forelegs are rearing up or galloping in the Egyptian fashion; lines on the head indicate some type of harness.

Numerous parallels to this ostracon have been collected in a definitive article about Astarte on horseback.[1] Though no example bears her name, the iconography is certain enough to allow positive identification. Astarte was a Syrian mother goddess and goddess of war, the consort of Ba'al.[2] In Egypt she was identified with Hathor and Isis as a mother goddess,[3] and at Memphis she was known as the daughter of Ptah, having the powers of Sekhmet, the greatest war goddess.[4] In both Syria and Egypt Astarte was considered to have mastery over horses, which were newly introduced into Egypt in the Eighteenth Dynasty, and it was she who was responsible for the prowess of Thutmose IV as a horseman.[5]

L.H.H.

1. Leclant 1960, p. 37:1-67, figs. 18-23, pl. 3a.
2. Mercer 1935, p. 192.
3. Mercer 1949, p. 219.
4. Gardiner 1932a, p. 82.
5. Leclant 1975, cols. 499ff.

Bibliography: Leclant 1960, p. 41, fig. 18; Peck 1978a, p. 86, no. 11.

Literature: Stadelmann 1967.

417

The solar disk denotes Hathor's celestial nature, while the cow horns indicate her importance as a symbol of fertility. (Likewise, the king was "the bull of his herd," viz. mankind.) The vulture headdress identifies her with the goddess of motherhood, Mut.

A close parallel is in New York,[1] and a virtually identical *menat* found at Amarna, complete with its bead necklace,[2] suggests a date for all three pieces in the late Eighteenth Dynasty.

L.H.H.

1. Hayes 1959, p. 269.
2. Frankfort and Pendlebury 1933, pl. 36:3.

Bibliography: Dunham and Janssen 1960, p. 48, pl. 128a.

Literature: Arundale and Bonomi 1837, pp. 20-21, fig. 36.

418
Decorative counterpoise

From Semna fort, room r
Dynasty 18
Height 13.8 cm.
Museum of Fine Arts. Harvard University—Museum of Fine Arts Expedition (29.1199)

This bronze counterpoise or *menat* was originally suspended from a necklace by the ring at the back. The decoration consists of openwork designs with chased details representing aspects of the goddess Hathor. On her head is a sun disk between cow's horns mounted on a *polos* with uraei; her full wig is covered by a vulture headdress. The body of the goddess is a shrine inside which stands a full-length figure of Hathor. She wears her wig, disk, and horns and an archaic sheath dress displaying a beaded pattern; before her she holds a *was* scepter, a symbol of dominion. The edges of the shrine and the medallion below are decorated with the traditional block border found in Theban tombs. Within the medallion a dappled cow wearing the disk and horns rides on a papyrus boat through the marshes sacred to Hathor, symbolized by a large papyrus plant bent over the back of the cow.

The *menat* counterpoise was an important ritual object used by

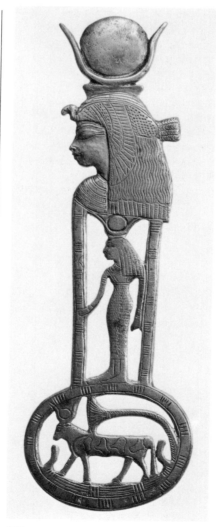

418

419
Snake amulet

Provenance not known
New Kingdom
Length 9 cm.; width 6.5 cm.
Field Museum of Natural History, Chicago (31008)

An Egyptian cobra is represented traditionally with a vertically undulating body and a head tensed to spring. Amulets in that form are quite common and were designed to protect the wearer from evil, symbolized by the snake. Votive or propitiatory statuettes with a similar protective intention are also attested from domestic and temple excavations.[1]

Because of the unusual form of this mottled light and dark blue faience piece, it is not possible to identify its function with certainty. The heads of the two serpents are slightly raised and looking off at an angle, their bodies posed naturalistically, coiled together and balancing each other within the shape of the base. With small sculptures of this sort it is often difficult to identify them definitely as either amulets or votive statuettes.

L.H.H.

1. Bruyère 1933, p. 225.

Bibliography: Hornemann 1969, no. 1843.
Literature: Anthes 1943, p. 59.

419

420

420

Bes-image
Provenance not known
Dynasty 18, probably reign of
Amenhotep III
Height 3.8 cm.; width of base 4.5 cm.
Museum of Fine Arts. Pierce Fund (98.942).
Formerly in the Hilton Price Collection

The head of lapis or a related stone displays features typical of the Bes-image: the ears are large and feline; thick plastic eyebrows run obliquely over the furrowed forehead, which is bisected vertically by a deep crease; traces of cosmetic lines extend from the outer canthi; two folds of flesh extend obliquely from the broad flat nose down across the cheeks. The extremely wide open mouth has teeth and a tongue projecting over the lower lip; the whiskers consist of short curved strokes covering the cheeks only; the hair is rendered as alternating vertical bands of blue stone and white inlay. There is a shallow, ovoid hole in the top of the head and a deep rectangular slot in the bottom.

Many antiquities housed in museums and private collections once served functions now difficult to identify. This is especially true when an object that once formed part of a complicated ensemble becomes separated from its ancient context. This dark blue head of a Bes-image inlaid in white presents such a dilemma. The gods represented by the Bes-image, including Aha, Bes, Hayet, and Soped, were never part of the chief pantheon of Egyptian divinities. Their only association with the major deities occurred when one or more of them participated in the birth of the Sun God, protecting the divine child from malevolent forces. The birth of the solar infant became the paradigm for the creation of the king, and Bes-images occasionally appear in representations of pharaoh's miraculous birth. In their more common aspect, however, the gods of the Bes-image functioned as household guardians charged with protecting the family, especially pregnant women and young children.

Egyptologists have recognized isolated figures similar to this as game pieces, knife pommels, and decorative elements on mirrors or ornate vessels. But until a complete object incorpor-

ating a comparable head comes to light, we must content ourselves with appreciating this forceful grimacing countenance without fully understanding why it was created.

A similar piece, inscribed with the name of Amenhotep III, is in the Egyptian collection in Moscow.[1]

J.F.R.

1. Ballod 1913, p. 45.
Bibliography: Price 1908, pl. 12.

Appendix

(Transcriptions)

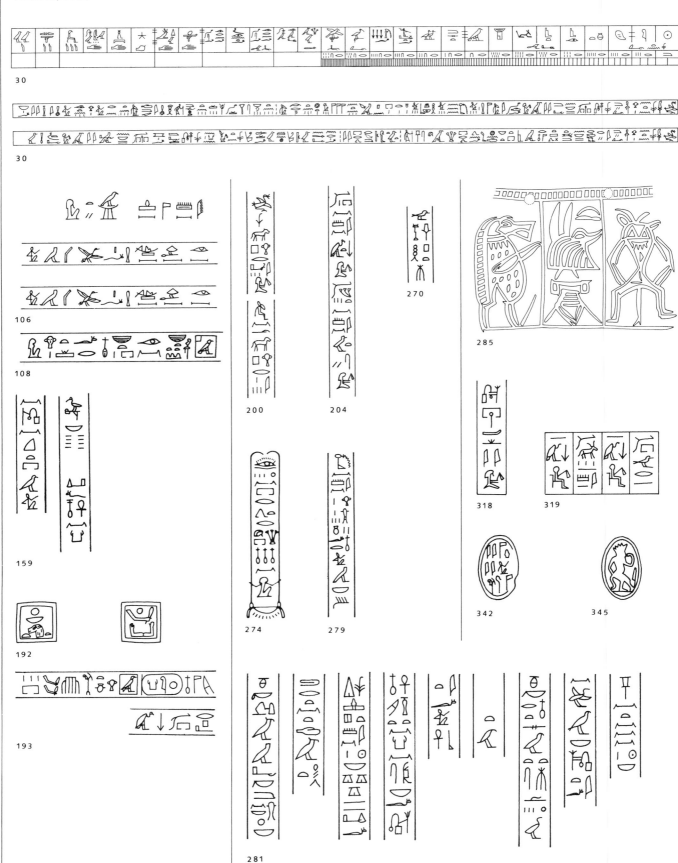

30

30

106

108

159

192

193

200

204

270

285

274

279

318

319

342

345

281

351

355

356

357

358

359

360

361

378

367

371

371

362

387

383

395

398

392

410

390

407

411

415

Bibliography

Abbreviations

AJA =American Journal of Archaeology, Baltimore and Norwood

ARCE Newsletter =Newsletter of the American Research Center in Egypt, Baltimore

ASAE =Annales du Service des Antiquités de l'Egypte, Cairo

BBM =Bulletin of the Brooklyn Museum, Brooklyn

BES =Bulletin of the Egyptological Seminar, New York

BIE =Bulletin de l'Institut d'Egypte (de l'Institut Egyptien), Cairo

BIFAO =Bulletin de l'Institut Français d'Archéologie Orientale, Cairo

BiOr =Bibliotheca Orientalis, Leiden

BMA =Brooklyn Museum Annual, Brooklyn

BMFA =Bulletin of the Museum of Fine Arts, Boston

BMMA =Bulletin of the Metropolitan Museum of Art, New York

Bull. MRAH =Bulletin des Musées Royaux d'Art et d'Histoire, Brussels

BWAG =Bulletin of the Walters Art Gallery, Baltimore

CdE =Chronique d'Egypte, Brussels

FIFAO =Fouilles de l'Institut Français d'Archéologie Orientale du Caire, Cairo

GM =Göttinger Miszellen, Gottingen

HAS =Harvard African Studies, Cambridge

IEJ =Israel Exploration Journal, Jerusalem

JAOS =Journal of the American Oriental Society, New Haven

JARCE =Journal of the American Research Center in Egypt, Boston

JEA =Journal of Egyptian Archaeology, London

JEOL =Jaarbericht van het Voraziatisch-Egyptisch Genootschap (Gezelschap) ''Ex Oriente Lux,'' Leiden

JGS =Journal of Glass Studies, Corning

JHS =Journal of Hellenic Studies, London

JNES =Journal of Near Eastern Studies, Chicago

LAAA =Liverpool Annals of Archaeology and Anthropology, Liverpool

LA =Lexikon der Agyptologie, Wiesbaden

MDAIK =Mitteilungen des Deutschen Archäologischen Instituts, Cairo, Berlin, Wiesbaden, Mainz

MDOG =Mitteilungen der Deutschen Orientgesellschaft, Berlin, Leipzig

MIE =Memoires de l'Institut d'Egypte (de l'Institut Egyptien), Cairo.

MIO =Mitteilungen des Instituts für Orientforschung, Berlin

MMJ =Metropolitan Museum Journal, New York

MMS =Metropolitan Museum Studies, New York

MIFAO =Mémoires publiés par les Membres de l'Institut Français d'Archéologie Orientale du Caire, Cairo

PSBA =Proceedings of the Society of Biblical Archaeology, London

RdE =Revue d'Egyptologie, Cairo and Paris

RT =Recueil de Travaux Relatifs à la Philologie et à l'Archéologie Egyptiennes et Assyriennes, Paris

RA =Revue Archéologique, Paris

RIHAO =Revista del Instituto de Historia Antigua Oriental, Buenos Aires

SAK =Studien zur altägyptischen Kultur, Hamburg

SNR =Sudan Notes and Records, Khartoum

SSEA Journal =Journal of the Society for the Study of Egyptian Antiquities, Toronto

WZKM =Wiener Zeitschrift für die Kunde des Morgenlandes, Vienna

ZAS =Zeitschrift für Agyptische Sprache und Altertumskunde, Leipzig and Berlin

Abbott 1853
H. Abbott. *Catalogue of a Collection of Egyptian Antiquities, the Property of Henry Abbott, M.D. Now Exhibiting at the Stuyvesant Institute.* New York, 1853.

Abbott 1915
H. Abbott. *Catalogue of a Collection of Egyptian Antiquities, the Property of Henry Abbott, M.D.* New York, 1915.

Agyptische Sammlung des Bayerischen Staates 1966
Agyptische Sammlung des Bayerischen Staates. *Die Agyptische Sammlung des Bayerischen Staates. Ausstellung in den Ausstellungs Räumen der Staatlichen Graphischen Sammlung. München, vom 21. Juli bis 5. Okt. 1966* (by H. Müller). Munich, 1966.

Agyptisches Museum 1967
Agyptisches Museum. Staatliche Museen (West Berlin). *Agyptisches Museum Berlin* (by W. Kaiser). Berlin, 1967.

Aldred 1951
C. Aldred. *New Kingdom Art in Ancient Egypt.* London, 1951.

Aldred 1952
C. Aldred. *The Development of Ancient Egyptian Art, from 3200 to 1315 B.C.* London, 1952.

Aldred 1954
C. Aldred. ''Fine Wood-Work,'' in C. Singer et al., eds., *History of Technology* 1. Oxford, 1954 (pp. 684-703).

Aldred 1957
C. Aldred. ''Hair Styles and History,'' in *BMMA* 15, no. 6 (1957), pp. 141-147.

Aldred 1961
C. Aldred. *New Kingdom Art in Ancient Egypt During the Eighteenth Dynasty, 1570 to 1320 B.C.* Rev. ed. enlarged. London, 1961.

Aldred 1965
C. Aldred. *Egypt to the End of the Old Kingdom.* New York, 1965.

Aldred 1968
C. Aldred. *Akhenaten, Pharaoh of Egypt: A New Study.* London, 1968.

Aldred 1971
C. Aldred. *Jewels of the Pharaohs.* New York, 1971.

Aldred 1973
C. Aldred. *Akhenaten and Nefertiti.* New York, 1973.

Aldred 1975
C. Aldred. ''Bildhauer und Bildhauerei,'' in *LA* 1 (1975), cols. 800-805.

Aldred 1976
C. Aldred. ''The Horizon of the Aten,'' in *JEA* 62 (1976), p. 184.

Allen 1974
T. Allen. *The Book of the Dead or Going Forth by Day.* Chicago, 1974.

Altenmüller 1965
H. Altenmüller. *Die Apotropaia und die Götter Mittelägyptens.* Munich, 1965.

Altenmüller 1971
H. Altenmüller. ''Eine neue Deutung der Zeremonie des *'in'it rd,*'' in *JEA* 57 (1971), pp. 146-154.

Altenmüller 1977
H. Altenmüller. ''Hand,'' in *LA* 2 (1977), cols. 938ff.

Amelineau 1899
E. Amelineau. *Les Nouvelles Fouilles d'Abydos 1895-6.* Paris, 1899.

Amiran 1962
R. Amiran. ''The 'Arm-Shaped' Vessel and its Family,'' in *JNES* 21 (1962), pp. 161-174.

Amiran 1969
R. Amiran. *Ancient Pottery of the Holy Land.* Jerusalem, 1969.

Andreu 1979
G. Andreu. ''An Etymological Problem,'' in *JEA* 65 (1969), pp. 166-167.

Andrews 1976
C. Andrews. *Egyptian Jewellery.* Banbury, 1976.

Anthes 1936
R. Anthes. ''Die hohen Beamten namens Ptahmose in der 18 Dynastie,'' in *ZAS* 72 (1936), pp. 60-68.

Anthes 1943
R. Anthes. ''Die Deutschen Grabungen auf der Westseite von Theben in den Jahren 1911 und 1913,'' in *MDAIK* 12 (1943), pp. 1-68.

Antiquarium Quarterly 1925-1926
Anonymous. ''Wine Jars of the Lady Em Netchem,'' in *Antiquarium Quarterly* 1 (1925-1926), p. 178, pl. 17.

Appel 1946
B. Appel. *Skin, Beauty and Health.* Westfield, Mass. 1946.

Arkell 1962
A. Arkell. ''An Early Pet Cat,'' in *JEA* 48 (1962), p. 158.

Arnold 1977
D. Arnold. ''Hausbau,'' in *LA* 2 (1977), cols. 1062-1064.

Art Museum of South Texas 1976
The Art Museum of South Texas, Corpus Christi. *Greek Vases from the Boston Museum of Fine Arts, March 12-May 2, 1976.* Corpus Christi, 1976.

Arundale and Bonomi 1837
F. Arundale and J. Bonomi. *Gallery of Antiquities Selected from the British Museum.* London, 1837.

Aspinall et al. 1972
A. Aspinall et al. ''Neutron Activation Analysis of Faience Beads,'' in *Archaeometry* 14 (1972), pp. 27-40.

Asselberghs 1961
H. Asselberghs. *Chaos en Beheersing.* Leiden, 1961.

Assmann 1977
J. Assmann. ''Harfnerlieder,'' in *LA* 2 (1977), cols. 972-982.

Åström 1969
P. Åström. ''A Red Lustrous Wheel-Made Spindle Bottle and its Contents,'' in *Medelhausmuseet Bulletin* 5 (1969), pp. 16-21.

Åström et al. 1976
P. Åström, D. Bailey, V. Karageorghis. *Hala Sultan Tekke 1, Excavations 1897-1971.* Göteborg, 1976.

Auth 1976
S. Auth. *Ancient Glass at the Newark Museum.* Newark, 1976.

Ayrton and Loat 1908-1909
E. Ayrton and W. Loat. ''Excavations at Abydos,'' in *The Egypt Exploration Fund Archaeological Report 1908-1909.* London, 1909 (pp. 2-5).

Ayrton and Loat 1911
E. Ayrton and W. Loat. *Predynastic Cemetery at El Mahasna.* London, 1911.

Ayrton et al. 1904
E. Ayrton, M. Currelly, and A. Weigall. *Abydos* 3. London, 1904.

Badawy 1948
A. Badawy. *Le Dessin architectural chez les anciens Egyptiens.* Cairo, 1948.

Badawy 1954
A. Badawy. ''La Loi de frontalité dans la statuaire égyptienne,'' in *ASAE* 52 (1954), pp. 275-307.

Badawy 1966
A. Badawy. *Architecture in Ancient Egypt and the Near East.* Cambridge, 1966.

Badawy 1968
A. Badawy. *A History of Egyptian Architecture: The Empire.* Berkeley, 1968.

Baines 1975
J. Baines. ''Ankh-Sign, Belt and Penis Sheath,'' in *SAK* 3 (1975), pp. 1-24.

Baker 1966
H. Baker. *Furniture in the Ancient World, Origins and Evolution, 3100-475 B. C.* London, 1966.

Bakir 1952
A. Bakir. *Slavery in Pharaonic Egypt.* Cairo, 1952.

Bakir 1970
A. Bakir. *Ancient Egyptian Epistolography.* Cairo, 1970.

Bakr 1977
M. Bakr. ''Der Ohrschmuck in den antiken Kulturen des Niltals,'' in E. Endesfelder et al., eds., *Agypten und Kusch.* Berlin, 1977 (pp. 57-62).

Ballod 1913
F. Ballod. *Prolegomena zur Geschichte der Zwerghaften Götter in Agypten.* Moscow, 1913.

Banks 1912
E. Banks. *Bismya, or the Lost City of Adab.* New York, 1912.

Barag 1962
D. Barag. ''Mesopotamian Glass Vessels of the Second Millennium B. C.,'' in *JGS* 4 (1962), pp. 9-27.

Barguet 1953
P. Barguet. ''L'Origine et la signification du contrepoids de collier-menat,'' in *BIFAO* 52 (1953), pp. 103-111.

Barta 1968
W. Barta. *Aufbau und Bedeutung der altägyptischen Opferformel.* Glückstadt, 1968.

Barucq 1963
A. Barucq. *L'Expression de la louange divine et de la prière dans la Bible et en Egypte.* Cairo, 1963.

Basel Kunsthalle 1953
Basel Kunsthalle. *Schaetze altaegyptischer Kunst.* Basel, 1953.

Bates 1917
O. Bates. ''Ancient Egyptian Fishing,'' in O. Bates, ed., *HAS 1: Varia Africana* 1. Cambridge, 1917 (pp. 201-271).

Baumgartel 1955
E. Baumgartel. *Cultures of Prehistoric Egypt.* Rev. ed. Oxford, 1955.

Baumgartel 1960
E. Baumgartel. *The Cultures of Prehistoric Egypt* 2. New York, 1960.

Beck 1934a
H. Beck. ''Glass Before 1500 B. C.,'' in *Ancient Egypt and the East* (June 1934), pp. 7-21.

Beck 1934b
H. Beck. ''Notes on Glazed Stones,'' in *Ancient Egypt and the East* (December 1934), pp. 69-83.

Bellinger 1950
L. Bellinger. ''Textile Analysis: Early Techniques in Egypt and the Near East,'' in *Textile Museum Workshop Notes* 2 (1950).

Bellinger 1951
L. Bellinger. ''Textile Analysis: Early Techniques in Egypt and the Near East,'' pt. 2 in *Textile Museum Workshop Notes* 3 (1951).

Bellinger 1959
L. Bellinger. ''Craft Habits, Part 1: Loom Types Suggested by Weaving Details,'' in *Textile Museum Workshop Notes* 19 (1959).

Bénédite 1907
G. Bénédite. *Miroirs.* Cairo 1907.

Bénédite 1908
G. Bénédite. ''Un Envoi de l'institut archéologique du Caire au Musée du Louvre,'' in *Bulletin des Musées de France* (1908), p. 17.

Bénédite 1911
G. Bénédite. *Objets de toilette: 1ère partie: Peignes, etc.* Cairo, 1911.

Bénédite 1924
G. Bénédite. *Objets de toilette: 1ère partie:*

Benson 1963
J. Benson. ''Coarse Ware Stirrup Jars of the Aegean,'' in *Berytus* 14 (1961-1963), pp. 37-51.

Berger 1934
S. Berger. ''A Note on Some Scenes of Land-Measurement,'' in *JEA* 20 (1934), pp. 54ff.

Berman 1947
E. Berman. *Thomas Jefferson Among the Arts.* New York, 1947.

Berriman 1955
A. Berriman. ''Some Marked Weights in the Petrie Collection,'' in *JEA* 41 (1955), pp. 48-50.

Bezold and Budge 1892
C. Bezold and E. Budge. *The Tell el-Amarna Tablets in the British Museum.* London, 1892.

Bianchi 1978
R. Bianchi. "The Striding Draped Male Figure of Ptolemaic Egypt," in H. Masler and M. Strocka, eds. *Das Ptolemaïsche Agypten*. Mainz, 1978.

Bianchi 1980
R. Bianchi. "Not the Isis Knot," in *BES* 2 (1980), pp. 9-31.

Bietak 1966
M. Bietak. *Ausgrabungen in Sayala-Nubien 1961-1965. Denkmäler der C-Gruppe and der Pan-Gräber Kultur*. Vienna, 1966.

Bietak 1979
M. Bietak. "Urban Archaeology and the 'Town Problem' in Ancient Egypt," in K. Weeks, ed., *Egyptology and the Social Sciences*. Cairo, 1979 (pp. 97-144).

Binns et al. 1932
C. Binns et al. "An Experiment in Egyptian Blue Glaze," in *Journal of the American Ceramic Society* 15 (1932), pp. 271-272.

Birch 1868
S. Birch. "Egyptian Expressions of Value," in *ZAS* 6 (1868), pp. 37-39.

Bissing 1898a
W. von Bissing. "Altägyptische Gefässe in Museum zu Gise," in *ZAS* 36 (1898), pp. 122ff.

Bissing 1898b
W. von Bissing. "Stierfang auf einem ägyptischen Holzgefäss der XVIII. Dynastie," in *Athenische Mitteilung* 23 (1898), pp. 242-266.

Bissing 1899
W. von Bissing. "Funde und Erwerbungen in und aus Agypten 1897-1898/99," in *Archäologischer Anzeiger* 14 (1899), p. 57.

Bissing 1901
W. von Bissing. *Metallgefässe*. Vienna, 1901.

Bissing 1902
W. von Bissing. *Die Fayencegefässe*. Vienna, 1902.

Bissing 1907a
W. von Bissing. "Casque ou Perruque," in *RT* 30 (1907), pp. 159-161.

Bissing 1907b
W. von Bissing. *Steingefässe*. Vienna, 1907.

Bissing 1908
W. von Bissing. "Sur l'Histoire du Verre en Egypte," in *Rev. Arch* 11 (1908), pp. 211-221.

Bissing 1914
W. von Bissing. "Two Silversmiths' Models from Egypt," in *Ancient Egypt and the East* (1914), pp. 112-114.

Bissing 1941
W. von Bissing. *Die Fussboden aus dem Palaste des Königs Amenophis IV. zu el Hawata*. Munich, 1941.

Bittel 1933
K. Bittel. "Vorläufiger Bericht über die dritte Grabung in Boğazköy," in *MDOG* 72 (1933), pp. 1ff.

Björkman 1971
C. Björkman. *A Selection of the Objects in the Smith Collection of Egyptian Antiquities at the Linköping Museum, Sweden*. Stockholm, 1971.

Blackman 1917
A. Blackman. "The Nugent and Haggard Collections of Egyptian Antiquities," in *JEA* 4 (1917), pp. 39-46.

Blackman 1918
A. Blackman. "Sacramental Ideas and Usages," in *PSBA* 40 (1918), pp. 57-66.

Blackman 1922
W. Blackman. "Some Occurrences of the Corn-'Arûseh in Ancient Egyptian Tomb Paintings," in *JEA* 8 (1922), p. 235.

Blackman 1936
A. Blackman. "Review of A. Gardiner's *Hieratic Papyri in the British Museum: Third Series: Chester Beatty Gift*," in *JEA* 22 (1936), pp. 104ff.

Blackman 1937
A. Blackman. "Preliminary Report on the Excavations at Sesebi, Northern Province, Anglo-Egyptian Sudan, 1936-7," in *JEA* 23 (1937), pp. 145-151.

Blackman and Apted 1953
A. Blackman and M. Apted. *The Rock Tombs of Meir* 6. London, 1953.

Bleeker 1967
C. Bleeker. *Egyptian Festivals*. Leiden, 1967.

Bleeker 1973
C. Bleeker. *Hathor and Thoth*. Leiden, 1973.

Blegen 1921
C. Blegen. *Korakau, A Prehistoric Settlement near Corinth*. Boston, 1921.

Boehmer 1979
R. Boehmer. *Die Kleinfunde aus der Unterstadt von Boğazköy*. Berlin, 1979.

Boeser 1911
P. Boeser. *Beschreibung der aegyptischer Sammlung des Niederländischen Reichsmuseums der Altertümer in Leiden* 4. The Hague, 1911.

Boeser 1913
P. Boeser. *Beschreibung der aegyptischer Sammlung des Niederländischen Reichsmuseums der Altertümer in Leiden* 2. The Hague, 1913.

Boeser 1925
P. Boeser. *Beschreibung der aegyptischer Sammlung des Niederländischen Reichsmuseums der Altertümer in Leiden* 12. The Hague, 1925.

Boessneck 1953
J. Boessneck. "Die Haustiere in altägypten," in *Veröffentlichungen der Zoologischen Staatssammlung München* 3 (1953), pp. 1-50.

Bogoslovsky 1980
E. Bogoslovsky. "Hundred Egyptian Draughtsmen," in *ZAS* 107 (1980), pp. 89ff.

Bonnet 1928
H. Bonnet. *Ein Frühgeschichtliches Gräberfeld bei Abusir*. Leipzig, 1928.

Bonnet 1952
H. Bonnet. *Reallexikon der aegyptischen Religionsgeschichte*. Berlin, 1952.

Bonnet and Valbelle 1980
C. Bonnet and D. Valbelle. "Un Prêtre d'Amon de Pnoubs enterré à Kerma," in *BIFAO* 80 (1980), pp. 1-12.

Bonomi 1846
J. Bonomi. *Catalogue of a Collection of Egyptian Antiquities, the Property of Henry Abbott, Esq., M.D.* Cairo, 1846.

Borchardt 1895
L. Borchardt. "Ein 'ex libris' Amenophis III," in *ZAS* 33 (1895), pp. 72-73.

Borchardt 1897
L. Borchardt. "Gebrauch von Henna im alten Reiche," in *ZAS* 35 (1897), pp. 168-170.

Borchardt 1899
L. Borchardt. "Miscellen: Die Hieroglyphe 🜊," in *ZAS* 37 (1899), p. 82.

Borchardt 1905a
L. Borchardt. "🜊,🜊 š₃ 'das Rasiermesser," in *ZAS* 42 (1905), pp. 78-81.

Borchardt 1905b
L. Borchardt. "Statuen von Feldmessern," in *ZAS* 42 (1905), pp. 70-72.

Borchardt 1907
L. Borchardt. "Voruntersuchung von Tell el-Amarna in Januar 1907," in *MDOG* 34 (1907), pp. 14-31.

Borchardt 1907a
L. Borchardt. "Das Dienstgebäude des auswärtigen Amtes unter den Ramessiden," *ZAS* 44 (1909), pp. 59ff.

Borchardt 1910
L. Borchardt. *Das Grabdenkmal des Königs Sá³ḥu-ré* 1. Leipzig, 1910.

Borchardt 1911
L. Borchardt. "Ausgrabungen in Tell el-Amarna 1911," in *MDOG* 46 (1911), pp. 1ff.

Borchardt 1912
L. Borchardt. "Ausgrabungen in Tell el-Amarna 1911/12," in *MDOG* 50 (1912), pp. 1ff.

Borchardt 1913a
L. Borchardt. "Ausgrabungen in Tell el-Amarna 1912/13," in *MDOG* 52 (1913), pp. 1-55.

Borchardt 1913b
L. Borchardt. *Das Grabdenkmal des Königs Sá³ḥu-ré* 2. Leipzig, 1913.

Borchardt 1914
L. Borchardt. "Ausgrabungen in Tell el-Amarna 1913/14," in *MDOG* 55 (1914), pp. 3ff.

Borchardt 1916
L. Borchardt. "Das altägyptische Wohnhaus im 14. Jahrhundert v. Chr.," in *Zeitschrift für Bauwesen* 66 (1916), pp. 509-558.

Borchardt 1920
L. Borchardt. *Die Altägyptische Zeitmessung*. Berlin, 1920.

Borchardt 1932a
L. Borchardt. "Ein Brot," in *ZAS* 68 (1932), pp. 73-78.

Borchardt 1932b
L. Borchardt. "Eine Holzschtel mit Darstellung einer Ländlichen Szene in Nubien," in S. Glanville, ed., *Studies Presented to F. Ll. Griffith*. London, 1932 (pp. 257-262).

Borchardt and Ricke 1980
L. Borchardt and H. Ricke. *Die Wohnhäuser in Tell el-Amarna*. Berlin, 1980.

Boreux 1932
C. Boreux. *Guide-catalogue sommaire: Musée national du Louvre* 2. Paris, 1932.

Bosse-Griffiths 1980
K. Bosse-Griffiths. "Two Lute-Players of the Amarna Era," in *JEA* 66 (1980), pp. 70-82.

Bossert 1937
T. Bossert. *Altkreta: Kunst und Handwerk in Griechenland, Kreta und auf den Kykladen währen der Bronzezeit*. 3rd ed. Berlin, 1937.

Bothmer 1949
B. Bothmer. "The Dwarf as Bearer," in *BMFA* 47 (1949), pp. 9ff.

Bothmer 1967
B. Bothmer. "Private Sculpture of Dynasty XVIII in Brooklyn," in *BMA* 8 (1966-1967), pp. 55-89.

Bothmer 1970
B. Bothmer. "More Statues of Senenmut," in *BMA* 11 (1969-1970), pp. 124-143.

Boufides 1970
N. Boufides. "Shabaka and Amenirdis," in *Athens Annals of Archaeology* 3 (1970), pp. 275-285.

Bourriau 1979
J. Bourriau. "Egyptian Antiquities Acquired in 1977 by Museums in the United Kingdom," in *JEA* 65 (1979), pp. 151ff.

Bourriau 1981
J. Bourriau. *Umm el-Ga'ab: Pottery from the Nile Valley before the Arab Conquest*. Cambridge, 1981.

Bourriau and Millard 1971
J. Bourriau and A. Millard. "The Excavation of Sawama in 1914 by G. A. Wainwright and T. Whittemore," in *JEA* 57 (1971), pp. 28-40.

Boussac 1896
H. Boussac. *Le Tombeau d'Anna*. Paris, 1896.

Boylan 1922
P. Boylan. *Thoth: The Hermes of Egypt*. Oxford, 1922.

Breasted 1905
J. Breasted. *A History of Egypt*. New York, 1905.

Breasted 1912
J. Breasted. *Development of Religion and Thought in Ancient Egypt*. New York, 1912.

Breasted 1930
J. Breasted. *The Edwin Smith Surgical Papyrus*. Chicago, 1930.

Breasted 1936
J. Breasted. *Geschichte Aegyptens*. 2nd ed. tr. by H. Ranke. Vienna, 1936.

Breasted 1948
J. Breasted, Jr. *Egyptian Servant Statues*. Washington, 1948.

Brill et al. 1974
R. Brill, I. Barnes, and B. Adams. "Lead Isotopes in Some Ancient Egyptian Objects," in A. Bishay, ed., *Recent Advances in Science and Technology of Materials: 2nd Cairo Solid State Conference*. New York, 1974 (pp. 9-27).

Brinks 1977
J. Brinks. "Haus," in *LA* 2 (1977), cols. 1055-1061.

Brissaud 1979
P. Brissaud. "La Céramique égyptienne du règne d'Aménophis II à la fin de l'époque Ramesside," in *Hommages à la mémoire de Serge Sauneron 1927-1976. I. Égypte pharaonique*. Cairo, 1979 (pp. 11-32).

British Museum 1894
British Museum. *The Book of the Dead, Facsimile of the Papyrus of Ani in the British Museum* (ed. P. Renouf). London, 1894.

British Museum 1904
British Museum. *A Guide to the Third and Fourth Egyptian Rooms* (by E. A. W. Budge). London, 1904.

British Museum 1914
British Museum. *Wall Decorations of Egyptian Tombs*. London, 1914.

British Museum 1922
British Museum. *A Guide to the Fourth, Fifth, and Sixth Egyptian Rooms and the Coptic Room*. London, 1922.

British Museum 1930
British Museum. *A General Introductory Guide to the Egyptian Collections in the British Museum*. London, 1930.

British Museum 1937
British Museum. *Ancient Egyptian Sculpture Lent by C. S. Gulbenkian, Esq*. London, 1937.

British Museum 1964
British Museum. *A General Introductory Guide to the Egyptian Collections*. London, 1964.

British Museum 1975
British Museum. *Catalogue of Lamps in the British Museum: Greek, Hellenistic, and Early Roman Pottery Lamps* (by D. Bailey). London, 1975.

British Museum 1976a
British Museum. *Catalogue of Egyptian Antiquities in the British Museum: Glass* (by J. Cooney). London, 1976.

British Museum 1976b
British Museum. *Catalogue of Egyptian Antiquities in the British Museum: Musical Instruments* (by R. Anderson). London, 1976.

British Museum 1978
British Museum. *Jewellery through 7000 Years*. London, 1978.

Brooklyn Museum 1943
Brooklyn Museum. *Toilet Articles from Ancient Egypt, From the Charles Edwin Wilbour Memorial Collection and the Collection of the New York Historical Society in the Brooklyn Museum* (by E. Riefstahl). Brooklyn, 1943.

Brooklyn Museum 1952
Brooklyn Museum. *Egyptian Art in the Brooklyn Museum Collection* (by J. Cooney). Brooklyn, 1952.

Brooklyn Museum 1956
Brooklyn Museum. *Five Years of Collecting Egyptian Art: 1951-1956* (by J. Cooney). Brooklyn, 1956.

Brooklyn Museum 1960
Brooklyn Museum. *Egyptian Sculpture of the Late Period 700 B. C. to A. D. 100* (by B. Bothmer). New York, 1960.

Brooklyn Museum 1966
Brooklyn Museum. "Additions to the Museum Collections: Department of Ancient Art," in *BMA* 7 (1965-1966), p. 119.

Brooklyn Museum 1968
Brooklyn Museum. *Ancient Egyptian Glass and Glazes in the Brooklyn Museum* (by E. Riefstahl). New York, 1968.

Brack and Brack 1977
A. and A. Brack. *Das Grab des Tjanuni: Theben Nr. 74*. Mainz, 1977.

Brack and Brack 1980
A. and A. Brack. *Das Grab des Haremhab: Theben Nr. 78*. Mainz, 1980.

Brothwell and Sandison 1967
D. Brothwell and A. Sandison, eds. *Diseases in Antiquity: A Survey of the Diseases, Injury, and Surgery of Early Populations*. Springfield, 1967.

Brovarski 1977
E. Brovarski. "An Allegory of Death," in *JEA* 63 (1977), p. 178.

Brown 1963-1964
W. Brown. "The Indian Games of Pachisi, Chaupar, and Chausar," in *Expedition* 6 (1963-1964), pp. 32ff.

Brugsch 1889
H. Brugsch. "Das altägyptische Goldgewicht," in *ZÄS* 27 (1889), pp. 85-96.

Brumbaugh 1975
R. Brumbaugh. "The Knossos Game Board," in *AJA* 79 (1975), pp. 135ff.

Brunner 1957
H. Brunner. *Altägyptische Erziehung*. Wiesbaden, 1957.

Brunner 1975
H. Brunner. "Blindheit," in *LA* 1 (1975), cols. 828-833.

Brunner-Traut 1938
E. Brunner-Traut. *Der Tanz im Alten Aegypten*. Glückstadt, 1938.

Brunner-Traut 1955a
E. Brunner-Traut. "Ägyptische Tiermarchen," in *ZÄS* 80 (1955), pp. 12-32.

Brunner-Traut 1955b
E. Brunner-Traut. 'Die Wochenlaube," in *MIO* 3 (1955), pp. 11-30.

Brunner-Traut 1956
E. Brunner-Traut. *Die altägyptischen Scherbenbilder (Bildostraka) der deutschen Museen und Sammlungen*. Wiesbaden, 1956.

Brunner-Traut 1968
E. Brunner-Traut. *Altägyptische Tiergeschichte und Fabel*. Darmstadt, 1968.

Brunner-Traut 1970a
E. Brunner-Traut. "Gravidenflasche: Das Salben des Mutterleibes," in *Archäologie und altes Testament: Festschrift für Kurt Galling*. Tübingen, 1970 (pp. 35-48).

Brunner-Traut 1970b
E. Brunner-Traut. "Das Muttermilchkrüglein: Ammen mit Stillumhang und Mondamulett," in *Die Welt des Orients* 5 (1970), pp. 145-164.

Brunner-Traut 1971
E. Brunner-Traut. "Nachlese zu zwei Arzneigefässen," in *Die Welt des Orients* 6 (1971), pp. 4-6.

Brunner-Traut 1972
E. Brunner-Traut, in a letter to the editor. *IEJ* 22 (1972), p. 192.

Brunner-Traut 1974
E. Brunner-Traut. *Die Alten Agypter*. Stuttgart, 1974.

Brunner-Traut 1979
E. Brunner-Traut. *Egyptian Artists' Sketches. Figured Ostraka from the Gayer Anderson Collection in the Fitzwilliam Museum, Cambridge*. Istanbul, 1979.

Brunner-Traut 1980a
E. Brunner-Traut. "Horn(als Gefäß)," in *LA* 3 (1980), cols. 8-9.

Brunner-Traut 1980b
E. Brunner-Traut. "Huhn," in *LA* 3 (1980), cols. 70-72.

Brunton 1920
G. Brunton. *Lahun 1. The Treasure*. London, 1920.

Brunton 1927
G. Brunton. *Qau and Badari* 1. London, 1927.

Brunton 1928
G. Brunton. *Qau and Badari* 2. London, 1928.

Brunton 1930
G. Brunton. *Qau and Badari* 3. Longon, 1930.

Brunton 1937
G. Brunton. *Mostagedda and the Tasian Culture*. London, 1937.

Brunton 1948
G. Brunton. *Matmar*. London, 1948.

Brunton and Caton-Thompson 1928
G. Brunton and C. Caton-Thompson. *The Badarian Civilization*. London, 1928.

Brunton and Engelbach 1927
G. Brunton and R. Engelbach. *Gurob*. London, 1927.

Bruyère 1925
B. Bruyère. "Stèles trouvées par M. E. Baraize à Deir el Médineh," in *ASAE* 25 (1925), pp. 76-96.

Bruyère 1926
B. Bruyère. *Rapport sur les fouilles de Deir el Médineh* (FIFAO 3, pt. 3). Cairo, 1926.

Bruyère 1927
B. Bruyère. *Rapport sur les fouilles de Deir el Médineh* (FIFAO 4, pt. 3). Cairo, 1927.

Bruyère 1928
B. Bruyère. *Rapport sur les fouilles de Deir el Médineh* (FIFAO 5, pt. 2). Cairo, 1928.

Bruyère 1929
B. Bruyère. *Rapport sur les fouilles de Deir el Médineh* (FIFAO 6, pt. 2). Cairo, 1929.

Bruyère 1932
B. Bruyère. *Meret Seger à Deir el Médineh* (MIFAO 58). Cairo, 1932.

Bruyère 1933
B. Bruyère. *Rapport sur les fouilles de Deir el Médineh* (FIFAO 8, pt. 3). Cairo, 1933.

Bruyère 1934
B. Bruyère. *Rapport sur les fouilles de Deir el Médineh* (FIFAO 10, pt. 1). Cairo, 1934.

Bruyère 1937a
B. Bruyère. *Rapport sur les fouilles de Deir el Médineh 1* (FIFAO 14). Cairo, 1937.

Bruyère 1937b
B. Bruyère. *Rapport sur les fouilles de Deir el Médineh 2* (FIFAO 15). Cairo, 1937.

Bruyère 1939
B. Bruyère. *Rapport sur les fouilles de Deir el Médineh 3* (FIFAO 16). Cairo, 1939.

Bruyère 1948
B. Bruyère. *Rapport sur les fouilles de Deir el Médineh* (FIFAO 20, pt. 1). Cairo, 1948.

Bruyère 1953
B. Bruyère. *Rapport sur les fouilles de Deir el Médineh* (FIFAO 26). Cairo, 1953.

Buchholz 1974
H. Buchholz. "Agäische Importe. Künstlerische Anregungen und Vasennachahmungen in Agypten," in *Archäologische Anzeiger* 89 (1974), pp. 439-462.

Budge 1898
E. Budge. *The Book of the Dead: The Chapters of Coming Forth by Day*. London, 1898.

Budge 1925
E. Budge. *The Mummy: A Handbook of Egyptian Funerary Archaeology*. 2nd ed. Cambridge, 1925.

Bull 1936
L. Bull. "Egyptian Antiquities from the Pier Collection," in *Bulletin of the Associates of Fine Arts at Yale University* 7 (1936), pp. 30-34.

Burlington Fine Arts Club 1895
Burlington Fine Arts Club. *Exhibition of the Art of Ancient Egypt*. London, 1895.

Burlington Fine Arts Club 1921
Burlington Fine Arts Club. *Catalogue of an Exhibition of Ancient Egyptian Art*. London, 1921.

Burlington Fine Arts Club 1922
Burlington Fine Arts Club. *Catalogue of an Exhibition of Ancient Egyptian Art*. London, 1922.

Burton 1912
W. Burton. "Ancient Egyptian Ceramics," in *Journal of the Royal Society of Arts* 60 (1912), pp. 594-599.

Butzer 1974
K. Butzer. "Modern Egyptian Pottery Clays and Predynastic Buff Wares," in *JNES* 33 (1974), pp. 377-382.

Butzer 1976
K. Butzer. *Early Hydraulic Civilization in Egypt*. Chicago, 1976.

Cadogan 1969
G. Cadogan. "Mycenaean Trade," *Bulletin of the Institute of Classical Studies, University of London* 16 (1969), pp. 152ff.

Caley 1962
E. Caley. *Analyses of Ancient Glasses, 1790-1957.* Corning, 1962.

Caminos 1954
R. Caminos. *Late Egyptian Miscellanies.* London, 1954.

Campbell 1910
C. Campbell. *Two Theban Princes, Kha-em-uast and Amen-khepeshf, Sons of Rameses III, Menna, a Landsteward and their Tombs.* London, 1910.

Canby 1980
J. Canby. "Of Fruit and Fish and Jewels," in *BWAG* 32, no. 4 (1980), pp. 2ff.

Capart 1904
J. Capart. "Nouvelles Acquisitions, section égyptienne," in *Bulletin des Musées Royaux des arts décoratifs et industriels à Bruxelles, IIIe année* 12 (1904), pp. 80-92.

Capart 1905
J. Capart. *Recueil de Monuments égyptiens* 2. Brussells, 1905.

Capart 1907
J. Capart. *L'Art et la parure féminine dans l'ancienne Egypte.* Brussells, 1907.

Capart 1927
J. Capart. *Documents pour servir à l'étude de l'art égyptien* 1. Paris, 1927.

Capart 1931
J. Capart. *Documents pour servir à l'étude de l'art égyptien* 2. Paris, 1931.

Capart 1935
J. Capart. "Les Ex-Libris d'Aménophis III," in *CdE* 10 (1935), pp. 23-25.

Capart 1941
J. Capart. "Statuettes Funéraires égyptiennes," in *CdE* 16 (1941), pp. 196-204.

Capart 1947
J. Capart. *L'Art Egyptien* 4. Paris, 1947.

Carnarvon and Carter 1912
G. Herbert, Earl of Carnarvon, and H. Carter, *Five Years' Explorations at Thebes.* London, 1912.

Carter 1903
H. Carter. "Report on General Work Done in the Southern Inspectorate," in *ASAE* 4 (1903), pp. 43-50.

Carter 1916
H. Carter. "Report on the Tomb of Zeser-ka-ra Amenhetep I," in *JEA* 3 (1916), pp. 147-154.

Carter 1923
H. Carter. "An Ostracon Depicting a Red Jungle-Fowl," in *JEA* 9 (1923), pp. 1-4.

Carter 1927
H. Carter. *The Tomb of Tut-ankh-amun* 2. London, 1927.

Carter 1933
H. Carter. *The Tomb of Tut-ankh-amun* 3. London, 1933.

Carter 1971
G. Carter. "Pre-Columbian Chickens in America," in C. Riley, ed., *Man Across the Sea.* Austin, 1971 (pp. 178-218).

Carter and Mace 1923
H. Carter and A. Mace. *The Tomb of Tut-ankh-amun* 1. London, 1923.

Carter and Newberry 1904
H. Carter and P. Newberry. *The Tomb of Thoutmôsis* 4. London, 1904.

Cartland 1916a
B. Cartland. "The Dress of the Ancient Egyptians I. In the Old and Middle Kingdoms," in *BMMA* 11 (1916), pp. 166-171.

Cartland 1916b
B. Cartland. "The Dress of the Ancient Egyptians II. In the Empire," in *BMMA* 11 (1916), pp. 211-214.

Caton-Thompson and Gardner 1934
G. Caton-Thompson and E. Gardner. *The Desert Fayum.* London, 1934.

Caubet and Lagarce 1972
A. Caubet and J. Lagarce. *Report of the Department of Antiquities of Cyprus.* Nicosia, 1972.

Černý 1929
J. Černý. "A Note on the 'Repeating of Births,' " in *JEA* 15 (1929), pp. 194-198.

Černý 1937-1938
J. Černý. "Deux Noms de poisson du Nouvel Empire," in *BIFAO* 37 (1937-1938), pp. 35-40.

Černý 1954
J. Černý. "Prices and Wages in the Ramesside Period," in *Cahiers d'histoire mondiale* 1 (1954), pp. 903-921.

Černý 1965
J. Černý. *Hieratic Inscriptions from the Tomb of Tut'ankhamun.* Oxford, 1965.

Černý 1970
J. Černý. "Survivance d'une ancienne pratique," in *RdE* 22 (1970), pp. 201-203.

Černý 1971
J. Černý. "Language and Writing," in J. Harris, ed., *The Legacy of Egypt.* 2nd ed. Oxford, 1971 (pp. 197-219).

Černý 1973a
J. Černý. *A Community of Workmen at Thebes in the Ramesside Period.* Cairo, 1973.

Černý 1973b
J. Černý. *The Valley of the Kings.* Cairo, 1973.

Černý 1975
J. Černý. "Egypt: From the Death of Ramesses III to the end of the Twenty-first Dynasty," in Edwards et al., eds., *The Cambridge Ancient History* 2, pt. 2. Cambridge, 1975 (pp. 606-619).

Černý 1977
J. Černý. *Paper and Books in Ancient Egypt.* Chicago, 1977.

Cesnola 1903
L. Cesnola. *A Descriptive Atlas of the Cesnola Collection of Cypriote Antiquities in the Metropolitan Museum of Art, New York* 3, pt. 2. Boston, 1885-1903.

Chabas 1869
F. Chabas. "Sur Quelques Instruments égyptiens de mesurage," in *ZAS* 7 (1869), pp. 57-63.

Champollion 1827
J. Champollion. *Notice descriptive des monuments égyptiens du Musée Charles X.* Paris, 1827.

Champollion 1845
J. Champollion. *Monuments de l'Egypte et de la Nubie d'après les dessins...* 3. Paris, 1845.

Champollion 1889
J. Champollion. *Monuments de l'Egypte et de la Nubie. Notices Descriptives...* 2. Paris, 1889.

Chase 1971
W. Chase. "Egyptian Blue as a Pigment and Ceramic Material," in R. Brill, ed., *Science and Archaeology.* Cambridge, 1971 (pp. 80-90).

Chassinat 1901
E. Chassinat. "Une Tombe inviolée de la XVIIIe dynastie découverte aux environs de Médinet el-Gorab dans le Fayoûm," in *BIFAO* 1 (1901), pp. 225-234.

Chassinat 1906a
E. Chassinat. "Appendix," in *Egypt Exploration Fund Archaeological Reports 1905-6.* London, 1906 (pp. 81-85).

Chassinat 1906b
E. Chassinat. *Fouilles de Qattah.* Cairo, 1906.

Chassinat and Palanque 1911
E. Chassinat and C. Palanque. *Une Campagne de Fouilles dans la Nécropole d'Assiout.* Cairo, 1911.

Cheney 1968
S. Cheney. *Sculpture of the World.* New York, 1968.

Childe 1954
V. Childe. "Wheeled Vehicles," in C. Singer et al., eds., *History of Technology* 1. Oxford, 1954 (pp. 716-729).

Christ-Dyroff 1901
W. Christ-Dyroff. *Führer Durch das Antiquarium.* Munich, 1901.

Christie et al. 1980
Christie, Manson, and Woods, Ltd. *Fine Antiquities: The Properties of Baron Alain de Conde, the Late D. E. Bower, Esq., the Pierpont Morgan Library, and from Various Sources.* Wed., Apr. 23, 1980. London, 1980

Clark 1949-1950
C. Clark. "Costume Jewelry in Egypt in the XVIII Dynasty," in *BMMA*, n.s. 8 (1949-1950), pp. 154ff.

Clark 1959
R. Clark. *Myth and Symbol in Ancient Egypt.* London, 1959.

Clarke and Engelbach 1930
S. Clarke and R. Engelbach. *Ancient Egyptian Masonry: The Building Craft.* London, 1930.

Cleveland Museum 1916
Cleveland Museum of Art. *Catalogue of the Inaugural Exhibition of the Cleveland Museum of Art* (June 6-Sept. 20, 1916), no. 10, p. 205.

Closson 1932
E. Closson. "Hautbois égyptiens antiques au Musée du Conservatoire Royal de Bruxelles," *CdE* 7 (1932), pp. 50-52.

Coltherd 1966
J. Coltherd. "The Domestic Fowl in Ancient Egypt," in *Ibis* 108 (1966), pp. 217-223.

Cooney 1948
J. Cooney. "Three Ivories of the Late XVIII Dynasty," in *BBM* 10 (1948), pp. 1ff.

Cooney 1951
J. Cooney. "Equipment for Eternity," in *BBM* 12 (1951), pp. 1-12.

Cooney 1952
J. Cooney. Review of H. Ranke's "The Egyptian Collection of the University Museum," in *AJA* 56 (1952), pp. 85-86.

Cooney 1953
J. Cooney. "Egyptian Art in the Collection of Albert Gallatin," in *JNES* 12 (1953), pp. 1ff.

Cooney 1960a
J. Cooney. "Curatorial Departments: Dept. of Ancient Art," in *BMA* I (1959-1960), pp. 69ff.

Cooney 1960b
J. Cooney. "Glass Sculpture in Ancient Egypt," in *JGS* 2 (1960), pp. 10ff.

Cooney 1965a
J. Cooney. *Amarna Reliefs from Hermopolis in American Collections.* Brooklyn, 1965.

Cooney 1965b
J. Cooney. "Some Antiquities from Thebes," in *Bulletin of the Cleveland Museum of Art* 52 (1965), pp. 1-6.

Cooney 1965c
J. Cooney. "Some Persian Influence in Late Egyptian Art," in *JARCE* 4 (1965), pp. 39-48.

Cooney 1974
J. Cooney. "Egyptian Art," in O. Muscarella, ed., *Ancient Art: The Norbert Schimmel Collection.* Mainz, 1974.

Cooney and Simpson 1976
J. Cooney and W. K. Simpson. "An Early Dynastic Statue of the Goddess Heqat," in *Bulletin of the Cleveland Museum of Art* 43 (1976), pp. 202-209.

Corning Museum 1957
Corning Museum of Glass. *Glass from the Ancient World. The Ray Winfield Smith Collection.* Corning, 1957.

Cortland 1917
B. Cortland. "Egyptian Weights and Balances," in *BMMA* 12 (1917), pp. 85-90.

Cottevieille-Giraudet 1931
R. Cottevieille-Giraudet. *Rapport sur les fouilles de Médamoud, 1930: Le Verrerie-les graffiti (FIFAO* 8, pt. 2). Cairo, 1931.

Courtois and Lagarce 1969
L. Courtois and J. Lagarce. "Review of R. S. Merrillees 'The Cypriote Bronze Age Pottery Found in Egypt,' " in *Syria* 46 (1969), pp. 153-156.

Cox 1977
J. Cox. "The Construction of an Ancient Egyptian Wig (c. 1400 B. C.) in the British Museum," in *JEA* 63 (1977), pp. 67ff.

Cramer 1936
M. Cramer. "Ägyptische Denkmäler im Kestner-Museum zu Hannover," in *ZÄS* 72 (1936), pp. 81-108.

Crowfoot 1954
G. Crowfoot. "Textiles, Basketry and Mats," in C. Singer et al., eds., *A History of Technology* 1. Oxford, 1954 (pp. 413-447).

Crowfoot and Davies 1941
G. Crowfoot and N. de G. Davies. "The Tunic of Tut'ankhamūn," in *JEA* 27 (1941), pp. 113-130.

Curtius 1913
L. Curtius. *Die Antike Kunst.* Berlin, 1913.

Curto and Mancini 1968
S. Curto and M. Mancini. "News of Kha' and Meryt," in *JEA* 54 (1968), pp. 77-81.

Cyprus Museum 1961
Kypriakon Mouseion. *A Guide to the Cyprus Museum* (by P. Dikaios). 3rd ed., rev. Nicosia, 1961.

Dambach and Wallert 1966
M. Dambach and I. Wallert. "Das Tilapia Motiv in der altägyptischen Kunst," in *CdE* 41 (1966), pp. 273-294.

Darby et al. 1977
W. Darby et al. *Food: The Gift of Osiris.* New York, 1977.

Daressy 1901
G. Daressy. "Rapport sur la Trouvaille de Hatiay," in *ASAE* 2 (1901), pp. 1-13.

Daressy 1902
G. Daressy. *Fouilles de la Vallée des Rois.* Cairo, 1902.

Daressy 1918
G. Daressy. "Une Mesure égyptienne de 20 hin," in *ASAE* 18 (1918), pp. 191-192.

Daumas 1957
F. Daumas. "Le Sanatorium de Dendara," in *BIFAO* 56 (1957), pp. 54-55.

Daumas 1965
F. Daumas. *La Civilisation de l'Egypte pharaonique.* Paris, 1965.

David 1973
A. David. *Religious Ritual at Abydos (c. 1300 B.C.).* Warminster, 1973.

Davies 1903
N. de G. Davies. *The Rock Tombs of el Amarna* 1. London, 1903.

Davies 1905a
N. de G. Davies. *The Rock Tombs of el Amarna* 2. London, 1905.

Davies 1905b
N. de G. Davies. *The Rock Tombs of el Amarna* 3. London, 1905.

Davies 1906
N. de G. Davies. *The Rock Tombs of el Amarna* 4. London, 1906.

Davies 1908a
N. de G. Davies. *The Rock Tombs of el Amarna* 5. London, 1908.

Davies 1908b
N. de G. Davies. *The Rock Tombs of el Amarna* 6. London, 1908.

Davies 1913
N. de G. Davies. *Five Theban Tombs.* London, 1913.

Davies 1917
N. de G. Davies. *The Tomb of Nakht at Thebes.* New York, 1917.

Davies 1922
N. de G. Davies. *The Tomb of Puyemrê at Thebes.* New York, 1922.

Davies 1924
N. de G. Davies. "A Peculiar Form of New Kingdom Lamp," in *JEA* 10 (1924), pp. 9-14.

Davies 1925a
R. Davies. "Some Arab Games and Puzzles," in *SNR* 8 (1925), pp. 137ff.

Davies 1925b
N. de G. Davies. *The Tomb of the Two Sculptors at Thebes.* New York, 1925.

Davies 1926
N. de G. Davies. "The Egyptian Expedition 1925-1926: The Work of the Graphic Section," in *BMMA: Egyptian Supplements* (1926), pp. 3-16.

Davies 1927
N. de G. Davies. *Two Ramesside Tombs at Thebes.* New York, 1927.

Davies 1929
N. de G. Davies. "The Town House in Ancient Egypt," in *MMS* 1 (1929), pp. 233-255.

Davies 1930
N. de G. Davies. *The Tomb of Ken-Amūn at Thebes.* New York, 1930.

Davies 1932
N. de G. Davies. "Tehuti: Owner of Tomb 110 at Thebes," in S. Glanville, ed., *Studies Presented to F.Ll. Griffith.* London, 1932 (pp. 279-290).

Davies 1933
N. de G. Davies. *The Tomb of Nefer-ḥotep at Thebes.* New York, 1933.

Davies 1935
N. de G. Davies. *Paintings from the Tomb of Rekh-mi-Rē'at Thebes.* New York, 1935.

Davies 1941
N. de G. Davies. *The Tomb of the Vizier Ramose.* New York, 1941.

Davies 1943
N. de G. Davies. *The Tomb of Rekh-mi-Rē'at Thebes.* New York, 1943.

Davies 1948
N. de G. Davies. *Seven Private Tombs at Ḳurnah.* London, 1948.

Davies 1963
N. M. Davies. *Scenes from Some Theban Tombs.* Oxford, 1963.

Davies 1974
W. V. Davies, "An Inscribed Axe Belonging to the Ashmolean Museum, Oxford," in *JEA* 60 (1974), pp. 114-118.

Davies 1977
W. V. Davies. "Tut'ankhamūn's Razor-Box: A Problem in Lexicography," in *JEA* 63 (1977), pp. 107-111.

Davies and Davies 1923
N. de G. Davies and N. M. Davies. *The Tombs of Two Officials of Thutmose the Fourth.* London, 1923.

Davies and Davies 1933
N. M. Davies and N. de G. Davies. *The Tombs of Menkheperrasonb, Amenmose, and Another (nos. 86, 112, 42, 226).* London, 1933.

Davies and Faulkner 1947
N. de G. Davies and R. Faulkner. "A Syrian Trading Venture to Egypt," in *JEA* 33 (1947), pp. 40ff.

Davies and Gardiner 1915
N. M. Davies and A. Gardiner. *The Tomb of Amenemhet (no. 82).* London, 1915.

Davies and Gardiner 1920
N. de G. Davies and A. Gardiner. *The Tomb of Antefoker (no. 60).* London, 1920.

Davies and Gardiner 1926
N. M. Davies and A. Gardiner. *The Tomb of Huy.* London, 1926.

Davies and Gardiner 1936
N. M. Davies and A. Gardiner. *Ancient Egyptian Paintings.* Chicago, 1936.

Davis 1908
T. Davis. *The Funeral Papyrus of Iouiya.* London, 1908.

Davis et al. 1907
T. Davis, G. Maspero, and P. Newberry. *The Tomb of Iouiya and Touiyou.* London, 1907.

Davis et al. 1908
T. Davis et al. *The Tomb of Siptah.* London, 1908.

Davis et al. 1910
T. Davis et al. *The Tomb of Queen Tîyi.* London, 1910.

Dawson 1938
W. Dawson. "Pygmies and Dwarfs in Ancient Egypt," in *JEA* 24 (1938), pp. 185-189.

de Meulenaere 1971
H. de Meulenaere. "Les Chefs de Greniers du nom de Saésé au Nouvel Empire," in *CdE* 46 (1971), pp. 223-233.

de Meulenaere 1975a
H. de Meulenaere. "Arzt," in *LÄ* 1 (1975), cols. 455-459.

de Meulenaere 1975b
H. de Meulenaere. "Arzteschule," in *LÄ* 1 (1975), cols. 79-80.

de Wit 1951
C. de Wit. *Le Rôle et le sens du lion dans l'Egypte ancienne.* Leiden, 1951.

de Wit 1957
C. de Wit. "Les Génies des quatre vents au temple d'Opet," in *CdE* 32 (1957), pp. 25-39.

Decamps de Mertzenfeld 1954
C. Decamps de Mertzenfeld. *Inventaire commenté des ivoires Phéniciens et apparentés découverts dans le Proche-Orient.* Paris, 1954.

Decker 1975
W. Decker. "Bad," in *LÄ* 1 (1975), cols. 598-599.

Deines et al. 1958
H. von Deines et al. *Übersetzung der medizinischen Texte (Grundriss der Medizin der alten Ägypter 4,1).* Berlin, 1958.

Derchain 1972
P. Derchain. *Hathor Quadrifons.* Istanbul, 1972.

Derchain 1975
P. Derchain. "La Perruque et le crystal," in *SAK* 2 (1975), pp. 55-74.

Deshayes 1953
J. Deshayes. "Les Vases mycéniens de la Deiras (Argos)," in *Bulletin de Correspondance Héllenique* 77 (1953), pp. 59ff.

Desroches-Noblecourt 1938
C. Desroches-Noblecourt. "Un Modèle de Maison Citadine du Nouvel Empire," in *RdE* 3 (1938), pp. 17-25.

Desroches-Noblecourt 1952
C. Desroches-Noblecourt. "Pots anthropomorphes et recettes magico-médicales dans l'Egypte ancienne," in *RdE* 9 (1952), pp. 49-67.

Desroches-Noblecourt 1953
C. Desroches-Noblecourt. "Concubines du Mort et mères de famille au Moyen Empire," in *BIFAO* 53 (1953), pp. 7-49.

Desroches-Noblecourt 1954
C. Desroches-Noblecourt. "Poissons, tabous et transformations du mort," in *Kêmi* 13 (1954), pp. 33-42.

Desroches-Noblecourt 1962
C. Desroches-Noblecourt. *L'Art égyptien.* Paris, 1962.

Desroches-Noblecourt 1963
C. Desroches-Noblecourt. *Tutankhamen.* New York, 1963.

Desroches-Noblecourt 1976
C. Desroches-Noblecourt. *Ramses le Grand.* Paris, 1976.

Desroches-Noblecourt and Kuentz 1968
C. Desroches-Noblecourt and C. Kuentz. *Le Petit Temple d'Abu Simbel. 1. Etude archéologique et épigraphique.* Cairo, 1968.

Deville 1874
A. Deville. *Histoire de l'Art de la verrerie dans l'Antiquité.* Rouen, 1874.

Dikaios 1969
P. Dikaios. *Enkomi: Excavations 1948-58.* Mainz, 1969.

Dittmann 1939
K. Dittmann. "Eine Mantelstatue aus der Zeit der 4. Dynastie," in *MDAIK* 8 (1939), pp. 165-170.

Dittmann 1955
K. Dittmann. "Die Bedeutungsgeschichte des aegyptischen Klappstuhls," in *Studi in Memoria di Ippolito Rosellini* 2. Pisa, 1955 (pp. 43-56).

Dixon 1972
D. Dixon. "Disposal of Personal, Household, and Town Waste in Ancient Egypt," in P. Ucko et al., eds., *Man, Settlement and Urbanism.* Hertfordshire, 1972 (pp. 647-650).

Donohue 1978
V. Donohue. "Pr-nfr," in *JEA* 64 (1978), pp. 143ff.

Dothan 1979
T. Dothan. *Excavations at the Cemetery of Deir el Balaḥ.* Jerusalem, 1979.

Dothan and Ben-Tor 1972
T. Dothan and A. Ben-Tor. "Excavations at Athienou, Cyprus, 1971-72," in *IEJ* 22 (1972), pp. 201ff.

Dothan and Ben-Tor 1974
T. Dothan and A. Ben-Tor. *Excavations at Athienou, Cyprus, 1971-2.* Exhibition at the Israel Museum. Jerusalem, 1974.

Doumas 1968
C. Doumas. "A Mycenaean Rhyton from Naxos," in *Archäologische Anzeiger* 83 (1968), pp. 374-389.

Downes 1974
D. Downes. *The Excavations at Esna 1905-06.* Warminster, 1974.

Drenkhahn 1975
R. Drenkhahn. "Brot," in *LdA* 1 (1975), col. 871.

Drenkhahn 1976
R. Drenkhahn. *Die Handwerker und Ihre Tätigkeiten im Alten Agypten.* Wiesbaden, 1976.

Drioton 1940
E. Drioton. "Un Ancien Jeu Copte," in *Bulletin de la Société d'archéologie Copte* 6 (1940), pp. 177ff.

Drioton 1944
E. Drioton. "La Cryptographie par perturbation," in *ASAE* 44 (1944), pp. 17-33.

Drower 1954
M. Drower. "Water-Supply, Irrigation, and Agriculture," in C. Singer et al., eds., *History of Technology* 1. Oxford, 1954 (pp. 520-557).

Ducros 1908
H. Ducros. "Etude sur les balances égyptiennes," in *ASAE* 9 (1908), pp. 32-53.

Ducros 1910
H. Ducros. "Deuxième Etude sur les balances égyptiennes," in *ASAE* 10 (1910), pp. 240-253.

Ducros 1911
H. Ducros. "Troisième Etude sur les balances égyptiennes," in *ASAE* 11 (1911), pp. 251-256.

Dunham 1937
D. Dunham. "Two Parallels to Ancient Egyptian Scenes," in *BMFA* 35 (1937), pp. 50-54.

Dunham 1950
D. Dunham. *The Royal Cemeteries of Kush* 1: *El Kurru.* Cambridge, 1950.

Dunham 1955
D. Dunham. *The Royal Cemeteries of Kush* 2: *Nuri.* Boston, 1955.

Dunham 1958
D. Dunham. *The Egyptian Department and Its Excavations.* Boston, 1958.

Dunham 1963
D. Dunham. *The Royal Cemeteries of Kush* 5: *The West and South Cemeteries at Meroë.* Boston, 1963.

Dunham 1965
D. Dunham. "A Collection of 'Pot-Marks' from Kush and Nubia," in *Kush* 13 (1965), pp. 131-147.

Dunham 1967
D. Dunham. *Second Cataract Forts* 2: *Uronarti, Shalfak, and Mirgissa.* Boston, 1967.

Dunham 1970
D. Dunham. *The Barkal Temples.* Boston, 1970.

Dunham 1978
D. Dunham. *Zawiyet el-Aryan: The Cemeteries Adjacent to the Layer Pyramid.* Boston, 1978.

Dunham and Janssen 1960
D. Dunham and J. Janssen. *Second Cataract Forts* 1: *Semna Kumma.* Boston, 1960.

Ebbell 1937
B. Ebbell. *The Papyrus Ebers: The Greatest Egyptian Medical Document.* London, 1937.

Ecole du Caire 1981
Ecole du Caire (IFAO). *Un Siècle de fouilles françaises en Egypte 1880-1980.* Cairo, 1981.

Edgar 1925
C. Edgar. "Engraved Designs on a Silver Vase from Tell Basta," in *ASAE* (1925), pp. 256-258.

Edwards 1888
A. Edwards. "The Provincial and Private Collections of Egyptian Antiquities in Great Britain," in *RT* 10 (1888), pp. 121-133.

Edwards 1937
I.E.S. Edwards. "A Toilet Scene on a Funerary Stela of the Middle Kingdom," in *JEA* 23 (1937), p. 165.

Edwards 1971
I.E.S. Edwards. "The Early Dynastic Period in Egypt," in I.E.S. Edwards et al., eds., *Cambridge Ancient History* 1, pt. 2. 3rd ed. Cambridge, 1971 (pp. 1-70).

Edwards 1972
I.E.S. Edwards. *Treasures of Tutankhamun.* London, 1972.

Edwards 1976a
I.E.S. Edwards. *Treasurers of Tutankhamun.* New York, 1976.

Edwards 1976b
I.E.S. Edwards. *Tutankhamun's Jewelry.* New York, 1976.

Edwards 1979
I.E.S. Edwards. "Zoomorphic Anomalies in Tutankhamun's Treasures," in *AJA* 83 (1979), pp. 205-206.

Eggebrecht 1975a
E. Eggebrecht. "Axt," in *LA* 1 (1975), col. 587.

Eggebrecht 1975b
A. Eggebrecht. "Brandstempel," in *LA* 1 (1975), cols. 850-852.

Eggebrecht 1975c
A. Eggebrecht. "Keramik," in C. Vandersleyen, ed., *Propyläen Kunstgeschichte 15: Das Alte Agypten.* Berlin, 1975 (pp. 343ff.).

Eggebrecht 1977
E. Eggebrecht. "Hacke," in *LA* 2 (1977), cols. 924-925.

Eidelberg 1968
M. Eidelberg. "Tiffany Favrile Pottery: A New Study of a Few Known Facts," in *Connoisseur* 169 (1968), pp. 57ff.

Eisa 1948
E. Eisa. "A Study on the Ancient Egyptian Wigs," in *ASAE* 48 (1948), pp. 9-18.

Ellis and Buchanan 1966
R. Ellis and B. Buchanan. "An Old Babylonian Gameboard with Sculptured Decoration," in *JNES* 25 (1966), pp. 192ff.

El-Nadoury and Vercoutter 1979
R. El-Nadoury and J. Vercoutter. "Inventors and Technologists of Pharaonic Egypt," in *Unesco Courier* 32 (1979), pp. 47-54.

Emery 1954
W. Emery. *Excavations at Sakkara: Great Tombs of the First Dynasty* 2. Cairo, 1954.

Emery 1958
W. Emery. *Excavations at Sakkara: Great Tombs of the First Dynasty* 3. Cairo, 1958.

Emery 1961
W. Emery. *Archaic Egypt.* Edinburgh, 1961.

Emery 1962
W. Emery. *A Funerary Repast in an Egyptian Tomb of the Archaic Period.* Leiden, 1962.

Emery and Kirwan 1935
W. Emery and L. Kirwan. *The Excavations and Survey Between Wadi Es-Sebua and Adindan 1929-1931.* Cairo, 1935.

Engelbach 1915
R. Engelbach. *Riqqeh and Memphis* 6. London, 1915.

Engelbach 1923
R. Engelbach. *Harageh.* London, 1923.

Engelbach 1931
R. Engelbach. "Recent Acquisitions in the Cairo Museum," in *ASAE* 31 (1931), pp. 129-131.

Epstein 1966
C. Epstein. *Palestinian Bichrome Ware.* Leiden, 1966.

Epstein 1971
H. Epstein. *The Origin of the Domestic Animals of Africa* 1. New York, 1971.

Erichsen 1933
W. Erichsen. *Papyrus Harris I: Hieroglyphische Transkription.* Brussels, 1933.

Erman 1895
A. Erman. "Agyptisches Waschgeräth," in *ZAS* 33 (1895), p. 144.

Erman 1934
A. Erman. *Die Religion der Aegypter.* Berlin, 1934.

Erman 1971
A. Erman. *Life in Ancient Egypt,* H. Tirard, tr. New York, 1971.

Erman and Grapow 1928
A. Erman and H. Grapow. *Wörterbuch der Aegyptischen Sprache* 2. Leipzig, 1928.

Ettinghausen 1962
R. Ettinghausen. *Ancient Glass in the Freer Gallery of Art.* Washington, 1962.

Evans 1921
A. Evans. *The Palace of Minos at Knossos* 1. London, 1921.

Evans 1928
A. Evans. *The Palace of Minos at Knossos* 2. London, 1928.

Evans 1930
A. Evans. *The Palace of Minos at Knossos* 3. London, 1930.

Evans 1935
A. Evans. *The Palace of Minos at Knossos* 4. London, 1935.

Evers 1929
H. Evers. *Staat aus dem Stein: Denkmäler, Geschichte und Bedeutung der Agyptischen Plastik während des Mittleren Reiches.* Munich, 1929.

Evrard-Derriks 1972
C. Evrard-Derriks. "A Propos des miroirs égyptiens à manche en forme de statuette féminine," in *Revue des archéologiques et historiens d'art de Louvain* 5 (1972), pp. 6-16.

Evrard-Derriks 1975-1976
C. Evrard-Derriks. "Le Miroir représenté sur les peintures et bas-reliefs égyptiens," in *Orientalia Lovaniensia Periodica* 6-7 (1975-1976), pp. 223-229.

Fairbanks 1928
A. Fairbanks. *Catalogue of Greek and Etruscan Vases 1: Early Vases, Preceding Athenian Black-Figured Ware.* Cambridge, 1928.

Fairman 1935
H. Fairman. "Topographical Notes on the Central City, Tell El'Amarnah," in *JEA* 21 (1935), pp. 136-139.

Fairman 1949
H. Fairman. "Town Planning in Pharaonic Egypt," in *Town Planning Review* 20 (1949), pp. 33-51.

Fairman 1951
H. Fairman. "The Topography of the Central City," in J. Pendlebury, *The City of Akhenaten* 3. London, 1951 (pp. 189-212).

Fakhry 1943
A. Fakhry. "A Note on the Tomb of Kheruef at Thebes," in *ASAE* 42 (1943), pp. 449-508.

Farid 1973
S. Farid. "Preliminary Report on the Excavations of the Antiquities Department at Kôm Abû Billo," in *ASAE* 61 (1973), pp. 22-26.

Farina 1929
G. Farina. *La Pittura Egiziana.* Milan, 1929.

Faulkner 1936
R. Faulkner. "The Bremner-Rhind Papyrus I," in *JEA* 22 (1936), pp. 121-140.

Faulkner 1941
R. Faulkner. "Egyptian Military Standards," in *JEA* 27 (1941), pp. 12-18.

Faulkner 1955
R. Faulkner. "The Installation of the Vizier," in *JEA* 41 (1955), pp. 9-17.

Fazzini 1975
R. Fazzini. *Images for Eternity: Egyptian Art from Berkeley and Brooklyn.* Brooklyn, 1975.

Fechheimer 1921
H. Fechheimer. *Kleinplastik der Agypter.*
Berlin, 1921.

Feigenbaum 1958
A. Feigenbaum. "History of Ophthalmia (Including Trachoma) in Egypt: Evidence for its Seasonal Occurrence in Antiquity," in *Acta Medica Orientalia* 17 (1958), pp. 130-141.

Fernea 1973
R. Fernea. *Nubians in Egypt: Peaceful People.*
Austin, 1973,

Feucht-[Putz] 1967
E. Feucht-[Putz]. *Die Königlichen Pektorale: Motive, Sinngehalt und Zweck.* Bamberg, 1967.

Feucht 1971
E. Feucht. *Pektorale nichtköniglicher Personen.*
Wiesbaden, 1971.

Feucht 1977a
E. Feucht. "Gold, Verleihung des," in *LA* 2 (1977), cols. 731-733.

Feucht 1977b
E. Feucht. "Halsschmuck," in *LA* 2 (1977), cols. 933ff.

Fimmen 1924
D. Fimmen. *Die kretisch-mykenische Kultur.*
Leipzig, 1924.

Firth 1912
C. Firth. *The Archaeological Survey of Nubia. Report for 1908-1909.* Cairo, 1912.

Firth 1915
C. Firth. *The Archaeological Survey of Nubia. Report for 1909-1910.* Cairo, 1915.

Firth 1927
C. Firth. *The Archaeological Survey of Nubia. Report for 1910-1911.* Cairo, 1927.

Firth and Gunn 1926
C. Firth and B. Gunn. *Excavations at Saqqara: Teti Pyramid Cemeteries.* Cairo, 1926.

Fischer 1961
H. Fischer. "A Supplement to Janssen's List of Dogs' Names," in *JEA* 47 (1961), pp. 152-153.

Fischer 1963
H. Fischer. "Varia Aegyptiaca," in *JARCE* 2 (1963), pp. 17-51.

Fischer 1968
H. Fischer. *Dendera in the Third Millennium B. C.*
New York, 1968.

Fischer 1969
H. Fischer. "Egyptian Art," in *Metropolitan Museum of Art Annual Report* 28 (1969), pp. 69-70.

Fischer 1972
H. Fischer. "Some Emblematic Uses of Hieroglyphs with a Particular Reference to an Archaic Ritual Vessel," in *MMJ* 5 (1972), pp. 5-23.

Fischer 1975
H. Fischer. "An Elusive Shape within the Fisted Hands of Egyptian Statues," in *MMJ* 10 (1975), pp. 9-21.

Fischer 1976
H. Fischer. *Varia. (MMA Egyptian Studies* 1).
New York, 1976.

Fischer 1977a
H. Fischer. "The Evolution of Composite Hieroglyphs in Ancient Egypt," in *MMJ* 12 (1977), pp. 5-19.

Fischer 1977b
H. Fischer. *The Orientation of Hieroglyphs* 1: *Reversals. (MMA Egyptian Studies* 2). New York, 1977.

Fischer 1977c
H. Fischer. "Fächer und Wedel," in *LA* 2 (1975), cols. 81-85.

Fischer 1978a
H. Fischer. "Notes on Sticks and Staves," in *MMJ* 13 (1978), pp. 5-32.

Fischer 1978b
H. Fischer. "Review of *Stöcke und Stäbe im pharaonischen Agypten,*" in *JEA* 64 (1978), pp. 158-162.

Fischer 1980a
H. Fischer. "Hunde," in *LA* 3 (1980), cols. 77-81.

Fischer 1980b
H. Fischer. "Kopfstütze," in *LA* 3 (1980), cols. 686-693.

Fischer 1980c
H. Fischer. "Lampe," in *LA* 3 (1980), cols. 913-917.

Fischer 1980d
H. Fischer. "Möbel," in *LA* 4, fasc. 2 (1980), cols. 180-189.

Fitzwilliam Museum 1978
Fitzwilliam Museum. *Glass at the Fitzwilliam Museum.* Cambridge 1978.

Fitzwilliam Museum 1979
Fitzwilliam Museum. *All for Art: The Ricketts and Shannon Collection* (J. Darracott, ed.).
Cambridge, 1979.

Forbes 1954
R. Forbes. "Chemical, Culinary, and Cosmetic Arts," in C. Singer et al., eds., *History of Technology* 1. Oxford, 1954 (pp. 238-298).

Forsdyke 1911
E. Forsdyke. "Minoan Pottery from Cyprus and the Origin of the Mycenaean Style," in *JHS* 31 (1911), pp. 110ff.

Fořtová-Sámalova 1963
P. Fořtová-Šámalová. *Egyptian Ornament.*
London, 1963.

Fossing 1940
P. Fossing. *Glass Vessels Before Glass-Blowing.*
Copenhagen, 1940.

Foucart 1932
G. Foucart. *Tombes thébaines* (MIFAO 57).
Cairo, 1932.

Frankfort 1929a
H. Frankfort. *The Mural Painting of El-Amarneh.*
London, 1929.

Frankfort 1929b
H. Frankfort. "Preliminary Report on the Excavations at El-Amarnah, 1928-1929," in *JEA* 15 (1929), pp. 143-149.

Frankfort 1939
H. Frankfort. *Cylinder Seals.* London, 1939.

Frankfort 1978
H. Frankfort. *Kingship and the Gods.*
Chicago, 1978.

Frankfort and Pendlebury 1933
H. Frankfort and J. Pendlebury. *The City of Akhenaten* 2. London, 1933.

Frédéricq 1927
M. Frédéricq. "The Ointment Spoons in the Egyptian Section of the British Museum," in *JEA* 13 (1927), pp. 7-13.

Fulco 1976
W. Fulco. *The Canaanite God Rešep.*
New Haven, 1976.

Furumark 1941
A. Furumark. *The Mycenaean Pottery.*
Stockholm, 1941.

Furumark 1950
A. Furumark. "The Settlement at Ialysos and Aegean History," in *Opuscula Archaeologia* 6 (1950), pp. 150ff., 223ff.

Fuscaldo 1972
P. Fuscaldo. "Las divinidades Asiaticas en Egipto. Reshep y Qadesh en Deir el-Medina," in *RIHAO* 1 (1972), pp. 115-136.

Fuscaldo 1976
P. Fuscaldo. "El Culto Oficial de las Divinidades Asiaticas en Egipto durante el Imperio Nuevo," in *RIHAO* 3 (1976), pp. 127-144.

Gaballa 1977
G. Gaballa. "Three Acephalous Stelae," in *JEA* 63 (1977), pp. 122-126.

Gabra 1935
S. Gami. "Quelques Cannes du Musée du Louvre," in *Mélanges Maspero* 1, fasc. 1. (*MIFAO* 66). Cairo, 1935 (pp. 573-577).

Gabra 1956
S. Gabra. "Papaver Species and Opium through the Ages," in *BIE* 37 (1956), pp. 39-56.

Gabra 1969
S. Gabra. "Coudée votive de Touna el Gebel Hermopolis Ouest: La Khemenow pa Meket des Egyptiens," in *MDAIK* 24 (1969), pp. 129-135.

Gaillard 1923
C. Gaillard. *Recherches sur les poissons représentés dans quelques tombeaux égyptiens de l'ancien empire.* Cairo, 1923.

Gamer-Wallert 1970
I. Gamer-Wallert. *Fische und Fischkulte im alten Agypten.* Wiesbaden, 1970.

Gardiner 1906
A. Gardiner. "Four Papyri of the Eighteenth Dynasty from Kahun," in *ZAS* 43 (1906), pp. 27-47.

Gardiner 1932a
A. Gardiner. "The Astarte Papyrus," in S. Glanville, ed., *Studies Presented to F. Ll. Griffith.* London, 1932 (pp. 74-85).

Gardiner 1932b
A. Gardiner. *Late-Egyptian Stories.* Brussels, 1932.

Gardiner 1938
A. Gardiner. "The House of Life," in *JEA* 24 (1938), pp. 157-179.

Gardiner 1946
A. Gardiner. "Davies's Copy of the Great Speos Artemidos Inscription," in *JEA* 32 (1946), pp. 43-56.

Gardiner 1948a
A. Gardiner. *Ramesside Administrative Documents.*
London, 1948.

Gardiner 1948b
A. Gardiner. *The Wilbour Papyrus* 3. *Translation.*
Oxford, 1948.

Gardiner 1952
A. Gardiner. "Tuthmosis III Returns Thanks to Amūn," in *JEA* 38 (1952), pp. 6-23.

Gardiner 1957
A. Gardiner. *Egyptian Grammar*, 3rd ed.
Oxford, 1957.

Gardiner and Černý 1957
A. Gardiner and J. Černý. *Hieratic Ostraca* 1.
Oxford, 1957.

Gardiner et al. 1933
A. Gardiner, A. Calverley, and M. Broome. *The Temple of King Sethos I at Abydos* 1.
London, 1933.

Gardiner et al. 1935
A. Gardiner, A. Calverley, and M. Broome. *The Temple of King Sethos I at Abydos* 2.
London, 1935.

Garstang 1901
J. Garstang. *El Arábah: A Cemetery of the Middle Kingdom.* London, 1901.

Garstang 1903
J. Garstang. *Mahâsna and Bêt Khallâf.*
London, 1903.

Garstang 1907
J. Garstang. *The Burial Customs of Ancient Egypt.*
London, 1907.

Garstang 1909
J. Garstang. "Excavations at Abydos, 1909: Preliminary Description of the Principal Finds," in *LAAA* 2 (1909), pp. 125-129.

Gatty 1879
C. Gatty. *Catalogue of the Mayer Collection* 1: *The Egyptian, Babylonian, and Assyrian Antiquities.*
Liverpool, 1879.

Gauthier 1908
H. Gauthier. "Rapport sur une campagne de fouilles à Drah Abou'l Neggah en 1906," in *BIFAO* 6 (1908), pp. 121-171.

Gauthier 1912
H. Gauthier. *Le Livre des rois d'Egypte* 2. (*MIFAO* 18). Cairo, 1912.

Gauthier 1914
H. Gauthier. *Le Livre des rois d'Egypte* 3. (*MIFAO* 19). Cairo, 1914.

Gauthier-Laurent 1935-1938
M. Gauthier-Laurent. "Les Scènes de coiffure féminine dans l'ancienne Egypte," in *Mélanges Maspero* 1, fasc. 2. Cairo, 1935-1938 (pp. 673-696).

Gautier and Jéquier 1902
J. Gautier and G. Jéquier. *Mémoire sur les fouilles de Licht.* Cairo, 1902.

George 1970
B. George. *Zu den altägyptischen Vorstellungen vom Schatten als Seele.* Bonn, 1970.

George 1978
B. George. "Hathor, Herrin der Sistren," in *Medelhausmuseet Bulletin* 13 (1978), pp. 25-31.

George 1980
B. George. "Drei altägyptische Wurfhölzer," in *Medelhausmuseet Bulletin* 15 (1980), pp. 7-15.

Ghalioungui 1963
P. Ghalioungui. *Magic and Medical Science in Ancient Egypt.* London, 1963.

Gill 1906
A. Gill. "Examination of the Contents of a Mycenaean Vase Found in Egypt," in *AJA* 10 (1906), pp. 300ff.

Giorgini 1961
M. Giorgini. "Soleb: Campagna 1959-60," in *Kush* 9 (1961), pp. 182-197.

Giorgini 1965
M. Giorgini. *Soleb 1: 1813-1963.* Florence, 1965.

Giveon 1980
R. Giveon. "Resheph in Egypt," in *JEA* 66 (1980), pp. 144ff.

Gjerstad et al. 1934
E. Gjerstad et al. *The Swedish Cyprus Expedition* 1. Stockholm, 1934.

Glanville 1926
S. Glanville. "A Note on Herodotus II, 93," in *JEA* 12 (1926), pp. 75ff.

Glanville 1928
S. Glanville. "The Letters of Aaḥmōse of Peniati," in *JEA* 14 (1928), pp. 294-312.

Glanville 1932
S. Glanville. "Scribe's Palettes in the British Museum," in *JEA* 18 (1932), pp. 53-61.

Glanville 1936
S. Glanville. "Weights and Balances in Ancient Egypt," in *Royal Institute of Great Britain. Proceedings 1935* 29 (1936), pp. 10-40.

Godley 1921
A. Godley. *Herodotus* 1. New York, 1921.

Goedicke 1968
H. Goedicke. "The Capture of Joppa," in *CdE* 43 (1968), pp. 219-233.

Goldstein 1979a
S. Goldstein. *Pre-Roman and Early Roman Glass in the Corning Museum of Glass.* Corning, 1979.

Goldstein 1979b
S. Goldstein. "A Unique Royal Head," in *JGS* 21 (1979), pp. 8-16.

Gout-Minault 1976
A. Gout-Minault. "Saï 1974-5: Tombes pharaoniques," in *Etudes sur l'Egypte et le Soudan anciens* 4 (1976), pp. 87-103.

Gowland 1898
W. Gowland. "An Ancient Egyptian Toilet-Box belonging to W. L. Nash, F.S.A., with an Analysis of its Contents by W. Gowland, F.C.S., F.S.A.," *PSBA* 20 (1898), pp. 267ff.

Goyon 1970
G. Goyon. "Les Instruments de forage sous l'Ancien Empire," in *JEOL* 21 (1970), pp. 154-163.

Goyon 1972
J.-C. Goyon. *Rituels funéraires de l'ancienne Egypte.* Paris, 1972.

Graefe 1973
E. Graefe. "Amun-Re, 'Patron der Feldmesser,' " in *CdE* 48 (1973), pp. 36ff.

Grant 1934
E. Grant. *Rumeileh, being Ains Shems Excavations (Palestine).* Haverford, 1934.

Grapow 1915-1917
H. Grapow. *Religiöse Urkunden.* Leipzig, 1915.

Grapow et al. 1954-1973
H. Grapow et al. *Grundriss der Medizin der alten Agypter.* Berlin, 1954-1973.

Grapow et al. 1955
H. Grapow et al. *Von den medizinischen Texten.* (*Grundriss der Medizin der alten Agypter* 2). Berlin, 1955.

Grapow et al. 1956
H. Grapow et al. *Kranker Krankheiten und Arzt.* (*Grundriss der Medizin der alten Agypter* 3). Berlin, 1956.

Grapow et al. 1958
H. Grapow et al. *Die medizinischen Texte in Hieroglyphischer Umschreibung autographiert.* (*Grundriss der Medizin der alten Agypter* 5). Berlin, 1958.

Grapow et al. 1959
H. Grapow et al. *Wörterbuch der ägyptischen Drogennamen.* (*Grundriss der Medizin der alten Agypter* 6). Berlin, 1959.

Gratien 1978
B. Gratien. *Les Cultres Kerma.* Lille, 1978.

Greiss 1957
E. Greiss. *Anatomical Identification of Some Ancient Egyptian Plants and Materials.* (*MIE* 55). Cairo, 1957.

Griffith 1892
F. Griffith. "Notes on Egyptian Weights and Measures," in *PSBA* 14 (1892), pp. 403-450.

Griffith 1893
F. Griffith. "Notes on Egyptian Weights and Measures," in *PSBA* 15 (1893), pp. 301-316.

Griffith 1896
F. Griffith. *Beni Hasan* 3. London, 1896.

Griffith 1898
F. Griffith. *Hieratic Papyri from Kahun and Gurob.* London, 1898.

Griffith 1900
F. Griffith. *Stories of the High Priests of Memphis.* Oxford, 1900.

Griffith 1921
F. Griffith. "Oxford Excavations in Nubia," in *LAAA* 8 (1921), pp. 65-104.

Griffith 1923
F. Griffith. "Oxford Excavations in Nubia," in *LAAA* 10 (1923), pp. 73-171.

Griffith 1926
F. Griffith. "A Drinking Siphon from Tell el-'Amarnah," in *JEA* 12 (1926), pp. 22-23.

Griffith et al. 1900
F. Griffith et al. *Beni Hasan* 4. London, 1900.

Griffiths 1970
J. Griffiths. *Plutarch's De Iside et Osiride.* Cambridge, 1970.

Grose 1977
D. Grose. "Early Blown Glass: The Western Evidence," in *JGS* 19 (1977), pp. 9-29.

Grose 1978
D. Grose. "Ancient Glass," in *Toledo Museum of Art: Museum News* 20, no. 3 (1978), pp. 67-90.

Grüss 1932
J. Grüss. "Untersuchung von Broten aus der Aegyptischen Sammlung der Staatlichen Museen zu Berlin," in *ZAS* 68 (1932), pp. 79-80.

Guglielmi 1979
W. Guglielmi. "Probleme bei der Anwendung der Begriffe 'Komik,' 'Ironie,' und 'Humor' auf die altägyptische Literatur," in *GM* 36 (1979), pp. 69-85.

Guidotti 1978
M. Guidotti. "A Proposito dei Vasi con Decorazione Hathorica," in *Egitto e Vicino Oriente* 1 (1978), pp. 105-118.

Guillevic and Ramond 1971
J. Guillevic and P. Ramond. *Musée Georges Labit: Antiquités Egyptiennes.* Toulouse, 1971.

Guksch 1978
H. Guksch. *Das Grab des Benja, gen. Paheqamen Theben Nr. 343.* Mainz am Rhein, 1978.

Gunn 1916
B. Gunn. "The Religion of the Poor in Ancient Egypt," in *JEA* 3 (1916), pp. 81-94.

Gunther 1972
C. Gunther. "How Glass is Made," in *Toledo Museum of Art: Museum News* 15, no. 1 (1972), pp. 3-22.

Habachi 1952
L. Habachi. "Khata'na-Qantir: Importance," in *ASAE* 52 (1952), pp. 443-562.

Habachi 1965
L. Habachi. "Varia from the Reign of King Akhenaten," in *MDAIK* 20 (1965), pp. 70-92.

Habachi 1969
L. Habachi. *Features of the Deification of Ramses II.* Glückstadt, 1960.

Habachi 1977
L. Habachi. *The Obelisks of Egypt.* New York, 1977.

Haberey 1957
W. Haberey. "Der Werkstoff Glas in Altertum," in *Glastechnische Berichte: Zeitschrift für Glaskunde* 30 (1957), pp. 188-194.

Haberey 1961
W. Haberey. *Glas im Wandel der Zeiten.* Kalender, 1961.

Hall 1901
H. Hall. *The Oldest Civilization of Greece.* London, 1901.

Hall 1913
H. Hall. *Catalogue of Egyptian Scarabs, etc., in the British Museum.* London, 1913.

Hall 1926
H. Hall. "An Egyptian Royal Bookplate: The Ex-Libris of Amenophis III and Teie," in *JEA* 12 (1926), pp. 30-33.

Hall 1928a
H. Hall. *The Civilization of Greece in the Bronze Age.* London, 1928.

Hall 1928b
H. Hall. "Minoan Faience in Mesopotamia," in *JHS* 48 (1928), pp. 64ff.

Hall 1928c
H. Hall. "Objects of Tutankhamen in the British Museum," in *JEA* 14 (1928), pp. 74-77.

Hall 1930
H. Hall. "Recent Egyptian and Assyrian Acquisitions," in *British Museum Quarterly* 5 (1930), p. 50, pl. 22.

Hall 1980
R. Hall. "A Pair of Linen Sleeves from Gurob," in *GM* 40 (1980), pp. 29-39.

Hall 1981
R. Hall. "The Pharaonic *mss* Tunic as a Smock?," in *GM* 43 (1981), pp. 29-38.

Hamada 1938
A. Hamada. "A Stela from Manshiyet es-Sada," in *ASAE* 38 (1938), pp. 217-230.

Hankey 1967
V. Hankey. "Mycenaean Pottery in the Middle East," in *Papers of the British School at Athens* 62 (1967), pp. 107ff.

Hankey 1973
V. Hankey. "The Aegean Deposit at el-Amarna," in *The Mycenaeans in the Eastern Mediterranean.* Nicosia, 1973 (pp. 128-136).

Hankey and Warren 1974
V. Hankey and P. Warren. "The Absolute Chronology of the Aegean Late Bronze Age," in *Bulletin of the Institute of Classical Studies, University of London* 21 (1974), pp. 142ff.

Harden 1967
D. Harden. "Some Aspects of Pre-Roman Mosaic Glass," in *Annales du 4e Congrès des Journées Internationales du Verre: Ravenna.* Liege, 1967 (pp. 13-20).

Harden 1969
D. Harden. "Ancient Glass I: Pre-Roman," in *Archaeological Journal* 125 (1969), pp. 46-72.

Harden et al. 1968
D. Harden et al. *Masterpieces of Glass.* London, 1968.

Hari 1964
R. Hari. *Horemheb et la reine Moutnedjemet.* Geneva, 1964.

Harris 1961
J. Harris. *Lexicographical Studies in Ancient Egyptian Minerals.* Berlin, 1961.

Harris 1971a
J. Harris. "Medicine," in J. Harris, ed., *The Legacy of Egypt.* 2nd ed. Oxford, 1971 (pp. 112-137).

Harris 1971b
J. Harris. "Technology and Materials," in J. Harris, ed., *The Legacy of Egypt.* 2nd ed. Oxford, 1971 (pp. 83ff.).

Harris 1976
J. Harris. "The Folding Stool of a Famous Soldier," in *Acta Orientalia* 37 (1976), pp. 21-25.

Hartenberg and Schmidt 1969
R. Hartenberg and J. Schmidt. "The Egyptian Drill and the Origin of the Crank," in *Technology and Culture* 10, no. 2 (1969), pp. 155-166.

Hartmann 1923
F. Hartmann. *L'Agriculture dans l'ancienne Egypte.* Paris, 1923.

Hassan 1936
S. Hassan. *Excavations at Giza* 2: *1930-1931.* Cairo, 1936.

Hassan 1948
S. Hassan. *Excavations at Giza* 6, pt. 2: *The Offering List in the Old Kingdom.* Cairo, 1948.

Hassan 1953
S. Hassan. *Excavations at Giza* 8: *The Great Sphinx and its Secrets.* Cairo, 1953.

Hassan 1975
S. Hassan. *The Mastaba of Neb-Kaw-Her* 1: *Excavations at Saqqara, 1937-38.* Cairo, 1975.

Hassan 1976
A. Hassan. *Stöcke und Stäbe im Pharaonischen Aegypten.* Munich, 1976.

Hay 1869
J. Hay. *Catalogue of the Collection of Egyptian Antiquities belonging to the Late Robert Hay, Esq., of Linplum, Drawn up under the Superintendence of Joseph Bonomi, Curator of Sir John Sloane's Museum.* London, 1869.

Hayes 1935
W. Hayes. "The Tomb of Nefer-Khewet and his Family," in *BMMA, Egyptian Supplements* (November 1935), pp. 17ff.

Hayes 1937
W. Hayes. *Glazed Tiles from a Palace of Ramesses II at Kantîr.* New York, 1937.

Hayes 1941
W. Hayes. "Daily Life in Ancient Egypt," in *National Geographic* 80, no. 4 (1941), pp. 419-515.

Hayes 1948
W. Hayes. "Recent Additions to the Egyptian Collection," in *BMMA* 7 (1948), p. 60.

Hayes 1951
W. Hayes. "Inscriptions from the Palace of Amenhotep III," in *JNES* 10 (1951), pp. 35-40, 82-104, 156-183, 231-242.

Hayes 1953
W. Hayes. *The Scepter of Egypt* 1. New York, 1953.

Hayes 1959
W. Hayes. *The Scepter of Egypt* 2. New York, 1959.

Hayes 1973
W. Hayes. "Egypt: Internal Affairs from Tuthmosis I to the Death of Amenophis III," in I.E.S. Edwards et al., eds., *The Cambridge Ancient History* 2, pt. 1, 3rd ed., Cambridge, 1973 (pp. 313ff.).

Haynes 1977
J. Haynes. "The Development of Women's Hairstyles in Dynasty Eighteen," in *SSEA Journal* 8, no. 1 (1977), pp. 18ff.

Hayward 1965
H. Hayward. *World Furniture.* New York, 1965.

Haywood 1971
R. Haywood. *The Ancient World.* New York, 1971.

Heerma van Voss 1955
M. Heerma van Voss. "The Jackals of the Sun Boat," in *JEA* 41 (1955), p. 127.

Helck 1954a
W. Helck. "Die Sinai-Inschrift des Amenmose," in *MIO* 2 (1954), pp. 196ff.

Helck 1954b
W. Helck. *Untersuchungen zu den Beamtentiteln des ägyptischen Alten Reiches.* Glückstadt, 1954.

Helck 1955
W. Helck. *Urkunden der 18. Dynastie: Historische Inschriften Tuthmosis' III und Amenophis II,* pt. 4, vol. 4 (*Urkunden des ägyptischen Altertums* 17). Berlin, 1955.

Helck 1958
W. Helck. *Zur Verwaltung des Mittleren und Neuen Reiches.* Leiden, 1958.

Helck 1963
W. Helck. *Materialien zur Wirtschaftsgeschichte des Neuen Reiches* 4. Wiesbaden, 1963.

Helck 1967
W. Helck. "Eine Briefsammlung aus der Verwaltung des Amuntempels," in *JARCE* 6 (1967), pp. 135-151.

Helck 1971
W. Helck. *Das Bier im alten Agypten.* Berlin, 1971.

Helck 1975a
W. Helck. "Ahmose Peniati," in *LA* 1 (1975), cols. 109-110.

Helck 1975b
W. Helck. "Arbeiterabteilungen und- organisation," in *LA* 1 (1975), cols. 371-374.

Helck 1975c
W. Helck. "Augenschminke," in *LA* 1 (1975), col. 567.

Helck 1977
W. Helck. "Haus," in *LA* 2 (1977), cols. 1061-1062.

Hemmy 1937
A. Hemmy. "An Analysis of the Petrie Collection of Egyptian Weights," in *JEA* 23 (1937), pp. 39-56.

Hermann 1932
A. Hermann. "Das Motiv der Ente mit zurückgewendetem Kopfe im ägyptischen Kunstgewerbe," in *ZAS* 68 (1932), pp. 86-105.

Hermann 1937
A. Hermann. "Die Katze im Fenster über der Tür," in *ZAS* 73 (1937), pp. 68-74.

Hermann 1957
A. Hermann. "Buchillustrationen auf ägyptischen Bücherkästen," in *MDAIK* 15 (1957), pp. 112ff.

Hermann 1959
A. Hermann. *Altägyptische Liebesdichtung.* Wiesbaden, 1959.

Hermann 1963
A. Hermann. "Jubel bei der Audienz," in *ZAS* 90 (1963), pp. 49-66.

Hermann 1968-1969
A. Hermann. "Fliege (Müche)" in *Reallexikon für Antike und Christentum* 7 (1968-1969), cols. 1110-1124.

Hermitage 1974
The Hermitage. *Egyptian Antiquities in the Hermitage* (B. Piotrovsky, ed.). Leningrad, 1974.

Hickmann 1948a
H. Hickmann. "Miscellanea musicologica I: Note sur une harpe au Musée du Caire," in *ASAE* 48 (1948), pp. 639-663.

Hickmann 1948b
H. Hickmann. "Miscellanea musicologica II: Sur l'Accordage des instruments à corde," in *ASAE* 48 (1948), pp. 649ff.

Hickmann 1949a
H. Hickmann. *Instruments de musique.* Cairo, 1949.

Hickmann 1949b
H. Hickmann. "Miscellanea musicologica III: Observations sur les survivances de la chironome égyptienne dans le chant liturgique Copte," in *ASAE* 49 (1949), pp. 417-427.

Hickmann 1949c
H. Hickmann. "Miscellanea musicologica V: Note sur une petite harpe en forme de bêche ou de pelle," in *ASAE* 49 (1949), pp. 432-436.

Hickmann 1949d
H. Hickmann. "Miscellanea musicologica VI: Quelques Précurseurs égyptiens du luth court et du luth échancré," in *ASAE* 49 (1949), pp. 437-444.

Hickmann 1950
H. Hickmann. "Miscellanea musicologica VII: Les Harpes de la tombe de Ramsès III," in *ASAE* 50 (1950), pp. 523-545.

Hickman 1951
H. Hickmann. "Classement et classification des flûtes, clarinettes et hautbois de l'Egypte ancienne," in *CdE* 26 (1951), pp. 17-27.

Hickmann 1952
H. Hickmann. "Miscellanea musicologica XI: Les Luths aux frettes du Nouvel Empire," in *ASAE* 52 (1952), pp. 161-183.

Hickmann 1953
H. Hickmann. "La Musique polyphonique dans l'Egypte ancienne," in *BIE* 34 (1953), pp. 229-244.

Hickmann 1954a
H. Hickmann. "Dieux et déesses de la musique," in *Cahiers d'histoire* égyptienne 6 (1954), pp. 31-59.

Hickmann 1954b
H. Hickmann. "Les Harpes de l'Egypte pharaonique: Essai d'une nouvelle classification," in *BIE* 35 (1954), pp. 309-376.

Hickmann 1954c
H. Hickmann. "Usage et signification des frettes dans l'Egypte pharaonique," in *Kêmi* 13 (1954), pp. 92ff.

Hickmann 1956a
H. Hickmann. "Du Battement des mains aux planchettes entrechoquées," in *BIE* 37 (1956), pp. 67-122.

Hickmann 1965b
H. Hickmann. "La Danse aux miroirs: Essai de reconstitution d'une danse pharaonique de l'Ancien Empire," in *BIE* 37 (1956), pp. 151-190.

Hickmann 1956c
H. Hickmann. *Musicologie pharaonique: Etudes sur l'evolution de l'art musical dans l'Egypte ancienne.* Strasbourg, 1956.

Hickmann 1956d
H. Hickmann. *45 Siècles de musique dans l'Egypte ancienne.* Paris, 1956.

Hickmann 1957
H. Hickmann. "Le Grelot dans l'Egypte ancienne," in *BIE* 38 (1957), pp. 100ff.

Hickman 1958
H. Hickmann. "La Chironomie dans l'Egypte pharaonique," in *ZAS* 83 (1958), pp. 96-124.

Hickmann 1977
E. Hickmann. "Harfe," in *LA* 2 (1977), cols. 966-972.

Hilton-Price 1897
F. Hilton-Price. *A Catalogue of the Egyptian Antiquities in the Possession of F. G. Hilton-Price.* London, 1897.

Hilzheimer 1932
M. Hilzheimer. "Dogs," in *Antiquity* 6 (1932), pp. 411-419.

Hodgson 1936
L. Hodgson. "Egyptian Blue Frit," in *Society of Mural Decorators and Painters in Tempera: Occasional Papers* 3 (1936), pp. 36-38.

Höhr-Grenzhausen. Rastel-Haus 1978
Höhr-Grenzhausen. Rastel-Haus. *Meisterwerke altägyptischer Keramik: 5000 Jahre Kunst und Kunsthandwerk aus Ton und Fayence. Höhr-Grenzhausen, Rastel-Haus, 16. September bis 30. November 1978.* Höhr-Grenzhausen: The Museum, 1978.

Holmberg 1946
M. Holmberg. *The God Ptah.* Lund, 1946.

Holthoer 1977
R. Holthoer. *New Kingdom Pharaonic Sites: The Pottery.* Lund, 1977.

Honey 1946
W. Honey. *Glass: A Handbook and Guide for the Study of Glass Vessels of all Periods and Countries and a Guide to the Museum Collection, Victoria and Albert Museum.* London, 1946.

Honigsberg 1940
P. Honigsberg. "Sanitary Installations in Ancient Egypt," in *Journal of the Egyptian Medical Association* 23 (1940), pp. 199-246.

Hooke 1954
S. Hooke. "Recording and Writing," in C. Singer et al., eds., *History of Technology* 1. Oxford, 1954 (pp. 744-773).

Hope 1977
C. Hope. "Two Examples of Egyptian Blue-Painted Pottery in Medelhausmuseet," in *Medelhausmuseet Bulletin* 12 (1977), pp. 7-11.

Hope 1978
C. Hope. *Malkata and the Birket Habu: Jar Sealings and Amphorae*. London, 1978.

Hornemann 1966
B. Hornemann. *Types of Ancient Egyptian Statuary* 4. Copenhagen, 1966.

Hornemann 1969
B. Hornemann. *Types of Ancient Egyptian Statuary* 7. Copenhagen, 1969.

Hornung and Staehelin 1976
E. Hornung and E. Staehelin. *Scarabäen und andere Siegelamulette aus Basler Sammlungen*. Mainz, 1976.

Hoskins 1835
G. Hoskins. *Travels in Ethiopia. . . .* London, 1835.

Hôtel Drouot 1904
Hôtel Drouot. *Antiquités égyptiennes trouvées à Abydos, Vente des lundi 8 et mardi 9 fevrier 1904.* Paris, 1904.

Hôtel Drouot 1971
Hôtel Drouot. *Sale Catalogue. D. David-Weill Collection.* Paris, June 16, 1971.

Hughes 1959
G. Hughes. "The Cosmetic Arts in Ancient Egypt," in *Journal of the Society of Cosmetic Chemists* 10, no. 3 (1959), pp. 159-176.

Husson 1977
C. Husson. *L'Offrande du miroir dans les temples égyptiens de l'époque gréco-romaine.* Lyon, 1977.

Isaac Delgado Museum 1967
Isaac Delgado Museum of Art. *Odyssey of an Art Collection: Unity in Diversity: 5000 Years of Art (Stafford Collection).* New Orleans, 1976.

IsMEO 1977
Istituto Italiano per il Medio ed Estremo Oriente. "IsMEO Activities," in *East and West* 27 (1977), pp. 451ff.

Ivanov 1978
I. Ivanov. *Treasures of the Varna Chalcolith Necropolis.* Sofia, 1978.

Jacoby and Spiegelberg 1903
A. Jacoby and W. Spiegelberg. "Der Frosch als Symbol der Auferstehung bei den Agyptern," in *Sphinx* 7 (1903), pp. 215-219.

Jacquet-Gordon 1979
H. Jacquet-Gordon. "A Deposit of Middle Kingdom Pottery from Karnak North (abstract of a paper given at the ICE Congress at Grenoble in 1979)," in *Bulletin de Liaison* 4 (1979), pp. 29-30.

James 1961
T. G. H. James. *Hieroglyphic Texts from Egyptian Stelae, etc.* 1. 2nd ed., London, 1961.

James 1962
T. G. H. James. *The Hekanakhte Papers.* New York, 1962.

James 1970
T. G. H. James. *Hieroglyphic Texts from Egyptian Stelae, etc.* 9. London, 1970.

James 1972
T. G. H. James. *The Archaeology of Ancient Egypt.* New York, 1972.

James 1974
T. G. H. James. *Corpus of Hieroglyphic Inscriptions in the Brooklyn Museum.* Brooklyn, 1974.

Jannsens 1970
P. Jannsens. *Paleopathology.* London, 1970.

Janssen 1950
J. Janssen. "Une Stèle du dieu Reshef à Cambridge," in *CdE* 25 (1950), pp. 209-212.

Janssen 1958
J. Janssen. "Uber Hundenamen im pharaonischen Agypten," in *MDAIK* 16 (1958), pp. 176-182.

Janssen 1975
J. Janssen. *Commodity Prices from the Ramessid Period: An Economic Study of the Village of Necropolis Workmen at Thebes.* Leiden, 1975.

Janssen and Hall 1981
J. Janssen and R. Hall. "(Ḥtrj n) jsh= 'Pair of Sleeves'?" in *GM* 45 (1981), pp. 21-26.

Jenkins 1969
J. Jenkins. "A Short Note on African Lyres in Use Today," in *Iraq* 31 (1969), p. 103.

Jéquier 1910
G. Jéquier. "Une Pièce du costume militaire," in *RT* 32 (1910), pp. 173-174.

Jéquier 1911
G. Jéquier. *Décoration égyptienne.* Paris, 1911.

Jéquier 1921
G. Jéquier. *Les Frises d'objets des sarcophages du Moyen Empire.* Cairo, 1921.

Jéquier 1928
G. Jéquier. *Le Mastabat Faraoun.* Cairo, 1928.

Jéquier 1933
G. Jéquier. *Deux Pyramides du Moyen Empire.* Cairo, 1933.

Jonckheere 1959
F. Jonckheere. *Médecins de l'Egypte pharaonique.* Paris, 1958.

Jones 1932
H. Jones. *The Geography of Strabo* 8. New York, 1932.

Jones 1960
F. Jones. *Ancient Art in the Art Museum, Princeton University.* Princeton, 1960.

Jones 1970
D. Jones. "The Toledo Museum's New Glass Gallery," in *The Glass Club Bulletin* 93/94 (March-June 1970), p. 10.

Joseph Pilsudski University 1937
Joseph Pilsudski University. *Tell Edfou 1937* (by B. Bruyère et al.). Cairo, 1937.

Joseph Pilsudski University 1950
Joseph Pilsudski University. *Tell Edfou 1939* (by K. Michalowski et al.). Cairo, 1950.

Junker 1942
H. Junker. *Der sehende und blinde Gott.* Munich, 1942.

Junker 1944
H. Junker. *Giza* 7. Vienna, 1944.

Junker 1947
H. Junker. *Giza* 8. Vienna, 1947.

Kačalov 1959
N. Kačalov. *Steklo.* Moscow, 1959.

Kákosy 1977
L. Kákosy. "Heqet," in *LA* 2 (1977), cols. 1123-1124.

Kamal 1911
A. Kamal. "Rapport sur les fouilles exécutées dans la zone comprise entre Deîrout au Nord et Deîr-el-Ganadlah, au Sud," in *ASAE* 11 (1911), pp. 3-39.

Kämpfer 1966
F. Kämpfer. *Viertausend Jahre Glass.* Munich, 1966.

Kantor 1947
H. Kantor. "The Aegean and the Orient in the Second Millennium B.C.," in *AJA* 51 (1947), pp. 3ff.; reprinted as a monograph with the addition of appendices and an index:
H. Kantor. *The Aegean and the Orient in the Second Millennium B.C.* Bloomington, 1947.

Kantor 1965
H. Kantor. "The Relative Chronology of Egypt and its Foreign Correlations before the Late Bronze Age," in R. Ehrich, ed., *Chronologies in Old World Archaeology.* Chicago, 1965 (pp. 1ff.).

Kantor 1979
H. Kantor. "Chogha Mish and Chogha Bonut," in *Oriental Institute Annual Report 1978-1979.* Chicago, 1979 (pp. 33-39).

Kaplony 1975
P. Kaplony. "Barbier," in *LA* 1 (1975), cols. 617-619.

Kaplony 1977
P. Kaplony. *Die Rollsiegel des Alten Reiches* 1. Brussels, 1977.

Karo 1911
G. Karo. "Minoische Rhyta," in *Jahrbuch des Archäologischen Instituts* 26 (1911), pp. 249ff.

Karo 1933
G. Karo. *Die Schachtgräber von Mykenai.* Munich, 1933.

Kayser 1958
H. Kayser. "Die Gänse des Amon," in *MDAIK* 16 (1958), pp. 193ff.

Kayser 1966
H. Kayser. *Das Pelizaeus-Museum in Hildesheim.* Hamburg, 1966.

Kayser 1969
H. Kayser. *Agyptisches Kunsthandwerk.* Braunschweig, 1969.

Kayser 1973
H. Kayser. *Die ägyptischen Altertümer im Roemer-Pelizaeus-Museum in Hildesheim.* Hildesheim, 1973.

Kees 1941
H. Kees. *Die Götterglaube im Alten Aegypten.* Leipzig, 1941.

Kees 1956
H. Kees. *Totenglauben und Jenseitsvorstellungen der alten Agypter.* Berlin, 1956.

Kees 1961
H. Kees. *Ancient Egypt: A Cultural Topography.* Chicago, 1961.

Keimer 1924
L. Keimer. *Die Gartenpflanzen im alten Agypten.* Hamburg, 1924.

Keimer 1925
L. Keimer. "Egyptian Formal Bouquets," in *American Journal of Semitic Languages and Literatures* 41 (1925), pp. 145-161.

Keimer 1926
L. Keimer. "Agriculture in Ancient Egypt," in *American Journal of Semitic Languages and Literatures* 42 (1926), pp. 283-288.

Keimer 1927
L. Keimer. "Le *Potamogeton lucens* L. dans l'Egypte ancienne," in *Revue de l'Egypte ancienne* 1 (1927), pp. 182-197.

Keimer 1929a
L. Keimer. "Bemerkungen und Lesefrüchte zur altägyptischen Naturgeschichte," 2: "Zu dem Ex Libris-Täfelchen aus Fayence (British Museum No. 22878) mit dem Namen Amenophis III und der Königen Teje," in *Kêmi* 2 (1929), pp. 90-94.

Keimer 1929b
L. Keimer. "Nouvelles Recherches au sujet du *Potamogeton lucens* L. dans l'Egypte ancienne," in *Revue de l'Egypte ancienne* 2 (1929), pp. 210-253.

Keimer 1931
L. Keimer. "Sur l'Ornementation d'un bracelet en ebène datant du Nouvel Empire," in *Revue de l'Egypte ancienne* 3 (1931), pp. 42ff.

Keimer 1932
L. Keimer. "Pendeloques en forme d'insectes faisant partie de colliers égyptiens," in *ASAE* 32 (1932), pp. 129-150.

Keimer 1938a
L. Keimer. "Pavian und Dūm-Palme," in *MDAIK* 8 (1938), pp. 42-45.

Keimer 1938b
L. Keimer. "Remarques sur quelques représentations de divinités-béliers et sur un groupe d'objets de culte conservés au Musée du Caire," in *ASAE* 38 (1938), pp. 297-331.

Keimer 1939
L. Keimer. "La Boutargue dans l'Egypte ancienne," in *BIE* 21 (1939), pp. 215-243.

Keimer 1947
L. Keimer. *Interpretation de quelques passages d'Horapollon.* (ASAE 5 Supplement). Cairo, 1947.

Keimer 1948a
L. Keimer. *Remarques sur le tatouage dans l'Egypte ancienne.* Cairo, 1948.

Keimer 1948b
L. Keimer. "La Signification de l'hieroglyphe RD," in *ASAE* 48 (1948), pp. 89ff.

Keimer 1949a
L. Keimer. Review of H. E. Winlock, *The Treasures of Three Egyptian Princesses* (N. Y., 1948), in *BiOr* 6 (1949), pp. 137-139.

Keimer 1949b
L. Keimer. "The Decoration of a New Kingdom Vase," in *JNES* 8 (1949), pp. 1-5.

Keimer 1951
L. Keimer. "Les Oignons et les poissons de Cham en-Nessim," in *Cahiers d'histoire égyptienne,* series 3, fasc. 4 (1951), pp. 352-356.

Keimer 1952
L. Keimer. "Remarques sur les 'cuillers à fard' du type dit à la nageuse," in *ASAE* 52 (1952), pp. 59-72.

Keimer 1953
L. Keimer. "Notes pris chez les Bišarīn et les Nubiens d'Assouan, pt. 4," in *BIE* 34 (1953), pp. 329-400.

Keimer 1954
L. Keimer. "Das Bildhauer-Modell eines Mannes mit abgeschnittener Nase," in *ZÄS* 79 (1954), pp. 141-143.

Keimer 1956a
L. Keimer. "Chanticleer in Ancient Egypt," in *Egypt Travel Magazine* 27 (1956), pp. 6-11.

Keimer 1956b
L. Keimer. "La Nourriture des anciens Egyptiens. Que mangeaient-ils? Que buvaient-ils?" in *Egypt Travel Magazine* 22 (1956), pp. 6-10.

Keimer 1957
L. Keimer. "Le Sycomore, arbre d'Egypte," in *Egypt Travel Magazine* 29 (1957), pp. 21-28.

Keller 1909
O. Keller. *Die antike Tierwelt*. Leipzig, 1909.

Kelley 1976
A. Kelley. *The Pottery of Ancient Egypt*. Toronto, 1976.

Kemp 1972
B. Kemp. "Temple and Town in Ancient Egypt," in P. Ucko et al., eds., *Man, Settlement and Urbanism*. London, 1972 (pp. 657-680).

Kemp 1976
B. Kemp. "The Window of Appearance at El-Amarna, and the Basic Structure of this City," in *JEA* 62 (1976), pp. 81-99.

Kemp 1977a
B. Kemp. "The Early Development of Towns in Egypt," in *Antiquity* 51 (1977), pp. 185-200.

Kemp 1977b
B. Kemp. "The City of El-Amarna as a Source for the Study of Urban Society in Ancient Egypt," in *World Archaeology* 9 (1977), pp. 123-139.

Kemp 1978
B. Kemp. "Imperialism and Empire in New Kingdom Egypt (c. 1575-1087 B.C.)," in P. Garnsey and C. Whittaker, eds., *Imperialism in the Ancient World*. Cambridge, 1978 (pp. 7ff.).

Kemp 1979a
B. Kemp. "Preliminary Report on the El-'Amarna Survey, 1978," in *JEA* 65 (1979), pp. 5-12.

Kemp 1979b
B. Kemp. "Wall Paintings from the Workmen's Village at Amarna," in *JEA* 65 (1979), pp. 47-53.

Kendall 1978
T. Kendall. *Passing through the Netherworld: The Meaning and Play of Senet, an Ancient Egyptian Funerary Game*. Belmont, Mass., 1978.

Kenyon 1973
K. Kenyon. "Palestine in the Time of the Eighteenth Dynasty," in I.E.S. Edwards et al., eds., *The Cambridge Ancient History* 2, pt. 1, 3rd ed. Cambridge, 1973 (pp. 526-556).

Kestner Museum 1958
Kestner Museum. *Ausgewählte Werke der aegyptischen Sammlung: Aegyptische Kunst* (by I. Woldering). 2nd ed. Hannover, 1958.

Kestner Museum 1976
Kestner Museum. *Jahresbericht 1973-6*. Hannover, 1976.

Khawam 1971
R. Khawam. "Un Ensemble de moules en terrecuite de la 19e dynastie," in *BIFAO* 70 (1971), pp. 133-160.

Kiefer and Allibert 1971
C. Kiefer and A. Allibert. "Pharaonic Blue Ceramics, the Process of Self-Glazing," in *Archaeology* 24 (1971), p. 107ff.

Killen 1980
G. Killen. *Ancient Egyptian Furniture*. Warminster, 1980.

Kingery et al. 1976
W. Kingery et al. *Introduction to Ceramics*. New York, 1976.

Kirby 1947
P. Kirby. "The Trumpets of Tutankhamen and their Successors," in *Journal of the Royal Anthropological Institute* 77 (1947), pp. 33-45.

Kirby 1952
P. Kirby. "Ancient Egyptian Trumpets," in *Musical Yearbook* 7 (1952), pp. 250-255.

Kisa 1908
A. Kisa. *Das Glas im Altertüme* 1. Leipzig, 1908.

Klebs 1931
L. Klebs. "Die verschiedenen Formen des Sistrums," in *ZÄS* 67 (1931), pp. 60-63.

Kisch 1966
B. Kisch. *Scales and Weights: A Historical Outline*. New Haven, 1966.

Kischkewitz 1972
H. Kischkewitz. *Egyptian Drawings*. London, 1972.

Klasens 1975
A. Klasens. "Amulet," in *LÄ* 1 (1975), cols. 232-236.

Klebs 1934
L. Klebs. *Die Reliefs und Malereien des Neuen Reiches*. Heidelberg, 1934.

Knobel et al. 1911
E. Knobel et al. *Historical Studies*. London, 1911.

Knudtzon 1907
J. Knudtzon. *Die El-Amarna Tafeln*. Leipzig, 1907.

Koenigsberger 1936
O. Koenigsberger. *Die Konstruktion der ägyptischer Tür*. Glückstadt, 1936.

Königliche Museen 1894
Königliche Museen zu Berlin. *Ausführliches Verzeichniss der ägyptischen Altertümer, Gypsabgüsse und Papyrus* hrsg. von der Generalverwaltung. Berlin, 1894.

Königliche Museen 1895
Königliche Museen zu Berlin. *Agyptische und vorderasiatische Alterthümer aus den Königlichen Museen zu Berlin* 1. Berlin, 1895.

Königliche Museen 1897
Königliche Museen zu Berlin. *Agyptische und vorderasiatische Alterthümer aus den Königlichen Museen zu Berlin* 2: *Agyptische Alterthümer*. Berlin, 1897.

Komorzynski 1951
E. Komorzynski. "Blinde als Musiker im Alten Aegypten," in *Zeitschrift über das Blindwesen* 6 (1951) pp. 3-5.

Krönig 1934
W. Krönig. "Agyptische Fayence-Schalen des Neuen Reiches," in *MDAIK* 5 (1934), pp. 144-167.

Kühne 1969
K. Kühne. "Agyptische Fayencen," in S. Wenig, ed., *Grabungen der Deutschen Orient-Gesellschaft,* pt. 1, 1969 (pp. 6-27).

Kühnert-Eggebrecht 1969
E. Kühnert-Eggebrecht. *Die Axt als Waffe und Werkzeug im alten Agypten*. Berlin, 1969.

Kunsthaus Zurich 1961
Kunsthaus Zurich. *5000 Jahre aegyptische Kunst,* 11 Feb.-16 Apr. (by H. Müller). Zurich, 1961.

Lacau 1904
P. Lacau. *Sarcophages antérieurs au Nouvel Empire* 1. Cairo, 1904.

Lacau 1909
P. Lacau. *Stèles du Nouvel Empire* 1. Cairo, 1909.

Lacau 1926
P. Lacau. *Stèles du Nouvel Empire* 2. Cairo, 1926.

Laffont 1973
E. Laffont. "Des Cordophones conglais," in *Arts d'Afrique Noire* 6 (1973), pp. 16-23.

Landi and Hall 1979
S. Landi and R. Hall. "The Discovery and Conservation of an Ancient Egyptian Linen Tunic," in *Studies in Conservation* 24 (1979), pp. 141-152.

Landsberger 1960
B. Landsberger. "Einige unerkannt gebliebene oder verkannte Nomina des Akkadischen," in *WZKM* 56 (1960), p. 117ff.

Lane 1871
E. Lane. *An Account of the Manners and Customs of the Modern Egyptians* 2. London, 1871.

Lange 1941
K. Lange. "Das Tier in der altägyptischen Kunst," in *Atlantis: Länder, Völker, Reisen*. Leipzig, 1941 (pp. 25-29).

Lange and Hirmer 1968
K. Lange and M. Hirmer. *Egypt: Architecture-Sculpture-Painting in Three Thousand Years*. London and New York, 1968.

Lange and Schäfer 1902
H. Lange and H. Schäfer. *Grab- und Denksteine des Mittleren Reiches im Museum von Kairo* 4. Berlin, 1902.

Langton 1940
N. Langton. *The Cat in Ancient Egypt*. Cambridge, 1940.

Lansing 1920a
A. Lansing. "Excavations at Thebes 1918-19," in *BMMA Egyptian Supplements* (July 1920), pp. 4-11.

Lansing 1920b
A. Lansing. "Excavations at Thebes 1919-20," in *BMMA Egyptian Supplements* (July 1920), pp. 11ff.

Lansing 1928
A. Lansing. "Accessions to the Egyptian Collection," in *BMMA* 23, no. 6 (1928), pp. 158-160.

Lansing 1934
A. Lansing. "The Egyptian Expedition: The Excavations at Lisht," in *BMMA Egyptian Supplements* (November 1934), pp. 4ff.

Lansing 1938
A. Lansing. "A Silver Bottle of the Ptolemaic Period," *BMMA* 33 (1938), pp. 199-200.

Lansing and Hayes 1937
A. Lansing and W. Hayes. "The Egyptian Expedition 1935-6: The Museum's Excavations at Thebes," in *BMMA Egyptian Supplements* (January 1937), pp. 4-39.

Laskowska-Kusztal 1978
E. Laskowska-Kusztal. "Un Atelier de perruqier à Deir el-Bahari," in *Etudes et Travaux* 10 (1978), pp. 83ff.

Lauer 1976
J.-P. Lauer. *Saqqara: The Royal Cemetery of Memphis*. London, 1976.

Lauer and Altenmüller 1975
J.-P. Lauer and H. Altenmüller. "Architektur des alten Reiches," in C. Vandersleyen, ed., *Propyläen Kunstgeschichte* 15: *Das alten Agypten*. Berlin, 1975 (pp. 113-150).

Lauer et al. 1951
J. Lauer, V. Täckholm, and E. Åberg. "Les Plantes découvertes dans le souterrains de l'enceinte du roi Zoser à Saqqarah (IIIe Dynastie)," in *BIE* 32 (1951), pp. 121-157.

Leach 1954
E. Leach. "Primitive Time-Reckoning," in C. Singer et al., eds., *A History of Technology* 1. Oxford, 1954 (pp. 110-127).

Leake 1952
C Leake. *The Old Egyptian Medical Papyri*. Lawrence, (Kansas) 1952.

Leclant 1953
J. Leclant. "Deux Acquisitions récentes du Musée de Khartoum (nos. 5458 et 5459)," in *Kush* 1 (1953), pp. 47-52.

Leclant 1956
J. Leclant. "La 'Mascarade' des boeufs gras et le triomphe de l'Egypte," in *MDAIK* 14 (1956), pp. 128-145.

Leclant 1960
J. Leclant. "Astarte à cheval d'après les représentations égyptiennes," in *Syria* 37 (1960), pp. 1-68.

Leclant 1966
J. Leclant. "Fouilles et travaux en Egypte et au Soudan," in *Orientalia* 35 (1966), pp. 127-178.

Leclant 1975
J. Leclant. "Astarte," in *LA* 1 (1975), cols. 499-509.

Leeds 1922
E. Leeds. "Alabaster vases of the New Kingdom from Sinai," in *JEA* 8 (1922), pp. 1-4.

Leek 1972
F. Leek. "Teeth and Bread in Ancient Egypt," in *JEA* 58 (1972), pp. 126-133.

Leek 1973
F. Leek. "Further Studies Concerning Ancient Egyptian Bread," in *JEA* 59 (1973), pp. 199-204.

Leemans 1842
C. Leemans. *Monumens égyptiens du Musée d'Antiquités* 2. Leiden, 1842.

Leemans 1848-50
C. Leemans. *Aegyptische Monumenten van het Nederlandsche Museum van Oudheden te Leyden* 2, pt. 2. Leiden, 1848-1850.

Lefebvre 1924
G. Lefebvre. *Le Tombeau de Petosiris* 3. Cairo, 1924.

Lefebvre 1956
G. Lefebvre. *Essai sur la médicine égyptienne de l'époque pharaonique.* Paris, 1956.

Lefebvre 1960
G. Lefebvre. "Lait de vache et autres laits en Egypte," in *Rde* 12 (1960), pp. 59-65.

Legrain 1894
G. Legrain. *Collection H. Hoffmann: Catalogue des antiquités égyptiennes.* Paris, 1894.

Legrain 1903
G. Legrain. "Notes d'inspection. V. Sur Maia . . .," in *ASAE* 4 (1903), pp. 213ff.

Leibovitch 1960
J. Leibovitch. "The Statuette of an Egyptian Harper and Stringed Instruments in Egyptian Statuary," in *JEA* 46 (1960), pp. 53ff.

Lenormant 1857
F. Lenormant. *Catalogue d'une collection d'antiquités égyptiennes.* Paris, 1857.

Lenzen 1961
H. Lenzen. *XVII vorläufiger Bericht über die unternommenen Ausgrabungen in Uruk-Warka, 1961.* Berlin, 1961.

Lepsius 1865
K. Lepsius. *Ueber die Altaegyptische Elle und ihre Eintheilung.* Berlin, 1865.

Lepsius 1897
K. Lepsius. *Denkmäler aus Agypten und Athiopien* 1. Leipzig, 1897.

Lesko 1977
L. Lesko. *King Tut's Wine Cellar.* Berkeley, 1977.

Letellier 1978
B. Letellier. *La Vie quotidienne chez les artisans de Pharaon.* Metz, 1978.

Lewin et al. 1974
P. Lewin et al. "Nakht, a Weaver of Thebes," in *Rotunda* 7, No. 4 (1974), pp. 14-19.

Lichtheim 1945
M. Lichtheim. "The Songs of the Harpers," in *JNES* 4 (1945), pp. 178ff.

Lichtheim 1973
M. Lichtheim. *Ancient Egyptian Literature. A Book of Readings* 1. *The Old and Middle Kingdoms.* Berkeley, 1973.

Lilyquist 1979
C. Lilyquist. *Egyptian Mirrors from the Earliest Times through the Middle Kingdom.* Berlin, 1979.

Lloyd 1933
S. Lloyd. "Model of a Tell el-Amarna House," in *JEA* 19 (1933), pp. 1ff.

Lloyd 1954
S. Lloyd. "Building in Brick and Stone," in C. Singer et al., eds., *A History of Technology* 1. Oxford, 1954 (pp. 456-490).

Lloyd 1976
A. Lloyd. *Herodotus, Book II, Commentary 1-98.* Leiden, 1976.

Loat 1905
W. Loat. *Gurob.* London, 1905.

Loret 1889
V. Loret. "Les Flûtes égyptiennes antiques," in *Journal Asiatique* 14 (1889), pp. 111-142, 197-237.

Loret 1902
V. Loret. "L'Emblème hiéroglyphique de la vie," in *Sphinx* 5 (1902), pp. 138-147.

Loret and Poisson 1895
V. Loret and J. Poisson. "Etudes de botanique égyptienne," in *RT* 17 (1895), pp. 177-199.

Los Angeles County Museum of Art 1974
Los Angeles County Museum of Art. *Age of the Pharaohs. Catalogue of an Exhibition at the Los Angeles County Museum of Art, April 4-June 16, 1974, no. 50.* Los Angeles, 1974.

Loud 1939
G. Loud. *The Megiddo Ivories.* Chicago, 1939.

Lowie Museum 1966
Robert H. Lowie Museum of Anthropology. *Ancient Egypt: An Exhibition . . . March 25-October 23, 1966.* Berkeley, 1966.

Lucas 1922
A. Lucas. "The Inks of Ancient and Modern Egypt," *Analyst* 47 (1922), pp. 9-14.

Lucas 1928
A. Lucas. "Egyptian Use of Beer and Wines," *Ancient Egypt and the East* 1 (1928), pp. 1-5.

Lucas 1930
A. Lucas. "Ancient Egyptian Wigs," in *ASAE* 30 (1930), pp. 190-196.

Lucas 1962
A. Lucas. *Ancient Egyptian Materials and Industries.* 4th ed. (rev. by J. Harris). London, 1962.

Luckner 1971
K. Luckner. "Art of Egypt. Part II," in *Toledo Museum of Art: Museum News* 14, no. 3 (1971), pp. 59-82.

Lythgoe 1917
A. Lythgoe. "The Egyptian Expedition," *BMMA Egyptian Supplements* (May 1917), pp. 7-26.

Lythgoe 1927
A. Lythgoe. "The Carnarvon Egyptian Collection," in *BMMA* 22 (1927), pp. 31-38.

Mace 1911
A. Mace. "The Murch Collection of Egyptian Antiquities," in *BMMA Egyptian Supplements* (Jan. 1911), pp. 7-28.

Mace 1922
A. Mace. "Excavations at Lisht," in *BMMA Egyptian Supplements* (Dec. 1922), pp. 4-18.

Mace and Winlock 1916
A. Mace and H. Winlock. *The Tomb of Senebtisi at Lisht.* New York, 1916.

MacIver and Mace 1902
D. MacIver and A. Mace. *El Amrah and Abydos 1899-1901.* London, 1902.

MacIver and Woolley 1911
D. MacIver and L. Woolley. *Buhen.* Philadelphia, 1911.

MacKay 1920
E. MacKay. "Kheker Friezes," in *Ancient Egypt and the East* (1920), pp. 111-122.

MacKay 1924
E. MacKay. "The Representation of Shawls with a Rippled Stripe in the Theban Tombs," in *JEA* 10 (1924), pp. 41ff.

MacKay 1929
E. Mackay. *A Sumerian Palace and the "A" Cemetery at Kish, Mesopotamia* 2. Chicago, 1929.

MacKay 1931
E. Mackay. "Further Links between Ancient Sind, Sumer, and Elsewhere," in *Antiquity* 5 (1931), pp. 459ff.

Macramé 1971
Macramé, Techniques and Projects, 2nd ed. (by the editors of Sunset Books). Menlo Park, 1976.

Majno 1975
G. Majno. *The Healing Hand: Man and Wound in the Ancient World.* Cambridge, 1975.

Manniche 1975
L. Manniche. *Ancient Egyptian Musical Instruments.* Munich, 1975.

Manniche 1976
L. Manniche. *Musical Instruments from the Tomb of Tutankhamun.* Oxford, 1976.

Manniche 1977
L. Manniche. "Some Aspects of Ancient Egyptian Sexual Life," in *Acta Orientalia* 38 (1977), pp. 11-23.

Manniche 1978
L. Manniche. "Symbolic Blindness," in *CdE* 53 (1978), pp. 13-21.

Manuelian 1981
P. Manuelian. "Notes on the So-Called Turned Stools of the New Kingdom," in W. K. Simpson and W. Davis, eds., *Studies in Ancient Egypt, the Aegean, and the Sudan: Essays in Honor of Dows Dunham.* Boston, 1981 (pp. 125-128).

Mariette 1872
A. Mariette. *Album du Musée de Bulaq.* Cairo, 1872.

Mariette 1889
A. Mariette. *Monuments divers recueillis en Egypte et en Nubie.* Paris, 1889.

Marinatos 1971
S. Marinatos. *Excavations at Thera* 4. Athens, 1971.

Marinatos 1972
S. Marinatos. *Excavations at Thera* 5. Athens, 1972.

Marinatos 1974
S. Marinatos. *Excavations at Thera* 6. Athens, 1974.

Marshall 1931
J. Marshall. *Mohenjo-daro and the Indus Civilization.* London, 1931.

Martin 1954
R. Martin. "Papyrus Marshes Provided Egypt with Sport, Food, and Writing Material," in *Chicago Natural History Museum Bulletin* 25 (1954), p. 6.

Martin 1971
G. Martin. *Egyptian Administrative and Private-Name Seals.* Oxford, 1971.

Martin 1974
G. Martin. *The Royal Tomb at El-'Amarna.* London, 1974.

Martin 1977
K. Martin. "Haus-Darstellung," in *LA* 2 (1977), cols. 1064-1065.

Maspero 1887
G. Maspero. *L'Archéologie égyptienne.* Paris, 1887.

Maspero 1889
G. Maspero. *Egyptian Archaeology* (A. Edwards, tr.). 2nd ed. rev. New York, 1889.

Maspero 1912
G. Maspero. *Art in Egypt.* London, 1912.

Maspero 1913
G. Maspero. *Egyptian Art* (E. Lee, tr.). New York, 1913.

Maspero 1915
G. Maspero. *Guide du visiteur au Musée du Caire.* Cairo, 1915.

Megevand 1974
D. Megevand. "La Harpe Celtique," in *Bulletin du groupe d'acoustque musicale de l'Université de Paris* 6, no. 73 (1974), pp. 1-11.

Mekhitarian 1954
A. Mekhitarian. *Egyptian Painting.* New York, 195-

Mercer 1935
S. Mercer. "Astarte in Egypt," in *Egyptian Religion* 3 (1935), pp. 192-203.

Mercer 1939
S. Mercer. *The Tell El-Amarna Tablets.* Toronto, 1939.

Mercer 1942
S. Mercer. *Horus, Royal God of Egypt.* Grafton, Mass., 1942.

Mercer 1949
S. Mercer. *The Religion of Ancient Egypt.*
London, 1949.

Merrillees 1962a
R. Merrillees. "Bronze Age Spindle Bottles from the
Levant," in *Opuscula Atheniensia* 4 (1962),
pp. 189-196.

Merrillees 1962b
R. Merrillees. "Opium Trade in the Bronze Age
Levant," in *Antiquity* 144 (1962), pp. 287-292.

Merrillees 1968
R. Merrillees. *The Cypriote Bronze Age Pottery
Found in Egypt.* Lund, 1968.

Merrillees 1974
R. Merrillees. *Trade and Transcendence in the
Bronze Age Levant.* Göteborg, 1974.

Merrillees and Winter 1972
R. Merrillees and J. Winter. "Bronze Age Trade
between the Aegean and Egypt. Minoan and
Mycenaean Pottery from Egypt in the Brooklyn
Museum," in *Miscellanea Wilbouriana* 1 (1972),
pp. 101ff.

Mertz, 1978
B. Mertz. "The Pleasures of Life," in *Ancient
Egypt: Discovering its Splendors.*
Washington, D.C., 1978 (pp. 102-139).

Metropolitan Museum of Art 1944
Metropolitan Museum of Art. *The Home Life of
the Ancient Egyptians: A Picture Book* (by N.
Scott). New York, 1944.

Mez-Mangold 1971
L. Mez-Mangold. *A History of Drugs.* Basel, 1971.

Michalowski 1968
K. Michalowski. *Art of Ancient Egypt.* New York,
1968.

Miosi 1973
F. Miosi. "Two Additional Examples of Right Side
Breast-Feeding," in *Society for the Study of
Egyptian Antiquities* 3 (1973), pp. 4-7.

Mogensen 1930
M. Mogensen. *La Glyptothèque Ny Carlsberg: La
collection égyptienne.* Copenhagen, 1930.

Moldenke and Moldenke 1952
H. and A. Moldenke. *Plants of the Bible.*
New York, 1952.

Möller 1924
G. Möller. *Die Metallkunst der alten Agypter.*
Berlin, 1924.

Mond and Emery 1927
R. Mond and W. Emery. "Excavations at Sheikh
Abd el-Gurneh 1925-6," in *LAAA* 14 (1927),
pp. 13-34.

Mond and Emery 1929
R. Mond and W. Emery. "The Burial Shaft of the
Tomb of Amenemhat," in *LAAA* 16 (1929),
pp. 49-74.

Monica 1975
M. Della Monica. *La Classe ouvrière sous les
pharaons.* Paris, 1975.

Monnet-Saleh 1970
J. Monnet-Saleh. *Les Antiquités égyptiennes de
Zagreb.* Paris, 1970.

Montagu 1978
J. Montagu. "One of Tutankhamun's Trumpets,"
in *JEA* 64 (1978), pp. 133-134.

Montet 1931
P. Montet. "Contribution à l'étude des mastabas
de l'Ancien Empire: 4.- Le signe 𓃺 et le nom du
barbier," in *Kêmi* 4 (1931), pp. 178-189.

Montet 1937
P. Montet. *Les Reliques de l'art Syrien dans
l'Egypte du Nouvel Empire.* Paris, 1937.

Montet 1951
P. Montet. *Les Constructions et le tombeau de
Psousennès à Tanis.* Paris, 1951.

Montet 1962
P. Montet. *Everyday Life in Egypt in the Days of
Ramsses the Great.* Chatham, England, 1962.

Moorey 1970
P. Moorey. *Ancient Egypt.* Oxford, 1970.

Morant 1939
H. de Morant. "Les Objets de toilette dans
l'ancienne Egypte," in *La Nature*, no. 3053
(July 15, 1939), p. 36.

Moret 1902a
A. Moret. *Du Caractère religieux de la royauté
pharaonique.* Paris, 1902.

Moret 1902b
A. Moret. *Le Rituel du culte divin journalier en
Egypte.* Paris, 1902.

Morgan 1895
J. de Morgan. *Notice des principaux monuments
exposés au Musée de Gizeh.* Cairo, 1895.

Morse 1967
D. Morse. "Tuberculosis," in D. Brothwell and A.
Sandison, eds., *Diseases in Antiquity: A Survey of
the Diseases, Injury and Surgery of Early
Populations.* Springfield, 1967 (pp. 249ff.).

Moussa and Altenmüller 1971
A. Moussa and H. Altenmüller. *The tomb of Nefer
and Kahay.* Mainz am Rhein, 1971.

Moussa and Altenmüller 1977
A. Moussa and H. Altenmüller. *Das Grab des
Nianchchnum und Chnumhotep.* Mainz am
Rhein, 1977.

Müller 1906
W. Müller. *Egyptological Researches. Results of a
Journey in 1904.* Washington, 1906.

Müller 1915
K. Müller. "Frühmykenische Reliefs," in *Jahrbuch
des Archäologischen Instituts* 30 (1915), pp. 242ff.

Müller 1955
H. Müller. "Ein Konigsbildnis der 26. Dynastie mit
der 'Blauenkrone' im Museo Civico zu Bologna,"
in *ZAS* 80 (1955), pp. 46-68.

Müller 1960
H. Müller. "Egitto Antico," in *Enciclopedia
Universale dell'Arte* 4. Venice and Rome, 1960.

Müller 1964
H. Müller. *Agyptische Kunstwerke, Kleinfunde und
Glas in der Sammlung E. und M. Kofler-Truniger,
Luzern.* Berlin, 1964.

Müller 1969
H. Müller. "Ein Siegelring Ramses' II," in
Pantheon 27, no. 5 (1969), pp. 359ff.

Müller 1970
H. Müller. "Bericht des staatlichen Kunst
Sammlungen-Neuerwerbungen-Staatliche
Sammlung ägyptischer Kunst," in *Münchner
Jahrbuch der bildenden Kunst* (1970), p. 186.

Müller 1977
C. Müller. "Haar," in *LA* 2 (1976), col. 924.

Münzen und Medaillen 1969
Münzen und Medaillen. *Kunstwerke der Antike:
Auktion 40, Dec. 13, 1969.* Basel, 1969.

Munro 1969
P. Munro. "Eine Gruppe spätägyptischer
Bronzespiegel," in *ZAS* 95 (1969), pp. 92-109.

Munsell 1905
A. Munsell. *A Color Notation.* Boston, 1905.

Murnane 1977
W. Murnane. *Ancient Egyptian Coregencies.*
Chicago, 1977.

Murray 1911
M. Murray. "Figure Vases in Egypt," in E. Knobel
et al., eds., *Historical Studies.* London, 1911
(pp. 40-46).

Murray 1945
A. Murray. *Homer: The Odyssey.* London, 1945.

Murray 1963
M. Murray. *The Splendour that was Egypt.* Rev. ed.
New York, 1963.

Murray and Nuttall 1963
H. Murray and M. Nuttall. *A Handlist to Howard
Carter's Catalogue of Objects in Tut'ankhamūn's
Tomb.* Oxford, 1963.

Murray and Walters 1900
A. Murray and H. Walters. *Excavations in Cyprus.*
London, 1900.

Musées Royaux 1934
Musées Royaux d'art et d'histoire: Département
egyptien. *Album.* Brussels, 1934.

Musées Royaux 1958
Musées Royaux d'art et d'histoire. *Antiquités,
Extrême-Orient.* Brussels, 1958.

Museum of Fine Arts 1903
Museum of Fine Arts. "The Egyptian
Department," in *BMFA* 1 (1903), p. 25.

Museum of Fine Arts 1904
Museum of Fine Arts. "An Ephod (?) from
Thebes," in *BMFA* 2 (1904), pp. 7-8.

Museum of Fine Arts 1942
Museum of Fine Arts. *Ancient Egypt as
Represented in the Museum of Fine Arts* (by
W. S. Smith). Boston, 1942.

Museum of Fine Arts 1946
Museum of Fine Arts. *Ancient Egypt as
Represented in the Museum of Fine Arts* (by
W. S. Smith). 2nd ed. Boston, 1946.

Museum of Fine Arts 1952
Museum of Fine Arts. *Ancient Egypt as
Represented in the Museum of Fine Arts* (by
W. S. Smith). 3rd ed., rev. Boston, 1952.

Museum of Fine Arts 1960
Museum of Fine Arts. *Ancient Egypt as
Represented in the Museum of Fine Arts* (by
W. S. Smith). 4th ed., rev. Boston, 1960.

Museum of Fine Arts 1965
Museum of Fine Arts, Boston. Research
Laboratory. *Application of Science in the
Examination of Works of Art.* Boston, 1965.

Museum of Fine Arts 1971
Museum of Fine Arts. *Museum of Fine Arts,
Boston: Western Art.* Kodansha, 1971.

Museum of Fine Arts 1972
Museum of Fine Arts. *The Rathbone Years.*
Boston, 1972.

Museum of Fine Arts 1977
Museum of Fine Arts. *The Museum Year 1976-77:
The Hundred and First Annual Report of the
Museum of Fine Arts.* Boston, 1977.

Museum of Fine Arts 1978
Museum of Fine Arts. *The Museum Year 1977-78:
The One Hundred Second Annual Report of the
Museum of Fine Arts.* Boston, 1978.

Museum of Fine Arts 1979
Museum of Fine Arts.*The Museum Year 1978-79:
The One Hundred Third Annual Report of the
Museum of Fine Arts.* Boston, 1979.

Mylonas 1973
G. Mylonas. *Ho Taphikos Kuklos B ton Mykenon.*
Athens, 1973.

Nagel 1931
G. Nagel. "Quelques Représentations de chevaux
sur des poteries de Nouvel Empire," in *BIFAO* 30
(1931), pp. 185-194.

Nagel 1938
G. Nagel. *La Céramique du Nouvel Empire à Deir
el Médineh.* Cairo, 1938.

Nagel 1949
G. Nagel. "Un Détail de la décoration d'une
tombe thebaine: Un Vase avec une représentation
de chevaux," in *JEA* 35 (1949), pp. 129-131.

Nagy 1977
E. Nagy. "Fragments de sistres au Musée des
Beaux Arts," in *Bulletin du Musée Hongrois Beaux
Arts* 48-49 (1977), pp. 49-70.

Nash 1902
W. Nash. "Ancient Egyptian Draughts-Boards and
Draughts-Men," in *PSBA* 24 (1902), pp. 341ff.

Naville 1894
E. Naville. *Ahnas el Medineh (Heracleopolis
Magna).* London, 1894.

Naville 1896
E. Naville. *The Temple of Deir el Bahari* 2.
London, 1896.

Naville 1898
E. Naville. *The Temple of Deir el Bahari* 3.
London, 1898.

Naville 1907
E. Naville. *The 11th Dynasty Temple at Deir el-Bahari* 1. London, 1907.

Naville 1908
E. Naville. *The Temple of Deir el Bahari* 6. London, 1908.

Naville 1913
E. Naville. *The 11th Dynasty Temple at Deir el-Bahari* 3. London, 1913.

Naville et al. 1914
E. Naville et al. *The Cemeteries of Abydos. Part I. The Mixed Cemetery and Umm El-Ga'ab.* London, 1914.

Needler 1953
W. Needler. "A Thirty-Square Draught-Board in the Royal Ontario Museum," in *JEA* 39 (1953), pp. 60ff.

Needler 1967
W. Needler. "Looking at Ancient Egypt in the Royal Ontario Museum," in *Connoisseur* 166 (1967), pp. 95-100

Needler and Graham 1953
W. Needler and J. Graham. "Jewellery of the Ancient World," in *Royal Ontario Museum of Archaeology Bulletin,* no. 20 (January 1953).

Negbi 1978
O. Negbi. "Cypriote Imitations of Tell el-Yahudiyeh Ware from Toumba tou Skourou," in *AJA* 82 (1978), pp. 137ff.

Nelson 1936
G. Nelson. "A Faience Rhyton from Abydos in the Boston Museum of Fine Arts," in *AJA* 40 (1936), pp. 501ff.

Nelson 1949
H. Nelson. "The Rite of 'Bringing the Foot' as Portrayed in Temple Reliefs," in *JEA* 35 (1949), pp. 82-87.

Nelson and Hölscher 1934
H. Nelson and U. Hölscher. *Work in Western Thebes 1931-33.* Chicago, 1934.

Nesbitt 1878
A. Nesbitt. *A Descriptive Catalogue of the Glass Vessels in the South Kensington Museum.* London, 1878.

Neuberg 1962a
F. Neuberg. *Antikes Glas.* Darmstadt, 1962.

Neuberg 1962b
F. Neuberg. *Ancient Glass.* Toronto, 1962.

New Orleans Museum of Art 1977
New Orleans Museum of Art. *Eye for Eye: Egyptian Images and Inscriptions.* Baton Rouge, 1977.

New-York Historical Society 1873
New-York Historical Society. *Catalogue of the Museum and Gallery of Art of the New-York Historical Society, 1873.* New York, 1873.

New-York Historical Society 1915
New-York Historical Society. *Catalogue of the Egyptian Antiquities of the New York Historical Society.* New York, 1915.

Newberry 1893a
P. Newberry. *Beni Hasan* 1. London, 1893.

Newberry 1893b
P. Newberry. *Beni Hasan* 2. London, 1893.

Newberry 1907
P. Newberry. *Scarab-Shaped Seals.* London, 1907.

Newberry 1908
P. Newberry. *Scarabs.* London, 1908.

Newberry 1920
P. Newberry. "A Glass Chalice of Tuthmosis III," in *JEA* 6 (1920), pp. 155-160.

Newberry 1928
P. Newberry. "The Pig and the Cult-Animal of Set," in *JEA* 14 (1928), pp. 211-225.

Newberry 1933
P. Newberry. "A Statue and a Scarab," in *JEA* 19 (1933), pp. 53-54.

Newton 1924
F. Newton. "Excavations at El-Amarnah, 1923-4," in *JEA* 10 (1924), pp. 289-298.

Nims 1965
C. Nims. *Thebes of the Pharaohs.* New York, 1965.

Noble 1969
J. Noble. "The Technique of Egyptian Faience," in *AJA* 73 (1969), pp. 435-439.

Noll 1978
W. Noll. "Mineralogie und Technik der bemalten Keramiken altägyptens," in *Neues Jahrbuch für Mineralogie Abhandlungen* 133 (1978), pp. 227-290.

Noll and Hangst 1975
W. Noll and K. Hangst. "Zur Kenntnis der altägyptischen Blaupigmente," in *Neues Jahrbuch für Mineralogie, Monatshefte* (1975), pp. 209-214.

Nolte 1968
B. Nolte. *Die Glasgefässe im alten Agypten.* Berlin, 1968.

Northampton et al. 1908
W. Compton, Marquis of Northampton et al. *Report on Some Excavations in the Theban Necropolis 1898-99.* London, 1908.

O'Connor 1972
D. O'Connor. "The Geography of Settlement in Ancient Egypt," in P. Ucko, et al., eds., *Man, Settlement and Urbanism.* London, 1972.

Oesterley 1927
W. Oesterley. *The Wisdom of Egypt and the Old Testament in the Light of the Newly Discovered 'Teaching of Amen-em-ope.'* New York, 1927.

Oliver 1968
A. Oliver. "Millefiori Glass in Classical Antiquity," in *JGS* 10 (1968), pp. 48-70.

Oliver 1977
A. Oliver. *Silver for the Gods: 800 Years of Greek and Roman Silver.* Toledo, 1977.

Omlin 1973
J. Omlin. *Der Papyrus 55001 und seine satirisch-erotischen Zeichnungen und Inschriften.* Turin, 1973.

Oppenheim et al. 1970
A. Oppenheim, R. Brill and D. Barag. *Glass and Glassmaking in Ancient Mesopotamia.* Corning, 1970.

Oriental Institute 1930
University of Chicago, Oriental Institute Epigraphic Survey. *Medinet Habu, 1. Earlier Historical Records of Ramses III* (by H. Nelson et al.). Chicago, 1930.

Oriental Institute 1938
University of Chicago, Oriental Institute Sakkarah Expedition. *The Mastaba of Mereruka* 2. (P. Duell, Field Director). Chicago, 1938.

Oriental Institute 1939
University of Chicago, Oriental Institute Epigraphic Survey. *The Excavation of Medinet Habu 2. The Temples of the Eighteenth Dynasty* (by U. Hölscher). Chicago, 1939.

Oriental Institute 1941
University of Chicago, Oriental Institute Epigraphic Survey. *The Excavation of Medinet Habu 3. The Mortuary Temple of Ramses III,* pt. 1 (by U. Hölscher). Chicago, 1941.

Oriental Institute 1951
University of Chicago, Oriental Institute Epigraphic Survey. *The Excavation of Medinet Habu 3. The Mortuary Temple of Ramses III,* pt. 2 (by U. Hölscher). Chicago, 1951.

Oriental Institute 1970
University of Chicago, Oriental Institute Epigraphic Survey. *The Excavation of Medinet Habu 8. The Eastern High Gate.* Chicago, 1970.

Otto 1960
E. Otto. *Das ägyptische Mundöffnungsritual* 2. Wiesbaden, 1960.

Otto 1964
E. Otto. *Gott und Mensch nach den ägyptischen Tempelinschriften der griechisch-römischen Zeit.* Heidelberg, 1964.

Otto 1975
E. Otto. "Bastet," in *LA* 1 (1975), cols. 628-630.

Page 1976
A. Page. *Egyptian Sculpture, Archaic to Saite, from the Petrie Collection.* Warminster, 1976.

Parker 1962
R. Parker. *A Saite Oracle Papyrus from Thebes in The Brooklyn Museum (Papyrus Brooklyn 47.218.3).* Providence, 1962.

Passalacqua 1826
J. Passalacqua. *Catalogue raisonné et historique des antiquités découvertes en Egypte.* Paris, 1826.

Paton 1925
D. Paton. *Animals of Ancient Egypt.* Princeton, 1925.

Pavlov and Khodzhash 1959
V. Pavlov and S. Khodzhash. *Khudozhestvennoe remeslo Drevnego Egipta.* Moscow, 1959.

Pawlicki 1974
F. Pawlicki. "Egipskie sistra," in *Rocznik Muzeum Nardowego w Warszawie* 18 (1974), pp. 7-21.

Payne 1966
J. Payne. "Spectrographic Analysis of Some Egyptian Pottery," in *JEA* 52 (1966), pp. 176ff.

Peck 1978a
W. Peck. *Egyptian Drawings.* New York, 1978.

Peck 1978b
W. Peck. "Two Seated Scribes of Dynasty Eighteen," in *JEA* 64 (1978), pp. 72-75.

Peet 1914
T. E. Peet. *The Cemeteries of Abydos, pt. 2, 1911-1912.* London, 1914.

Peet 1921
T. E. Peet. "Excavations at Tell el-Amarna: A Preliminary Report," in *JEA* 7 (1921), pp. 169ff.

Peet and Loat 1913
T. E. Peet and W. Loat. *The Cemeteries of Abydos 3.* London, 1913.

Peet and Woolley 1923
T. E. Peet and C. Woolley. *The City of Akhenaten 1. Excavations of 1921 and 1922 at el-Amarneh.* London, 1923.

Peltenburg 1973
E. Peltenburg. "On the Classification of Faience Vases from Late Bronze Age Cyprus," in *Acts of the First International Congress of Cypriote Studies* (1973), pp. 129ff.

Peltenburg 1974
E. Peltenburg. "The Glazed Vases, Including a Polychrome Rhyton," Appendix I in V. Karageorghis, *Kition 1. The Tombs.* Nicosia, 1974 (pp. 105ff.).

Peltenburg 1967
E. Peltenburg. "The Faience Vases from Tombs 1 and 2 at Hala Sulta Tekké 'Vizaja,'" Appendix 6 in P. Åström, D. Bailey, V. Karageorghis, eds. *Hala Sultan Tekké 1.* Göteborg, 1976 (pp. 104ff.).

Pendlebury 1930a
J. Pendlebury. *Aegyptiaca: A Catalogue of Objects in the Aegean Area.* Cambridge, 1930.

Pendlebury 1930b
J. Pendlebury. "Egypt and the Aegean in the Late Bronze Age," in *JEA* 16 (1930), pp. 75ff.

Pendlebury 1931
J. Pendlebury. "Preliminary Report of Excavations at Tell El-'Amarnah, 1930-31," in *JEA* 17 (1931), pp. 233-244.

Pendlebury 1932
J. Pendlebury. "Preliminary Report of the Excavations at Tell El-'Amarnah, 1931-2," in *JEA* 18 (1932), pp. 143-149.

Pendlebury 1933
J. Pendlebury. "Preliminary Report of the Excavations at Tell El-'Amarnah, 1932-1933," in *JEA* 19 (1933), pp. 113ff.

Pendlebury 1935
J. Pendlebury. *Tell El-Amarna.* London, 1935.

Pendlebury 1936
J. Pendlebury. "Summary Report on the Excavations at Tell El-'Amarnah, 1935-1936," in *JEA* 22 (1936), pp. 194-198.

Pendlebury 1951
J. Pendlebury. *The City of Akhenaten 3.* London, 1951.

Perla 1976
F. Perla. "El Culto oficial de las divinidades asiáticas en Egipto durante el Imperio Nuevo," in *RIHAO* 3 (1976), pp. 127-145.

Perrot and Chipiez, 1882
G. Perrot and C. Chipiez. *Histoire de l'art dans l'antiquité* 1 (*L'Egypte*). Paris, 1882.

Peterson 1973
B. Peterson. "Zeichnungen aus einer Totenstadt," in *Medelhausmuseet Bulletin* 7-8 (1973), pp. 9-141.

Peterson 1978
B. Peterson. "Steingefässe aus dem Neuen Reich," in *Medelhausmuseet Bulletin* 13 (1978), pp. 6-13.

Petrie 1883
W. M. F. Petrie. "On the Mechanical Methods of the Ancient Egyptians," in *Journal of the Anthropological Institute* [of Great Britain and Ireland]. (August 1883), pp. 88-106.

Petrie 1886
W. M. F. Petrie. *Naucratis* 1. London, 1886.

Petrie 1888
W. M. F. Petrie. *Nebesheh (Am) and Defenneh (Tahpanhes)*. London, 1888.

Petrie 1889
W. M. F. Petrie. *Historical Scarabs*. London, 1889.

Petrie 1890
W. M. F. Petrie. *Kahun, Gurob and Hawara*. London, 1890.

Petrie 1891
W. M. F. Petrie. *Illahun, Kahun and Gurob 1889-90*. London, 1891.

Petrie 1892a
W. M. F. Petrie. *Medum*. London, 1892.

Petrie 1892b
W. M. F. Petrie. *Ten Years Digging in Egypt, 1881-1891*. New York, 1892.

Petrie 1894
W. M. F. Petrie. *Tell El-Amarna*. London, 1894.

Petrie 1895
W. M. F. Petrie. *Egyptian Decorative Art*. London, 1895.

Petrie 1896a
W. M. F. Petrie. *Koptos*. London, 1896.

Petrie 1896b
W. M. F. Petrie. *Naqada and Ballas*. London, 1896.

Petrie 1898
W. M. F. Petrie. *Deshasheh*. London, 1898.

Petrie 1900a
W. M. F. Petrie. *The Royal Tombs of the First Dynasty* (pt. 1). London, 1900.

Petrie 1900b
W. M. F. Petrie. *Dendereh 1898*. London, 1900.

Petrie 1901
W. M. F. Petrie. *Diospolis Parva: The Cemeteries of Abadiyeh and Hu, 1898-9*. London, 1901.

Petrie 1904
W. M. F. Petrie. *Methods and Aims in Archaeology*. London, 1904.

Petrie 1906a
W. M. F. Petrie. *Hyksos and Israelite Cities*. London, 1906.

Petrie 1906b
W. M. F. Petrie. *Researches in Sinai*. London, 1906.

Petrie 1907
W. M. F. Petrie. *Gizeh and Rifeh*. London, 1907.

Petrie 1909a
W. M. F. Petrie. *Memphis* 1. London, 1909.

Petrie 1909b
W. M. F. Petrie. *Qurneh*. London, 1909.

Petrie 1910
W. M. F. Petrie. *Arts and Crafts of Ancient Egypt*. Chicago, 1910.

Petrie 1913
W. M. F. Petrie. *Tarkhan I and Memphis V*. London, 1913.

Petrie 1914a
W. M. F. Petrie. *Amulets*. London, 1914.

Petrie 1914b
W. M. F. Petrie. *Tarkhan II*. London, 1914.

Petrie 1915a
W. M. F. Petrie. *Exhibition Handbook*. London, 1915.

Petrie 1915b
W. M. F. Petrie. "The Metals in Egypt," in *Ancient Egypt and the East*" (1915). pp. 12-23.

Petrie 1917a
W. M. F. Petrie. *Scarabs and Cylinders with Names*. London, 1917.

Petrie 1917b
W. M. F. Petrie. *Tools and Weapons*. London, 1917.

Petrie 1925
W. M. F. Petrie. *Buttons and Design Scarabs*, London, 1925.

Petrie 1926
W. M. F. Petrie. *Weights and Measures*. London, 1926.

Petrie 1927
W. M. F. Petrie. *Object of Daily Use*. London, 1927.

Petrie 1928
W. M. F. Petrie. *Gerar*. London, 1928.

Petrie 1930
W. M. F. Petrie. *Antaeopolis*. London, 1930.

Petrie 1931
W. M. F. Petrie. *Seventy Years in Archaeology*. London, 1931.

Petrie 1932
W. M. F. Petrie. *Ancient Gaza* 2. London, 1932.

Petrie 1934
W. M. F. Petrie. *Measures and Weights*. London, 1934.

Petrie 1937
W. M. F. Petrie. *Funeral Furniture and Stone Vases*. London, 1937.

Petrie 1938
W. M. F. Petrie. "The Present Position of the Metrology of Egyptian Weights," in *JEA* 24 (1938), pp. 180-181.

Petrie 1953
W. M. F. Petrie. *Corpus of Proto-Dynastic Pottery*. London, 1953.

Petrie and Brunton 1924
W. M. F. Petrie and G. Brunton. *Sedment*. London, 1924.

Petrie et al. 1912
W. M. F. Petrie, G. Wainwright, and E. Mackay. *The Labyrinth, Gerzeh, and Mazghuneh*. London, 1912.

Phillips 1941
D. Phillips. "Cosmetic Spoons in the Form of Swimming Girls," in *BMMA* 36 (1941), pp. 173-175.

Phillips 1944
D. Phillips. "Fish Tales and Fancies," in *BMMA* 2 (1944), pp. 184-189.

Phillips 1948
D. Phillips. *Ancient Egyptian Animals*. New York, 1948.

Piankoff 1974
A. Piankoff. *The Wandering of the Soul*. Princeton, 1974.

Piccione 1980
P. Piccione. "In Search of the Meaning of Senet," in *Archaeology* 33 (1980), pp. 55-58.

Pieper 1909
M. Pieper. *Das Brettspiel der alten Agypter*. Berlin, 1909.

Pieper 1931
M. Pieper. "Ein Texte über das ägyptische Brettspiel," in *ZAS* 66 (1931), pp. 15ff.

Pierret 1874
P. Pierret. *Recueil d'inscriptions inédites du Musée égyptien du Louvre* 1. Paris, 1874.

Pierret 1895
P. Pierret. "La Coudée royale du Musée Egyptien du Louvre," in *PSBA* 17 (1895), pp. 208-209.

Pietschmann 1894
R. Pietschmann. "Drei Fische zu einem Kopf . . . ," in *ZAS* 32 (1894), p. 134.

Pijóan 1950
J. Pijóan. *Summa Artis. Historia general del Arte* 3: *El Arte egipico*. Madrid, 1950.

Pillet 1952
M. Pillet. "Les Scènes de naissance et de circoncision dans le temple nord-est de Mout, à Karnak," in *ASAE* 52 (1952), pp. 77-104.

Piovano 1952
P. Piovano. "Contributo alla conoscenza della flora faraonica aggiunta allo studio delle piante egiziane del Museo Egizio di Torino," in *Nuovo Giornale Botanico Italiano* 59 (1952), pp. 43-48.

Pollock 1974
N. Pollock. *Animals, Environment, and Man in Africa*. Westmead, U.K., 1974.

Porter and Moss 1934
B. Porter and R. Moss. *Topographical Bibliography of Ancient Egyptian Hieroglyphic Texts, Reliefs, and Paintings* 4: *Lower and Middle Egypt*. Oxford, 1934.

Porter and Moss 1960
B. Porter and R. Moss. *Topographical Bibliography of Ancient Egyptian Hieroglyphic Texts, Reliefs, and Paintings* 1: *Theban Necropolis* 1. 2nd ed., rev. Oxford, 1960.

Porter and Moss 1964
B. Porter and R. Moss. *Topographical Bibliography of Ancient Egyptian Hieroglyphic Texts, Reliefs, and Paintings* 1: *Theban Necropolis* 2. 2nd ed., rev. Oxford, 1964.

Porter and Moss 1972 *Topographical Bibliography of Ancient Egyptian Hieroglyphic Texts, Reliefs, and Paintings* 2: *Theban Temples*. 2nd ed., rev. Oxford, 1972.

Posener 1934
G. Posener. "A Propos de la stèle de Bentresh," in *BIFAO* 34 (1934), pp. 75-81.

Posener 1951
G. Posener. "Ostraca inédits du Musée de Turin," in *RdE* 8 (1951), pp. 178-180.

Posener 1959
G. Posener. *Dictionnaire de la civilisation égyptienne*. Paris, 1959.

Posener 1969
G. Posener. "'Maquilleuse' en Egyptien," in *RdE* 21 (1969), pp. 150-151.

Posener 1975
G. Posener. "La Piété personelle avant l'âge amarnien," in *RdE* 27 (1975), pp. 195-210.

Poursat 1977
J.-C. Poursat. *Les Ivoires mycéniens*. Paris, 1977.

Prager 1975
E. Prager. *Ancient Egypt: A Survey*. New York, 1975.

Price 1908
F. Price. *A Catalogue of the Egyptian Antiquities in the Possession of F. G. Hilton Price*, London, 1908.

Prisse d'Avennes 1846
E. Prisse d'Avennes. *Revue archéologique ou recueil de documents et de mémoires relatifs à l'étude des monuments et à la philologie de l'antiquité et du Moyen Age*, vol. 2:2. Paris, 1846.

Prisse d'Avennes 1847
E. Prisse d'Avennes. *Monuments égyptiens*. Paris, 1847.

Prisse d'Avennes 1878
E. Prisse d'Avennes. *Histoire de l'art égyptien: Atlas* 2. Paris, 1878.

Pritchard 1950
J. Pritchard, ed. *Ancient Near Eastern Texts Relating to the Old Testament*. Princeton, 1950.

Pritchard 1954
J. Pritchard, ed. *The Ancient Near East in Pictures*. Princeton, 1954.

Pusch 1976
E. Pusch. "Ein zweiter Beleg für das Spielbrett Kairo JdE 68.127," in *GM* 22 (1976), pp. 53ff.

Pusch 1977
E. Pusch. "Eine unbeachtete Brettspielart," in *SAK* 5 (1977), pp. 199ff.

Pusch 1979
E. Pusch. *Das Senet-Brettspiel in alten Agypten, pt. 1: Das inschriftliche und archäologische material*. Munich/Berlin, 1979.

Quibell 1896
J. Quibell. *Ballas*. London, 1896.

Quibell 1900
J. Quibell. *Hieraconpolis* 1. London, 1900.

Quibell 1901
J. Quibell. "A Tomb at Hawaret el Gurob," in *ASAE* 2 (1901), pp. 141-143.

Quibell 1908a
J. Quibell. *Excavations at Saqqara 2, 1906-1907*. Cairo, 1908.

Quibell 1908b
J. Quibell. *The Tomb of Yuaa and Thuiu*. Cairo, 1908.

Quibell 1909
J. Quibell. *Excavations at Saqqara 3, 1907-1908*. Cairo, 1909.

Quibell 1912
J. Quibell. *Excavations at Saqqara 4, 1908-9, 1909-10: The Monastery of Apa Jeremias*. Cairo, 1912.

Quibell 1913
J. Quibell. *Excavations at Saqqara 5, 1911-1912: The Tomb of Hesy*. Cairo, 1913.

Quibell 1923
J. Quibell. *Excavations at Saqqara 6, 1912-1914: Archaic Mastabas*. Cairo, 1923.

Quibell 1935
J. Quibell. "Stone Vessels from the Step Pyramid," in *ASAE* 35 (1935), pp. 76-80.

Quibell and Green 1902
J. Quibell and F. Green. *Hierakonpolis* 2. London, 1902.

Quibell and Hayter 1927
J. Quibell and A. Hayter. *Excavations at Saqqara: Teti Pyramid, North Side*. Cairo, 1927.

R. L. H. 1927
R. L. H. "Egyptian Acquisitions," in *British Museum Quarterly* 2, no. 3 (1927), pp. 63-64.

Raison 1968
J. Raison. *Les Vases à inscriptions peintes de l'âge mycénien et leur contexte archéologique*. Rome, 1968.

Rand 1970
H. Rand. "Figure-Vases in Ancient Egypt and Hebrew Midwives," in *IEJ* 20 (1970), pp. 209-212.

Randall 1966
R. Randall. "Jewellery through the Ages," in *Apollo* 84 (December 1966), pp. 495-499.

Ranke 1933
H. Ranke. "Medicine and Surgery in Ancient Egypt," in *Bulletin of the Institute of the History of Medicine* 1, no. 7 (August 1933), pp. 237-257.

Ranke 1935
H. Ranke. *Die Agyptischen Personennamen* 1. Glückstadt/Hamburg, 1935.

Ranke 1936
H. Ranke. *The Art of Ancient Egypt*. Vienna, 1936.

Ranke 1950
H. Ranke. "The Egyptian Collection of the University Museum," in *University of Pennsylvania Museum Bulletin* 15, nos. 2-3 (November 1950).

Ranke 1952
H. Ranke. *Die Agyptischen Personennamen* 2. Glückstadt/Hamburg, 1952.

Redford 1965
D. Redford. "The Coregency of Tuthmosis III and Amenophis II," in *JEA* 51 (1965), pp. 107-122.

Redford 1967
D. Redford. *History and Chronology of the Eighteenth Dynasty*. Toronto, 1967.

Reed and Osborn 1978
C. Reed and D. Osborn. "Taxonomic Transgressions in Tutankhamun's Treasures," in *AJA* 82 (1978), pp. 273-283.

Reisner 1905
G. Reisner. *The Hearst Medical Papyrus*. Leipzig, 1905.

Reisner 1907
G. Reisner. *Amulets* 1. Cairo, 1907.

Reisner 1910
G. Reisner. *Archaeological Survey of Nubia. Report for 1907-1908*. Cairo, 1910.

Reisner 1915
G. Reisner. "Accessions to the Egyptian Department during 1914," in *BMFA* 13 (1915), pp. 71-83.

Reisner 1920a
G. Reisner. "Note on the Statuette of a Blind Harper in the Cairo Museum," in *JEA* 6 (1920), pp. 117-118.

Reisner 1920b
G. Reisner. "The Viceroys of Ethiopia," in *JEA* 6 (1920), pp. 28-55, 73-88.

Reisner 1923a
G. Reisner. "Excavations at Kerma, 1-3," in *HAS* 5 (1923).

Reisner 1923b
G. Reisner. "Excavations at Kerma, 4-5," in *HAS* 6 (1923).

Reisner 1955
G. Reisner. *A History of the Giza Necropolis*. London, 1955.

Reisner 1958
G. Reisner. *Amulets* 2. Cairo, 1958.

Reisner and Smith 1955
G. Reisner and W. S. Smith. *The Tomb of Hetepheres*. Cambridge, 1955.

Rhodes 1980
L. Rhodes. *Science within Art* (exhibition catalogue). Cleveland, 1980.

Ricke 1932
H. Ricke. *Der Grundriss des Amarna-Wohnhauses*. Leipzig, 1932.

Ricke 1966
H. Ricke. "Ein Hausmodell im Kestnermuseum zu Hannover," in *ZAS* 93 (1966), pp. 119-123.

Ricke et al. 1967
H. Ricke, G. Hughes, and E. Wente. *The Beit El-Wali Temple of Ramesses II*. Chicago, 1967.

Riederer 1974
J. Riederer. "Recently Identified Egyptian Pigments," in *Archaeometry* 16 (1974), pp. 102-109.

Riefstahl 1944
E. Riefstahl. *Patterned Textiles in Pharaonic Egypt*. Brooklyn, 1944.

Riefstahl 1948
E. Riefstahl. *Glass and Glazes from Ancient Egypt*. Brooklyn, 1948.

Riefstahl 1952a
E. Riefstahl. "An Ancient Egyptian Hairdresser," in *BBM* 13, pt. 4 (1952), pp. 7-16.

Riefstahl 1952b
E. Riefstahl. *People of the Black Land*. Brooklyn, 1952.

Riefstahl 1961
R. Riefstahl. "Ancient and Near Eastern Glass," in *Toledo Museum of Art: Museum News* 4, no. 2 (1961), p. 27-46.

Riefstahl 1967
R. Riefstahl. "The Complexities of Ancient Glass," in *Apollo* 86, no. 70 (December 1967), pp. 428-437.

Riefstahl 1972
E. Riefstahl. "A Unique Fish-Shaped Glass Vial in the Brooklyn Museum," in *JGS* 14 (1972), pp. 10ff.

Riefstahl 1975
E. Riefstahl. "An Additional Footnote on Pleating in Ancient Egypt," in *ARCE Newsletter* 92 (1975), pp. 28-29.

Riefstahl and Chapman 1970
E. Riefstahl and S. Chapman. "A Note on Ancient Fashions: From Early Egyptian Dresses in the Museum of Fine Arts, Boston," in *BMFA* 68 (1970), pp. 244-259.

Rieth 1958
A. Rieth. "Zur Technik des Bohrens im alten Agypten," in *MIO* 6 (1958), pp. 176-186.

Robins 1939
F. Robins. "The Lamps of Ancient Egypt," in *JEA* 25 (1939), pp. 184-187.

Rodenwaldt 1912
G. Rodenwaldt. *Tiryns* 2: *Die Fresken des Palastes*. Athens, 1912.

Roeder 1924
G. Roeder. *Agyptische Inschriften aus den Königlichen Museen zu Berlin* 2, pt. 1. Leipzig, 1924.

Roeder 1937
G. Roeder. *Agyptische Bronzewerke*. New York, 1937.

Roeder 1952
G. Roeder. *Volksglaube in Pharaonenreich*. Stuttgart, 1952.

Roeder 1956
G. Roeder. *Agyptische Bronzefiguren*. Berlin, 1956.

Rogers 1948
E. Rogers. "An Egyptian Wine Bowl of the XIXth Dynasty," in *BMMA* 7 (1948), pp. 154-160.

Romano 1980
J. Romano. "The Origin of the Bes-Image," in *BES* 2 (1980), pp. 39-56.

Rosellini 1834
I. Rosellini. *I Monumenti dell' Egitto e della Nubia*. Pisa, 1834.

Rosenvasser 1972
A. Rosenvasser. "The Stela Aksha 505 and the Cult of Ramesses II as a God in the Army," in *RIHAO* 1 (1972), pp. 99-114.

Roth 1913
H. Roth. *Ancient Egyptian and Greek Looms*. Halifax, 1913.

Roveri 1969
A. Donadoni Roveri. *I Sarcofagi Egizi dalle origini alla fine dell' antico regno*. Rome, 1969.

Rowe 1936
A. Rowe. *A Catalogue of Egyptian Scarabs, Scaraboids, Seals, and Amulets in the Palestine Archaeological Museum*. Cairo, 1936.

Ruffer 1919
A. Ruffer. "Food in Egypt," in *MIE* 1 (1919), pp. 1-88.

Ruffer 1921
A. Ruffer. *Studies in the Paleopathology of Egypt*. Chicago, 1921.

Ruffer 1967
A. Ruffer. "Note on the Presence of 'Bilharzia Haematobia' in Egyptian Mummies of the Twentieth Dynasty, 1250-1000 B.C.," in D. Brothwell and A. Sandison, eds., *Diseases in Antiquity: A Survey of the Diseases, Injury, and Surgery of Early Populations*. Springfield, 1967 (pp. 177ff.).

Ruffer and Ferguson 1967
A. Ruffer and A. Ferguson. "An Eruption Resembling Variola in the Skin of a Mummy of the Twentieth Dynasty (1200-1000 B.C.)," in D. Brothwell and A. Sandison, eds., *Diseases in Antiquity: A Survey of the Diseases, Injury, and Surgery of Early Populations*. Springfield, 1967 (pp. 346-348).

Ruffle 1977
J. Ruffle. *The Egyptians*. Oxford, 1977.

Rushdy 1911
M. Rushdy. "The Treading of Sown Seed by Swine," in *ASAE* 11 (1911), pp. 162-163.

Rzoska 1976
J. Rzoska. *The Nile: Biology of an Ancient River*. The Hague, 1976.

Saad 1943
Z. Saad. "Preliminary Report on the Excavations of the Department of Antiquities at Saqqara 1942-43," in *ASAE* 43 (1943), p. 449-486.

Sachs 1920
C. Sachs. *Altägyptische Musikinstrumente*. Leipzig, 1920.

Sachs 1921
C. Sachs. *Die Musikinstrumente des Alten Aegyptens*. Berlin, 1921.

Säve-Söderbergh 1941
T. Säve-Söderbergh. *Aegypten und Nubien*. Lund, 1941.

Säve-Söderbergh 1946
T. Säve-Söderbergh. *The Navy of the Eighteenth Egyptian Dynasty*. Uppsala, 1946.

Säve-Söderbergh 1950
T. Säve-Söderbergh. "Varia Sudanica," in *JEA* 36 (1950), pp. 24-40.

Säve-Söderbergh 1957
T. Säve-Söderbergh. *Four Eighteenth Dynasty Tombs*. Oxford, 1957.

St. Louis Art Museum 1975
St. Louis Art Museum. *Handbook of the Collections*. St. Louis, 1975.

Sainte Fare Garnot 1949
J. Sainte Fare Garnot. "Deux Vases égyptiens représentant une femme tenant un enfant sur ses genoux," in *Mélanges d'archéologie et d'histoire offerts à Charles Picard*. Paris, 1949 (pp. 905-916).

Sainte Fare Garnot 1955
J. Sainte Fare Garnot. "L'Offrande musicale dans l'ancienne Egypte," in *Mélanges d'histoire et d'esthétique musicales offerts à Paul-Marie Masson* 1. Paris, 1955.

Saldern 1962
A. von Saldern. "Ancient Glass at Corning," in *The Connoisseur Yearbook*. London, 1962 (pp. 24-33).

Saldern 1966
A. von Saldern. "Mosaic Glass from Hasanlu, Marlik, and Tell al-Rimah," in *JGS* 8 (1966), pp. 9-25.

Saleh 1970
J. Saleh. *Les Antiquités égyptiennes de Zagreb*. Paris, 1970.

Saleh et al. 1974
S. Saleh, Z. Iskander, et al. "Some Ancient Egyptian Pigments," in A. Bishay, ed., *Recent Advances in the Science and Technology of Materials: Second Cairo Solid State Conference 1973*. New York, 1974.

Sambon 1906
A. Sambon. *Les Verres antiques*. Paris, 1906.

Samih 1964
W. al-Din Samih. *Daily Life in Ancient Egypt*. New York, 1964.

Samson 1972
J. Samson. *Amarna*. Warminster, 1972.

Sandison 1975
A. Sandison. "Chirurgie," in *LA* 1 (1975), cols. 947-950.

Sandison 1977
A. Sandison. "Frauenheilkunde und -sterblichkeit," in *LA* 2 (1977), cols. 295-297.

Sarton 1936
G. Sarton. "On a Curious Subdivision of the Egyptian Cubit," in *Isis* 25 (1936), pp. 399-402.

Saunders 1963
J. Saunders. *The Transitions from Ancient Egyptian to Greek Medicine*. Lawrence, 1963.

Sauneron 1959
S. Sauneron. "Les Songes et leur interpretation dans L'Egypte ancienne," in *Sources Orientales* 2. Paris, 1959 (pp. 17-61).

Sayce 1922
A. Sayce. "Texts from the Hittite Capital Relating to Egypt," in *Ancient Egypt and the East*, no. 3 (1922), (pp. 65-70).

Sayre 1965
E. Sayre. "Summary of the Brookhaven Program of Analysis of Ancient Glass," in *Application of Science in the Examination of Works of Art* (by the Boston Museum of Fine Arts Research Laboratory). Boston, 1965 (pp. 145-154).

Schachermeyr 1967
F. Schachermeyr. *Ägäis und Orient*. Vienna/Cologne, 1967.

Schäfer 1905
H. Schäfer. "Die altägyptischen Prunkgefässe mit aufgesetzten Randverzierungen," in K. Sethe, ed., *Untersuchungen zur Geschichte und Altertumskunde* 4. Leipzig, 1905 (pp. 3-44).

Schäfer 1910
H. Schäfer. *Agyptische Goldschmiedearbeiten*. Berlin, 1910.

Schäfer 1919
H. Schäfer. "Agyptische Abteilung aus einem Agyptischen Kriegslager," in *Amtliche Berichte aus den Preuszischen Kunstsammlungen* 40, no. 8 (1919), pp. 155-184.

Schäfer 1932
H. Schäfer. "Die Ausdeutung der Spiegelplatte als Sonnenscheibe," in *ZAS* 68 (1932), pp. 1-7.

Schäfer 1934
H. Schäfer. "Zum Ehrengold," in *ZAS* 70 (1934), pp. 10-13.

Schäfer 1971
H. Schäfer. "Altaegyptische Pflüge, Joche, und andere Landwirtschaftliche Geräte," in *Annual of the British School at Athens*, no. 10 (1903-1904), pp. 127-143 (Klaus reprint). Liechtenstein, 1971.

Schäfer 1974
H. Schäfer. *Principles of Egyptian Art*, ed. E. Brunner-Traut, tr. J. Baines. Oxford, 1974.

Schäfer and Andrae 1925
H. Schäfer and W. Andrae. *Die Kunst des Altes Orients*. Berlin, 1925.

Schaeffer 1932
C. Schaeffer. "Le Fouilles de Minet-el-Beida et de Ras-Shamra: troisième campagne (Printemps 1931)," in *Syria* 13 (1932), pp. 1ff.

Schaeffer 1936
C. Schaeffer. "Les Fouilles de Ras Shamra-Ugarit: septième campagne (Printemps 1935)," in *Syria* 17 (1936), pp. 105-149.

Schaeffer 1949
C. Schaeffer. *Ugaritica* 2. Paris, 1949.

Schaeffer 1952
C. Schaeffer. *Enkomi-Alasia*. Paris, 1952.

Schaeffer 1954
C. Schaeffer. "Les Fouilles de Ras Shamra-Ugarit, quinzième et dix-septième campagnes (1951, 1952 et 1953)," in *Syria* 31 (1954), pp. 14-67.

Scharff 1939
A. Scharff. "Agypten," in W. Otto, ed., *Handbuch der Archäologie* 1. Munich, 1939 (pp. 433ff.).

Schiaparelli 1927
E. Schiaparelli. *Tomba Intatta dell' Architetto Cha*. Turin, 1927.

Schliemann 1881
H. Schliemann. *Ilios, The City and Cemetery of the Trojans*. New York, 1881.

Schlögl et al. 1978
H. Schlögl et al. *Geschenk des Nils. Aegyptische Kunstwerke aus Schweizer Besitz*. Basel, 1978.

Schlott 1969
A. Schlott. *Die Ausmasse Aegyptens nach altäegyptischen Texten*. Tübingen, 1969.

Schott 1972
A. Schlott. "Altägyptische Texte über die Ausmasse Agyptens," in *MDAIK* 28 (1972), pp. 109-113.

Schmitz 1978
F.-J. Schmitz. *Amenophis* 1. Hildesheim, 1978.

Schneider 1977
H. Schneider. *Shabtis*. Leiden, 1977.

Schneider and Raven 1981
H. Schneider and M. Raven. *De Egyptische Oudheid*. Leiden, 1981.

Schott, 1952
S. Schott. *Das schöne Fest vom Wüstentale*. Wiesbaden, 1952.

Schott 1958
S. Schott. "Eine Kopfstütze des Neuen Reiches," in *ZAS* 83 (1958), pp. 141-144.

Schott and Krieger 1956
S. Schott and P. Krieger. *Les Chants d'amour de l'Egypte ancienne*. Paris, 1956.

Schuler 1959
F. Schuler. "Ancient Glassmaking Techniques," in *Archaeology* 12 (1959) pp. 47-52, 116-122.

Schulman 1957
A. Schulman. "Egyptian Representations of Horsemen and Riding in the New Kingdom," in *JNES* 16 (1957), pp. 263-271.

Schulman 1964
A. Schulman. *Military Rank, Title and Organization in the Egyptian New Kingdom*. Berlin, 1964.

Schulman 1967
A. Schulman. "Ex-votos of the Poor," in *JARCE* 6 (1967), pp. 153-156.

Schulman 1970
A. Schulman. "Some Remarks on the Alleged 'Fall' of Senmūt," in *JARCE* 8 (1969-1970), pp. 29-48.

Schulman 1981
A. Schulman. "Reshep Times Two," in W. K. Simpson and W. Davis, eds., *Studies in Ancient Egypt, the Aegean, and the Sudan: Essays in Honor of Dows Dunham*. Boston, 1981 (pp. 157-166).

Scott 1939
N. Scott. "Three Egyptian Turbans of the Late Roman Period," in *BMMA* 34 (1939), pp. 229-230.

Scott 1942
N. Scott. "Egyptian Cubit Rods," in *BMMA* 1 (1942), pp. 70-75.

Scott 1944
N. Scott. "The Lute of the Singer Harmose," in *BMMA* 2 (1944), pp. 159-163.

Scott 1956
N. Scott. "Recent Additions in the Egyptian Collection," in *BMMA* 15 (1956), pp. 72-92.

Scott 1965
N. Scott. "Our Egyptian Furniture," in *BMMA* 24 (1965), pp. 129-150.

Scott 1973
N. Scott. "The Daily Life of the Ancient Egyptians," in *BMMA* 31 (1973), pp. 121-172.

Seele 1974
K. Seele. "University of Chicago, Oriental Institute Nubian Expedition: Excavations between Abu Simbel and the Sudan Border, Preliminary Report," in *JNES* 33 (1974), pp. 1-43.

Segall 1943
B. Segall. "Some Sources of Early Greek Jewelry," in *BMFA* 41 (1943), pp. 42-46.

Seidel and Wildung 1975
M. Seidel and D. Wildung. "Rundplastik des Neuen Reiches," in C. Vandersleyen, ed., *Propyläen Kunstgeschichte* 15: *Das Alte Agypten*. Berlin, 1975 (pp. 240-255).

Seipel 1975
W. Seipel. "Kleinkunst und Grabmobiliar," in C. Vandersleyen, ed., *Propyläen Kunstgeschichte* 15: *Das Alte Agypten*. Berlin, 1975 (pp. 359-385).

Sethe 1903
K. Sethe. *Urkunden des alten Reiches*. Leipzig, 1903.

Sethe 1906
K. Sethe. *Urkunden der 18. Dynastie* 1. Leipzig, 1906.

Sethe 1907a
K. Sethe. "Uber Einige Kurznamen des Neuen Reiches," in *ZAS* 44 (1907), pp. 87-92.

Sethe 1907b
K. Sethe. *Urkunden der 18. Dynastie* vol. 3, pt. 4. Leipzig, 1907.

Sethe 1910
K. Sethe. *Die Altaegyptischen Pyramidentexte* 2. Leipzig, 1910.

Sethe 1916
K. Sethe. "Die Alteste Erwähnung des Haushuhns in einem Agyptischen Texte," in *Festschrift Friedrich Carl Andreas*. Leipzig, 1916 (pp. 110-116).

Sethe 1929
K. Sethe. *Amun und die Acht Urgötter von Hermopolis. Eine Untersuchung über Ursprung und Wesen des Agyptischen Götterkönigs*. Berlin, 1929.

Sigerist 1951
H. Sigerist. *A History of Medicine* 1: *Primitive and Archaic Medicine*. New York, 1951.

Silverman 1969
D. Silverman. "Pygmies and Dwarves in the Old Kingdom," in *Serapis* 1 (1969), pp. 53-62.

Silverman 1978
D. Silverman. *Masterpieces of Tutankhamun*. New York, 1978.

Simpson 1926
D. Simpson. "The Hebrew Book of Proverbs and the Teaching of Amenophis," in *JEA* 12 (1926), pp. 232-239.

Simpson 1949
W. K. Simpson. "The Tell Basta Treasure," in *BMMA* 8 (1949), pp. 61-65.

Simpson 1953
W. K. Simpson. "New Light on the God Reshef," in
JAOS 73 (1953), pp. 86-89.

Simpson 1959
W. K. Simpson. "The Vessels with Engraved Designs
and the Repoussé Bowl from the Tell Basta
Treasure," in *AJA* 63 (1959), pp. 29-45.

Simpson 1960
W. K. Simpson. "Reshep in Egypt," in *Orientalia* 29
(1960), pp. 63-74.

Simpson 1963
W. K. Simpson. *Heka-Nefer and the Dynastic
Material from Toshka and Arminna.*
New Haven/Philadelphia, 1963.

Simpson 1965
W. K. Simpson. *Papyrus Reisner* 2. Boston, 1965.

Simpson 1969-1970
W. K. Simpson. "A Short Harper's Song of the Late
New Kingdom in the Yale University Art Gallery," in
JARCE 8 (1969-1970), pp. 49-50.

Simpson 1970
W. K. Simpson. "A Statuette of Amunhotpe III in
the Museum of Fine Arts," in *BMFA* 68 (1970),
pp. 260ff.

Simpson 1972
W. K. Simpson. "Acquisitions in Egyptian and
Ancient Near Eastern Art in the Boston Museum of
Fine Arts 1970-71," in *Connoisseur* 179 (1972),
pp. 113-122.

Simpson 1976a
W. K. Simpson. *The Mastabas of Qar and Idu.* (*Giza
Mastabas* 2). Boston, 1976.

Simpson 1976b
W. K. Simpson. *The Offering Chapel of
Sekhemankh-Ptah in the Museum of Fine Arts,
Boston.* Boston, 1976.

Simpson 1977
W. K. Simpson. *The Face of Egypt: Permanence and
Change in Egyptian Art.* Katonah, 1977.

Simpson 1978
W. K. Simpson. *The Mastabas of Kawab, Khafkhufu
I and II.* (*Giza Mastabas* 3). Boston, 1978.

Simpson et al. 1973
W. K. Simpson, E. Wente, and R. Faulkner. *The
Literature of Ancient Egypt,* 2nd ed. New Haven,
1973.

Skinner 1954
F. Skinner. "Measures and Weights," in C. Singer
et al., eds., *History of Technology* 1. Oxford, 1954
(pp. 774-784).

Skinner 1967
F. Skinner. *Weights and Measures: Their Ancient
Origins and their Development in Great Britain up
to A.D. 1855.* London, 1967.

Śliwa 1975
J. Śliwa. *Studies in Ancient Egyptian Handicraft:
Woodworking.* Warsaw/Krakow, 1975.

Smith 1912
G. Smith. *The Royal Mummies.* Cairo, 1912.

Smith 1914
G. Smith. "Egyptian Mummies," in *JEA* 1 (1914),
pp. 189-196.

Smith 1938
E. Smith. *Egyptian Architecture as Cultural
Expression.* New York, 1938.

Smith 1949
W. S. Smith. *A History of Egyptian Sculpture and
Painting in the Old Kingdom,* 2nd ed.
Oxford, 1949.

Smith 1952
W. S. Smith. "An Eighteenth Dynasty Egyptian
Toilet Box," in *BMFA* 50 (1952), pp. 74ff.

Smith 1958
W. S. Smith. *The Art and Architecture of Ancient
Egypt.* Baltimore, 1958.

Smith 1963
W. S. Smith. "The Stela of Prince Wepemnofret," in
Archaeology 16 (1963), pp. 2-13.

Smith 1965
W. S. Smith. *Interconnections in the Ancient Near
East.* New Haven, 1965.

Smith 1969
H. Smith. "Animal Domestication and Animal Cult
in Dynastic Egypt," in P. Ucko and G. Dimbleby,
eds., *The Domestication and Exploitation of Plants
and Animals.* Chicago, 1969 (pp. 307-314).

Smith 1972
H. Smith. "Society and Settlement in Ancient
Egypt," in P. Ucko, R. Tringham, and G. Dimbleby,
eds., *Man, Settlement and Urbanism.*
London, 1972 (pp. 705-720).

Smith and Dawson 1924
G. Smith and W. Dawson. *Egyptian Mummies.*
London, 1924.

Sobhy 1924
G. Sobhy. "An Eighteenth Dynasty Measure of
Capacity," in *JEA* 10 (1924), pp. 283-284.

Söderbergh 1968
B. Söderbergh. "The Sistrum, a Musicological
Study," in *Ethnos* 33 (1968), pp. 91-133.

Sotheby 1899
Sotheby & Company. *The Forman Collection:
Catalogue of the Egyptian, Greek and Roman
Antiquities... Which Will Be Sold by
Auction... 19th of June, 1899, and Three Following
Days.* London, 1899.

Sotheby 1917
Sotheby, Wilkinson and Hodge. *Catalogue of an
Important Collection of Egyptian and other
Antiquities: the Property of Field Marshall Lord
Grenfell....* London, 1917.

Sotheby 1922
Sotheby and Company. *Catalogue of the
MacGregor Collection of Egyptian Antiquities.*
London, 1922.

Sotheby 1924
Sotheby, Wilkinson and Hodge. *Sale Catalogue of
the Collection of the Reverend William Franklin
Hood* (11 November 1924). London, 1924.

Sotheby 1926
Sotheby and Company. *Catalogue of the
Collections Formed by the Late Lord Carmichael of
Skirling... Which Will Be Sold by Auction... on
Tuesday, the 8th of June, 1926, and Two Following
Days.* London, 1926.

Sotheby 1930
Sotheby and Company. *Sale Catalogue of the
Collection of Edward Towry-Whyte* (May 20,
1930). London, 1930.

Sotheby 1949
Sotheby, Parke-Bernet. *The Notable Art Collection
Belonging to the Estate of the Late Joseph
Brummer.* New York, 1949.

Sotheby 1964
Sotheby, Parke-Bernet. *Sale Catalogue of the
Ernest Brummer Collection, November 16-17, 1964.*
London, 1964.

Spalinger 1977
A. Spalinger. "On the Bentresh Stela and Related
Problems," in *SSEA Journal* 8 (1977), pp. 11-18.

Spanton 1917
W. Spanton. "The Water Lilies of Ancient Egypt," in
Ancient Egypt and the East (1917), pp. 1-20.

Speleers 1923
L. Speleers. *Recueil des inscriptions égyptiennes
des Musées royaux du Cinquantenaire à Bruxelles.*
Brussels, 1923.

Spencer 1979
A. Spencer. *Brick Architecture in Ancient Egypt.*
Warminster, 1979.

Spiegelberg 1894
W. Spiegelberg. "Ostraca Hiératiques du Louvre," in
RT 16 (1894), pp. 64-67.

Spiegelberg 1909
W. Spiegelberg. *Ausgewählte Kunst-Denkmäler der
ägyptischen Sammlung der Kaiser Wilhelms
Universität.* Strasburg, 1909.

Spiegelberg and Erman 1898
W. Spiegelberg and A. Erman. "Grabstein eines
syrischen Söldners aus Tell Amarna," ZAS 36
(1898), pp. 126ff.

Staatliche Museen 1899
Staatliche Museen. *Altes u. Neues Museum, Berlin.
Ausführliches Verzeichnis der aegyptischen
Altertümer und Gipsabgüsse,* 2nd ed. Berlin, 1899.

Staatliche Sammlung Agyptischer Kunst 1976
Staatliche Sammlung Agyptischer Kunst. *Staatliche
Sammlung Agyptischer Kunst,* 2nd ed.
Munich, 1976.

Stadelmann 1967
R. Stadelmann. *Syrisch-Palästinensische Gottheiten
in Agypten.* Leiden, 1967.

Staehelin 1966
E. Staehelin. *Untersuchungen zur ägyptischen
Tracht im Alten Reich.* Berlin, 1966.

Staehelin 1975a
E. Staehelin. "Amtstracht," in *LA* 1 (1975),
cols. 230-231.

Staehelin 1975b
E. Staehelin. "Arbeitstracht," in *LA* 1 (1975),
cols. 385-386.

Staehelin 1978
E. Staehelin. "Zur Hathorsymbolik in den
ägyptischen Kleinkunst," in *ZAS* 105 (1978),
pp. 76-84.

Steindorff 1912
G. Steindorff. *Die Blütezeit des Pharaonenreiches.*
Leipzig, 1912.

Steindorff 1928
G. Steindorff. *Die Kunst der Agypter.* Leipzig, 1928.

Steindorff 1935
G. Steindorff. *Aniba* 1. Glückstadt, 1935.

Steindorff 1937a
G. Steindorff. *Aniba* 2. New York, 1937.

Steindorff 1937b
G. Steindorff. "Ein bronzener Gefässuntersatz," in
ZAS 73 (1937), pp. 122-123.

Steindorff 1928
G. Steindorff. *Die Kunst der Agypter.* Leipzig, 1928.

Steindorff 1946
G. Steindorff. "The Magical Knives of Ancient
Egypt," in *BWAG* 9 (1946), pp. 41-51.

Steindorff and Seele 1942
G. Steindorff and K. Seele. *When Egypt Ruled the
East.* Chicago, 1942.

Stern 1976
E. Stern. "Bes Vases from Palestine and Syria," in
IEJ 26 (1976), pp. 183-187.

Sterns 1918
F. Sterns. "Some Bisharin Baskets in the Peabody
Museum," in *HAS* 2 (1918), pp. 194-196.

Steuer 1948
R. Steuer. *Wḥdw: Aetiological Principle of Pyaemia
in Ancient Egyptian Medicine.* Baltimore, 1948.

Steuer 1961
R. Steuer. "Controversial Problems Concerning the
Interpretation of the Physiological Treatises of
Papyrus Ebers," in *Isis* 52 (1961), pp. 372-389.

Steuer and Saunders 1959
R. Steuer and J. Saunders. *Ancient Egyptian and
Cnidian Medicine: The Relationship of Their
Aetiological Concepts of Disease.*
Berkeley/Los Angeles, 1959.

Störk 1977
L. Störk. "Gans," in *LA* 2 (1977), cols. 373-375.

Störk 1980
L. Störk. "Katze," in *LA* 3 (1980), cols. 367-370.

Stone and Thomas 1956
J. Stone and L. Thomas. "The Use and Distribution
of Faience in the Ancient East and Prehistoric
Europe," in *Proceedings of the Prehistoric
Society* 22 (1956), pp. 37-84.

Strauss 1974
E. Strauss. *Die Nunschale. Eine Gefässgruppe des
Neuen Reiches.* Munich/Berlin, 1974.

Stubbings 1951
F. Stubbings. *Mycenaean Pottery in the Levant.*
Cambridge, 1951.

Swiny 1980
S. Swiny. "Bronze Age Gaming Stones from
Cyprus," in *Report of the Department of
Antiquities, Cyprus* (Nicosia, 1980), pp. 54-78.

Täckholm 1952
V. Täckholm. *Faraos Blomster.* Copenhagen, 1952.

Täckholm 1961
V. Täckholm. "Botanical Identification of the Plants Found at the Monastery of Phoebammon," in Charles Bachtly, ed., *Le Monastère de Phoebammon dans le Thebaïde* 3. 1961 (pp. 1-38).

Täckholm 1974
V. Täckholm. *Students' Flora of Egypt,* 2nd ed. Beirut, 1974.

Tait 1963
G. Tait. "The Egyptian Relief Chalice," in *JEA* 49 (1963), pp. 93-139.

Taylor and Scarisbuck 1978
G. Taylor and D. Scarisbuck. *Finger Rings from Ancient Egypt to the Present Day.* London, 1978.

Tefnin 1971
R. Tefnin. "La Date de la statuette de la dame Toui au Louvre," in *CdE* 46 (1971), pp. 35-49.

Terrace 1964
E. Terrace. "Recent Acquisitions in the Department of Egyptian Art," in *BMFA* 62 (1964), pp. 49-63.

Terrace 1966
E. Terrace. " 'Blue Marble' Plastic Vessels and other Figures," in *JARCE* 5 (1966), pp. 57-63.

Terrace 1968
E. Terrace. "The Age of Empire and Rebellion: The New Kingdom in Boston," in *Connoisseur* 169 (1968), pp. 49-56.

Terrace and Fischer 1970
E. Terrace and H. Fischer. *Treasures of Art from the Cairo Museum: A Centennial Exhibition 1970-71.* London, 1970.

te Velde 1967
H. te Velde. *Seth: God of Confusion.* Leiden, 1967.

Thausing and Goedicke 1971
G. Thausing and H. Goedicke. *Nofretari: A Documentation of her Tomb and its Decoration.* Graz, 1971.

Thomas 1959
E. Thomas. "Terrestrial Marsh and Solar Mat," in *JEA* 45 (1959), pp. 38-51.

Thomas 1966
E. Thomas. *The Royal Necropoleis of Thebes.* Princeton, 1966.

Thomas 1981
A. Thomas. *Gurob: A New Kingdom Town.* Warminster, 1981.

Thorwald 1962
J. Thorwald. *Science and Secrets of Early Medicine.* New York, 1962.

Toledo Museum of Art 1967
Toledo Museum of Art. *Art in Glass: A Guide to the Glass Collections.* Toledo, 1967.

Toledo Museum of Art 1976
Toledo Museum of Art. *A Guide to the Collections.* Toledo, 1976.

Towry-Whyte 1902
E. Towry-Whyte. "Types of Ancient Egyptian Draughts-Men," in *PSBA* 24 (1902), pp. 261ff.

Tylor and Griffith 1894
J. Tylor and F. Griffith. *Ahnas and Paheri.* London, 1894.

Tytus 1903
R. de P. Tytus. *A Preliminary Report on the Re-Excavation of the Palace of Amenhetep III.* New York, 1903.

Ucko and Dimbleby 1969
P. Ucko and G. Dimbleby, eds., *The Domestication and Exploitation of Plants and Animals.* Chicago, 1969.

Van de Walle 1963
B. Van de Walle. "Une Tablette scolaire provenant d'Abydos," in *ZÄS* 90 (1963) pp. 118-123.

Van de Walle 1969
B. Van de Walle. *L'Humour dans la littérature et dans l'art de l'ancienne Egypte.* Leiden, 1969.

Van de Walle and de Meulenaere 1973
B. Van de Walle and H. de Meulenaere. "Compléments à la prosopographie médicale," in *RdE* 25 (1973), pp. 58-83.

Van der Sleen 1973
W. Van der Sleen. *A Handbook on Beads.* Liège, 1973.

Vandier 1935
J. Vandier. *La Tombe de Nefer-abou.* (MIFAO 69). Cairo, 1935.

Vandier 1949
J. Vandier. *La Réligion égyptienne,* 2nd ed. Paris, 1949.

Vandier 1955
J. Vandier. *Manuel d'archéologie égyptienne* 2. Paris, 1955.

Vandier 1958
J. Vandier. *Manuel d'archéologie égyptienne* 3. Paris, 1958.

Vandier 1964a
J. Vandier. *Manuel d'archéologie égyptienne* 4. Paris, 1964.

Vandier 1964b
J. Vandier. "Quelques Remarques sur la preparation de la boutargue," in *Kêmi* 17 (1964), pp. 26-34.

Vandier 1965
J. Vandier. "Iousaas et (Hathor)-Nebet-Hetepet," in *RdE* 16 (1965), pp. 1-142.

Vandier 1969
J. Vandier. *Manuel d'archéologie égyptienne* 5, Paris, 1969.

Vandier 1970
J. Vandier. *Les antiquités égyptiennes au Musée du Louvre,* 4th ed. Paris, 1970.

Vandier d'Abbadie 1936
J. Vandier d'Abbadie. *Catalogue des ostraca figurés de Deir el Médineh* 1. Cairo, 1936.

Vandier d'Abbadie 1937
J. Vandier d'Abbadie. *Catalogue des ostraca figurés de Deir el Médineh* 2. Cairo, 1937.

Vandier d'Abbadie 1938
J. Vandier d'Abbadie. "Une Fresque civile de Deir el Médineh," in *RdE* 30 (1938), pp. 27-35.

Vandier d'Abbadie 1946
J. Vandier d'Abbadie. *Catalogue des ostraca figurés de Deir el Médineh* 3. Cairo, 1946.

Vandier d'Abbadie 1952
J. Vandier d'Abbadie. "Cuillères à fards de l'Egypte ancienne," in *Recherches* (October 1952), no. 2, pp. 20-29.

Vandier d'Abbadie 1965
J. Vandier d'Abbadie. "Les Singes familiers dans l'ancienne Egypte, II. Le Moyen Empire," in *RdE* 17 (1965), pp. 177-188.

Vandier d'Abbadie 1966
J. Vandier d'Abbadie. "Les Singes familiers dans l'ancienne Egypte III. Le Nouvel Empire," in *RdE* 18 (1966), pp. 143-201.

Vandier d'Abbadie 1972
J. Vandier d'Abbadie. *Catalogue des objets de toilette égyptiens au Musée du Louvre.* Paris, 1972.

Vandiver 1982
P. Vandiver. "Technological Change in Egyptian Faience," in A. Franklin, ed. *Archaeological Ceramics.* Washington, 1982 (section 15).

Vávra 1954
J. Vávra. *Das Glas und die Jahrtausende.* Prague, 1954.

Velter and Lamotha 1978
A. Velter and M-J. Lamotha. *Les Outils du corps.* Milan, 1978.

Vercoutter 1956a
J. Vercoutter. *Egypte et le monde égéen préhellénique.* Cairo, 1956.

Vercoutter 1956b
J. Vercoutter. "New Egyptian Texts from the Sudan," in *Kush* 4 (1956), pp. 66-82.

Vercoutter 1959
J. Vercoutter. "The God of Kush," in *Kush* 7 (1959), pp. 120ff.

Vercoutter 1970
J. Vercoutter. *Mirgissa* 1. Paris, 1970.

Vercoutter et al. 1976
J. Vercoutter et al. *Image of the Black in Western Art 1: From the Pharaohs to the Fall of the Roman Empire.* Fribourg, 1976.

Vermeule 1964
E. Vermeule. *Greece in the Bronze Age.* Chicago, 1964.

Vermeule 1971
C. Vermeule. "Greek Vases — Early Bronze Age to the Late Archaic Period — in the Boston Museum of Fine Arts," in *Connoisseur* 177 (1971), pp. 37ff.

Vermeule 1975
E. Vermeule. *The Art of the Shaft Graves at Mycenae.* Norman, Okla., 1975.

Vermeule 1981
E. Vermeule. "Mycenaean Drawing, Amarna and Egyptian Ostraka," in W. K. Simpson and W. Davis, eds., *Studies in Ancient Egypt, the Aegean, and the Sudan: Essays in Honor of Dows Dunham.* Boston, 1981 (pp. 193ff.).

Vermeule and Wolsky 1977
E. Vermeule and F. Wolsky. "The Bone and Ivory of Toumba tou Skourou," in *Report of the Department of Antiquities, Cyprus, 1977* (Nikosia, 1977), pp. 80-96.

Vernier 1907
E. Vernier. *La Bijouterie et la joaillerie égyptiennes.* Cairo, 1907.

Vernier 1927
E. Vernier. *Bijoux et Orfèvreries.* Cairo, 1927.

Vigneau 1936
A. Vigneau. *Encyclopédie photographique de l'art* 1. Paris, 1936.

Villa Hügel 1961
Villa Hügel. *5000 Jahre Aegyptische Kunst* (by H. Müller). Essen, 1961.

Vittman 1974
G. Vittman. "Was There a Co-Regency of Ahmose with Amenophis I?" in *JEA* 60 (1974), pp. 250-251.

Volker-Carpin 1970
R. Volker-Carpin. "Poultry Farming and the Poultry Industry in Ancient Egypt," in *Veterinary Medical Review,*" no. 4 (1970), pp. 276-287.

Vollgraff 1904
W. Vollgraff. "Fouilles d'Argos," in *Bulletin de Correspondance Hellénique* 28 (1904), pp. 377ff.

von Deines and Westendorf 1962
H. von Deines and W. Westendorf. *Wörterbuch der Medizinischen Texte.* (Grundriss der Medizin der alten Agypter 7, 2.) Berlin, 1962.

von Deines et al. 1958
H. von Deines, H. Grapow and W. Westendorf. *Übersetzung der Medizinischen Texte* (Grundriss der Medizin der alten Agypter 4). Berlin, 1958.

Von Droste zu Hülshoff 1980a
V. von Droste [zu Hülshoff]. "Igel," in *LA* 3 (1980), col. 124.

Von Droste zu Hülshoff 1980b
V. von Droste zu Hülshoff. *Der Igel im alten Agypten.* Hildesheim, 1980.

Wace 1954
A. Wace. "Excavations at Mycenae," in *Papers of the British School at Athens* 49 (1954), pp. 231ff.

Wace 1956
A. Wace. "Excavations at Mycenae," in *Papers of the British School at Athens* 51 (1956), pp. 107ff.

Währen 1963
M. Währen. *Brot und Gebäck im Leben und Glauben der alten Agypter.* Bern, 1963.

Wainwright 1920
G. Wainwright. *Balabish.* London, 1920.

Wainwright 1925a
G. Wainwright. "Wooden Door and Stool from Kom Washim," in *ASAE* 25 (1925), pp. 105-111.

Wainwright 1925b
G. Wainwright. "Turnery, etc., from Kom Washim," in *ASAE* 25 (1925), pp. 112-119.

Wallert 1962
I. Wallert. *Die Palmen im Alten Agypten: Ein Untersuchung ihrer praktischen, symbolischen und religiösen Bedeutung.* Berlin, 1962.

Walters Art Gallery 1980
Walters Art Gallery. *Jewelry, Ancient to Modern.* New York, 1980.

Wanscher 1966
O. Wanscher. *The Art of Furniture: 5000 Years of Furniture and Interiors.* New York, 1966.

Ward 1902
J. Ward. *The Sacred Beetle.* New York, 1902.

Warren 1969
P. Warren. *Minoan Stone Vases.* Cambridge, 1969.

Waterer 1946
J. Waterer. *Leather.* London, 1946.

Weber 1969
M. Weber, *Beiträge zur Kenntnis Schrift- und Buchwesens der alten Agypten.* Cologne, 1969.

Weber 1977
M. Weber. ''Fliege,'' in *LA* 2 (1977), pp. 264ff.

Weeks 1979
K. Weeks. *The Anatomical Knowledge of the Ancient Egyptians and the Representation of the Human Figure in Egyptian Art* (Yale University Ph.D. dissertation, 1970). Ann Arbor, 1979.

Wegner 1950
M. Wegner. *Die Musikinstrumente des alten Orients.* Münster in Westfalen, 1950.

Weigall 1901
A. Weigall. ''Some Egyptian Weights in Professor Petrie's Collection,'' in *PSBA* 23 (1901), pp. 378-395.

Weigall 1908
A. Weigall. *Weights and Balances.* Cairo, 1908.

Weigall 1924
A. Weigall. *Ancient Egyptian Works of Art.* London, 1924.

Weinstein 1973
J. Weinstein. ''Foundation Deposits in Ancient Egypt: A Dissertation in Oriental Studies'' (University of Pennsylvania Ph.D. dissertation, 1973). Ann Arbor, 1973.

Wenig 1967
S. Wenig. *Die Frau im alten Agypten.* Leipzig, 1967.

Wenig 1978a
S. Wenig. *Africa in Antiquity: The Arts of Ancient Nubia and the Sudan 1: The Essays.* Brooklyn, 1978.

Wenig 1978b
S. Wenig. *Africa in Antiquity: The Arts of Ancient Nubia and the Sudan 2: The Catalogue.* Brooklyn, 1978.

Wente 1962
E. Wente. ''Egyptian 'Make Merry' Songs Reconsidered,'' in *JNES* 21 (1962), pp. 118-128.

Wente 1963
E. Wente. ''Two Ramesside Stelas Pertaining to the Cult of Amenophis I,'' in *JNES* 22 (1963), pp. 30-36.

Wente 1967
E. Wente. *Late Ramesside Letters.* Chicago, 1967.

Wente 1975-1976
E. Wente. ''A Misplaced Letter to the Dead,'' in *Orientalia Lovaniensia Periodica* 6-7 (1975-1976), pp. 596-600.

Werbrouck 1939
M. Werbrouck. ''Les Multiples Formes du dieu Bès,'' in *Bulletin des Musées Royaux d'art et d'histoire* 11 (1939), pp. 78-82.

Westendorf 1975
W. Westendorf. ''Augenheilkunde,'' in *LA* 1 (1975), cols. 560-562.

Western 1973
A. Western. ''A Wheel Hub from the Tomb of Amenophis III,'' in *JEA* 59 (1973), pp. 91-94.

Whitaker 1967
I. Whitaker. *Crafts and Craftsmen.* Dubuque, 1967.

Wild 1966
H. Wild. ''Brasserie et panification au tombeau de Ti,'' in *BIFAO* 64 (1966), pp. 95-121.

Wild 1975
H. Wild. ''Backen,'' in *LA* 1 (1975), cols. 594-598.

Wildung 1977
D. Wildung. *Egyptian Saints: Deification in Pharaonic Egypt.* New York, 1977.

Wilkinson 1837
J. Wilkinson. *The Manners and Customs of the Ancient Egyptians* 2. London, 1837.

Wilkinson 1883a
J. Wilkinson. *The Manners and Customs of the Ancient Egyptians* 1. Boston, 1883.

Wilkinson 1883b
J. Wilkinson. *The Manners and Customs of the Ancient Egyptians* 2. Boston, 1883.

Wilkinson 1883c
J. Wilkinson. *The Manners and Customs of the Ancient Egyptians* 3. Boston, 1883.

Wilkinson 1971
A. Wilkinson. *Ancient Egyptian Jewellery.* London, 1971.

Wilkinson 1979
C. Wilkinson. ''Egyptian Wall Paintings: The Metropolitan Museum's Collection of Facsimiles,'' in *BMMA* 36 (1979), pp. 1-56.

Williams 1913
C. Ransom Williams. ''Egyptian Furniture and Musical Instruments,'' in *BMMA* 8 (1913), pp. 72-79.

Williams 1918
C. Ransom Williams. ''The Egyptian Collection in the Museum of Art at Cleveland, Ohio,'' in *JEA* 5 (1918), pp. 166-178, 272-285.

Williams 1920
C. Ransom Williams. ''An Egyptian Chair in the Anderson Collection,'' in *New-York Historical Society Quarterly Bulletin* 4, no. 3 (October 1920), pp. 67-70.

Williams 1924
C. Ransom Williams. *Gold and Silver Jewelry and Related Objects.* New York, 1924.

Williams 1972
R. Williams. ''Scribal Training in Ancient Egypt,'' in *JAOS* 92 (1972), pp. 214-221.

Williamson 1974
W. Williamson. ''The Scientific Challenge of Ancient Glazing Techniques,'' in *Earth and Mineral Sciences* 44 (1974), pp. 17-22.

Wilson 1947
J. Wilson. ''The Artist of the Egyptian Old Kingdom,'' in *JNES* 6 (1947), pp. 231-249.

Wilson 1948
J. Wilson. ''The Oath in Ancient Egypt,'' in *JNES* 7 (1948), pp. 129ff.

Wilson 1951
J. Wilson. *The Culture of Ancient Egypt.* Chicago, 1951.

Wilson 1962
J. Wilson. ''Medicine in Ancient Egypt,'' in *Bulletin of the History of Medicine* 36 (1962), pp. 114-123.

Wilson 1964
P. Wilson. ''The Home Forum,'' in *Christian Science Monitor* (March 18, 1964), p. 6.

Wilson 1975
V. Wilson. ''The Iconography of Bes in Cyprus and the Levant,'' in *Levant* 7 (1975), pp. 77-103.

Winlock 1922
H. Winlock. ''Excavations at Thebes'' in *BMMA Egyptian Supplements* (December 1922), pp. 19-48.

Winlock 1926
H. Winlock. ''The Museum's Excavations at Thebes,'' in *BMMA Egyptian Supplements* (March 1926), p. 5.

Winlock 1932a
H. Winlock. ''The Egyptian Expedition 1930-1931,'' in *BMMA Egyptian Supplements* (March 1932), pp. 3ff.

Winlock 1932b
H. Winlock. *The Tomb of Queen Meryet-Amun at Thebes.* New York, 1932.

Winlock 1933
H. Winlock. ''Elements from the Dahshūr Jewelry,'' in *ASAE* 33 (1933), pp. 135-139.

Winlock 1934
H. Winlock. *The Treasure of El Lāhūn.* New York, 1934.

Winlock 1936a
H. Winlock. ''An Egyptian Flower Bowl,'' in *MMS* 5 (1936), pp. 147ff.

Winlock 1936b
H. Winlock. *A Special Exhibition of Glass in the MMA.* New York, 1936.

Winlock 1941
H. Winlock. *Material Used at the Embalming of King Tut-'ankh-amūn.* New York, 1941.

Winlock 1942
H. Winlock. *Excavations at Deir el Bahari, 1911-1931.* New York, 1942.

Winlock 1948
H. Winlock. *The Treasure of Three Egyptian Princesses.* New York, 1948.

Winlock 1955
H. Winlock. *Models of Daily Life in Ancient Egypt from the Tomb of Meket-Re at Thebes.* Cambridge, 1955.

Woldering 1967
I. Woldering. *Gods, Men and Pharaohs.* Fribourg, 1967.

Wolf 1930
W. Wolf. ''Das ägyptische Kunstgewerbe,'' in H. Bossert, *Geschichte des Kunstgewerbes aller Zeiten und Völker* 4. Berlin, 1928-1930 (pp. 48-142).

Wolf 1931
W. Wolf. *Das schöne Fest von Opet.* Leipzig, 1931.

Wolf 1957
W. Wolf. *Die Kunst Aegyptens: Gestalt und Geschichte.* Stuttgart, 1957.

Woolley 1922
C. Woolley. ''Excavations at Tell el-Amarna,'' in *JEA* 8 (1922), pp. 48ff.

Woolley 1934
C. Woolley. *Ur Excavations* 2: *The Royal Cemetery.* Philadelphia, 1934.

Wreszinski 1912
W. Wreszinski. *Der Londoner Medizinische Papyrus und der Papyrus Hearst.* Leipzig, 1912.

Wreszinski 1913a
W. Wreszinski. *Der Papyrus Ebers.* Leipzig, 1913.

Wreszinski 1913b
W. Wreszinski. *Vom altägyptischen Kunstgewerbe.* Berlin, 1913.

Wreszinski, 1923
W. Wreszinski. *Atlas zur altaegyptischen Kulturgeschichte* 1. Leipzig, 1923.

Wreszinski 1926
W. Wreszinski. ''Bäckerei,'' in *ZAS* 61 (1926), pp. 1-15.

Wreszinski 1935
W. Wreszinski. *Atlas zur altaegyptischen Kulturgeschichte* 2. Leipsig, 1935.

Wulff 1966
H. Wulff. *The Traditional Crafts of Persia.* Cambridge, 1966.

Wulff et al. 1968
H. and H. Wulff and L. Koch. ''Egyptian Faience—A Possible Survival in Iran,'' in *Archaeology* 21 (1968), pp. 98ff.

Yoyotte 1968
J. Yoyotte. *Treasures of the Pharaohs.* Geneva, 1968.

Yoyotte 1968b
J. Yoyotte. ''Une Théorie étiologique des médecins égyptiens,'' in *Kêmi* 18 (1968), pp. 78ff.

Zaky and Iskander 1942
A. Zaky and Z. Iskander. ''Ancient Egyptian Cheese,'' in *ASAE* 41 (1942), pp. 295-313.

Zervos 1956
C. Zervos. *L'Art de la Crète.* Paris, 1956.

Zeuner 1954
F. Zeuner. ''Domestication of Animals,'' in C. Singer et al., eds., *History of Technology* 1. Oxford, 1954 (pp. 327-352).

Ziegler 1977
C. Ziegler. ''Le Sistre d'Henouttaouy,'' in *Revue du Louvre* 27, no. 1 (1977), pp. 1-4.

Ziegler 1979
C. Ziegler. *Les Instruments de musique égyptiens du Musée du Louvre*. Paris, 1979.

Zivie 1977
A.-P. Zivie. "Un Fragment de coudée de la XIXe dynastie," in *RdE* 29 (1977), pp. 215-223.

Zivie 1979
A.-P. Zivie. "Nouveau aperçus sur les 'coudées votives,'" in *Hommages à Serge Sauneron* 1. Cairo, 1979 (pp. 319ff.).

Zonhoven 1979
L. Zonhoven. "The Inspection of a Tomb at Deir el-Medîna (O. Wein Aeg. 1)," in *JEA* 65 (1979), pp. 89-198.

Concordance

(Objects listed by lender)

accession number	catalogue number
Walters Art Gallery, Baltimore	
42.196	352
47.1a-b	170
48.426a-b	157
48.459	11
48.1534	155
48.1608a-b	153
57.1474	340
57.1475	339
The Bancroft Library, University of California, Berkeley	
none	406
Lowie Museum of Anthropology, University of California, Berkeley	
LMA 5-2100	277
LMA 6-6562	57
LMA 6-6728	53
LMA 6-7916	54
LMA 6-8557	52
LMA 6-15174	390
LMA 6-22018	320
LMA 6-22230	151
LMA 6-22231	150
LMA 6-22882	354
LMA 6-22915a-b	305
Agyptisches Museum, Berlin	
1016	61
2774	213
4562	140
6772	283
6910	196
6913	136
6931	202
7004	100
7100	365
9532	368
10756	371
12552	41
13156	84
14348	204
14476	405
20995	130
21530	99
22597	72
Museum of Fine Arts, Boston	
72.516	119
72.555	114
72.571	122
72.740	375
72.788	270
72.789	395
72.1370	66
72.1415	169
72.1427	62
72.1482	165
72.1500	65
72.1522	142
72.2611	359
72.2620	357
72.2875	346a
72.2915	345
72.3885	360
72.4158	287
72.4167	381
72.4308	288
72.4310	101
72.4330	271
72.4341	229
72.4343	203
72.4738a-b	131
72.4748	98
72.4757c	97

accession number	catalogue number
87.548	68
91.141a-b	132
94.254	361
95.1420	134
98.942	420
99.450	182
99.451	182
00.701a-b	266
00.702	161
00.711a-c	4
00.713	272
00.7268	127
00.7269	127
01.7273a-b	115
01.7317	228
01.7318	278
01.7324	273
01.7325	394
01.7353	278
01.7355	261
01.7396	145
01.7426	32
02.525	404
03.1035	199
03.1036a-b	200
03.1536a-d	128
03.1720	201
03.1721	201
04.1868	123
04.1882a-b	121
06.2493	358
06.2498	378
09.376	149
09.650	56
11.982	348
11.1468	91
11.2425a-b	263
11.2940	67
11.3003	51
11.3009	59
11.3095	370
11.3096	370
11.3097	370
18.219	325
19.1550	55
20.1799	20
24.1785	86
24.1787	223
24.1788	289
27.787	416
27.872	214
27.884	349
27.895	314
27.896	314
27.1438	8
29.1151	355
29.1188	369
29.1197	215
29.1198	216
29.1199	418
29.1201	105
29.1204	104
29.1206	393
36.493	343
37.10	388
37.11	73
37.552a-c	94
39.733	12
45.969	311
48.296	240
49.1918	205
52.1978	315
57.152	209
57.444	344

accession number	catalogue number
62.810	328
64.9	70
143.64	164
67.1134	318
67.1137	319
1970.9	162
148.70	380
1974.2	250
226.1974	396
1976.784	383
1977.619	139
1978.303	342
1978.521	356
1978.565	208
1978.691	192
1979.47	341
1979.159	171
1979.204	141
1981.281	126
1981.282	234

The Brooklyn Museum

accession number	catalogue number
11.671.1	282
11.671.2	282
16.68	386
37.40E	37
37.41E	45
37.316E	179
37.440E	46
37.559E	180
37.600E	237
37.605E	247
37.608E	251
37.710E	350
37.725E	331
37.744E	292
37.826E	332
37.827E	335
37.1444E	195
37.1749E	413
40.522	307
48.27	15
48.162	176
48.181	379
49.8	7
49.51	284
49.53	401
52.148.1	5
52.148.2	6
52.149a-b	306
54.1	409
57.64	197
58.28.6	298a
59.2	74
59.18	353
60.27.1	218
61.192	351
65.133	21

Musées Royaux d'Art et d'Histoire, Brussels

accession number	catalogue number
E. 580	397
E. 3102	152
E. 4138	147
E. 4991	117
E. 5336	58
E. 6369	384
E. 6852	63
E. 7041	35
E. 7308	9
E. 7534	308
E. 8420	181

Fitzwilliam Museum, Cambridge

accession number	catalogue number
E. 1.1938	183
E. 13.1947	330
E. 14.1901	285
E. 67a.1939	324
E. 67c.1937	49
E. 68.1937	48
E. 72.1932	267
E. 152.1932	221
E. 176.1900	322
E. 320.1939	297a
E. 322.1939	298c
E. 324.1939	298d
E. 343.1954	286
E. 383h.1939	299
E. 423.1932	10
E. 426.1932	118
E. 460.1939	194
EGA 30.1947	337
EGA 103.1947	338
EGA 125.1949	232
EGA 224.1947	290
EGA 281.1947	300
EGA 2591.1943	303
EGA 2600.1943	301
EGA 3002.1943	415
EGA 4290.1943	417
EGA 4298.1943	3
EGA 4572.1943	219
EGA 6374.1943	346d
EGA 6375.1943	346b
EGA 6376.1943	346c

Field Museum of Natural History, Chicago

accession number	catalogue number
30177b	106
30912	79
31008	419
31551	392
31718	198

The Oriental Institute Museum, University of Chicago

accession number	catalogue number
532	13
1058/2	222
13591	382
16528	24
18284	207
21044	50
1978.1.8	82

Cleveland Museum of Art

accession number	catalogue number
14.625	120
14.680	398
20.1977	81
20.2002	407

The Corning Museum of Glass

accession number	catalogue number
55.1.59	178
59.1.7	174
59.1.44	297b

Detroit Institute of Arts

accession number	catalogue number
48.142	110
48.143	111

Baker Museum of Furniture Research, Grand Rapids

accession number	catalogue number
none	39

Kestner-Museum, Hannover

accession number	catalogue number
2938	410
1935.200.168	2
1951.54	399

Pelizaeus-Museum, Hildesheim

accession number	catalogue number
380	408
4544	412
4887	75

accession number	catalogue number

Rijksmuseum van Oudheden, Leiden

A 116 A/F 176/E.xix	238
A AL 26/H385/E.xlii 139	116
AD 14/H118/E.xlii 38	143
AH 148/H546/E.xxvi 2	260
Ao1e/G53-54/E.xl. 12a	304
AT 35/H463/E.xlii 61	64

Merseyside County Museums, Liverpool

M11187	279
M11568	193
M13516	249
44.12.17	264
56.20.576	334
56.21.603	76
1977.108.2	329
1977.108.4	313
1977.108.6a,b	293
1977.108.9a,b	295
1977.109.20	403

British Museum, London

589	414
2472	40
2476	42
2482	43
5114	366
5337	280
5966	248
18156	47
22730	168
22731	160
22834	23
22878	400
24391	265
24661-24676	374
26226	148
32723	333
51068	274
54317-8	294
66824	275
66840	326
68539	18

Science Museum, London

1929-657	31

University College, London, Petrie Museum

1935-421	33d
1935-421	33a
1935-427	33b
1935-468	36
8448	109
8539	112
14210	239
14365	243
14366	246
22909-20	172
26935	227
27746	347
28052	113
29019	34
30134	226
30135	224
30136	281

Victoria and Albert Museum, London

1006-1868	185
1011-1868	175

Mr. and Mrs. E. Kofler-Truniger, Lucerne

411F	253
K2700A	138

Manchester Museum, University of Manchester (England)

659	167
2950	124
2954	125
6231a-f	376
8598	217
11172	262

Staatliche Sammlung Agyptischer Kunst, Munich

473	236
630	173
1575	158
1576	154
2945	186
5520	19

The Metropolitan Museum of Art, New York

10.130.1540	296
11.150.34	28
15.6.47	321
26.2.47	242
26.7.839	22
26.7.1142	302
26.7.1176	184
26.7.1180	188
43.2.1	363
55.92.2	80

Norbert Schimmel, New York

197	372
199	252

Frederick Stafford, New York

none	362

Ashmolean Museum of Art and Archaeology, Oxford

E.2431	90
E.2775	87
1890.823	402
1913.480	268
1921.1309	323
1922.77	163
1923.622	255
1924.74	77
1959.438	189
1961.232	411
1961.536	387

Musée du Louvre, Paris

AF 2352	336
AF 2624	191
AF 8276	156
E 3163	108
E 3217	254
E 3610	159
E 5357	1
E 11124	257
E 11224	187
E 11610	190
E 12659	89
E 14372	144
E 14437	38
E 14446	129
E 14470	364
E 14482	133
E 14500	210
E 14551	93
E 14554	96
E 14654	44
E 14673	95
E 16324	92
E 16414	137
N 713	107
N 882	83
N 1359	230

N 1376	135
N 1446	367
N 1447a-b	367
N 1538	30
N 1715	231
N 1725a	241
N 1738	245
N 1749	258
N 1750	244
N 1960a	327
N 2320	377
N 2915	389
N 3028	391

University Museum, Philadelphia

E. 2470	317
E. 6761	88
E. 9260	259
E. 9947	78
E. 11156	146
E. 14187	276
E. 14198	235
E. 14237	103
E. 14369a,b	71
E. 15426	85
E. 15436	102
E. 15789	310

The Art Museum, Princeton University

52.87	69

The St. Louis Art Museum

16.1940	309
177.1925	166

Toledo Museum of Art

25.744	17
51.405	177
53.152	256

Royal Ontario Museum, Toronto

905.2.103	211
906.6.9	16
906.6.10-11	29
907.18.26	26
907.18.31	14
907.18.45	212
907.18.54	25
907.18.280	27
909.80.17	298b
909.80.517	225
910.2.62	60
910.4.35	206
910.81.6	312
910.100.5	373
910.139.1	33c
910.165.773	269
913.55	233
922.8.56	316
929.52.13	220
948.34.156	385
979.2.45	291

979x2.45	

Addenda and Errata

p. 13: For "Christine Ziegler" read "Christiane Ziegler"

p. 55, cat. 26: For "Height 16.2 cm." read "Height 18.2 cm." For accession number "907.18.26" read "907.18.25"

p. 59, cat. 30: For "cubit is painted black" read "cubit is dark brown"

p. 60, caption below picture: For "31" read "31, 33"

p. 61, cat. 32: picture is upside down

p. 95, cat. 75, footnote 3: For "18931-41292" read "1983 1-41 292"

p. 101, right column: For "hedgehog vase (see cat. 89)" read "hedgehog vase (see cat. 87)"

p. 109, center column: For "(e.g. *bedduka*)" read "(Eg. *bedduka*)"

p. 132, cat. 127: For "(cat. 26)" read "(cat. 261)"

p. 146, cat. 145: For "see cats. 26, 115, 127, 261, and 278" read "see cats. 115, 127, 261, and 278"

p. 150, cat. 156: For "lotus blossoms and mandrake" read "lotus blossoms and poppies"

p. 200, middle column: For "each thigh (cat. 143)" read "each thigh (cat. 218)"

p. 210, cat. 248: For "lotus, see cat. 138)" read "lotus, see cat. 139)"

p. 224, middle column: For "gurds" read "guards"

p. 227, right column: After "probably dates from Dynasty 12" add footnote 1a, which reads "According to Janine Bourriau, who is preparing a publication of the tomb group."

p. 229, cat. 295: Examination has revealed that the material of the earrings is copper.

p. 230, cat. 295: For "gold wire" read "copper wire"

p. 230, cat. 296: For "(see cat. 293)" read "(see cat. 295)"

p. 241, cat. 323: For "(see cat. 318)" read "(see cat. 313)"

p. 246, cats. 334 and 336: photos reversed

p. 265, right column: For "reproduced with cat. 371" read "reproduced with cat. 375"

p. 269, cat. 374: After "in the netherworld" delete "(see p. 223)"

p. 272, left column: For "As noted above (p. 268)" read "As noted above (p. 269)"

p. 286, cat. 394: At the end of entry add initials "D.P.S."

p. 288, cat. 398: For "Amen-em[Opet]." read "Amenem[opet]." and for "Amenem opet" read "Amenemopet"

p. 290, right column: For "have sufficed thus many" read "have sufficed. Thus many"

p. 292, cat. 401: Upon examination of the actual bottle it seems likely that the object in the right hand of the woman is indeed a horn vessel with a spoon tip.

p. 292, cat. 402: For "(cf. cat. 405)" read "(cf. cat. 401)"

pp. 293-4, cat. 405: For "(cf. cat. 366 and pp. 102-103)" read "(cf. cat. 366)"

p. 305, cat. 415: According to Morris Bierbrier, the name of the son is probably "Pen-nub" rather than "Saen. . ."

p. 309: The top line of the inscription on cat. 351 has been omitted.

p. 315: Between "British Museum 1922" and "British Museum 1930" add "British Museum 1927/R.L.H. 'Egyptian Antiquities,' in *British Museum Quarterly* 2 (1937), pp. 63-64."

p. 319, "Gabra 1935": For "S. Gami" read "S. Gabra" and for "fasc. 1" read "fasc. 2"

p. 321, "Hickmann 1965b": After "Hickmann 1956a" read "Hickmann 1956b"

p. 323: Insert "Koenigsberger 1936" after "Königliche Museen 1897"

For "Roemer-und Pelizaeus-Museum" throughout read "Pelizaeus Museum"

We would also like to thank Dr. Wilma Witherspoon for advice and suggestions.